SECOND EDITION

Only Connect

A Cultural History
of Broadcasting
in the United States

Michele Hilmes

University of Wisconsin–Madison

THOMSON

WADSWORTH

Australia • Brazil • Canada • Mexico • Singapore • Spain
United Kingdom • United States

THOMSON
WADSWORTH

Only Connect: A Cultural History of Broadcasting in the United States
Second Edition
Michele Hilmes

Publisher: Holly J. Allen
Editorial Assistant: Meghan Bass
Senior Technology Project Manager: Jeanette Wiseman
Senior Marketing Manager: Mark Orr
Marketing Assistant: Alexandra Tran
Marketing Communications Manager: Shemika Britt
Project Manager, Editorial Production: Lori Johnson
Creative Director: Rob Hugel
Executive Art Director: Maria Epes

Print Buyer: Karen Hunt
Permissions Editor: Bob Kauser
Production Service and Compositor: Integra
Photo Researcher: Sarah Evertson, Image Quest
Copy Editor: Christianne Thillen
Cover Designer: Irene Morris
Cover Image: SuperStock
Text and Cover Printer: Transcontinental Printing/Louiseville

Library of Congress Control Number: 2005935697

ISBN 0-495-05036-9
ISBN 978-0-495-05036-0

Thomson Higher Education
10 Davis Drive
Belmont, CA 94002-3098
USA

For more information about our products, contact us at:
Thomson Learning Academic Resource Center
1-800-423-0563

For permission to use material from this text or product, submit a request online at **http://www.thomsonrights.com**.

Any additional questions about permissions can be submitted by e-mail to **thomsonrights@thomson.com**

Contents

Chapter 7
At Last Television, 1934 to 1955 144

Chapter 9
The Classic Network System, 1965 to 1975 **208**

Chapter 10
Rising Discontent, 1975 to 1985 **243**

Chapter 12

Everything That Rises Must Converge: Regulation and Industry in a New Millennium 325

Chapter 13

Convergence Culture in the New Millennium 362

Chapter 14

Conclusion: TV after TV **388**

Preface

Only Connect traces the history of U.S. broadcasting in its cultural context. Each chapter opens with an overview of the social tensions of a particular historical period, looks at the media environment surrounding broadcasting, and proceeds to examine not only industrial and regulatory developments but also the rich texture of programming innovations, the audiences they created, and the debates they provoked. Some chapters depart from this structure, or change the sequence of the sections slightly, where it seems to be called for by the unique characteristics of the period under discussion.

For the second edition, I have attempted to take the lessons of the last 10 years toward a more integrated global view of American broadcasting history, making connections where I can to the experience of other nations, and in the final chapters drawing the reader's focus as much as possible to the increasingly flexible borders and boundaries that mark our twenty-first-century media experience. I have included the work of recent historians and analysts, and have attempted to chart the enormous explosion of new possibilities, policies, and uses sparked by the proliferation since 2000 of digital technology. I have also tried to incorporate the sensibility of a post-9/11 world, very different from the 1999–2000 boom years in which the first edition was written.

Uniquely, this book employs a Connection, or case study approach. Each Connection, and there are two or three in each chapter, goes into a particular issue, event, program, or influential figure in depth, as an illustration of the larger picture the chapter has sketched out. Most Connections are based on the work of one or two historians whose research has broken important ground in the field, and I encourage readers to consult their publications directly for deeper insights than this broad overview can accommodate. The purpose of the Connection structure is not only to illustrate key developments in broadcasting history in all their fascinating detail, but to point to significant works in this vital field and to encourage readers to think about history as a lively area of scholarship and debate, not as inert facts in a static past.

Only Connect seeks to place broadcasting in a detailed web of social, political, and cultural connections that inform and illuminate what takes place in the studio, on the screen, and in the living rooms of the nation. In doing so, it highlights the tensions and contradictions that run through broadcasting's history, bringing out social struggles, utopian and dystopian visions of media power, attempts to restrict what can be said and heard over the air, and disputes ever opening up the airwaves to a more democratic and increasingly global system of voices and images. This history views broadcasting as a central and crucial arena in which American culture has been defined and debated, and through which both our largest and smallest concerns are played out. Though this volume's focus on American broadcasting reflects the highly nationalized context within which broadcasting debuted and was brought under control around the world in the twentieth century, it traces the course of broadening and reaching out that characterizes the larger story of broadcast and electronic media as they move into their second century.

I argue that media are not just a part of our history; they *are* our history. Across the media our social and cultural memories and experiences are performed, constructed, preserved, retrieved, and mobilized to make meaning. To "kill your television" is essentially to discount and destroy your contact with life as it is lived in the twentieth and twenty-first centuries—a deeply antisocial act. Instead, we should engage with our media and work toward understanding their functions and uses.

Only Connect is an interventionist history, seeking to generate questions as much as to provide answers. To write in this way is not to imply that previous histories have nothing to teach us: They do. They taught me, and I have drawn heavily from many of them in researching this book. Throughout, the work of Christopher Sterling and John Kitross, in *Stay Tuned: A Concise History of Broadcasting in the United States*, 3rd edition (Erlbaum 2002), has provided a basic reference point and remains one of the most comprehensive sources for U.S. broadcasting history, particularly in the areas of policy and industry structure. I owe them a great debt in this book. Similarly, Erik Barnouw's masterful three-volume history has inspired generations of students to pursue the study of the fascinating mélange that is broadcasting in this country; all of us draw on his work and particularly admire the progressive vision he brings to the role media can, and should, play in a democratic system (*A History of Broadcasting in the United States*, Oxford 1966, 1968, 1970). I am also appreciative of Michael Emery and Edwin Emery's sweeping *The Press and America*, 8th edition (Simon & Schuster 1996) for a cultural interpretation of the history of print media. Other historians without whose reference works the field would be much impoverished include John Dunning (*On the Air: The Encyclopedia of Old-Time Radio*, Oxford 1998), Tim Brooks and Earle Marsh (*The Complete Directory to Prime Time Network TV Shows 1946–Present*, Ballantine Books 1982), Alex McNeil (*Total Television*, Penguin Books 1996), Harry Castleman and Walter J. Podrazik (*The TV Schedule Book*, McGraw-Hill 1984), and Harrison B. Summers (editor, *A Thirty Year History of Programs Carried on National Radio Networks in the United States, 1926–1956*, Arno 1971). For general background reading on U.S. history, nothing is more useful than Howard Zinn's *The Twentieth Century: A People's History* (Harper 1988). There are also many scholars whose works I have featured in the Connection sections of this book, or included in the text, who have done important and groundbreaking work in the field of media studies. I'd like to thank them all, and hope that they in turn will find this book of use.

ACKNOWLEDGEMENTS

The people who helped me in the writing, revision, and publication of this volume are numerous and have not only inspired and guided my work but have saved me from some really embarrassing errors. Special thanks go to Jennifer Wang and Jason Mittell, my first readers, who provided more helpful suggestions than I can enumerate and caught more mistakes than I will ever fully admit to! Douglas Battema supplied a thoroughgoing critique and, crucially, a depth of background on the history of sports in the media, which this writer badly needed. Caryn Murphy aided crucially in the revision of the text for the second edition. Thanks also to my readers through Wadsworth, whose reviews guided my revisions. They are Douglas Battema, University of Wisconsin at Madison; Susan L. Brinson, Auburn University; Steven Classen, California State University at Los Angeles; Susan Douglas, University of Michigan; William E. Loges, University of Southern California; Anna McCarthy, New York University; Edward Morris, Columbia College at Chicago; Lisa Parks, University of California at Santa Barbara; Michael K. Saenz, University of Iowa; Thomas Schatz, University of Texas at Austin; Reed W. Smith, Georgia Southern University; and Thomas Volek, University of Kansas. Karen Austin, my former editor at Wadsworth, helped to bring this project to fruition through her enthusiasm and support; without her it wouldn't have happened. I owe Holly

Allen and her editorial team at Wadsworth Thomson many thanks for their shepherding of the book through its launch and revision into a second edition. I appreciate the careful work of production editor Kalpalathika Rajan. Copy editor Christianne Thillen made this edition a much more elegantly worded text.

I also wish to thank all those who have adopted this volume over the last five years. Your comments—and, often, corrections and reminders—have inspired and motivated me to rethink and revise. This edition is markedly better for your interventions. Please keep sending them in! I am most pleased to think of this book as a collaborative effort, a joint effort of not just the one historian writing these words but of all the teachers, colleagues, students, friends, family, and readers whose interactions with this work make it a meaningful text.

Overall, I dedicate this book to my colleagues and students, past and present, at the University of Wisconsin–Madison. Without the scholarly environment that they have created—with its truly impressive array of ideas, theories, research, publication, discussion and, yes, argument—my own intellectual life would be greatly diminished. I believe the last 12 years working at Madison have taught me more than any other academic experience of my life, and I'm grateful to be part of this lively, provocative, and productive group. As our former graduate students go out to universities and occupations around the world, I am proud to be able to cite their work and contributions in my own scholarship and to know that they are influencing generations of students in turn. I am particularly grateful to the College of Letters and Science at the University, and to my colleagues in the Communication Arts Department, for granting me the sabbatical leave that made it possible to write this volume. And I could never have taken it on—as with so much in my life—without the support and lively encouragement of my husband Bruce and daughter Amanda. They are my inspirations. I offer this second edition to the memory of my mother, Rosemary Lanahan Hilmes, who passed away in the spring of 2005.

We cannot truly understand the workings of broadcasting, our most pervasive medium, if our histories focus only on the stories of the few at the top and ignore the many oppositions and uprisings of subordinate groups as they have struggled for a stronger position in our imperfect democracy, through our imperfect media. Though I have only glancingly alluded to it, I hope my strong commitment to a more perfect and egalitarian political system, with democracy as its base and a vital and diverse media to support it, has come through clearly in this work. *Only Connect* seeks to demonstrate the ways in which the United States has developed, struggled, argued, and connected through its broadcast media in particular. First radio, then television, now supplemented by the Internet, have both united and divided us as a nation and as citizens of the world. Yet I believe the overall progression (not without serious remissions) from a controlled paucity of authoritarian voices to a more diverse, open, and inclusive system is the good news of the twentieth century. It didn't happen without work, debate, and conflict, and many signs at the beginning of the twenty-first century point to a renewed danger of concentration of control and closing off of democratic possibilities. However, as I note in the concluding chapter, it is heartening to see the amazing creativity and inventiveness not only in technology but in conceptualizations and use that ordinary people, given the chance, can make of even the most adverse systems. History teaches us this lesson again and again. I can only hope that this volume might contribute to the reimagining of the future through the revision of our stories of the past.

MAKING HISTORY

The title of this book, *Only Connect*, comes from *Howards End*, a novel written by British author E. M. Forster in 1910. You may have seen the film produced in 1992 by Merchant Ivory and released to much critical success in the United States. It's about the intersecting lives of three families in Edwardian England—the romantic, liberal Schlegels; the wealthy, conservative Wilcoxes; and the poor, struggling Basts—who meet by chance and who, through a series of accidents and misunderstandings, find their lives forever altered.

Forster opens the book with the phrase "Only connect ..." above the first paragraph, and the process of making connections—between actions and their outcomes, between rich and poor, between the past and the present—creates all manner of problems for the characters.

In the book's climactic scene, Margaret Schlegel tries to make Henry Wilcox see that his behavior affects the lives of others. He doesn't see the connection between his own adulterous affair with Mrs. Bast, which ruined her life and her husband's, and his condemnation of Margaret's sister Helen's out-of-wedlock pregnancy.

> "Not any more of this!" she cried. "You shall see the connection if it kills you, Henry! You have had a mistress—I forgave you. My sister has a lover—you drive her from the house. Do you see the connection? Stupid, hypocritical, cruel—oh, contemptible!—a man who insults his wife when she's alive and cants with her memory when she's dead. A man who ruins a woman for his pleasure, and casts her off to ruin other men.... These men are you. You can't recognize them, because you cannot connect.... Only say to yourself: 'What Helen has done, I've done.'" (Forster 1973, 305)

Henry Wilcox here stands for the inequities and blind spots of a whole way of life in early twentieth-century England, a time during which change took place so rapidly that people's values, beliefs, and perceptions could barely keep up. It takes a while longer for Henry and the other characters to realize the results of these failed connections, but by the end of the book Margaret and Henry are married, Helen has had her baby in defiance of Victorian morals, and the future seems brighter. Some connections have been made, and Forster holds out the promise of barriers lifted and contradictions at least temporarily resolved.

Why begin a book about the history of broadcasting with a quote from an author who wrote before radio, and most certainly before television, were even invented? For one

thing, Forster's novel is about the tragedies that occur when connections fail, or are mishandled. Sometimes it's communication that fails—the telegram arrives too late, a dying woman's will is ignored, or two conversations overlap in a way that confuses them both. Other times it's a social or perceptual connection that's missed—the failure to understand how one family's affluence and good fortune is gained at the expense of a whole class of others or how an unconsidered effort to fix things can have tragic results. The novel is also a meditation on the changes that twentieth-century culture and "progress" are making on traditional ways of life, how a shift in one direction can cut off another, and how each "improvement" comes along with possibilities for ruin.

This ambiguity at the heart of progress—the push-pull tension that says as one thing is gained, another might very well be lost—forms the core of Forster's vision in *Howards End* and also informs the history of broadcasting in our century. With each new marvel of communication—promising so much progress and improvement in quality of life—came worry about the negative effects of the new connections. For each utopian hope, there was a corresponding dystopian fear, and many of them, as we shall see, revolved around the barriers that new forms of communication and connection both knocked down and, in other places, built up.

History, too, is about making connections. This first chapter will not plunge immediately into a chronology of broadcasting-related events, but will spend some time considering exactly what role I, as the author of this book, and you, as its reader, play in the construction and use of this thing called "history." You may have picked up this book because it is part of a course on the history of broadcasting, or because you are interested in reading an overview of radio and television's impact on twentieth-century culture, or because you have an interest, personal or professional, in the media and like to keep up with books in this field. The subject of this book most likely seemed transparent: a tracing of the various circumstances, conditions, and actions that led to the development of broadcasting and its uses in the United States, with all the major players and programs highlighted and the most important issues discussed. The word *cultural* in the title might have alerted you to the likelihood that radio and TV programs and their audiences would be emphasized over the more traditional emphasis on industry and policy found in many books on the subject.

However, even a moment's reflection will reveal that the enormously complex and varied set of events that might be said to comprise broadcasting's past—even if we limit it to the United States and to primarily this single century and to only the national networks that are our common experience—cannot possibly be included within the pages of one book. This is particularly true if we consider the ways that radio and television have intersected with people's lives as an important part of the history of broadcasting. For example, suppose we consider that TV's history is not just a history of the networks, or of the FCC (Federal Communications Commission), or of media magnates like Rupert Murdoch or David Sarnoff, but equally of the many people, you and me included, who have used the medium, carried its information and meanings into our lives, figured in the marketing and programming plans of decision makers, and understood ourselves and our world through its representations. Then television would have a billion histories—as many histories as there are viewers to experience it. Where could we possibly begin such a history? How could we draw lines around it sufficient to contain it within the covers of a single book?

In short, we can't. And part of the intellectual heritage of twentieth-century postmodernism is acknowledgment of this fact. The traditional historian takes a stance above and beyond the content of the book—omniscient, omnipresent, and invisible, neutrally and objectively setting out what is manifestly true about the past: "just the facts." This book is predicated on the premise that such a stance is false and misleading. Each book, and especially a textbook designed for the classroom, starts out with a distinct set of assumptions and theories that guide the author in making the inevitable and extensive selections—what to put in, what to leave out—that go into writing a book. As cultural and historical theorists such as Michel Foucault and Michel de Certeau teach us, each book starts with a preconceived framework of ideas—about what's important and what's not, who counts in history and who doesn't, which sets of causes and effects are relevant to the story and which aren't—that all too often the author hides behind a mask of neutral knowledge and objectivity.

However, it is not the selection and privileging process that is at fault here—no book can be written, no story told without it—but rather the denial that such a process exists, and most of all the corresponding erasure of the role of you, the reader. Are you just a passive recipient of the "true facts" about the history being told? Does history happen without you, or do you play a role in deciding what history is?

Throughout this history, you will be frequently reminded that this author has made selections and omissions in the countless billions of events that make up the history of broadcasting and what led to the particular choices and inclusions made. You will be introduced to the work of many other historians and authors as we go through this historical narrative, so that their varied and sometimes conflicting perspectives can serve as a balance to mine—and to yours. You will be encouraged not to read this history as a seamless whole, as an inevitable and already completed progression of events, but as a creative process of *interpretation* and *construction* in which you can, at any moment, intervene. You can draw upon your own knowledge, look into historical evidence at your own initiative, evaluate the interpretation given an event or program, and ask some hard questions that the book overlooks. This is what making history is all about; it is not just a historian in a room surrounded by books and musty documents, writing out some true and self-evident story of the past "as it really happened," but a process by which both writers and readers activate a certain perception of their culture, past and present, and put it into use in their daily lives and shared understandings.

I don't pretend that our role is equal; as the author, I have obviously set the ground rules and laid out the field of play. And I won't deny—as you may not either—that who I am as a person plays an important role in the choices I have made: As a white, middle-class, midwestern American woman born in the mid-1950s, my interpretation of events comes along with not only a set of overt theoretical beliefs, which I can and will highlight and discuss, but with a set of assumptions and biases of which I am not always aware. If you occupy a social or cultural position different from mine—if you are, say, a young African American woman, or an older Asian man, or a son of Latino immigrants, or from an Orthodox Jewish family, or perhaps even a cousin of mine with a very different set of opinions—then you will no doubt see many holes in my perceptions, many points at which your experience of our mediated culture departs from mine that need to be included. And when you express these views, putting them into words in class or into writing as you do your own historical work, you enter into the process of constructing history, and you enrich it.

The Power of History

So what are the basic goals of this book and the conceptual framework it uses to get there? My purpose is to offer an overview of the complex and often profound ways that our primary twentieth-century broadcast media—radio and television—have intersected with our national culture to produce not only institutions (such as networks, stations, cable channels, the FCC) but also texts (programs, messages, representations, documents), social discourses (ways of thinking and talking about these phenomena), and audiences (real, experienced, measured, and imagined). I believe that the best way to understand how broadcast media work in our society is to look at them as conduits for social and cultural *power*. This includes the power to create understandings about the world and the people who live in it, the power to direct our attention toward some things and away from others, the power to influence how we see ourselves and our potential in life, the power to ensure that certain kinds of things get said over and over, while others remain silent, on the margins, without a voice.

Obviously the media are centers of huge amounts of economic and social power, not only in the United States, but all over the world. The single largest sector of the U.S. export economy is now media and intellectual property. Radio and television are multibillion-dollar-per-year businesses. Hundreds of thousands of people are employed in the entertainment sector of our economy. Our political process, and the political processes of other nations, have been and continue to be fundamentally influenced by the power of the media.

It Flows Two Ways

Yet, we the audience are not powerless in this media megalith. Every day we pick and choose among a variety of programs, messages, and meanings available to us. We understand media texts depending on our own knowledge, values, and experiences. We accept the truth of some messages and reject others. Of course, the power to make meaning out of texts is not necessarily equal: Analogous to the author/reader situation, the producer of a text makes the initial plays while the audience has a harder time being heard. One has all the mighty machinery of the media industry on its side, the other can find it difficult to talk back or to find an entry point into the machine.

Are we ever influenced in our thinking without our conscious knowledge, persuaded of the fact of something without being totally aware of it? Yes, or advertising wouldn't be as effective as it is! This can be particularly true when television or radio produces an overwhelming consensus about something, when it frames or represents a "fact" over and over, in a variety of settings, in a way that conforms with deep-seated social mores. For instance, one popular way of explaining the domestic sitcoms of the 1950s and 1960s is that they simply reflected the reality of people's lives during that conservative, family-oriented, rather dull period of history. As postwar baby boom families purchased TV sets for their new suburban living rooms, naturally they wanted to see people just like them on TV. Donna Reed families begat *The Donna Reed Show.* Does this explanation work?

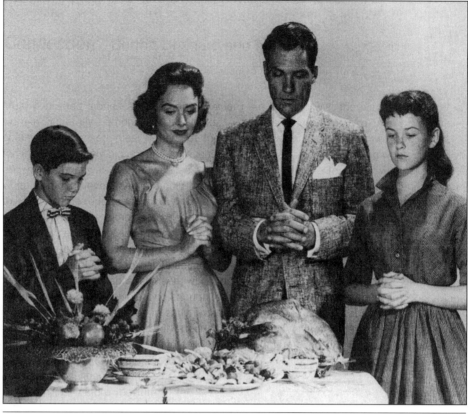

A typical American family, *Donna Reed* version.

This brings us to the first Connection in this book. The Connection feature pulls together the historical or theoretical material in a focused case study. Typically, a Connection highlights the work of scholars or historians in the field, summarizing their arguments and referring you to their work if you are interested.

Connection Seeing Through the Fifties

Here, we consider the way that television and history intersect. Before getting into a more theoretical consideration of just what history is and how it has been redefined by poststructuralist theorists and historians in the late twentieth century, let's go back and look at a basic historical fact that most of us already know about television: Television in the 1950s

emphasized the white middle-class family to the exclusion of all else. Furthermore, we might also know that this was simply a reflection of how American society "was" in the 1950s—a point of view that even affected political policymakers in the 1990s. Conservative leaders in the early nineties like Newt Gingrich, Pat Robertson, and Governor Kirk Fordice of Mississippi invoked a 1950s vision of the "safe streets, strong families, and prosperous communities of yesteryear," and others recalled the era as a time in which "things were better" and "the country was moving in the right direction" (Rosenbaum 1994). "Strong families" meant heterosexual, nuclear units with a dad who worked, a mom who stayed home and looked after the house, and good clean kids who respected their parents. "Things were better" because the government stayed out of people's private lives, and families were self-sufficient and right-thinking.

Where does this perception of the past, specifically the 1950s, come from? Certainly many programs on television during this time did depict such families, and many of them were highly rated. *Father Knows Best* (CBS/NBC 1954–1962), *Leave It to Beaver* (CBS/ABC 1957–1963), *The Donna Reed Show* (ABC 1958–1966), *The Adventures of Ozzie and Harriet* (ABC 1952–1966), *Make Room for Daddy* (ABC/CBS 1953–1964), *Dennis the Menace* (CBS 1959–1963), and *Beulah* (ABC 1950–1953) all featured a family composed of a stay-at-home mom, a vaguely employed (but always white collar) dad, a minimum of two children with at least one being male (you could have a family of all sons but never all daughters). They were always white but of no discernable ethnic heritage (not noticeably Irish, or Polish, or Italian), of no particular religion but definitely Christian (never Catholic, however, or Jewish). The mere possibility of anything or anyone not heterosexual was *never* alluded to, and though Mom or Daughter might occasionally get restive about their preordained domestic fate, they always got over it in a humorous manner that reinforced the rightness of "traditional" ways.

These families lived for the most part in a substantial suburban single-family home, with a yard and trees and neighborhood schools that the kids could walk to. Their kitchens contained the most modern appliances; they dressed well, owned at least one car, and entertained regularly. They ate meals together, served by Mom (unless there was a maid, usually depicted as an African American woman, as in *Beulah* or *Make Room for Daddy*). Not only were all the families affluent and mysteriously nonethnic, so was everyone else in their neighborhood and social circle.

Mary Beth Haralovich explains the success of this type of show by linking it to the economic needs of the networks and their advertisers during these crucial postwar decades (Haralovich 1992). She discusses the various government incentives encouraging home ownership in covertly segregated communities outside the city limits, the strategies of the expanding postwar consumer products industry, and the rise of market research designed to promote consumption. These three trends were closely tied to the emergent business of the television broadcast networks, as they promoted TV set sales to suburban homeowners, aired shows sponsored by the manufacturers of home appliances and other consumer goods, and increasingly used market research to match up audiences, products, and appropriate programming.

Both programs and advertising spots reinforced the same consumerist lifestyle: The Cleaver's kitchen featured the same appliances advertised during the commercial breaks; the Nelsons could be seen using the Kodak cameras that sponsored their show. By combining these strategic economic imperatives with a realistic film-based style of production, programs such as the ones listed earlier produced a representational universe that naturalized the conditions they were in fact trying very hard to sell to the American public: the ideal consuming family. By featuring families such as these—and *only* families such as these, excluding

working-class, nonwhite, and nontraditional families—such programs seemed to claim that this was how Americans just naturally *were*. (If not, something was *wrong* with them.)

In fact, as Haralovich and others have shown, this was far from an accurate picture either of most of the programs on TV at that time or of the average American family. Most families in the United States were in fact not nearly as affluent, "nonethnic," or "traditional" as their TV models. The statistical majority of U.S. citizens occupied lower-middle- and working-class jobs and neighborhoods, identified strongly with their diverse ethnic and racial heritages, and included a far higher percentage of women working outside the home.

TV's efforts to convert Americans to an affluent, consumption-based lifestyle can be seen as an ongoing social project that in fact *contradicted* the way that most of us actually lived our lives. Educational films such as "A Date with Your Family" (Simmel-Meservey Films, 1950), for instance, demonstrates how clearly *unnatural* such a middle-class milieu was for its intended audiences, who needed to be instructed in how to conduct family life along proper middle-class consumerist lines. As sociologist Stephanie Coontz wryly puts it, "Contrary to popular opinion, *Leave It to Beaver* was not a documentary" (Coontz 1992, 29).

Secondly, these programs, though popular, were far from the dominant or most highly rated programs of the 1950s and 1960s. A quick look at the top-rated 25 shows for 1959–1960 reveals only *The Danny Thomas Show* (*Make Room for Daddy*), *Dennis the Menace,* and *Father Knows Best;* westerns made up the largest number of top programs (*Gunsmoke, Wagon Train, Have Gun Will Travel, Wanted*: *Dead or Alive, The Rifleman,* and many more) and by far outranked the family shows overall. Meanwhile, other shows featured playboy detectives (*77 Sunset Strip*), a single working woman (*The Ann Sothern Show*), stand-up comedians (*The Red Skelton Show, The Ed Sullivan Show*) and "hillbillies" (*The Real McCoys*). A look at local television schedules might even contradict the unarguably dominant "whiteface" of TV, as Douglas Battema argues (Battema 1996).

Could it be that our perception of the 1950s, both socially and on television, is more influenced by Nick at Nite reruns than any kind of historical fact? And this is not simply idle speculation when government policy depends on just such questions. How we interpret the meaning of the domestic sitcoms of the 1950s depends on the connections we make: Do we connect these sitcoms to a historical mode of family life as it simply "was," as conservative rhetoric in the 1990s attempted (and that we might deconstruct by looking at conservative political objectives)? Or do we connect them to a host of industrial and social strategies and changes, as Haralovich does (and that we might query by looking at other historical influences)? Depending on the context into which we put these television programs, and the explanations we write around them, their history changes, even though the facts of their existence do not.

HISTORY = THE PAST + HISTORIOGRAPHY

History is a slippery object. The family sitcoms mentioned earlier are historical texts, produced in the past under a particular set of circumstances. Does that make them history? And if so, can we understand them, as some politicians in the nineties apparently did, as transparent windows to the world of the past? Clearly this is wrong, but how can we make sense not only of television's—and radio's—relationship to the

past but of history itself? Here we need to make a distinction: The English language uses the same word, *history*, to denote both "the past" (all those events that occurred sometime before the present moment) and "historiography" (writings about the past). They are not the same, and Keith Jenkins in *Re-Thinking History* suggests that we break apart the two terms to arrive at the equation given at the beginning of this section: *History* (our understanding of what happened in the past) *consists inseparably of both the past and historiography* (K. Jenkins 1991).

Jenkins points out the many logical reasons why we can never know anything about the past without the intervention of some kind of writing or telling: The past is such an infinitely immense body of events that our consciousness could never encompass it all; the past is infinitely variable, depending on the perceptions of each discrete participant or observer. The past cannot be directly experienced, but only hinted at through what Jenkins calls *traces* of the past—documents, records, memories passed on through verbal or visual means, monuments, artifacts, or television shows. Some traces are more closely connected to the past than others (the courtroom transcript of a trial, say, rather than a news story or a docudrama about it); some we call reliable whereas others are flawed (but why?); *all* must go through a process of interpretation and validation to mean anything.

Historical Erasures

Just as the writing of history must depend on some available and credible traces of the past (or else we would not grant it the special status of *fact* as opposed to *fiction*), the past can be known only through such traces and through the writing that brings them together. The past does not exist independently of historiography—for how could we ever know it except through what is written or somehow preserved? But neither could history ever be written without careful use of clues to the past, or it would cross the border into fiction.

Furthermore, as historian Michel-Rolph Trouillot reminds us in *Silencing the Past*, history is made not only by official historians, writing official histories. Rather, we produce and use history every day, and such use alters the historical record. If we, or a politician, choose to remember the United States in the 1950s as a place patterned after *The Donna Reed Show*, then this use becomes part of the historical record and thus a part of history. The repeated assertion that 1950s America resembled a small number of TV sitcoms actively begins to erase from our common memory—from our history—a whole set of events (such as militant labor strikes, African Americans' struggles for basic civil rights, restrictions against blacks and Jews in many "idyllic" suburban communities, and Cold War politics playing out behind the scenes) that were every bit as much of the past as the happy domestic families on TV (Trouillot 1995).

Even though some events can be proved to have happened, if they are not repeated in the right places, or worse, if they are overlooked or omitted by powerful histories, they can be silenced out of existence. Trouillot uses the example of the successful revolution in Haiti in the 1790s that brought former slaves to power and established an independent black-governed state. The story of Haiti's revolution was downplayed or written out of accepted Western history by white American and European writers unable to face the contradiction between treasured democratic ideals and the kind of race-based thinking that allowed and justified enslavement.

We might think similarly about the history of working women on television. A medium that depended on extraordinarily powerful female producers and executives—Lucille Ball, Donna Reed, Ann Sothern, Joan Davis, and others—could not permit these women to play themselves as themselves: successful businesswomen. Instead, the prevailing emphasis on getting women out of their wartime jobs and back into the home to be good consumers meant that television's women had to present themselves as housewives only (or domestic laborers, if they were nonwhite), even if some, like Lucy, constantly struggled to get out. Thus the history of 1950s America becomes a pastoral vision of moms at home, even though by 1960, fully 40 percent of American women worked outside the home and made up over a third of the total workforce, and even though in television many women found powerful and influential careers.

History and Nation

What determines which facets of the infinitely variable past are preserved and remembered, and which are forgotten and silenced? Here is where social power comes in, and with it another extremely relevant concept for the study of broadcasting: the nation. If you were born and raised in the United States, you have probably never thought about broadcasting as a specifically national medium. That is because you live in one of the largest and relatively most closed-off culture-producing nations in the world. We export our media products across the globe, and it is a rare country that has not had some experience with U.S. films, music, or television, not to mention similar products from other countries.

In contrast, unless you speak Spanish and have tuned in to the growing world of Spanish-language media, you have probably never experienced media made outside the United States except on an occasional basis—a recording from Brazil, perhaps, a movie from India, or a BBC show on public television. We Americans—meaning citizens of the United States—live in a cultural cocoon created by our own powerful media industries. Despite our reputation as a melting-pot country where a myriad of cultures meet and adapt—and there is much truth to that—when it comes to television, in particular, we are extremely insular. When's the last time you saw a sitcom from Singapore, a soap opera from Mexico, a news report from Russia, a police drama from France? Yet citizens of most of these countries routinely watch news on CNN, reruns of *Friends*, the latest episode of *The Bold and the Beautiful* or *NYPD Blue*. They are learning much about our culture (much of it misleading); we are woefully ignorant of theirs.

Our Way

Included in this ignorance is the indisputable fact that broadcasting, in particular, is deeply tied up in the nationalist project. That is, from the very beginning, as we shall see, control over broadcasting has been a crucial part of defining who we are as a nation, defending our national interests over those of other countries, and creating a sense of our national heritage and history. This is also true for other nations; in fact, in virtually every other country in the world, radio (and later television) was considered

such a vital part of national interest that it was put under the direct control of government or supported by public funds. Only in the United States was broadcasting permitted to be funded by private, commercial corporations through the sale of advertising time. Most other countries thought that was a crazy idea—just asking for social disorder and squandering a valuable national resource. But we did it our way.

Our unique broadcasting history came about partially because of our lucky position as a very large country without much concern about competition for limited broadcasting frequencies, or much worry that our two contiguous neighbors—Canada and Mexico—would infringe on our broadcasting territory. It was also a result of the deep-rooted American reluctance to let the federal government make too many of our important decisions for us—and our equally strange willingness to let major corporations take on that role instead.

One of the greatest utopian promises of the revolutionary new technology of radio in the 1920s was its ability to tie our vast and varied country together as a nation. Here was a medium through which a polyglot people could not only learn to speak proper English but also learn about their national heritage and just what it meant to be American. When television came along, these promises were heightened. In 1941, David Sarnoff promised an eager nation that "The ultimate contribution of television will be its service towards unification of the life of the nation, and, at the same time, the greater development of the life of the individual" (Sarnoff 1941, 145). Even today, you must be a U.S. citizen to own a broadcasting station. (Witness Australian Rupert Murdoch's problems in this area when he purchased the Fox network.) Similarly, one of the strongest arguments used by the media industry to get the deregulatory Telecommunications Act of 1996 passed was that only by these concessions could the U.S. industry remain a worldwide power and resist takeover by powerful foreign companies.

Borders and Identities

As historians Joyce Appleby, Lynn Hunt, and Margaret Jacob point out in their book, *Telling the Truth About History*, an important aspect of the developing discipline of history in the United States and Europe—what the authors call "scientific history"—was its concern with demonstrating and justifying the spread of Western knowledge and democratic nationalism. This nationalism is the defining focus of most history as we know it, as nationalism has been one of the prime motivating factors in the past events of the last two centuries. But, defining *nation* does not just mean fighting wars, instituting governments, and defending our borders against foreign encroachments; it also means shaping a notion of who we are and who we are not, of giving ourselves an identity as a nation apart from all others (Appleby, Hunt, and Jacob 1994).

This means that the structuring categories of identity within our national social system—those classifications and hierarchies that define each person's role and allot his or her position in life (most relevantly race, gender, ethnicity, sexuality, class)—are just as vital to our national history as laws, wars, and politics (the stuff of traditional historiography). For instance, we can understand one of the central events of the twentieth century, World War II, in two ways. The first is as a war of *national* borders: Germany's attempt to take control of other countries and those countries' defense of their national sovereignty. The other is as a war of *interior* borders, or identity: the

attempt of a nation to assert a superior Aryan national identity and to wipe out its Jewish citizens and others who did not conform. Borders and identities—these are the stuff of nations. And so they are the stuff of history. Equally, they are the stuff of broadcasting.

This book, therefore, although conforming to the nationalist focus of broadcasting generally and confining most of its attention to the United States, constantly remains aware of that border and takes frequent glances across it, looking for what it excludes and leaves out. We'll attempt always to keep in mind that there is nothing natural about the way broadcasting developed in the United States (in fact, it is very different from the rest of the world) and let those comparisons and contrasts inform our analysis as we go along.

Second, we'll trace the ways in which identity's interior borders have played such a central role in the formation of broadcasting structures, programs, and practices. Race/ethnicity and gender, in particular, provide some of our culture's primary social strategies of classification and stratification, in real life as on TV; we'll see how radio and television participated in dominant ways of thinking, used gender and race in their programs and industry structures, challenged the dominant social system, and generally contributed to our ongoing social shifts of power.

Finally, in this book we will look at radio and television as one of our nation's primary sites of cultural negotiation, dispute, confrontation, and consensus, a place where all of these things—nation, power, culture, history, identity—come together in a frequently infuriating and always fascinating mélange of sounds, images, and endless discussion. Just to kick things off, our second Connection looks at a particularly exotic example of broadcasting's "woollier" side to examine what happens when radio, populism, power, knowledge, and nation engage in a border skirmish.

Connection The Strange Case of Dr. Brinkley

Starting in 1923, residents of a good part of the state of Kansas were treated to a new experience, carried over the astounding new medium of radio. They heard themselves addressed like this:

> You men, why are you holding back? You know you're sick, you know your prostate's infected and diseased.... Well, why do you hold back? Why do you twist and squirm around the old cocklebur ... when I am offering you these low rates, this easy work, this lifetime-guarantee-of-service plan? Come at once to the Brinkley Hospital before it is everlastingly too late. (Fowler and Crawford 1987)

This was only one small part of the pitch made over radio station KFKB (for *Kansas Folks Know Best*, "The Sunshine Station in the Heart of the Nation") by John Romulus Brinkley, "M.D., Ph.D., M.C., LL.D., D.P.H., Sc.D.; Lieutenant, U.S. Naval

Reserves; member, National Geographic Society." Though most of these degrees and distinctions had been achieved at less than distinguished institutions (such as the Bennett Eclectic Medical School in Chicago) or through outright purchase, Brinkley had by the early 1920s built up a considerable practice centered around his miracle cure for "male trouble": the implantation of goat glands from special Toggenburg goats (known otherwise for their wool, but this was not what interested Brinkley) into the testicles of patients experiencing such symptoms as "No pep. A flat tire." Brinkley's hospital adjoined a flourishing stock farm so that, as historians Gene Fowler and Bill Crawford describe, "transplant recipients could stroll among the frisky bucks and take their choice" (Fowler and Crawford 1987, 17).

In 1923, Brinkley was awarded one of the first radio station licenses in Kansas, based in the small town of Milford where the Brinkley Hospital was located. The station schedule included a typical assortment of musical performances and "talks," including three medical lectures a day by the good doctor. Soon he added another feature, *The Medical Question Box*, during which he read letters from listeners seeking medical advice, diagnosed his listeners' ailments over the air, and recommended patented medicines—prescribed by number—that they could obtain from one of the 1,500 certified members of the Brinkley Pharmaceutical Association across the country. Patients began streaming into Milford for the relief the doctor provided; the town's post office could barely handle the volume of mail that poured in. The new medium of radio had created one of its first regional stars. A survey done by the *Radio Times* in 1929 pronounced KFKB "the most popular radio station in America" (Fowler and Crawford 1987, 24).

But Brinkley was on a collision course with both the FRC (Federal Radio Commission, the FCC's precursor) and the powerful American Medical Association (which Brinkley reviled on air as the "Amateur Meatcutters' Association"). When KFKB was given an upgrade to 5,000 watts while the *Kansas City Star*'s application to take its station to equal power was denied, the newspaper launched an exposé of Brinkley's medical franchise. Their investigation was buttressed by the ongoing public accusations of medical quackery against Brinkley made by Dr. Morris Fishbein, head of the AMA, which was beginning its successful drive for the professionalization of the practice of medicine. Soon the FRC reversed its previously tolerant stance and in late 1929 revoked Brinkley's license, charging that he was in fact operating a point-to-point service for commercial purposes and not a proper broadcasting station in the public interest.

The Kansas Medical Board revoked Brinkley's medical license a few months later. Brinkley—known simply as "Doctor" by everyone, even his wife—fought back by running a write-in campaign for governor of Kansas in 1930, using the slogan "Let's Pasture the Goats on the Statehouse Lawn." His campaign was a model of populist appeal; Gene Fowler and Bill Crawford claim that later southern politicians, Huey Long and W. Lee "Pappy" O'Daniel (another radio sage), would use Brinkley's example in their successful campaigns in Louisiana and Texas, respectively. Here Brinkley deviates from the picture of the lovable quack (after all, in the 1930s the AMA was still promoting tobacco use as safe and recommending that pregnant women drink alcohol) and into the dark side of the power of radio populism: bigotry and anti-Semitism. Jason Loviglio explores the links Brinkley's political speeches made between the health of the "red-blooded American man" and the attempts by Hollywood and Jews ("they of the circumcision") to "emasculate" true (white Protestant) Americans. These less-than-virile qualities would later be associated in

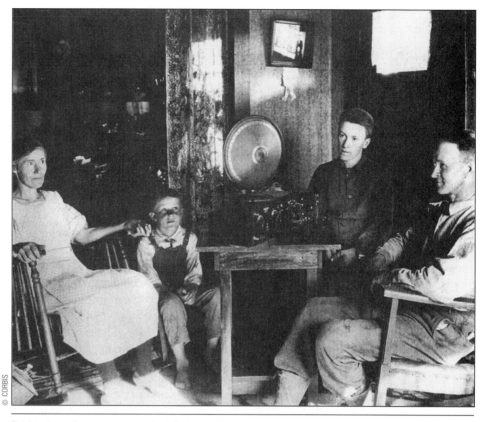

Brinkley's audience was overwhelmingly working class and rural. Radio brought considerable novelty to their lives.

Brinkley's increasingly fascist diatribes with the New Deal, communists, income taxes, and federal and professional regulators generally.

By all rights Brinkley should have won the 1930 governor's race; his write-in votes gave him the victory, but his political opponents pressed a case that invalidated over 50,000 ballots that did not have his name written down exactly as "J. R. Brinkley" (as opposed to "Dr. Brinkley" or simply "Doctor"). Rejected by his country's national institutions—federal, state, and professional—despite his considerable and continuing popular support, Brinkley made a move that defied the national basis of broadcasting and revealed radio's inherently subversive character: He determined to continue broadcasting into U.S. national territory from the safety of Mexico. Opening up his pioneering "border blaster" station XER in Villa Acuña, Mexico, just across the Rio Grande from Del Rio, Texas, Brinkley capitalized both on the Mexican government's desire to use these stations to forge a more equitable frequency agreement with the United States and on the unique nation-defying capability of radio. As Brinkley observed, "Radio waves pay no attention to lines on a map" (Fowler and Crawford 1987, 23).

XER (later renamed XERA) sprang to life with 50,000 watts, later upped to 150,000, then to 500,000, and eventually to an unbelievable 1 million watts of power (the highest

permitted in the United States at the time was 50,000). The station was able to reach most of the continental United States, at a favorable position on the dial right between popular stations WGN Chicago and WSB Atlanta. It developed into a showcase not only for the doctor's flourishing medical practice, but for a host of other popular cultural forms either outlawed or marginalized by sanctioned U.S. broadcasting: fortune-telling, astrology, the radio equivalent of personals columns, direct selling to listeners, hillbilly (early country) and Mexican music, and fundamentalist preachers of uncertain denomination. Brinkley himself expanded into other medical concerns, including one recommendation with which he was years ahead of the AMA: "If you have high blood pressure, watch your diet. Eat no salt at all" (Fowler and Crawford 1987, 41).

But the forces of sanctioned knowledge—in this case, medical—could reach even where broadcasting regulations couldn't. In March 1939 Dr. Fishbein published a series of articles in the AMA publication *Hygeia* called "Modern Medical Charlatans," in which Brinkley played a featured role. Brinkley filed suit against Fishbein and the AMA for libel, but the tide had begun to turn. Despite an outpouring of popular support, the case was lost, and soon the fickle public came forward with a host of lawsuits against the doctor. Not long after, the Mexican government, having finally reached a better frequency allocation agreement with the United States, closed down the station.

The demise of Dr. Brinkley's astonishing career did not bring a halt to the world of the border blasters. Many similar stations continued to operate into the 1970s and 1980s, bringing a host of currently illegitimate or unauthorized programs and voices into U.S. airspace and providing a forum where figures like the legendary DJ Wolfman Jack and the charismatic black preacher Reverend Ike could thrill with a touch of the forbidden. Today their inheritors are mostly Spanish-language stations, still bringing a different cultural voice across national boundaries and pointing up the contradictions that the advent of broadcasting introduced to an apprehensive nation: A medium that knows no boundaries is bound and restrained by national laws and regulation; a medium that reaches the public directly and effectively creates an equally pressing desire to direct and control it; a medium that holds out democratic promise falls under the sway of racist demagogues. Broadcasting must, by law, operate within the public interest—but what if it's goat glands the public really wants?

The story of Dr. Brinkley encapsulates the way that radio became a focal point for questions of nations and borders, knowledges and identities, authoritative power and the threat of uncontrolled populism. It is a story that is omitted or downplayed in most accounts of U.S. broadcasting because it concerns culture literally at the margins of dominant history: pushed across the border, excluded, maverick, unofficial, and unsanctioned. It concerns an area of culture (many would be unwilling to give it that name) that falls far outside the places and spaces where culture is usually created. Situated in small-town rural America, appealing to the uneducated working classes, addressing them in ways not approved of by such elite institutions as the AMA but clearly speaking to their innermost fears and hopes, mobilizing ethnocentric racist appeals that created an "us" that was embattled, misunderstood, sick, and tired—Dr. Brinkley and his brethren on the border made

connections via the miracle medium of radio that the larger society could not tolerate (Loviglio 1995). His story shows us where the borders of broadcasting culture are, and who gets to draw them.

CONCLUSION

Thus history is not the mere writing down of static, dead events in a fixed chronology. Rather, it is a continuous and interactive process, constantly taken up, shaken up, revised, and utilized by people in the here and now, including the readers of this book. When it comes to broadcasting, we will see that the same issues of inclusion and exclusion, of fact and fiction, of borders and identities, of empowered and silenced voices that play such a vital role in the making of history also form the significant forces in the development of radio and television. As we begin with an examination of the cultural milieu from which broadcasting arose, we will be looking at the currents of power swirling around radio's imagination, invention, deployment, and use. The central task will be to make the connections that help to explain why radio, television, and newer technologies developed as they did. We can also begin to imagine the connections that failed: the technological potential that was suppressed, the programs that never made it to a wider audience, the possibilities for a different kind of interaction with broadcasting that were shunted off to one side or actively discouraged. In addition, we'll examine the ways our culture devised to think about this new set of phenomena: the discursive patterns that encouraged thinking and talking about radio in some ways and not in others, and the hopes and fears that engendered them.

Throughout, be looking for the gaps in this history, the questions that you have that go unaddressed here, or the issues that don't get fully explored. Then, make your own intervention into history. This book sets out some guideposts for a tour through the almost hundred-year-old existence of our culture's most central and controversial medium. It is up to each one of us to take these signs and interpretations, connect them, and make them into history.

BEFORE BROADCASTING

Where does a cultural history of U.S. broadcasting start? It would be easy to begin with the invention of radio, because this is the basic technological breakthrough that allowed broadcasting to emerge onto the cultural scene. From there we could trace radio's progression and evolution until it attained its current state of perfection in the 1990s. But wait: What we've just sketched is the typical progress narrative, by which a certain phenomenon springs into existence; undergoes a pattern of "natural" growth based on its "essential" qualities; is improved upon, updated, and advanced; and arrives at some equally arbitrary stopping point. By this narrative, once movies were invented, they got better and better until they became the Hollywood film industry today. Automobiles just had to evolve the way they did, and now have reached technological fulfillment in, say, the Hummer. In radio, one clever invention followed another, leading inevitably to the exact kind of radio and television that we have now.

This kind of story has a certain charm—it can be made easily into television documentaries, for example, like Ken Burns's recent *Empire of the Air*. Yet it closes off historical investigation in some important ways: From what cultural milieu did the invention spring, and what problems did it promise to solve? How were some potential uses of this new technology privileged and others discouraged? Could it be that progress in one direction shuts down development in another?

Empire of the Air also provides an excellent example of another trope of historical writing: the "great man" narrative. By this popular historical device, radio's invention and progress stems from the actions of a handful of extraordinarily powerful, creative, and influential men (and they are almost always men). Their actions, personal characteristics, feuds, decisions, and genius determine the direction of history. They are the ones who identify the primary potential inherent in the new technology and personally direct its "natural" growth. In Burns's entertaining 1992 PBS film, we are told the history of radio through the personas of three figures: inventor and con man Lee De Forest; rags-to-riches RCA chairman David Sarnoff; and eccentric, thwarted technological genius Edwin Howard Armstrong. Certainly these men were important individuals whose position, farsightedness, or talent thrust them to the forefront of events and who did indeed exert a strong and lasting influence on the history of radio.

Yet we forget that those on the tip of the iceberg of history are held up by other people and events of the past, those not receiving so much attention. We might justifiably turn our attention to the events and circumstances that produced these men and their achievements, and that discouraged or obscured other participants in radio's development. David Sarnoff's role as untiring radiotelegraph operator, relaying news of the *Titanic* disaster (somewhat embellished by the RCA chairman in later years), could not have played out without technical, legislative, cultural, and social developments that set the scene for his starring performance.

What was the context for radio's development? Out of what mixture of social, cultural, and technological forces did radio emerge—not only as a machine, but as a practice? Who decided that we needed a technology that could make sounds fly invisibly through the air, to be received at a great distance by those with the right kind of technological know-how? What surrounding social and cultural circumstances influenced the ways that this technology developed and was put into use? And was the development of radio always a straightforward progression? If so, progress for whom?

These questions take us back in time, to a period shortly after the turn of the twentieth century and before the World War I. This is not a dead and long-past period, as we might think from our position in a new century, but a vital time whose concerns and interests touch us even today. We are not so very different from our great-great-grandparents. We worry about the same things (new technology's threat to children, the fear of social disorder), we share the same interests (the lives of celebrities, salacious true stories of our fellow citizens' misdeeds), and we struggle with similar problems (immigration, intolerance, the economy, warring nations). U.S. radio came into being at a particular time, in the particular social stew of the Progressive era, and it is here that we venture to trace the multiple roots of broadcasting history.

SOCIAL CONTEXT: THE PROGRESSIVE ERA

Society not only continues to exist *by* transmission, *by* communication, but it may fairly be said to exist *in* transmission, *in* communication. There is more than a verbal tie between the words common, community and communication. Men [*sic*] live in a community in virtue of the things they have in common; and communication is the way in which they come to possess things in common. (Dewey 1915, 4)

In our nostalgia for the past—demonstrated, for example, by our glorification of a handful of 1950s sitcoms as icons of a better time—we tend to think of years gone by as a more innocent, more stable, less troubled time than today. Things were better back then. In the words of the opening song of Norman Lear's famous seventies sitcom *All in the Family*, "Those were the days." In fact, we are probably describing our feelings about our own idealized childhood more than any particular historical period. If even the 1950s in the United States—a period of relative affluence and stability, though not quite of Donna Reed proportions—can be said to have its dark underbelly, then the period from 1890 to 1920 in this country might be said to resemble hell on earth: children 8 and 10 years old working at heavy machinery for 12 hours a day; no Social Security for older folks who might end their days in poorhouses; a higher crime rate than at any time until the 1970s; Jim Crow laws in full force and about 70 lynchings per year in the South and

Midwest; a full-fledged Ku Klux Klan campaign against Catholics, with crosses burning on church lawns; no poverty programs; and starving immigrants arriving at our ports to find not streets paved with gold, but a hard land indeed.

Immigration and Nativism

More than any other factor, it was the force of immigration that turned these decades at the beginning of the twentieth century upside down. People from all countries streamed into the United States at a greater rate than ever before. More than 30 million immigrants, many from southern and eastern Europe, left their homes for the new country during this 30-year period. By 1910, the proportion of foreign-born people residing in the United States had reached 14.5 percent, the highest by far in the twentieth century. (In 1970 the figure was 4.3 percent; by 1999 it had risen to 10 percent.) In a country with only a tenuous hold on a national sense of identity and unified culture, this influx of millions of people with different languages, cultural traditions, religions, politics, and ways of thinking created an unprecedented feeling of social disruption and instability. Nativist organizations and movements sprang up, such as the Ku Klux Klan and the America First party, dedicated to upholding a white western European supremacist position to keep the forces of "difference" in their place.

This period was also marked by a population shift from country to city. In 1880, over 70 percent of the population lived on farms or in rural areas; by 1920 that proportion was down to less than 50 percent, and urban residents constituted the majority of the population. Living conditions in America's cities reached a new crisis of crowding, disease, crime, and poverty. America's racial minorities continued to be treated as not fully American, their rights to vote, own property, find decent employment, and expect fair and equitable application of laws systematically violated. Irish and Italian Catholic immigrants, frequently looked down upon by the Anglo-Saxon Protestant majority, soon found an advantage in learning to think of themselves as simply "white" and in adopting the racial prejudices prevalent in their new country.

Progressive Intervention, Popular Resistance

In response to these widespread problems, a movement of social intervention and remediation sprang up. Sometimes called the Progressive movement, its theorists and practitioners believed that the only way to improve these troubling conditions was through a scientific approach to people and their problems, combining sociological study and analysis with social work, education, and legislative reform. John Dewey, quoted earlier, was a major Progressive theorist; Jane Addams and her Hull House workers applied Progressive thought to the immigrant neighborhoods and streets of Chicago. Rather than simply reject the "foreigners" in their midst and retreat to the hostile racism of the nativist movement, Progressives believed that America's strength lay in its successful assimilation of the diverse cultural currents swirling through the country. Not only white middle-class Protestants subscribed to Progressive values; these years also mark the birth of such organizations as the National Association for the Advancement of Colored People (NAACP), Marcus Garvey's Universal Negro

Improvement Association, the General Federation of Women's Clubs, the National Consumer's League, and the National Association of Colored Women.

These groups understood that communication was one of the primary, most essential factors in assimilation, progress, and democracy. Immigrants could not become true Americans, could not arrive at an understanding of and appreciation for their new lives as citizens of a democracy, without communication. African American and other ethnic and racial groups could not bring their message to the wider public without techniques of publicity and discussion. Similarly, established white citizens could not be brought to a full understanding of other cultures' and races' rights without information and connection. Although education was the primary means to bring the nation together, especially for the children of the immigrants, another way to reach all Americans was through the popular media. Communication would help to create a common culture and a sense of community. Progressives were the first group to theorize the media's social effects and to include it in their social platforms. The way that radio was received and understood when it entered the picture owes much to Progressive concerns.

However, Progressives met with considerable resistance to their reforming task, not just from nativists or cultural conservatives, but from a collection of strong though unorganized forces in American society that we might loosely dub "populism." A populist stance might derive from a number of positions—from ethnic or racial groups who wanted to hang onto their own culture; from free-market entrepreneurs like Dr. Brinkley, who simply wanted to pursue profits by catering to popular tastes and interests; from working-class people who had their own ways of thinking and doing things that might not conform to reformers' standards; or from local politicians and social groups responding to local conditions. In the general context of First Amendment freedoms, free-market philosophy, and the young but growing spirit of multiculturalism that made up the broad mainstream of American experience, this was a powerful force. It wasn't always a progressive or liberal force; demagogues like Father Coughlin (more about him soon) or quacks like Dr. Brinkley could use populist rhetoric to turn people against each other and fan the flames of fear and hatred.

Yet *populist* literally means "of the people," and the hugely varied and widely disparate people of the United States generated, almost automatically, enormous resistance to attempts to define and control them. For instance, the Women's Suffrage Movement, another strong force toward change during the twentieth century's early decades, arose out of the milieu of upper-middle-class Progressive reform—yet its accomplishment of obtaining, in 1920, the right to vote for *all* of America's women produced profound effects arising out of ordinary women's power of numbers, and huge diversity, that no progressive elite could hope to control.

Many of the assumptions on which our nation was founded—the separation of public and private spheres, the gendering of labor, the control of reproduction, the ownership of economic assets, ideas about men's and women's essential differences— were thrown into disarray by the very idea of women exercising their opinions in the public space of politics. To admit women to the polling booths was not a mere Progressive reform; it opened the door to the idea that beliefs underlying many aspects of American life might need to be reconsidered. Furthermore, as new forms of media expanded throughout the country—popular books and magazines, films, the penny

press—much of it addressed to women, then as now, as the primary purchasers of goods for the family, women's voices and experiences were given a new public life. Radio would continue this tradition of popular feminized address and open up more areas of debate and controversy.

The War to End All Wars

The new popular media also played a large role in the domestic context of World War I. The nationalist fervor stirred up by the need to mobilize a nation for war grew out of the pressures of immigration and nativism; in many ways those pressures were brought to a boiling point by the war's demand for unity. As historian Robert Wiebe, in particular, points out, the United States remained a "segmented society" into the early teens (Wiebe 1967). Immigrants lived in ethnic enclaves in city and country, spoke their own language, often sent money home, and even returned home again themselves in numbers far greater than popular memory recalls. But the war provoked a need for all to declare themselves as "American" and to forsake their foreign ways—not in the gentle, assimilatory manner prescribed by the Progressives but with loyalty oaths, denial of ethnic heritage, and expulsion if necessary. Frankfurters became hot dogs, Dachshunds were renamed "liberty hounds," and German-language papers were forcibly shut down. Immigrants from Eastern Europe and Russia, in particular, were viewed with deep suspicion. As would occur later with World War II, the spirit of isolationism ran high: Why should we get involved in Europe's problems? In response, war hawks stepped up their nationalist rhetoric.

On April 6, 1917, President Wilson declared America's involvement in a war that had been raging in Europe since 1914. One week later, he named newspaper editor George Creel to head the Committee on Public Information, the first organized propaganda effort sponsored by the U.S. government using modern communications media. The Creel committee not only censored what newspapers could print about the U.S. war effort but also became the main source for what could and could not be said about the war. The committee also had the power to request the cooperation of the advertising industry, which complied by creating a highly successful campaign to sell war to the American public. Critics (on both the nativist right and the pacifist left) wondered if marketing techniques weren't overwhelming careful, rational thought and worried about the susceptibility of the masses to such a coordinated propaganda effort. In this politicized environment of fear and suspicion arose some of the first studies of media's effects on public opinion (Lasswell 1927).

THE RISE OF POPULAR MEDIA

From 1890 to 1920, American popular media blossomed like, some would say, weeds on a hot day. Scientific inventions and technological improvements—the telegraph, telephone, mechanized printing, photography and rotogravure processes, and the nascent motion picture—led to an explosion in numbers, forms, and types of media by the 1910s. A corresponding rise in advertising enabled a new form of financial support and dissemination for popular media. From the earlier period of the colonial press, when only the

wealthy could afford books and newspapers, the rise of advertising-based media combined with technological developments to bring affordable books, magazines, newspapers, and other printed and pictorial material into the reach of almost every household.

It also brought a shift in the purpose and address of the media: From organs of opinion published by and for the wealthy and educated elite, the media became *popular*—directed at the common people, reflecting their concerns and interests, using forms of address and communication that they could understand and enjoy. Businesses with goods to sell paid to have their products advertised in newspapers, magazines, and even in books and films. This source of revenue allowed publishers to charge the public very low prices, often only a few pennies. The public, for its end of the bargain, accepted advertising material as part of the information and entertainment they received. The advertising-based method of finance also meant that more people than ever before could be reached by one publication. This feature is what made commercial media profitable, but it also led to increasing fears of how easily such mass audiences might be influenced or manipulated. These fears would play a large role in the early debates over radio.

The Press and Magazines

It was the steam-driven printing press that allowed the first form of popular media to emerge: the penny press of the 1830s. Samuel Morse's pioneering development of the telegraph in the 1840s enabled the nascent press industry to expand the reach and breadth of its reporting—to make almost instantaneous connection with all different parts of the country—and soon the popular press spread like wildfire. By 1915 over 2,300 daily newspapers appeared in English in American cities and towns, and over 150 were in foreign languages. Most cities had at least two competing papers, and major cities like New York and Chicago boasted more papers than an individual reader could get through in a day. Competition spawned controversy; new media entrepreneurs like William Randolph Hearst (later the subject of a famous Orson Welles film, *Citizen Kane*) introduced sensationalized crime stories, muckraking reports of corruption in high places, and an emphasis on emotional stories that were believed to appeal to the female audience these papers courted. In reply, Adolph Ochs's sedate *New York Times* attempted a cooler, more intellectual journalism marked by newly developing standards of objectivity and journalistic neutrality.

By the teens another form of journalism had arrived: the smaller format and heavily pictorial tabloids, led by New York's *Illustrated Daily News*. Patterned after successful British papers of this ilk, the tabloids developed a combination of sensational headlines, prurient pictures, gossip, scandal, and news that related to common people's daily lives. They would soon become the most widely circulated publications in America's largest cities, providing a perspective shunned by more respectable dailies. Similarly, the nation's African American minority supported a flourishing black press, led by influential papers like the Chicago *Defender*, the Pittsburgh *Courier*, and New York's *Amsterdam News*. Largely excluded from coverage in white newspapers, the nation's black and ethnic communities depended on papers like these to represent their points of view, cover issues from their perspective and in their communities, and crusade for social and political reform.

Magazines developed at an equal pace. Early magazines such as *Godey's Ladies Book* and *St. Nicholas* focused on women and children's interests, respectively. Others, such as *Harper's Monthly*, the *Literary Digest*, and *The Atlantic Monthly*, served a relatively highbrow general public with social, literary, and political content. They were later challenged by more popular titles like *The Saturday Evening Post*, *McClure's*, and *The Ladies' Home Journal* that combined muckraking social commentary with fiction, fashion, and features. These new middlebrow journals boasted circulations in the hundreds of thousands, creating a new national audience that could be mobilized behind serious social issues. Many credit the passage of the Pure Food and Drug Act of 1906, which curtailed the activities of some of publishing's heaviest advertisers, with crusading magazine journalism.

However, not all popular journals proved so highminded. A host of specialized magazines sprang up in the late teens and twenties, often tied to other popular culture phenomena. Movies propagated film glossies like *Photoplay* and *Motion Picture Stories*, which told tales of the stars' personal lives to their fascinated fans. Physical fitness maven Bernarr Macfadden founded a media empire with titles like *True Story* and *True Crime*. These extremely popular publications featured accounts of illicit romance, moral dilemmas, and assorted walks on the wild side, all told as "true stories" in the first person by "ordinary" members of the public. Stories were selected by an editorial board that reflected the audience: "Numerous girl readers, including stenographers, dancing teachers, and even wrestlers, who were instructed to read not for style or good taste, but 'for interest,' and to rate a manuscript on a scale of 90 to 100, depending on how they felt while reading it" (Ernst 1991, 77).

Advertising Agencies

The rise of advertising-based media both depended on and itself produced a corresponding rise in the profession of advertising. From brokers who bought a certain amount of page space in each city's dailies and weeklies and then peddled the space to businesses to advertise their products, advertising grew into a flourishing profession. The first true advertising agencies, founded in the 1880s, offered not only media placement but also design and execution of advertising campaigns, market research, and growing professional expertise. By 1920, businesses spent over $3 billion a year on advertising, a good portion of that in the popular media.

Music, Vaudeville, and Film

The urbanization of the United States, in turn, further strengthened an already booming popular entertainment establishment. Music halls, vaudeville circuits, music publishing, and the new nickelodeons and small film theaters brought aural and visual culture into easy reach of urban residents; expanding vaudeville "wheels" or circuits, film chains, and the growing music business extended popular culture's reach even into the hinterlands. These entertainments, even more than print, had an enormous appeal for arriving immigrants, because the barrier of language was lessened and the opportunities for participation increased.

Music has always played an important role in American life, but before the advent of recordings and radio, people had to make it themselves. If any aspect of popular culture can be said to have suffered at the hands of new technology, it is the world of the amateur musician. Before the 1920s, if you wanted to prolong the delicious experience of hearing the latest tunes performed on the stage by a touring vaudeville troupe, you had to purchase the sheet music and play it yourself, perhaps accompanied by friends and relatives. Barbershop quartets and amateur chamber music formed an important part of social life, entertaining the whole community from the bandstand in the park or on the street corner in good weather. Music publishing was an expanding and vital industry, with millions of copies of sheet music sold each year. Thus music publishers and talent bookers put out much of early radio's programming. The phonograph, expanded and abetted by the radio, would soon change all that.

In America's teens and twenties, vaudeville provided to cities large and small a range of popular entertainments—from singers and dancers to juggling acts, comedians, pet tricks, acrobatics, comic and dramatic skits, burlesque, musical acts, minstrel shows, operatic shorts, silent films, and ventriloquists. From the premiere theaters of Broadway to the giant Orpheum and Keith circuits to tiny local theaters and open-air venues, America went crazy for vaudeville as the main entertainment in town. Many theaters featured talent nights, where members of the community could try out their own skills as performers. Stars such as Fanny Brice, Jack Benny, Fred Allen, and George Burns and Gracie Allen got their start this way; vaudeville entertainment existed in and of the communities that embraced it, not in a distant Hollywood. Though it constantly struggled for respectability and was never embraced by espousers of high culture, it was America's main showcase of popular culture from the 1860s until radio brought it down in the 1930s. Revived briefly by early television's variety shows in the 1950s, vaudeville is now only a distant memory.

One threat that vaudeville fairly successfully weathered was that of film. It helped that early movies were silent. From their beginnings in the short novelty pieces of the first decade to the development of longer narratives, cinematic techniques, and popular stars in the teens, the movies had become an established national industry by the postwar years. By 1922, over 40 million people attended the movies weekly, and Mary Pickford (America's Sweetheart), D. W. Griffith, Charlie Chaplin, and Lillian Gish were household names. The major motion picture companies still with us today were founded during this period: United Artists, Fox, MGM, Paramount, Warner Bros., Columbia, Universal. Film, vaudeville, the popular theater, and the music business fed off one another's talent and creative energy; it was common for a vaudeville star to make films, publish sheet music, and perform onstage, just as film stars moved around on this entertainment juggernaut in a variety of venues. Soon radio would elbow its way into these cozy relationships.

Early films often formed part of the vaudeville lineup; later, as special motion picture theaters were built, "going to the movies" usually meant seeing not only one feature film, but a series of comic shorts, cartoons, newsreels, a serial or two, perhaps a stage spectacle based on the main feature (in a major city), and finally the feature itself, all accompanied by a full orchestra, a theater organ, or at the very least a pianist. The special effects may have been minimal, but as an event, movie going could not be beat. In ethnic neighborhoods, silent movies were often accompanied by a narrator

translating the title cards and providing a running commentary in the local language. Young people, in particular, found at the movies a glimpse of a more affluent, glamorous life than the local neighborhood or strict old-world traditions allowed. Parents began to worry that the movies were corrupting the morals of their sons and daughters by exposing them to dangerous Hollywood ways. And indeed, several studies have shown that young women from immigrant families, in particular, used popular culture as a way of breaking out of the strict roles prescribed by traditional family and social structures (Ewen and Ewen 1992).

Sports and Spectacle

Many other popular activities vied with the media for the public's attention and leisure time, and some of them provided material for broadcasting. Organized sports, growing in popularity since the 1880s, represented a major leisure-time activity, especially for men and boys. The Progressive spirit, which had always emphasized the benefits of physical activity and fitness, recommended sports such as baseball as excellent outlets and conveyors of good social values for young men of the immigrant and lower classes. Other nations felt similar pressures. The Olympic Games were revived in 1896, based on the ancient Greek ideal of bringing athletes from many nations together to compete. The first professional sports leagues were organized in the late 1880s, providing an entertaining spectacle for the male public. Other leisure-time facilities included amusement parks, parks and playgrounds, dance halls, dime museums, and even the new palaces of consumption—department stores. This is the popular culture milieu from which broadcasting sprang.

PROGRESSION AND REPRESSION

The Invention of Mass Culture

Not everyone looked upon this explosion of popular culture with delight. The terms *mass culture* and *mass communication* began to appear in discussions of current social trends, with overtones of faceless, threatening mobs overwhelming individualism and self-control. In the context of social disruption related earlier regarding immigration, it is not surprising that Progressive thinking had its repressive side. These strange, foreign, or different people should not be hated, reviled, and rejected; rather, they should be educated and civilized: Americanized. This could only happen, many well-intentioned reformers felt, by teaching the immigrants how to suppress their baser savage instincts (any tastes and habits different from those of upper-middle-class Western European Americans) in favor of sanctioned high culture. Organizations like Anthony Comstock's New York Society for the Suppression of Vice patrolled burlesque theaters, dance halls, and workmen's clubs, while social workers attempted to turn city youth's attention away from the temptations of movies, jazz, and confession magazines and toward a sphere of "higher" art and entertainment.

The term *mass* also had political implications; economic theorist Karl Marx employed it to refer to "the people," the laboring proletariat, who he argued would

eventually rise up and overthrow the dominant capitalist order. *Mass culture* was often considered to be the suspect terrain of immigrants, militant labor unions, and Communists and hence represented a clear and present danger—in the words of the 1918 Sedition Act—to established order and control. Much more than the equivalent term *popular culture*, which would not gain widespread use until after World War II, *mass culture* and *mass communication* are terms that date from the conflicted late teens and early twenties of the twentieth century and denote a deep uneasiness with populist democracy and technological progress.

High and Low in the Culture Wars

Not surprisingly, these are the same years during which American society consolidated the bifurcation of culture that had begun in the late 1800s into "high culture" and "low culture," as historian Lawrence Levine describes (Levine 1988). Even as popular media disseminated its low, mass, often vulgar forms to a growing "lowbrow" public, other institutions created a separate and elevated sphere for the more legitimate high forms favored by educated Western European elites. Opera houses, symphony halls, "legitimate" theaters, museums, and libraries simultaneously preserved higher forms from the taint of the popular market and restricted admission to those able to appreciate (and afford) such fine arts; yet they also provided a way for those from more humble backgrounds to educate themselves, elevate their tastes and aspirations, and hence achieve a form of upward social mobility.

Connection The Scandal of Jazz

In 1917, according to a report in the venerable penny press *The New York Sun*, a new kind of sound agitated the ears of white Americans. Writer Walter Kingsley reported a conversation he'd had with vaudeville impresario Florenz Ziegfeld, who described how his "Ziegfeld girls" had encountered a kind of music they'd never heard before on a tour to Cuba. These strange sounds, said Ziegfeld, "put little dancing devils in their legs, made their bodies swing and sway, set their lips to humming and their fingers to snapping" (Hilmes 1997, 47).

Ziegfeld quickly made use of a new technology that allowed him to avoid the perils of travel and bring the music to him: He commissioned a recording from the Victor phonograph company, which sent a technician "down there" and brought back what this one, highly biased account called the first strains of jazz in America. Ziegfeld featured the new music in his next Broadway "Follies," and the rest is history.

In fact, jazz was an American invention, and it is significant that Ziegfeld's highly self-serving historical narrative displaces it offshore—across the border—to Cuba. Historians have long debated the origins of jazz as a musical form, with little consensus except that it emerged from the black communities of the South, migrated north, and via the expanding popular culture industry began to reach a wider—and whiter—audience in the late teens

and early twenties. By the late twenties white musicians and bandleaders had begun to appropriate the form, blending it with more European musical traditions to create the big-band sound so popular on early radio. Aiding this process was the invention of our first medium of recorded sound: the phonograph.

Thomas Edison figures as the primary innovator in the technology of capturing sound through its analog transformation into magnetic signals embedded in wax on a cylinder, later refined into a flat disk made of acetate. Early phonographs could both record and play, because the needle on a long arm either put down or picked up concentric tracks of magnetic translations of sound waves that were either drawn in or amplified outward by a large trumpet horn. The impact of recorded sound on the spread of non-mainstream music cannot be overstated. It is one of the first technologies that allowed music and sounds from far-off or socially isolated places to be brought to the wider society without the observer having to travel there, or bring the musicians into places where they weren't particularly wanted, or force the music to suffer translation into unfamiliar note systems or performances. With jazz, a highly specific (and highly racialized) cultural form was detached from its environment and transplanted into new settings via technology.

Phonograph companies sent recording technicians into the hills of Kentucky, down the red clay roads of the black South, and onto Native American reservations to record sounds and music unique to those cultures. Combined with the migration of America's largest excluded minority, African Americans, to northern and midwestern cities, by the end of the teens a market for what were called race records developed in both white and black neighborhoods. Jazz began to emanate not just from the downtown nightclubs, and not just from the segregated halls of the cities' "darktowns," but from middle-class living rooms via the phonograph (and later, as we shall see, the radio). And although many enjoyed and popularized this phenomenon, the backlash was swift and vocal.

"Mezz" Mezzrow, an early (white) Chicago jazzman, put it bluntly: "Our music was called 'nigger music' and 'whorehouse music' and 'nice' people turned up their noses at it" (Hilmes 1997, 47). The editor of the *Musical Courier* described one jazz band's performance as "a kind of savage rite" with "all of the players jolting up and down and writhing about in simulated ecstasy, in the manner of Negroes at a Southern camp-meeting afflicted with religious frenzy" (Hilmes 1997, 47). The national music chairwoman of a major Progressive-affiliated reform group, the General Federation of Women's Clubs, wrote an article in 1921 called "Does Jazz Put the Sin in Syncopation?" Describing jazz as "originally the accompaniment of the voodoo dancer, stimulating the half-crazed barbarian to the vilest deeds . . . to stimulate brutality and sensuality," she explained the threat that jazz posed to civilized life:

> Jazz disorganizes all regular laws and order; it stimulates to extreme deeds, to a breaking away from all rules and conventions; it is harmful and dangerous, and its influence is wholly bad. A number of scientific men who have been working on experiments in musio-therapy with the insane, declare that . . . the effect of jazz on the normal brain produces an atrophied condition on the brain cells of conception, until very frequently those under the demoralizing influence of the persistent use of syncopation . . . are actually incapable of distinguishing between good and evil, between right and wrong. (Hilmes 1997, 47–48)

In 1922, the Ninth Recreational Congress, a gathering of Progressive reform groups concerned with youth and leisure activities, declared a war on jazz. One speaker, Professor Peter Dykeman of the University of Wisconsin, claimed that "Jazz is the victim of its wild, modern devotees, who are as bad as the voodoo worshipers of darkest Africa." He linked the spread of this "African" practice explicitly to new technology, claiming, "We are in danger of becoming a nation of piano-pumpers, radio-rounders, and grafanola-grinders. Those mechanical instruments, if unwisely used, are dangerous to the musical life of America" (Hilmes 1997, 49).

These outcries against jazz grew out of Progressive beliefs in the power and importance of communication in national culture, combined with fear of the undisciplined masses and linked to deeply rooted racism. They called for regulation of these new technologies and cultural forms, made on the basis of a racial, ethnic, and class-based hierarchy of taste and high/low culture distinction. Jazz's very popularity spoke against it and awoke troubling notions of uncontrolled, barbaric masses disporting themselves without discipline or restraint. As early as 1922, radio was being identified as one of these trouble spots, and we will see that the link between jazz and radio would have a lasting effect on its industrial structures and regulation.

FROM RADIOTELEGRAPHY TO THE WIRELESS

We are now ready to introduce the technological innovation hovering at the edge of the Progressive era, which began to feature more and more largely in the rhetoric of these decades. Americans had become used to the telegraph's ability to transmit coded messages via wire over long distances, and to the wired voice medium of the telephone that brought personal communication into homes and offices. But the ability to transmit without wires—*wireless*—remained only a vision until the Italian/British inventor Guglielmo Marconi made it a reality during the very last years of the nineteenth century. Backed by decades of research by other innovators, Marconi had dazzled the Americans with a ship-to-shore radio report on the America's Cup race in 1899, and he was at last able in 1901 to send the dots and dashes of Morse code (long used in telegraph communication) from England to Newfoundland across the Atlantic.

Marconi was followed by Canadian inventor Reginald Fessenden and American Lee De Forest, both of whom contributed key devices to the development of wireless *telephony*, the transmission of noncoded voice and music. Fessenden's high-speed alternator allowed him to send out what has been called the first true broadcast: a concert of music and holiday readings transmitted on Christmas Eve 1906 from Brandt Rock, Massachusetts. De Forest's disputed invention of the Audion tube permitted better amplification of received radio waves that made later low-cost crystal sets possible. Finally, the even more powerful Alexanderson alternator, the brainchild of General Electric engineer Edward Alexanderson, meant that consistent transmission over very long distances, even overseas, would finally become a reality.

These inventions were first aimed at solving the urgent industrial problem of ship-to-ship and ship-to-shore communication. In an age during which expansive imperial and industrial empires made the global shipping trade a vital national concern, communication between ships and ports, the expedient dispatch of cargo, and the ability to call for help in emergencies urgently required a medium that could cross the waves without wires. Wireless sets were installed on ships as early as 1899. The *Titanic* disaster in 1912—made infinitely worse because of insufficient and inattentive wireless operators—provoked the passage of the Radio Act of 1912. It was a revised version of an earlier piece of legislation, the Wireless Ship Act of 1910. This set of rules, a version of which was jointly agreed upon by 29 nations, mandated radio equipment for all long-distance vessels and set up standards of operation to enable wide and continuous mutual communication. The U.S. Navy also adopted radio communication early on, and wireless soon became an important aspect of national defense. Already the federal government had been brought into the radio business, setting an important precedent.

As these technological steps in the faster, further, and more accurate slinging of sounds across the airwaves—often called *the ether* in the terminology of the times— garnered publicity and public investment, they intersected with innovators whose genius lay not so much in technology as in use. America's growing population of radio amateurs soon became a major determining factor in decisions about how to use this new medium, how to direct and control it, and how to think about it in the context of American culture. The term *amateur* refers to the growing group of technologically adept tinkerers—young and old, male and female, from all ethnic and class backgrounds—who became fascinated with the possibilities of this new technology and determined to experiment on their own. Often putting together their own radio sets, which could both receive and transmit, wireless amateurs tapped out identifying messages in Morse code and received others' messages in an ongoing contest to see "how far they could hear." Edwin Howard Armstrong, Lee De Forest, and Frank Conrad, innovators in radio, all started out as amateurs, experimenting at home with the wonders of the ether.

The technological breakthrough that made amateur wireless possible was the development of the *crystal set*. This was a low-power device that used silicon-based crystals to detect radio-wave transmissions, a system that was inexpensive and simple enough that almost anyone could obtain the basic components and put together a radio set capable of picking up both code and voice transmissions. During the pre-World War I years, from 1906 to 1917, the amateur community boomed. Radio amateur organizations and publications sprang up that would later become major lobbying and opinion centers as radio went public. There were two major national organizations: the Radio League of America, founded by Hugo Gernsback, claimed to have 10,000 members by 1910; and the American Radio Relay League (ARRL), founded in 1914 by Hiram Percy Maxim and still active in ham radio operations today. These two colorful visionaries might be thought of as the computer hackers of today's Internet scene. Great men or not, their story (in the Connection that follows) brings together the spirit, struggles, and personalities that mark the amateur movement and allows us a glimpse of a very different way that radio might have developed.

Connection Radio Hackers: Hugo Gernsback and Hiram Percy Maxim

It is hard for us today to understand the world of innovation in which the early radio amateurs lived. We are so accustomed to radio and television as one-way media—receive only—that the idea of a radio or television set that could both receive and send messages is hard to envision. Likewise, we are so used to the idea that only big companies can broadcast over the airwaves that it sometimes comes as a shock to remember that the frequencies on the electromagnetic spectrum that allow these companies to broadcast in fact belong to the public—to us—and are only managed on our behalf by the federal government, which grants such companies licenses. Why can't we use these frequencies to send out our own signals? Why isn't broadcasting more like the Internet—a medium of open, individual access, little centralized control, using an infrastructure of public computers and data links to allow us both to browse and to post, to receive and to contribute information, to be active originators as well as passive receivers?

This is the vision that the amateurs had for radio, and for more than a decade it was the dominant model. It took a concerted effort by big business and government, feeding on the elite public's fear of the masses, to change that vision to the highly centralized, one-way, restricted-access system that is broadcasting. Hugo Gernsback and Hiram Percy Maxim headed organizations whose members fought against this centralization of control of early radio, and the story of what became of their model might serve as a warning for what could happen to the Internet as well.

You may have heard of Hugo Gernsback in quite a different context: He is more widely known as the father of science fiction. In 1925, after basically giving up on amateur radio, Gernsback took his futuristic visions to another medium, founding *Amazing Stories* magazine and publishing some of the first science fiction in the United States. He also wrote sci-fi novels himself, and the annual Hugo Awards for outstanding achievement given by the World Science Fiction Convention each year are named after him.

An immigrant, Gernsback arrived from Luxembourg as a young man in 1904 with an invention to market: an improved dry battery. He started up a radio supply house on the back of this innovation; and he soon began to publish one of our first magazines of popular technology, called *Modern Electronics.* It later became the still widely circulated *Popular Science.*

This was the first period of wireless growth. Using Morse code (because voice transmission wouldn't become practical until around 1915), hosts of radio hackers built their own crude crystal sets and began venturing onto the airwaves. Calling out to one another using code phrases that efficiently conveyed "I'm here" and "I receive you," and constantly striving to receive distant signals, the amateurs soon began to organize themselves into clubs and associations to promote DXing (as it was called) as a hobby, to share techniques and tales, and eventually to lobby for favorable treatment from an increasingly intrusive government.

Hiram Percy Maxim also got involved in radio during this time. Maxim came from a family of inventors; his father and grandfather founded the Maxim-Vickers Company of England, which made munitions and later ventured into electronics. Hiram Percy himself graduated from MIT (Massachusetts Institute of Technology) at age 16; his early inventions include a gas-powered tricycle, an electric automobile, and finally (based on exhaust muffler technology) the Maxim silencer for guns. Born in 1869, Maxim was 45—old by amateur radio standards—when he founded the ARRL. Realizing even then that amateurs were being perceived as disruptive, undisciplined "small boys" whose signals interfered with more "respectable" uses of the medium (and who sometimes played practical jokes on air), Maxim set out to organize amateurs into a network of operators across the nation—a relay league—who could be counted on in times of emergency to hurry to their stations and spread the word from operator to operator, alerting authorities and sharing important communication. The ARRL lobbied Congress for a few special high-power frequencies to allow more expedient relaying, published a book of members and callsigns, and began to publish its own magazine, *QST* (still published today). The ARRL also encouraged better standards of operation and responsibility and thus helped to improve the reputation of amateur radio as a field. As historian Susan Douglas puts it,

> Maxim clearly sought to discipline America's amateurs and to establish distinctions between those who were skilled operators with efficient apparatus and those who were hacks. He wanted to make the amateurs, both in reality and in image, more docile and cooperative, more in harmony with the prevailing social order. (S. Douglas 1987, 297)

With this kind of initiative and improved press coverage, amateur radio grew into a highly regarded hobby for young men (and a few women). Amateurs ventured into voice transmission as this became possible and began to innovate some of the practices that would mark early broadcasting. Concerts, of both live and recorded music, were played to all who could receive them. Speakers were invited to give talks on issues of the day. Operators invited friends in and indulged in chatting and joke telling, or exchanged information on community events, special sales, weather and sports reports, and the like. As the United States felt increased pressure to enter World War I, radio was promoted as patriotic training, sure to come in handy for the boy who enlisted with these important skills.

In April 1917, the United States formally declared war on Germany. At this point the government ordered amateurs to shut down their transmitters for the duration. Many amateurs entered the Signal Corps, and they later formed an important core of innovators after the war with the improved technology they liberated from the Navy. This is the point, too, at which many more women became involved in wireless operation, because they were recruited to serve as trainers for the male operators who would go overseas. As the cover of *QST* put it, in its last issue before wartime suspension, "The Ladies Are Coming." But not until September 1919 would the Navy Department, under whose jurisdiction radio fell, lift the ban on amateur transmitting. By 1921, more than 10,000 licensed amateurs sent and received invisible messages across U.S. airspace.

The amateurs, with a few prominent figures like Hugo Gernsback and Hiram Percy Maxim at the head of national organizations, had established a new form of communication. As a *QST* editorial put it in 1921, "Do you realize that our radio provides about the only way by which an individual can communicate intelligence to another beyond the sound of his own voice without paying tribute to a government or a commercial interest?" (*QST* 1921).

Women amateurs made up a relatively small but enthusiastic part of the citizen radio movement.

These organized amateurs defined and fought for their vision of radio, what they began to call *citizen radio.* Establishing an important argument that the airwaves belonged not to any private interest but to the public, to the citizens, they envisioned radio as a minimally controlled, open-access, two-way medium that would allow citizens to communicate freely, under voluntary codes of behavior that would be enforced by the community. If this sounds something like early Internet philosophy, it is not a coincidence.

What happened? In 1922, radio broadcasting suddenly began to look like a viable business opportunity (as we shall see in Chapter 3). Hundreds of commercial operators applied for licenses, representing a wide variety of business concerns from radio equipment manufacturers to department stores, newspapers, religious establishments, and even dry cleaners and chicken farms. Broadcasting a mixed schedule of entertainment and information designed to promote and publicize their businesses, nascent commercial operators began to crowd the available spectrum space. Amateur organizations like the ARRL soon began to resent not only these untrained and undisciplined operators hogging their bandwidth but also the tendency of businesses to blame the amateurs for the crowding. Stories about the carelessness and dangerous hoaxes played by the amateurs began appearing in the press. Who knew who these amateurs were? They might be Reds, or militant unionists,

or even jazz enthusiasts, indulging in their corrupting tastes and spreading them invisibly through the airwaves! The amateurs tried to correct and calm these fears. They pointed to the far more frequent violations caused by commercial stations, which had a substantial investment to protect and didn't mind whose frequency they stepped on. They defended their practices and argued that the commercial stations broadcast the most questionable material. But their lobbying and press power waned as major corporations like RCA, Westinghouse, and General Electric got into the game.

In 1922, as Chapter 3 describes, the U.S. government passed some severe restrictions, designed to aid the corporate broadcaster, on the new business of radio. These decisions created three different *bands* on which operators might broadcast and for which a license was required. The amateurs were consigned to the least favorable assignment, below 200 megahertz (MHz), and forbidden to broadcast most of those things that they themselves had pioneered: music, talk, weather and sports reports, and news. By 1923 relations between commercial interests and amateurs had soured to the extent that *QST* no longer reported on station broadcasts and began to focus on purely amateur activity. By 1924, the magazine had adopted a cynical, defeatist tone as it editorialized,

> But say, isn't it funny how the cupidity of commercial interests is always being attracted by amateur development? The history of amateur radio in this country has largely been one of guarding our cherished right to existence from the designs of somebody who would like to have something of ours, generally because they think they can make some money out of it. Ho, hum. (Hilmes 1997, 41)

The era of amateur radio came to an end as radio became big business. The vision of citizen radio faded from public memory.

Hugo Gernsback turned his attention to the more promising world of science fiction. In the years to come he would imagine, though not develop, such devices as fluorescent lighting, radar, jukeboxes, tape recorders, loudspeakers, and television. Later writers such as Arthur C. Clarke and Ray Bradbury would acknowledge Gernsback's influence on their work. He experimented with some of the world's first television broadcasts from station WRNY in New York City in 1926 and encouraged his readers to build their own TV receivers, much like they had built their crystal sets a few years before. He imagined, in his writings, multistage rocket boosters to the moon and tethered space walks. Gernsback's death in April 1967 occurred just two years before the Apollo moon landing.

Hiram Percy Maxim turned his efforts toward international amateur radio. He is credited with founding the International Amateur Radio Union (IARU) in 1925. Maxim continued as the president of the ARRL until his death in 1936, where he helped to ensure the continuation of ham radio against the increasing inroads of commercial spectrum usage. By 1934 there were over 46,000 licensed ham operators in the United States, and the ARRL's Emergency Corps played a crucial role in such disasters as the 1936 Johnstown flood and a major East Coast hurricane in 1938.

These are two great men whose stories fade beside those of the radio victors like David Sarnoff, William S. Paley, and the radio stars whose fame rests on a very different vision of what broadcasting could be. Gernsback and Maxim represent the

side that lost and that was forced into obscurity and relative silence by big business, commercialization, and national regulation. Yet the concept of public ownership of the airwaves, the idea that the people have some rights and interests in the way that broadcasting is organized and performed, is a legacy we owe the radio amateurs, not the major corporations that followed. And it seems clear that this vision is the one that informed the early development of Internet and web technology—and that it might be vulnerable to the same pressures that destroyed amateur radio. Is it 1922 in the story of the Internet? As radio moves into the boom years of the 1920s, the parallels become uncanny.

CONCLUSION

This chapter has tried to paint a picture of the complex social and cultural web into which radio was introduced in the 1920s. The late teens and early twenties were a period of immense social and political upheaval. Immigration, nativism, World War I, the newfound power of women, migration from farms to cities, the growth and problems of urban life, and a growing popular culture challenged Progressive notions of assimilation and control. Entertainment industries like publishing, advertising, sports, movies, and vaudeville rose up to amuse, inform, cajole, and educate this polyglot breed of Americans. A new kind of popular culture developed at the grassroots level that many, especially the established elites, feared and resisted. Mass communication began to be recognized as a powerful new social phenomenon in an atmosphere of expanding democracy and social instability. The advent of radio drew on and affected all these trends. Far from arriving as a finished, uncontroversial technology that could be easily adapted to existing structures and hierarchies, radio stirred up conflicts, offered competing uses, provoked struggles over whose interests would prevail, and raised fears about the dangerous cultural forces that might be unleashed by this invisible medium of connection and communication. Out of these many forces radio broadcasting arose as a vital and necessary participant in the American experience.

BROADCASTING BEGINS, 1919 TO 1926

In 1915, filmmaker Cecil B. DeMille directed a sensational, controversial movie called *The Cheat* for the newly formed Paramount Pictures corporation. Though it was made a bit earlier than the period we'll be dealing with in this chapter, the movie paints a telling picture of America in the prosperous and xenophobic teens and twenties. Considering that it was remade twice—in 1923 and 1931—it apparently spoke to citizens of the day as well.

Set in an affluent Long Island community, the film involves a wealthy, bubble-headed young society woman who has been entrusted with the proceeds from her Red Cross chapter's drive to aid Belgian refugees. Her husband, who has been experiencing some difficulties in the volatile financial market of those decades, has cut off her dress allowance. Determined to have a new dress at all costs, she remembers what she overheard at a recent dinner party about a stock that just cannot go wrong, and she takes the club funds to a broker, who invests them thinking that they are her own. The stock, of course, goes down rather than up, and she must come up with more funds if she wishes to recoup her initial investment. In desperation, she turns to the "shadiest" person she knows: her mysterious, sinister Japanese neighbor, who lives in a nearby mansion surrounded by exotic decor. He agrees to loan her $10,000, but on one condition: If she cannot repay him by the stated time, she will become his mistress.

When she fails and comes to beg for more time, he reveals the "savage beneath the skin" and viciously brands her with his own special mark, to show that she is now his. This scene in particular outraged audiences and censors, especially because the film makes it clear exactly what will happen next. But in the nick of time her husband rushes in and shoots the "evil Oriental." The husband is arrested and tried, and the repentant, chastened wife proclaims her own guilt in a climactic courtroom scene, culminating with her revealing the scar in the shape of a Japanese character that the brand has made. The courtroom erupts in a riot of outrage against the Japanese merchant, with the (all white male) audience shouting "Lynch him! Lynch him!" while urging the court to "right the wrong of the white woman." The role of the sinister Japanese was played by Sessue Hayakawa, who built a career out of such parts in the absence of other opportunities for Asian actors at the time.

In its evocation of affluence and sudden reversals, dependent but resentful wives, authoritarian yet insecure husbands, social climbing and fear of ostracism, and particularly its projection of all that is wrong with modern society onto a non-American, Asian character, this film captures much of the spirit of the 1920s. During this time the stock market and the general economy boomed; more Americans became middle class or wealthy during this decade than ever before, and the prosperity seemed like it would go on forever. Many invested in the stock market. New ventures sprang up by the thousands. The banking and financial sector took precedence over old-line manufacturing and transportation industries. The media industries expanded, converged, and spread across the country. Americans just wanted to have fun.

Yet, the fun ended. The stock market crashed in 1929, ushering in the Depression. And, in fact, those times of well-being had not been shared by all. With the unprecedented economic prosperity and social change, along with an equally strong backlash of racism, fear of immigrants, and fundamentalist morality, the 1920s resemble 1990s America more than a little. The borders of the nation—both internal and external—were being patrolled with a vengeance, and it is in this charged milieu that radio broadcasting became a national medium.

Restrictions and Backlash

After World War I, which had slowed the influx of foreigners to American shores, immigration began to pick up again in 1920. However, the militant Americanism whipped up by wartime propaganda now viewed this flow as a threat rather than an opportunity. In 1921 the most stringent set of immigration restrictions in the United States was enacted and later codified in the National Origins Act of 1924. This legislation not only restricted the number of people from other countries who could enter this country to less than 200,000 a year but also set quotas on the national origins of immigrants, based on pre-1890 immigration records—at a time well before most of the eastern European and Asian immigration started. This meant that only northern and western Europeans would be admitted in any numbers from that time forward—a deliberate program to whiten and aryanize the United States. Asian immigration was cut off almost completely, because the Chinese Exclusion Act, which did exactly what it sounds like, had been in effect since 1882. These laws, and the social attitude that they reflected, effectively closed the book on the early pluralistic period of American culture. From that point on, an emphasis on unity, consensus, and assimilation would prevail—even as a multitude of factors fought against it.

Not surprisingly, these attitudes fed the flames of the nativist resurgence that the war years had legitimized. The Ku Klux Klan, which had died out after the post-Reconstruction restoration of white supremacy in the South, revived in 1915 under the inspiration, some claim, of D. W. Griffith's film *Birth of a Nation*. However, the Klan remained small and obscure until the postwar years, when a renewed attention not only to persecution of African Americans but also to the dangers posed by Roman Catholics, Jews, foreigners, Bolsheviks, and organized labor boosted its membership to over 4 million in 1925. By that time the Klan was not only in the South but also in the

Midwest. Membership peaked again in 1928 during the campaign of the first-ever Catholic candidate for President, Alfred E. Smith. Lynching and cross burning remained popular Klan activities throughout the decades.

Black Resistance

Nativists and racist groups were very threatened by the rise of the early civil rights movement. The African American community, in particular, had responded to the patriotic call of the war years by putting aside their objections to segregation and discrimination in the military and society at large and enlisting in the war effort. Promised that their service to their country would result in social reforms after the war, but instead slapped with renewed hatred, segregation, and unemployment, Black Americans felt betrayed. Reformers began to advocate a more militant, less conciliatory stance. Leaders like W. E. B. DuBois, one of the founders of the NAACP and editor of its influential magazine *The Crisis*, advocated a new kind of black nationalism and black cultural identity.

In the meantime, continued migration to the cities brought sizable African American communities together—in New York's Harlem, Chicago's South Side, Pittsburgh, Detroit, and many other industrial centers. This is the period of the Harlem Renaissance, an uprising of African American literature, art, and political theorizing exemplified by such figures as Countee Cullen, Claude McKaye, Langston Hughes, Zora Neale Hurston, and many others.

Black musicians like Louis B. Armstrong, Count Basie, Bessie Smith, Alberta Hunter, and Duke Ellington achieved national fame during these years, giving the twenties the memorable title "the Jazz Age." Developing media like recordings, movies, the popular press, and soon radio brought their achievements to a national audience. And due in part to enforced segregation, African American communities built up economic and social institutions of their own. Black universities thrived, the black press gained prestige and importance, and the educated black middle class grew in size and social clout. Yet still America remained deeply segregated.

What Did Women Want?

Freud's famous perplexed question might be answered in many different ways during the 1920s. Though American women had won the right, at last, to vote in elections, many other social and political areas remained closed. Most universities and professions would not admit women; many public and civic spaces were off limits to females; and though married women could now own property, it was nearly impossible for a woman to establish credit or obtain backing for business ventures. Reproductive control could not even be discussed publicly, much less made widely available, despite the struggles of birth control pioneers like Margaret Sanger.

However, a spirit of rebellion against traditional gender roles pervaded the land. Women cut off their long Victorian tresses in favor of the new bobbed look; they traded in ankle-length skirts for the short skirts above the knee; they ventured out on the town for entertainment, where they might even drink and smoke cigarettes; and despite all discouragements, they took on jobs and hoped for careers. The flapper—a

quintessential 1920s good-time girl—arrived, and 22 percent of women worked outside the home by 1930. More women entered universities, and women's clubs and organizations continued their widespread influence in many areas of social and political reform. One of the most effective was the League of Women Voters, still active today. The consumer movement would strengthen during the next few decades, largely through women's organizing.

Yet it is often reported that the push for the women's vote—much anticipated and feared as a potential power in social reform and politics—at this early stage produced only one clear result: Prohibition. The Eighteenth Amendment to the Constitution, passed in 1919, made the production, transportation, and sale (if not consumption) of alcohol a federal offense. In practice, however, keeping Americans from drinking proved utterly impossible and may even have set back the impact of American women on politics. It also drove drinking underground, where some of the forces most feared by reformers were able to gain an impressive foothold. Through many techniques—including smuggling alcohol from Cuba and the Bahamas, mixing denatured alcohol with flavoring, and manufacturing their own alcohol out of corn—bootleggers sold their illicit goods to a national market of tavern, restaurant, and nightclub owners, who learned that it could be profitable to cheat the federal government. Prohibition, though stemming from deeply moral and paternalistic impulses to lift the benighted working classes and immigrants out of their slough of poor self-control, backfired by creating a nation of happy scofflaws. Perhaps there are parallels in drug enforcement today.

Popular Entertainments

The twenties represent the first decade of modern mass media. American film became not just a national but a global phenomenon, as motion picture studios sprang up, consolidated, purchased theater chains across the country, and exported their products abroad. By the end of the twenties virtually every town and hamlet in the United States had its downtown movie theater, and movie attendance per week more than doubled, reaching an all-time high national average of three visits to the theater per household per week. Audiences followed the adventures of serial stars like Pearl White, thrilled to the exotic sex appeal of Rudolph Valentino, laughed and cried with Charlie Chaplin, swashbuckled with Douglas Fairbanks, suffered along with the good heroines like Lillian Gish, and secretly wished to emulate the bad girls like Clara Bow and Theda Bara. Movie magazines abounded, film celebrities increasingly became news, and many flirted with the new medium of radio. When the talkies were introduced in 1927, a whole new era of cooperation between film and radio began, despite the disappointment of a few soprano-voiced male stars and leading ladies with impenetrable accents. Before long the moral influence of the movies and their exotic source in Hollywood attracted national concern. The Hays Office was created in 1922 to patrol film morality and censor the worst offenses, under the fairly willing cooperation of the Motion Picture Producers and Directors Association (MPPDA).

This was the high point of vaudeville, which continued to rival films by presenting live stage entertainment coast to coast. Vaudeville and film became increasingly intertwined, with stage stars moving easily to pictures, and screen gems frequently featured on stage. Some producers took vaudeville to new "legitimate" heights, as variety shows

and revues began to dominate Broadway. Impresarios like Florenz Ziegfeld produced a Follies spectacular each year on Broadway, where soon-to-be stars of film and radio like Fanny Brice dazzled audiences.

The music industry experienced an enormous expansion. More professional musicians found paid employment in the 1920s than in any decade before or since. Each vaudeville performance, stage revue, Broadway musical, film theater, and radio station had to have its in-house musicians—often an entire orchestra—and nightclubs, speakeasies, hotels, restaurants, and dance halls provided additional venues. Sales of sheet music and recordings added to the vitality of America's musical culture, and popular singers and performers became virtual members of the household. Song and dance crazes swept the nation: the Charleston, the Lindy, the Bunny Hop.

In print it was the era of jazz journalism. The sensational tabloids increased in number and readership. Sex scandals, murder trials, graphic photographs, and screaming headlines vied for attention on the newsstand. Though the number of daily papers declined, consolidation in the journalism industry brought national newspaper chains into competition. Syndication reached new levels, as newspapers sought to hold readers by providing not only news coverage but feature stories, recipes, advice columns, serialized fiction, sports analysis, and, above all, comics. The comic strip had debuted a few years earlier, but by the twenties pages of the daily and weekly paper began to fill up with such perennial favorites as *Dick Tracy*, *Barney Google*, and *Popeye and Olive Oyl*. Some comics took on serial story lines, such as *The Gumps*, *Little Orphan Annie*, and *Gasoline Alley*. Magazines proliferated in all genres, publishing far more fiction and poetry than can be found today, and the confession magazine in particular enthralled the public with stories like "Side Door to Hell," "I Killed My Child," and "How Can I Face Myself? I Let Him Cheapen Me."

With all of this media activity (much of it supported by advertising) and with the consumer products industry reaching new heights along with the economy, this was also a period of great growth for the advertising industry. Major firms expanded nationally and internationally, merged and consolidated, and began to create specialized bureaus and techniques for the various media. By the late 1920s a few perceptive firms had instituted their own radio departments, preparing for further ventures into this promising new medium. While memorable phrases and catchy jingles began to find ineradicable places in popular memory, and the ad industry gained prestige and respectability, a certain suspicion of these new magicians of prosperity remained. A jingle from 1932 sums up most Americans' mixed feelings about the whole profession:

> Glorifying pink chemises, eulogizing smelly cheeses,
> Deifying rubber tires, sanctifying plumbers' pliers,
> Accolading rubber panties, serenading flappers' scanties . . .
> Some call us the new town criers, Others call us cock-eyed liars! (Marchand 1985, 50)

Who Are These Americans?

There are myriad other important social strands we might trace during this vital and creative decade. Sacco and Vanzetti and the Red scare, the Scopes trial, labor organizing, Charles Lindbergh's famous flight, Babe Ruth's amazing baseball feats, the host of American writers and artists who left America for Europe—all of these are memorable

parts of Roaring Twenties culture. But the underlying common denominator of these years, on all levels, was the fear of fragmentation and the yearning for some kind of national unity. In the face of political disputes, labor unrest, foreignness and difference, racial tensions, gender troubles, and violent crime, the nation struggled to define itself as something whole, identifiable, coherent.

What was America, and who were Americans? Did we really have our own culture, character, and identity? Or were we just a shifting, volatile mass of separate parts, all in conflict with one another, with no common ground on which to stand? Even our geography worked against an easy assumption of integration, being vast and spread out over distances incomprehensible to most nations.

But as historian Robert Wiebe has theorized, one identifiable factor was pulling America together. This was what had allowed the United States, despite all internal fragmentation and opposition, to spring together so quickly in 1917 when war beckoned and to organize and fight effectively. This is what the twenties boom would build on and the crash of 1930 would call into question: the close alliance of interests between modern corporations and the federal government. This alliance developed to a greater degree in the United States than in most other nations of the world. The working relationship developed by such government organizations as the Federal Trade Commission (established in 1914), the Interstate Commerce Commission (1887–1996), the Federal Reserve System (1913), and many other departments at both the federal and state level at once allowed for a certain amount of government control over business and created favorable conditions for big business to prosper. The government, in turn, realized that in a divided country suspicious of centralized control, private corporations could do more to stabilize and shape conditions voluntarily, but with guidance, than outright state intervention or ownership might.

The alliance of government and industry put labor unions, in particular, outside the fold. It meant that labor would from here on out be fighting an uphill battle against unfavorable legislation. It also meant something in terms of national identity: Whoever these Americans were, they would be defined not only as citizens living in a community or as workers building an economy, but most importantly as consumers living in a marketplace. Industry, particularly the booming consumer products and media industries, would serve as the essential link among conflicting concepts of the people, the public, the audience, the nation. Government would do at least part of its job through the intermediary of the private corporation. This central alliance would have a direct and lasting impact on the new communication medium of radio.

RADIO ACTIVITY

RCA: The Radio Corporation of America

A decisive moment in shaping U.S. broadcasting occurred in 1919, just after the war. Radio had played an important part in the war effort, and it had not gone unnoticed by the U.S. Navy and other government observers that one company owned the patents and manufactured almost all the vital parts and units necessary for effective radio transmission: the British Marconi company, still run by inventor Guglielmo Marconi.

Luckily, the British were our allies, so cooperation in radio development during wartime was no problem. But administrators in Washington predicted that the next time this might not be so. In the atmosphere of distrust and isolationism that followed World War I, the U.S. government sought a way to bring radio into its national fold, safe from outside interference.

One idea was to let the government, most probably the Department of the Navy, take over radio outright. Many argued vociferously for this position, and indeed it was the path taken by almost every other nation faced with a similar decision during these years. Radio, as a technology and as a form of national communication, seemed simply too vital to national interests, and too important as a unifier for cultural and social systems, to be left in the hands of private owners who might use it as they pleased. Also, groups such as the amateurs had argued that the spectrum was a public resource, not to be sold or assigned to private use. Of course, the amateurs would certainly have balked at the idea of the Navy—one of their most hated foes—taking over, and many Americans felt the same way, not least of whom were the major companies who had already invested heavily in the new technology.

In March 1919, while this debate raged, it began to look like the General Electric Corporation (GE) might sell not only a number of the advanced Alexanderson alternators to the British Marconi Company but also exclusive rights to future sales. This would have given Marconi a virtual world monopoly on state-of-the-art radio equipment, including within the United States, where the American Marconi subsidiary would have assumed a dominant position. Even General Electric felt a little queasy about this proposition, and GE chairman Owen D. Young approached Acting Secretary of the Navy Franklin D. Roosevelt for guidance.

Though the exact nature and extent of government assistance is not clear, GE was encouraged to purchase a controlling interest in the American Marconi company; later, it purchased the rest of the stock. Why would British Marconi go along with such a move? Well, because the U.S. government had seized control of all operating stations, including Marconi's, during the war and had not yet given them back, Marconi recognized that it stood a better chance of realizing some profit this way than if it tried to resist the compelling combination of federal and corporate power. It sold out, and walked away with exclusive rights to the use of the Alexanderson alternators in Europe, its home market. GE, with the help of the government, now had almost total control over U.S. radio.

In October 1919 GE, with the guidance of the federal government, formed a subdivision that was grandly titled the Radio Corporation of America (RCA). This nationalistic organization, comprised of the powerful radio oligopoly that would dominate broadcasting for most of the century, brought together the major companies involved in radio research to pool their patents and coordinate the development of radio in the United States. It was stipulated in RCA's charter that its ownership must be 80 percent American, that its board of directors must consist entirely of U.S. citizens, and that one member must be a representative of the government. One of those board members was David Sarnoff, formerly with American Marconi; later he would be named president of RCA. Westinghouse and the American Telephone and Telegraph Corporation (AT&T) became part of RCA in 1920. In 1921 the United Fruit Company became a minor partner, because of its involvement in radio communication in its fruit shipping business.

Through a complicated system of agreements, the companies involved in RCA agreed to divide up the business as follows: AT&T could manufacture and sell radio *transmitters* and could specialize in the field of radiotelephony (providing a telephonelike service between interested parties). GE and Westinghouse could manufacture *radio receivers*, which they then would sell to RCA. RCA would operate as a *sales agent* to retailers for all radio receivers; authorize others to manufacture receivers using AT&T, GE, and Westinghouse patents and collect and distribute their royalties; and operate all maritime and transoceanic stations obtained as part of the deal. All four companies could manufacture equipment for their own use—meaning that all could, if they so desired, build and operate their own domestic radio broadcasting stations. In 1921, no one understood very clearly what exactly radio broadcasting might be. Very soon, they would.

Early Regulation

By 1920, various amateurs, experimenters, businesses, and other interested parties had begun to take advantage of improvements in voice transmission made during the war by airing an invisible, but not unnoticed, national show. Most simply talked, some played music, and some put out various reports for the edification of the local and national listeners. More and more people applied for broadcasting licenses. In January 1922, the Interstate Commerce Commission (ICC), under whose jurisdiction radio fell, inserted this clause into all amateur station licenses: "This station is not licensed to broadcast weather reports, market reports, music, concerts, speeches, news, or similar information or entertainment." To keep their license, amateurs now had to agree to these restrictions and accept an assignment to the less desirable airspace below 200 megahertz (MHz). These were the grandfathers of ham radio operators today. Those who wished to continue providing information or entertainment had to apply for a more stringent broadcasting license on the 360-MHz band. Thousands did, and quickly this band became crowded, with signals overlapping and interfering with one another, especially in major metropolitan areas. All the members of RCA, including RCA itself, established early stations.

Westinghouse was the first major corporation to venture on air, because it had its own in-house amateur: Dr. Frank Conrad, an engineer. Conrad had joined the amateur fraternity in the teens; his broadcasts became so popular in the Pittsburgh area by 1920 (aided by the recordings he played that were donated by and credited to a local record shop) that the Joseph Horne department store mentioned Conrad's ethereal concerts in their newspaper ads aimed at selling radios to the public. Noting this, Conrad's superiors at Westinghouse concluded that receiver sales could be enhanced only if they began to provide some organized, regular entertainment that could be received on them. Conrad's garage station soon became KDKA—often referred to (with some dispute) as the nation's oldest station. In 1921 Westinghouse opened up two more stations: WBZ in Springfield, Massachusetts, and WJZ in Newark, New Jersey.

Defining "Quality"

But there was a problem. How could Westinghouse provide its superior brand of service—and thereby convince the public to buy RCA radio sets—if it was to be constantly harassed and interrupted by the uncontrolled broadcasts of area amateurs? And recall from our discussion of the jazz panic in Chapter 2 that these are the very

years during which much concern arose over just what kind of music and culture might be wafting invisibly through the airwaves and into middle-class homes. Westinghouse went to the ICC to present a solution to the problem: If the government itself was not to take charge of this powerful new medium, then perhaps it should help big business to establish order and control. Westinghouse officials proposed that the ICC create a new radio frequency at 400 MHz, and a new type of Class B station license.

Class B broadcasters would have to meet more stringent standards of quality than those for Class A stations on the 360-MHz band. Besides broadcasting at a higher power—500–1000 watts—a Class B station was expressly forbidden to play phonograph records on the air, or any other kind of recording. Instead, they were restricted to airing "live talent." This is the origin of radio and television's insistence on the superiority of live programming that would persist into the 1960s. The intention of this rule was, first, to give precedence to stations that were not duplicating something that the public could get elsewhere in another form—to keep radio entertainment unique and original. (This would later hinder the movie studios from getting into radio, as we shall see.) Second, the rule would have the effect of making sure that the desirable 400-MHz licenses went only to wealthier and more established organizations, because providing live entertainment on the air was much more expensive and difficult than playing records (and might cut down on objectionable jazz).

Setting an important precedent, government and business, working together, had come up with a way to "improve" broadcasting and restrict access to "responsible" parties, without infringing on any actual First Amendment rights as to what radio broadcasting should consist of. Class B licenses became available by the end of 1922. Though their frequency and name changed in the aftermath of later radio conferences, the principle of classification and preferment remained, along with the first blow to open access on the airwaves.

AT&T, GE, and RCA all opened up stations on the new 400-MHz band within the year. RCA, after a failed experiment with station WDY, agreed to take over WJZ and a new station, WJY, from Westinghouse in 1923 and moved the stations to New York City. AT&T opened up station WEAF in New York City in August 1922. GE made its on-air debut with WGY in Schenectady, New York, in February 1922. They were joined by many others.

Radio Conferences

The decision to create station classification had come about as a result of the 1922 Radio Conference, convened by Secretary of Commerce Herbert Hoover on February 27. Fifteen representatives from government and industry were invited to discuss current problems and future plans for radio. Some important recommendations coming out of this conference were

- To keep radio under the control of the Commerce Department, rather than the Navy or the Post Office, as in Britain
- To continue to have the Commerce Department assign frequencies, power, and hours of operation, rather than letting anyone broadcast whenever and wherever desired
- To ensure that radio should be operated in the *public interest*, rather than in the selfish private interest of the individual broadcaster.

Though a bill introduced to make these and other resolutions into law failed to emerge from committee, they set the tone for further discussions.

Another National Radio Committee conference was called in March 1923, and again it was a small one with only 20 delegates—none from the amateur community or from the general public. Notable here were recommendations for dividing the country into five regions for the purpose of assigning licenses and an extended discussion of how radio was to be financed, given the increasing restiveness of the American Society of Composers, Authors and Publishers (ASCAP). The powerful music rights organization had become concerned that too much of its artists' material was being played on the radio, with no compensation to its creators. Nothing was resolved at the conference, but a group of broadcasters, seeing the writing on the wall, got together that same month to form the National Association of Broadcasters (NAB) to look after their copyright interests as a group. They are still a power in the broadcasting industry today.

It was agreed at the second conference that the Commerce Department must continue its work of selectively assigning licenses. But later that year a legal challenge was filed arguing that the Radio Act of 1912 had given the government no such right; the assigning of licenses and frequencies was a purely clerical task that should involve no preference or exclusion. Congress needed to pass a new radio bill if more than this minimal kind of regulation was wanted. However, it failed to do so, and stations continued to proliferate on the airwaves.

A third conference was convened in October 1924, this time with an expanded base of 90 delegates and with small broadcasters and others outside the government-industry alliance included. Here tensions between RCA and operators of smaller stations began to emerge, sparked by RCA's statement that it would soon begin a chain of superpower 50,000-watt stations across the United States, in the absence of any restrictions preventing it. No agreement was reached, except that monopolistic practices should be discouraged (a shot at RCA), and no concrete recommendations were made to Congress. Finally, Secretary Hoover determined to resolve the issue of radio once and for all. Calling the largest conference yet—400 delegates from across the nation—on November 9, 1925, he deliberately restricted the debate to the problem of how (not whether) to limit the increasing number of stations flooding the airwaves, on what standard of public interest such decisions should be made, and by whom.

Principles and Precedents

The results of this conference were introduced to Congress as House Resolution 5589 in December 1925 and eventually became the Radio Act of 1927. In Chapter 4 we discuss the provisions of this critical piece of legislation, which led directly to the Communications Act of 1934 and our current body of law on broadcasting. But the conference resolutions set in place several important concepts that would dominate U.S. broadcasting for the next several decades. First, the principle of open access to all was rejected in favor of restrictions based on *quality*: a few quality broadcasters were better for the nation than many poor or mediocre ones. Second, this distinction should involve the notion of the *public interest*: Although a difficult term to define, a standard should be used by all parties to decide who would be allowed on the air and who would not. Third, radio, unlike the press and the movies, would be a *regulated* medium,

despite potential infringement of First Amendment protections. Neither government nor private interests alone should be allowed to dominate radio; decisions as to quality and public interest should be made by an alliance of the two.

Finally, radio would become a *commercial* medium in private hands. Advertising was given a tacit okay as a means of support for radio, although an excessively direct or hard-sell approach would not be regarded favorably; advertising on the air should display good taste. This meant that, after all debate, the United States would not seek government or public funds for broadcasting, unlike most other nations. Related to this, ASCAP's claims for compensation were determined to be just, and from that point on broadcasts were to be considered public performances. Permissions would have to be sought and royalties paid. This too would raise the stakes for radio, making it harder for low-budget stations to survive. Thus the groundwork was laid for American radio to develop into a privately owned, government-regulated, advertising-supported national system of communication and cultural unification.

Early Broadcasters

Though most stations during this early period were owned by radio equipment manufacturers and dealers, other categories included educational institutions, newspapers, and retailers. About 75 percent of early stations fell into the commercial category, meaning that their purpose was to promote or publicize the main business of their parent company. Direct advertising as we know it today was frowned upon, but indirect advertisement through simply publicizing a service, performer, publication, or company was entirely accepted and in fact provided most of the material on early radio.

Radio drew blithely and fairly indiscriminately from the popular entertainments of the day: Music publishers and song pluggers put on shows featuring their music; talent agencies thrust their clients before the mike; magazines sent representatives to read stories and articles over the air; newspapers provided news reports, serials, and household columns; hotels and nightspots provided live broadcasts of their in-house orchestras; movie theaters broadcast their stage shows and organ recitals; vaudeville houses and theaters previewed their shows; and retail outlets and businesses sponsored various programs with a discreet plug or two at open and close. Most programs were less than 15 minutes long, and a piano was always kept on hand in the studio in case some talent failed to show up and the announcer might be forced to fill in.

How did this chaotic, experimental world of early broadcasting evolve by the end of the decade into the regularly scheduled, daypart-divided world of recognizable program genres? What forces and influences shaped early radio practices, and how did early broadcasters decide what was appropriate—or inappropriate—for the newborn medium? How did the idea of the "network" emerge? The answers to these questions would become important worldwide, as the United States literally capitalized on its head start in radio to provide ideas and examples (not always the best examples) to countries across the globe. Here we look at the career of Bertha Brainard, who got in on the ground floor of radio with a few fresh ideas that she turned into precedent-setting programs. She eventually became the first director of commercial programming for our first network, the National Broadcasting Company (NBC), and had considerable influence on how radio actually took shape and prospered. Her individual story lets us see the confluence of many important elements that shaped American broadcasting.

Connection Bertha Brainard and NBC

Most published stories about Bertha Brainard—in keeping with the way the media treat women generally—emphasize her looks. A successful woman in a man's world, she seemingly surprised most writers of the period by being "five feet two and intensely feminine," "scarcely big enough to reach a microphone," and "possessing what Elinor Glyn designates briefly as 'It' " (a twenties word for sex appeal). "Petite, pretty, with her pink and white skin, blue eyes, and red gold hair, she looks more like a butterfly than an important executive," one reporter gushed. Another put it bluntly: "People who do business for the first time with WJZ are rather surprised to learn that Miss Brainard is really the 'boss' of the works" (*Broadcasting Advertising* 1937; Greene 1927; McMullen 1928).

Brainard must have gotten used to such a reaction, and certainly her career shows that if anything she used it to her benefit. She entered radio at a crucial moment before the industry had fully established itself, when, as is often the case in cutting-edge movements, gender roles stayed flexible long enough to let at least a few women through the door. Many women seized opportunities in early broadcasting; some made great successes with their work in the field. Others were diverted into more traditional feminine paths such as secretarial work and public service and child-oriented programming. But Brainard stayed on the business side of the developing industry and rose to positions that allowed her to exercise a considerable influence on the medium.

Born just before the turn of the century in Montclair, New Jersey, she followed the traditional path of many women lucky enough to go to college by pursuing a teaching degree. World War I diverted her into the war effort. She became one of those young ladies doing men's jobs, in this case driving an ambulance in New York City that transported wounded soldiers from ships to area hospitals. After the war she briefly became manager of a resort hotel (where most likely her responsibilities included arranging for entertainment for the guests) and then took a job on the *Daily News Record*, a trade journal of the New York fashion industry. Most accounts say that her first brush with radio was listening to her brother's crystal set as stations came back on the air after 1919. She became convinced of the enormous possibilities in this new medium but also was sure that it could not grow without a higher standard of entertainment in its programs. Why not bring together the enormous reserve of live talent in the New York City area with the growing medium of publicity that was radio?

Brainard's timing was perfect. She approached Westinghouse station WJZ soon after it had gone on the air in Newark, New Jersey, with an idea, as one article puts it: "Why not link radio to the stage by broadcasting a weekly dramatic review?" (Greene 1927). Alliteratively titled "Bertha Brainard Broadcasting Broadway," her show went on the air in the spring of 1922. Soon Brainard was bringing Broadway stars themselves before her microphone, to talk about their roles and even to perform skits. From there it was a short step to begin broadcasting entire performances from the theater, with herself as narrator, commentator, and host. The success of this very early show led to

Photofest

Bertha Brainard served as NBC's first director of commercial programming.

her appointment as WJZ's program director. In 1923 she was named assistant manager of the station, just as WJZ outgrew its Newark studios and moved to a deluxe new broadcasting facility on 42nd Street in Manhattan, not far from Broadway's twinkling lights and pools of talent. Though many early stations across the country were emulating these practices by bringing whatever local talent they could find to put on "ether performances," few could rival WJZ's prime location and Brainard's head start. Soon she had inaugurated many new programs, including the first hour-long show directed especially to women as an audience.

Brainard's position as manager of NBC's flagship station meant that as RCA began to experiment with linking stations together into a *network* (see the following section), it was her task to provide the programs. In 1929 she became director of commercial programming for the entire NBC network and took over programming responsibilities as they shifted from providing a space on which promoters could display their wares to a department that actively created innovative and attractive programming that advertisers might be persuaded to sponsor. In particular, she recognized that women would comprise the major part of the broadcasting audience and that programming directed toward women would have the greatest appeal to advertisers. She believed that drama had a particular appeal for women and audiences generally and pushed for a more entertainment-based schedule that included music, variety, comedy, sports, and theater, as well as news coverage that kept radio's dramatic focus in mind.

A quick sample of programs introduced on NBC in the very early years under Brainard include musical programs like the *Brunswick Hour of Music*, the *National Symphony Orchestra*, and the *Maxwell House Hour*; one of the first news commentary programs, by Frederick William Wile; and for women, the General Mills *Betty Crocker* cooking show and the *Radio Household Institute* program. Sustaining programs—those put on by NBC as a service, not for commercial sponsors—include *Cheerio*, an inspirational talk show; public affairs discussion by the Foreign Policy Association; a number of religious programs; an informative drama show called *Great Moments in History*; and dramatic sketches (forerunners of the situation comedy) like *Real Folks of Thompkins Corners* and *Romance Isle* (a precursor to *Fantasy Island*, perhaps?).

In 1932, Bertha Brainard proposed a vision for the economic support of radio that, had it been adopted, might have provided a very different economic model for radio and television. In a memo to NBC's sales director, she wrote:

> I am looking forward to the day when you and the sponsors realize that the daytime hours are our most important selling times and the rates for the daytime hours will be double those of the evening, in view of the fact that all our real selling will be done to the women in the daytime, and the institutional good will programs will be directed to the mixed audiences after 6:00 p.m. I am such a confirmed feminist that I thoroughly believe this is going to take place, and in the not too distant future. (Hilmes 1997, 138–139)

Though her predictions never came true, they offered a vision of radio that acknowledged the consumer power of women and provided a way to shelter prime-time programs from an overly commercial function. At night, sponsors might provide programming for corporate publicity—much as on PBS today—rather than for selling products. What actually happened, however, was that by the mid-1930s program production passed out of the networks' hands and into the control of the advertising agencies and sponsors. The networks would become little more than censors and custodians of airtime, and the power of early programmers like Brainard would wane. Yet it was on such early stations as WJZ and WEAF, as we shall see, that the precedents for broadcast genres and practices were set.

The Network Idea

The *network* (sometimes referred to as a chain or a web) represents a key innovation in broadcasting, but it took a while for both industry and regulators to grasp its full potential. Rather than a series of separate stations, each broadcasting from its local area, or a set of superpower stations (like Dr. Brinkley's) blasting across entire regions, networking was the interconnection of broadcasting stations using wires. A program could be produced in one location—say a talent-filled city like New York—and sent over land lines from station to station, city to city, across the country. Though this took an over-the-air medium actually out of the air and back into wires similar to telephone or telegraph, it allowed for important improvements in central control, cultural unification, and economic efficiency.

With a network, one large corporation could supervise the programs for an entire national grid of stations, rather than letting a lot of small-time and possibly irresponsible stations in a lot of small cities broadcast whatever they pleased. Certain standards of quality could be maintained, bringing nationally recognized and legitimated talent to towns and cities from coast to coast. Advertisers who were ensured of large audiences nationally might finance the most glamorous and high-budget productions. Though both RCA and AT&T experimented with linking stations together in the mid 1920s, it was AT&T that had the most pressing commercial reason for developing the idea.

AT&T's network idea arose out of its frustration with the limited role assigned to it by the RCA agreement of 1919. Restricted to providing telephone-based services only, AT&T came up with an exciting plan in 1923. If it opened a station and allowed individuals and businesses to buy blocks of time on the air to fill with whatever

materials they might like (rather than providing its own schedule of programming), this would resemble the use of a telephone booth rather than actual broadcasting, from which AT&T was barred. WEAF gave the name "toll broadcasting" to the idea, to show its affinity with telephone practices.

Now AT&T needed a few forward-looking businesses and ad agencies who could be convinced that radio could enhance their sales plans. The N. W. Ayer Agency, which had already begun experimenting with radio advertising, had little trouble persuading the National Carbon Company that a little radio could do wonders for Eveready battery sales. First of all, radio had begun to move from the garage into the living room. Before 1920, amateurs had to build their own receivers. They were bulky and messy, trailing wires and dripping battery acid. But the first commercially manufactured sets became available that year, and between 1923 and 1924 the number of households owning at least one radio set more than tripled. Though still only about 5 percent of all households owned a radio, that percentage nearly doubled each year of the decade until by 1930 it reached almost 50 percent. After the introduction of Edwin Howard Armstrong's superheterodyne receiver in 1924, quality and ease of reception improved. Another decisive breakthrough would come in 1926, when sets were introduced that could be plugged directly into household current, rather than relying on batteries.

But in 1923 it was the prospect of selling batteries to the growing crowd of radio owners that excited N. W. Ayer and the National Carbon Company. And so on December 4, *The Eveready Hour* made its debut on WEAF. Drawing on the experience of WEAF's other groundbreaking show, Samuel Rothafel's *Capital Theater Gang* (later known as *Roxy's Gang*), National Carbon determined to stage a variety program. Based on vaudeville and music hall precedents, this program would bring together a varied cast of singers, musicians, storytellers, dramatic skits, and a central announcer around a different unifying theme each week. Often the themes invoked a patriotic or nostalgic note, celebrating American identity and historical heritage. Graham MacNamee, WEAF's charismatic general announcer, served as master of ceremonies, and an abundance of stars drawn from stage and screen made guest appearances. But what tied the show together was a few central performers who returned each week, creating a sense of continuity and community in the invisible radio audience; this led not only to increased battery sales, but to a whole new kind of relationship between performer and public.

A form of invisible, private yet public intimacy developed between isolated listeners, sitting with headphones in urban living rooms or remote farmhouses, and their weekly radio friends who seemed to speak directly to them, whispering in their ear, returning each week to delight and entertain. Film stars were visible and compelling, but they appeared irregularly up there on the screen and never as themselves. Stage performers were live, right there in front of you, but separated by a stage platform and available only in public. On the radio, though, charming new friends performed only for *you*. They addressed you, hoped you liked the show, told you what had happened in the week intervening, and begged for some kind of return indication of friendship. No wonder "applause cards" (mail-in response cards) poured in by the thousands.

Connection "Eveready Red" Wendell Hall

The most popular member of *The Eveready Hour* troupe was ukulele-strumming, red-headed Wendell Hall. Hall had started out in vaudeville, traveling around the country as the world's one and only singing xylophonist. Fortunately for his reputation and the history of radio, Hall at some point decided to jettison the bulky xylophone in favor of the much smaller and lighter ukulele, and for this instrument he composed the 1923 hit tune "It Ain't Gonna Rain No Mo." Barnstorming around the country to promote his song, Hall performed not only on stage and in music stores, but increasingly on local radio stations. The tune became one of the first national hits of early radio. National Carbon signed him on. Buttressed by the kind of visibility Hall had gained, the company tied his bright red hair to their product—batteries with a red-painted top—and he became "the redheaded music maker" and "Eveready Red" to his fans.

Hall saved many of those cards and letters that kept coming in. They are archived at the State Historical Society of Wisconsin and paint a poignant, lively picture of the impact of this new radio intimacy on the lives of people from all walks of life. Some seemed surprised at their actions, like this couple from New York: "My Dear Wendell—for such you must be called—anyone who can 'radiate' such a genial personality as you, at once becomes a friend. Each night you have entertained us, we have just grinned, until it hurt."

Some turned their cards into works of art, as with one fan who decorated the front with a sketch of Hall as the face of a locomotive train coming down the tracks, with red hair flaming. He wrote, "I want this to show my appreciation for the 'Red Headed Music Maker'—you old brick head. You are as much of a crackerjack as any I have heard." Others testified to Hall's humor: "If there is any grouch around that you couldn't pull a laugh out of he must be dead from the neck up." Some, like this letter from Washington, D.C., were sent not to Hall but to his sponsor:

> Please, oh please give us more of the Red Headed Music Maker, everytime we hear him we like him better, he sure is funny as a crutch. After you hear him two or three times and you pick up the paper and find he is going to perform you feel just like you are going to a nice big party and someone you know is going to be there.

But one of the most touching sets of letters comes from a listener in Davenport, Iowa, who wrote successively on March 19 and 21, 1924. Her notes, in spiky handwriting with seemingly random words underlined, give a clue as to radio's powerful intimate voice.

> Grandma was aroused from "dreamland" last night at midnight by the "Radio" which is at the head of my bed—sounded like a voice in my room.... I am so anxious to hear "red head" again I fell in love with him even if I am 74 years old.

Early radio entertainers aroused a sense of intimate familiarity in listeners of all ages—a new kind of social relationship.

Grandma wrote again two days later, this time asking for one of the "gifts" that radio performers often used to gauge their popularity:

> <u>Dear</u> Sir—guess I can call you "<u>dear</u>" as your "little red headed sweetheart" is too far away to get jealous of "Grandma" who is 74 years old but "<u>fell</u> in love" with <u>you</u> and your "red head." Wish I could see you and tell you how much I have enjoyed your <u>music</u> on "<u>Yuku</u>" and <u>your songs</u> etc. I could see your <u>smiling</u> face and <u>snapping</u> eyes <u>in imagination</u>. Now I want your <u>picture</u> and I hope I am not to [*sic*] late to get one amid the <u>many</u> others who want one also. . . . I am a lover of the "Radio."

Popular radio announcers and performers found themselves inundated with such letters. Many sent gifts, gave news of their own family events (as if the radio stars knew the listener as well as the listener knew them), and even proposed marriage. Perhaps to ward off more such letters, Hall was married on *The Eveready Hour* in 1924.

Wendell Hall, though born in Kansas, often adopted a southern accent and sang songs in the minstrel dialect. Another letter points to one of radio's more unsettling features—its invisibility—which might allow important visual social cues to go unnoticed or to be confused. In the socially divided 1920s, in which race and ethnicity in particular marked a person's place, radio could blur racial, ethnic, and even gender distinctions. This could be either pleasurable or distressing, as a letter from a 1924 listener indicates:

> The very idea of that lady wanting to know if you were white or colored. What's the difference as long as she was being entertained and enjoyed it? We all have paid good money to hear and see colored entertainers while she was getting her concert free. I suppose your southern drawl threw her completely off the track, and she could only picture you with a dark face when she heard you speak. Quite different with me. . . . Won't you please send me a photo of yourself, regardless of color? (Hilmes 1997, 66–67)

Radio did provide greater access to the general public than formerly possible for African American performers, particularly in the area of music. On the other hand, it also breathed new life into the minstrel show blackface tradition—where white performers impersonated African Americans by smearing their faces with dark makeup and joked and sang in a heavy dialect. The minstrel style waned onstage even as it persisted into the 1940s on radio. *The Eveready Hour* featured George Moran and Charlie Mack in their popular "Two Black Crows" act. Such a minstrel duo became a standard feature on radio variety shows. Ethnic impersonators also abounded—with imitations of Irish, Russian, Italian, German, Greek, Mexican, and many other accents—and grew into one of radio's (and vaudeville's) staple comedy forms.

As *The Eveready Hour* built in popularity, AT&T continued its network plans. In spring 1924 it connected stations in 12 cities for a special broadcast of the Republican National Convention. By October AT&T was ready to begin offering a daily 3-hour block of programs over land lines, originating from WEAF; by spring 1925, the offer had been taken up by 13 stations in 12 cities. *The Eveready Hour*, airing on Tuesdays from 9 to 10 p.m., formed a cornerstone of the schedule. Other key early network programs included *The A&P Gypsies* from 9 to 10 p.m. on Mondays and *The Goodrich Silvertone Orchestra* (featuring the "Silver Masked Tenor") on Thursdays from 10 to 11 p.m.

By late 1924, the huge popularity of this growing radio medium made it clear that the RCA members would have to resolve their competitive situation somehow, because the 1920 agreement had not anticipated the new uses to which radio technology was being put. Westinghouse, GE, and RCA itself were frustrated by AT&T's refusal to let them use phone company lines to try their own network experiments; AT&T's jealous guarding of its lines combined with its aggressive entry into radio station operation had the appearance of an attempt to monopolize the entire industry. In November, a judge issued a finding that AT&T did not have an exclusive right to wireless telephony under the earlier agreement.

This prompted a reconsideration of priorities, and in July 1926 AT&T sold station WEAF to RCA and retreated into its primary business: the sale of telephone service. Now RCA owned the two flagship stations of two nascent networks, referred to as the Red network (anchored by WEAF) and the Blue network (anchored by WJZ). The commercial network era was about to begin. Just two months later, in September 1926, RCA announced the debut of its National Broadcasting Company, and our first truly national network was born. Chapters 5 and 6 will take up the story from this momentous event. *The Eveready Hour* and Wendell Hall would continue as one of NBC network's original hits until 1930, by which time over 50 variety shows graced the airwaves.

Other Important Early Stations and Programs

However, AT&T and the RCA partners were not the only game in town, and New York City did not have a monopoly on broadcasting innovation. Chicago, in particular, was a vital center of radio production until well into the 1930s. Its distinctive style rested on the fact that here, newspapers owned the major stations. Newspaper publishers had been among the earliest to see the publicity value of radio and to recognize what we would now call synergies in content. One of the earliest pioneering newspaper stations was WWJ-Detroit, owned by the *Detroit News*. But Chicago had a concentration of competing newspapers and stations. The two most important, both founded in 1922, were WGN, (still) owned by the *Chicago Tribune*, and WMAQ, owned by the *Chicago Daily News*.

Not surprisingly, such stations used the newspaper model as a guide to radio content. They also took full advantage of Chicago's position as a center for jazz music, scheduling a plethora of broadcasts from nightclubs and hotels. While WGN concentrated on more cultural and educational programming in keeping with its image of serious public service to the city, WMAQ experimented with more popular forms. The nationally sensational blackface comedy series *Amos 'n' Andy* debuted on WGN, as an experiment in a comic-strip-based serial form, but soon switched to WMAQ, from which it was syndicated across the nation. WMAQ began broadcasting the Chicago Cubs games in 1924. As program director Judith Waller put it:

> The *Chicago Daily News* was a family newspaper and as we got underway I became interested, and I think the paper was interested too, in publicizing the various departments of the paper. When I thought of a women's program, I would think of it emanating from the women's department of the paper, or a children's program coming from the children's department.... We tried to tie the paper and the station together. (Hilmes 1997, 72)

Later, Chicago would originate one of radio and television's most persistent and enduring genres—the soap opera. Again, this would draw on the serialized women's fiction featured in most popular papers of the day and prove just as appealing in a new form.

Another group of influential stations were operated by universities and educational institutions. One of the leaders—and a leading candidate for the "oldest station in the nation" contest—was WHA at the University of Wisconsin in Madison. Broadcasting even before the war, a hardy gang of experimenters led by Professor Earle Terry became some of the most outspoken purveyors of a model for radio based on education. Transmitting school programs, lectures, informational talks for farmers, public affairs discussions, children's programs, and household advice shows, WHA became a

powerful advocate for educational radio. Much later, it would play a key role in educational television.

However, as we shall see in the next chapter, after 1927 the number of educational stations dropped dramatically. From 1927 through the 1930s, the numbers going off the air exceeded the number of new licenses until by 1937, only 38 educational stations remained. Although this seems a strange phenomenon when so much was made of radio's ability to educate and inform, we can see the roots of this result in the social discourse around radio in the early 1920s.

Social Discourse

As radio developed as an industry, as an experiment in media regulation, and as a new experience for listeners, it also became a center of debate and discussion. How was radio talked about and understood, both by influential figures and by the general public? What cultural influences and associations were employed in defining the potential and problems of this new technology? What did people talk about when they talked about radio?

Utopian Hopes, Dystopian Fears

One key idea in the social discourse of the 1920s, as we have seen, was the desire for national unity. Immigration laws, Americanization drives, education, and reform all worked toward the goal of an assimilated American identity that would pull together this disparate nation into a unified whole. Of course, it was felt that such unification might also have its dangerous side. Some types of division and distinction were to be preserved and even encouraged, such as that between races, between men and women, between social classes. All culture was not equal, as the jazz debates proved. Some cultural elements and practices were thought of as debased, barbaric, and not to be tolerated; others were considered uplifting, beneficial, and desirable.

The most common recurring element in early discussions of radio, in the United States and in other countries, was the notion of *national unity*. "Repeatedly, the achievement of cultural unity and homogeneity was held up, implicitly and explicitly, as a goal of the highest importance" (S. Douglas 1987, 306–307). The new medium of radio promised to aid beneficial cultural standards of unification but also threatened to weaken some important social divisions and distinctions. Radio was much discussed in the press, in government debates, in club meetings, and no doubt around the dinner table and in the backyard. Utopian hopes and dystopian fears for radio's unifying propensities fell into four areas.

First, radio promised a new kind of *physical unity*. The miracle of wireless transmission could link together the vast distances of this nation in a way never before possible. Remote communities could tune in to symphony concerts and news analysis from faraway cities. Chicago could hear what New York was doing, and the remote West Coast cities of Los Angeles and San Francisco could beam their culture back East. Pittsburgh could hear Seattle, and Bangor could listen in to Dallas, along with all points in between. Shut-ins—those whose physical condition or isolation made it

difficult for them to participate in communal culture—could have it brought to them via radio waves. Geographic and physical separation could be overcome by electrical agitations in the ether.

However, removal of physical barriers to communication could also pose a threat. It could tear down the boundaries between middle-class neighborhoods and the nightclub strip downtown, between decadent city and innocent country, between the private home and the public forum. Women might have their domestic privacy invaded by seductive salesmen or romantic crooners while their husbands were at work. Children could enter into cultural spaces where their physical presence would have been strictly forbidden. Writer Bruce Bliven gives a foretaste of these worries in a 1924 article called "The Legion Family and Radio" (and here *legion* means "those whose numbers are legion," such as the masses or common people):

> Ten-year-old Elizabeth is a more serious problem. Whenever she can, she gets control of the instrument [radio], and she moves the dials until (it is usually not a difficult task) she finds a station where a jazz orchestra is playing. Then she sinks back to listen in complete contentment, nodding in rhythmic accord with the music. Her eyes seem far away, and a somewhat precocious flush comes gradually upon her cheeks. . . . Mother Legion abominates jazz. (Hilmes 1997, 15–16)

Elizabeth would never be allowed to attend a jazz club, but with radio the suspect racialized music could come to her. Such fears were widespread, and would soon be translated into social research. Dr. Brinkley's story, too, illustrates what many considered the dangers of too powerful—and too undisciplined—use of radio's physical unification.

Second, radio promised *cultural unity*. Implied in the worries about radio and jazz noted earlier is the notion that some kinds of cultural unity might be problematic—everyone's children listening to jazz, Dr. Brinkley's medical advice—but radio also promised greater exposure than ever before to reforming, uplifting cultural influences on a national scale. In England, the British Broadcasting Corporation (BBC) had made this notion its cornerstone, building a publicly owned and financed national broadcasting system to give the public "not want it wants, but what it needs." Other countries followed suit. As we will see, the formation of our own National Broadcasting Company (NBC) promised some very similar cultural benefits, and early regulation clearly favored this vision. Broadcasting would be selective, not open; would prefer "quality" to diversity; and would operate in the public interest, as defined by important official gatekeepers.

However, radio possessed certain characteristics that defied this sort of cultural control. It was invisible, knew no physical boundaries itself, and had a long tradition of free-spirited amateur broadcasting behind it. Despite the nationally unifying efforts of networks, local stations abounded, providing their idiosyncratic and often suspect local fare. Foreign-language stations, in particular, managed to remain on the air in small numbers until World War II, although they often came under federal scrutiny.

But the element that more than anything else, it seemed, might incline radio toward the vulgar, the barbaric, and the illegitimate was its commercial base in advertising. Advertisers wanted to sell products, and this they would do through whatever means proved most effective. If jazz sold products, then it would be jazz; if

blackface performances did the same thing, then blackface it was. Though the national networks might prefer to control and unify cultural expression on a high level, and though the government might encourage this mission, as long as advertising remained the basic support of radio, an avenue for the proliferation of diverse popular tastes remained. Cultural unity and commercialism seemed at odds, unless they could be forcibly harnessed together.

Another form of unity radio could accomplish was *linguistic.* Radio (with a few exceptions) spoke English, though many Americans could not. Radio was seen as an instrument for spreading fluency in the unifying English language, and not just any English: proper, grammatical, and unaccented English, as it should be spoken. Up until World War II, the United States contained pockets of ethnic groups whose members—despite having been born here, and perhaps even having parents who were born here—continued to speak another language at home, attend church services in that tongue, and read foreign-language newspapers. Now they could be brought into the English-speaking fold. They could also achieve class mobility, by learning how to speak properly and avoid the working-class *ain't* and double negative. And what sorts of culture would be conveyed in this perfect English? Don E. Gilman, later to become NBC's head of programming on the West Coast, in 1929 brought radio's potential for linguistic, cultural, and physical unity together in one glorious vision:

> In America, no ... homogeneity exists, or can be obtained, until the entire population has been taught to speak the same language, adopt the same customs, yield to the same laws, from childhood. Now, thanks to radio, the whole country is flooded with the English language spoken by master-elocutionists. American history, American laws, American social customs are the theme of countless radio broadcasters whose words are reaching millions of our people, shaping their lives toward common understanding of American principles, American standards of living.... Wholesale broadcasting, coupled with restricted immigration cannot fail eventually to unite the entire American people into closer communication than anything yet achieved in the history of our development. (Hilmes 1997, 20)

Yet pesky broadcasters did not always cooperate! In fact, radio provided a whole new venue for that other American tradition—colorful slang. A breezy, colloquial style soon became apparent on many popular shows. Despite the excoriations of English teachers and public denunciation of various radio performers, a slang-filled, everyday dialect began to pervade the land. And this was not radio's only linguistic transgression. As a purely aural medium, radio used language detached from its visual context. Who could tell whether that reasonable-sounding, unaccented speech actually stemmed from a Bolshevik? A Red labor organizer? A "Negro" or "Oriental"? Could we even be sure that that high voice was a woman's (men frequently played women's roles)? As for Jewish or Catholic, how could we ever tell? As a result, radio's dominant programs obsessively rehearsed the linguistic markers of difference.

Minstrel dialect marked African Americans, and few black performers were allowed to speak in anything but minstrel dialect, no matter what their natural speech; because otherwise, how would we know? Heavy ethnic accents marked Asians, Mexicans, and Irish in comic skits throughout the land; that's how we might realize their ethnic identity, and of course recognize a "normal" voice as nonethnic. "Normal"

came to mean *not* Irish, Asian, Mexican, Italian, African, Greek—though of course that's what most Americans actually were, by birth or heritage.

Radio opened up as many means of transgression of social identities—perhaps more—as it did means of normalizing them. This led to a demand for the fourth kind of unifying force: *institutional unity.* Given its extraordinary powers—physical, cultural, and linguistic—this medium seemed to cry for centralized control. The amateurs had experienced the first outbreak of anxiety over radio chaos and had been banished as a system of preferment was established. Major corporations and the federal government agreed with this mandate, as did many social theorists of the day. Even advertising created a unifying institutional force, as the economies of scale introduced by networking forged a national consumer base for nationally produced programs and nationally marketed products. And, as we shall see, these same economies combined with regulatory preferences gradually squeezed out much of radio's early localism and diversity.

Yet institutional unity had its dystopian side as well. Many clearly perceived that a unity based on commercial purposes would shut out much of radio's potential. Profits would be pursued at the expense of creative possibilities, unless something could be done to check this tendency. To some, a unified medium of popular culture itself posed a threatening prospect; and as later programs like the top-rated *Jack Benny Program* and satirist Fred Allen began to poke fun at the pretensions of high culture, some regretted radio's very scope and reach. Federal regulation of this national medium created a peculiar double standard around First Amendment freedom of speech guarantees. If the government could regulate radio, could the press be next? Later disputes over such provisions as the Fairness Doctrine would bring these contradictions out in the open.

Public Service versus Commercialism

As just referred to briefly, the tensions rooted in radio's possibilities and potentials, both good and bad, circled around two concepts: public service and commercialism. Radio's use of the limited public resource of the electromagnetic spectrum, together with perceptions of unusual social power, combined to create public service expectations for the new medium. Yet radio's advertising-based system of financial support, as well as the private ownership of stations, pulled it in the opposite direction, toward unrelieved private profit.

The public service model of broadcasting, developed in Great Britain and adopted over much of the globe, fit in with Progressive notions of reform, uplift, and central control. Though it might provide top-down culture (a system by which the license fees of many supported the cultural tastes of a few), it also invited the masses of the public to participate freely, to pull themselves up by their cultural bootstraps, to enter into the authorized public life of the nation. Of course, this offer implied that their own tastes, ideas, and cultures were not as fit or as suitable for propagation; and it was decades before the BBC recognized that subordinated groups like the working class or women might desire, and benefit from, material that treated their own experiences as equally important and legitimate. Also, it implied that nothing commercial could possibly operate in the public service.

The commercial model adopted in the United States addressed some of these concerns but presented pressing problems of its own. Few other nations chose to adopt it, at least partly because untrammeled commercialism meant a heavy American influence. A public service system could at least keep U.S. corporations and cultural influences out. In the United States, the commercial system ushered in an awkward and potentially dangerous government-assisted oligopoly, as we shall see. Rather than follow a purely competitive model, the United States opted for a government-protected and -regulated system without the element of public accountability that a fully public system might require. Through rules and regulations that privileged and protected a small group of national corporations, and often very explicitly shut out any true competition or challenge, the U.S. commercial model allowed a range of popular diversity not often seen in public service systems; but at the same time it kept many other possibilities from developing, especially any form of programming that lay outside the broad mainstream.

The U.S. policy of hiding corporate preferment behind a smoke screen of open competition would last for decades and require a whole new set of resistant technologies (such as VCRs, cable, and the Internet) before a more truly diverse and choice-based broadcast environment could grow. Meanwhile, a lot of companies got rich off the public airwaves. If the British insisted that commercial and public service were opposite, contradictory, and mutually exclusive, the American system tried to prove that they were one and the same and thus failed to examine the places where that easy equation breaks down.

Public Interest

The key phrase around which all these tensions came home to roost like so many bedraggled chickens was "the public interest." Appearing first in 1922, but confirmed in the Radio Act of 1927 as "the public interest, convenience, or necessity," this was the wiggle word that supposedly put a check on the greedy inclinations of advertisers and broadcasters to squeeze the last dollar out of our hybrid system, in favor of paying the public back for its gracious concession of public airspace. It is the token of the basic quid pro quo of the American system: that, in exchange for free use of the spectrum, broadcasters would forgo profit maximization in favor of less profitable service to the public. However, what exactly this meant was never fully defined, because to define would have meant to enforce, and to enforce would have meant to censor—a violation of First Amendment protections. In the following chapters, we will trace the evolution of the concept of the public interest as it shifted and changed in relation to its social context, industrial conditions, and social theories. Later, industry spokesmen would claim that the public interest is what the public is interested in. The history of broadcasting shows that it was never that simple.

CONCLUSION

In the period between 1919 and 1926, radio broadcasting emerged from its previous domain in the garages and attics of the amateurs and became a truly American social practice. Joining the social upheavals and disturbances of the Jazz Age, a time of rising affluence, increasing social tensions, technological advancement, and cultural

experimentation, radio added its own unique voice to the mix. New institutions arose to address and control the growing business of radio. The Radio Corporation of America was formed in an atmosphere of nation building following the World War I. Though many of its structures were similar to those in other nations, the United States, significantly alone among the major nations of the world, chose to entrust its rapidly growing broadcasting system to the hands of major private corporations rather than to the state. Innovators like Bertha Brainard at NBC and Wendell Hall of *The Eveready Hour* helped to flesh out this structure with entertainment, intimate address, and the creation of a new kind of audience identity. The rise of the commercial network represented America's major contribution to broadcast industry and culture. As it gained in social centrality and importance to people's everyday lives, radio also attracted serious debate. How should such a powerful new medium be controlled and shaped to best serve the public interest of all Americans? How could its threatening aspects be contained and its promises be developed? Over the next decade, Americans would strive to provide answers to these questions, and in so doing build one of the largest and most successful broadcasting systems in the world.

THE NETWORK AGE, 1926 TO 1940

The boom economy of the 1920s got off to a slow start. Not until 1924 did the stock market begin to rise. During 1925 and 1926, the bull market charged ahead, and feelings of prosperity strengthened to the extent that the culture of conservation of the preceding century began to give way to the new culture of consumption. In 1927 there was a sharp spike in the stock index, and 1928 saw a frenzied rise in speculation and ill-founded investments. Credit had become the name of the game. Consumers purchased on credit, businesses expanded on credit, and investors extended themselves well beyond any sensible margin to invest on credit in the stock market. "Buy now, pay later" became the slogan of the time. More Americans owned their own homes (via mortgage), owned at least one car (on credit), and shopped in expanding downtown department stores (with charge cards) than ever before.

Though a recession in the summer of 1929 brought about a steep drop in home construction, newly founded investment trust companies pushed the stock market ever higher. Radio served as cheerleader and accompanist to the orgy of affluence, coming to rely increasingly on ad support at a time when advertising sang the theme song of the decade. Why worry about corporate control, commercial domination, or the sale of the public interest when it was obvious this state of affairs was good for everybody? It seemed that no matter how the radio pie was sliced, there would be plenty to go around. If things were a little bleaker in Europe, with war-torn countries struggling to put their economies and political systems back together and to pay off debt to American lenders—well, they would catch up. The rising tide of affluence would float all boats into the slipstream of progress, behind the luxury liner *America*.

SOCIAL CONTEXT: DEPRESSION AND A NEW DEAL

But in October 1929, this pleasant daydream came to a screeching halt. On Monday, October 28, the infamous Black Monday, the floor collapsed as the market dropped 49 points, the worst single daily drop during the entire Depression. Tuesday's index sank further. By Friday the New York Stock Exchange suspended trading to catch up with paperwork and allow the market to take a breather. Despite feints toward recovery, over the next three years the market staggered down, down, and even further down. It hit rock bottom in the desperate years of 1932 and 1933, at which point the *Times* stock

index stood at 58 (from a high of 452 in September 1929), one-fourth of American workers had lost their jobs, and banks foreclosed on tens of thousands of family farms as farmers found no market for their crops. By 1932 Hoovervilles, shantytowns where the homeless and unemployed eked out a precarious existence, dotted urban landscapes and countrysides. Bread lines, soup kitchens, and trucks piled high with displaced families' belongings were common sights. Though cartoons showing bankers jumping out of Wall Street windows provide one vision of the crisis, most people in the middle- to upper-income brackets managed to hang on, though in reduced circumstances. But for the urban and rural lower-middle and working classes, it was disaster.

President Herbert Hoover struggled mightily to turn back this tide of ruin. Pursuing the alliance tactics of government and industry that had worked so well in previous Progressive era crises, he urged bankers to continue to lend, corporations to invest, and above all to avoid doubting the general soundness of the American economy. On the advice of industry, Hoover and the Republican Congress passed the disastrous Smoot-Hawley Tariff in 1930, attempting to shore up the national economy by raising the bars to entry for goods from other lands. European economies, already unstable, now began to collapse. The Depression extended worldwide. Hoover carried only six states in the election of 1932.

A newly elected Democratic President, Franklin Delano Roosevelt, came to office in January 1933 with a nation in deep trouble and no ready-made plan to change the well-established way of doing things. But clearly something had to be done. Convening Congress in emergency session immediately after his inauguration, Roosevelt began to encourage and approve recovery legislation, starting with banking and agriculture (and also finally repealing Prohibition with the Twenty-First Amendment in 1933). The New Deal began, but it would take a while for its policies to split the old government-corporate alliance and make a difference for a struggling society.

Depression

Unemployment hit urban workers the hardest; this meant black and immigrant laborers in particular. Even those who were employed found their work cut back to a few hours a week, bringing in too little to pay the rent, much less feed a family. Many had been led into taking out loans—for homes or household goods—during the boom years; now bank failure meant that not only did people lose whatever money they had saved up, but they were in debt that they could not possibly pay off. Often evicted and thrown out on the street, they moved in with family members or drifted from shelter to shantytown. Historian Lizbeth Cohen reports that in Chicago, only half those employed in manufacturing industries in 1927 still had jobs, however partial, by 1933. Industrial payrolls fell to a catastrophic one-quarter of what they had been only five years before (Cohen 1990, 217). Ethnic organizations, religious groups, and city agencies that had played an important role in helping new immigrants and tiding others over hard spots found their resources depleted and overwhelmed. As these traditional community-building resources declined, Americans felt themselves cut off from their ethnic and community ties.

Black workers were often the first to be let go, as supervisors (usually white) tried to save their own neighbors and ethnic group members. According to Cohen, by the

end of 1932, between 40 and 50 percent of Chicago's black workers were unemployed. Mexican workers suffered too, and ethnic tensions were exacerbated. In terms of age, men over 40, exactly those who had built up some seniority and had families to support, found themselves nearly unemployable as companies sought less costly younger workers. Some turned toward radical politics. Although the American Communist Party did not experience a huge upturn in membership, more people joined Communist and Socialist Party protests against inadequate employment and relief efforts. These parties made special efforts to recruit African American and Latino workers who were hardest hit. But as Cohen observes, even political radicals advocated federal government assistance and guidance to lead the country out of its economic morass. As existing structures of family, community, city, and corporate authority collapsed under the weight of the Depression, people began to look to the federal government to do something—anything—to relieve the unbearable pressures on their lives.

A New Deal

After 1935, a shift occurred in the comfortable relationship between government and corporate America established in the earlier decades of the century. With the breakdown of the economy came a breakdown in public trust of industrial beneficence and a demand that the government step in to get things back on track. During the early years of Roosevelt's administration, even industry itself looked for help and guidance from federal agencies and regulators; later a much more antagonistic relationship would develop as Roosevelt became at once one of the most loved, and most hated, presidents in American history.

Some of the more enduring efforts of the New Deal to get the nation back on its feet were the Civilian Conservation Corps (CCC), which employed thousands of young men, ages 18–25, in public improvement work; the Tennessee Valley Authority (TVA), a federally funded plan to build dams and create electrical power for the impoverished Tennessee River Valley and surrounding regions; and the Agriculture Adjustment Act (AAA), which established a system of loans, land controls, and crop subsidies to aid American farmers. Another program of the New Deal was the Works Progress Administration (WPA), which employed over 3 million people a year in conservation and public works.

Though all these New Deal programs were controversial, and some were inefficiently run, they provided employment and hope in the Depression's darkest years. Despite efforts made to extend the era's racial discrimination to these projects and keep minorities out (the black press sometimes referred to the NRA, described in the next paragraph, as the Negro Removal Act), organized groups founded during the Progressive era were able to exert pressure to include African Americans, in particular, in these recovery programs.

However, one of the first initiatives of the Roosevelt administration proved more controversial: the founding of the National Recovery Administration in 1933. The NRA attempted to formally yoke together government and industry leadership, via government funds and coordination of industrial planning. It foundered violently on the shoals of conflicting authority and labor organization. Though many businesses were

willing to accept industry-wide rules and codes enforced by the federal agency, others balked at the intrusion of government into private enterprise. Small businesses claimed that the government favored large corporations. The labor provisions of the NRA codes proved particularly inflammatory, as they attempted to guarantee workers the right to organize unions and bargain collectively.

The National Labor Relations Board was established in 1934, but its efforts were so strongly resisted that it took the National Labor Relations Act of 1935 to mobilize compliance. One of the most powerful pieces of pro-union legislation ever passed, the act led to the development of the Congress of Industrial Organizations (CIO), a huge umbrella organization of mostly unskilled workers in such industries as steel, rubber, and automobile manufacturing, which first rivaled, then joined, the American Federation of Labor (AFL) to create the largest and most inclusive labor organization in U.S. history. The new alliance of government and labor would lead to two crucial trends in American life as the thirties led inexorably into the war years, and as radio developed into a national medium: (1) the growth of a new kind of grassroots American culture—more assimilated, more government oriented, and united by radio; and (2) increasing hostility between both small and big business and the Roosevelt administration. These twin pressures would lead to a corresponding rise in populist politics that carved out the controversial ground in between. Radio would play an increasingly important role amid this cauldron of cultural tensions.

Radio Ground Rules

The Radio Act of 1927 as well as its successor, the Communications Act of 1934, are pre-Depression documents. They reflect the easy relationship between leaders of industry and the federal government, with its basic trust in the ability of corporations to govern themselves in the interest of the public, under federal rulemaking designed to preserve stability and give mild guidance. We will see that if the Communications Act had been written even one year later, it is possible that radical changes might have been made in our national broadcasting system.

As discussed in Chapter 3, the 1924 lawsuit that invalidated the existing framework of broadcast regulation led to the hasty formulation of a piece of legislation introduced to Congress in December 1925. Extensive lobbying and debate caused ratification of the eventual Radio Act to be postponed until February 1927. Many issues remained unresolved, but with no authority to do anything about the increasing disorder in the airwaves—over 200 new stations went on the air in 1926, with little attention paid to overlapping signals, assigned power, or times on the air—Congress was under pressure to pass any kind of legislation that would relieve the congestion. The 1927 act was intended as an interim measure, setting up the Federal Radio Commission (FRC) as a center of national radio authority to bring some kind of order to the airwaves. However, the commission was authorized to operate for only one year, at which point it would have to be revisited and reauthorized.

This requirement that the right to regulate radio be renewed every year is a sign of the controversies and conflicts swirling around this radical new medium. As historian

Robert W. McChesney argues, those who were best organized and best positioned to have a voice in rulemaking for radio were able to heavily influence the eventual outcome. Not surprisingly, those were the major radio manufacturing companies, whose expert advice dominated FRC hearings and fact-finding efforts. Amateurs, small-station operators, and educational institutions with precarious budgets found themselves shoved to the sidelines while corporate America divided up the airwaves to its own benefit. The Radio Act of 1927 gave the FRC the right to select applicants for given frequencies and power but provided little guidance as to what the relevant criteria for selection should be. The phrase "public interest, convenience, or necessity" was borrowed from public utilities law as a guideline, although how that interest, convenience, or necessity was to be determined remained a political football.

General Order 40

In March 1927, with the ink on the new act barely dry, the FRC embarked on a full-scale reordering of the airwaves. One Department of Commerce official remarked that "the success of radio broadcasting lay in doing away with small and unimportant stations" (McChesney 2001, 19). But heavy opposition from smaller station owners made outright revoking of licenses too risky politically. Instead, the FRC developed a practice based on its earlier Class B decision. It immediately set about creating a number of national "clear channel" stations: superior quality broadcasting stations with enough power to be heard over an entire region, assigned to a frequency where they would have no competition (unless it came from over the Mexican border!). For the lower-power stations, the FRC designed a complicated system of frequency sharing: One station was assigned, say, to the morning hours on a particular wavelength; another had the afternoons; and a third had the right to broadcast in the evenings.

But how to justify the more favorable assignments? First, the FRC commissioned a poll of newspaper and magazine radio editors to try to determine which were the *most popular stations* in the communities they served. Here we can see early regulators toying with the populist idea that the public interest should be defined simply as "what the public is interested in." However, upon discovering that the public favored such stations as KFKB, where Dr. Brinkley held forth on goat glands, the FRC decided that popularity would not produce the effect they desired. So they hired Louis G. Caldwell as general counsel to rethink both the practice and principles of broadcast regulation. Caldwell came to the FRC with experience as the Chicago Tribune Company's radio advisor and as chair of the American Bar Association's Standing Committee on Communications. He became the main author of the FRC's precedent-setting 1928 General Order 40 and one of the most influential figures in the history of broadcast regulation.

Caldwell advised the FRC to try a second way of sorting things out: the public interest standard should be determined by *technological superiority*. Preferential treatment should go to stations that could "bring about the best possible broadcasting reception conditions throughout the United States," which meant, in practice, those with the deepest pockets and highest-quality transmitting equipment. Armed with this standard, General Order 40 rearranged the assignments of 96 percent of the existing stations in the country. The unchanged 4 percent were mostly those powerful stations with clear channel assignments owned by or affiliated with networks. Frequency

sharing agreements were put into effect, with licenses that could be renewed or challenged every three months. This led to an outburst of dispute, with those assigned to poor broadcasting times or substandard frequencies inundating the FRC with appeals. It also led to much hostility within the industry, as broadcasters battled one another for more favorable spots. However, the FRC's stated goal to close down "unimportant" stations began to work; McChesney reports that by November 1928, within a year of General Order 40's implementation, there were 100 fewer stations on the air (McChesney 1994).

Yet this standard still allowed broadcasters like Dr. Brinkley, who had plenty of money and could afford excellent equipment, to remain on the air, as well as troublesome but technologically proficient stations like WCFL, the Chicago Federation of Labor's pro-union broadcasting station. In 1929 the FRC shifted tactics, coming up with a third definition of the public interest: *general public service* stations versus *propaganda* stations. "General public service" stations were those that did not reflect one set of private, selfish interests but rather set out to provide a "well-rounded program" that would serve "the entire listening public within the listening area of the station" (FRC 1929, 32). The other category the FRC called "propaganda stations," whose main purpose was to spread their own views or pursue one agenda rather than open up the station to a variety of groups and purposes. The former would be given precedence in license disputes and the latter discouraged from remaining on the air. In the first, general public service category, the FRC placed private commercial stations, those that sold their time slots to a variety of advertisers; in the second, less good, "propaganda" category, they placed most stations owned by educational institutions and nonprofit groups. This is just the opposite of how we came to understand public broadcasting in the second half of the twentieth century. How did the FRC arrive at this definition?

We must recall the cozy relationship between industry and government here. The year was 1928, still the height of the stock market boom and America's romance with corporate leadership. Commercial profit drove the economy, advertising drove commercial profits, and the result was good for everyone. Thus, by the FRC's reasoning, even though it was true that commercial broadcasters employed advertising to make a profit, which was a selfish, private concern, the side product was a service that benefited *all* Americans, not just those interested in education or labor (or goat glands, or religion, or movies). Thus advertisers, with their drive to provide that which makes the public happy, could be entrusted to provide a fairer, less partisan, better-rounded broadcasting service to the untrustworthy masses of the American public.

As for educational and nonprofit stations, the reasoning went, Congress could not possibly give a station license to every single group that might want one for its own purpose. And if they had to choose some groups over others, wouldn't that be undue government tampering with free speech rights? Because *every* group could not get a license, then *no* groups should be shown unfair preference. Instead of seeming to endorse any number of random grab-bag groups that might use their air franchise to proclaim radical, subversive, controversial, dangerous, and selfish views, Congress decided that such groups could simply buy time on a commercial station like everyone else.

The effect of this categorizing principle was to drive nonprofit stations off the air in unprecedented numbers. Usually assigned to unfavorable hours on undesirable frequencies, and required to defend their hard-won frequency assignment every three

months—often against far more affluent commercial challengers—the nonprofit stations had little left over to actually run their broadcasting service. So a downward spiral began. After the stock market crash in 1929, as the Depression deepened, nonprofit groups that had been hanging on tenuously lost whatever hold on broadcasting they had. Meantime, as we shall see, the commercial radio industry flourished. But critics of the commercial system and educational broadcast reformers had not given up.

The Communications Act of 1934

As McChesney points out, because the Communications Act of 1934 made few fundamental changes from the structures laid down in the Radio Act of 1927, historians have assumed that its passage was trouble free and preordained (McChesney 1994). In fact, in every year between 1927 and 1934 there were numerous bills for the reform, improvement, and sometimes radical overturning of the established commercial system introduced into Congress. Rather than quiescent years of social and political agreement, these were years of debate, organization, and both legislative and public opinion battles about the nature and structure of the U.S. broadcasting system.

During this period, U.S. broadcasters, regulators, and the general public watched their neighbor to the north, Canada, completely scrap its previously commercial system and institute a public service network funded by license fees, patterned after the BBC. This provided an important lesson for both sides. Though commercial interests won out in the United States, their victory was by no means inevitable and was certainly not achieved without raising some important questions that continue to trouble our commercial network system to this day.

On one side in the battle for the public airwaves were the commercial broadcasters, led by the emergent but highly successful new advertising-based networks (NBC and CBS), and the trade/lobbying group, the National Association of Broadcasters (NAB). Their opponents consisted of a handful of public interest groups and educational broadcasters, backed by certain elements of a resentful newspaper industry as well as the American Civil Liberties Union (ACLU). Most influential on the nonprofit side was the National Committee on Education by Radio (NCER), founded in 1930 to consolidate concerns of educators, public broadcasters, and cultural critics of the commercial system. By 1934 it had over 11,000 members, who lobbied hard for some basic changes in the organization, structure, and financing of American broadcasting. Some of the ideas proposed by the educational group included

- Setting aside a fixed percentage of stations for educational purposes, so that educational broadcasters would not have to compete with commercial stations for license assignments (this happened in the FM band, finally, in 1942)
- Adopting an entirely new broadcasting system modeled on those in Great Britain or Canada, with public funding and public ownership of stations
- Creating on the local, regional, and national levels a number of publicly owned and operated stations (funded by taxes) that would supplement but not replace existing commercial stations and networks:

Despite much public support and an extensive lobbying campaign that did produce several bills and amendments in Congress, the nonprofit side was defeated by the

commercial system at every turn. At least partly, this result must be credited to the Depression, which was deepening just as the regulatory debate heated up and made any thought of diverting much-needed government funds away from more direct economic relief seem frivolous. Yet, had the reformers managed to delay passage of the Communications Act even one more year, so that it might have met a more activist federal government with an established principle of public intervention in commercial spheres, it might have tipped the scales toward at least some elements of reform. But on June 18, 1934, President Roosevelt signed the Communications Act of 1934 into law. The Federal Communications Commission (FCC) replaced the FRC as radio's regulatory body. Building on the precepts of the Radio Act of 1927, the Communications Act codified into a lasting body of regulations—still in force today, despite some major revisions—that made advertising-based commercial network broadcasting the backbone of the American system.

The Romance Hits a Few Bumps

However triumphant the commercial system seemed after 1934, passage of the Communications Act did not end the tension inherent in radio's *private* use of *public* airwaves. Though the American public appeared largely overjoyed with the entertainment and information provided to them by the commercial networks and stations—as we shall see in Chapter 5—strong pockets of resistance remained.

The FCC began its first term in 1934 with seven commissioners appointed to staggered seven-year terms, with no more than four members to be from the same political party. Not only radio but also telephone and telegraph operations would fall under the new commission's jurisdiction. Most FCC members possessed legal, public utility, or engineering backgrounds, and many of them would go on to take positions in the broadcasting industry afterward—a cozy relationship that later became subject to federal investigation itself. All were white men drawn from the educated elite. (Not until 1948 would the FCC get its first female commissioner, Frieda Hennock; not until 1972 would the first African American commissioner, Benjamin Hooks, take his seat, and Latinos would have to wait for Henry Rivera in 1981. We're still waiting for the first African American woman FCC commissioner. Rachelle Chong, the first Asian American, and Gloria Tristani, the first Latina, were appointed in the nineties by President Clinton.) As a body chosen to represent the public interest, these men presented a decidedly skewed picture. Like many privileged reformers before them, they saw their first duty as protecting the American public from dangerous influences and its own deplorable inclinations.

First cracking down on "substandard" broadcasters like Dr. Brinkley, the FCC inaugurated a "raised eyebrow" system of programming and advertising standards. Though broadcasters' First Amendment rights prevented outright censorship, the FCC published guidelines and suggestions for responsible broadcasting that frowned on (among other things) medical quackery, astrology and fortune-telling, contraceptive advertising, favorable references to hard liquor, racial or religious defamation, obscenity and indecency, excessive violence, the playing of recorded music, on-air solicitation of funds, and some violations of advertising decorum, such as too frequent or lengthy ads or the interruption of serious programs.

One stipulation against the presentation of only one side of a controversial issue (not covering any of the topics just mentioned, though) would eventually lead to the controversial Fairness Doctrine. Though nonrenewal of stations' licenses was the biggest threat the FCC could make, it rarely came to that (only two licenses were revoked and eight turned down for renewal between 1934 and 1941). But broadcasters realized that their best interests were served by observing the raised eyebrow and acting accordingly, instituting a system of *self-regulation*.

President Roosevelt would go on to become the first president to make extensive use of the radio to communicate with the American public, in his famous Fireside Chats. His administration, however, would launch a series of investigations into the business practices of the growing industry, as the vague precept of "public interest, convenience, and necessity" failed to provide much practical assistance in keeping the profit motive from dominating the new national medium. Though commercial broadcasters made extensive promises to follow up their high-flown public service rhetoric with concessions to the needs of educational and nonprofit groups, in practice nonprofit or public service programs made up a very small part of network schedules. When they were given airtime at all, such programs (usually low rated) were pushed to the margins of broadcasting, or found their times changed so often that audiences couldn't follow them. Furthermore, advertising agencies began in the early 1930s to produce the bulk of radio programming directly, taking over what had been envisioned as a major responsibility of regulated, licensed station owners. Consolidation occurred as broadcasting practices became highly profitable and standardized. By 1938, almost 40 percent of the stations on the air were owned by or affiliated with either NBC or CBS; for the powerful clear channel stations, that proportion was 28 out of 30.

As President Roosevelt's New Deal progressed, his appointees on the FCC began to take a more interventionist approach to radio's commercial limitations—not by attempting to censor programs but by looking at the internal operations and structures of the industry itself, in an effort to open up the airwaves to greater diversity. Attempting to ward off a commercial monopoly of the airwaves, the FCC investigated AT&T's rate structure between 1936 and 1939, recognizing that the telephone company's exclusive arrangements with NBC and CBS (and highly discriminatory rates for any interlopers) were squeezing out competition. The slight but effective reduction in land-line rates helped to support one of the major networks' main competitors, the Mutual Broadcasting System, founded in 1934 by a consortium of powerful independent stations.

In 1941, furthering this investigation, the FCC published its "Report on Chain Broadcasting," a study that had begun in 1938 to look into such anticompetitive practices as exclusive affiliation contracts and limitations on the right of stations to refuse network programs (clearances). The report ended by barring many such practices and furthermore recommended a provision that no one company could own more than one network—a clear slap at NBC, whose Blue and Red chains dominated the nation. (The result would be the formation of the American Broadcasting Company, ABC, built from the divested NBC Blue chain.) Later, other prohibitions would be added: the "duopoly" rules (no one company could own more than one station in the same market, only recently repealed) and (much later) "cross-ownership," which

© Bettmann/CORBIS

Franklin Delano Roosevelt was the fist American president to make frequent and effective use of radio's potential for national address.

barred newspapers from owning radio stations in the same market, or vice versa. However, existing cross-ownership was grandfathered in, which let such companies as the *Chicago Tribune* keep their stations.

Yet, surely FDR and his appointees kept in mind—especially as the war neared—that just as commercial network radio had become central to American life, it had also become central to American politics. Roosevelt needed the cooperation of the radio networks just as much as the networks needed the arm's-length regulation of the federal government. So although the FCC put restrictions on some of the more egregious violations of the public interest and open-market competition principles, it also took on an increasingly protective role, such as keeping out interlopers like the film industry, making sure that new technologies such as FM (frequency modulation) would be developed with the least disruption to established interests, and never seriously considering any federal intervention in the commercial, privatized development of television. Only a few voices—none within the FCC itself—spoke out about radio's highly discriminatory treatment of racial minorities or nearly complete ban on allowing labor unions any time on the air. The relationship between corporate America and the federal government, though at times strained, remained solid. The war years would bring this relationship even closer, though they would also produce a new wave of criticism. However, in radio's growth decades of the 1930s and 1940s, most Americans paid far more attention to the amusements and ideas

issuing from the box in the living room than they did to the machinations of companies and regulators in Washington. It was the radio age.

NETWORKS TRIUMPHANT

> Announcing the NATIONAL BROADCASTING COMPANY, Inc. *National radio broadcasting* with better programs permanently assured by this important action of the *Radio Corporation of America* in the interests of the listening public. . . . *The purpose of that company will be to provide the best program available for broadcasting in the United States.* . . . The Radio Corporation of America is not in any sense seeking a monopoly of the air. . . . It is seeking, however, to provide machinery which will insure a national distribution of national programs, and a wider distribution of programs of the highest quality. (Hilmes 1997, 10)

With these confident words, RCA publicized its formation of the first official national commercial broadcasting network on September 9, 1926. Its first broadcast went out over 25 telephone-wire-linked stations on November 15, featuring a live 4-hour show hosted by new NBC President Merlin H. Aylesworth in New York. Singers and entertainers from remote sites in Chicago, Kansas City, and other locations were switched on at the appropriate time, capitalizing on networking's ability not only to send out a signal to various points but to transmit from them, too. By January 1927, NBC had its second network, the Red, up and running with former AT&T station WEAF as its flagship. Consolidating management of both networks at its new headquarters at 711 Fifth Avenue in New York City, RCA thus inaugurated the era of network broadcasting.

For a time NBC had the field to itself. Stations scrambled to sign on as *affiliates* of the only game in town, meaning that they and only they would be authorized to receive NBC programs in their area. Usually, NBC chose the most powerful and popular station in a given city as its affiliate. But the second-best station could sign on with the other NBC chain. Others were out of luck, although for a while NBC allowed some duplication within the same market. A favorable arrangement with AT&T meant that, although NBC's initial announcement assured the public that "If others will engage in this business the Radio Corporation of America will welcome their action, whether it be cooperative or competitive," in practice any rival to NBC's chains would have to struggle with inferior quality telegraph wires (Hilmes 1997, 10).

However, as the newly commissioned FRC began its station reassignment process in the spring of 1927, under the Radio Act that contained specific stipulations against monopoly, it began to seem to the triumphant RCA/AT&T alliance that perhaps some kind of competition in the network business might be desirable, if only for appearance's sake. At about the same time a small group of entrepreneurs, shut out of NBC's de facto monopoly, announced plans to form their own network. Their efforts, and eventual success, provided NBC's only real competition until the mid-forties and pushed radio broadcasting in a different direction than it might otherwise have taken. NBC's confident assertions of upholding elite standards, providing only the best in broadcasting, would soon be shaken by an upstart whose only cultural claim was that it tried harder—not to please the guardians of highbrow culture but to please the fickle audience and its even more fickle intermediary, the radio advertiser.

Connection CBS: "We Try Harder"

In the spring of 1927 Arthur Judson was a frustrated man. With new radio regulation in place, the situation with ASCAP clarified, and NBC's announcement of the beginning of chain broadcasting, things should have looked bright for his talent business. Having formed the Judson Radio Program Corporation in January of that year, aimed at providing an economical alternative to ASCAP's high-priced roster of creative talent, he looked to NBC as a lucrative client. But that network, intent on establishing a talent bureau of its own, told him in no uncertain terms to take a hike.

Judson focused on a more radical approach. With associates George A. Coats, an Indiana promoter with important connections, and well-known radio sports announcer J. Andrew White, he formed a company called United Independent Broadcasters (UIB) and set about showing NBC what was what. They would create their own network. They would approach stations unaffiliated with NBC, purchase a few hours of time, and produce programs to appear during those hours using the talent they already had under contract. Advertisers would pay good money to sponsor such programs, especially when they could reach a regional or national audience via station interconnection—the basic principle of commercial broadcasting. By late spring the new network had agreements with 12 potential affiliates, including WOR New York, which would be its hub. And UIB, with its low overhead, could charge lower prices for the same high-quality programs and station coverage than NBC could, and still make a profit. All the partners had to do was get AT&T to provide the land lines to link the stations together.

This proved difficult. AT&T was not anxious to jeopardize its exclusive agreement with NBC for a bunch of ragtag promoters who looked unlikely to be able to pay their bills even if AT&T granted the service. They were flatly turned down. This was a setback indeed, because a regular broadcasting service needed the quality and reliability of transmission that only AT&T could provide, having long ago established a monopoly on national telephone service. But George Coats had a few cards up his sleeve. In an interview published many years later, Arthur Judson recalled:

> We now had the stations, but before we could operate we had to have telephone lines. We held a good many rather hectic meetings to discuss the question of getting them. We applied to the telephone company and were informed that all of their lines were in use and that it would be impossible to furnish lines for at least three years. We argued but got nowhere. Finally Coats, who was from Indiana, said, "I think I'll go down to Washington. I know some Indiana people in Washington." He came back and said, "There's a friend of mine down there." I said, "Who is he?" "Well," he said, "he's just a man about Washington who fixes things. He has contacts." Coats went down to Washington again, came back and said: "If you give him two checks, one for $1000 and the other for $10,000, he will guarantee that you will get the wires." (Hilmes 1990a, 20)

Possibly the "fixer" Coats mentioned had some link to the influential head of the Interstate Commerce Commission—Indiana Senator James E. Watson, a powerful voice in the history of broadcast regulation.

An ancillary factor may have been the new company's timing: With station reassignment going on, NBC could not afford a hard-line monopolistic position and may have pushed AT&T to concede to what looked like, after all, an operation with very little capitalization or hope of success. The Columbia Phonograph Corporation had invested in UIB and contributed its name to the project in hopes of promoting its recording artists via the new chain, but its own business was faltering. The Columbia Broadcasting System (CBS) made its debut on September 25, 1927, with a Metropolitan Opera broadcast, but a month later was over $100,000 in debt. Columbia Records backed out. A Philadelphia station owner, Jerome Louchheim, stepped in to tide them over, but it wasn't until the struggling business attracted the attention of William S. Paley, young vice president of the Congress Cigar Company of Philadelphia, that its fortunes began to improve. Paley had been one of the network's early sponsors, touting his company's cigars with a musical variety show called *La Palina Concert*. Convinced that radio advertising was the wave of the future, Paley bought a controlling interest in the network in September 1928. He would stay on as head of CBS until 1977.

One of Paley's first innovations was an adjustment of the station payment and compensation scheme. Under the existing arrangement used by both NBC and CBS at the time, the network paid the station each time it aired a *sponsored* program, meaning a program for which the network received payment from advertisers. This was a fixed amount, from $30 to $50 per evening hour, which many larger stations felt was far from enough, given the size of their market and their normal charges for airtime. But stations were additionally required to pay the network for any network *sustaining* programs that they aired locally; that is, programs that the network supplied that did not have a national sponsor. Sometimes these programs were serious or highbrow shows that helped to fulfill the station's public service obligations; sometimes they were programs that the station could sell to local advertisers to bring in revenue. Charges ranged from $45 to $90 an hour, an amount that smaller stations often found hard to meet. Although radio remained one of the few areas of U.S. business relatively unaffected by the Depression—indeed, these were growth years for the radio business—the declining economy hit the smallest operations hardest.

Paley's plan did away with the station's payments for sustaining programs in favor of a tighter agreement for guaranteed clearances, with payment to the stations on a sliding scale adjusted for station power and market size. In other words, CBS affiliates could have all of the CBS network programs, sustaining and commercial, without charge—in fact, the network would pay them. But they had to agree to take *the entire network schedule* and not arbitrarily opt out of a given program for their own reasons. For that kind of guarantee to his network's sponsors—that their programs would be heard over all the network's affiliates, with no exceptions—Paley was willing to commit himself to a considerable expenditure. Rates paid by the network to the stations now ranged from $125 to $1,250 for an hour-length commercial evening program, which was a substantial inducement. (This practice continues today in the form of *station compensation*: the fee that networks pay their affiliates for *clearance* of their schedules to receive commercial network programs.) Meanwhile, NBC affiliates were required to pay the network a flat rate of $1,500 a month, regardless of their size, until NBC finally adopted Paley's system too in 1935.

© Bettmann/CORBIS

CBS tried harder to innovate popular programs and to tighten network/affiliate relations.

This novel practice indicates one important difference between CBS and NBC, at least in their earlier days. Even on its more commercial Red network, NBC stood poised between two poles. It had achieved its position of prominence by promising a level of public service—defined in its announcement and elsewhere as "highest-quality" programs of the "best" kind—even as the pressure to find commercial sponsorship demanded a wider audience than these quality programs could deliver. NBC needed to be specific about exactly what it provided as a public service—its sustaining shows—and what it did to make money. CBS, on the other hand, suffered under no such expectations. As the smaller, struggling, lower-priced network, without RCA's deep pockets or governmental ties, CBS unabashedly "tried harder" to get whatever sponsorship it could. It developed an aggressive policy of recruiting top talent and by 1938 featured as many of the nation's top-rated shows as did NBC's two networks put together.

In fact, historian Erik Barnouw credits CBS with spearheading most of the major innovations in radio programming that mark the more glorious moments of the radio age:

> The outburst of creative activity that came to radio in the second half of the 1930s was largely a CBS story. The first stirrings were at CBS, and while these eventually awakened much of the industry, the most brilliant moments were at CBS—in drama, news, and almost every other kind of programming. (Barnouw 1968, 55)

We'll talk about programs in more detail in Chapter 5; but an overview of standout efforts by CBS would have to include its *Columbia Workshop* program, which began as a sustaining effort broadcasting serious drama and evolved into Orson Welles's famed *Mercury Theatre*

of the Air (and its momentous "War of the Worlds" broadcast), later sponsored by Campbell Soup. Also, CBS was the first to build up a news division offering coverage that would become crucial during World War II. Howard K. Smith, Lowell Thomas, Edward R. Murrow, William L. Shirer, and other preeminent names came together at CBS in the late 1930s to pioneer the concept of the "news roundup," broadcasts from remote sites and nations brought together in a combination of news and analysis. Other well-regarded CBS shows included *The American School of the Air*, Arch Oboler's *Lights Out*, Du Pont's history series *Calvacade of America*, and the prestige drama program *Lux Radio Theatre*.

However, even its most respected programs demonstrate the comfortable relationship with sponsors from which CBS might occasionally distance itself but always embraced in the end. Barnouw relates the amusing story of the network's attempt to ban controversial ads for laxatives, a type of product advertising that tended to receive the raised eyebrow from the FCC and other cultural critics (Barnouw 1968, 60–62). CBS offered several programs sponsored by laxative manufacturers. With great fanfare, Paley announced in May 1935 that such products in questionable taste could no longer be advertised on the CBS airwaves. This policy would take effect as soon as present contracts with advertisers had expired. General praise, from the FCC and from the press, ensued. It was common practice at that time for sponsors to let their contracts lapse for the summer months, when listenership was lowest, and return under new contracts in the fall.

What the public didn't know was that Paley's announcement inspired laxative advertisers to simply extend their contracts through the summer and into fall. Because no contracts expired, no renewals had to be refused, and CBS made even more money than usual. As Barnouw says, "The year in which CBS got its 'avalanche of praise' for banning laxatives turned out to be one of its best laxative years—the best, some say. Eventually the laxative ban was forgotten" (Barnouw 1968, 61). Likewise, the network's much-touted limitations on outright sales talk, 10 minutes during the evening hours and 15 minutes per hour during the day, did not affect the popular practice of integrating product pitches into the dramatic content of the show.

CBS's need to try harder to establish itself led it to some sticky situations in its early years. Father Coughlin, a Catholic priest from Royal Oak, Michigan, whose anti-Semitic and hate-filled diatribes won him a large populist following during the Depression years, found a home on CBS until he became too hot to handle (see Chapter 6). And CBS pioneered the practice of sponsored news and political commentary programs, such as the *Ford Sunday Evening Hour*, on which Ford executive William J. Cameron was allowed to criticize the New Deal and espouse Henry Ford's antilabor philosophy. *Liberty* magazine's *Forum of Liberty* program gained a prestigious on-air platform for leaders of industry to broadcast their antilabor, anti–New Deal views in exchange for buying advertising in the magazine. And CBS joined the other networks in allowing news programs to be commercially sponsored, particularly as the war boosted ratings in the forties.

Yet CBS set a certain tone, a certain style, in the radio business that stood in sharp contrast to NBC's stuffier corporate image. CBS's slick promotional brochures proclaimed the gospel of radio to the business community, with much attention paid to ornate covers and deluxe presentation. Paley himself and his stylish wife, "Babe" Paley, began to move in glamorous social circles, imparting an air of distinction to the network. Phrases such as "grace and swift maneuver," "suave," "brilliant, dynamic, acquisitive," were used to describe the culture at CBS, whereas NBC's corporate culture was called "ponderous." Underneath there lay a keen attention to the bottom line.

By 1938, the upstart network was in first place, if NBC's two networks are counted separately. NBC boasted 135 affiliates, divided between the Red and Blue, to CBS's 106, although CBS affiliates tended to be smaller, lower-power stations. CBS brought in almost $29 million in total network revenues in 1938, with a profit of $3 million. NBC's revenue that same year totaled $38 million: $27 million from the Red and $11 million from the Blue. As an indicator of the perceived value of network time to advertisers, CBS in that year charged $8,525 per evening hour, while NBC charged $8,400 for an hour on its Red network and $7,800 for an hour on Blue.

Both companies had embarked on a campaign to own as many of the desirable clear channel stations in their network lineup as possible. Besides WABC-New York, which became CBS's flagship station, Paley acquired eight more between 1928 and 1936. Profits from owned and operated stations (O&Os) have always been higher than network profits themselves; in 1938 the profit margin for CBS stations was 16 percent, compared to a 10.5 percent profit ratio for the network (*Fortune* 1938a). Trying harder brought success.

Until barred by federal investigation in 1941, both CBS and NBC owned their own talent bureaus, furthering their monopolistic hold on the radio entertainment business. NBC's Artists' Service and CBS's Columbia Artists, Inc., signed actors, musicians, humorists, and other kinds of talent to long-term contracts and then took a percentage on the work they found in radio and other productions. Barnouw reports that in 1935 Columbia Artists had under contract "approximately half the artists touring in the United States" (Barnouw 1968, 62). A producer coming to CBS with a new program found herself required to employ CBS talent, or face prohibitive charges; independent or ad hoc networks like the Mutual Broadcasting System, struggling to compete with NBC and CBS, ended up enriching them anyway if they used talent under contract to their rivals.

Later, both networks added recording companies to their subsidiary list and moved into the *transcription* business (the production and distribution of recorded programs). Plus, as Broadcast Music Inc. (BMI)—the rival to ASCAP formed by the NAB in 1939 and owned by broadcasters—gained in power, networks controlled a piece of the music-rights pie as well. In many ways, the networks of the 1930s and early 1940s resembled the vertically integrated film companies of the studio system days; and like the film studios, they would be required to divest themselves of some of their monopolistic features in the New Deal spirit of the 1940s.

If CBS tried harder, then another upstart network of the 1930s exerted sometimes desperate efforts to stay afloat. Necessity, the mother of invention, also pioneered some unique and blithely populist program forms. The Mutual Broadcasting System network arose from the combined efforts of four powerful independent stations—WOR-New York, WGN-Chicago, WLW-Cincinnati, and WXYZ-Detroit—that carved out a place for themselves and other stations left out of the network oligopoly. By 1940, Mutual had 160 affiliates, many in smaller cities and rural areas; most of those stations also belonged to one of the smaller regional chains such as the Don Lee network on the West Coast or the Colonial network of New England.

Eschewing the big-budget variety and prestige drama productions that dominated NBC and CBS prime-time schedules, Mutual developed a strong presence in such

less-reputable or marginalized genres as sponsored news, thriller dramas for young audiences like *The Shadow*, *The Lone Ranger*, and *Bulldog Drummond*, quiz shows such as *Double or Nothing*, and religious programs like *The Lutheran Hour*, *The Old-Fashioned Revival Hour*, and *The Voice of Prophecy*. Though Mutual started out with very loose affiliation agreements—more like a program syndicator than a network—by the late thirties, competition caused the organization to tighten its affiliate structure so as to deliver coverage to advertisers.

It is not mere irony that CBS, the network that had innovated some of the most successful practices in the history of broadcasting, is also responsible for the eventual regulatory crackdown that would ensue. In hammering out its station compensation deal, which effectively encouraged the expansion of the network system, CBS also undermined the very assumptions upon which the U.S. regulatory structure had been based. The Communications Act of 1934 had designated the individual broadcasting station as ultimate gatekeeper and responsible party in controlling this new medium, using its licensing system as the means by which broadcasters were required to answer to the public. The CBS system pulled the rug out from under this approach, mandating that stations simply turn over the bulk of their programming responsibilities to the unlicensed, unsupervised networks. Except as it affected their owned and operated stations, networks remained outside the regulatory reach of the FCC. And as networks made the decision to allow advertisers and their agencies to provide the bulk of radio programming, control over this influential medium receded further and further from government hands.

Gradually, exactly the kind of radio structure that early regulators and critics had most wished to avoid came to prevail across the land: A restricted-access, vertically integrated oligopoly, dominated by two large corporations and supported by increasingly blunt and intrusive commercial advertising, exerted what could be called a stranglehold on radio programming, outside of any kind of public supervision or control. Public airwaves were producing immense amounts of private profit; educational and other public service programs occupied less and less space on the broadcast schedule; stations unaffiliated with the networks found it hard to survive, and local control over the voices in the air declined as each year rolled by. Radio was suffocating in its own success. This is not to say that the system failed to produce much that pleased and served the American public—it obviously did, judging by radio's popularity—but what was produced came from increasingly narrow parameters.

Yet blame cannot be placed entirely on the networks, whose actions merely pursued the possibilities put before them. By advocating the kind of paternalistic, elite version of regulation that valued established hierarchies and good taste above social diversity and expressive freedom, regulators of radio's middle decades backed themselves into a corner. They wanted cultural control and they got it—just not the kind they had had in mind. Commercial networks like CBS and its even more populist, hardscrabble competitor, the Mutual network, followed their audience maximization mandate; they provided a vast array of popular entertainments, many of which spoke to and for the masses far better than did the earnest educational efforts of high-minded reformers. Commercial advertisers did, in fact, know their public, and reverted to their own version of serving up "what the public is interested in"—focused, of course, on selling their own products. Yet regulators, rather than opening up the airwaves to more possibilities and creating a diversity of broadcast opportunities, chose instead to close ranks around their

established system. Regulators increasingly used their power to protect the economic interests of existing networks and powerful stations, occasionally requiring them to make small adjustments here and there when egregious violations came to light.

THE SPONSOR'S MEDIUM

What happened to NBC's lofty visions of radio showmanship? When the FRC placed the hot potato of programming decisions into corporate rather than public hands, who would end up grasping hold and who would get burned? As we have seen, early radio stations based their operations around whatever related talent or business needed publicity, but NBC at least saw its role as a network in very different terms. Instead of letting the entertainment market dictate what programming might be made available, NBC programmers like Bertha Brainard from the commercial side, Phillips Carlin from the sustaining program side, and their boss John Royal, Vice President of Programming, envisioned their task as program builders. Rather than let publicity seekers come to them, they actively sought out talent, came up with program concepts, and orchestrated and produced programs from the well-appointed radio studios at NBC headquarters, which soon moved to the elaborate Rockefeller Center when it was completed in 1936. Then, if a well-heeled sponsor wanted to purchase the program and bracket it with a certain (controlled) amount of sales talk for his product, fine. Indeed, this is how money would be made. But early NBC saw itself as the primary program impresario, playing a crucial gatekeeping role in keeping radio on a high and tasteful—yet profitable—path. As Brainard described her task in a 1926 letter to a potential client, "This department secures suitable talent of known reputation and popularity, creates your program and surrounds it with announcements and atmosphere closely allied with your selling thought" (Hilmes 1997, 97).

This state of affairs would last about six years. By 1932 the major point of creative control of programs had shifted to the advertising agencies of major radio sponsors; by 1936 almost all of the prime-time and most of the daytime hours were completely out of the networks' control except for some mild censorship (see p. 81). Networks would not regain their power to select programs and set schedules until after the quiz show scandals of television in the late 1950s. What happened? How could such powerful near monopolies lose the ability to shape the central component of their business?

Three factors intervened in the early to mid-1930s to shift the center of radio production away from the networks to the sponsors. First, the Depression undermined profitability. Even the electronics industry felt some of the effects of the Depression. RCA's stock fell along with everyone else's, and investing large amounts of money in programs "on spec," without a guaranteed sponsor, began to seem less and less attractive. When advertising agencies stepped forward with a complete program package, asking only that their clients be allowed to buy time at high prices from the network, it was an easy deal to make. The networks complied and soon found the most lucrative and popular parts of their schedules preemptively occupied by sponsored, preproduced programs. CBS pursued this vision from the start.

Second, advertising agencies discovered radio. Radio presented an attractive publicity opportunity. And the payment schedule worked out during these early years

proved particularly enticing. An agency that put together a program could take its usual 10 to 15 percent fee from its client on the total cost of the show, and on top of that it could get an additional 15 percent from the network when it brokered the purchase of airtime. This was a nice piece of double-dipping and hastened the perception of agencies that radio was a good place to direct their efforts. A few agencies, as we have seen with *The Eveready Hour* produced by the N. W. Ayer agency, got into radio very early on; but it was around 1929 to 1930 when most agencies established in-house radio departments.

Third, radio went Hollywood in the 1930s. Given the economics described earlier, it made sense for agencies to produce the most elaborate, high-budget show possible, because this made their fees higher. Why scrape by with cheap, lesser-known talent, with little name recognition, and thus guarantee themselves a smaller fee, when they might go for the big names (with big costs but also big followings) and make more money? And where else to find the big stars but in Hollywood? If the networks seemed reluctant to look too much toward the West Coast for their talent (their own talent bureaus could not rival the studios for top stars under contract), then the agencies would wrest control of production from the stuffy network executives and take it into their own hands. Allied with cooperative film studios, ad agencies bypassed the program departments and talent bureaus of the networks and thus boosted their own fees. This helped to produce the noted swing toward Hollywood (discussed in Chapter 5) and helped bail out movie studios that had been heavily hit by the Depression. It also very quickly turned radio into a multimillion-dollar business. By 1938, costs for a top-rated prime-time 1-hour variety program like the *Chase and Sanborn Hour* (starring ventriloquist Edgar Bergen and his dummy, Charlie McCarthy) ran to almost $36,000 per show, with total production costs of $20,000 and airtime charges of $15,900 (*Fortune* 1938b).

The competition between CBS and NBC also plays an important role here. It is very possible that without a real competitor, NBC could have kept up its genteel highbrow role indefinitely, charging high prices for the programs it devised for its clients and using some of those profits to produce high-quality sustaining programs, according to the original plan. With CBS in the game, competing for lucrative contracts and pushing the more generally popular kind of programming for all it was worth, NBC had to jump into the fray or lose out entirely. If sponsors began to chafe under the restrictive contract terms and more cautious approach to programs at NBC, they could take their ideas to CBS and find a welcome reception. Of course, if it hadn't been CBS, another group would surely have moved into the opening to start up a rival network.

Without the state-guaranteed protected monopoly of a system like the BBC, commercialization was bound to lead to ever-greater competition, competition would lead to going after the mass audience, and mass audience meant the triumph of the popular over the tasteful and elite. But it is easy for us to forget today the vital central role played by advertising agencies in the shaping of our national broadcasting culture. It was in the production meetings and client negotiations of the nation's major agencies that radio programming took shape and evolved into its mature forms, many of which are still with us on television. The FCC thought that it could control radio through its stations, but almost before the ink on the Communications Act had dried, the real power had drifted out of government oversight and into the hands of the commercial marketplace.

This produced an outburst of popular creative innovation, unrivaled since early movie days. It led to the familiar characteristics of the American system of radio, whose names became household words not only in this country but eventually throughout much of the world. History books talk about the William S. Paleys and David Sarnoffs, but those men had very little to do with the everyday sounds and experiences that wafted across America all day and most of the night. Radio was the product of numerous advertising personnel, who commissioned the scripts, hired the talent, oversaw production, and dunned the sponsor for payment.

Who were these men and women? They are too numerous to ever emerge fully from the obscurity of the past, but a few have left archives of their activities that give us a glimpse into this busy and vital world. One of those is J. Walter Thompson, a company that would become a major center of radio innovation.

Connection J. Walter Thompson, Radio Showmen to the World

In the spring of 1929, a mighty battle took place within the walls of the J. Walter Thompson agency, a New York–based firm that had been a leader in advertising innovations since 1870. Radio production was heating up, and although JWT had been one of the earlier firms to establish a radio production department, times had changed with more and more clients eager to pursue the hot new medium with their own advertising dollars.

By the end of the twenties almost 50 percent of U.S. households owned at least one radio. Radio itself was changing, with more big-name variety shows and an increasing trend toward drama, and although the major emphasis of most stations was still on music, different possibilities were beginning to emerge. JWT set up a radio department in 1927 under the direction of William S. Ensign, who had created *The Eveready Hour* for N. W. Ayer and served as the musical director for *Roxy and His Gang*. Ensign began signing on major clients like Goodrich Tire, Shell Oil, and Maxwell House Coffee, while other agencies began quickly setting up their own departments to compete.

Ensign moved on in the spring of 1929 and was replaced by Henry P. Joslyn, who had come up in the JWT ranks as head of the music department, specializing in what still made up most of the programs that JWT built for its clients. It seemed a likely choice. But just two months later, the decision began to appear shortsighted: If the future of radio lay not so much in judicious music selection but more in drama, comedy, and variety, then skills were required in overall showmanship, not just in music. And who was this radio audience? What did listeners prefer to hear over the air, and how could it best be linked to the selling interests of their clients? These were the new questions that needed to be answered.

Contenders for the position of head of radio at JWT posed three different solutions. For Joslyn, music was and always would be the backbone of radio. Selecting the finest musicians, writing a small amount of "continuity" (the dialogue or sketch that provided a bridge between musical numbers), and crafting introductions that made a discreet reference to the sponsor's product—this was the stuff of radio.

A second contender, Aminta Casseres, had a different idea. Casseres was the highest-ranking woman at JWT, in a company with a unique approach to the question of gender. Under the supervision of Helen Lansdowne Resor, codirector of the firm with her husband Stanley Resor, JWT had long before instituted separate men's and women's editorial groups. Men worked with men, women worked with women—a system that the Resors believed produced the best and most profitable results. Because American women purchased millions of household products and they were also the major radio audience, women were needed in the advertising business to best understand and speak to their own sex; and because women were less likely to be listened to and properly promoted under male supervision, a separate women's division was maintained. (A number of former suffragists worked in the JWT women's group, selling products to U.S. women just as they had labored to sell the idea of voting rights in the teens.) Casseres was head of the women's editorial group. In her vision for radio, drama predominated. She was particularly interested in emotional and human interest stories because she believed that these were best targeted to reach radio's main audience of women. Later she led JWT's development of daytime serial drama.

The third likely candidate was head of new business, John U. Reber. Sometimes referred to as the Grim Reber, he was a straightlaced New Englander who nonetheless saw the future of radio in big-name variety productions. A leading proponent of the theory that ad agencies could do a far better job of creating radio programming than the radio networks, Reber argued for a tighter relationship with Hollywood, vaudeville, and theater. He argued that these entertainment industries, unlike the radio networks but similar to the advertising business, had their fingers on the pulse of the American public. Rather than try to uplift or improve tastes, or restrict programs to a cautious, highbrow mainstream, Reber believed in radio as a popular medium, calibrated to "what the public was interested in." And he didn't mind spending money to achieve it. Reber was convinced that it was the presence of established big-name stars that would build radio. Unlike Casseres, who envisioned creating new program forms that would be unique to radio, Reber believed in drawing on the entertainment forms already available and popular with the public, beyond mere music.

A young scriptwriter newly employed at JWT in the spring of 1929 humorously related what happened as these three vied for the position of radio director:

> Mr. Joslyn, who had long been head of the radio department, called me in. He liked my continuity, he said. Would I make such and such changes in the script before 10 o'clock the next morning? Feeling that my script must have had merit to warrant his attention I gurgled with delight and said yes sir. . . .
>
> On returning to my desk, I was summoned by Miss Aminta Casseres, one of the copy executives. She said that as the new head of the radio department, she wanted to thank me for writing this continuity. She asked if I could make certain revisions—a very different set from the ones Joslyn suggested. Would I bring her a revised script back in the morning, say at 10? I said yes ma'am, and returned to my office to ponder. . . .
>
> It was not for long. The phone rang and I was asked to come to John Reber's office. He said that he had been appointed head of radio and liked my stuff. Here were the changes to make (all different from the other two sets). . . .

> I was not at the meeting when these three worthies, each armed with one of my scripts, fought out their conflicting ideas. ... But after several weeks of intramural shenanigans, during which I had to write all the Thompson shows three different ways, Reber emerged, bleeding, as Our Radio Chief. (Hilmes 1997, 145–146)

Reber's final selection as radio head set U.S. broadcasting on a path it would follow for the next 30 years. Although he was not alone in his innovations, JWT under Reber's direction did lead the pack in certain kinds of highly popular programs including the *Rudy Vallee/ Fleischman's Yeast Hour*, the *Lux Radio Theater*, *The Jack Benny Program*, and many other of radio's preeminent hits of the thirties and forties. By 1938 the agency was producing at least five of each year's top 10 shows, all from Hollywood. Reber's stars included not only Vallee and Benny but George Burns and Gracie Allen, Al Jolson, Walter Winchell, Eddie Cantor, Major Bowes, Fanny Brice, and Edgar Bergen and Charlie McCarthy.

The American Medium

How did this alliance among Hollywood, advertising, and radio shape the fundamental aspects of the medium? One characteristic that marked U.S. radio as different from its noncommercial rivals, such as the BBC, was the early development of *consistent scheduling*. Radio programs from the earliest days appeared on the same day at the same time, encouraging audiences to build their own schedules around their favorite shows. This seems like an obvious advantage; but only if we believe, as U.S. radio innovators did, that catering to the audience's convenience and building up the largest possible listenership are the goals of radio production. For the BBC, a more important goal was to provide cultural improvement through radio. With this motivation, it made more sense to treat radio programs like special events, unique and occasional, much like attending the theater or a symphonic concert. Audiences were required to consult their program guide, make specific plans to listen to this or that, and get up and go about their business when the program was done. In the United States, a high premium was placed on keeping the listener tuned in all day long, if possible to the same station, so as to maximize the publicity given to performers and products.

Though U.S. radio schedules remained fairly diverse until the network era, they soon stabilized into the system of time slots (from 15 minutes to 1 hour), starting on the hour and at quarter-hour and half-hour intervals, with one show flowing continuously into the other (punctuated by commercials and station identification). This is the system that worked best in the competitive commercial environment of U.S. radio, as devised by networks, sponsors, and agencies working in concert. In Great Britain and other countries without such pressures, shows were intermittent and of varying lengths, with simple silence (or dead air, as it was called in the United States) not just tolerated but often required between programs so as to preserve a proper respect for the material.

Agencies like J. Walter Thompson would spearhead another key broadcasting characteristic: the *daytime/nighttime programming distinction* that soon began to mark radio and still marks network television. In JWT's vision, nighttime radio became the star-studded equivalent of a night on the town. True, major advertisers sponsored the

programs and aired their ads, but in a way that minimized their intrusiveness. This daytime/nighttime distinction led to the programming by daypart that still exists today. We'll look at the factors that led to this differentiation in Chapter 5.

A third important characteristic of American radio, the technique of *integrated advertising*, was pioneered at JWT, starting with the Rudy Vallee show and extending throughout the nighttime schedule. By this method, a pitch for the product or mention of the sponsor was worked into the dramatic content, rather than stopping the program for a separate, explicit commercial. For example, Rudy Vallee, nightclub host, strolls casually among the tables and just happens to hear a young couple talking with enthusiasm about Fleischmann's Yeast. Cecil B. DeMille brings out one of his weekly guest stars, who incidentally mentions the wonderful job that Lux Soap does on her curtains. Gracie Allen asks innocently how they manage to get milk out of carnations, for sponsor Carnation Instant Milk. Such indirect promotion saved major stars from having to make explicit product pitches and frequently added to the humor of the show—particularly as some comedians, like Jack Benny, introduced the habit of humorously insulting the sponsor. It still sold goods.

Network Woes

Once ad agencies had seized the reins of program production and showed few signs of giving them back, what was a network to do? Well, for starters, simply collecting the fee for use of airtime kept network sales departments busy, and these departments played a key role in persuading clients to try radio, assisting agencies in collecting audience data, and recommending talent for agency productions. Also, the networks provided studios and studio technicians for the actual broadcast, because all went out live.

But networks had another function—that of cultural gatekeeper, or central censor, of what went out over their expensive air. Some of this function was strictly commercial: keeping sponsors from insulting each other, or colliding too abruptly (a show for Marlboro immediately followed by one from Lucky Strike), or violating FCC standards. But ultimately one of the networks' key functions devolved into their so-called Continuity Acceptance departments. (Scripts were known as continuities at this time, and hence this title means Script Acceptance.) These centers of script review and program observation attempted to ride herd on the wild and woolly ad agency producers, who were blithely unconcerned with FCC eyebrows or considerations of good taste. Today they're referred to as Standards and Practices departments, or something similar, and serve much the same function for television.

At NBC, the head of Continuity Acceptance was Janet MacRorie, a former schoolteacher of Scottish descent, known in some quarters as "the old maid." Hers was largely a thankless task. Ad agencies took delight in slipping double entendres past the censors, especially in radio where inflection or emphasis could shift a meaning completely. And because network radio went out live, even if the script were approved there were no guarantees that the performers would stick to it. In the 1930s the networks adopted the practice of assigning one of their own producers to every agency show broadcast from their studios, to keep an eye on things and to note every deviation from the approved written script. JWT's archives contain microfilms of such "as-broadcast" scripts, and sometimes the deviations are highly significant.

For instance, Louis Armstrong, the famous jazz trumpeter, was signed on as host for a summer replacement for *The Rudy Vallee Show* in 1937. In keeping with the racial prejudice of the time, a script was prepared for him that insisted on his speaking in heavy minstrel dialect. Armstrong, a well-spoken man without any such accent in his normal speech, refused to repeat the insulting dialect and inserted his own introductions and bridges. The NBC floor producer noted his substitute dialogue with increasing exasperation and reported these deviations to his superiors. The show was canceled after six weeks, and no African American musician would host his own sponsored network show again until Nat King Cole in 1946. Armstrong gained a reputation of being difficult to work with, and although the jazz great's career was hardly impeded by the event, the episode demonstrates the kind of cultural policing that took place under network guidelines and shows the limits of cultural diversity the advertisers were willing to allow.

MacRorie labored mightily to set network shows on the right course, producing NBC's first program policy manual and sending a constant barrage of memos about offensive programs to the heads of programming, sales, and network operations. In 1938, as the Roosevelt administration prepared to launch its investigation of the radio industry, MacRorie fired off a memo to Lenox R. Lohr, president of NBC networks, venting her frustration with what little effect network policies had had on agency-produced daytime serials:

> With criticism mounting against the merit of radio programs in general and the question of public interest stressed so strongly, I believe we should ask for change in type of material used on the following programs broadcast from New York:
>
> a. "John's Other Wife"—a daytime show. Quite bad; story poor—an endless conflict between the wife and her husband's business associates. . . .
> b. "Just Plain Bill and Nancy"—a daytime show of no merit whatever—tragedy is paramount—babies arriving, babies dying, adults going out of their minds—oxygen tents, hospitals, murders, robberies, etc. . . .
> c. "Dick Tracy"—the moral of right coming out on top is greatly overshadowed by colorful deeds and skill of the miscreants. Plenty of gun play and screams. . . .
> d. "Mrs. Wiggs of the Cabbage Patch"—a succession of calamities—never a happy moment—robberies, murders, deaths by natural causes, gangsters, ex-convicts—no relation between radio script and book of same title. (Hilmes 1997, 126)

The memo goes on in the same vein; the shows continued unabated. The same type of material can be found today not only in the women's daytime ghetto of the soaps, but in prime time as well.

Yet a memo responding to some of MacRorie's earlier complaints, from head of network sales Roy Witmer, sets out the problem in a nutshell:

> I hold no brief for these particular programs. I too think they are morbid. But are we to give the radio audience what they apparently like to listen to or what we think they ought to have? The advertisers pursue the former course. The British Broadcasting Company the latter. (Hilmes 1997, 126)

In Chapter 5 we will take up in more detail the question of the kinds of programs created during the fertile decades of the thirties and forties by the American system of

national commercial networks, supported by advertising and programmed by sponsors and agencies. And as audiences tuned in by the millions, social critics took note. A body of academic radio research began to develop, not much of it looking favorably on the radio business, even as networks and agencies honed their market research skills.

CONCLUSION

In this chapter we have examined the development of the American model of commercial network broadcasting. We've looked at the regulatory and social context within which networks emerged, the battles over control and structure of the medium, and the way the radio industry survived and adapted. Far from reflecting a natural and simple process of technological development, U.S. broadcasting emerged out of a great deal of indecision and controversy over the direction it would take and might well have evolved very differently. But we've also seen how commercial forces were able to triumph over would-be reformers, to shape the system to reflect their own economic interests.

Yet the industry itself was not a unified and monolithic enterprise. Though NBC and CBS quickly became the two major players, exerting a strong oligopolistic control over radio broadcasting in the United States, they also competed with each other and with the ever-more-powerful forces of the advertising industry. This chapter has also traced the often overlooked influence of advertising agencies in radio program production and outlined the struggle for control over content that they waged with the networks. The next chapter takes that focus further by examining the radio programs that resulted from this creative and highly commercialized conflict. Combined, the radio networks, the advertising agencies, and the taken-for-granted American public created what some have called the golden age of U.S. radio broadcasting.

RADIO FOR EVERYONE, 1926 TO 1940

While currents of regulatory debate swirled behind the scenes and the industry began its rapid expansion, the American public learned to regard itself in a whole new light and to conduct itself in a whole new manner. In increasing numbers, people invited radio into their homes. By 1931 over half of U.S. households owned at least one radio set; by the end of the decade that percentage had reached over 80 percent.

Radios were introduced into automobiles in 1930, and by 1940 over one-quarter of all cars sold could tune into local radio stations on the road. The cost of radio receivers dropped steadily, though they still represented a considerable investment of a family's income. Surveys done during the Depression years showed that the household radio was the last item that struggling families would choose to give up, as it spoke to them of a world outside their troubles and reminded them that they were not alone.

Radio was one of the few industries relatively unaffected by the Depression. As *Business Week* reported in 1932, "It's like going into a different world when you leave the depression-ridden streets for the office of a big broadcasting company. Men going past are fat and cheerful. Cigars point ceilingward, heels click on tiles, the merry quip and the untroubled laugh ring high and clear" (Hilmes 1990a, 54). Other media were not so lucky. As movies, vaudeville, and the press all suffered a downturn in their fortunes, radio gathered its resources, sweeping them all into its creative whirlwind and creating the programs and experiences soon known around the world as American radio. Radio became one of the twentieth century's most hybrid forms, through a combination of direct borrowing, skillful adaptation, and piecemeal creativity, based on radio's unique characteristics and capabilities. It created a new form of truly American culture.

THE MEDIA MILIEU

Nothing was more American than Hollywood, and the film industry showed an early interest in radio. WEAF's first popular show, *Roxy and His Gang*, started out as a simple remote broadcast of the pre-film stage show at New York's Capital Theater, owned by the Balaban and Katz chain (soon to be bought by Paramount). In the days before regulatory and network standardization, when the main business of radio

was inviting various representatives of entertainment businesses on the air to publicize themselves, it seemed natural that Hollywood, with its immense reservoirs of talent under contract, should join in to publicize that other national medium—the cinema. In 1925, Harry Warner of Warner Bros. put forth a prediction and a challenge:

> I am in favor of the motion picture industry, after the wave-length situation has been adjusted (as it will be)—building and maintaining its own broadcasting stations in New York and Los Angeles, and possibly in the Middle West. Through these sources... programs could be devised to be broadcast before and after show hours, tending to create interest in all meritorious pictures being released or playing at that time. Nights could be assigned to various companies, calling attention to their releases and advising where they were playing in that particular locality. Artists could talk into the microphone and reach directly millions of people who have seen them on the screen but never came in contact with them personally or heard their voices. Such programs would serve to whet the appetites of the radio audience and make it want to see the persons they have heard and the pictures they are appearing in. (Hilmes 1990a, 34–35)

Warner followed up on this vision by opening up station KFWB in Los Angeles that same year, and a second one, WBPI, in New York City in 1926. In summer 1926, Sam Warner took a portable transmitter on a cross-country tour, broadcasting from theaters showing Warner Bros. films.

Over the next few years, organ concerts and the like from movie theaters became a staple of evolving radio schedules. Pathé, the newsreel company, started a news release service based on its theater productions. And in the tumultuous spring of 1927, as NBC's fledgling network sent out its first scheduled broadcasts, and as CBS organized to do the same, the movie industry made a play for the big time. On May 24, the Paramount-Famous-Lasky Corporation (forerunner of Paramount Pictures) announced that it too would start up a radio network "for dramatizing and advertising first-run motion pictures." However, due to resistance from its exhibitors who felt wary of radio's competition with the box office, and having difficulty getting phone lines to build the network out of AT&T, the organization abandoned its plans after a few months. As the film industry converted to sound, however, a tie-up between radio and motion pictures seemed like a no-brainer. In 1929, RCA bought out the film studio RKO, and soon RKO stars and film-related programs began to show up on NBC. And in the summer of 1929, just months before the stock market crash, Adolph Zukor of Paramount again entered into negotiations with William Paley about a CBS/Paramount partnership. A stock transfer was hammered out, by which terms Paramount received a 49 percent interest in CBS while CBS received a certain amount of Paramount shares. In three years, Paramount would have the option of either buying the rest of CBS or simply regaining its own stock by turning back CBS's. By 1932, however, the country was in the depths of the Depression, and although radio's fortunes continued upward, the film industry was in steep decline. Rather than further consolidate the two firms' mutual interests, Paramount withdrew its merger offer, and the brief alliance was over. RCA would quietly divest itself of RKO in the late 1930s. It was not until the 1980s and 1990s that Hollywood studios found conditions favorable to owning broadcasting networks.

Radio Still Goes Hollywood

However, as broadcasting became a profitable business in the 1930s, its voracious need for talent sent it scrambling westward to Hollywood—to the film stars, writers, directors, and producers whose combined efforts would make radio great. Heightened tensions with movie exhibitors in 1932 would produce the short-lived (and much exaggerated) "radio ban," by which various studios promised to limit the appearances of their stars on radio, lest they use up their appeal in the rival medium. But by 1936 Hollywood had already become the major center of radio production, surpassing Chicago and even New York. The combination of Hollywood and broadcasting would drive American radio to a level of success and popularity envied around the world. How many other nations had a similar reservoir of talent, and such a well-oiled publicity machine, to draw on?

Aided by an FCC investigation (authorized by President Roosevelt in 1935) of telephone land-line rates, AT&T lowered its charges for lines to the West Coast, effective in 1937. Soon both NBC and CBS had built major production studios in Los Angeles, only a stone's throw from the luxurious studios of their movie competitors. Film stars became frequent and highly sought-after radio guest stars, particularly on the extremely popular comedy-variety programs hosted by such renowned radio names as Jack Benny, Rudy Vallee, Eddie Cantor, Edgar Bergen and Charlie McCarthy, Bing Crosby, and Al Jolson. Another Hollywood-inspired program type was the "prestige drama," featuring adaptations of Hollywood films or major stage productions, the most famous of which was the *Lux Radio Theatre* with movie director Cecil B. DeMille as host. Hollywood celebrity gossip programs hosted by Walter Winchell, Hedda Hopper, and Louella Parson drew ratings higher than most dramatic programs.

And as the synergy between Hollywood and radio continued, radio stars began to depend on film appearances to cement their popularity. The blackface duo Gosden and Correll of *Amos 'n' Andy* fame made *Check and Double Check* for their parent company's film arm, RKO, in 1929. Rudy Vallee and Bing Crosby became almost as well known for their films as for their radio shows. A whole genre of celebrity showcase films like *The Big Broadcast of 1932* (and subsequent Big Broadcasts for the next three years), *Hollywood Hotel*, and their ilk showed audiences what their radio friends looked like and provided the film industry with a whole new line of profit. Orson Welles would follow up his reputation-making "War of the Worlds" broadcast with a contract from RKO to produce his even more widely lauded *Citizen Kane* in 1940.

The movie studios would continue to take more than a passive interest in radio over the next two decades. Some would sponsor shows—as in MGM's *Good News* series of 1938—while others got into the transcription (radio syndication) business. And by the mid-1930s, television loomed on the mental horizon of all in the entertainment industry. Once again, the film studios would make a play to take a major position in that lucrative new entertainment form; once again they would be defeated by a combination of FCC protectionism and their own business practices. It took an Australian interloper, Rupert Murdoch, to finally consummate the marriage of film and broadcasting, bringing the 20th Century Fox studio together with TV station ownership to form the Fox network in 1988. Paramount had to wait until 1993 to get

its network with UPN (the United Paramount Network). By a final ironic twist, Paramount and CBS at last completed their long-postponed merger in 1999 as part of the Viacom empire.

The Afterlife of Vaudeville

These were hard years for the once thriving vaudeville business. Movies had siphoned off many of vaudeville's leading attractions, the Depression caused box office receipts to drop precipitously, and radio mopped up what was left. Yet vaudeville lived on in radio. An astonishing number of radio stars moved onto the airwaves with a version of their stage acts, from Burns and Allen to Jack Benny, Fred Allen, Fanny Brice, Al Jolson, Edgar Bergen, and Eddie Cantor. Radio humor largely stemmed from vaudeville humor, with its traditions of the male-female duo (Gracie Allen and George Burns, Jack Benny and Mary Livingston, Fred Allen and Portland Hoffa), the satiric and bawdy burlesque (Fanny Brice, George Jessell, Weber and Fields, Jack Pearl, Abbott and Costello, Red Buttons and Phil Silver), but perhaps most of all its long heritage of ethnic and minstrel humor.

We've already noted the minstrel or blackface tradition, from which radio's first blockbuster hit *Amos 'n' Andy* derived. Many other comedy routines drew on this race-based genre, and indeed radio preserved the minstrel tradition long after it had ceased to exist in any other form. Some of radio's popular minstrel acts, in which white men played blacks through use of accent and dialect, include George Moran and Charlie Mack as "The Two Black Crows," Harvey Hindermeyer and Earl Tuckerman as "The Gold Dust Twins," and Pick Malone and Pat Padgett as "Pick and Pat," who also played "Molasses and January" on NBC's *Maxwell House Show Boat*. Both Al Jolson and Eddie Cantor got started as blackface performers.

African Americans, too, performed in the minstrel tradition, from stage stars like Bert Williams to radio duos like Ernest "Bubbles" Whitman and Eddie Green and stand-alone comedians such as Eddie Anderson on *The Jack Benny Program*. Other early radio shows based entirely on minstrels include *The Dutch Masters Minstrels* (NBC Blue, 1929–1932), the *Sinclair Minstrel Show* (NBC Blue, 1932–1935), and *Pick and Pat* (NBC Red, 1934). Such programs fell into a category sometimes called hillbilly and minstrel shows. Even as late as 1940, the minstrel type remained popular (*Plantation Party* ran on NBC Red from 1938 to 1943), but by the postwar years hillbilly programs, featuring strongly accented rural white characters, had taken over completely.

Ethnic acts in some ways resembled their blackface counterparts but differed as well. Long established in vaudeville, these humorous routines used heavy accents from a variety of national identities, buffoonish costumes, halting and confused English, and a certain amount of physical slapstick. Though almost any ethnic group could be skewered, vaudeville favored Irish, Dutch (German), and Jewish and what one *Variety* writer charmingly called "Double Wop" (Italian duo) acts. Often these acts were performed by members of the burlesqued ethnic group; sometimes they were not. On radio, ethnic comics played staple roles in many comedy variety shows, from Sam Hearn's "Schlepperman" on *Jack Benny* to Mel Blanc as Pedro, a Mexican gardener, on the *Judy Canova Show* and Minerva Pious as "Mrs. Nussbaum" and

Charlie Cantor as "Socrates Mulligan" on *The Fred Allen Show*. The hillbilly act also grew out of this tradition, and by the World War II years had become the only acceptable form of dialect comedy left (grandparent of the most popular television show of 1962–1964, *The Beverly Hillbillies*).

But it is in the form of the variety show itself, network radio's preeminent prime-time offering, that we can see the influence of vaudeville on radio most clearly. From *The Rudy Vallee Show* through *Jack Benny* and *Bing Crosby* to TV programs like *The Ed Sullivan Show*, *The Smothers Brothers*, *Saturday Night Live*, *In Living Color*, and even *Late Night with David Letterman*, we can see strong remnants of vaudeville's typical variety act structure. Combining a host/announcer with comedy sketches, musical performances, dance, monologues, and satiric banter—sometimes even animal acts—the variety show takes myriad forms today. The vaudeville circuit of touring companies and local theaters is gone, but it lives on electronically.

The Swing Decades

If radio kept movies at arm's length and swallowed up vaudeville, the music industry took to radio like a duck to water and rose to new heights of success and cultural influence. Even as the recording industry faltered during the Depression years, radio moved into the gap. Music had been the first, most important type of radio content, and it remained a dominant component even as drama, talk, comedy, and quiz shows proliferated. More than 40 percent of NBC's total programming during the thirties consisted of music. No show was complete without a studio orchestra or ensemble; even programs that later became predominantly spoken—like *The Burns and Allen Show*—started out as comedy skits interspersed with musical performances.

Musicians built their careers through a combination of live performances, radio gigs, song publishing, and recordings, and radio provided a vital and lucrative venue that could be relied on to pay the bills. Radio embraced a variety of musical genres, but probably the dominant one was jazz's cleaned-up, whiter cousin, big-band swing. From Vincent Lopez and Paul Whiteman to Benny Goodman, Eddie Duchin, Tommy Dorsey, Fred Waring, Guy Lombardo, Glen Miller, and of course Phil Spitalny's All-Girl Orchestra on the *Linit Hour of Charm*, big-band music ruled the day. Even those performers and bands that never had their own regular program performed constantly as guests and on live remotes from nightspots and concert venues.

However, the airwaves were not nearly as open to the leading African American bandleaders, whom many considered artistically the best. Even such prominent musicians as Duke Ellington, Cab Calloway, Nat King Cole, and Louis Armstrong found themselves without a sponsor, without a regular venue, far more frequently than their white counterparts and imitators did. Calloway was featured briefly on Mutual in 1941 and on NBC Blue in 1942; Ellington had a brief four months on Mutual in 1943, and Armstrong was never featured again after 1937. Cole had the first African American–led, regularly sponsored network show from October 1946 to April 1948 on NBC, but this was after wartime attention to race relations had begun to open up the network schedule a bit. Mixed orchestras—combining white and black players—were frowned upon by most club venues, so a real barrier existed to African American musicians' ability to benefit from radio's enthusiastic adoption of all things swing.

Women artists, black and white, found the jazz scene a tough one to break into, but not primarily because of radio. Famed singers and instrumentalists like Alberta Hunter, Billie Holiday, Lil Hardin, and Mary Lou Williams performed on radio but never headlined their own show. Ella Fitzgerald managed to get a one-season contract on the newly formed ABC in 1943 and performed occasionally on *The John Kirby Show*, an all-black musical program featured briefly on CBS from April 1940 to January 1941.

Other musical forms either could not have existed without radio's peculiar qualities or could never have found national audiences. As historian Allison McCracken recounts, radio spawned a whole new style of singers, called "crooners," who stood up close to the mike, sang softly and yearningly into it, and seemed to speak directly into the hearts of their adoring, mostly female, audiences (McCracken 1999). Bing Crosby, Rudy Vallee, Frank Sinatra, Perry Como, Sammy Kaye, and a legion of others provoked critical disdain for their feminized, sexual style even as they built up recording and movie careers. Radio created the first musical superstars, mostly in the arena of jazz and swing. Other more regional or ethnic forms of music found an audience that they might not have had. Country and western music in particular, though never a large component of networks' schedules, drew in listeners from across the nation in shows like *National Barn Dance*, *The Grand Ol' Opry*, and *The Gene Autry Show*. Room existed on the radio dial for blues, gospel, religious, ethnic, folk—and yes, even classical—music. The focus of this book—and most existing records—on the national networks also obscures the much more varied output of America's thousands of local stations, where a variety of musical cultures flourished. Radio had America singing.

The Press-Radio Wars and the Birth of Broadcast News

Relations between the newspaper industry and radio were not as comfortable. Though newspapers had been among the first to try out the new medium of radio in the 1920s, and several large publishers owned powerful and influential stations, the Depression provoked a split between pro- and anti-radio forces, with many publishers claiming that radio was siphoning off not only readers but also advertisers, in a tight market.

News did not take up a large amount of broadcast time in the twenties and early thirties. NBC and CBS both aired a few 15-minute programs in 1932, mostly on a sustaining basis. NBC had David Lawrence's *Our Government* and William S. Hard's *Back of the News*, both broadcasting only once a week. The magazine *Literary Digest* sponsored Lowell Thomas with a daily quarter-hour broadcast, consisting mostly of commentary delivered in a friendly, folksy style. CBS offered Edwin Hill's *Human Side of the News*, Frederick W. Wile on *The Political Situation* (both once a week), and H. V. Kaltenborn's *Current Events* three times a week, all on a sustaining basis. *Time Magazine* began its oft-parodied but highly popular *March of Time* news dramatization series on CBS in 1931, produced by the Batten, Barten, Durstine, and Osborne (BBDO) agency. In 1932, CBS debuted Boake Carter in a sponsored news show for Philco Radios five times a week.

The Associated Press news service had reluctantly adopted a policy of allowing stations to use news bulletins, because the threat to the kind of coverage that newspapers could provide seemed minimal. Then American aviator and hero Charles Lindbergh's baby son was kidnapped.

The Lindbergh kidnapping, and the subsequent trial of Bruno Hauptmann for the crime, provoked a crisis in press-radio relations. This was the first national media event in which radio played a significant role. Both networks and several local stations sent their own reporters to cover the event, transmitting interviews, commentary, and trial coverage over the air to a captivated nation. For the first time radio vied with newspapers over coverage of a breaking story, and the press erupted in panic. Charging first that radio broadcasts were cutting into newsstand sales (though in fact readership went up), then that radio reports featured emotional and sensational reporting (perhaps more a reaction to the fact that radio coverage was live), press spokesmen cast radio in the role of the enemy.

Widespread coverage of the presidential election in November of that same year exacerbated the conflict. At a meeting in December 1932, the American Newspaper Publishers Association (ANPA) recommended that first, the wire services should stop providing news to radio stations until the news had been published in the papers; and second, that newspapers should stop providing radio programming schedules as a service and instead require stations to pay for the privilege. In the face of this challenge, networks began their first concerted efforts at building up their own news-gathering operations. Unhappy with this turn of events, newspaper and radio representatives met in December 1933 at the Biltmore Hotel in New York. The resulting Biltmore agreement stipulated that in return for the news industry setting up a Press-Radio Bureau, the networks would suspend their own news-gathering efforts. All three major wire services—Associated Press (AP), United Press (UP), and the International News Service (INS)—would filter their reports to the bureau, which itself would produce bulletins no longer than 30 words each, sufficient for two 5-minute newscasts daily, to air mid-morning (after the morning papers were out) and late in the evening (after the afternoon papers). Radio commentators were forbidden from referring to news less than 12 hours old. And a ban was placed on sponsored news. Unfortunately for fearful members of the press, these extreme restrictions merely caused radio to revolt.

Radio networks and stations turned to different news providers—most notably the Transradio Press Service, Inc., a commercial wire service that had no problems with defying the Biltmore plan. Soon UP and INS jumped ship as well, leaving only the newspaper-owned cooperative AP holding the bag. And networks—perhaps realizing that if the press objected so vociferously to radio's potential as a news medium, there might actually be something in it—began to take news far more seriously than before. As the political situation in Europe worsened, both NBC and CBS began to put together news bureaus in various significant cities at home and abroad. When the war broke out, these organizations would leap into action.

However, the clash provided an opportunity for the educational broadcasters who were currently involved in the struggle over radio regulation. Newspaper owners' enmity for the commercial broadcasters led them to turn a sympathetic ear toward the cause of noncommercial radio (as had occurred 10 years earlier in Great Britain). Organizations like the NCER (National Committee on Education by Radio) were able to achieve a good amount of publicity for their cause, and many leading journals picked up the anticommercial radio cry.

Even movie exhibitors got into the act, joining forces with newspapers and educational broadcasters in decrying the threat of commercial radio. (It is no

coincidence that the so-called radio ban was declared by the film industry in 1932; see Hilmes 1990a.) Movie theaters had always had to pay for movie listings in local papers and saw no reason that radio stations should not do the same. Many of these allied interests declared themselves in favor of a government-owned system to supplant the current commercial one. Citing radio broadcasters' irresponsibility and unfitness for the important task of covering the news, the press and related interests called for a level of government control over broadcasting that they would never have tolerated in their own realm. This resembles the argument that the British press made at the time that the BBC was founded. Rather than allow a competitor (for advertising and for audiences), the press advocated restrictions on radio that on the face of it would seem to set a dangerous precedent for its own industry.

But in the late thirties, after passage of the Communications Act, many newspapers adopted an "if you can't beat 'em, join 'em" attitude. By the end of the decade, almost 30 percent of the nation's 800 stations were owned by newspaper companies, a policy encouraged by the NAB in its own self-interest. The UP began offering a special radio news service in 1936, and INS and AP later followed suit. The number of news programs on the air in 1940 was double the number in 1932, most of them several times a week, and the great majority were sponsored. But this trend toward commercial success brought with it certain drawbacks. Elizabeth Fones-Wolf has investigated the impact of sponsors on coverage of labor and industry issues, and she concludes that such sponsors wielded considerable pro-industry leverage over the news that reached the American public (Fones-Wolf 1999).

Yet newspaper owners' initial hostility to radio may have helped to temper anti–New Deal sentiment, as Roosevelt turned to radio to bypass a largely conservative, hostile press. Many have concluded that radio played a major role in FDR's reelection in 1936. There is also evidence that the president eyed with suspicion the increasing convergence of the press and radio through station ownership. Under his leadership, the FCC would embark on an investigation of the cross-ownership of radio stations and newspapers in the same market, though no rule would be passed for several decades.

On a less contentious but equally important front, newspapers contributed much of their "non-news" offerings to the new medium. Competition in the teens and twenties had diversified the content of daily and weekly papers, which published not only sports coverage but also features, women's pages, puzzles and quizzes, advice columns, household hints, children's pages, serialized fiction, and comic strips. Many of these offerings became nationally syndicated in the 1920s, as newspaper empires such as Hearst and Scripps Howard expanded across the country, and powerful city papers like Colonel Robert R. McCormick's *Chicago Tribune* exerted influence over the Midwest. Radio borrowed many of these formats for its early shows. Shows such as *Blondie, Li'l Abner, Dick Tracy, Little Orphan Annie,* and *Terry and the Pirates* all started as syndicated comic strips. In turn, newspapers garnered circulation by capitalizing on radio popularity. Comic strips based on radio programs and summaries of radio serials—not to mention gossip and publicity about radio's burgeoning celebrity culture—began to fill the pages of daily newspapers. And most papers considered their radio schedule listings an important part of their service obligations to the public—a vital element in radio's success.

Magazine Chat and Women's Programs

We've already seen that magazines of political and critical opinion, like *The Literary Digest* and *Time*, played important roles in bringing the news format to radio. More populist publications, like the confession magazine, contributed to successful early shows, including *Love Stories*, *Mary and Bob*, and the *Court of Human Relations*, a forerunner of much of the material on Court TV or *Judge Judy*. Popular thriller magazines brought shows such as *True Detective Mysteries* and *The Shadow*. But the greatest influence from magazines may have been the women's daytime talk show, based on the kind of familiar and intimate domestic address pioneered in women's magazines since the days of *Godey's Ladies' Book*. Women who had been brought up on *The Ladies' Home Journal*, *Good Housekeeping*, *The Woman's Home Companion*, and *McCall's*—with their recurring columnists who talked about matters of special interest to women in a chatty, informal tone—looked to radio for the same kind of information and companionship. Many journalists and columnists made the transition to radio, including Emily Post, Mrs. Julian Heath, Ida Bailey Allen, the various Betty Crockers (an artificial persona invented by General Mills to advertise household products), Nellie Revell, and perhaps most famously, Mary Margaret McBride. These magazines also featured serialized fiction centered on women's lives—a format that later would explode into the daytime radio serial, commonly known as the soap opera.

Radio itself spawned a whole new area of magazine publication. The radio journal, from its earlier more technical debut in *Radio Broadcast*, the American Radio Relay League (ARRL) publication *QST*, and *Radio News*, soon expanded to include a host of more program-based periodicals like *Radio Program Weekly*, *Radio Revue*, *Broadcast Weekly*, *Radio in the Home*, *What's On the Air?* and many others. With in-depth features on various shows, celebrity profiles, letters from listeners, plot summaries for the serials, and national radio schedules, these magazines were the prototype for today's *TV Guide*, *Entertainment Weekly*, *Soap Opera Digest*, and the like. They gave listeners a sense of going behind the scenes to learn more about the world they listened in on every day and made audiences into fairly savvy consumers of radio fare. Letters written to the various programs frequently reflect a sense of participation and power; they praise what they like, condemn what they find obnoxious, and threaten to discontinue use of the sponsoring product if problems aren't resolved to their liking. Magazines served not only to publicize the budding medium but also contributed to a sense of community among listeners that could be mobilized to effect change (Newman 2001).

POPULAR COMMERCIAL RADIO

During the 1930s radio invented itself as a popular, commercial medium. From movies, vaudeville, music, and newspaper and magazine elements like comic strips, serialized fiction, and household chat columns, filtered through the interests and marketing techniques of the advertising industry, a new type of popular culture filled the air and percolated into the structures of everyday life. By the

mid-1930s, gathering around the radio in the living room at night after dinner was a common experience that united Americans nationwide, across class, race, gender, regional, and ethnic differences. Though it was the white urban middle class that adopted radio first, radio's audience quickly expanded. Housewives kept the radio humming in the daytime as they performed their often isolated and unappreciated duties; children rushed home from school to hear the latest adventure serials; rural audiences tuned in to farm news and country music shows; preachers took to the air and new radio congregations gathered 'round on Sunday mornings for services; sports fans kept track of their team's progress; news reports provided coverage that supplemented the urban dailies and rural weeklies. President Roosevelt spoke to each and every American personally in his occasional Fireside Chats. Music accompanied parties, dinners, leisure time, and the drive to work. The breakfast show emerged to provide national accompaniment to even the earliest hours of the day. American families had become radio families.

What kind of national community did radio create? We have seen how early commentators, critics, and regulators regarded radio's potential for encouraging a unified national identity and the fears that such possibilities raised. Not surprisingly, radio reproduced many of the same cultural and social divisions that typified the rest of life. The virtual exclusion of African Americans and other minority groups from the air, and the confinement of their representations to minstrel and ethnic stereotypes, meant that radio's "blindness" did not extend to race and that these groups would be "spoken for" rather than being allowed to find their own voices. Ethnic differences continued to be emphasized in vaudeville-based comedy shows, with certain groups marked out as different—Jews, Irish, Italians, Asians, and Mexicans, in particular—and others streamlined into a white middle-class normalcy.

Later, programs based around the average American family would become the standard (though the life they portrayed was far from average), and their early prototypes can be seen in highly popular programs such as *One Man's Family*, created and written by Carlton Morse; *The Aldrich Family*, a teen-centered half-hour comedy; and *Vic and Sade*, Paul Rhymer's much-loved saga about "radio's home folks." An acknowledgment of working-class life pervaded radio (as it did early television), as the drama of assimilation became an early popular form. Programs such as *The Rise of the Goldbergs*, *Amos 'n' Andy*, *Fibber McGee and Molly*, *Duffy's Tavern*, and many similar skits on the ubiquitous variety shows played out the struggles of immigrant or migratory laboring families to assimilate within American culture. So did many of the daytime serials, which tended to focus on much less affluent lifestyles than do today's soaps. Of course, radio's lack of visual cues meant that listeners could fill in the scarce background provided with material from their own imagination. One could imagine *Ma Perkins* or *Vic and Sade* in a variety of settings, from humble to comfortable.

And though women's representations were fairly severely circumscribed on nighttime shows, during the daytime a lively variety of possibilities opened up, due to women's purchasing power. This enfranchisement by virtue of the marketplace created an abundance of wish-fulfillment programs that showed female characters

moving in social, political, and economic circles that were denied to women in actual American life. Unlike the sidekick, helpmeet, and victim roles of nighttime, during the daytime women played the central roles; their actions counted (for good or ill), and issues and problems that particularly affected women made up the bulk of the drama. This acknowledgment was largely confined to white middle-class women, however; women of color remained on the margins of daytime radio's imaginary world, occasionally appearing as household workers or as "problems" for white characters to deal with. Yet the real-life world of radio itself—the world of writing, producing, and performing—provided a host of new careers for women, whose efforts created some of the best-loved and longest-lasting formats of broadcasting. (We'll look at one such innovator, the mother of soap operas Irna Phillips, later in the chapter.)

One other characteristic of radio shows was their frequent self-consciousness about their own position as radio shows. Rather than trying to hide the mechanisms of radio production behind the realist mise-en-scène that the movies had developed—pretending that the camera doesn't exist and that we can somehow view what is simply "really happening"—radio tended to draw on its stage inheritance by acknowledging the presence of audiences, addressing them directly, providing proxy audiences in the studio during the broadcast (the origins of both the "live studio audience" and the laugh track), and often basing shows around some concept of, well, putting on a radio show! This kind of *self-reflexivity*, as it is sometimes called, did not extend into all areas. We have seen how integrated advertising pretended to be part of a program's dramatic content, and many shows, especially daytime serials and the situation comedy format that developed in the late thirties and early forties, adopted a kind of invisible eavesdropping aesthetic. The variety show, however, explicitly proclaimed itself as a theatrical radio production, complete with host, transitions between acts, musical interludes, and interactions with the audience. (Inheritors of this aesthetic today are the late-night talk shows like *David Letterman* and *Jay Leno*.)

Most of radio's top-rated variety shows in the 1930s and 1940s featured a self-reflexive production aesthetic, and most of them combined it with another distinctive aesthetic feature of network radio, something we might call *false authorship*. By this device, the actual authors of radio's increasingly commercial output—the advertising agencies and sponsors—hid behind a facade and claimed that someone else was responsible for the shows, that someone else was their author. Usually, this "false author" was the host or the star of the show. Cecil B. DeMille called himself "the producer" of *The Lux Radio Theatre* when introducing the stars of that evening's performance. He went on to pretend that he himself had selected each episode's movie adaptation and leading players. Yet he actually did none of those things; he merely read the script handed to him by J. Walter Thompson radio producers. Jack Benny, as we shall see, gave this role of false author a new, ironic twist. Benny pioneered the radio show about putting on a radio show, with himself as the vain, penny-pinching, autocratic "producer" and his brilliant cast of comedians as his bumbling, dysfunctional "family." Each week they brought to the airwaves a show that satirized not only American culture, but radio itself.

Connection Jack Benny and His Radio Family

Young Benny Kubelsky of Waukegan, Illinois, hardly seemed destined for a career as radio's most beloved comic host, whose fractured violin playing and chronic cheapness would delight audiences for over 30 years. But when his parents gave him violin lessons, they started him down that still unimaginable path. Benny got rather good and in 1912 joined forces with orchestral pianist Cora Salisbury to form a musical act on the local vaudeville circuit. Calling themselves "Salisbury and Kubelsky—from Grand Opera to Ragtime," they did well enough that established concert violinist Jan Kubelik objected to the confusion created by the similarity of the two men's names.

Changing his stage name to Ben K. Benny, the young performer switched partners and began to introduce humor into his act, exaggerating his effort in playing difficult numbers, rolling his eyes, waving his little finger in the air languorously during easy sections. This act succeeded to the point that in 1917 Benny and his partner performed as the second act at New York's famed Palace Theater—only to run into problems again, as established comedian Ben Bernie complained not only about name confusion but also about the similarity of Benny's shtick to his own. Finally adopting the moniker that would make him famous, Jack Benny shifted his act to something resembling his later persona: a would-be suave and sophisticated man-about-town whose pretentious efforts to impress were undermined by his own neurosis and ineptitude, resulting in discovery and embarrassment. By 1924 the Palace was billing him as its star attraction.

In 1928 he was asked to perform as master of ceremonies at the Palace, along with an act that now included Mrs. Jack Benny—formerly Sadie Marks (a cousin of the Marx brothers)—whose stage name was Marie Marsh but who soon would become known nationwide as Mary Livingston. After being invited onto radio in 1932 in New York by a young Ed Sullivan, who hosted an interview show on WHN, Jack came to the attention of Bertha Brainard at NBC. She set up an audition for him with the N. W. Ayer Agency and its client, Canada Dry. They approved of the young comedian, and *The Canada Dry Ginger Ale Program* would run for a year with Benny as host. It was a standard musical variety program that confined Benny to simple comic introductions. Before too long he had introduced Mary Livingston onto the program, in the character of an enthusiastic but critical fan who at once built Benny up and deflated him at important moments.

The year 1933 was a watershed for radio's first big breakthrough format—the comedy variety show. In the previous year only two such shows were on the air, one of them Eddie Cantor's vaudeville-inspired music interspersed with comedy act that soon garnered the highest radio ratings. By January 1933, NBC and CBS had scheduled 12 such programs, including Benny's; Cantor's show reached astronomical ratings. Canada Dry dropped the sponsorship in January 1933, but General Motors picked it up and resumed in a new revitalized format. By 1936 *The Jack Benny Program* was the highest ranked in the bunch. Like other programs in this genre, Benny's show combined comic skits (featuring not only himself and Mary, but other recurring characters), routines by guest stars (sometimes in

© Bettmann/CORBIS

Jack Benny built up a 20-year comedic reputation of legendary cheapness. Here he counts his money, probably thinking of ways to avoid giving his cast raises.

combination with the cast), and musical performances. Unlike most other shows (but similar to the early *Eveready Hour*), *The Jack Benny Program* began to develop the idea of the "radio family": a recurring cast of characters who got together each week to put on a radio show, with Benny as "himself," a variety show comedian and host, and Mary and the others as "themselves," his loyal but often disgruntled employees.

Unlike earlier shows, however, the Benny program took this concept outside the radio studio and created skits based on the "private lives" of the performers—all fictional and humorously constructed by an outstanding group of comic writers. Over the years a complex and detailed life was built up around Benny and his cast, involving their professional as well as "personal" lives. Cast members would come over to his house, go

shopping or on trips together, sometimes take the show on the road and get in numerous scrapes on the way. Mary Livingston did not play Jack's wife (though audiences were well aware of their real-life marriage) but instead a kind of secretary; Eddie Anderson was added to the cast in 1937 as Jack's valet and butler Rochester; and commercial announcer Don Wilson, bandleader Phil Harris, and Kenny Baker (later Dennis Day) as singer and comedic stooge made up the central core of the show.

So Mary might accompany Jack to buy Christmas presents for the cast and run into Rochester doing the same; a regular guest star like Ronald Colman also played the part of Benny's neighbor in Beverly Hills who might drop in on Jack unexpectedly to complain about noise coming from his place; a skit might feature Dennis Day and his mother, who disapproved of Benny, at home over breakfast discussing how to ask for a raise. At other times the radio family would clearly be together in the studio, involved in the activities necessary to putting together a radio show. Jack would complain to Phil Harris about the orchestra, Don Wilson would make constant attempts to introduce the sponsor's name into the conversation, and Rochester would brush off Jack's attempts to have his jacket pressed before the show.

This mixture of fiction and "reality" blended into another of the show's innovations: satiric sketches that lampooned other forms of popular and high culture, from movies to literature to the theater. These could take on the tone of self-satire; for example, the not-very-good fictional comedy team of the fictionalized "Jack Benny Show"—underpaid, overworked, and led around by the nose by their stingy, demanding, and self-deceiving boss "Jack Benny"—performing inept and poorly executed skits based on respectable properties such as *Little Women* or *Uncle Tom's Cabin* or movie westerns. On another level, of course, well appreciated by their in-the-know radio audience, the highly skillful team of comedians brilliantly lampooned not only the objects of their satire but radio performance itself. Their wit included a well-known Benny trait: skewering the sponsor. Benny had been making mild fun of his sponsor and the sponsor's products since the Canada Dry days, which was what got him canceled. Later underwriters like General Motors and, most famously, General Foods—maker of Jell-O gelatin—didn't mind the humor as long as it sold the products. Benny's introductory phrase, "Jell-O, everybody!" became a catchword.

What made this show so popular? Why does it stand as an emblem of the radio-era comedy variety program, the most famous program in the most loved genre on radio? And why is there nothing like it on the air today? First of all, it drew on an extremely talented group of comedy writers who had honed their abilities in vaudeville—a demanding form no longer available as training ground for today's aspiring gagsters. During the show's early years, its head writer was Harry Conn, who had also helped to build up *The Burns and Allen* show. He left over a contract dispute in 1936 and was replaced by Bill Morrow and Ed Beloin, both also from vaudeville. Many feel that the greatest years of the show were those after 1943, with the four-man writing team of Sam Perrin, Milt Josefsberg, George Balzer, and John Tackaberry.

Though several of these comic writers had backgrounds in vaudeville, by this time radio comedy had evolved enough of its own character that a new form emerged, faster and more polished than the old one and more devoted to what would later become the situation comedy. Rather than presenting a series of separate gags and sketches, performed more like a stand-up comedian or a late-night talk-show host would, the later show relied more and more on character development, running story lines, and longer unified scenes. Also, by the 1940s the show was able to build on its very popularity, drawing on the audience's familiarity with the

personalities of the characters and developing running gags. Jack's famous cheapness, for instance, was so well known that when a 1940s program had a robber hold up Jack with the line "Your money or your life!" the long pause that followed produced roars of laughter from an audience who could fill in Jack's response from long familiarity: "I'm thinking."

Secondly, through its self-reflexivity the program was able to comment humorously on the peculiarities of American life and culture as well as on the strange and unique nature of radio itself—one of the central peculiarities of American life. The show seemed to acknowledge all of radio's cultural ambivalence—as a "public interest" medium dominated by commercial sponsorship, as a cultural form permeated by commerce, as an invisible medium that created indelible images—and to thumb its nose at those who would criticize it. It thus marked out an important piece of cultural ground in the decades between the wars: a popular and populist space that poked fun at the pretensions of high culture even as it aspired to a very high level of entertainment itself. But this was popular entertainment—aimed not at those in the cultural elite but at the common woman and man, who by their appreciation of cultural satire proved that they were not such dumb masses after all. (*The Simpsons* might embody this kind of attitude today.) Irreverent, disrespectful of pretentiousness, yet still aimed at the broad mainstream, the Benny program seemed to embody all that was the best and worst about radio, and about American life.

Even its racial politics show some movement in a more liberal, less repressive direction—all the while preserving basic hierarchies. Eddie Anderson, whose gravelly voice and emphatic delivery made him instantly recognizable, was one of radio's highest paid and most prominent African American stars. In his role as Rochester he carried on the repressive minstrel tradition in certain ways: cast as a servant; addressing the other cast members as "Mr." and "Mrs." while they called him by his first name; speaking in dialect; portrayed as highly sexual, free spending, and feckless; and given to drinking and gambling, Rochester could have been another insulting addition to the long line of Zip Coons of blackface humor. But the program's writers, and Anderson himself, added a level of self-conscious satire to the role that worked to subvert the so-called naturalness of minstrel conventions.

First of all, the show portrayed Jack as comically inept and dependent on Rochester's greater good sense, skill, and organization. Rochester ran Jack's household, kept track of his engagements, drove him places in the ancient Maxwell car and repaired it when necessary, and made wry comment on Jack's peculiarities. He frequently talked back to his boss and refused to act subserviently; in one skit, when Rochester is asked to answer a ringing doorbell, he replies, "Boss, you're nearer to it than I am." In another, when Jack asks Rochester to spar with him because he's trying to learn to box, Rochester knocks Jack out with a well-placed punch. Rochester has all the traditional manly qualities that Jack seemingly lacks: the ability to attract women, enjoyment in spending money freely, and an active social life outside of work.

Second, the show allowed Rochester to be aware of dominant white impressions of blacks and to enjoy subverting them. In one program, when Jack asked Rochester for a suit he has sent to be pressed, Rochester replied, "Gee, I'm lazy. Don't I remind you of Stepin Fetchit?" (a black film actor known for his highly stereotyped roles). Supporting this subversion of minstrel holdovers was the construction of the character of Phil Harris. Supposedly the bandleader (though in fact someone else handled the actual direction of the show's orchestra), Harris was a white character who "doubled" Rochester and in fact surpassed him in displaying most of the traits of blackface comedy. Uneducated and

ignorant, given to mispronouncing the English language and speaking ungrammatically, a flashy playboy with an addiction to gambling, women, and liquor, associated with jazz music through his bandleader role, Harris embodied most of the negative stereotypes of the minstrel representation and showed them as completely compatible with whiteness. Next to Harris, Rochester seemed a model of calm, competent normalcy.

Though these characterizations can cut two ways—playing with racial representations by citing them can just reinforce them in some people's minds—it certainly allowed the show to be understood by many as a less repressive and even mildly liberating variation on the largely unrelieved whiteness of the radio dial. African American audiences and media embraced Anderson's character (the *Chicago Defender* billed the show in its radio listings as "Eddie Anderson—with Jack Benny"), and it earned favorable mention by African American advocacy groups.

But above all it was the character created by Benny himself that drew massive audiences to the show over a 20-year period. Sometimes referred to as "America's fall guy," Benny specialized in a kind of humor that took on social hypocrisies and contradictions and focused them onto himself. By turning social satire inward, Benny's humor became personalized and individualized, rather than the kind of overt social commentary made by fellow comedian Fred Allen. (The manufactured feud between Benny and Allen marked some of the high points of both programs in the late thirties.) When the show ran a contest in the 1940s asking for essays on the theme of "I Can't Stand Jack Benny Because ...," the winning entry captured some of this unique appeal:

> He fills the air with boasts and brags / And obsolete obnoxious gags.
> The way he plays his violin / Is music's most obnoxious sin.
> His cowardice alone, indeed / Is matched by his obnoxious greed.
> In all the things that he portrays / He shows up my own obnoxious ways.
> (Hilmes 1990a)

Benny's double-edged humor—at once bringing up socially reprehensible traits and, by showing Jack's pompous and silly reaction to them, making them semi-acceptable—turned his show into a place where social contradictions could be humorously explored.

The Rochester/Phil Harris doubling exposed some of the arbitrariness of accepted racial representations. One character, the floorwalker played by Mel Blanc, introduced a note of exaggerated gay representation that some have said was a rare acknowledgment of non-heterosexual identity in network radio. The character of Schlepperman, a dialect-speaking Jewish character, took on a strange piquancy next to Benny's own secular/assimilated Jewish identity. Though certainly not all audiences picked up on the inner joke behind the outer more obvious and traditional humor, it gave the program a depth and an edge lacking in most others.

Benny took his show onto television in 1950 and continued it until 1965. Though it never hit the ratings heights that the radio version had, it continued to delight audiences with its self-mocking humor even as sitcoms and westerns began to dominate the TV schedule. Jack Benny himself continued in guest appearances and specials until well into his 70s. Few television performers or creators today could match such a long-running success story; this is partly due to the strangely static nature of established radio programs and to the adaptability of Benny's basic humor and format, in a program that could have been created only on radio.

Dramatic Adaptations

Another highly rated program type on network radio's nighttime schedule was the dramatic adaptation program. Though few in number—in the 1938 to 1939 season there were only six such shows on the air—their consistently high ratings and high publicity profiles make them a significant form. Either stage or screen properties could be adapted, but the most popular were the movie-based shows like *The Lux Radio Theatre*, *Hollywood Playhouse*, *The Screen Guild Playhouse*, and *The Silver Theater*. Even when the dramas enacted were stage plays, they always presented a glittering roster of Hollywood stars. Other notable programs of this type were *Mercury Theater of the Air* (Orson Welles created this show, later known as *Campbell Playhouse* after the soup company assumed sponsorship) and the *Cavalcade of America*, a series based on dramatic reenactments of important moments in American history.

The Lux Radio Theatre resulted from the entry of agency J. Walter Thompson into radio and remained one of its stellar properties. Relying on the Hollywood showmanship of film director Cecil B. DeMille (known for his biblical and historical epics, as well as for the riding crop and boots he affected on the set), the show's famous opening line, "And now . . . Lux presents *Hollywood!*" helped to start the rush to the West Coast and cemented the Hollywood/radio axis. Though film studios gave up the idea of using the show to preview films early on—due to exhibitors' objections—it became a popular spot to build up stars' reputations and to popularize a movie in another, shortened aural form. DeMille actually had very little to do with putting together the show, but his carefully constructed "false author" persona as producer emphasized the Hollywood connection and helped to keep Hollywood glamour at arm's length from outright commercial selling. Almost every major star and significant movie made an appearance on *Lux* sooner or later, and ratings remained high until television's ability to show actual movies took away the program's raison d'être.

The most famous radio drama of all times may be Orson Welles's panic-inducing "War of the Worlds" adaptation on the *Mercury Theater*. The show started on a sustaining basis on CBS in 1938 and was designed to ward off federal investigation into radio's overcommercialization; the young and controversial Welles was hired to continue the innovative dramatic work he had done as part of the Works Progress Administration (WPA) theatrical group. Some element of "false authorship" clings to *Mercury Theater* as well. Most accounts agree that after the first couple of broadcasts, the group that Welles had gathered around him—notably John Houseman and Howard Koch—actually did most of the dramatic selection and writing. Still, Welles's inimitable sense of drama and timing permeated the productions, as well as his penchant for self-reflexive and confrontational material. Howard Koch was given writing credit for "War of the Worlds," much to Welles's later chagrin. And none of the *Mercury Theater* group anticipated the real-life drama that the play would set off.

Due to a variety of factors—most analyses blame the prewar tensions of the time as well as the fact that listeners tuned in during a musical interlude in the Bergen and McCarthy show on NBC, thus misunderstanding that this was not a news bulletin but a play—a sizable number of Americans gasped at news of a Martian invasion of New Jersey. They were riveted to their radios as the aliens vaporized much of the New Jersey militia and began marching toward New York, and then listeners began to flee

their homes in hysteria. While CBS got sued, Welles got a Hollywood contract that he parlayed into *Citizen Kane*. The show continued under Campbell's sponsorship until 1940, with less and less involvement by Welles.

Comedy Series

Starting out with a few groundbreaking shows like *Amos 'n' Andy* and *The Rise of the Goldbergs* in the early 1930s, the comedy series came into its own in the late 1930s and developed into what we now call the situation comedy or sitcom. The basic idea was to take a group of humorous or eccentric characters, place them in a comic situation, and let the hilarity commence. Radio's early and long-running series include *Lum and Abner*, based on a couple of hillbilly shopkeepers in an Arkansas town and played by Chester Lauck and Norris Goff; *Easy Aces*, an early dysfunctional-couple comedy of sharp husband-and-wife insults created by Goodman and Jane Ace out of their former vaudeville routine; and the domestic comedy *The Aldrich Family*, centered around awkward teenager Henry Aldrich and his beleaguered parents. Later, Fanny Brice enlivened the airwaves in the comedy *Baby Snooks*, which revolved around a precocious and devilish child, a *Dennis the Menace* prototype.

Just to show that it's the exception that proves the rule, two programs that seem like strong antecedents to television sitcoms don't actually fit into the comedy series bracket. The well-respected domestic serial *One Man's Family*, created and written by Carleton E. Morse, ran in the evenings on NBC, in a variety of half-hour time slots under various sponsors, yet presented a serial drama whose story line held audiences enthralled for over 15 years. It was not primarily humorous, though there could be much humor in its familial interchanges, nor did it traverse the same terrain as daytime's serials, though much of its family-based drama revolved around love, relationships, tragedy, and emotions. Focused on the Barbour family and set in Sea Cliff, California, it attracted ratings as high as most star-studded variety programs and is one of the most fondly remembered of old-time radio's top shows. Perhaps because of the high quality of its writing, or because it was male centered rather than focused primarily on women, or because of the high authorial reputation of its creator, *One Man's Family* was able to hang onto its evening time slot when other more feminized serials lost their (often highly rated) perch and were banished to daytime. However, not even this program's success was able to convince networks and agencies that the serial format could work in nighttime; it would take *Dallas*, 35 years later, to do that.

Another program that continues to live on in popularity even after 50 years off the air is *Vic and Sade*, Paul Rhymer's much-loved creation. More comedy than drama; not exactly a serial, because its story line didn't rely on continuations; yet following the life curve of the Gook family in "the small house halfway up in the next block" (somewhere in small-town Illinois), *Vic and Sade* ran on daytime from 1932 to 1945, mostly on NBC. Although the show was a series of comic sketches more than anything else (it resembles situation comedy more closely than does *One Man's Family*), its daytime slot put it in a world of soap operas and kids' shows. Its use of comic character names may be unmatched by any other radio program, from the Gooks themselves to Chuck and Dottie Brainfeeble, Rishigan Fishigan of Sishigan, Michigan (who married Jane Bayne

from Paine, Maine), Ruthie Stembottom, Hank Gutstop, Orville Wheeney, Blue-Tooth Johnson, and Smelly Clark, not to mention the cast of eccentrics summoned up by Uncle Fletcher's tall tales. The show was produced in Chicago and sponsored by Procter & Gamble, the daytime colossus. Why it stayed on daytime is hard to say, unless its low-key humor and quirkiness would have wilted in the spotlight. More than others it was a quintessential radio show, relying on the aural tools of voice, pacing, accent, and dialogue to achieve its effect. Like other shows that most creatively employed radio's special characteristics—Fred Allen comes to mind—it didn't make the transition to television.

Thriller Dramas

Another type of nighttime series programming that gained in popularity through the 1930s and 1940s was the thriller drama. These could range from the crime and police series like *Big Town*, *Gangbusters*, *Mr. District Attorney*, and *Crime Doctor* through fantasy/action adventure such as *The Shadow* and *Inner Sanctum* to more traditional mystery/adventure series like *Sherlock Holmes* and *I Love a Mystery*. Even a series based on western adventure, like the long-running *Death Valley Days* or *The Lone Ranger*, forerunner to TV's ubiquitous westerns, might be included in this category. Most were 30-minute shows that ran in the evenings, though a few occupied the kid-friendly late afternoon hours and some ran several times a week. Many were adapted from comics, crime novels, or movie serials. Though popular—or perhaps because of that popularity—they also attracted a certain amount of social criticism due to their emphasis on violence and horror. Was the emotion evoked by radio's sound-based thrills more powerful or dangerous than film's (or television's) graphic depictions? Many parents thought so, and some of the first studies of radio centered on the effects of such shows on children, particularly potential disruption of their sleep habits.

Quiz Shows

Another genre unique to the radio medium, the quiz show has antecedents in the newspaper's puzzle pages or magazine's "test your knowledge" features. On radio, quiz shows combined information-based formats with personalities and in later years might also rely on audience participation. Two of the most popular were *Kay Kyser's Kollege of Musical Knowledge* and *Information, Please*. The former, led by bandleader Kay Kyser, asked contestants questions based on popular music, leading to monetary awards. *Information, Please* was a panel-type show—hosted by Clifton Fadiman, book critic for the *New Yorker* magazine—that drew together a group of illustrious guests to answer questions sent in by the public. Assembling celebrities from the worlds of politics, literature, the arts, show business, and sports, the program awarded prizes to listeners whose questions could stump the experts and encouraged witty banter among the panelists. Though the quiz genre could prove controversial—especially with later giveaway programs that dispensed large sums of money to listeners who called in the correct answer—no one could criticize the highbrow playfulness of *Information, Please* nor the self-reflexive irony of the quiz show parody, *It Pays To Be Ignorant*.

Sports

Though in retrospect the marriage of sports and broadcasting might seem inevitable, in the beginning sports posed some problems for the new medium. In the first place, a new type of announcer was needed—one who could make the game come alive in sound only, describing the action in a way that was at once both clear and engaging. A few star announcers emerged in the twenties and early thirties, including Graham McNamee, Ted Husing, Red Barber, and Bill Stern. Baseball, college football, and boxing were the most popular broadcast sports, with the World Series attracting by far the most radio attention and inspiring the earliest networking experiments. Local stations made a practice of broadcasting local events.

Yet there were problems as coverage went national. In the days before lighted stadiums, most games were played during the day, during the "women's" hours when men were presumed to be at work. Should a network alienate its female listeners and sponsors by disrupting cherished serials and count on a male audience, which it usually claimed did not exist in the daytime? Were sporting events of sufficient national import and news value to be counted as a public service, or could they be sponsored without detracting from the viability of local teams and stadiums? Finally, could they become the property of only one sponsor or station through a contractual arrangement, or were events such as the World Series of sufficient cultural stature that the networks would have to share?

These and other questions were eventually resolved, and league sports along with major prizefights, wrestling matches, horse races, tennis matches, and college football became major contenders for radio time and dollars. The Mutual network finally gained financial viability when it acquired exclusive broadcast rights to the World Series in 1939, under the sponsorship of Gillette, in a manner similar to the upstart Fox network's coup over CBS for National Football League (NFL) rights in 1996. Yet not all sponsors were happy with sports broadcasts, especially when their highly rated programs were preempted for special sporting events by networks mindful of the public service value of emphasizing this popular program genre. The networks, however, continued to play up the idea that providing sports coverage was an important part of their public service obligation, as much to avert one network being allowed to purchase the right to broadcast exclusively (if it was *news*, then how could it be exclusive?) as to boost profits. That this male-attracting form of entertainment could be held up as vital public service, while the programs preferred by women were denigrated as trivial and worthless, shows how gender entered into decisions about early radio programming (Battema 2000).

Religious Programming

Sports promoters and out-of-work vaudeville stars were not the only folks to see opportunity in the air. Radio seemed a God-given device to spread gospel preaching and religious instruction over the nation, to reach those who for various reasons could not attend services, and to extend the proselytizing of evangelistic denominations. As historian Tona Hangen informs us, stations aired religious programs from the earliest days, and many religious organizations and individual figures applied for licenses

(Hangen 1999). One of the more colorful early broadcasters was Aimee Semple McPherson and her International Church of the Foursquare Gospel, radiating from her Angelus Temple in Los Angeles.

During the post-Radio Act period, when religious stations were classified as propaganda outlets, many of these stations lost their licenses and went to the system of buying time just like any commercial sponsor. The networks at first sold time to anyone who could afford it, but as Father Coughlin put tolerance to the test (see Connection in Chapter 6), that policy began to change. CBS and NBC both adopted policies of granting free time to representatives of the three major religious groups (Protestant, Catholic, and Jewish) and denying all others equally. Long-running network mainstream religious programs include *The Catholic Hour* on NBC; *The CBS Church of the Air*, which alternated denominations; *Hymns of All Churches*, heard on CBS in the daytime; *Message of Israel* on NBC; *The Mormon Tabernacle Choir,* mostly on CBS; *National Vespers*, a Protestant interdenominational program on NBC; and *Religion in the News* on NBC. Some fundamentalists and other sects turned to putting together their own ad hoc networks by buying time from local stations.

The Mutual network continued to be friendly to religious broadcasts, and many popular programs such as *The Lutheran Hour, The Old-Fashioned Revival Hour*, and *The Voice of Prophecy* found a home with Mutual, as did several other programs that had lost their place after the network policy change. Though radio preaching attracted much suspicion for the amount of on-air fund-raising it had to do—and for a few highly publicized charlatans of the air who were seen as bilking a gullible population of the elderly and unsophisticated—this kind of fund-raising was necessary for genuinely religious men and women, who had to pay substantial sums for their radio outreach time. Hangen argues that despite the struggle nonmainstream groups faced in using radio to its maximum, the new medium profoundly changed the face of fundamentalist religion and entered America's spiritual life in a manner that continues today.

DAYTIME RADIO

Soaps: Serial Drama for Women

Before 1935, network evening schedules still featured a small number of highly popular serial programs that were designed to appeal particularly to women: *Just Plain Bill, Myrt and Marge*, and *The O'Neills* ran five times a week on CBS in the early evening hours, with Gertrude Berg's ever-popular *The Goldbergs* on NBC in a similar slot. By 1936, despite ratings higher than those for many nighttime variety programs, the serials were gone, banished to new positions on the daytime schedule. Here they survived but earned ratings of less than half their former numbers (though still relatively high by daytime standards, when fewer people overall were listening). This practice continues even today. Why would networks undercut the popularity of successful programs by rescheduling them at a time when smaller audiences are available? Why would sponsors go along with this?

The answer has less to do with economics or with viewing patterns than it does with social and regulatory pressures. In the aftermath of the Communications Act of 1934, the networks set out to demonstrate their high public service goals rather than simply the most commercially profitable programming. Serial dramas for women failed this test on several levels. First, because women were perceived as radio's main "selling audience"—a frequently quoted statistic asserted that women purchased more than 85 percent of all household products—programs directed toward women missed few chances to push commercial goods. All of these programs were sponsored, usually by humble products like soap or toothpaste; many made heavy use of integrated advertising, permeating the drama of the program with less-than-subtle plugs for the sponsor's product. This kind of overt commercial selling began to look less appealing as broadcasters attempted to distance themselves from their commercial roots.

Second, culture produced by or for women has always been regarded with disdain in the Western tradition, even as women have provided the main audience for most forms of modern culture. From Herman Melville's condescending remarks about the "damned mob of scribbling women" whose novels captured greater sales than his, to the exclusion of women from classical orchestras, to the diminished critical reputation awarded female-oriented genres (the romance novel, the women's film, the melodrama) and women's interests in general (the newspaper's "women's pages" with recipes and society notes), work produced by women or for women has always come under considerable cultural suspicion. And, as many social historians have noted, women also became associated with the "mass" in "mass culture." Because many characteristics deemed at the time to be feminine—irrationality, emotionalism, susceptibility to persuasion, passivity—were also associated with mass culture, the concept of "the mass" became feminized. Radio's new soap opera genre awoke all of these reactions and became a new touchstone of discredited, feminized, commercialized mass culture.

Usually written and produced by women, centered around female characters and female concerns, appealing unambiguously to women as a primary audience (though many men became captivated as well), radio's soaps attracted more than their fair share of social criticism. So the networks had a dilemma: How could they capitalize on the demonstrated interest of their main selling audience in these discredited dramatic forms while still maintaining their position as purveyors of quality programs of the highest standards?

The answer lay in what seemed like a natural fact: More women were at home during the day to listen. However, as later ratings would show, the networks exaggerated the difference in the gender balance of daytime and nighttime audiences quite a bit. Later audience figures would show that although women outnumbered men at all times of the day and night, the absolute number of women in the audience was higher in the evening hours than in the daytime. The proportion of women to men was only slightly higher in the daytime: roughly 70/30, as opposed to a 60/40 ratio at night. This is not a big difference. But thinking of daytime as primarily women's time had two advantages. First, networks could boost the rates charged to sponsors for daytime hours, even though the audience was smaller, by emphasizing what we now call "targeted marketing" directly at their most valuable consumers. Second, confining such programs to the daytime meant that the critical audience of professional

men, in particular, would not be home to hear them! Under cover of daytime, out of the bright light of nighttime's public scrutiny, a separate women's sphere could be allowed to flourish. This also had the advantage of neatly reproducing Victorian notions of women's separate domain in the home, a comforting and nonthreatening tradition.

It worked. The daytime women's serial drama, now referred to as "soaps," grew to unimagined heights. From only 10 in 1934, soaps had expanded to over 54 in 1940, taking up most of the day between 9:45 and 6:00 on all three networks. Usually 15 minutes in length, recurring every weekday, and separated only by the ubiquitous commercials, soaps became a controversial cultural form: a place where women could hear their unique concerns addressed; a place of social interaction among listeners, fans, and producers; and a new form of drama that eventually took over the televisual medium. Although many contributed to this format and although its development was inevitable, a few notable figures stand out in the creation of this vital twentieth-century form. The most visible, both then and now, was "the mother of soap opera," Irna Phillips.

Connection All Irna's Children

It is possible that the soap opera might have come into being without Irna Phillips, but her imprint is so large on the field that surely dramatic serial production would have evolved differently had she not been there to come up with the basic recipe and stir the pot. Not only did she originate the first successful daytime serial specifically for women (*Painted Dreams* on Chicago station WGN in 1930), but she went on to create the single longest-running show in U.S. broadcasting (*The Guiding Light*, started in 1937 and *still* going on TV) as well as a host of other highly popular shows. *Today's Children*, *Women in White*, *Road of Life*, *Lonely Women*, *The Right to Happiness*, and *The Brighter Day* were all created and produced by Phillips in the 1930s and 1940s. Her influence extended into television and into our present era: Both Agnes Nixon, creator of television soaps *All My Children* and *One Life to Live*, among many others, and William Bell of *The Young and the Restless* trained as staff writers under Phillips.

Phillips was a schoolteacher when she, too, noticed the opportunities radio presented the entrepreneurial woman. The youngest daughter in a family of 10 children, she studied drama and psychology at the University of Wisconsin and then moved to Dayton, Ohio, for a teaching job. Back home visiting family in Chicago, she auditioned for a radio acting job and eventually turned up on WGN in a daytime chat show called *Thought for a Day*, which she both wrote and performed. Station manager Henry Selinger took note of her abilities and set her the task of creating a serial drama program for the daytime female audience. Phillips came up with *Painted Dreams*, the story of Mother Moynihan, her daughter Irene, and her lodger Sue Morton.

The drama centered on the struggles of the "new woman" to find a place in the world: Was it to be the traditional domestic role of wife and mother or the new role of career

woman? This was a drama central to Phillips's own life. She claimed that Mother Moynihan was closely patterned after her own mother (who lived with Phillips until she died in 1938), and surely the aspiring modern girl, Irene Moynihan, had something in common with Irna herself. When WGN claimed that it owned *Painted Dreams* in 1932, Irna disassociated herself with that title and created a new serial, *Today's Children*, very similar to the first (now centered on Mother Moran, her daughters Eileen and Francis, and boarder Kay Norton) and took the show to rival station WMAQ. It ran until 1937 and spawned a host of imitators. Phillips herself played Mother Moran.

This time, Phillips was careful to retain full ownership of the program, even subsidizing its production out of her own funds until a sponsor, General Foods, picked it up, followed by Pillsbury in 1933. She became a fiercely independent radio entrepreneur, producing all her own shows through a partnership with Carl Wester & Company and allowing agencies, sponsors, and networks little control over her expanding soap opera empire. Phillips wrote most of the early shows herself; later she expanded to a system by which she plotted out the large narrative arcs and her team of hired writers filled in the dialogue. By 1940 she had four top-rated serials on the air at once, a record rivaled only by the team of Frank and Anne Hummert.

Phillips's success stemmed in large part from her frank and outspoken creative philosophy. She believed strongly in the appeal and usefulness of dramatic serials in the lives of women. Asked about her dramatic formula, she responded that daytime serials must focus on three basic themes: self-preservation, family, and sex. She addressed her programs adamantly to women and centered them in women's lives—her first two programs had no central male characters—and believed that her audiences were intelligent and interested in learning. She took pride in working with social agencies and medical professionals as she developed her story lines, which frequently dealt with real-life problems and issues. She often protested the censorship her programs received, claiming that nighttime shows could get away with far more daring material in the controversial areas of sex, race, and politics than could the soaps. And though Phillips believed that in the world of soaps, home and family must always be paramount among women's concerns, many of her shows centered on professional women and the struggle between the demands of marriage and career.

As radio's output standardized in the 1930s, it was the daytime soaps that came in for some of the heaviest criticism. Unlike the nighttime shows, daytime serials were dominated by a feminine culture that often ventured into forbidden territory. Soaps were about relationships, as they are today, and relationships could be dicey subjects, especially on conservative 1940s radio. The open-ended story lines of serials allowed for endless development of "problem" material, and even when the plot elements resolved on a strongly moral note— the baby turns out not to be illegitimate, the divorce is reversed, the affair is revealed as an illusion—plenty of time had been given to the deliciously immoral possibilities they offered. Critics everywhere objected, from the networks' Continuity Acceptance departments, to the more highbrow journals, to those concerned with child welfare and social policy. In a review of a proposed Phillips soap in 1934, an NBC reviewer laments:

> This program . . . is another of the amateurish type of programs that have attained such popularity with a certain class of listeners. . . . It panders to the crude emotions of the shopgirl type of listener, and it trades upon the maudlin sympathies of the neurotic who sits entranced before the radio, clutching a copy of "True Confessions" and (possibly) guzzling gin and ginger ale. Despite the many things that

are wrong in a show of this type, it will undoubtedly be successful. . . . It will sell
cheap products to vulgar people. . . . But to people who have an I.Q. of something
higher than 15 years, it will be another of the dreadful things that the radio brings.
(Hilmes 1997, 157)

It is easy to see the condescension in these remarks, along both gender and class lines.
The reviewer assumed that programs catering to a feminine working-class or "shopgirl"
audience had less of a right to exist than did other, more legitimate programs—and further,
that all women who liked such programs could be equated with gin-guzzling shopgirls.

Such criticisms could come even from the heart of the industry itself, as when in 1943
Variety—then and today the bible of the entertainment industry—ran a four-part series
called "Analyzing the Daytime Serials." The author took on Phillips directly:

Thus, over the last few years, Miss Phillips' stories have contained a variety of
brutal physical situations, divorces, illegitimate births, suggestions of incest and
even murders. Whether that sort of material is emotionally or mentally upsetting to
neurotic listeners is a matter for psychiatrists to decide. Admittedly, however, it is
hardly uplifting, or inspiring, or, in the normal sense, even entertaining. Yet there is
nothing objectionable in such material if it is used with taste and dramatic skill, as
Shakespeare and Eugene O'Neill prove. But in undiscriminating or clumsy hands,
it inevitably arouses resentment. (Hilmes 1997, 157–158)

Phillips took issue with this characterization of her work, and with its assumptions that
her audiences were stupid and neurotic. In a later response, she asked, "Does the I.Q. of a
housewife change after six o'clock . . .? Or does the advertiser, who knows that approxi-
mately 98 percent of all products used in the home is purchased by the home maker, ignore
the daytime serial listener after six o'clock?" Here she asserted the idea that the audience
at night and during the day consisted largely of the same people, in which case their
frequent characterization as "neurotic" or somehow abnormal could not possibly be true.

But the criticisms most taken to heart by Phillips were the charges that the events her
serials portrayed were not realistic but were in fact, as the *Variety* article claimed elsewhere,
"hopelessly melodramatic" or "morbid." What seemed to excite the most criticism were
plots that focused on a lack of male control over female sexuality and reproduction—hence
the objections to story lines suggesting divorce, affairs, illegitimate births, and even adop-
tion of children by single women. Phillips defended her material by citing statistics and by
referring to her own life: She, a single woman, had adopted and raised two children. She
also emphasized that her plots never endorsed immorality and always resolved along
acceptable lines in the end. However, as the *Variety* quote suggests, it may have been a
question of whose hands the writing was in rather than what it actually portrayed.

Phillips's soaps were progressive in many ways for her day, but still reflected an
almost exclusive address to the white middle-class audience. Though she took on the
issue of ethnic difference and assimilation (both *Today's Children* and *Guiding Light*
were set in industrial towns with many different ethnic groups living side by side; the
early *Guiding Light* centered on an Orthodox Jewish family), only rarely did a

nonwhite figure appear in a Phillips drama and then only as an ancillary character. Conforming to the tastes of a "consumerist caste" envisioned by the agencies and networks as almost entirely white, soap operas left nonwhite Americans on the margins of dramatic inclusion. In the early 1950s, as racial codes loosened somewhat on radio, a few entrepreneurial producers would create all-black serials such as *The Story of Ruby Valentine* and *The Life of Anna Lewis*, both aired on the National Negro Network (NNN). During these years, Spanish-speaking Americans lucky enough to live close to the Mexican border, or in Puerto Rico or Cuba, could enjoy the immensely popular *telenovelas* produced by Mexican and Cuban radio. But few found their way onto U.S. airwaves.

Criticisms of daytime fare continue even today, though their focus shifted to daytime talk shows in the nineties. This result may be due to the fact that elements of the daytime serial drama have become standard features of prime-time television. Continuing story lines, emphasis on the personal lives of the characters, concentration on relationships and sexuality, even in the formerly pristine environment of police dramas and the like, have migrated from day to night. Most shows are soaps now, in some way or another, and although daytime continues its serial dramas, they are in decline. However, daytime's other children, the woman's chat shows, have built new empires in daytime TV and radio.

Daytime Talk

From the earliest days, "talks" specifically oriented to women in the homemade up an important part of daytime schedules. These "home service" programs—usually featuring appealing hostesses who cheerfully dispensed household, child-rearing, and health information interspersed with light musical entertainment—became some of the most popular shows on the air during radio's earliest years. The precedent for all of these may well have been the U.S. Department of Agriculture's *Housekeeper's Chats*, whose main hostess was called Aunt Sammy (Uncle Sam's wife). In the days before networks, scripts were sent to stations all over the country, and each local station cast its own Aunt Sammy to host a 15-minute program featuring household advice, recipes, skits with incidental characters, and segments during which Aunt Sammy read listeners' letters and responded to them over the air. This emphasis on listener interactivity combined with a casual, chatty tone (often with the creation of a fictional central character) to mark out the intimate, public/private world of the daytime talk program.

Two other innovations are worth considering, in light of what daytime talk would become. First, daytime hours, particularly on local stations, have long provided an opportunity for the individual woman entrepreneur/producer to franchise her own format (much as Oprah Winfrey began producing her own show and selling it to stations). Home economics professional Ida Bailey Allen put together her own program, cultivated audience loyalty by starting her Radio Homemakers Club, and sold her own advertising time to sponsors whose products she endorsed on the show. This format combined household advice with features on the arts, live music, dramatic skits, and special segments for children. Allen also pioneered the concept of the interactive studio audience, with a "bodyguard" holding a (barely) portable microphone as Allen

ventured into the audience to air their questions and comments directly. Many other professional women took a similar route into radio.

Second, these programs offered an early model of the magazine concept program, which television executives would later latch onto with much fanfare in the 1950s (notably Sylvester "Pat" Weaver on NBC). Their evolution has many roots, but an early NBC prototype was the *Woman's Radio Review*, which combined separate segments and multiple sponsorship, as did Ida Bailey Allen's show. This format would mutate into the popular breakfast program of the late 1930s and 1940s, complete with a male-female team, light banter, celebrity guests, news and weather, and product plugs. *Today* and *Good Morning America* were not far behind. But one daytime chat figure rose to exceptional prominence and left an indelible mark on daytime talk's sometimes suspect territory.

Mary Margaret McBride started out as a print journalist, moving into feature article writing in the 1920s with high-profile interviews of titans of culture and industry in the country's leading magazines. By the time the Depression hit, she was one of the highest-paid writers in the United States; but her income took a considerable tumble as the print industry retrenched. Having explored the world of radio in a series of articles, McBride determined that greater fortune might lie in a change of venue. She auditioned for the role of "Martha Deane," a fictional persona invented by station WOR to deliver the household advice format, and won the part. But the character of Martha Deane—a grandmotherly type with a large, advice-needy family—could not contain the ebullient McBride for long. In 1934, early in the show's run, she suddenly paused on-air, drew a breath, and proclaimed:

> I find it necessary to kill all my family. I'm not a grandmother. I don't have any children. I'm not even married. I'm not interested in telling you how to take spots out of Johnny's suit or how to mix all the leftovers in the ice box. I'm a reporter and I've just been to the flea circus. If you would like to hear about it, I'll tell you. (Hilmes 1997, 279)

McBride embarked on a career of such unscripted, spontaneous chat. In these early network days, when all the networks had to exert control over was the written script or "continuity," almost everything on radio was required to follow the printed plan. Not McBride. Her emphasis on ad-libbed talk, including her unscripted interviews with guests, marked out a new kind of informality and unpredictability on the air. Soon she originated her own three-times-weekly program under her own name, while still maintaining the *Martha Deane* show on WOR. She was another independent broker—booking her own sponsors, inviting her own guests, and choosing her own topics. By 1940 McBride was presiding over two daily 45-minute shows—one on NBC and one on CBS—buying the time, lining up the sponsors, and collecting the fees. Her income began to exceed $100,000 per year, a princely sum in those days. It was estimated that by the late 1940s, her show reached 20 percent of the available audience, more than 8 million listeners per day. For her show's fifteenth-anniversary celebration she filled Yankee Stadium, and extra subway trains ran all day to handle the crowds.

Although she received more than 5,000 letters weekly, became the recipient of numerous industry awards, and attracted guests like General Omar Bradley, Eleanor Roosevelt, and New York Mayor Fiorello La Guardia, McBride came in for the same sort of criticism directed at the soaps. She was called trivial, naive, cozy, fluttering, and twittering. Her listeners were compared to addicts and assumed to be unintelligent,

Mary Margaret McBride was a fiercely independent producer and innovator of the unscripted talk show genre. Here she interviews Margaret Mead, a prominent anthropologist.

susceptible, and easily led. Much was made of McBride's plump, middle-aged appearance and fondness for colorful hats. Most of all, it was the unashamed consumer orientation of her show that offended. McBride prided herself on testing all the products offered by her sponsors and personally endorsing them with unscripted praise. Rather than airing carefully produced ads, McBride assumed that her audience had a legitimate interest in the purchase of consumer products, because it was a part of their job as housewives, and treated endorsements of household products as worthwhile news—somewhat disingenuously because they were also her sponsors, though she always admitted this. Many mainstream critics felt that nothing serious could go on in this atmosphere of feminized commercialism, despite McBride's obvious effectiveness as both a marketer and a radio personality.

Yet could 8 million listeners really be wrong? If McBride's success is judged by her numerous imitators, the answer would be no. Her program continued to be highly popular through the 1940s, yet the transition to television proved impossible. She tried a prototype show in 1948 on NBC, scheduled unfortunately against Bob Hope on CBS. One critic's reaction showed the problems she faced:

> Perhaps the ladies in the daytime can survive Miss McBride's effusive and interminable commercials, but for the men at home in the evening they are hard to take after a day at the office. To watch Miss McBride shift—without pause or loss of breath—from a eulogy

of Kemtone paint to an analysis of Russia is an ordeal not quickly forgotten. If nighttime television is to be daytime radio, away video, away! (Hilmes 1997, 284)

If this critic had viewed some of the nighttime news programs, he would have seen a similar blending of the commercial and the serious. Yet more was at stake here than pauses and shifts of subject matter.

CRITIQUES OF MASS CULTURE

McBride and Phillips and the shows and audiences they created occupied an embattled space in the late 1930s and early 1940s as social discord rose, war in Europe loomed large on the horizon, and the Depression refused to lift. Just as television is blamed for a number of social ills today, radio began to look like a central component of what was wrong with America as the thirties waned. A more organized and institutionalized investigation of radio and its effects would not take place until the wartime threat had materialized, but during the 1930s public intellectuals on both the right and the left found much to dislike in U.S. radio (Lenthall 2001).

For conservative commentators writing in such journals as *Commonweal*, *Harper's*, and *The Atlantic Monthly*, radio represented the eclipse of established cultural norms and values by a new kind of vulgar, democratic populism. By turning such an important national medium over to the shopkeepers and money-grubbers, they argued, radio had paved the way for debasement and trivialization of American culture, a dumbing down that undermined personal creative expression in favor of mass mentality. Pandering unashamedly to the lower classes and women; ignoring the values of traditional authority; catering to emotion, sensation, and mindless entertainment over serious discussion, education, and cultural uplift, American radio, they believed, had squandered its immense potential for social good. Behind broadcasters' sunny chat and jokes lurked a kind of mass-speak that encouraged homogenized mass thinking. We have seen these opinions expressed from various sources earlier in this chapter; many of its spokesmen had been involved in the fight for educational radio in the early 1930s. By the end of the decade, many felt that their worst fears had been confirmed.

The same kind of criticism came from the left, but with a slightly different spin. Critics writing in journals like *The New Republic* and *The Nation* did not embrace the democratic nature of U.S. radio, but instead excoriated it. For them, it was not so much that elite values and traditional authority were under attack but that commercial radio represented the triumph of capitalism and consumer culture in its most naked form. In turning over radio to the large, industrial corporations that now owned it, these critics claimed that radio had become an outlet for blatant self-interest and preservation of the status quo. It was a purveyor of *false consciousness*, the Marxist term for the spurious ideologies propagated by those in power to keep the working classes in their place. Behind these tendencies were the nefarious arms of the growing advertising sector, for which market considerations were the only ones of value. The American people, leftist critics believed, were being sold a bill of ideological goods— pro-capitalism, antilabor—just as they were being sold the products advertised so endlessly on the radio. The transformation of active citizen into passive consumer

was the ultimate means of pacifying any kind of movement for social or political change.

Both conservative and left-wing critics thus distrusted this new mass culture of radio. And radio's defenders were few. Besides the industry itself, whose claims could be dismissed as entirely self-interested; and besides the public, which seemed bent on passive, uncritical enjoyment of radio entertainment, no one, it seemed, was eager to leap to radio's defense. As the war approached, these criticisms intensified. Radio would clearly play an important role in war; how that role would take shape seemed increasingly up in the air. Would broadcasting be taken over by the government (as in World War I when stations were shut down, and as Hitler had done in Germany) and become an instrument of propaganda? Would it continue down its blithe commercial path, peddling goods while Europe burned? Or did it have a greater role to play? Though the war years were brief, they represent a watershed in radio's development, use, and social position. They also raised a last fragile bulwark before the onslaught of television.

Conclusion

From a collection of individual stations offering an eccentric mix of local entertainments, radio by the 1940s grew into an enormously profitable industry and a central focus of American life. Advertising agencies, networks, and stations, with a heavy dose of Hollywood, created unique new forms of entertainment, information, and expression. Though primarily intended to sell consumer goods, the avenues of creative innovation opened up by this amazingly successful medium allowed a variety of programs, genres, stars, and audiences to emerge that spoke to the hopes, fears, and desires of the American public. Jack Benny became America's fall guy on the most popular type of radio show, the comedy-variety format, providing sophisticated and humorous satire of social pretensions and hierarchies to a new middlebrow audience. As the networks divided their schedules into distinct daytime and nighttime realms, daytime became the territory of women. Innovators like Irna Phillips invented a new form, the daytime serial or soap opera, that addressed the interests of women in highly melodramatic, continuing narratives, and Mary Margaret McBride set out on the path that would lead to *The Today Show* and *Rosie O'Donnell.* Yet despite radio's popular success, the medium came under increasingly heavy criticism as the war years drew near. Both conservative and left-wing critics objected to radio's cultivation of lowbrow tastes and its heavy permeation by advertising. Radio's very success became a mark of its limitations, and as war rumbled in the distance, it seemed change might be on the horizon.

War at Home and Abroad, 1940 to 1945

Though the United States did not officially declare war on the Axis powers until after the bombing of Pearl Harbor in December 1941, the conflict raging in Europe had a considerable effect on U.S. politics, social debate, and culture generally from the late 1930s on. Radio featured centrally in these debates—both in terms of the fears that the new technology spawned regarding its use as a means of propaganda and in terms of its potential to rally, inform, and unite the American public during difficult times. As war rumbled distantly and then broke fiercely and intensely, radio would cement its cooperative role with the federal government as it gained respectability by bringing Americans news and information. It would also serve as a staging ground for the battles over democracy at home. As the United States attempted to answer the vital questions of "who we are and why we fight," radio spoke with more authority and immediacy than any other medium. The war would provoke enormous social changes in America and around the world, and the second half of the twentieth century—the television era—would have to come to grips with them.

Social Context: The Winds of War Blow Change

Embattled Isolationism

As early as 1933, trouble brewed abroad. Amid economic depression and upheavals, Adolf Hitler's Nazi Party came to power in Germany. In 1935 Italy's longtime fascist dictator Benito Mussolini marched into Ethiopia. Most Americans, meantime, had adopted a philosophy of suspicious isolationism. U.S. involvement in World War I seemed in retrospect a nightmarish mistake that had won the United States very little and yet cost so much in human suffering. The only ones who seemed to have prospered from the war to end all wars were the munitions manufacturers and Wall Street bankers, as the Senate's Nye Committee reported in 1936 after a two-year investigation.

In this political climate President Roosevelt formulated his 1934 Good Neighbor Policy, which limited U.S. involvement in the political affairs of South and Central America; and Congress passed the Neutrality Acts of 1935 and 1936, which specifically forbade sale of war materials to those involved in fighting. Much suspicion attached, as

well, to the Soviet Union's uncertain role in European politics. A Soviet alliance with Germany would be disastrous news for democracy in Europe, but would a link with Allied powers aid the advance of socialism and "godless communism?" Better to stay out of the whole thing.

Japan invaded China in 1937. In early 1938 Hitler took over Austria and later that year brought Czechoslovakia under Nazi rule. On the night of November 9, 1938, in a major escalation of the Nazi persecution of Jews, German militia, police, and citizens destroyed over 7,000 Jewish businesses and 170 synagogues throughout Germany and Austria. As rumors of Kristallnacht ("night of broken glass") spread, Hitler began to seem less like a head of state bent on expanding his national territory and more like a brutal racist dictator on a course of terror and extortion. Then, in 1939, Germany signed its fateful nonaggression pact with the Soviet Union and in August invaded Poland. On September 3, 1939, Great Britain and France declared war on Germany. World War II had begun.

But still the sentiment toward isolationism in the United States remained high. Gradually the Roosevelt administration weakened the Neutrality Acts to allow aid to the Allied powers and began to develop a more interventionist strategy, but the problem of unifying a divided nation behind a call to arms remained. The Depression had caused serious social turmoil and weakened people's faith in central corporate and government institutions. Despite the efforts of the New Deal to restore morale and boost employment and social welfare, a slump in 1937 had driven employment rates back down to their 1934 level, and the stock market lost half of the gains it had made since 1933. Amid bad news from Europe and Depression at home, Americans turned against themselves. Labor unions mounted drives for workers' rights as employers fought them off, leading to riots and unrest. Rising support for the Socialist Party and for Russia provoked violent anti-Red backlash. Demagogues from the right espoused anti-Semitic views even as other groups, viewing the persecution of Jews under Hitler, began to unite under the banner of tolerance and equality.

How could such a divided nation agree on anything, much less getting involved in a war that seemed far away, separated from American interests by two oceans? Even as the Germans swept into the Netherlands and France in 1940, even as Italy joined in on the Axis side by declaring war on Britain and France in June, even as the Germans began to drop bombs on England during the summer of 1940, Americans remained united only in their desire to keep out of the war. Then, on December 7, 1941, the Japanese, who had entered into alliance with the Axis powers, dropped wave after wave of bombs on the American naval base at Pearl Harbor, Hawaii, wreaking mass destruction. On December 8, 1941, Congress declared war against Japan and, a few days later, against Germany and Italy. We were in.

Who We Are, Why We Fight

Though a direct attack on U.S. territory quickly reversed much of America's isolationist sentiment, much needed to be done to rally the entire population behind the war effort. The armed forces mounted massive recruitment drives as well as instituting a draft for men of military age. As manufacturing production turned to military equipment, a nation that had been taught to consume now needed to be instructed in how to conserve resources. War bonds needed to be sold, women needed to be recruited to work in the jobs that men abandoned to enter the military, a whole nation needed to be mobilized

and inspired. Not least in this mobilization effort was the difficult task of explaining "who we are and why we fight." Each of these clauses was problematic.

Who were we as a nation? A divided group of separate ethnic and religious groups, all fighting over allocation of resources and rights? Or a unified nation possessing certain central values of democracy, human rights, and individual freedom? Why were we fighting? Was it only a struggle over where certain borders would be drawn in faraway Europe and Asia? Or was it a battle to preserve freedom, national self-determination, and democracy across the world?

America's ethnic and racial minority groups had particularly divided sentiments. As in World War I, many Americans were being asked to fight for abstract human rights overseas that they were consistently and concretely denied at home. To make matters worse, the U.S. armed forces retained a degree of racist separatism even greater than that of most cities and regions in the United States. Black and white troops were strictly segregated; blacks were banned from most officer positions and combat roles; military bases abided by Jim Crow laws that refused to permit African American troops to eat in the same mess halls, enjoy the same enlisted men's clubs, and worship in the same chapels. Though many of these restrictions were eased as the war progressed, full integration of the military did not occur until President Truman's hotly resisted reform took place in 1949, well after the war had ended. The military itself perpetrated civil rights violations throughout the war that it purported to condemn abroad.

In fact, the rhetoric of freedom and democracy, combined with such egregious offenses against the rights of U.S. citizens, provoked a greater degree of racial unrest at home than the country had yet seen. Asian Americans were uprooted from their homes and businesses and incarcerated in internment camps. Riots erupted across the nation, especially in cities that had attracted large numbers of African American and Latino/a workers in the defense industries. In the South, black soldiers in uniform were lynched by white mobs. The black press played a crucial role in mediating these tensions—acknowledging the manifest inequalities and hypocrisies in U.S. war-inspired rhetoric while still encouraging black Americans to play their part. Many powerful papers, such as the *Chicago Defender* and the *Pittsburgh Courier*, pushed for struggle on what they called the "double V" front: victory at home against racism as well as victory abroad against the Nazis. For their efforts they were regarded with much suspicion and distrust by the government. Both the Army itself and the FBI mounted investigations of the black press (much as FBI director J. Edgar Hoover would later spy on the civil rights movement). Yet the nascent movement for civil rights looked increasingly toward the government to redress these inequalities, spurred by the promises of democracy and justice inherent in wartime rhetoric.

Another group whose wartime experience would greatly affect subsequent politics was American women. As the war progressed and more and more of the male population signed on to serve in the military, women were aggressively recruited to fill formerly men-only jobs in defense industries, in domestic production and services, and in women's auxiliary armed forces. Women learned that they could do these jobs well—in some cases, better than their male counterparts—and that the world would not end if they were not at home every minute to care for children and tend to domestic duties. They also had the heady new experience of getting paid on very nearly an equal basis for

the work they did—leading most U.S. women to report, in a survey done at the end of the war, that they did not want to give up their jobs to returning troops but would rather find some way of staying employed. And in fact, they did. Even though the government based its "full employment" policies after the war only on male employment, women continued to make up an increasing percentage of the U.S. paid workforce—though not in the same high-paying jobs that they'd held during the war. Even the social push toward suburbanization and domestication after the war would have only a temporary effect on women's employment.

The Military-Industrial Complex

If some of President Roosevelt's New Deal policies, combined with the confidence-destroying effects of the Depression, had weakened or at least strained the comfortable relationship between U.S. corporations and the federal government, wartime exigencies quickly healed the rifts. A new era of not always harmonious but vital alliances began even before war was declared, as once again corporations realized that their interests were protected by national defense (and that finally the war would break the back of Depression) and the government became fully cognizant that America's victory would largely stem from its system of production.

Corporate America geared up for war, and the government saw to it that industry got what it needed. This would continue after the war as well, as we shall see, and would usher in a new era of what many have called "corporate liberalism." Eventually wartime hero, four-star general, and President Dwight D. Eisenhower, in his last speech upon ceding office to John F. Kennedy in January 1961, would warn against what he saw as the encroaching powers of the "military-industrial complex" pitting its needs against those of the American people. However, this danger was far from the public's mind in the 1940s.

The radio industry would become a key player in the war mobilization effort and in the cooperative relationship with federal initiatives. Both at home and abroad, U.S. radio would play a crucial role in inspiring a nation to unify behind the war, by bringing new voices to the definition of national identity, disseminating wartime messages and news to the American public, reassuring and entertaining troops overseas, and spreading the values of American democracy over the world. This close cooperation would pay off as television, its development temporarily halted by wartime emergency, sprang into full force after the war. From a sometimes suspect purveyor of mass entertainment and consumerism to a trusted guardian of the national and public interest, the broadcasting industry would make a crucial transition during the war years. Even if the wartime honeymoon did not last long, it would have lasting effects on the U.S. television system.

Central to this transition was the way that the broadcasting audience was understood. Did radio (and later television) create a passive and easily manipulated audience of the uneducated masses, ripe for dangerous propaganda and susceptible to all manner of pernicious influences? The phenomenon of Nazi Germany (and of a few inflammatory figures at home—like Father Coughlin, as we will see later in this chapter) would seem to confirm this view. Or was the radio audience a democratic public of rational individuals, using information judiciously to make reasoned decisions, choosing what to believe just as they chose what to listen to? This is the view that the broadcasting industry most liked to convey, and they began to fund social scientific research to support it. But perhaps this

view was merely a further strategy of a manipulative and corrupt capitalist system, by which large corporations used their wealth and power to persuade consumers to buy products to the exclusion of all other interests. Could we talk about an informed and rational American public when their avenues of information were so totally dominated by self-interested private business? Here the influence of a body of critical intellectuals— many of them members of the German Frankfurt School exiled in the United States— came into consensus with homegrown American mass culture critiques and into conflict with some of their former colleagues, now happily conducting industry-based research in the United States.

All of these viewpoints had been brewing through the 1930s, but they reached a stage of crisis in 1938 and 1939 as war seemed imminent. Before we can understand how federal regulators and the radio industry ultimately responded to the war, we need to explore what both government and industry were finding out about the nature of the public. Who were they? And would they fight? If so, for what, and how could they best be persuaded? Did they need to be protected from dangerous propaganda, even if this meant stepping on key democratic values like freedom of speech? Could a democracy employ propaganda techniques without contradicting its own basic principles? American radio would cobble together answers to these questions and put them into operation, right or wrong. What they decided on had much to do with how they understood that great unknown: the American radio public.

Social Discourse: Thinking about Radio

Industry Conceptions of the Audience

For the early radio amateurs, the concept of audience was not an abstraction but fairly concrete: I know who can hear me because they radio me back. The idea that there might be others listening in was fairly irrelevant, like the lurkers on an Internet discussion group. What counted was interaction and response. When one-way broadcasting became the dominant form of radio, especially in its commercialized U.S. version, a new concept was created: the broadcast audience. At first, stations and networks thought of their audiences as a simple aggregate number: How many people with radio sets can I reach with my broadcast signal?

There was no way of knowing how many people were actually tuned in at any given time, or what they thought about what they heard, unless they took the considerable trouble to pen a letter to the station. Stations promised potential sponsors the simple possibility of an audience, and sponsors were content to go with that. Very quickly, however, the concept of "applause cards" (postcards made available at the radio dealers for audiences to fill out and mail in) came into being, to encourage the only kind of response available in that age of expensive long-distance rates and few telephones. Thus, the preferred form of radio audiencehood was a fairly interactive one still: those who took the time to stand up and be counted and to express opinions regarding what they had heard.

Slowly, as the industry consolidated, a less voluntary and more standardized means of understanding the audience was needed. The first type of actual audience measurement system came from the advertisers, who after all were the ones being asked to pay a

certain amount for time on the air at certain times of the day and felt they needed to know more about what they were getting. The Association of National Advertisers hired researcher Archibald Crossley to devise a way to find out what people were actually listening to. This produced the Cooperative Analysis of Broadcasting (CAB) reports, starting in 1930. The CAB system used a *telephone recall* method, by which teams of researchers called up numbers chosen randomly from the telephone directory and asked people to list what they had been listening to the day before, as well as certain demographic information like age, sex, and household income. As Eileen Meehan argues, this produced a picture of a "high quality/low quantity" audience: Numbers of listeners were rather small, but well educated and affluent (Meehan 1990). Why? In these early years of the Depression, only 41 percent of homes subscribed to telephone service, and only a fraction of these paid extra to have their names listed in a directory. Thus, the CAB surveys reached only an affluent fraction of total radio households, producing a picture of an affluent audience with strong purchasing power: what Meehan calls "the consumerist caste," a very desirable one to advertisers. But asking them to remember everything they listened to the previous day produced a small number of specific recalled programs.

Thus, the CAB ratings painted a picture of the radio audience as a good bit smaller and wealthier than it probably was, which suited advertisers' purposes because it could result in reduced rates. The networks countered by supporting a rival method developed in 1932 by the C. E. Hooper company, often called the Hooperatings. While drawing on the same telephone directory database (though emphasizing urban listings, an even more desirable consumer group because they had access to the stores), Hooper employed a *telephone coincidental* method. Calling a randomly selected household, they simply asked what the radio was tuned to now. This produced a high-quality/high-quantity result, because far more people could say what was on at that moment, and the same affluent group provided the answers. The networks and stations preferred this result, so they could charge more for their advertising time.

Eventually, the Hooperatings wiped out the competition and maintained a ratings monopoly from 1936 to 1942. As telephone ownership and directory listings became more widespread, the representativeness of Hooper's sample grew; but none of the parties paying for the service—networks, stations, agencies, and sponsors—had much interest in the accuracy of the demographics they produced. A picture of the audience as a large group of affluent consumers avidly tuned to radio suited all their purposes. What were the less-affluent classes listening to? Who cared?

In fact, one of the earliest ways of thinking about the audience specifically focused on justifying the narrowness of ratings samples. NBC promised advertisers that it could provide a "class" versus a "mass" audience: an affluent, well-educated group of listeners who presumably would possess the purchasing power to make program sponsorship result in product sales. As we will soon see, this also may have been part of NBC's attempt to distinguish itself from CBS, its more populist rival, as well as to allay growing fears of the mass manipulation side of radio's utopian promises. However, in 1942 a new ratings entrant weighed in with an improved method that eventually swept the field.

The Nielsen Company was a market research firm that got into broadcast audience measurement in 1942, after spending several years testing a device for the automatic registration of radio listening developed in the 1930s at MIT. Nielsen's groundbreaking

Audimeter was a recording device that could be attached to radio receivers in people's homes. It would automatically register when the radio was turned on and identify the channel to which it was tuned. By the mid-1940s, Nielsen was dispensing to the major networks and stations data that promised greater accuracy than the potentially misleading answers audiences sometimes gave to the Hooper surveyors. Though ratings had always been a factor considered in making programming decisions, the Nielsen ratings provided a new scientific basis and helped networks and stations visualize how audiences listened throughout a whole evening—the beginnings of the notion of "audience flow." Combined with other measurement techniques soon to follow, networks began to get an idea of what audiences preferred—broken down by age, gender, and region—not just about a whole program, but even moment by moment within the show. Nielsen quickly adapted its ratings method to television after the war. By 1950 it had achieved monopoly in the field, although a few rivals would emerge later.

All of these techniques were based on individual responses to a specific, narrowly defined question: What do you listen to? Though they reinforced many cultural assumptions—preferring (to this day) middle-class audiences, breaking respondents down into "heads of household" (men) and "ladies of the house" (women) in ways that compounded gender stereotypes, and always undercounting children—they worked for a system that desperately needed some scientific means of talking about the audience. Numbers could be used to set prices, and if advertising sold goods and everyone made money, why worry if the statistics really painted an accurate social picture of the American public? However, the numbers produced by ratings have always been used to make more sweeping social analyses than their fragile claims to truth can bear. To social critics of the thirties and forties, they represented the ominous vulnerability of the masses to mindless, materialistic brainwashing. To the growing field of communications researchers, they represented just the tip of the iceberg of what social science research could and should do.

The Rise of U.S. Media Research

Radio was not the first mass medium to attract attention from social researchers. The earliest roots of U.S. media research can be seen in the studies of propaganda use during World War I, most notably by University of Chicago political scientist Harold Lasswell. Lasswell's work centered on the potential that new means of mechanized publication and distribution presented in times of war. Another influential thinker was Walter Lippmann, editor of *The New Republic*, a highly regarded magazine of liberal opinion. Though he did not conduct research himself, Lippmann's essays about the democratic potential and danger of new mass media influenced many other theorists and provoked widespread debate.

The movies also inspired studies on the media's social effects, most notably in the large-scale research project initiated by the Payne Fund in the 1930s. It produced several volumes of findings, mostly on movies and young people, looking for links between movie attendance habits and social attitudes, emotions, sexual behavior, and tendency toward juvenile delinquency.

In the Payne Fund's emphasis on the susceptible audience of young people, and in Lasswell's and Lippmann's conclusions regarding the mass media's potential for manipulation and propaganda, we can see a vision of the American public emerging that is

large, faceless, vulnerable, and easily swayed by the persuasive powers of mass communication. Though these researchers implied that it was the forms and characteristics of the new mass media themselves that presented a danger, we can discern under these claims a fear of the "mass" audiences that they created, newly empowered by inexpensive, popular media addressed not to the educated elite but to the man and woman on the street.

In the mid-1930s, the war brewing in Europe not only brought new social urgency to these issues but also caused an influx of European-trained social scientists and theorists, mostly from Germany, and many of them Jews fleeing Nazi genocide. From the University of Frankfurt's acclaimed Institute for Social Research came Theodor Adorno, Max Horkheimer, and Leo Lowenthal (often referred to as the Frankfurt School). Though much of their most influential work would not be completed until their return to Frankfurt after the war, Adorno in particular would contribute to American thinking on the media through his research at Princeton University. There he joined the Office of Radio Research, a group founded by Austrian refugee Paul F. Lazarsfeld (formerly of the University of Vienna). This influential organization was funded by the Rockefeller Foundation, a source of nongovernmental grant money that, under the direction of John Marshall, began to define its mission as centrally involved with the problems of mass media and democracy. It had helped to establish the Princeton Radio Research Project in 1936, headed by Hadley Cantril and Frank Stanton (who would go to CBS as director of research and later become network president). As war approached, the Rockefeller Foundation provided funding for 10 crucial sites of research into media, public opinion, and propaganda. They would serve as the basic foundation for future media research in the United States. Out of these research centers came basic concepts about the emerging radio public and the media that would be put into effect in the war efforts just a few years later. But to understand why these questions of audience capacity and responsibility seemed so urgent, one man embodies all the perils and possibilities that radio as a medium seemed to offer in these tension-ridden prewar years: Father Charles Coughlin, the radio priest.

Connection Father Coughlin and the Masses

It is possible that no single individual had more of an impact on thinking about the radio audience than Father Coughlin, the radio priest from the Shrine of the Little Flower in Royal Oak, Michigan (outside Detroit). His actual religious and political legacy amounts to very little. But during the years that his radio program blasted over American airwaves, no figure was more controversial, or more public, or more popular. Father Coughlin put to the test not only the parameters of American democracy but also the openness of the U.S. system of radio and the perils it held as a democratic medium. He at once demonstrated the effectiveness of radio as a medium for reaching the masses of the public directly, without intervention by cultural or social authority, and inspired that system to shut down such influence. He played into the hands of

those social critics and scholars who most feared the power of the mass public in a democratic, capitalistic system: their worst fears, confirmed. Yet his eventual silencing showed how easily the media industry could use its corporate powers to muzzle popular opinion—something that didn't make social critics very happy, either.

Father Coughlin's career began as part of the early romance between religion and radio. Leaders of America's religious organizations, from the largest to the tiniest sect, were quick to see the potential that radio offered for a whole new kind of ministry. Many churches were early station license holders, but the reorganization of General Order 40—and their classification as "propaganda" stations—meant that by 1930 most were off the air. However, the broadcasters had pledged to make time available to diverse interests. NBC had from the first adopted a policy of not selling time to religious broadcasters. Instead, they would offer free airtime to representatives of the three major denominations—Catholic, Protestant, and Jewish—and air the broadcasts as sustaining programming. All others were out of luck, and so were individuals from within these three groups who wished to broadcast their own messages.

Yet, because the Federal Radio Commission (FRC) also specifically included religious programs as part of a station's public service obligations, many local stations made time available. Accordingly, Father Coughlin began a children's religious show at Detroit station WJR in 1926. This went over so well—the parish priest had a knack for broadcasting and a sonorous, compelling voice—that Coughlin expanded into broadcasts for adults on a hookup to WMAQ-Chicago, later joined by WLW-Cincinnati. Encouraged by the thousands of letters of support flowing into his Royal Oak rectory from his Radio League of the Little Flower, Coughlin took his mission to the network airwaves in October 1930 by purchasing a slot on CBS—still trying harder to make a profit—at the favorable time of 7 p.m. on Sunday evenings.

It was the Depression that in many ways made Father Coughlin's fortune. Addressing a nation struggling with economic problems and the social disruption they brought, Coughlin offered messages of sympathy and solace that seemed to speak directly to each listener. Like Wendell Hall and Dr. Brinkley before him—like President Roosevelt in his Fireside Chats—Coughlin knew how to take advantage of radio's capacity for intimacy. As one biographer wrote, "To an uncanny degree, Charles Coughlin constructed a personal bond between himself and each listener. The result was the transcendence of physical, social and denominational distance: Coughlin had built an electronic neighborhood" (Warren 1996, 26).

As long as the charismatic priest stayed on the subject of spiritual aid to a country in crisis, he provoked little concern. But his very engagement with his audience soon led him to foray into politics. It was the threat of international communism that first attracted Coughlin's attention. An anticommunist stance was hardly controversial, but Coughlin began to link the actions of "capitalists and bankers" at home and abroad to the communist menace and to urge corporations to weaken communism's appeal by raising the wages and standard of living of U.S. laborers; this activity galvanized the radio audience and began to worry network executives.

In January 1931 matters came to a head. CBS got wind of the political subject matter of the priest's planned January 4 broadcast and requested that he delete objectionable material. Coughlin promised that he would, and then spent the entire broadcast inveighing against CBS's attempts to censor him. Letters of support for the priest poured into network and station offices across the country. CBS canceled his contract, under the auspices of instituting a new policy forbidding the sale of time to individual religious figures, similar to NBC's. From then on, the CBS *Church of the Air* would provide free time to a consortium of

authorized religious bodies—and to no one else. The gatekeepers were closing the gate; already, one important policy change rests on Coughlin's doorstep.

But networks, by regulatory design, were not the only game in town. Coughlin now cobbled together his own ad hoc network, buying time from local stations in cities across the country. Over 26 stations covering most of the East and Midwest, the radio priest continued to send out his increasingly political messages. Donations poured in to cover costs and support his work. By the mid-1930s it was estimated that his radio congregation comprised over 10 million regular listeners. His office staff in Royal Oak increased to over 100 clerical workers involved full time in opening mail and posting donations, which amounted to roughly $20,000 per week. When station WOR-New York polled its listeners on "the most useful citizen politically in 1933," almost 55 percent answered, "Father Coughlin." WCAU in Philadelphia asked its listeners which they would prefer on Sunday afternoons, Father Coughlin or the New York Philharmonic broadcast? Coughlin came out ahead with 112,000 votes to 7,000 for the Philharmonic, clearly a vote of mass over class.

He became an early endorser of presidential candidate Franklin D. Roosevelt, attacking President Hoover's corporation-friendly policies and championing FDR as an ally of the common man against the rapacious corporations and banks that had driven the country into economic failure. Many credit him for aiding the FDR landslide victory in 1932, with slogans like "Roosevelt or Ruin." However, as the New Deal progressed Coughlin began to take issue with New Deal policies. In 1934 he created what many viewed as the beginnings of his own political party, the National Union for Social Justice (NUSJ), and began publishing a monthly newsletter, *Social Justice.* The last clause in NUSJ's platform statement perhaps best sums up Coughlin's populist appeal: "Human rights to be held above property rights; government's chief concern should be with the poor; the rich can take care of themselves."

As long as Coughlin saw FDR and the New Deal as champions of the poor and the working class, all went well. But as the Roosevelt administration began to broaden its focus from the domestic toward involvement in the crisis heating up in Europe, Coughlin increasingly pulled in the opposite direction, toward isolationism and anti-Semitism. By linking aid for beleaguered European governments facing the Nazi threat with the interests of "international bankers," and in turn associating bankers with "international Jewish conspiracies," and, further, with Russian communism, by 1936 Coughlin had assembled the ideological elements and rhetorical strategies that would propel him to further heights of support and controversy. It also led to a decisive break with Roosevelt. Coining colorful disparaging phrases like "banksters" and the "Jew Deal," Coughlin's rapidly growing anti-Roosevelt stance led him into alliance with groups he had earlier excoriated, like the Liberty League, a group of wealthy right-wing bankers and industrialists, and later the German-American Bund, a pro-Hitler group. Coughlin campaigned actively against FDR in the 1936 elections, calling him "Franklin Double-Crossing Roosevelt." The radio priest's audience peaked in 1938, when a survey showed that over 16 million people tuned in to his program at least once a month (though only 52 percent reported that they "approved or agreed" with his message). He became a strident isolationist, resisting the considerable intrusion of pro-Allied programming that began to appear on the airwaves in the late 1930s and speaking out against Roosevelt's loosening of the Neutrality acts.

However, after the events of Kristallnacht in November 1938, listenership and approval began to decline. As the United States increasingly came out on the Allied side of the conflict, Coughlin was viewed as more and more of a threat and an embarrassment, not only to the

Father Charles E. Coughlin of Royal Oak, Michigan, showed a tension-ridden nation the dark side of radio's populist appeal.

radio industry but to the Catholic Church. His influence was further undercut by the second major policy change his popularity inspired. In 1939, at the height of Coughlin's attack on congressional repeal of the arms embargo, the National Association of Broadcasters announced a major change in its broadcasting code. The new rule barred all controversial speakers from the air, unless they appeared as part of a panel or discussion featuring divergent views that would balance them. Here we see the beginnings of the troubled Fairness Doctrine.

Coming not from a network but from the NAB, whose codes affected nonaffiliated stations as well, the rule dealt a considerable blow to Coughlin's ability to buy time. It effectively gave squeamish stations a reason to deny him. Although, critics pointed out, such a restriction really should have applied as well to the corporate-sponsored news analysts and commentators so prevalent on the airwaves, it was clearly directed toward Coughlin and would be used primarily to restrict other populists like him. Many felt that this restriction set a dangerous precedent, undermining freedom of speech on the air. Though the NAB claimed that the rule was intended to prevent individuals of great financial power from buying their way into the nation's consciousness, in fact Coughlin's financial support came not from the coffers of wealthy corporations or families but from hundreds of thousands of small donations. His was not the influence of the capitalist elite, but rather of the masses.

The NAB had used a liberal argument (fear of the monied elite) to support a conservative strategy (fear of the masses), with applause from both sides. Left and right united in the effort to suppress Coughlin, in a way that would come back to haunt them both.

Effectively, this new rule closed the one remaining loophole that remained in networks' and stations' ability to censor controversial opinion: the dollar loophole. Mere ability to pay was no longer a sufficient guarantor of getting on the air. In fact, now broadcasters, though enjoined to keep the public informed through news and discussion, had an *obligation* to restrict all those outside the broad mainstream of political views from reaching a susceptible public. What would identify an acceptable spokesman or cause? Well, endorsement by a responsible corporation might be one way, or an official institutional position another. By this way of thinking, major corporations could, and did, sponsor conservative, pro-business programs, and because they were not "individuals," could buy time freely. Their very endorsement made the political viewpoint noncontroversial. Yet spokespersons from less well-established or official groups—including labor unions and civil rights groups—would fall under the heading "controversial individuals" and be unable to purchase airtime except as part of a station-planned debate or discussion.

For Coughlin, the increased unwillingness of stations to sell him airtime, combined with disapproval of his new bishop, forced him to cancel his 1940–1941 broadcasting season. He continued to publish his newsletter *Social Justice* and remained the parish priest at the Shrine of the Little Flower until his retirement in the 1960s. Yet the repercussions of his radio career remain. Father Coughlin illustrates the fear of the power of the "great unwashed" that radio stirred up in the minds of those in charge. His popular support from what they believed to be the uneducated, easily manipulated masses, and most likely his suspect background as a Catholic priest from the Irish working class, turned the weight of the conservative mass culture critics against him—even though his anti–New Deal politics were closer to theirs. His scurrilous anti-Semitism and rejection of liberal policies meant that he could count on no support from the left—even though his suppression meant a freedom of speech restriction that later would be used against them.

It's certainly difficult to defend a man like Father Coughlin; but if we look past his ominous black-robed figure to the crowds behind him, we sense radio's real dilemma as war approached. Could the public be trusted to make up its own mind about such vital public affairs? Or was radio simply too powerful and persuasive a medium to remain truly free?

RADIO GOES TO WAR

The NAB code inspired by Father Coughlin would have one other effect as war approached. Because the new policy discouraged open debates on controversial issues, broadcasters tended to limit outright political programs to President Roosevelt's Fireside Chats, authorized government spokesmen, and carefully balanced panel discussions of pro- and anti-interventionist policies. Yet as it became clear that the Roosevelt administration was tending toward getting involved in the conflict in Europe on the side

of the Allies, and as the federal government's investigation of monopoly in the radio network business continued to gather steam, broadcasters found a way to curry the administration's favor by coming down on the interventionist side in a subtle and more politically acceptable way.

By 1939, commercially sponsored and sustaining "morale-building programs" abounded on the airwaves, taking the place of outright debate and discussion. These public service programs allowed networks both to fulfill their regulatory obligations and to rally behind the Roosevelt administration's wishes, yet without overtly taking sides. They tended to focus on broad questions of the "who we are and why we fight" theme, because open discussion of political views was out. Soon a wide array of sponsors found reason to air a host of high-minded programs glorifying the uniquely democratic nature of American society and praising its values of individual freedom and inclusiveness.

One especially popular and attractive theme was to celebrate America's immigrant heritage and focus on the "e pluribus unum" ideal: Out of many, one. By concentrating on America's proud tradition of assimilating many ethnic and national identities into a unified culture of democracy, an answer could be provided to the "who we are" question. Of course, some identities proved more troubling than others in this glorification of the melting-pot ethos.

Both Jewish groups—who believed in assimilation while maintaining important aspects of cultural and religious difference—and racial and ethnic minorities—who had been forcibly shut out of America's celebratory meltdown—saw the new trend in programming as an opportunity to speak out about social injustice and to reinscribe themselves into the national narrative in a more enlightened and progressive way. From 1941 to 1945, African Americans in particular, often in a coordinated effort with Jewish antidefamation groups and progressive religious alliances, found a new voice on the airwaves that had long been repressed and denied. Organizations such as the National Conference of Christians and Jews, the Common Council for American Unity, the Anti-Defamation League of the B'nai B'rith, the Union for Democratic Action, the Council Against Intolerance in America, and many others not only combated anti-Semitic propaganda at home and abroad but also began to espouse a broader definition of racial and ethnic unity.

Connection Americans All, Immigrants All

It might come as a surprise to more recent graduates of U.S. primary and secondary schools, but America's history was once defined as only that of its dominant minorities—the British and French. History books concentrated on the experience of the Pilgrims (never the Native Americans they encountered) and on their descendants' American progress, making no more than a brief reference to the passages by which most current Americans arrived on these shores: poor, in flight from repression or starvation, and often met with considerable hostility from their reluctant co-citizens. Others, of course, were forced here under conditions of slavery

or were denied basic rights such as property ownership and education, as with Asian Americans. But very little of this history was acknowledged in the assimilationist, consensus period of U.S. historiography, from the Progressive era until the 1940s.

The winds of war began to blow a long-postponed change into concepts of the American past. When Rachel DuBois, a high school teacher with a Quaker background from New Jersey, first proposed her multipart radio series and entitled it simply "Immigrants All," she hadn't counted on opposition from more established "DAR types" who didn't want to associate themselves in any way with the term *immigrant*: It was "too depressing." But DuBois persisted. As historian Barbara Savage recounts, DuBois had come to the idea by way of the emerging field of intercultural education—a movement that sought to increase second-generation American students' self-esteem and ambition by teaching pride in their ethnic heritage and showing the falseness of racism and stereotyping (Savage 1999, 24). Once again Father Coughlin proved influential: DuBois had heard his broadcasts and found them deeply troubling to her students. Coughlin's radio diatribes trumpeted the notion, "This is a country for white Christians." DuBois commented, "You know who's left out. He yelled it everyday over the radio." In the climate of Nazi hate and racism at home, radio seemed the best bet for combating such messages.

DuBois approached Federal Commissioner of Education John Studebaker in the summer of 1938 with the idea of producing a series that focused on America's pluralistic heritage and how the heritage would survive only by battling prejudice and hatred. Eager to raise the profile of his underfunded agency, Studebaker agreed enthusiastically. Because NBC had recently turned down a proposal for a similar program, DuBois and Studebaker approached CBS, which agreed to give the series production space and a favorable Sunday afternoon time slot. They assigned their own production personnel to the job, with the chief writing responsibility going to Gilbert Seldes, a well-known writer and cultural critic who had just been hired by CBS as director of television programming. DuBois and her colleagues at the Service Bureau for Intercultural Education (an organization she had founded to support teachers' efforts) would do the research; Seldes would write the scripts.

The series that resulted was the first major radio effort to address issues of race and ethnicity in the progressive urgency of the war years. It would serve as a model for many others to come, though few would meet with its success. The title itself—*Americans All, Immigrants All*—demonstrates the central tension over which DuBois and Seldes would struggle. Should the series emphasize the unity and shared experience of the American public? Or should it celebrate the cultural variety of American ethnic groups and the uniqueness of their experiences, including the prejudice they encountered from other groups? Seldes argued for the former, sweeping ethnic and racial tensions aside under a dreamy cover of assimilation. DuBois argued insistently that prejudice and intolerance kept that dream from materializing and that this could not be changed until it was acknowledged and addressed.

CBS, which had been the first network to begin reporting news from the European front, saw the program as a way to stay ahead of its competitor in wartime awareness. Events conspired to give the series a high profile. The first episode of the 26-part series debuted on November 13, 1938, only five days after the shock of Kristallnacht. Opening with a generalized tribute to American democracy, the show then alternated the stories of 13 ethnic groups with interspersed synthesizing episodes dealing with American values, institutions, and historical events. It started with the story of the British and proceeded more or less in order of each group's arrival on U.S. shores.

Emphasizing hard work, family solidarity, and gradual upward progress, the programs were deemed a great success by those who heard them, especially those for whom the immigrant success model had worked. A family from Wisconsin reported, "It gives us a thrill and a tingling sensation up and down our spine, a feeling of elation and exhilaration that cannot be matched by anything any other country of the world offers." Another listener wrote, "I feel all choked up and want to cry, yet I am so happy inside that I could shout and sing, and laugh, thanking God that I live in America founded and built by Immigrants All, who have become Americans All." Some thanked the programs' creators for clearing up "misconceptions in my mind about groups of immigrants in this country" (Savage 1999, 34–35). The program won several awards, including a prestigious one from the Women's National Radio Committee, causing NBC to initiate a series of sharp interoffice memos trying to determine why they had turned down the proposed series.

Yet not all was sweetness and light. Despite the overarching structure of Seldes's assimilatory optimism, several episodes proved controversial. Savage points out the awkward combination of Puerto Rican, Mexican, and South American immigrants under the heading "Our Hispanic Heritage," as well as the combined Japanese/Chinese program (an odd grouping, considering the two countries were at war, and considering it simply left out all other Asians). Also, these nonwhite groups had experienced roadblocks to upward mobility and assimilation; it was difficult to argue that they had benefited from the "automatic progress" enjoyed by European ethnicities. It was hard to find good things to say about generations of Mexican farmworkers denied any other social avenue, or to explain why Asian American men were not permitted by law to participate in the California gold industry except as cooks, servants, and laundry workers. The programs simply glossed over these awkward historical facts—as the movement toward the unjust internment of Asian Americans took hold on the West Coast, and the zoot suit riots against Latinos/as prepared to erupt in Los Angeles.

Episodes on "The Negro" and "The Jews in the United States" provoked the most internal controversy. No African Americans had been asked to serve as advisors to the series, but DuBois insisted that the "Negro" script be vetted by at least one black consultant. Studebaker agreed to send the draft script to Alain Locke, a leading intellectual and professor at Howard University, and to famous writer and philosopher W. E. B. DuBois (no relation to Rachel). Both men recommended changes that emphasized black resistance to slavery and work in the abolitionist movement, highlighted African American contributions to twentieth-century American culture, and at least acknowledged the discrimination and unequal treatment blacks had experienced as "Americans All." Seldes disagreed strongly with these changes and had to be forced to go along with them.

But despite some snafus with the live broadcast, the rerecorded version of "The Negro" proved an encouraging precedent for future series. One black listener wrote:

> As a member of the Negro race I was extremely gratified at your fair and unbiased portrayal of the parts my race have played in helping to make America a better place for all groups to live in, even though at times we were somewhat discouraged by intolerant individuals who seem to enjoy a sadistic pleasure in denying us our inalienable rights. . . . I feel that your program is a forerunner to the fulfillment of our dreams. (Savage 1999, 44–45)

"The Jew in America" ran up against the problem of what Savage calls "a politics of invisibility versus a politics of visibility" (Savage 1999, 58). Unlike that of African Americans,

Jewish identity was far more invisible within America's white mainstream. Yet this presented problems of its own. Should the issue of American anti-Semitism be brought up, or should Jews retreat into the background of whiteness, refusing to acknowledge the difference that other groups had made of their identity? Many cited Father Coughlin as an influence that had to be rebutted by open discussion. In the end, the episode took an extremely cautious approach, emphasizing the achievements of noted Jewish individuals and stressing the long history of Jewish inclusion in American culture. But it was not cautious enough for Coughlin, who during his next broadcast used the show to buttress his anti-Semitic claims. To him, such historical success only proved the presence of an "international Jewish conspiracy" behind "even Columbus's discovery of America." Yet despite some controversy, *Americans All, Immigrants All* provided a model for future government-funded programs that stressed the new cultural pluralism.

It soon became obvious, however, that this would not be enough. Despite a variety of programs produced along similar lines—with titles like *Freedom's People; Speaking of Liberty; We, Too, Are Americans;* and *I'm an American!*—the basic contradiction between America's claims to democracy and freedom and the exacerbated wartime discrimination against African, Asian, and Latino/a Americans could not be wished away by high-minded propaganda. As the war escalated and more and more minority Americans experienced segregation in the military and violence at home, a new pressure to directly address racial issues emerged. Until this point, as we have noted earlier, the American airwaves presented a closed door to minorities, except in certain limited roles. Gradually racial tension led to a slow emergence of programs that actually allowed some minority writers, artists, and public figures to speak for themselves—not filtered through the scripts and agendas of white interests.

Beginning in 1941, as Savage traces, public affairs programs such as *America's Town Meeting of the Air* and *The University of Chicago Round Table* took the radical step of actually inviting black guests to discuss racial issues, though such guests were always carefully balanced by the presence of a "spokesman from the South." Black leaders pushed for immediate desegregation of the military and enforcement of fair employment rules. These demands were met with stark hatred from America's racist heartlands—as well as relief, encouragement, and militant agreement from the black and white racially progressive listeners long shut out of America's public discourse. Things rose to a peak in the summer of 1943 when, hard on the heels of the zoot suit riots in Los Angeles (where Mexican and black defense workers were attacked by white soldiers in the streets), came the Detroit riot in which 34 people were killed and 1,800 arrested, most of them black, after President Roosevelt sent in federal troops. Concerned groups urged the president to follow up this action by making a national address condemning violence—almost all of which was provoked and carried out by whites against blacks—but he continued to refuse to take a stand on race issues. Likewise, the OWI (Office of War Information) and other government agencies stalled and waffled, unable to agree on how to address this inflammatory racial issue and hampered by threats from a Dixie-dominated Congress to cut funding.

The Emergency Committee of the Entertainment Industry, a group hastily assembled by NAACP President Walter White in the wake of the riots, moved into the gap produced by federal inaction by bringing together black activists and racially progressive white liberals and entertainers to produce *An Open Letter on Race Hatred.* William Paley at CBS not only gave the program airtime but also sponsored and paid for it. Written, produced, and directed by William Robson, the program combined a frank plea for racial tolerance with dramatic reenactment of

the riots, emphasizing as well how such racial conflict at home looked to America's enemies abroad. It aired on July 24, 1943. In one section, which created a hypothetical Japanese propaganda broadcast, the program described the Detroit riot as one in which "hundreds of Negroes were sacrificed to the altar of American white superiority complex." It directly addressed the formerly taboo issue of white racism, admonishing audiences:

> We've got too tough an enemy to beat overseas to fight each other here at home. We hope that this documented account of the irreparable damage race hatred has already done to our prestige, our war effort, and our self-respect will have moved you to make a solemn promise to yourself that, wherever you are and whatever is your color or your creed, you will never allow intolerance or prejudice of any kind to make you forget that you are first of all an American with sacred obligations to every one of your fellow citizens.

The broadcast drew widespread praise in national media (though it also received thousands of condemnatory letters). Here was a program inspired by citizen action, sponsored by a broadcasting company, that went further than any government-produced effort had dared.

These two shows—*Americans All, Immigrants All* and *An Open Letter on Race Hatred*—mark the two poles of liberal American response to the domestic politics of World War II. From cautious inclusionism to a war-inspired call for simple enforcement of existing laws, such programs still kept the reins of communication firmly in the hands of the white majority, limiting the ability of blacks to speak out for themselves. The programs combined a sentimental appeal to basic American values with a not-so-subtle threat that the whole world is watching. The African American community's efforts to take up the opportunity that the war had created show clearly the roots of what would become the civil rights movement. They also demonstrate how far that movement had to go before America began living up to its own loudly trumpeted ideals.

Government-Industry Cooperation

After 1940, war-related radio programming attracted considerable attention from various government agencies and offices. From the Treasury Department in its war bond drives, to the Immigration and Naturalization Service, to the U.S. Navy and the Department of Education, government and industry combined to produce entertainment and information around the theme of national unification and mobilization. In 1942, with war formally declared, the government formed the Office of War Information (OWI) to coordinate all these efforts. The OWI, rather than taking over the press and the radio networks (as had happened in Germany), became the central site for distribution of information and program initiatives to the existing independent, mostly commercial media. In turn, the media industries cooperated enthusiastically with the OWI, even to the point of giving leading executives leaves of absence to serve as head of its various branches and to work on its campaigns.

The OWI operated on two fronts. At home, through its Domestic Branch, it encouraged joint efforts among advertisers, media, and government to disperse war information, keep up morale, encourage unified and democratic thinking, and support

wartime initiatives such as the employment of women in vital manufacturing and services jobs. It broke down into various bureaus covering news, advertising, motion pictures, radio, and other functions. Abroad, the Overseas Branch operated the Armed Forces Radio Service (AFRS), an extension of American radio to troops stationed around the world. The fact that others listened in was appreciated but not planned for; another government agency, the Foreign Information Service, would start up the outward-directed radio broadcasts that would soon become the Voice of America. We'll focus in this chapter first on the domestic front, as broadcasters brought wartime issues home into one of America's favorite soap operas; then we'll take a look at two of the AFRS's most popular and culturally significant programs.

Connection The Public Woman: The Story of Mary Marlin

As the OWI organized in the summer of 1942, it met with a corresponding organization on the private side: the War Advertising Council (WAC). The WAC was formed in the fall of 1941 by national advertisers eager to meet the government halfway to pitch morale and wartime messages to the American public.

The OWI would act as a clearinghouse for government agencies and the military, receiving their requests for publicity and public awareness and coming up with a schedule of specific campaigns to be disseminated to the media. The WAC would receive notice of these campaigns and pass them along through their various committees to be worked into media messages. For radio, the WAC's Radio Advisory Committee formed its Network Allocation Plan, which made sure that national advertisers and broadcasters received such propaganda initiatives in time to incorporate them into special informational programs, public service announcements, and regularly sponsored radio shows. As historian Gerd Horten writes, "It was, therefore, the advertisers and writers who packaged and sold the war to the American people" (Horten 1996, 47).

This system of government-industry cooperation allowed the federal government to avoid having to create a department for propaganda, as it had in the World War I, to much dissension. The OWI would consistently run into political opposition to any efforts it took on to publish and disseminate propaganda directly. It allowed the industry to continue to operate profitably throughout the war years, without fear of government shutdowns or takeovers. Many Americans felt reassured by such a decentralized system. They trusted their local newspapers and radio stations to handle wartime initiatives—such as the push for equal rights for African Americans—in a less controversial and more cautious way than a federal bureau might. Sometimes, as with CBS's initiative in producing *An Open Letter on Race Hatred*, private interests could go further than politically hampered government agencies could. Yet what would happen when the public interests clashed with industry interests? Could commercial media be trusted to put their own interests aside?

Beginning in April 1942, this system brought war information and morale-boosting propaganda to the public, using all the persuasive arts that the American advertising system

could muster up. Often these campaigns proved remarkably effective. Kate Smith, one of the country's most popular singers, sold millions of dollars in war bonds. Popular stars like Jack Benny and Fibber McGee and Molly worked home-front messages into their comedy routines. Here's Jack Benny on rationing, a plan to limit consumption of scarce goods initiated in late 1942:

WILSON: *Well, Jack, gas isn't the only thing being rationed nowadays.*

JACK: *No, there are a lot of things, Don. A half pound of sugar a week, no whipped cream, one cup of coffee a day, a meatless Tuesday . . . but we'll have to get used to it.*

MARY: *Get used to it. . . . You've been rehearsing for this all your life.*
(Horten 1996, 46–52)

These messages were certainly a remarkable turnaround for the advertising industry, which had been encouraging ever-greater heights of product consumption since radio's inception. Suddenly, conservation was the name of the game. But American business was actually doing better than it had for most of the Depression. Companies manufacturing and selling goods to the government—and most were—were guaranteed full coverage of their costs plus a 10-percent profit. In addition, 80 percent of their advertising expenses were tax deductible. With these kinds of incentives, it didn't matter that consumers had to restrict their consumption—the government was buying. And it paid to keep one's name before the public in a context of public service, even if a company had little to sell.

In a scene from the *Fibber McGee and Molly Program*, Fibber demonstrates how radio could be used not only to introduce information but also to anticipate negative public reactions and defuse them:

FIBBER: *I tell you it ain't fair, Molly, they can't do this to me—four gallons a week. Why, that's ridiculous.*

MOLLY: *I think so too.*

FIBBER: *You do?*

MOLLY: *Yes, you don't need four gallons!*

FIBBER: *Doggone it. I do too. Four gallons is outrageous! Where can I go on four gallons of gas?*

MOLLY: *Where do you wanna go, deary?*

FIBBER: *Well . . . gee whiz . . . What if I did want to go someplace? In an emergency or something.*

MOLLY: *You mean like running out of cigars? . . .*

FIBBER: *Ah, forget my cigars, I'm talking about this mileage rationing. I think it's a dirty deal. The whole thing is silly! It's going to make everybody stay at home. Why in two years a guy from Indiana won't know what a guy from Kansas is talking about.*

MOLLY: *Where are you from?*

FIBBER: *Illinois.*

MOLLY: *Then it's happened already. I don't even know what you're talking about.*
(Horten 1996)

Other program producers, like the prolific soap opera team of Frank and Anne Hummert, introduced war-related plots into their daily serials. On the race relations theme, less stereotyped black characters were added to the casts of several popular soaps, many of them soldiers. Another campaign, called "On the Victory Front," encouraged serials to suspend their usual story lines and consider what would happen if Hitler's forces won the war. On the Procter & Gamble soap *Life Can Be Beautiful*, a main character had a nightmare vision of the abuse of men, women, and children under Nazi rule. At the end of the week, the character woke up and life continued as beautifully as usual.

With an increasing proportion of American men overseas, the female audience gained in percentage and importance. Campaigns to rally women behind war work proved particularly successful over the air. J. Walter Thompson produced a series of short dramatic vignettes called "Listen Women!" as part of the "Womanpower" campaign initiated by the OWI and WAC in 1942, with slogans like "If you can run a vacuum cleaner, you can run a machine in a factory—easily!" Such spots, designed to air next to soaps in the daytime, may have convinced many women to take on wartime employment and to remember these principles even after the war. If what men did was so easy, why shouldn't women have such jobs in peacetime, as well? Spots in this series created a world in which women were strong, could operate heavy machinery easily, needed work for personal well-being, and had a well-defined duty to work as public citizens, not just as domestic partners. Heady words indeed, and they were picked up in regular radio programming as well.

One of the most popular serials during the war years was Jane Crusinberry's *The Story of Mary Marlin.* Started in 1934 on WMAQ, it moved to the NBC Red network in 1935, sponsored by Kleenex tissues (later Procter & Gamble) and produced by the Lord and Thomas agency. Jane Crusinberry continued to write the serial throughout its 10 years on the air, years that spanned the buildup to the war. The show's popularity peaked in 1943 as Mary Marlin, first the young wife and then the widow of Senator Joe Marlin (in the way of soaps, he later turned out to be not dead but just missing in action after a plane crash in Siberia), takes over her husband's position in the U.S. Senate.

This was an unusual role for a woman in the 1940s, real or fictional. In Washington, D.C., Senator Mary Marlin is faced not only with the usual soap opera problems of personal relations, romance, and intrigue but also with real social and political issues. As historian Jennifer Wang demonstrates in her study "49 Million Listeners Can't Be Wrong," Crusinberry had struggled under heavy agency and network censorship since 1937 to work political issues into her soap, but found that though listeners might approve, those in power did not (Wang 1999). But the urgent social problems of the war years helped to remove these restrictions. Now Mary could come out in the open with messages of democratic morale, often addressing women's specific needs. When the plot brought Mary up for reelection as senator in 1944, Crusinberry wrote her campaign speech:

> All through American history, the women of America have fought for a land of OPPORTUNITY, FAITH, AND FREEDOM.... In the year 1944, as it was in the year of 1692, this is a land of UNLIMITED future for Americans—men and women—IF ... IF that future holds UNLIMITED OPPORTUNITY—for every individual to attain the highest achievement of which he is capable—that is the Great American Dream. (Wang 1999)

State Historical Society of Wisconsin, 10059mp

Author Jane Crusinberry devoted herself to only one serial, *The Story of Mary Marlin*. Its heroine became a U.S. senator during the war years, reflecting women's newly public role in American life.

This was a very different kind of address than audiences were used to, on the soaps or elsewhere. The show's ratings were among the highest on daytime, peaking in 1943. Yet in 1944 Procter & Gamble dropped out as sponsor, due to discomfort with the show's increasingly political tone and Crusinberry's increasingly hostile resistance to the changes her producers wanted her to make. When Standard Brands picked up the program, J. Walter Thompson executives sought ways to tone down the political content. In 1944 they even hired Irna Phillips as a consultant; she agreed that the storyline needed to get back to "plain Mary Marlin ... the plain, average, everyday woman in a small town who loves her husband—a story that in many ways served as a mirror for a daytime audience in which their own lives were reflected" (Wang 1999).

In late 1944, Crusinberry was fired from her own soap. It continued to run, but suddenly the competent Mary, who had coped with widowed single motherhood and Senate office without too much difficulty, found that she was needed far more at home than in the public eye. When Joe's Aunt Elizabeth arrived one day to remove Mary's son Davey from her custody, the show's writers had her agonize:

> If this keeps up, Davey can be marked psychologically for the rest of his life. He can't have a normal childhood—he'll have no father to depend on—and his mother in a glass cage for everyone to stare at. . . . I won't have him grow up in an atmosphere like that. My career is hurting my child and Davey means more to me than anything in the world. If I have to resign from the Senate, I will. I can't ruin Davey's life. (Wang 1999)

Here was a return to "true womanhood"! Despite—or perhaps because of—this effort at redomestication, the program's ratings took a sharp downward dive. It was canceled in 1945. Crusinberry never attempted another serial.

As the war wound down, the newly public role that American women had been encouraged to take on also began to change. Even using a term like *public woman* shows how women in the public sphere present a challenge to accepted ways of thinking: The term *public woman* traditionally referred to a prostitute. A *public man*, on the other hand, is a figure of social and political position and responsibility. World War II had increased the trend in paid non-domestic employment for women, but it also began to redefine what a public woman might be in light of American democracy and twentieth-century social needs. Despite efforts to backtrack and

contain these changes as the wartime years gave way to the 1950s, and despite the OWI's campaigns aimed almost exclusively at white women, American women—black and white—would not forget the promises of a "new deal" in equity and public position made during the war.

Pitching America Overseas

The use of marketing techniques to keep up war morale found its most successful application in the creation of the Armed Forces Radio Service (AFRS). The Overseas Branch from the beginning was the most glittering facet of the OWI's public face, tightly tied to the world of Hollywood and radio entertainment. Its director was Thomas H. A. Lewis, who had been in charge of radio production for one of the nation's largest advertising firms, Young and Rubicam (Y&R). Lewis produced some of radio's major hit shows, including *The Kate Smith Show*, *The Aldrich Family*, and *The Screen Guild Theater.* He was also married to screen star Loretta Young. Other high-flying members of the Overseas Branch radio committee were CBS head William Paley, Niles Trammel (president of NBC), and John Reber from J. Walter Thompson, along with several heads of major companies that sponsored big-name shows on radio.

Like a true marketing man, Lewis decided that the best way to determine the kind of entertainment and information needed by troops overseas was to conduct an audience study. Basing his project on the successful campaign conducted a few years earlier by Y&R for Swan Soap, Lewis conducted (in July and August 1942) an extensive survey of his market—military personnel—just as Y&R's Swan campaign had surveyed housewives.

Lewis concluded from the results that what American troops needed to keep up their spirits was a combination of familiar radio programs from home and a number of specially produced programs acknowledging the specific situation of the soldier and showing appreciation for his extraordinary sacrifices in wartime. A network of radio stations would be established abroad, many of them in a portable form that could advance into new territory as the troops did, so that few would be cut off for long from the voices of reassurance and support. The overall message, Lewis concluded, should be "Morale, Americanism, security, things are going 'OK' at home, we are sending you the needed materials, we are doing all we can to help you, this is your country—America, you are the best soldier there is, the 'why' of things, and finally *you will win*" (Hilmes 1997, 260–261).

The AFRS first thought simply of recording existing shows and shipping them for rebroadcast overseas. Much of the historical record we have of radio during this period relies on the recordings, in these days before tape and before recorded broadcasts were considered respectable, on the extra-sized acetate platters used by the AFRS. At first the programs went out with commercials and all, but follow-up surveys proved that the troops were actually depressed by listening to endless pitches for products to which they had no access. After this, the recordings were "denatured"—the commercial spots were replaced by war information or morale-building plugs. In some cases, given that many radio shows used the integrated advertising method whereby product promotion was built right into the introduction and closing of the show, new programs were sometimes compiled out of bits and pieces of existing ones.

Staffed by advertising and radio men who had built their careers on showmanship, the AFRS lost no opportunities to bring in big-name Hollywood talent to make these

Frank Sinatra, Bing Crosby, and Bob Hope in a typically star-studded *Command Performance* ordered up by the troops during World War II.

refried bits something special. One of these creations was *Front Line Theater*, which took dramatic programs, denatured them, and put them together into one weekly format, hosted by actor Herbert Marshall. Peter Lorre served a similar role for *Mystery Playhouse*, which combined different suspense programs into a weekly extravaganza. Most stars were happy to donate their time for the war effort. Other shows were dreamed up specifically for the soldiers overseas.

Your Broadway and Mine overcame the competition and hostility between theater and radio by providing Broadway shows specially edited for radio. *The Sports Parade* made sure that men posted abroad could still keep up with their local teams; other shows re-created baseball games through the magic of radio. *Hi, Dad!* brought soldiers' children onto the air to relay messages to their absent fathers and tell them about family activities. One of the most popular AFRS shows was *GI Jive with Jill*, on which flirtatious hostess Martha Wilkerson, as "Jill," spun jazz records in between reading letters from servicemen and news stories from various hometown papers across the country. Of all the stars in the glittering AFRS constellation, none shone brighter than *Command Performance*, for which Hollywood's biggest stars—its highest-paid writers, directors, technicians, and producers—donated their time and services, and both CBS and NBC offered their studios for the broadcast.

AFRS also had unintended effects abroad. Great Britain was one of the first countries where sizable numbers of American troops were stationed, beginning in the summer of 1942 and peaking at over 1.5 million troops at the height of the war. As plans for the AFRS developed, the British Broadcasting Corporation (BBC) became very uneasy at the thought of an American invasion of their airwaves. Though the U.S. military promised only low-power transmitters operating only near bases and with none near London, it soon became apparent that wherever they could, the British public was tuning in to American radio and finding it greatly preferable to the war-diminished BBC service—at least for entertainment purposes. As a compromise, British and U.S. authorities cooperated to create the Armed Forces Network (AFN), operating throughout Britain as a joint venture of BBC and AFRS. The network would air British programs as well as American, with no commercials. This was the first time BBC had given up its monopoly of the airwaves, and some feared that this very different style of address and entertainment might win the British public over to the commercial system. Their fears were well founded; by the end of the war over 5 million Britons were tuning in regularly to the AFN, and they would remember the experience as BBC's charter came up for renewal after the war.

The Rise of Network News

During the war, U.S. radio networks proved themselves the best and most trusted avenues for news from the fighting fronts for the majority of the American public. NBC and CBS had been slow to take on news programming as part of their in-house duties, preferring instead to allow sponsors to provide commentators and analysts in commercial programs. But in the late 1930s, with the resolution of the press-radio war, networks began to establish news bureaus across the nation and in hot spots overseas. The journalists who made their reputation on radio during the war would become not only household names but also television's first news anchors in the postwar period. CBS in particular served as the home of distinguished journalism, with Edward R. Murrow, Lowell Thomas, Eric Sevareid, William L. Shirer, Chet Huntley, Elmer Davis (head of the OWI from 1942 to 1945), Charles Collingwood, and Howard K. Smith as primary figures. Murrow served as CBS's European news director. His live reports from London during the blitz, in the air over Berlin in 1943, and as American troops entered German concentration camps in 1944 still mark a high point in journalistic immediacy and impact. NBC had H. V. Kaltenborn and George Hicks. When NBC Blue became ABC after 1943, it too established a lineup of news commentators, including H. R. Baukage, Martin Agronsky, and Raymond Gram Swing.

The fact that most of these programs were sponsored caused increasing tension in the years leading up to the war. First of all, following in the tradition of radio announcers, most news commentators were obliged to deliver commercials as well as news. This tradition of integrated advertising would continue into television, where sponsored news shows such as the *Camel News Caravan* featured newscaster John Cameron Swayze segueing seamlessly from world affairs to exciting news about Camel's new toasted taste. As newsmen like Raymond Gram Swing and H. V. Kaltenborn found themselves delivering reports from war-torn Europe, relating stories of so much human suffering and courage, they began refusing to deliver integrated advertising and even

pushed to eliminate the middle commercial from the 15-minute broadcast. Others, however, continued in the same vein as most programming.

Commentators like Gabriel Heatter and Walter Winchell mixed entertainment with news reporting and enthusiastic product endorsement. William J. Cameron, who held forth in a brief intermission from musical entertainment on the *Ford Sunday Evening Hour*, prided himself on his pro-Ford, antilabor, and isolationist view as well as on his mixing of plugs for Ford cars with items of news analysis. Yet the sheer popularity and centrality of news during the war years made sponsorship of news programs irresistible. This meant that sponsors, who in effect owned and produced the programs, could if they wished intervene in editorial content. Under pressure from sponsors, a change took place in the rhetoric of news delivery. From frankly personalized accounts, with reporters speaking in first person and delivering the news through the lens of their own opinions, openly expressed, there emerged a less-personalized, more generalized and neutral style. In 1939, CBS announced a new policy encouraging this change: Newscasts would no longer have news *commentators*, they would have news *analysts*.

Erik Barnouw gives an example of how that policy affected one of H. V. Kaltenborn's newscasts from 1940, covering a speech by presidential candidate Wendell Wilkie. Kaltenborn's first version read, "I listened to Wendell Wilkie's speech last night. It was wholly admirable." But Kaltenborn crossed this out and substituted a new introduction: "Millions of Americans of both parties listened to Wendell Wilkie's speech last night. Most of them agreed that it was a wholly admirable speech" (Barnouw 1968, 136). This was both less honest (Kaltenborn had no idea about how most Americans felt) and less controversial (editorializing was masked with a tone of objective reporting). It was the shape of things to come.

Historian Elizabeth Fones-Wolf places such debates over proper news content and structure within the larger campaign waged by corporations to use radio for public image building during the thirties and forties, and afterward with television (Fones-Wolf 1999). Besides individual corporations, organizations like the National Association of Manufacturers (NAM) helped to promote and fund leading conservative commentators like Boake Carter and Fulton Lewis Jr., who inveighed against labor unions and government intervention in the market economy. Others, such as Upton Close and H. V. Kaltenborn, came out strongly against Roosevelt's foreign and domestic policies. General Motors hired its own news commentator, Henry J. Taylor, whose Monday night program took a particularly strong stand against unions, increased corporate taxes, and the expanding welfare state. These tactics could sometimes backfire. Boake Carter lost his news slot when the extremity of his antilabor views threatened to undermine sponsor Philco's business, especially after the Congress of Industrial Organizations (CIO) called for a Philco boycott. General Foods picked up the sponsorship, only to drop it a few seasons later under the same pressure. NBC pressured Upton Close off the air, even though his sponsor was happy with his views and took the program to Mutual. And H. V. Kaltenborn fought a long-running battle with NBC over his anti-Roosevelt rhetoric; but as long as his sponsor, Pure Oil, continued to support him, his show remained on the air. After the war, the CIO would begin to monitor network news commentary for antilabor invective and demand its own time to respond.

A few women were able to break into radio journalism during the war as well. One of the most famous, Dorothy Thompson, had provided commentary on NBC since 1936, but

© Bettmann/CORBIS

Edward R. Murrow took radio journalism to new heights in his first-person coverage of the war over CBS. He would go on to head CBS's news division, becoming one of the most influential of the early television journalists.

her increasingly fervent anti-Hitler slant led that network to drop her in 1938. She was picked up by Mutual in 1941 and returned to NBC Blue intermittently from 1942 to 1945, all the while continuing her distinguished print career. Bernardine Flynn, otherwise known as Sade on *Vic and Sade*, initiated a *News for Women* daytime series on CBS (sponsored by Procter & Gamble) that aired daily from 1943 to 1945. Helen Hiett reported on the Blue network from 1941 to 1942. These pioneering female journalists would open up news careers for such later figures as Pauline Frederick and Barbara Walters.

But despite the networks' growing commitment to news provision, and despite the high level of confidence in radio news expressed by the American public, broadcast news as an objective presentation of fact, untainted by product pitches or by overt editorializing, had yet to appear as an industry standard. This state of affairs would continue into television, breaking free only after the quiz show scandals helped to reduce the power of sponsors and put the networks in greater control of their own programming. Did this mean that commercial influence and editorial bias would disappear? Or did it mean that they would retreat under a cover of careful neutrality, replacing overt commentary with biased principles of selection and presentation? We will see these tensions played out as television enters the scene after the war.

UP AND DOWN WITH THE FCC

ABC Enters the Scene

Notwithstanding the overall spirit of cooperation between government and the broadcasting industry during the war, this was an active period of regulatory intervention by the FCC. In fact, as some historians contend, "Cooperation is not a word to describe wartime activities of the FCC" (Sterling and Kitross 2002, 259). Chairman James Lawrence Fly, a trusted associate of Roosevelt's, was determined to make commercial broadcasters more accountable to the public interest, wartime cooperation or no. In the first place, the monopoly investigation that had begun under President Roosevelt's second term reached a resolution in May 1941 in its *Report on Chain Broadcasting*, recommending not only changes in network-affiliate relations but also that no license should be granted to a station owned by any company that itself owned more than one network. This meant that NBC, if it wished to continue owning stations, must divest itself of one of its two networks. NBC and CBS both brought suit against the FCC's ruling, with Mutual on the other side supporting the new restrictions. After much legal wrangling—including an antitrust suit filed against the two networks by the Justice Department—the U.S. Supreme Court handed down a decision upholding the FCC's powers and enforcing the divestiture order.

Edward Noble, owner of the Lifesaver Company, made an offer to purchase NBC's always less-profitable Blue network for $8 million. But all was not resolved: Because it involved transferring three station licenses, the purchase required FCC approval.

During the approval hearings, the question of the relation of news to commercial sponsorship came up for specific discussion. Commissioner Fly asked Noble's representative Mark Woods very pointed questions about his policy on controversial programming. Woods responded with what had become the broadcasting party line: A show like the *Ford Sunday Evening Hour*, despite the militantly antilabor commentary delivered by William J. Cameron, was permissible because its primary purpose was to sell goods, not recruit listeners to a political organization or viewpoint. The network would not, however, sell time to an organization like the American Federation of Labor (AFL) because, as Woods explained, "they have a particular philosophy to preach." Didn't Cameron have a particular philosophy to preach, Fly queried? When Woods parried that question with the objection that the AFL was attempting to recruit

membership in an organization (a practice specifically barred by the NAB after its Radio League of the Little Flower experience), Fly inquired whether that wouldn't also apply to the American Red Cross or mutual life insurance companies. Woods responded that that was different.

Fly remained unconvinced. As a condition for approving the sale, he required Noble to submit a statement that on the new network, "all classes and groups shall have their requests, either for sponsored or sustaining time, seriously considered . . . in accordance with true democratic principles." The new network, the American Broadcasting Company (ABC), came into being on October 12, 1943. It adopted a policy of selling time to organized labor. Pioneer station WJZ lost its historic call letters as a part of this agreement, becoming the ABC anchor station WABC. Now there were four separate networks, though one would not make the transition to television. In early 1943, the FCC itself came under attack for its crusading policies; conservative Congressman Eugene E. Cox led the attacks, which claimed that the FCC had exceeded its mandate by interfering with broadcasting industry operations. Though the investigation yielded little, Fly resigned in 1944.

Spectrum Struggles

The second major battle of the war years centered around two new developments: the improved radio technology of frequency modulation (FM) and the impending technology of television. FM was a new technique for transmitting radio that produced a higher-quality signal with greater clarity of tone. Edwin Howard Armstrong had developed the technology in the 1930s, and at first it seemed to have a bright future. Though the building of FM stations was hampered by an FCC freeze on new licenses while it investigated station ownership in the early forties, FM had widespread industry support. But finding a place for it on the electromagnetic spectrum sparked a battle between FM and the backers of television, notably RCA. David Sarnoff fought bitterly with Armstrong over taking up potential favorable television frequencies for a new radio competitor. RCA had great investment in television, and Armstrong had refused to cut RCA in on FM development. Finally FM was assigned to a much higher-frequency band than previously, from 88 to 108 megahertz (MHz), making all existing FM receivers obsolete. This was a setback for FM from which it would not recover until the 1960s. But FM's time would come, aided by developments in high-fidelity stereo recording and by the FCC's decision to set aside the bottom channels of the FM band (88–92 MHz) for educational purposes.

But the FM battle was the minor skirmish in the struggle over TV allocations. Television had been under development since the 1930s, primarily in the laboratories of dominant radio powers RCA and CBS. RCA heavily supported a "television now" platform that recommended getting the stalled technology out to the consumer marketplace as soon as possible after the war. This timing would also allow a seamless transition from wartime electronics manufacturing to consumer electronics, without a fall in profit margins. To do so meant committing to RCA's system of television, which had been in development since the early thirties: a black-and-white standard operating on the VHF (very high frequency) band and taking up considerable bandwidth. This system would also interfere with FM allocations. CBS, on the other hand, supported delaying the

introduction of television until a color standard could be made available and advocated using the UHF (ultrahigh frequency) band, where much more space was available. Otherwise, CBS supporters argued, the United States would get a TV system with very limited space for channels and would stick consumers with soon-to-be-obsolete black-and-white receivers, when color was so close to being ready.

FCC hearings on television began in 1943 and continued through 1944. In early 1945, the FCC handed down decisions that would decisively shape U.S. broadcasting for decades to come. Going almost entirely with the RCA recommendations, the FCC settled television transmission in the VHF spectrum, allocating only 13 channels for national service. It approved RCA's black-and-white system to begin production as soon as the wartime exigencies lifted. Though there was widespread agreement in government and industry alike that 13 channels were too few for a national television service, RCA urged a vision of "television now" that saw this state as only temporary. However, as things turned out, this decision virtually doomed the far greater channel capacity of UHF broadcasting from the beginning. UHF presented a possibility for a many-channeled TV universe that would never be fulfilled, as the television industry dug in on the VHF band and resisted change. We will see how this shortage of channels led to the development of the classic network system oligopoly in the future. Color television would not become widely available until the 1960s.

Conclusion

Radio broadcasting played a central role in American life during the war-torn years of the 1940s. Yet its very centrality made it a controversial, tension-ridden medium on which many conflicting currents of American society played themselves out. Much of the concern over radio involved ideas about the audience: Did radio create a susceptible, easily manipulated mass public that needed to be firmly directed by experts disseminating the right kind of information? Or did radio reach a rational, reasonable group of responsible individuals who could make informed decisions based on a range of information and opinion?

Demagogues like Father Coughlin inflamed the debate, which led to a series of decisions that worked to restrict the scope and depth of political discussion on the airwaves. At the same time, as the war heightened the need to define "who we are and why we fight," radio offered up increased opportunities for less-powerful social groups to demand the ability to speak for themselves, to address the inequities and antidemocratic aspects of American life. For the first time, programs that explicitly addressed the history of racism and prejudice in the United States reached a broad public on the airwaves. Though these first efforts were cautious and hampered by oppositional views, they provided a vital forum for the momentum that would lead to civil rights reforms after the war. Other programs recruited American women into a newly defined sphere of paid work and public service.

Advertisers, stations, networks, and government agencies worked hand in hand, though not without friction, to build public morale and spread important wartime information and encouragement. Programs produced for American troops abroad boosted morale overseas. News coverage developed enormously but still struggled with

the conflicts between commercial and informative agendas, between self-interest and objectivity.

And meantime, television hovered in the wings. Though it would not be allowed on the public stage until the postwar years, important decisions affecting American television for the next 50 years were made in a close collusion between government and industry, as the American public looked the other way. Broadcasting as an industry emerged from the war years in a much strengthened position, despite the controversies surrounding it. Television would fulfill the promises that radio had made, and so often broken, decades before. It would be the "shining light in the center of the home," delivering the same utopian promises that radio had offered a few decades previously. Yet the war years had set the terms of the argument that would quickly focus attention on television's darker side, notably its established position in the pockets of commercial networks and sponsors. Television's amateurs, far from the inventive individuals in garages and attics who had built up early radio as a practice and a set of ideals, were engineers and scientists in the laboratories of RCA, CBS, and General Electric. TV belonged to industry from the start.

At Last Television, 1945 to 1955

The president who had led America through the struggles of war and the Depression did not live to see his final triumph: Franklin Delano Roosevelt died on April 2, 1945, less than a month before victory in Europe and two weeks before the first convention of the United Nations that he had worked so hard to achieve. Vice President Harry Truman assumed the office in his stead, and it was to Truman and the other Allied heads that Germany surrendered on May 8, 1945. War still raged on the Pacific front. President Truman presided over the momentous decision to drop atomic bombs on the Japanese cities of Hiroshima and Nagasaki, on August 6 and 9; by August 14, Japan had accepted the Allied terms of surrender. The war was over.

Between 35 and 50 million people perished during this war-torn decade, with heaviest losses in central and eastern Europe. European cities lay in ruins, their industrial centers and transportation systems destroyed. With the former major powers in realignment and disarray, a movement toward overthrow of colonial governments would soon begin across the globe. As negotiations at the end of the war attempted to resolve these complex issues, a standoff began to develop among the United States, European states, and their former ally the Soviet Union. Ink had hardly dried on the peace treaties before the first movements were seen of the struggle that would occupy the next several decades. The Cold War began almost before the World War II ended.

Social Context: Returning to Normalcy

A far more fortunate condition existed within the borders of the United States. Aside from the initial attack on Hawaii, no part of the United States had come under hostile invasion. Though over 300,000 American troops had given their lives in the fight, the main problems faced by the United States at the end of the war involved negotiating its way through the peace process and rebuilding the domestic economy. As soldiers, sailors, and airmen were demobilized between 1945 and 1947, they returned to an economy gearing up for a consumer boom and to "full employment" policies that gave high priority to placing ex-servicemen in well-paying jobs. Women during this transition to peacetime had a new job: returning to their role as homemakers, wives, and mothers. This last job became particularly pressing as the baby boom began. Between

1947 and 1960, an unprecedented number of children were born to war-generation parents, creating a demographic bulge that would have enormous effects on American popular culture and media.

Labor Unrest and the Rise of Corporate Liberalism

A sharp outbreak of strikes and labor disputes mark the immediate postwar years, much to the dismay of President Truman. During the winter of 1945–1946 General Motors workers went on strike for 113 days, in early 1946 steel workers threatened a general work stoppage, and in May the railroad unions joined in. Though a Democrat and longtime labor supporter, Truman proposed some of the most restrictive labor legislation in U.S. history, even at one point urging that recalcitrant workers be forcibly drafted into the military if they refused to comply with back-to-work orders. Truman vetoed the severe antilabor Taft-Hartley Act of 1947 (though it passed anyway) but continued to sit on the labor fence. Though the late 1940s through the early 1960s were growth years for unions, a new kind of social contract was about to take precedence.

A major area of initiative during the Truman administration was the expansion of social welfare policies. In the wake of the New Deal, Truman proposed his Fair Deal, and the postwar decades witnessed expansion of Social Security benefits, higher minimum wages, and a variety of housing subsidies, including the Federal Housing Authority (FHA) and Veterans Administration mortgages so crucial to suburban expansion. The GI Bill allowed more American men than ever before to get the kind of higher education formerly reserved for the upper classes. The Interstate Highway System was under construction with heavy federal funding, channeled through private construction companies, to the great benefit of the automotive industry.

This system of government initiatives benefiting the public through the intermediaries of American industry defines the new era of corporate liberalism. American corporations would play a central role in social welfare policies in the decades to come, prospering through federal initiatives and, in return, cooperating in extending benefits to their employees. In exchange for liberal concessions, workers were expected to play a cooperative role in the rise of the postwar economy. Big labor agreed with these conditions, and one of the strongest periods for labor union membership in the country's history emerged over the next two decades. However, with both unions and corporations defining their primary constituency as white men, other groups such as women and minorities lost ground in income and employment opportunities during these "good years."

The rise of corporate liberalism affected the development of American television. Increasingly, as we shall see, the Federal Communications Commission (FCC) would define its job as protecting the television industry against interlopers and competitors and would consistently work to restrict the number of television outlets and to keep them in major network hands. Along the same lines of tension that had developed before the war, it seemed that the interests of democracy could best be served by restricting control of this promising new medium to the ministrations of "experts": those established corporations that had served the government so well during the war. If this meant less democratic access to the airwaves, well, a new war had broken out.

The Cold War at Home

The polarization of power between the United States and the Soviet Union after the war, combined with conservative backlash against the civil reforms of the war years, provoked a fierce anticommunist reaction at home. The Soviet Union's avowed intentions of spreading communism worldwide became associated with "un-American" values at home—such as support for labor, civil rights for African Americans, and even women in the workplace. Many people who had espoused liberal causes had joined or attended meetings of the American Communist Party during the Depression years, or had friends who did; now this became a matter of sedition and criminal disloyalty. Former liberals (such as actor Ronald Reagan) hastened to recant. As the House Un-American Activities Committee (HUAC) convened in 1947 and Wisconsin Senator Joe McCarthy embarked on his colorful revelations of Reds in high places, the media industry was particularly hard hit.

A system of blacklisting developed, by which the industry relied on paid political consultants to tell them who might have an unseemly Red tinge to his or her views. Mention of a person's name in a publication such as *Red Channels*, a report done by publishers of the scurrilous anticommunist newsletter *Counterattack* on Communist influence in the radio and television industry, ended or severely impaired illustrious careers. Not surprisingly, a high proportion of these names were Jewish and African American. They included Langston Hughes, Leonard Bernstein, Norman Corwin, Lena Horne, Howard Koch (of "War of the Worlds" fame), Dorothy Parker, Zero Mostel, Pete Seeger, William L. Shirer, Jean Muir, Howard K. Smith, and Orson Welles. Also named was William Robson, author of *An Open Letter on Race Hatred*.

In the movie industry, the Hollywood Ten were indicted for their refusal to testify in front of the Committee; several went to jail, and all who refused to name names found their careers profoundly affected. Even those whose radical activity consisted merely of supporting President Roosevelt's bid for a fourth term could now be considered dangerous pro-communists and placed under investigation by Hoover's FBI.

In this atmosphere, it was not enough to simply be innocent; sometimes active anticommunist activities were required to clear one's name. This situation would have an effect on early television programming. So would the outbreak of the Korean War in 1950—America's first actual Cold War engagement. Unlike the government and media cooperation of World War II, the divided politics of the Cold War brought censorship efforts to the fore as the military attempted to control press coverage by force. The United States would not have its first television war until the outbreak of hostilities in Vietnam.

The Race Issue Redux

During the late war years, African Americans consolidated some of the political advances they had struggled for. In 1946 President Truman created a commission to investigate the subject of civil rights. The next year the National Association for the Advancement of Colored People (NAACP) attempted to use the new international Human Rights Commission of the United Nations to petition for racial justice in the United States. This enraged the anti-Roosevelt contingent by seeming to compound all

the things they most objected to about the postwar world order, and though the petition was blocked, it attracted international attention to the subject of American civil rights. Truman became the first American president to address the annual meeting of the NAACP in 1947, by finally taking a firm stand on race issues and acknowledging the federal government's obligation to enforce civil rights efforts—a message he delivered over national radio.

In the fall of 1947 Truman's commission released its report, entitled *To Secure These Rights*, which specifically rejected the "separate but equal" doctrine behind segregation laws and called for the immediate end to segregation in the military. The stage was set for a new era in racial struggle and coalition, leading up to the momentous *Brown v. Board of Education* decision in 1954 that began the desegregation of America's public schools. However, the Truman administration's simultaneous support for the Cold War crackdown would undercut this brief victory. Television, however, provided a new avenue for information for the civil rights struggle, and as radio changed in reaction to TV competition, a new venue for black voices on the air would finally emerge.

THE MEDIA ENVIRONMENT

Not just the broadcasting industry went through a period of adjustment and transition in the postwar decade. Along with the rest of the nation, U.S. media adjusted to sweeping changes in the contours of American life. A return to active consumption, new families being created left and right, the move to the suburbs, demand for cars and other durable goods, rising wages and prosperity, the beginnings of the youth market—all of these factors meant a boom in media consumption along with the advertised products that supported it. But not all the old players would survive. This was also an era of social criticism and an active federal government, of "the hucksters," the "generation of vipers," the "seduction of the innocent"—titles of popular books of social indictment during the postwar period—all of which at least partially blamed the media for social ills.

A New Deal at the Movies

A decade of exhibitor complaints and federal investigation led inexorably to the same kind of restructuring of the film industry as the FCC had imposed on radio in 1941. The Paramount decision of 1948 forced the major film studios—Paramount, MGM, Warner Bros., 20th Century Fox, and RKO—to divest themselves of their theater chains and reduce the vertical integration of the movie industry. Without the guaranteed venues for good and bad films alike that ownership of theaters had brought, the studios began to reduce their contractual commitments to the stables of actors, writers, directors, and producers that they had maintained throughout the studio system era. A new day of independent producers, more powerful agents and stars, and an influx of European talent and films began to dawn. On top of this industrial instability, the blacklist created an atmosphere of threat and intimidation as Hollywood craft unions flexed their muscles and the studios allied themselves with anti-Red forces to crack down on their own restive labor force. No wonder this was the era of *film noir*, the dark, conflicted, fatalistic style that delved under the surface of this period of victory and prosperity.

Television, too, loomed on the horizon. Film industry executives took an early interest in television, just as they had in radio. However, their efforts at direct competition were thwarted by a protectionist FCC and by recurring internal pressures. Warned against trying to own significant numbers of stations or to start networks—because as antitrust violators they could not qualify for licenses—industry leaders tried other routes. Paramount Studios owned Los Angeles station KTLA, having gotten a license before the antitrust decision. It also owned a half interest in the DuMont network, started in 1946 by Allen B. DuMont to compete with the fledgling television efforts of the big three. In 1953, one of the spun-off theater companies, United Paramount Theaters, would purchase ABC, marking a first step in the increased integration between film and television.

To compete with the rival medium, the film industry developed techniques and formats designed to blow the tiny black-and-white TV image right out of the water. Wide-screen formats like Cinerama and Cinemascope, three-dimensional techniques that required the use of special glasses, drive-in theaters where the whole family could take in a double feature from the comfort of their own car, and full glorious Technicolor all went where TV could not follow—yet. The blockbuster hit began to replace the constant supply of A and B grade movies, and possibly in a reaction to television's strict rules, the old Production Code that kept movies innocent was challenged and dissolved after a series of First Amendment lawsuits. A new period of screen sexuality and daring slowly emerged, led by the high critical acclaim that greeted some of the European films that found a spot on America's big screens. At the same time, studios such as Disney began to specialize in the baby boom child and teen audience.

Several studios became involved in developing early rivals to broadcast TV. One idea was *theater television*, a technique for broadcasting television signals onto movie screens in theaters. This concept gained some popularity early on—when few homes owned television sets—especially for big-ticket events like national sporting matches, but faded due to the FCC's refusal to grant permission for microwave transmission. Another alternative, *subscription television*, experimented with an early form of pay cable through which movies and other special programs could be transmitted into home sets for a fee. Again, the FCC stepped in to prevent testing of a technology they saw as a threat to over-the-air television. Americans would have to wait until the mid-1980s before they were allowed to experience uncut movies on cable.

Though studios would hold back on production for network television until the time was right, by the late 1950s most prime-time TV shows were produced on film by major Hollywood studios. In fact, the Hollywood-TV connection and rivalry would be responsible for some of the major characteristics of American television as it developed. Though denied outright ownership and network control for its first four decades, Hollywood would slowly take over television from the inside.

The Print Media

Newspapers and magazines emerged from the war years with higher circulations than ever. The premium that the war had brought to news coverage continued, and although suburbanization caused the number of cities with two or more dailies to drop, new dailies sprang up in the suburbs to take their place. Many newspapers became

television station owners, just as they had with radio. In many cities, a major newspaper not only owned a major AM radio station but also expanded its stable to include a network affiliate TV station and an FM station. This kind of concentration would cause the FCC to institute new rules regarding cross-ownership in the near future.

General interest magazines like *Life*, *Look*, and *The Saturday Evening Post* continued to see their circulations increase in the decade immediately following the war. The trend toward special-interest magazines began to accelerate. One notable addition to the magazine world was *Playboy*, whose controversial editor Hugh Hefner espoused a new kind of masculine lifestyle seemingly at odds with the family-oriented 1950s. Other titles to emerge in the late forties or early fifties include *Sports Illustrated*, William F. Buckley's *National Review*, and John Johnson's *Ebony*, founded in 1945 as the first national glossy general interest magazine for African American audiences. The black press continued strong in the immediate postwar years, with a circulation of nearly 2 million in 1947 among its combined newspapers. And as the media industry discovered the youth market, teenage girls became a particular target of magazine publishers with titles such as *Seventeen*, *Teen*, *Ingenue*, and *Mademoiselle*.

Books

The 1950s are known as the era of the paperback. With new specialty houses like Bantam Books, Penguin, Fawcett, Dell, and New American Library springing up, more new and classic titles at extremely low prices were available to the American reading public than ever before. For as little as 25 cents, readers could purchase new fiction and nonfiction blockbusters, like William L. Shirer's *Rise and Fall of the Third Reich*— though its doorstopper size meant a whopping price of $1.65. Genre authors like Dashiell Hammett, Raymond Chandler, and James M. Cain thrilled audiences with inexpensive print versions of *film noir*, while romance novels bloomed. Comic books found a whole new audience—during the war as light reading for soldiers and afterward, for their kids. In 1943 U.S. comic book sales totaled over 18 million monthly copies, constituting a third of all magazine sales, to a tune of $72 million.

Many of these comics, catering perhaps to the interests of their soldier readers, took on increasingly violent content. Congressional investigations were held in 1951 and 1954 on the influence of such violent media on children. The publication of psychologist Frederic Wertham's *Seduction of the Innocent* in 1954 marked the mid-stage of the latest media panic, charging that America's out-of-control popular media, particularly comic books, were coming between parents and children and leading to an outbreak of juvenile delinquency and rampant sexuality, including homosexuality. Though in fact crime statistics remained low throughout this period, the revived threat of mass media combined with the rising teen population ushered in a new era of media investigation and audience research.

Advertising and Public Relations

Advertisers returned enthusiastically to selling consumer products to the American people after the war. As the economy boomed, so did the advertising industry. Total advertising volume went from $2 billion in 1940 to $10 billion in 1955. Advertisers

resumed their pursuit of the female consumer even more relentlessly, targeting her as the major purchaser of household, personal care, child-related, and fashion products that drove the postwar economy. As Susan Douglas points out in *Where the Girls Are*, this situation put American women in a double bind. To be able to afford the shiny new things that absolutely every household needed to have, and to fill the teaching, secretarial, and retail positions opened up by the consumer economy, women took on paid employment outside the home in greater numbers than ever before. However, these were not the high-paid, unionized, manufacturing jobs of the war years; these were the pink-collar ghettos—specializing in low wages, part-time hours, and few benefits—that labor unions couldn't be bothered to organize.

On top of her outside employment, the American woman was portrayed in advertising as fully responsible for all the traditional women's duties—cooking, cleaning, raising children, running a household—except now with new labor-saving devices, she should find it ridiculously easy! Even as 55 percent of U.S. women found themselves on the double-shift mommy track—working in the house for an average of 99 hours a week and outside for pay another 10 to 40 hours—advertising on television and in print portrayed them as golf- and tennis-outfitted ladies of leisure, waving happily from behind the steering wheels of their new Chevy coupes. It wouldn't be long before this feminine mystique would be revealed in all of its duplicity. Surely it is no coincidence that during this postwar period, tranquilizer prescriptions to American women boomed.

As part of the corporate liberalism era of consensus building, corporate public relations expanded to sell the image of American business to the public and to handle relations with the generally friendly media. Large companies greatly expanded their public relations (PR) efforts; General Mills went from employing a three-person PR staff in 1945 to an in-house bureau of 20 in 1952, assisted by an outside PR firm. The major advertising agencies expanded into the field of PR, and new PR specialty firms sprang up. Early news programs sponsored by product manufacturers found a ready outlet for company PR thinly disguised as news segments. The business of America was business again.

Radio

Radio did not disappear or fade away during the postwar period of television introduction. But it changed, going from a nationally networked medium that served as America's central source of big-ticket advertising and home-based entertainment to a local, music-dominated, more diverse and fragmented industry that addressed a nation spending more and more time in front of the small screen. By 1953, nearly 60 percent of cars were equipped with radios; lightweight, portable transistor radios were introduced that same year. By 1960, the average American home had more than three radios; radio traveled along with family members as they drove to work, hung out with their friends, sunned themselves in the backyard. Yet between 1948 and 1956, the time spent by the average American family in listening to the radio dropped by 50 percent: from 4.4 to 2.2 hours per day. This drop reflected the decision made by the industry immediately after the war to shift network economics to television. For the first five years of its existence, TV service was supported by profits from the still lucrative radio

network operations; many programs were simulcast on both media. Quickly, the former radio networks repositioned themselves as TV networks—moving staff resources, sales efforts, talent, and programming to the new medium. However, quite a few national programs remained on radio through the early 1950s, particularly on daytime.

This slow transition was aided by the freeze on television station construction, instituted by the FCC in 1948. From 1948 until 1952, many cities remained TV-less, and while the major networks consolidated their ownership positions and built their cross-country networks, radio continued to provide the main entertainment for approximately half the country. In 1952 there were 108 TV stations on the air, and only 35 percent of U.S. homes owned a television set. So during the late forties and until the late fifties, many people continued their radio listening as before. Though the big-name prestige variety shows made the switch to TV early on, many continued with their aural portion simulcast on radio, and the comedy and thriller series that had become so prevalent during the war years continued as usual. Only now more and more of them were presented as sustaining shows, and more went out not live but as recordings. Daytime offerings continued robustly, because the TV networks delayed developing daytime schedules fully until the mid-fifties. Daytime serials were the last to go; Ma Perkins finally bid her loyal radio audience goodbye in 1960.

Gradually, radio stations began filling up the bulk of their daily schedule with locally produced shows. A growing number of programs centered on music, not on the live bands of network days but the playing of records on air. A new sound for radio slowly emerged, along with a new type of personality: the DJ, or disk jockey, spinning platters and filling in the recorded musical interludes with jokes and hip talk. And it wasn't just your father's music anymore. A new diversity of voices gained a place on the airwaves, bringing new varieties of musical expression with them. With the centralizing and standardizing influence of the networks slowly diminishing, radio could once again unleash its regional and local potential, become experimental again, and serve communities in a different way.

Connection DJs, Black Radio, and the Rise of Rock 'n' Roll

In the late 1940s, African Americans finally found a foothold on radio. A few programs and innovative entrepreneurs gave a foretaste of things to come. As William Barlow describes in *Voice Over: The Making of Black Radio* (1999), urban radio pioneers like Jack L. Cooper and Al Benson built up their own radio empires in the 1930s and early 1940s by buying time on local stations like WGES in Chicago, finding sponsors eager to sell to the black community, and playing the music they knew that community wanted to hear. In the early 1930s Cooper had originated a prototype of the disc jockey format on Chicago station WSBC. Because "race records"—recordings featuring black musicians playing black-oriented music—were not licensed by the American Society of Composers, Authors and Publishers (ASCAP), they provided a virtually free form of programming that, if the DJ also owned a

record store, could provide profits down the line. Cooper's *All Negro Hour* became the first DJ program on the air, and he soon added other DJs playing different varieties of music as he built up his Chicago radio business.

Many other local broadcasters, black and white, would adopt some form of the record-based program. But it is Benson's crucial addition of the distinctive, hip, jive-talking personality in 1945 that inspired the DJ format. As mainstream radio faded, and as the FCC created hundreds of new low-power stations across the country, such low-cost music-based shows became attractive to stations owners. At the same time, the increasing affluence of African Americans in urban centers made this overlooked audience attractive to advertisers. WDIA in Memphis, Tennessee, was the first station to shift to "black format" radio in 1949, led by black radio host Nat D. Williams. Other stations followed suit. Many of these combined a variety of programs—religion, news, drama, household advice—around a core of DJ-hosted music, mostly rhythm and blues (R&B) mixed with gospel and bebop. Early black DJs prided themselves on their colorful verbal style—referred to as "rhymin' and signifyin'"—which was often reflected in the unique names they used on air. WDIA's staff included Maurice "Hot Rod" Hulbert, A. C. "Moohah" Williams, the Reverend Dwight "Gatemouth" Moore, and Jean "the Queen" Steinberg. America's only black-owned station, WERD-Atlanta, featured "Joltin Joe" Howard and "Jocky Jack" Gibson, and "Daddy-O" Dailey held forth on WAIT-Chicago.

Soon the familiar process of cultural appropriation began to take place, as white DJs adopted black style and personas on air. This process was assisted by an ASCAP decision in 1939 to raise its radio fees, prompting the National Association of Broadcasters (NAB) to start its own music licensing bureau, called Broadcast Music International (BMI). To compete with behemoth ASCAP, BMI began looking for new artists and styles to promote. In the right place at the right time was Alan "Moon Dog" Freed, who started out with an R&B program on Cleveland's WJW in 1951. Adopting black street slang, playing black music, affecting a black accent, Freed was not the first racial ventriloquist to take to the airwaves (his ancestors can be found in *Amos 'n' Andy*'s creators), but his "crossover" privilege as a white man would allow him to reach a national audience with what he began calling rock 'n' roll music. He began hosting concerts that brought out the burgeoning mixed-race audience for this new hybrid, black-accented music. New York station WINS hired Freed in 1954; there he became, as Barlow puts it, "the airwaves' undisputed king of rock-and-roll broadcasting" (Barlow 1999, 182).

Another equally famous racial ventriloquist was Wolfman Jack on the border blaster XERF in Tijuana. Though he was actually Robert Smith from Brooklyn, New York, Wolfman Jack came to personify the spirit of rock 'n' roll in southern California (glorified forever in the movie *American Graffiti*, in which he appeared as himself). The Wolfman learned his technique from black DJ John R. of WLAC-Nashville, who by that time ran a DJ school to teach young white adherents how best to sound like black radio jocks. John R. was not the only one to adopt this tactic: Vernon Winslow of New Orleans trained a whole series of white men to take on his original "Poppa Stoppa" personality over WJMR. The station's white owners would not allow the original Vernon on the air, but instead paid him to produce acceptable black-sounding white substitutes. Later Winslow rose to fame himself as Doctor Daddy-O on rival station WEZZ.

Such black-styled DJs as Alan Freed and Wolfman Jack became important figures in the development of rock 'n' roll music. In these days before music formats, DJs exercised complete power over which records were played on their shows. Whole new record

labels—Chess, Sun, Atlantic, Dot—sprang up and thrived, dependent on the good favors of influential DJs. Toward the end of the 1950s the payola scandal (discussed in Chapter 8) would signal the beginning of the end of DJ autonomy, as the top-40 format placed power in the hands of station management and away from those of maverick platter spinners. Further, the type of racial mixing and hybridism so fundamental to rock 'n' roll music and its radio presentation began to stir up anxiety in white middle-class authorities, who would contribute to the early 1960s campaign to clean up radio (and television). Freed ended up disgraced and in jail.

Black-format radio stations would remain centers of local identity and pride for African American communities nationwide. During the civil rights struggles of the 1960s and the urban upheavals of the 1970s, black radio would play a vital role in disseminating information, calming rumors, and offering advice to black communities under siege. By the 1970s over 140 radio stations in the United States would be black owned. They would form the backbone of groups like the National Association of Black Owned Broadcasters (NABOB) and the National Black Media Coalition, which would lobby for increased African American presence in and ownership of the media. Rock 'n' roll, of course, was here to stay, as it became the new version of big-band swing: white faces covering black hits for increasing numbers of young white fans, waiting for the British invasion to consolidate it as a mainstream cultural form and marker of the baby boom era.

And America's black-radio-inspired DJ format would not stay at home. In the 1960s, European radio was still dominated by the state-subsidized monopoly broadcasters that had arisen in the 1920s. There was no place on the airwaves for youth-oriented music; the exciting strains of rock and roll that sometimes made their way via recordings across the Atlantic were kept carefully off the mainstream airwaves. So radio moved offshore. The famous "pirate broadcasters" of the 1960s put radio transmitters on ships anchored just outside national jurisdiction—in the British Channel, the North Sea, the Mediterranean—and aimed their powerful radio signals at England, France, the Netherlands, Spain, Germany, and many others. Playing American-inspired rock and roll, often staffed by American DJs, such pirate broadcasters as Radio Caroline, Radio London, Radio Veronica, and many more would internationalize rock music and eventually bring a new style to radio across Europe and across the world.

TELEVISION'S GOLDEN AGE

Very little public debate about who would control or fund television preceded the introduction of this long-anticipated technology. Unlike radio, which had gone through the period of amateur experimentation, competing models, and regulatory dispute, television slid smoothly out of the retooled factories of the major electronics firms and into American living rooms, complete with established corporate owners, regulatory structures, and even programming. NBC and CBS had long prepared for this day, and even during heated disagreements over technical standards and spectrum allocation, no one seriously proposed that they should have anything less than the major stake in the rapidly emerging TV industry. It was a done deal.

Equally certain was the fact that the movie industry should be kept far away from television, although film remained the medium closest to how television would actually look and sound. Despite its own wartime service, the film industry had always suffered from a roguish reputation, and the charges made by exhibitors of sharklike competitive methods and outright monopoly did not help. Those who looked to television for an increased level of public service programming—inspired by wartime efforts—could hardly feel enthusiastic about the influence of such a hugely commercial medium as the movies. In this spirit, *Consumer Reports* magazine, the voice of an emergent grassroots consumer movement that would become more and more powerful during the fifties and sixties, came out in February 1949 with an ardent condemnation against allowing any kind of movie industry influence in the new field of television. Many felt that film studios would seek to hold up the development of this competitor medium. Certainly one couldn't envision allowing the makers of such steamy dramas as *From Here to Eternity* or *Stromboli* into the living room to entertain one's children! And all those Reds in Hollywood could hardly be a good influence either. Cutting off the theater television and subscription TV business before the film industry could establish a foothold in either seemed like preventative medicine.

The former radio giants wasted no time in moving major talent from the aural-only airwaves onto the small screen. Though prime-time schedules before 1950 featured large blocks of boxing, wrestling, and other ready-made live programming (and the daytime remained totally empty), by 1950 many former radio hits had found their way to television, including *The Goldbergs*, *The Life of Riley*, *One Man's Family*, *The Aldrich Family*, *The Texaco Star Theater*, *Kay Kyser's Kollege of Musical Knowledge*, and many more. In new made-for-TV venues, other programs featured radio stars like Jack Benny, Arthur Godfrey, Ted Mack, Ed Wynn, Vincent Lopez, Don McNeill, George Burns and Gracie Allen, Frank Sinatra, Paul Whiteman, and numerous others. Sports programs like Gillette's *Friday Night Fights* also carried over, beginning with the Joe Louis–Billy Conn fight 1946, the first major postwar sporting event on television. By 1953 the flow had become a deluge, and television officially took over as America's primary in-home entertainment medium.

It is interesting to speculate on what would have happened had the FCC decided that radio and television should have different owners. In Great Britain, where television actually got an earlier start but where all remained in the hands of the BBC, the two media were encouraged to coexist. Even while television developed, slowly, as an entertainment and information medium, radio continued to be a vital presence in British life—not just for music and news but for drama, documentary, comedy, and public affairs. Countries with public service systems—like Britain, Canada, Australia, France, and just about every other—still have a tradition of diverse radio offerings whose counterparts are nearly nonexistent in the United States. Here, the radio networks simply abandoned radio for TV, driven by a conviction that it would provide the superior advertising medium. By the time radio proved to have a strong continuing appeal, its use and the expectations of its audiences had already shifted. Had the FCC, say, told CBS and NBC that they should keep their radio empires but stay out of television, and either told the film studios to have a go

at TV or selected competing companies like DuMont for preferable treatment, the American media universe might be quite different today. But the FCC had other matters on its mind.

THE BLUE BOOK

If one could characterize in a few words the FCC's actions in this crucial initial period for television, they would be "restrict, delay, consolidate." The postwar period started out with a bang, with the publication in 1946 of the FCC's famed Blue Book, actually entitled "Public Service Responsibility of Broadcast Licensees." Based on wartime reconsideration of the quid pro quo system of American broadcasting that it had administered for two decades, the report castigated U.S. stations and networks for not living up to public service expectations even though their profits had increased dramatically during that time. The Blue Book showed that the agreement made with educational groups during the early 1930s—that there was no need for separate educational stations, because existing commercial stations would provide ample time for educational programming—had been undercut and betrayed, with sustaining hours ever decreasing and public service programs relegated to the least attractive parts of the broadcast schedule.

The FCC reaffirmed its duty and willingness to act as an enforcer of broadcast standards during license renewal applications, laying out four areas that its officials would be looking for as they considered renewals: a balance of commercial and sustaining programs, the provision of local live programs, the presence of public affairs programs that discussed public issues, and the elimination of advertising excesses. (It is no coincidence that a main author of the report was Charles Siepmann, a former BBC executive.) Though the Blue Book went further than any other report had in spelling out the FCC's expectations of commercial stations, it did not threaten immediate action. It was met with the usual First Amendment protests from the industry, and although no striking reforms took place, the Blue Book set the tone for considerations of television licensing and performance. It marks the continued presence and agenda of the war-era reformers in the Office of War Information.

Another highly critical publication appeared in 1947: "The American Radio" was a report from the Commission on Freedom of the Press, authored by Llewellyn White. With such influential names behind it as Harold D. Lasswell, Archibald MacLeish, Arthur M. Schlesinger, Reinhold Niebuhr, and John Grierson, this analysis of radio's shortcomings called for not only more local and educational programming but also investigation of ownership concentration and other restrictive industry practices, more public affairs programming, the protection of First Amendment rights of broadcasters, and—not finally but most presciently—the separation of programming from sponsor control. The FCC and the flourishing television industry would both remember this last recommendation in the late 1950s as the quiz show scandal heated up. Television came into being under a quality mandate. Yet, once again, notions of quality were not tied to diversity and choice but to centralized regulation and control.

THE BIG CHILL

But the FCC had a more immediate problem on its hands. By the fall of 1948 it had become obvious that previous TV frequency allocations simply would not work. Though 50 stations were already on the air, with another 50 or so construction permits authorized, the 13 channels on the VHF band, with FM intruding in between, already were becoming cramped. Faced with the problem of overlapping signals and interference in New York and other large markets, the FCC realized it needed to rethink the whole system. In September 1948, the FCC instituted a "freeze" on new licenses, putting all those applications pending consideration into a hold pile until matters could be sorted out. No one anticipated that the freeze would last four years, as additional problems like RCA's and CBS's fight over color TV, the UHF problem, and pressures for educational frequency set-asides complicated the issue.

It was not until 1952 that the freeze was lifted. This meant that the 100-plus stations authorized to operate before 1948 enjoyed an extremely favorable position as the ownership of television sets went ever upward—from less than 1 percent in 1948 to over 34 percent in 1952—and the TV craze began. Although the freeze meant that many U.S. cities and towns had to wait until after 1952 to get any television service at all, this does not mean that the existing industry was unhappy. Far from it. During the freeze years, those in possession of station licenses were able to consolidate their control of the TV market and to benefit immensely from their monopoly over revenues during this early but rapidly profitable period.

Who were the major pre-freeze owners? Why, the radio powers, of course. With stations in large urban areas and little competition for network affiliation in most markets (where two stations usually split the competition), the major networks CBS and NBC were able to gain a secure foothold in the new medium by the time the freeze was lifted in 1952. ABC, hampered by its ownership changes in the pre-freeze years, ran a distant third. The freeze also prompted the origination of a new technology, which wouldn't offer too much threat for a while but later would emerge as the networks' main competitor: cable. With over-the-air TV frozen out of many markets, enterprising citizens—often the local television dealers—erected a tall antenna in a place where it could pick up TV signals from a not-too-distant city with a station and then ran wires from the antenna to the households in town that agreed to pay a small monthly fee. It was the only way to sell TV sets in some towns.

The FCC's "Sixth Report and Order," issued in April 1952, lifted the freeze and attempted to resolve all of the pending issues: frequency allocation, UHF stations, color, set-asides, and cable. New methods of separating signals and allocating them regionally were recommended, so that station assignments could go forward. Many feel that UHF television was effectively ruined as a means of providing station diversity by the so-called intermixture recommendations of this report. *Intermixture* meant that rather than making some markets all VHF stations and some markets all UHF, the FCC assigned both VHF and UHF licenses to many cities. This created persistent poor cousins in these markets, because UHF signals could not carry as far and required special antennae that did not exist on most TV sets already out there. If some cities had been given all-UHF assignments, the playing field would have been more level,

© Bettmann/CORBIS

CBS vice-president Frank Stanton shows off the new CBS model television set to FCC Chairman Wayne Coy. Unfortunately, the FCC would rule against CBS's plan for color television.

encouraging more competition and diversity. With the official intermixed system, the established VHF stations just got bigger, and most towns wound up with fewer stations overall.

The intermixture policy also provided a mixed opportunity for educational television. Frieda Hennock, the first female FCC commissioner, served as the motivating force behind the idea of developing educational TV. The "Sixth Report and Order" stipulated that when a city had at least three VHF stations, one more had to be set aside for educational use. In other cities and towns, educational stations were confined to the UHF zone. This meant that big cities such as New York and Boston ended up with powerful VHF public stations—WGBH in Boston and WNET-New York, for example—that would later become the backbone of the National Educational Television (NET) network and, later still, the Public Broadcasting Service (PBS). However, in most cities educational broadcasting was forced to struggle along on the UHF band.

Oddly, considering the importance of these other issues, the topic that held up the freeze for an additional year was color television. A complicated history of back-and-forth decisions had not been finally resolved when pressure to expand television inspired the lifting of the freeze, without resolution of the color issue. Not until December 1953 did the FCC finally approve the RCA color system, but by that time so many black-and-white sets had been manufactured and purchased, and so many programs geared to monochrome standards, that color TV would not become prevalent in American homes until well into the sixties. And cable television was allowed to live—barely. The FCC basically ignored its existence, but regulators' failure to act in the previous four years had given cable a foothold it would later consolidate. Overall, the big beneficiaries of the freeze and its resolution were the existing powerful stations and their network owners and affiliates. As dissenting commissioner Robert F. Jones summed up, "The allocation plan was designed to cause the least disruption to the existing channel assignments of these pre-freeze licensees . . . and gave each licensee a tremendous windfall" (Boddy 1990, 54).

By 1955 the U.S. television system was set to move into its period of greatest centralized control, least diversity, and highest profits. One more change would be necessary to give networks back the control over programming they had lost to advertisers in the 1930s, and this would happen in the wake of the late 1950s quiz show scandal. Restricting the number of stations available in the average city through its allocation and UHF decisions, allowing the freeze to consolidate power in a few hands, and—as we shall see—establishing a policy of favoring live programming that would aid network expansion, the FCC created television in the image of 1940s radio. It continued the philosophy it had adopted in the 1930s that reducing the *quantity* of broadcasters—number of stations, number of maverick voices on the air, number of overall owners—would produce a higher *quality* product. The fact that this hadn't worked so well with radio apparently gave the FCC little pause, aside from its Blue Book recommendations. Even those recommendations for reform would be put to work against quantity, openness, and diversity during the period of the classic network system that soon followed. Corporate liberalism, combined with the trust in experts, meant that big business would remain the crucial intermediary between government policy and the consuming public. It was, they assured us, for our own good.

THE MEANING OF *LIVE*

Early television cameras were light intensive, bulky, and relatively immobile. They had turret lenses that could not zoom smoothly in and out, and so to move from close-up to medium shot meant switching from one camera to the next. To move from one camera to another required a complex system of switchers in the control room, because television was above all live. Videotape would not become available for another 15 years, so the only way to record early TV was to film the picture off a TV set during the live broadcast; this was called a *kinescope* recording.

Its liveness also meant that television could not be postedited, but had to be edited "in camera" by switching from camera to camera in an intricate ballet of precise marks for actors, open and fluid sets, split-second timing, and frequent bloopers. Programs went out as they happened, as on radio, but with far greater possibility of something going wrong: a missed cue, a microphone hanging from a boom into the set, an actor emoting for the wrong camera, an ill-buttoned costume, noise from offstage penetrating the presentation.

Of course, television could simply have broadcast films, which had far superior visual quality, production flexibility, and capacity for postproduction editing and soundwork. This was not as easy as it might seem, because the 24-frame-per-minute film image had to be coordinated with the TV scanning mechanism via a bulky apparatus called a film chain; but it was still possible. In fact, RCA had relied on film for its early demonstrations of television at the World's Fair in 1939, because transmission problems plagued live TV. There were reasons for not relying on a film-based production system, however—at least before 1960.

First, the former radio powers were quick to perceive that their main strength—as against all possible competitors, particularly the film industry—was their sole

Early television equipment was bulky and hard to move. Sets had to be built to enable easy movement of the cast between scenes. Cameras required such intense light that sometimes performers' makeup melted under their fierce glare.

ability to produce a *live* presentation distributed nationwide, as they had with radio. Only a network, with its real-time connection from station to station across the country, could deliver a simultaneous signal of something happening *right now* to its affiliates and audiences; no other medium could do that. The early television industry emphasized the liveness, immediacy, and nation-connecting miracle of instantaneous sight again and again in its advertising and postwar public relations campaigns. It helped the networks hold onto their primary reason for being and to their industry dominance.

Second, the FCC still preferred live programming over recorded, as it always had with radio. By now, without the technical justification of poor recording quality, this bias toward live broadcasts had taken on a life of its own, detached from other considerations. Both of these rationales came together in the third major justification for liveness in early TV: keeping affiliates dependent on the networks. Had

the television industry gone toward filmed production, it would not only have undercut the unique regulatory position of the networks but also have given local stations many more options as to where to obtain programming material. With a film-based standard, local stations could have purchased filmed programs directly from the film producers, thus completely cutting out the networks. As AT&T struggled to complete cross-country coaxial land lines as quickly as possible, so that the networks could deliver a signal into every corner of the land, the specter of stations abandoning their network affiliation in favor of contracts with film distributors haunted the networks.

Here, too, the freeze worked to the TV networks' great advantage: By the time new stations were permitted on the air in the mid-fifties, the land-line network was completed. Yet many unconnected stations had meantime turned to airing Hollywood B films and shorts, a practice the networks intended to nip in the bud as soon as they could. With all the major stars and great radio shows on live TV, stations would soon revert to network programming. So, even though a technically superior alternative to live television production existed—unlike early radio, when recording technology was not up to snuff—television during its so-called golden age remained live, as awkward and faulty as that technique could be, due not to aesthetic or practical production reasons but to industry regulatory and economic imperatives. It also produced some extremely innovative, creative, and original programming that worked around the demands of early TV production in an amazingly effective way. Hollywood's influence was kept to a minimum in these early years, allowing the live theater an avenue of creative extension that rivaled vaudeville's impact on early radio.

By 1960, with the national network complete, Hollywood brought to heel, and the favorable changes wrought by the quiz show scandal, network television would shift almost completely away from live TV to the filmed programming it had resisted so vigorously. But the live period would leave its mark—not only on the forms of television programming, but on the way that television was thought about and criticized. Liveness had an aesthetic and a politics; the meaning of *live* cannot be found in the technology or the technique, but in the cultural stakes surrounding its deployment. To say that the era of live TV was its golden age says more about cultural and industrial battles than it does about art.

High Art: The Live Anthology Drama

The programs that gained the most critical attention during this early period of TV were not the carryovers from radio, no matter how popular they might have been, but the dramatic anthology programs with a heavy influence from the New York theater. Well-known writers and directors like Paddy Chayefsky, Rod Serling, Reginald Rose, Horton Foote, John Frankenheimer, Franklin Schaffner, and Gore Vidal started their careers on television during this period. Dramatic anthology programs featured original screenplays by theater-trained authors, with casts and staff drawn from the world of New York theater; they presented a stand-alone play each week that was designed specifically to adapt to and take advantage of the unique aspects of the televisual medium.

Not radio shows reworked for TV, not films simply run on the new medium, not stage plays; these dramas were more intimate, up close, and less action filled. The anthology showcases of the late 1940s and early to mid 1950s attempted to turn television into a self-conscious art form, despite its limitations. They also reflected the efforts of New York-based critics and cultural pundits to mark out a new era in broadcasting that could redeem the medium from the vulgar populism of radio and usher in a new era of good taste, high art, and "serious" content. A few live dramas from this period hit this mark and remain classics to this day. Most of the dramas produced, like most of the films and radio shows, fell far short of this vision. However, their heritage would not rely so much on the actual dramatic productions themselves, but on the rhetorical use that would be made of them in the regulatory and industry struggles to come.

Many dramatic anthologies were on the air during this period. Some of the best known and most prestigious include the *Philco Television Playhouse*, which ran from 1948 to 1955 on NBC with Fred Coe as producer. *Studio One*, on CBS from 1948 to 1958, was perhaps the most prestigious of all. It was produced by Worthington Minor and Herbert Brodkin and featured the work of directors like Franklin Schaffner, George Roy Hill, Sidney Lumet, and Yul Brynner. Sponsored by Westinghouse, the program featured Betty Furness as commercial spokeswoman. The *Kraft Television Theater*, produced by J. Walter Thompson, ran from 1947 until 1958 on NBC, then ABC, garnering high ratings and reviews. *Robert Montgomery Presents* on NBC ran from 1950 to 1957, with Hollywood star Montgomery presiding in Cecil B. DeMille fashion as "producer" in charge of a large cast of regular repertory players along with guests who were primarily Hollywood actors. This program tended to specialize more in adaptations of movie, book, and stage properties than in original plays, though it expanded into this area as time went on. Some of its sponsors included Johnson's Wax and Lucky Strike cigarettes.

U.S. Steel sponsored *The U.S. Steel Hour* from 1955 to 1963, bringing radio's *Theater Guild of the Air* to the TV format. The Theater Guild produced the shows biweekly, live from New York, with other anthology dramas like *The Motorola TV Hour*, *The Elgin Hour*, and *The Armstrong Circle Theater* on the other nights. It started on ABC but ended on CBS. All of these programs made heavy use of both theatrical and Hollywood acting talent, with increasing emphasis on known celebrity guest stars as the decade progressed. *Playhouse 90*, with John Frankenheimer as producer and director, specialized in 90-minute plays with top casts. It aired from 1956 to 1961 on CBS.

The demands of writing and producing an original half-hour or 1-hour presentation every week, combined with the difficulties of working in this awkward new medium, often challenged the ingenuity of directors and producers. Yet the sheer number of dramatic writers working under conditions of active innovation and a good deal of creative freedom contrasted with the formulaic industry practices of both radio and Hollywood. Live television briefly became the place to be for aspiring talent. A few classics emerged, such as Rod Serling's *Requiem for a Heavyweight* and *Patterns*, Paddy Chayefsky's *Marty*, and Reginald Rose's *Twelve Angry Men*. Some writers attempted a new kind of socially conscious drama that could run afoul of sponsors and networks. On *The U.S. Steel Hour*, Rod Serling attempted to stage a drama based

on the Emmet Till trial—the true story of a young black man murdered in Mississippi for whistling at a white woman—but found himself obliged to change the plot to a conflict involving the death of an old pawnbroker at the hands of a neurotic white man—set in New England. This kind of sponsor interference and conservatism would diminish the credit the commercial system would later receive for having created the golden age in the first place.

Not all live anthology dramas featured serious original drama. Many were hosted by popular screen figures and presented the kind of stories soon to be found on filmed programming. Ronald Reagan hosted *Death Valley Days*, an anthology of western adventure stories sponsored by "20-Mule-Team Borax." James Mason hosted the *Lux Video Theater*, still adapting film scripts to the broadcasting medium. *The Doctor* was a live anthology program featuring medical dramas on NBC. Others adopted the dramatic anthology format, but on film; the *Fireside Theater* featured half-hour filmed dramas produced by Hal Roach Studios and hosted by Jane Wyman. As the fifties progressed, live anthologies gave way to filmed anthologies. From there, it was a short step to regular filmed series.

Variety Shows

The early live period of television helped to keep the old vaudeville-based variety show alive, after many had pronounced it long dead. Radio's variety programs had become more like sitcoms in the 1940s, but the demands of live broadcasting brought back the theater heritage of vaudeville as well as more serious drama. The earliest and most sensational TV phenomenon was Uncle Miltie on *The Milton Berle Show* (actually called *The Texaco Star Theater* during its early years). The show debuted at the dawn of network TV—on June 8, 1948—and swept the nation by storm; it ran for 10 years on NBC, Tuesday nights. In a broad, slapstick style (not above pie-in-the-face humor), Berle clowned around, introduced a wide variety of guests and specialty acts, and parodied musical numbers. Berle was TV's first big unique hit. He became known simply as Mr. Television. Another top variety contender was *The Ed Sullivan Show*, which ran on CBS Sunday nights from 1948 until, amazingly, 1971. Like Berle, Sullivan had started out on radio but with only moderate recognition; on television, he became the new medium's major impresario and popular culture arbiter. Combining music, dance, acrobatics, juggling, and skits, Ed's show presented an entire generation of talented performers—from Elvis to the Beatles—in their national TV debut.

To compete with this Sunday night powerhouse, NBC tried counterprogramming. *The Colgate Comedy Hour*, hosted most notably by Dean Martin and Jerry Lewis from 1950 to 1955, combined music and comedy. Other variety shows worth mentioning include *Your Show of Shows*, with hosts Sid Caesar and Imogene Coca and a sterling list of comedy writers that included Mel Brooks, Neil Simon, Woody Allen, Lucile Kallen, Larry Gelbart, and Mel Tolkin—a who's who of TV, film, and theatrical comedy. Nat "King" Cole became the first, and for a long time the only, African American host of a network variety show on NBC in 1956. Country music had its own musical variety showcase with *Ozark Jubilee* on ABC. A number of women, including Dinah Shore, Martha Raye, and Ina Ray Hutton, hosted variety shows.

The Birth of the Sitcom

Female stars found a far more receptive venue in the emergent genre of situation comedy. From the late 1930s—when only Kate Smith and Fanny Brice headlined their own programs—to the late 1940s, the number of female-centered comedies, in particular, had risen dramatically. Though other, older programs had developed the prototypical situation comedy form—notably *Fibber McGee and Molly*, *The Aldrich Family*, *Amos 'n' Andy*, *Easy Aces*, and *Lum and Abner*, soon followed by elements of comedy-variety shows like the *Burns and Allen Show*, *Jack Benny*, and *The Bob Hope Program*—it is with the sudden influx of female comedians from 1943 to 1948 that the form assumes its final shape and begins to dominate the broadcasting medium.

The term *situation comedy* (shortened to sitcom) itself emerged around 1944 in entertainment industry publications like *Variety*. It refers to a form of comedy that, rather than the loosely organized string of gags that a stand-up comedian or variety show host might deliver, is built around a recurring cast of characters placed in a humorous situation. The situation could involve a beleaguered parent or couple dealing with a mischievous child—pioneered by *Baby Snooks* and later found in such classics as *Dennis the Menace*, *The Patti Duke Show*, and many others. Or it could involve a couple who have misunderstandings and humorous disagreements, as depicted on *I Love Lucy*, *The Dick Van Dyke Show*, or more recently, *Mad About You*. As the fifties turned into the sixties, the most popular variation became the domestic sitcom, in which a whole family is embroiled in mildly comic situations from week to week. This version produced such classics as *Ozzie and Harriet*, *Leave It to Beaver*, *The Donna Reed Show*, and updates like *The Brady Bunch*, *All in the Family*, *The Cosby Show*, and *Roseanne*. Later variations would include the workplace family—*Cheers*, *Taxi*, *Spin City*, *Just Shoot Me*—that became prevalent in the 1980s, but we can see their antecedents in the programs described in the following paragraphs. Another variation is the "group of friends" sitcom—*Seinfeld*, *Friends*, and their many imitators.

Efforts to inject some excitement and adventure into domesticated lives mark several of the early sitcoms, including perhaps the best known, *I Love Lucy*. Lucille Ball, too, had broken into prime-time comedy on radio in *My Favorite Husband* on CBS in 1948, playing the zany housewife to Richard Denning's tolerant husband. As television loomed, Ball, teamed with real-life spouse and Latin bandleader Desi Arnaz, formed her own production company (Desilu) to create *I Love Lucy* on film—one of the first of the filmed series. It debuted on CBS in 1951 and ran for 10 years with some of the highest ratings in early TV. High-spirited, full of energy, teeming with ideas and schemes, Lucy struggles endlessly to escape the tedium of her household and leap into the bright lights of entertainment, preferably on Ricky's show. But viewers could rest assured that Lucy's schemes would never work out and that after an entertaining half hour of increasing disaster, her exasperated husband would haul Lucy back home where she belonged. Yet because Lucy seemed (and in real life, Lucille Ball was) the more talented and hardheaded of the two, Ricky's act of containment at the end of each episode never quite satisfied, always leaving open the possibility that Lucy really would break out this time. Eventually, she would in fact, as Ball and Arnaz's marriage collapsed, the Desilu Company split up, and Ball went on to many more years of fame.

Lucille Ball, one of the talented film comediennes who rose to prominence in early television situation comedy, frequently struggled to escape her domestic role. In real life, her studio Desilu pioneered three-camera film production.

Desilu was also one of the first production companies to pioneer the *three-camera film* technique. With a very insightful eye to future fame and profits, Ball and Arnaz did not air their show live, but shot it on 35mm film. They accomplished this by adapting the three-camera live production technique to film production. Unlike film's standard single-camera cinematography, for TV Desilu stationed three cameras, all recording onto 35mm film at once, in the studio. Each scene would be shot from three different angles, giving postproduction editors plenty of shots to choose from. This also

gave the company a permanent record of the show, and allowed it to be syndicated after its network run. *I Love Lucy* would become one of the most frequently aired programs in the history of early television; it still shows up on cable channels today. Soon, the three-camera film technique would become standard for television production. It is still used today for comedies in particular, though producers in the 1980s would make a switch to single-camera techniques for hour-long dramas.

By fall 1954, the sitcom would dominate prime-time television, with 28 shows on the air. Ten of those had female leads, playing roles from secretary to reporter to lawyer. Fifteen more featured a male-female duo, as married couples with or without a family. We can see a trend emerging here: By the fall of 1960, only 20 situation comedies remained (adventure shows and westerns were taking up the slack); but of them, fully 14 had a domestic setting with parents and children—sometimes a single male parent, as with *My Three Sons* or the *Andy Griffith Show*, but usually with a mother substitute like Uncle Bud or Aunt Bea around. Though career women existed in the prime-time sitcom, they were few and far between. On the other hand, the domestic sitcoms of the late fifties and early sixties form the backbone for what we now think of as fifties television (though see the Connection in Chapter 1 for dispute). Many of these programs were highly rated and had long runs.

The rise of the sitcom marks the rise of CBS, the hard-charging number two network. CBS moved ahead of NBC in overall ratings to become number one in 1955, based largely on its success with situation comedies and quiz shows. It would hold this position through the rest of the 1950s and into the 1960s. The situation comedy also represents the triumph of filmed programming over live. Though a few early comedies were produced live—*The Honeymooners* and *Burns and Allen* are classics during this period—the narrative style and realistic mise-en-scène of the domestic comedy worked far better on film, using classic Hollywood narrative techniques. After the quiz show scandal, filmed television would become the standard format.

Finally, the sitcom remained until the 1990s the most receptive place for women on television in prime time. Crime, action-adventure, westerns, talk and interview, variety, and drama all tend to feature male leads and a higher proportion of male characters over all. By 1973, a survey showed that 74 percent of prime-time characters were male. But in sitcoms that proportion was quite different. Its emphasis on some kind of recurring group turned that setting into a "family" one, even if the members were unrelated. This made it an acceptable sphere of influence for women, unlike the public settings of other forms of programming. This would begin to change in the eighties, as women moved into more public settings; finally, in the nineties, as melodrama invaded even the most masculine narrative forms, this difference between the half-hour sitcom and the hour drama program faded almost completely.

News

Despite the heyday of live network news coverage during the war years, television would have to go through a period of struggle with the new technology to make a transition to what we think of as television news. With single sponsorship of programs still the rule, most network news shows of the 1940s and early 1950s didn't bill themselves as part of the network's central operation, but rather as the offerings of a

sponsor. Still only 15 minutes in length, they had names like *The Camel News Caravan*, NBC's evening news program from 1947 to 1956, which featured "breezy, bouton-niered" and often Camel-smoking John Cameron Swayze. *News and Views* aired on ABC from 1948 to 1951, succeeded by *After the Deadlines* and *All Star News*. Only CBS offered a straightforward *CBS Evening News* program every weekday evening at 7:30 (EST) from 1948 on, sponsored by Oldsmobile and hosted for its first 14 years by Douglas Edwards before Walter Cronkite took over in 1962. And struggling fourth-place DuMont offered a daily newscast only sporadically before closing down perma-nently in 1955.

Before the days of easy electronic news gathering, the question of how to adapt flexible radio coverage to the demands of television production remained problematic. Most networks turned to newsreels, a flourishing industry during the thirties and forties. Specialized newsreel production companies like Pathé, Fox-Movietone, and Hearst-MGM often sold their footage to the networks. NBC at first hired Jerry Fairbanks Productions, a Hollywood company specializing in theatrical shorts and industrial films, then switched to Fox-Movietone. CBS contracted with Hearst-MGM's Telenews divi-sion. In the early fifties the networks began to put together their own newsreel divisions, often staffed with ex-Hollywood producers shooting on 35mm or 16mm film.

The standard TV news format began to emerge: A live anchor sitting at a desk in the TV studio provided brief introductions to filmed news items, as well as delivering commercial announcements for the sponsor. Historians have noted that television news actually was handicapped by the switch to visuality: Simply showing pictures of anything could seem like news; and conversely, any kind of important event that didn't produce good pictures began to be defined as not truly newsworthy. This is a tension that continues in television news today. Other news-related formats began to emerge. CBS originated *You Are There* with Walter Cronkite, a Sunday evening show that featured news reenactments (similar to the *March of Time* films and radio broadcasts). Also on CBS, Edward R. Murrow hosted *See It Now*, a weekly half hour devoted to in-depth documentary coverage of a variety of subjects. Its most celebrated moment came in 1954 with Murrow's dramatic denunciation of Red-baiting Senator Joseph McCarthy. On NBC, network programming head Pat Weaver took a page from women's magazine-style radio programs with his new *Today* show, featuring numerous guests and feature segments along with news coverage. Other public affairs discussion programs that originated or moved to TV during this period are CBS's *Face the Nation* and NBC's *Meet the Press*. The latter show had been created for radio in 1945 by Martha Rountree and Lawrence Spivak. It moved to TV in 1947 with Rountree as moderator, and continues with a variety of distinguished hosts and guests to this day—the longest-running non-serial program on the air to date.

Sports

Early television lent a level of respectability to sporting events previously considered somewhat suspect, just by virtue of beaming them into the living rooms of middle-class families; there, they often attracted new enthusiastic audiences of women and children. Wrestling, in particular, had a heyday in the late 1940s and early 1950s matched only by the resurgence of professional wrestling in the nineties. Boxing, as well, found a

place on the TV dial. Both of these sports were well suited to the relatively immobile, static nature of early TV production, with their enclosed spaces and small number of opponents, though some baseball and football games were also telecast. Bowling, too, had its adherents.

Sports programs, like their radio precedents, had the advantages of building on an existing interest, attracting the desirable male audience, and fitting well within the public service aura of live TV. Some of the earliest shows were *The Gillette Cavalcade of Sports* on NBC, *Sports from Madison Square Garden* on CBS, and *Boxing* (and *Wrestling*) *from Jamaica Arena* on DuMont. Howard Cosell got his start in TV sports on *Sports Focus*, a sports commentary show on ABC every night at 7:00 p.m. in the late fifties. By the mid-fifties, however, these programs lost their dominance in prime time to the many other program options emerging on the networks. Sports would remain central to local station coverage, and national playoffs would still feature as network fare. Not until the 1960s, though—with increased camera flexibility and the rise of videotape— would sports coverage take on its current central place in the network TV lineup.

Daytime

Daytime remained the last frontier for television programmers. Daytime radio continued to attract considerable audiences throughout the 1950s, maybe because television offerings were so sparse. Before 10 in the morning, television was local station territory, with little or no network feed until 1954. Afternoons slowly began to fill up, but mostly with lighter versions of comedy-variety programs like *The Garry Moore Show* and *The Kate Smith Show* and with daytime sporting events. By late afternoon children's programs staked a franchise: *Howdy Doody*, *Space Patrol*, *Roy Rogers*, and *Quiz Kids* form indelible memories for the baby boom generation. Radio's wildly successful form, the soap, ventured only slowly onto TV's landscape. Not until fall 1951 did CBS introduce a midday made-for-television serial lineup, with *The Egg and I* (1951–1952), *Love of Life* (1951–1980), and, with Agnes Nixon as head writer, *The Search for Tomorrow* (1951–1986). These three serials were all 15 minutes in length, running back to back from noon to 12:45. *The Guiding Light*, created by Irna Phillips in 1937, ventured onto TV in the summer of 1952 and still appears today, making it America's longest-running broadcast program.

Syndication

Though this history confines itself almost exclusively to network television, we should keep in mind that the early television years were a period of intense local experimentation with the new medium. Much of the most interesting and diverse TV fare appeared only on local stations, occasionally being picked up by a network. But most of local TV, especially during this era of live broadcast, bloomed briefly to delight local audiences and then died out of general memory—and out of the historical archive. Evidence suggests that there was far more variety and diversity on local television than on the networks—especially in the area of African American and other minority programming—yet that venue awaits the efforts of future researchers to bring those programs to our attention.

However, one type of local programming that does still exist for study is syndicated material produced on film. *Syndication* is the practice of selling directly to stations, without going through a network, programs that each station can air at whatever time and with whatever frequency it desires. With syndicated programming, stations retain all the available commercial time and can sell it to their local sponsors. Syndication is often a highly lucrative form of programming for stations, especially those in smaller markets, because syndicated shows can be relatively inexpensive. Syndication of recorded programs—"transcriptions"—existed during the period of network radio but was not considered entirely respectable due to FCC guidelines. However, as those rules were relaxed in the late thirties and forties, many transcription companies sprang into existence. Among the best known were MGM, Jerry Fairbanks, and Frederick Ziv. Soon they would be joined by television syndicators, among them Desilu, Hal Roach Productions, Screen Gems (owned by Columbia Pictures), and Revue Productions (owned by talent agency MCA, later to merge with Universal Pictures to form MCA/Universal). Most of these companies also produced filmed programs for the networks, but during the age of live TV their bread and butter lay in syndicated sales to stations.

With the FCC's post-Blue Book emphasis on local programming, and with the delays in network construction and connection, many stations looked to syndicated programs to supply their part of the broadcasting public service mandate. Though live local news and events and discussion shows formed a large part of stations' public service, syndicated programs could bring stylish production values, national publicity and promotion, and higher sales rates than often amateurish live shows. And, as the Cold War heated up, station owners looked for ways to demonstrate their commitment to patriotism and anticommunism (because spies, Communist infiltrators, and dangerous radicals rarely appeared on the local scene, simply providing a local version of a blacklist didn't really have much impact). What was a station owner to do? In the early fifties, syndicated programming provided an answer.

Connection Cold War TV: *I Led 3 Lives*

Somewhere in the classified archives of the FBI there is a file marked "Herbert Philbrick," the name of a real-life Cold War domestic spy. Philbrick was an FBI agent who, in the chilly years of the 1940s, infiltrated the ranks of the American Communist Party. Posing as a mild-mannered, disaffected advertising executive for the Boston branch of the Paramount Pictures theater chain, Philbrick ingratiated himself with a local Communist Party chapter and carried out various information-gathering and communication tasks for them, all the while secretly reporting back to his FBI controllers. In 1949 Philbrick came out of the cold with his star testimony against 11 American Communist leaders and stepped into the national limelight. In 1952 he published a best-selling book entitled *I Led 3 Lives*, which Ziv Productions made into a syndicated TV program in 1953.

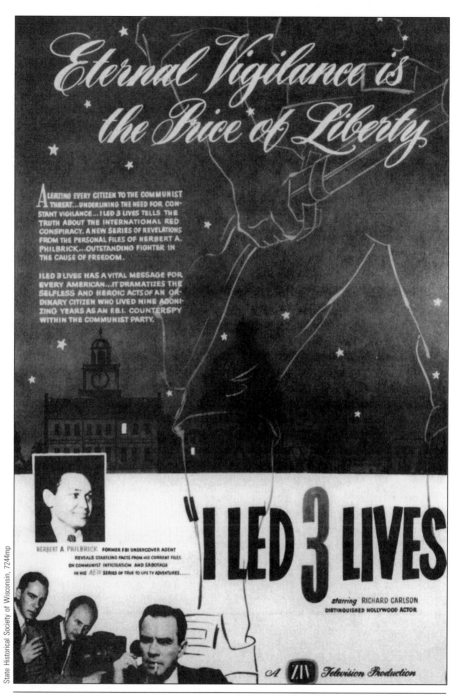

Syndicated programs like *I Led 3 Lives* not only entertained but let stations proclaim their anti-communist patriotism as a public service. It was an early type of docudrama in series form.

Historian Michael Kackman has investigated the Philbrick phenomenon, along with other 1960s espionage programs (Kackman 2005). As part of his research, Kackman requested a copy of Philbrick's file under the Freedom of Information Act. The FBI still won't give it up.

This was not the first "true story" spy drama of the Cold War. Kackman points to a long history of such films and radio series, including Hollywood films like *Walk East on Beacon* and *I Married a Communist.* Radio had *I Was a Communist for the FBI* from 1952 to 1954, another Ziv production adapted from the real-life story of informer Matt Cvetic; Warner Bros. had made the story into a film by the same name in 1951. Many "true story" law-and-order efforts had official government backing and encouragement. Perhaps the earliest is *Gangbusters*, a crime anthology series that had started out as *G-Men* in 1935 with the cooperation of FBI director J. Edgar Hoover. Hoover distanced himself from the later sensationalized version, which continued to dramatize law enforcement agencies' battles against organized crime and nefarious individuals. It mutated into something like *America's Most Wanted*, broadcasting clues to the identity of dangerous criminals and boasting that it had helped to capture as many as 286 armed and dangerous offenders each year. Later shows featured Colonel H. Norman Schwarzkopf of the New Jersey State Police (father of the Gulf War general), who dispensed the details about "wanted" criminals.

Dragnet picked up the law enforcement gauntlet in 1949. Producer Jack Webb worked closely with the Los Angeles Police Department in the production of this early police procedural, which would have a successful career on TV as well (see Chapter 9). In 1950 the Treasury Department got into the act with *Treasury Men in Action*, first on ABC and then on NBC. This popular show featured real cases from Treasury Department case files, as its agents cracked down on smugglers, counterfeiters, gun runners, tax evaders, and moonshiners. The Treasury Department gave its stamp of approval to every show. The appeal of these programs lay in their combination of good adventure yarns—spiffed up for the microphone or camera—that still gave the viewer a sense of real informational purpose. These were "true" stories about "real-life" events—not the gooey fiction of daytime serials or lightweight comedy. In the atmosphere of the Cold War, this format was a natural. These programs could serve both an entertainment and a public service function.

In the mid-1950s, not only TV and the movies but also the daily press were full of spy stories. World War II–era spies told tales in books and magazine articles, and newspapers reported on the testimony of postwar spies before Congress. It seemed that Russian agents were everywhere. FBI director J. Edgar Hoover capitalized on his image as the bulwark against such perfidy and treason and advocated FBI cooperation with the press and entertainment industry. NBC negotiated with the FBI for an officially sanctioned spy series from 1952 to 1954, though it never worked out. When Ziv decided to work with former agent Philbrick to produce *I Led 3 Lives* in 1953, Hoover gave his endorsement to the project, though the bureau was not involved in its production. But the program's "authenticity" played an important role in its promotion, as this quote from a publicity release indicates:

> *I Led 3 Lives:* Tense because it's Factual! Gripping because it's Real! Frightening because it's True! ... Not just a script writer's fantasy—but the authentic story of

the Commie's attempt to overthrow our government! You'll thrill to the actual on-the-scene photography ... factual from-the-records dialogue. ... Authentic sets and scripts personally supervised by Herbert Philbrick, the man who for nine agonizing years lived in constant danger as a supposed Communist who reported daily to the FBI! Never before has such a dramatic document appeared on TV! (Kackman 2005, 29)

Between 1953 and 1956, Ziv produced 117 episodes of the program. It became America's top-rated syndicated show, playing on stations all across the country.

One reason that *I Led 3 Lives* worked so well as a television series has much to do with how its narrative was framed; not as a typical action-adventure show, but as a family drama. In the logic of Cold War American culture, the best defense against Communism, and the surest markers of true Americanism, were solid, "traditional" family values, in particular the strong masculine father figure. Herb Philbrick, played by the deadpan Richard Carlson, was portrayed as a typical family man, with a wife and daughter, living in a middle-class neighborhood, with a middle-management job. His normalcy contrasts strongly with the characteristics of Communist agents he encounters. Kackman points out that at least half of the 117 episodes featured powerful Communist women as the main villain; they were mostly portrayed as sexless, aggressive, unattractive, and humorless. Communist men are shown as subservient, submissive, weak, and under the thumbs of these dominant "unnatural" females. Even though the show is mainly concerned with American Communists, many of the female comrades are represented as foreigners, with accents and odd clothing.

These evil women stand in contrast to Philbrick's own wife Mary (Virginia Stefan), a pearls- and shirtwaist-wearing domesticated partner who "sews buttons on instead of shooting them off"—one of the show's more memorable lines of dialogue. Even Philbrick's daughter Connie is contrasted in one episode, "Child Commie," with a hard-edged 10-year-old Communist girl who is sent into the Philbrick household to spy on them. When the girl attempts to tell Connie perverted versions of famous American historical legends—telling her that the Founding Fathers were hypocritical cowards—Connie knows immediately that something is wrong. Thus, even though Philbrick rarely stands up to his Communist bosses (he can't—in fact he has to play along with them in order to avoid blowing his cover), his mere existence as a normal American husband and father is his best answer to the perversities of the Communist world order as well as his best refuge against them. And, correspondingly, the program reinforced the "rightness" of traditional gender norms as a defense against political threat. It equated aggressive women with enemy agents, especially if they had a cause or job that they placed above caring for husband and family. A man who would allow such subversion in his own family was not only betraying himself, but his country.

This narrative reworking of Cold War battles in a domestic setting provides some telling links between the politics that went on behind the screen in television production and the seemingly unrelated representations that appear on them. Though other domestic sitcoms lacked the overt political proselytizing of *I Led 3 Lives*, they featured many of the same tensions and tropes. As Kackman puts it, "Red vixens like Comrade Marta, who would rather crack a skull than a smile, may have voiced troubling tensions of which June Cleaver and Harriet Nelson dared not speak" (Kackman 2005, 47). The status of *I Led 3 Lives* as a

syndicated program, never picked up by a network, illustrates that its message was slightly outside of the networks' mainstream politics. Yet its popularity and high ratings as a syndicated program demonstrate its resonance with related program types.

SOCIAL DISCOURSE

"TV Is Bad for Kids," Phase I

The 1950s were a relatively low-crime decade. Not until the mid-1960s would the U.S. crime rate begin to increase slowly and continue its upward climb into the nineties. Yet the late 1940s and early 1950s witnessed the rise of the juvenile delinquency scare, complete with congressional investigations, scientific studies, and fistfuls of fingers pointing at the mass media. James Gilbert, who studied this phenomenon in *Cycle of Outrage*, attributes this sudden awakening of a fear of youth crime to two major factors: (1) an increased attention to young people and the new *teen culture* that emerged after the war years and (2) the fear of family instability brought about by the entry of women into the workplace and the pressures to contain and redirect that movement after the war (Gilbert 1986). The "cycle of outrage" had a snowball effect. As attention during the war years to citizen morale in general produced research on the problems of young people, groups and agencies organized around youth concerns made it their business to emphasize teenagers and teen issues. Their reports were cyclically picked up by the press; Gilbert reports one sudden rise in articles on juvenile delinquency from 1943 to 1945—at the peak of women's outside employment—and again from 1955 to 1958. Press reports, in turn, stimulated more official involvement, such as the Senate Subcommittee to Investigate Juvenile Delinquency organized in 1953, which eventually produced more publicity, especially after the energetic Senator Estes Kefauver assumed the chairmanship in 1955.

The Kefauver hearings over the next two years brought a host of social scientists, experts from various fields, industry spokesmen, and concerned parents and citizens to testify in front of the committee. Though most focused on the newly exposed comic book industry—resulting in a code of ethics and considerable reorganization in that field—both movies and television attracted their share of blame for youthful degeneracy. Interestingly, many of these hearings were covered by television; when Paul Lazarsfeld testified before the Senate, he reported on the results of a study he'd done that looked at the effects of the Kefauver hearings themselves on youthful audiences. Television executives defended themselves, pointing to their 1952 code of ethics (see next section); social scientists asserted that children imitated the violent acts they viewed on television. The hearings were inconclusive and produced little in the way of reform, and some have suggested that Kefauver's main purpose was to attract publicity to himself. Yet the hearings established a precedent for the linking of television to concerns about its effects on children, in particular, and they produced a new emphasis on government funding of social science research around youth and violence issues. Phase II would begin in 1961, when Senator Dodd reconvened the investigation into television and spawned a whole new social science research industry.

"TV Needs to Control Itself"

Senator Kefauver believed that industries could best police themselves, under scrutiny by concerned federal agencies. Self-regulation was the key, rather than the passage of federal rules and regulations. No one could have agreed more with this diagnosis than the National Association of Broadcasters (NAB). Building on the codes established by NAB for radio in the 1930s and 1940s, the first television code appeared in 1952—in hasty response to the gathering Senate subcommittee. Mostly it repeated the same strictures developed in the earlier codes, but it included a few guidelines that affected visual material specifically. Producers were warned about plunging necklines on female performers, showing a married couple in or around a double bed (putting an unmarried couple in this situation was simply unthinkable), and the tasteful avoidance of shots of toilets in bathrooms. More to the point were the specific limits placed on the number of minutes of advertising time recommended for each hour of daytime or nighttime programming (6–10 minutes at night, 10–14 minutes during the day). Many UHF stations, struggling to succeed, found they couldn't subsist on these narrow margins. And the penalty for noncompliance was merely the removal of the NAB Television Seal of Quality from station promos, which most viewers didn't notice anyway.

Sponsors continued to dictate what could or could not be shown on their own programs; they also extended their influence beyond mere protections of products— for example, no cigars on a cigarette-sponsored show—to a conservative political climate restricting discussion of controversial issues like race, religion, labor, and above all, the Red scare itself. Networks happily went along with their sponsors' wishes, even as their hands-off programming system allowed them to distance themselves from outright charges of censorship. Soon, the networks would use this fortuitous distance to paint themselves as the good guys in the upcoming struggle for control.

"Commercial TV Is Free TV"

Despite the new attention to the TV and violence issue, commercial broadcast television held some very strong cards as it debuted after the war, and it would continue to play those cards well throughout the next decades to produce the classic network system of the sixties and seventies. As we shall see in Chapter 8 the networks managed to triumph over social critics and regulators in the wake of the quiz show scandal, turning what could have been disaster into a much-strengthened hand. And they were able to spin another troubling challenge into a favorable position in the mid-1950s: the debate over subscription television. With the benefit of hindsight, we can see that cable television, with its ability to offer consumers a greater variety of programs that they pay for directly, was bound to be a huge success and a strong challenge to network supremacy. Television industry executives and the FCC must have had some vision of this possibility as they contemplated the challenge issued by the Hollywood-backed subscription TV companies, despite their awkward and problem-plagued technology.

But aided by the FCC's protectionist policies, the television industry was able to turn the issue into a referendum on "free TV," linking the provision of advertiser-supported over-the-air television to basic values of democracy, freedom, and equal

rights for all. In the Cold War atmosphere of the mid-1950s, calling something "free" carried enormous rhetorical power.

Lobbyists for the broadcasting industry flooded the media with press releases bemoaning the threat to free TV that pay cable represented, pressured members of Congress into introducing bills to make it actually illegal, and perhaps most subtly of all, began to air feature films on broadcasting schedules to undercut the competition. Hollywood was once again cast as the great usurper of market freedom, attempting another evil scheme to undermine the free medium of television with its corrupting values. Lost in all this public relations spin was the notion that the public might actually want a different type of product than that offered by the networks. And, although the rhetoric of free TV would help the broadcast networks in the short run, eventually the very lock that they were able to place on the creation of American television would come back to haunt them. The early period of television created a bottleneck controlled by three major networks, but the pressure created by this bottleneck would soon build to the breaking point.

Conclusion

Television rolled off the war-greased assembly lines and into America's living rooms with astonishing ease and rapidity after the disruptions of the war years were over. From the beginning TV was dominated by the forces of big industry, but there was never any doubt that it would develop along the lines laid out by radio into a commercial network system, controlled by the former radio networks and funded by advertising. Cold War tensions only heightened the close relationship between government and industry, designated as *corporate liberalism*, and despite considerable social unrest brewing among America's minorities and redomesticated former wartime workers, television promised a normalizing nation the good life.

Decisions made in the regulatory sphere consolidated the big networks' hold over the developing medium, and put them in a strong position once the FCC freeze on TV station licenses had ended. Television programs resembled their radio counterparts more than a little. The networks encouraged the transition to TV by siphoning off radio profits to support the new medium, and they encouraged sponsors, agencies, and stars to jump onto the TV bandwagon. This left radio to fend for itself, and an era of black radio entrepreneurs blossomed. The all-music DJ format emerged from black radio practices, and a new kind of music filled the airwaves. Rock 'n' roll debuted as a musical form arising out of the collision of black and white audiences and crossover DJs on the newly available sphere of radio.

On television, meanwhile, a brief period of live drama influenced by the New York theatrical scene brought bold fare to the small screen and launched dozens of careers. Many consider this TV's golden age. But variety shows, westerns, and situation comedies also thrived and prospered. The situation comedy, in particular, would bring a feminine voice to prime time and soon dominated television schedules. News experimented and adapted to the visual demands of television, as did sports. The daytime remained a relatively undeveloped part of the schedule until the late fifties.

Yet all was not entirely rosy. Fears about television's effects on children emerged and would spread like wildfire in the next two decades. Broadcasters already showed disturbing signs of putting commercial ends above public interest responsibilities, despite the high-flown rhetoric surrounding television's debut. Such rhetoric could be deployed very effectively to squash competition—as with rival technologies theater television and subscription TV. The classic network system, with its tight, centralized control and limited program offerings, was about to take center stage. This crucial postwar period introduced most of the major factors that would position television as America's primary medium in the next decade. But it also had sowed the seeds of weakness and dispute that would trouble the next turbulent era.

THE DOMESTICATED MEDIUM, 1955 TO 1965

As we discussed in Chapter 1, the period of the late fifties and early sixties is frequently remembered as a time of tranquility, domesticity, and boring normalcy (despite the many ways that picture is false). Yet for the television industry it was a turbulent and formative time.

During this 10-year period, the quiz show scandal ruptured the whole sponsor-controlled system of production that had been in place since the 1930s. The payola scandal rocked radio and ushered in an era of specialized formats and the teen audience. A wave of corruption scandals hit the Federal Communications Commission (FCC), and a new era of federal regulation dawned under the "vast wasteland" critique of Kennedy appointee Newton Minow. The civil rights movement challenged the whiteface exclusion of television just as it did America's unjust social hierarchy, leading to a new era in television representation, news coverage, and public participation in the regulatory system. Out of all this disruption, a stable television structure emerged: the *classic network system* of American television that endured for 20 years and produced what are now considered classic U.S. programs, still exported around the world. Yet beneath this unified surface struggled many potential competitors, whose efforts would eventually break apart the classic network system and bring about cable, multiple channels, and new networks.

It might seem odd to break up the decades this way for the purpose of historiography. We tend to hear phrases like "the fifties" and "the sixties" in relation to events organized by decades, indicating that all the years falling within that span have something in common. I believe, however, that despite the trouble with any kind of grouping, events in U.S. history during this period are better understood with a slightly more flexible categorization. The fifties, I would argue, as we tend to understand them—the period of affluent suburban family building marked by corporate liberalism, the rise of teenagers as a demographic segment, and the era of wholesome family network television—actually didn't take shape until midway through the decade and then extended into the early sixties. What we think of as the sixties, as well—the youth movement, social disruption, more socially relevant programming, and the beginnings of network breakup—really didn't happen until the later part of the 1960s and continued into the early seventies. Obviously many elements most characteristic of these shifting times began earlier and carried over later, and it is part of the historian's task to gloss

over some irregularities and to force history into a narrative that can never do actual events full justice. So even as this book proceeds with its basic 10-year periodization—though it is situated mid-decade to mid-decade—you may well want to think about what effects this organization produces.

SOCIAL CONTEXT: THE WAY WE WEREN'T

Despite the prevailing picture of the 1955 to 1965 decade as a prosperous and contented one, the nation's economy was plagued by a series of recessions. In 1953 to 1954, the end of the Korean War resulted in manufacturing layoffs; another recession in 1957 and 1958 brought the unemployment rate up above 7 percent, and by 1960 it had reached 7.7 percent even as inflation sent up the cost of living. While suburbs flourished on the outskirts of cities, populated by baby boom families in middle-class ranch houses, the first urban ghettos formed in the declining city centers as the movement of agricultural workers from farm to town outpaced the number of jobs available. Not until the Great Society programs fostered under the Johnson administration in the mid-sixties would unemployment and living conditions improve for minorities and the marginalized.

For the white middle class, however, these were the *Donna Reed* years—at least they were supposed to be. High birthrates and federally subsidized mortgages produced an expansion of home ownership, as roomy single-family homes in neighborhoods with yards and quiet streets became the national ideal. It was a widely known but little discussed fact that many of these new neighborhoods had strict covenants against black, Jewish, and other minority ownership. State and federal governments underwrote a frantic campaign of school construction and highway development, most of it in the suburbs. Rising incomes made it possible for most families to afford one or even two cars, which was a good thing (for some) because the emphasis on extending street systems to the suburbs brought a corresponding drop in funding of public transportation. By 1960, over 60 percent of U.S. families had a middle-class income (between $3,000 and $10,000 annually) compared to only 31 percent in the 1920s. Two-thirds owned their own home, 75 percent owned a car, and 87 percent owned a television set.

Marriage rates were high and divorce rates low, as the number of births per woman reached a new peak. The ages of both men and women at first marriage dropped significantly, and so did women's average educational level as marriage took precedence over college degrees. Homosexuality was almost never discussed in polite company or in the national media, and in real life it was ruthlessly suppressed. Heterosexuality and married reproduction were the order of the day, and anything deviating from that standard was probably inspired by Communists, as the dominant thinking went. In 1954 the words "under God" were added to the phrase "one country ... indivisible" in the Pledge of Allegiance, with little opposition.

Though, as sociologist Stephanie Coontz points out, the 1950s family is now understood as the definition of the "normal," as "the way things ought to be," it was understood at the time as something new and different, a departure from previous decades and traditional norms (Coontz 1992). For the first time on a large scale, young married couples with children moved out of the parental home or neighborhood and

struck out on their own, sometimes not just across town but in an entirely different state. Wartime mobility translated into family mobility; now Grandma lived not just over the river and through the woods but somewhere back in the Midwest, far from the rapidly expanding West Coast and mountain areas where former GIs remembered the climate and sought out jobs. The nuclear family replaced the extended family as the norm. In the past, most middle-class families had employed servants to carry out burdensome domestic chores; now, consumer appliances and labor-saving devices, along with the drive to redomesticate women as wives and mothers, meant that most middle-class housewives performed their own housework—and with no aunts or mothers nearby to help out. The amount of time women spent on their own housework actually increased in the 1950s, labor-saving devices or no. Men, too, were encouraged to adopt the domestic family ideal, centering leisure activities around home and children. The basement workshop, or tinkering with the hi-fi system, provided a masculinized outlet for domestic impulses.

However, even as the white middle-class lifestyle took precedence in marketing, television, and the public consciousness, the United States was becoming a more demographically diverse society than ever before. Coontz points out that more immigrants from Mexico crossed the border in the two decades after World War II than in the previous hundred years. Immigration from Puerto Rico increased to the point that by 1960, more people of Puerto Rican descent lived in New York than in San Juan. Eighty percent of Latinos/as and African Americans lived in the cities, as opposed to less than half in previous decades. Asian American populations increased, but more slowly until the 1970s. These groups were largely left out of the era's prosperous suburbanization. America's overlooked minorities were concentrated in decaying urban centers as the nation's attention and spending moved to the suburbs; they were the last to be hired and the first to be laid off in the recurring economic recessions, and they were only marginally recognized as viable consumers in this consumption-oriented decade. Nevertheless, these minorities mounted the greatest struggle toward democratization of U.S. civic life undertaken since passage of the Nineteenth Amendment 40 years before. Meanwhile, on television, the banishment of early shows like *Amos 'n' Andy* and *Beulah* led to a virtual disappearance of African Americans from America's living rooms for the next 10 years—except as occasional guests or as "problems" in network news and documentary programs.

The Civil Rights Movement

The campaign for civil rights has roots that go back as far as the country itself, but in the mid-1950s landmark struggles and victories took place that set the nation on a different course and broke through centuries of hypocrisy and denial. Stimulated by the atmosphere of pressurized democracy of the war years and set in motion by groups like the National Association for the Advancement of Colored People (NAACP) and the Urban League, one significant breach of the barrier of white supremacy took place in 1954 when the Supreme Court under Eisenhower appointee Earl J. Warren handed down the *Brown vs. Board of Education* decision. Though school desegregation would take years to implement, it marked a disruption of the old "separate but equal" philosophy that had supported segregation and Jim Crow laws. The Montgomery bus

boycott, sparked by Rosa Parks and led by a young Martin Luther King Jr. in 1955, brought national attention to civil rights activists. President Eisenhower signed a watered-down Civil Rights Act in 1957; it was the first federal civil rights legislation on race in more than 80 years.

King's Southern Christian Leadership Coalition (SCLC) continued to organize nonviolent protests against the worst abuses of the American racial system. The protests were of a type inspired by Mohandas Gandhi, leader of India's decolonization movement. Consumer strikes and demonstrations made up the backbone of the campaign. The Student Nonviolent Coordinating Committee (SNCC) led Greensboro, North Carolina, college students in 1960 to stage a sit-in protest of segregated businesses by simply refusing to leave a whites-only lunch counter without being served. News photographs of well-dressed, tightly self-controlled African Americans being assaulted and dragged away by angry, abusive whites helped to legitimize the movement in many people's eyes and pointed to the importance that television would play in the struggle. The increasing involvement of white religious and student groups in such organizations as the Congress of Racial Equality (CORE) resulted in the 1961 Freedom Riders campaign, with black and white protesters from all over the country converging on southern bus lines to protest segregation's violation of interstate commerce law. Many were beaten; several were killed. Throughout, television showed pictures of nonviolent marchers being assaulted by police, dogs, fire hoses, and angry white mobs as the protest movement spread across the land.

President Kennedy assumed office in 1960 with a lackluster record on civil rights. He had earlier completely omitted racial equality from his list of "real issues of 1960" in a January speech, and introduced no civil rights legislation into Congress in the first two years of his administration. What little support the early Kennedy era offered to civil rights came from his brother Robert, who as attorney general sent federal troops into Alabama to protect the Freedom Riders. In August 1963 a massive march on Washington, D.C., brought the struggle to the nation's capital. Yet it was not until the fall of 1963 that the Kennedy administration sent troops to the universities of Mississippi and Alabama to force the states to live up to desegregation rules. And it took the deaths of four young girls from a bomb placed in a Birmingham, Alabama, church and the brutal assault and arrests of protest marchers to finally move Kennedy to come out in favor of a new civil rights bill. He was assassinated in November, before the bill could come to fruition, but many attribute the relatively smooth passage of President Johnson's revised Civil Rights Act of 1964 to Kennedy's memory.

The 1964 bill reformed voter registration; outlawed discrimination in public transportation, accommodation, and entertainment venues; banned school segregation; provided that federal funds could be withdrawn from institutions that violated anti-discrimination laws; and passed Title VII, perhaps the most important of all, which outlawed discrimination in the workplace and created the Equal Employment Opportunity Commission (EEOC). As the bill was debated, a few southern senators, thinking to derail it by making it absurd, threw "sex" into the categories of people who deserved protection, after "race" and "religious preference." It passed that way, and women received a measure of legal rights that they had never before enjoyed, along with racial minorities. With both groups, rights would not begin to translate to benefits until several decades and many lawsuits had intervened.

President Johnson took a far more activist stance on issues of race, equal rights, and poverty than had Kennedy. Johnson's War on Poverty and other Great Society programs created community agencies and funded their initiatives, established the Job Corps to train and employ urban youths, and organized Volunteers in Service to America (VISTA), the domestic equivalent of Kennedy's Peace Corps. Support for inner-city schools, expansion of Medicare, and rent supplements for low-income families soon followed. All of these helped to diffuse some racial unrest, but the first inklings of the northern urban riots to come occurred in New York around the time of the Republican convention of 1964. The civil rights movement was reaching the end of its first, nonviolent phase and would soon move into more militant demands for equality and justice. Television played a crucial role in all these struggles, and would find itself at the heart of the debate in a key regulatory battle during this period.

"Women: Neglected Assets"

The heading of this section, taken from a magazine article published in the early sixties, signaled the end of a brief era: the postwar interruption of the women's movement for equal opportunity and fair treatment that had begun with the birth of the republic. Though the rate of women employed outside the home continued to rise throughout the fifties and sixties, most of that occurred in the low-paying service sector. As more men than ever pursued higher education through the GI Bill, more women dropped out of college to marry, support hubby while he studied, and have children. Yet the young age of most marriages meant that by 1965 many of the baby boomers had reached school age, or even their teens, and their still youthful mothers found themselves looking around and thinking, "Is this all there is?"

In 1961, President Kennedy established a Presidential Commission on the Status of Women, chaired by Eleanor Roosevelt. In 1963 he helped push through Congress the Equal Pay Act, which for the first time prohibited paying women lower wages for the same work. Betty Friedan kicked off the second-wave feminist movement in 1963 with the publication of her groundbreaking book *The Feminine Mystique.* It soon became the number-one best-selling paperback in the country, a loud and clear call for women to reject the unfavorable terms of the postwar domestic bargain and take a far more activist stance. The late 1960s and 1970s would see the fiercest battles for women's rights since the suffrage era. As television predicated its growth and success on the attraction of a consuming audience of women, it too would have to begin addressing these contradictions and widening the representation of women. However, because the industry's ideal consumer consisted of the housewife at home whose main task was spending money on consumer goods for her family, it would take several years for TV's representational system to catch up with the needs and interests of the emerging "new woman."

The Trouble with Teens

As the United States became a child-centered society in the 1950s and 1960s, it was heading for the train wreck of the teenage years. In 1960 the first vanguard of the baby boom staggered into adolescence; many more would follow. The juvenile delinquency

scares of the earlier period had anticipated trouble, but now trouble erupted in the bosom of the family. Not just race, not just gender, not just class, but now generational conflict became a permanent part of the American scene. A new social demographic was born, and an industry sprang up to study its tastes, moods, and temptations. We'll see the enormous effect of this demographic bulge and social construction on the media and consumer culture, from radio and rock 'n' roll to television, movies, and those who would study and regulate them.

These U.S. teenagers came of age in an era of civil rights struggles, political idealism, and deep contradictions, and as these tensions grew in the sixties, the times were often cast as a war between the generations. "Young people today" seemed qualitatively different—certainly they were quantitatively different—from the youth of yesteryear. More affluent, more independent, better educated, schooled to expect nothing but equality, freedom, and fairness from their triumphant nation and outraged when it failed to materialize, the postwar generation (at least, its white, middle-class contingent) was on a collision course with the unfair realities of American culture. Yet before 1965 it seemed containable. The kids were weird, but they weren't yet danger-ous. It was the calm before the storm.

Already some indications of the political unrest to come had emerged. In the wake of the Bay of Pigs debacle, the group Students for a Democratic Society (SDS) formed and issued its Port Huron statement against racism and imperialism. Kennedy's misguided attempt to invade Cuba in a heated outbreak of Cold War tensions seemed to display both. College students began to demonstrate against atomic weapons, as the United States and the Soviet Union played a game of nuclear chicken. The free speech movement began on the campus of the University of California at Berkeley in 1964, when university authorities tried to ban on-campus political rallies. By 1965 the first demonstrations against the escalating "police action" in Vietnam had appeared on campuses across the land, as groups like SDS clashed with others like the Young Americans for Freedom, formed in support of conservative Senator Barry Goldwater. Both the women's movement and the gay rights movement stirred in cities and on campuses nationwide, getting ready for events to come. That all of these movements—from civil rights to gay rights to antiwar activities—were being organized by the emerging baby boom generation created a deep-seated dread in the hearts of parents and authorities everywhere. What was happening to this privileged, pampered generation of the nation's chil-dren? Was it television? Or was it rock 'n' roll?

LIVING WITH TV

As the rate of TV set ownership climbed from 64 percent in 1955 to 93 percent in 1965, other media had to adjust. The number of hours per day spent with the TV in the average household reached 5.5 in 1965. The number of hours spent listening to radio hit an all-time low of just under 2 in 1960 (from a high of 4); clearly television was consuming more time than just the difference in radio listening. Americans had gone TV mad. General interest magazines like *Life* and *The Saturday Evening Post* found

their circulations dipping precipitously. But *TV Guide* became the best-selling period-ical in the nation. The movies underwent a prolonged slump, rallying somewhat in the mid-sixties as they discovered the joys of the teen market. Drive-ins declined as population centers spread outward and overtook their valuable real estate, and down-town theaters of Hollywood's golden age continued to deteriorate (lack of parking, little public transportation); yet the period of suburban theater building had not yet gotten off the ground.

Hollywood Finds a Foothold

However, despite being locked out of network ownership or development of alter-natives like pay TV, Hollywood studios and independent producers quickly moved into creating programs for television. A few independents, like Desilu, Ziv, and Roach, had already seen the potential in this new medium. The major studios, hampered by theater divestiture and declining box office receipts as well as by hostility from net-works and exhibitors, ventured more slowly into production for the networks. As historian Christopher Anderson relates, a breakthrough moment occurred in 1954 when the Disney Studio, not yet a powerhouse in Hollywood, debuted its popular *Disneyland* program on ABC, the upstart network owned partially by United Para-mount Theaters. Earlier in 1954, Columbia Pictures subsidiary Screen Gems became the first studio to enter the TV sweepstakes with *Father Knows Best* on CBS and *The Adventures of Rin Tin Tin* on ABC. That same year, David O. Selznick Productions introduced a one-time special so glorious that it was carried on all three networks at once—a tribute to General Electric (sponsored, not surprisingly, by that company) called *Light's Diamond Jubilee*.

In 1955, more studios joined the TV stampede. Warner Bros. introduced *Warner Bros. Presents*, an ABC prime-time hour featuring a rotating lineup of three shows, each based on a successful movie: *Cheyenne*, *Kings Row*, and *Casablanca*. The latter two would fade, but *Cheyenne* became one of the first big western hits. Paramount Pictures began producing the *Colgate Comedy Hour* starring Dean Martin and Jerry Lewis, which made quite a business of showcasing Paramount stars and new film releases. Both MGM and 20th Century Fox debuted a similar film-based show in 1955. But these live, big-budget, big-name shows would ultimately prove less important both to studio profits and to television schedules than did their less prestigious production of filmed series. By the end of 1956, Hollywood was producing 71 percent of prime-time network programming, much of it on film.

The release of actual theatrical films to TV was slowed by the promise of pay TV as well as disputes over royalties with the Screen Directors Guild, the Screen Actors Guild, and the American Federation of Musicians. But by 1956 these difficulties had been resolved, and all of the studios began selling film packages to networks and stations alike. NBC debuted its *Saturday Night at the Movies* in fall 1961, shortly followed by other networks. Hollywood production now dominated television. Yet, in the wake of the quiz show scandal (discussed later in this chapter), networks retained tight control over production and ownership of TV series, making it much less profit-able for the studios than Hollywood felt it should be. Soon they would begin to lobby for regulatory change.

Connection Payola and the Rise of Format Radio

The medium that changed the most, as we have seen, and that by the mid-sixties had begun to thrive again, was radio. By the late 1950s rock 'n' roll radio had established itself as the voice of a new generation. Record sales depended on air exposure, and powerful DJs like Alan Freed and Wolfman Jack could make or break new releases by promoting them for all they were worth or by allowing them to die a slow death from neglect. DJs became the new media stars, courted by record company reps, sought out by musicians, idolized by their teen listeners, and reviled by authorities who observed this burgeoning new subculture with alarm (shades of the jazz scandal in the twenties!).

In 1959, the second annual Disk Jockeys Convention in Miami Beach attracted unfavorable national news coverage because of its raucous atmosphere of, as one paper put it, "Booze, Broads and Bribes." The bribes in particular caught the ears of rock's opponents, and the payola scandal slowly unrolled. It had become fairly common practice for record companies to offer cash incentives to influential DJs or program directors to promote the favorable treatment of their new release. This was all perfectly legal: The idea was that the DJ, as the resident expert in teen market taste, would act as a consultant as to the chances of a given song's success and take payment if he approved of it and was prepared to promote it. Some DJs, like Freed, even got partial writing credit for records they promoted, meaning that they got a percentage of the royalties received for record sales for the life of the recording. (Freed's name appears as coauthor of Chuck Berry's classic "Maybelline.")

But in 1959, inspired by the television quiz show scandal, the music rights organization ASCAP blew the whistle. Largely out of chagrin that its competitor BMI had developed a lock on the emerging new music, ASCAP suggested to eager federal investigators that because every respectable person could tell that rock 'n' roll was just mindless, oversexed pap, only a concerted effort by collusive DJs and record promoters could have forced such drivel down the throats of the American public. Perhaps it was a Communist plot to destroy the morals of our youth! The Federal Trade Commission (FTC) in Washington filed a series of complaints against record companies; the House of Representatives convened hearings in February 1960, and in May a grand jury brought charges against eight of the biggest DJs, including Freed. In September the FCC instituted new rules against the payment of cash or gifts in exchange for airplay of recorded music (Fornatale and Mills 1980, 45).

What resulted from the payola scandal was not a freer, more open music market, nor was it the end of influence peddling in the music business, a notoriously influence-driven field. It did result in a crackdown on the freedom of individual DJs to determine station playlists. Out of the crackdown a new industry practice solidified: the *top-40 format* first developed by Todd Storz and Gordon McLendon in the mid-fifties and marketed to stations across the country. The new format-driven radio station purchased a preplanned playlist and "music clock" from Storz or other entrepreneurs, rather than leave it in the hands of a local DJ. Based on national market research, the top-40 list reflected what listeners were buying and requesting across the country, determined what was on the way

up and on the way down, and decided how frequently a song should be played each broadcast hour or day.

A more standardized, homogenized sound developed. All the local radio station had to do was play the recommended records in the order indicated, announce the time, weather, and station call letters every 10 minutes or so, and plug in the local commercial spots. Soon other formats would develop based around other types of music and target markets—MOR, for middle of the road; country; black, later to become urban contemporary; CHR or contemporary hit radio, an updated form of top 40; beautiful music; and many others—all featuring standardized playlists and, later, complete syndication of 24 hours worth of music, news, and commercials delivered via tape or satellite. The maverick DJ was dethroned; corporations ruled the day. Rock 'n' roll stayed, but it wasn't what it had been.

One effect of the payola scandal was to further marginalize the African American artists who had provided so much of the music of the early rock period and who featured significantly in the hits promoted on early top 40. Chuck Berry, Frankie Lymon, the Shirelles, the Platters, Fats Domino, Little Richard, Sam Cooke, and Aretha Franklin are just a few who had hits on rock stations with predominantly white audiences; in 1957 fully 29 percent of the artists on the year-end pop charts were black (Garofalo 1990). Berry Gordy built Motown records during this period and, through sheer talent and persistence, hung on with top groups like the Supremes and the Temptations into the late sixties. But after 1960 formats started to "clean up" and harden, record labels consolidated and were absorbed by large media companies, rock 'n' roll became institutionalized, and, as usual, African Americans found themselves squeezed out. "Cleaning up" rock 'n' roll radio meant clearing out black voices and faces. The triumphant American tour of the Beatles in 1964—cute white guys from England, no less, imitating American rhythm and blues numbers—marked the virtual end of the integrated period of rock. Black-format radio went on to diversify into new musical styles and trends and would remain a vital part of the radio and recording industry, but the days of mixed audiences were drawing to a close.

Driving much of the rock 'n' roll craze was a demographic group that some media had begun to recognize and that awoke some of the most heated castigation and scorn of the whole teen phenomenon: teenage girls. It had come to marketers' attention that teenage girls possessed almost as much disposable income as their male counterparts and that they participated eagerly in the new teen consumer culture held out to them. The rise of girl groups in the early sixties—the Shirelles, the Ronettes, the Angels, the Dixie Cups, the Shangri-Las, the Chiffons, and artists like Dionne Warwick, Martha Reeves, Dusty Springfield, and of course Diana Ross and the Supremes, performing songs written by composers like Carole King and Ellie Greenwich—owed much to the newly powerful teenage girl audience.

The payola scandal in radio, as with the quiz show scandal in television, put an end to a system that had briefly given diverse cultural groups a certain amount of freedom. It substituted the control of more "responsible," centralized players and in radio led to a period of consolidation and standardization. Not until the undiscovered FM band became colonized by a renegade youth counterculture in the late sixties would radio once again slip out of control, however briefly. With television, a period of tight oligopoly was about to emerge that would dominate for the next 20 years.

THE CLASSIC NETWORK SYSTEM EMERGES

Historians often explain the television quiz show scandal as a brief disruption involving a few corrupt producers and their sponsors, who in order to make their programs more interesting, gave the answers to contestants ahead of time. This rigging of the results of a few highly rated programs—most notably *The $64,000 Question* and *Twenty-One*—seems, by itself, fairly insignificant for all the fuss it raised. Who expected quiz shows to be entirely fair anyway? In an era that tolerated incredibly dishonest racist machinations in the electoral process—a much more important arena for the nation—why on earth should it matter so much if a few entertainment programs cut the corners a bit? Quiz shows had always been a relatively marginal, though popular, part of the radio and television schedule, and by all accounts a certain amount of rigging and manipulation had always gone on, with the exasperated tolerance of networks, regulators, and the public alike. Yet all of a sudden in 1957 it became a national scandal. Why?

The indisputably dramatic results of the scandal can best be explained by looking at the convergence of some major tensions that television's first 10 years had barely kept under control. First, there is the influence of the World War II generation of public intellectuals and media reformers, whose disgust with the commercialization and conservative politics of radio had led to high hopes for the new medium of television. Under the guidance of the Blue Book, a new era of responsibility, innovation, and public accountability appeared to be in the offing. However, a growing contingent of influential critics, regulators, and journalists watched in dismay as the 1950s progressed, and sponsors stifled creative expression; networks gradually replaced live drama with sitcoms, westerns, and game shows; and television's potential for informed public service seemed to drain away. Fingers of blame pointed squarely at two old foes: the sponsors and Hollywood. Once again, as in the early 1930s, it seemed as though the growing alliance between Hollywood producers and sponsors eager for high ratings had stifled progressive freedom of expression.

Second, there was the example of Independent Television (ITV) in Britain. Commercial television had made its debut in Britain in 1955, amid much debate that had echoed across the Atlantic. The careful separation of advertising from production mandated by the new British Independent Broadcasting Authority set a model that many U.S. critics thought American TV should follow. By the British system, commercial station operators bought their programs from independent producers, and advertisers were allowed to buy time in a totally separate process without even knowing on what program their ads would appear. Selection and scheduling of programs stayed in the hands of licensed station operators exclusively, with no input from advertisers. Additionally, advertising was restricted to set points at the beginning and end of programs only, cutting out the intervention of commercials mid-program that many viewers found so intrusive and advertisers found so effective.

Network Finesse

Another effect of the quiz show scandal was that it actually furthered long-standing network goals. Though a few producers were fined, and the networks suspended production of some of the most frequently named game shows, the actual result of

the investigation in terms of convictions or FCC regulation amounted to very little. What made the scandal influential, though, was another set of tensions operating during this time: the desire of the networks to break free of the domination of sponsors and advertising agencies that they had tolerated for the past 30 years. Their interests temporarily coincided with the agenda of the critics and regulators.

To defend their integrity as license holders and programmers of licensed affiliates, the networks quickly saw the advantage of distancing themselves from the decisions made by sponsor-produced programs. We didn't cheat, they said: The sponsors did. The problem is that we lack control over our own programming. We need to take it back, and these problems will be solved. This approach suited critics and regulators very well; it placed the center of power back into hands that could more easily be regulated, because the FCC had very little influence over the advertising industry, and critics hoped that some of the extreme commercialism and materialism promoted by advertisers might be mitigated by networks' public service mandates.

The networks, led by NBC, had already begun to advocate a new kind of relationship of sponsors to TV: the *magazine concept,* developed by NBC chief Pat Weaver after the style of women's daytime talk shows, that substituted multiple sponsorship for single sponsors and made spot advertising the new order of the day. This system prevented a single sponsor from exercising the power over programming and scheduling that it previously had and let the networks regain the control over programming and scheduling decisions that they had lost in the 1930s. Seizing on the opportunity presented by the quiz show scandal and investigations, the networks promised that from now on they would play a new, activist role in programming. Gone would be the dependence on corrupt, ratings-driven advertisers; here to stay would be a new era of centralized network responsibility and control. It was the blueprint for the classic network system to follow. To regulators, critics, and the American public, the big-three networks said, in effect, remember what a good job we did during the war? Let us just take back our rightful role as program originators, get rid of powerful sponsors, and a better, more responsible system of television will result. We might call the network-dominated structure that followed *the classic network system.* It became the model that bespoke "American broadcasting" to the world, and even though almost everything has changed since then, many people still think of this period as the normative one for broadcast television.

The Classic Network System

The classic network system lasted from 1960 to about 1980. It is marked by highly centralized network control over all phases of the industry: production, distribution, and exhibition. This produced a period of tight vertical integration, similar to that of the movie studios before 1947, and of oligopoly, because only three networks dominated this period of broadcasting. Production control stemmed from a system of ownership interests, with multiple sponsorship limiting the influence of advertisers. As for production, networks either owned outright or owned an interest in most of their prime-time and daytime programming, and they controlled syndication rights as well. Distribution control reflected the ever-tightening relationship between networks and their affiliates, as network feed took over more of each station's total schedule. And exhibition control

was due to the networks' expansion of station ownership as they purchased stations in the largest U.S. metropolitan areas. This expansion led to a sharp decline in the production of first-run syndicated shows, like *I Led 3 Lives* and its colorful ilk, as networks tightened affiliate contracts and brought the sale of off-network reruns under their aegis.

Producers, both studios and independents, soon realized that now, with only the three networks as possible buyers for their televisual product rather than the hundreds of sponsors who had previously purchased and produced programs, the networks could demand lower prices, greater ownership interests, and more say in the creative process. By the late 1960s, the big-three networks essentially held television production in thrall, purchasing shows for less than it cost to make them. As a result, independent producers in particular were dependent on network investment to stay afloat; they had essentially become production arms of the network. Hollywood studios increasingly resented the large cut that the networks took out of domestic syndication.

Scheduling each evening's lineup became something of an art form, as the big three juggled shows and counterprogrammed against their competitors—with no sponsors to interfere with their decisions any more. Choices narrowed and diversity was reduced, as the network formulas became streamlined. As with radio, centralized control increased along with homogeneity and standardization. The more producers jostled for change, the tighter the networks cracked down. Yet, another characteristic of the classic network system was the resistance building up from forces on the fringes of the television oligopoly—from independent producers and Hollywood studios; from critics of TV's homogeneity, racial policies, and violence; from the developing public television movement; and from its soon-to-be-archrival, cable TV.

Color television became the industry standard in 1956, with NBC leading the way because its parent RCA's color standard had won the standardization war. CBS and ABC trailed behind, as the nation's local stations struggled to update equipment and consumers slowly converted. Most families would continue to rely on black and white until the mid-seventies. Other related areas of industry economics came under investigation in these years—for example, the Nielsen ratings system, whose numbers appeared completely compromised by network interference.

TV Reforms

As the smoke from the quiz show scandals cleared and as the Kennedy administration placed a new activist chair in charge of the FCC, critics who had believed the networks' claim that they could handle television production more responsibly than the sponsors could were to meet disappointment once more. Had the money-changing sponsors been driven out of the temple of broadcasting only to make television safe for *The Andy Griffith Show, Hawaiian Eye, Route 66,* and *Stagecoach West* (all shows that debuted in the fall 1960 season)? Even as early as 1959, as historian Michael Curtin recounts, network heads had met with then FCC chair John Doerfer and agreed on a plan to produce more serious news and documentary programs to counterbalance the commercialism and entertainment emphasis of much of TV (Curtin 1995). They began with stepped up coverage of the 1960 presidential campaign, making it the first real TV election and Kennedy the first TV president. The most famous moment came during the Kennedy-Nixon debate, in which Kennedy's movie-star good looks and ease in

front of the camera contrasted favorably with a sweating, nervous Richard Nixon. Television created the impression that Kennedy had clearly won the debate; radio listeners were left with a better impression of Nixon, but they were in the minority.

However, new FCC chair Newton Minow made his famous "vast wasteland" speech to the National Association of Broadcasters (NAB) convention in May 1960, indicating that these efforts were not enough (see "Minow the Intimidator" on page 190). In response, the networks stepped up their news and documentary production to levels unheard of before or since. In 1962, the three networks produced close to 400 documentaries all told, as opposed to a grand total of zero in 1957. By the fall of 1963 both NBC and CBS had expanded their nightly network news program to a full half hour. Though this emphasis on documentary production would not last very far into the Johnson administration, it brought a new ingredient to American television programming that at least temporarily quieted criticism and allowed the classic network system to consolidate control. Curtin (1995) argues that it also helped to expand the logic of the Cold War, since many of the documentaries focused on foreign issues rather than on the more controversial topics of problems at home. Yet domestic issues did receive a heightened degree of attention, as we shall see in the following discussion of documentary programming.

National Educational Television and the Lure of Cable

The debate over television's public service standards, stemming back to the days of radio and heightened by the quiz show scandal and the Minow FCC, received a further prod from two other nascent movements in the early 1960s. First, in 1963 the National Educational Television (NET) network was formed, supported by the Ford Foundation, and soon began to point out exactly what the commercial networks were leaving out of their increasingly profitable schedules. Minow himself had been instrumental in establishing the first program of federal grants for the construction of educational stations. More nonprofits joined the existing stations on the air, mostly in less-visible UHF frequencies. Documentaries, instructional programs, noncommercial and educational shows for children, and public affairs discussions began to find a national audience, as NET made it easier for educational stations to distribute programs and cooperate in production. However, as the civil rights movement moved into its more militant phase, and as the conflict in Vietnam intensified, NET began to produce some more openly political programs that took on not only government policy but also corporate involvement in the arms race and other political and economic issues. Soon, the increasing boldness of educational TV, the controversy provoked by some of NET's shows, and the continued criticism of the commercial networks would create demand for a truly national public broadcasting system, for the first time in U.S. history.

Cable television, too, held out some new possibilities. Rather than fading away as the freeze lifted and TV became available across the country, cable had hung on as a way of providing alternatives to the often limited TV service in many towns and cities. With its ability to import distant signals and to enable production of local shows directly for cable, Community Antenna Television (CATV) began to show promise of being a medium in its own right. The FCC remained unclear about whether it had jurisdiction over this terrestrial technology. But broadcasters, who a few years earlier had regarded local cable outfits as helpful extenders of their reach, now began to

perceive cable as a competitor and a threat. Pressure began to build for a stronger—or at least a clearer—regulatory stance, even as those disappointed with commercial television's performance began to think about how cable systems might be linked to provide a nationwide alternative source of entertainment and information. It would take another decade before satellite transmission provided this interconnection.

REGULATION: CORRUPTION, CRACKDOWN, AND COMPLACENCY

Lots of heat but little action might be said to characterize the FCC's role during the building of the classic network system from 1955 to 1965. We associate the era above all with Newton Minow's famous castigation of commercial broadcasters in 1961, but aside from a few years of heightened documentary production, the FCC's actions served more to consolidate and support commercial network power than anything else. In fact, Minow's words can be understood better as an effort to clean up the image of the FCC than as activist reform of the industry. As historian William Boddy relates in his book *Fifties Television* (1990), it needed cleaning.

The "Whorehouse Era"

The phrase "whorehouse era" comes from a later chair of the FCC; he used it to characterize the 1950s decade at the FCC, which he described the period as a time when "matters were *arranged*, not adjudicated" (Boddy 1990, 215). The easygoing relationship of industry with government during the Eisenhower years found its correlation at the FCC with heavy influence from the broadcasting and electronics industry on appointments made during that time. A study by the Library of Congress revealed almost no consistency or fairness in the FCC's licensing decisions, with the commissioners overruling their own hearing examiners almost half the time. Most notorious was Eisenhower-appointed FCC chair John Doerfer. An investigation of the FCC instigated by the House of Representatives in 1957 and 1958 revealed numerous suspect practices: acceptance of gifts from industry, travel paid for by TV interests that were then double or triple billed to the government, and far too cozy business relationships with the industry the FCC should have been regulating.

So another ingredient in the quiz show scandals was the FCC—trying furiously to act more like the guardians of public interest that they should have been, to offset accusations of their own corruption. Yet relations between the broadcasters and the regulators were so tight that Chairman Doerfer defused attempts to really crack down on industry misconduct by pointing toward self-regulation as the main remedy. At hearings in 1960 leading out of the quiz show scandal, various members of public advocacy groups testified in favor of structural changes to the American system of commercial broadcasting that could help to avoid such scandals in the future: establishing a public broadcasting system, instituting spectrum use fees, and enforcing more rigorously the FCC's own rules as set forth in the Blue Book. Those groups were treated to the spectacle of the chairman of the federal government's primary regulatory commission arguing *against* federal regulation of broadcasting. Doerfer was finally asked to resign, but not over his antiregulatory stance. It was the charge that he had spent time on a yacht owned by a

major television station company that finally did him in. According to Boddy, by then Doerfer was so embarrassing to the White House that a car was sent to Doerfer's home during a snowstorm to collect his resignation (Boddy 1990, 217).

Minow the Intimidator

However, by the early 1960s most members of Congress as well as the White House itself had become dependent on the free airtime that they routinely received from broadcasters. No one wanted to offend the powerful television networks too much; the same is true today, though cable has loosened the oligopoly slightly. Presidential candidate John F. Kennedy, who was certainly benefiting from generous network coverage, seemed ready to continue a hands-off policy. So his FCC Chair Newton Minow's 1961 speech to the NAB convention created quite a stir. To the industry bigwigs gathered there, Minow said:

> I invite you to sit down in front of your television set when your station goes on the air and stay there without a book, magazine, newspaper, profit-and-loss sheet or rating book to distract you—and keep your eyes glued to that set until the station signs off. You will see a procession of game shows, violence, audience participation shows, formula comedies about totally unbelievable families, blood and thunder, mayhem, violence, sadism, murder, Western badmen, Western goodmen, private eyes, gangsters, more violence and cartoons. And, endlessly, commercials—many screaming, cajoling, and offending. And most of all, boredom. True, you will see a few things you will enjoy. But they will be very, very few. And if you think I exaggerate, try it. ... Gentlemen, your trust accounting with your beneficiaries is overdue. Never have so few owed so much to so many. (Barnouw 1970, 197–198)

Yet, again, there is little evidence that even under Minow the FCC did much to actually change commercial practices, aside from advocating that the networks increase news and documentary programming. This emphasis, as we shall see, lasted only for a few years. More sweeping structural change, particularly the idea of funding a public broadcasting system, still had several years to go before becoming a reality.

But the repeated emphasis on violence in Minow's address indicates that it had become the dominant note to be sounded by future regulators: the problem with television was primarily its *violence*. This claim had the advantage of at once sounding undeniably bad (who could argue in favor of violence?), being almost impossible to define (verbal insults? war coverage? Road Runner cartoons?), and coming under protection of the First Amendment, so that there was little the federal government could actually do. As a stick to beat broadcasters with, it was considerably softer than, say, the idea of charging for use of the public spectrum or of stopping the protection of broadcasters from cable competition. These were measures that the government could actually propose and pass, if it felt so inclined, and clearly it didn't. Thus, violence was a perfect focus of attention and investigation for a government increasingly dependent on favorable relations with the television industry.

TV and Violence, Phase II

It is not surprising that the next wave of social dystopian concern over television went down precisely this path. Senator Thomas Dodd of Connecticut sprang onto the violence bandwagon in June 1961, ushering in three more years of hearings and investigation on

juvenile delinquency—still not a widespread social phenomenon—and its links to TV, in particular. Dodd's subcommittee invited testimony from some of the burgeoning school of social science researchers who reported the not surprising findings that children sometimes reenacted violent acts they had seen on television, such as wrestling or play fighting. This effect had long ago been demonstrated with movies, comic books, and even the scorned penny-dreadful novels of the 1800s. But television's novelty as a visual medium in the home—and the existence of funding and a national forum for such research—brought the issue of TV violence onto the front pages.

Once again, Dodd himself failed to follow through with any kind of meaningful recommendations or remedies. In fact, precisely the kind of programs that Dodd's researchers had condemned—action-adventure shows, westerns, cartoons—proliferated on television and became some of the most highly rated shows in both network run and syndication. One of his committee members even exclaimed, "It's as though they used our 1961 hearings as a shopping list!" (Barnouw 1970, 203). Yet the emphasis on TV violence and its effects on children, as well as the close relationship between social science research and federal investigations, would continue. As the crime rate shot up in the late 1960s, fueled by baby boomers' reaching the prime age for criminal acts, a new round of investigations sponsored by the surgeon general's office would produce the largest coordinated body of research on television yet. Its roots in the highly politicized atmosphere of regulatory power shifting would not go unremarked.

Slouching Toward Public TV

The heightened level of anticommercial TV rhetoric, though it did not immediately result in regulatory reform or in a public service broadcasting system, did help to clear the way for later developments. One of Newton Minow's accomplishments as FCC chair was to pass a ruling that TV manufacturers be required to include UHF reception capability on all sets produced. This helped the struggling, mostly UHF educational stations find an expanded audience. Yet Minow's main emphasis went to the time-honored practice of exhorting the commercial networks to step up to the plate and provide a "better class of programming" in exchange for the privileges they had been granted. If the networks would do this, the old argument went, we would have little need for a public broadcasting system. This led the networks into some interesting contortions, as they sought to mark out a space in the TV schedule specifically for programs that would satisfy public service requirements. Who was the public, and what did they want? Should the audience be allowed the types of programs they actually seemed to enjoy? Or should the FCC implicitly mandate a type of programming that the public *should* want? Was the definition of a public service program precisely that which the majority did not really want to watch?

PROGRAMMING FOR PROSPERITY: AMERICAN TV

The decade from 1955 to 1965 marks the emergence of what we, along with the rest of the world, now think of as American TV. From the earlier period of sponsor control, experimentation, affiliate expansion, black-and-white pictures, and regulatory pressures

emerged an era of network dominance, established industry standards and accepted practices, solidified program forms and genres, and regulatory sound and fury signifying very little—increasingly in glorious color. Today's TV may have less room for westerns and musical variety programs than in this early period, but it is hard to name a present program type that didn't take shape sometime between 1955 and 1965.

Sitcoms

We've already traced the importance of this still emerging genre in the late forties and early fifties. During the 1955 to 1965 period it was a program type still going strong, hitting a high point in 1965 when fully 35 sitcoms graced the prime-time airwaves. From an early emphasis on happy (or bickering) families (or couples), such as *Ozzie and Harriet*, *The Honeymooners*, *I Love Lucy*, *Father Knows Best*, and *Make Room for Daddy*, along with a diminishing number of professional women, like *Private Secretary*, *Meet Millie*, and *Our Miss Brooks*, the sitcoms in 1965 reflected a number of influences.

First of all, the hillbilly hurricane had hit. Taking the old ethnic comedy—such as *Amos 'n' Andy*, *The Life of Riley*, or *Life with Luigi*—and giving it a country hick twist, the hillbilly or rural sitcom started with the debut of *The Real McCoys* in 1957 and led by 1965 to *The Andy Griffith Show*, *The Beverly Hillbillies*, *Petticoat Junction*, *Green Acres*, *Gomer Pyle*, *The Farmer's Daughter*, and a few that didn't make it very far, such as *O.K. Crackerby* and *Tammy*. The two most popular—and were they ever popular—were *The Andy Griffith Show*, which enjoyed 11 straight seasons in the top-20 rated programs (the last three as *Mayberry R.F.D.*) and *The Beverly Hillbillies* with eight straight top-rated seasons.

If families weren't rusticating themselves, they found other strange predicaments to be in, many of them unworldly. *Bewitched*, *My Favorite Martian*, *I Dream of Jeannie*, *The Munsters*, *The Flintstones*, *My Mother the Car*, and *The Addams Family* put a magical, alien, prehistoric, or ghoulish spin on the American family. Others took the format in the direction of the workplace family, with a strange emphasis on military settings: *McHale's Navy*, *Mr. Roberts*, *Hogan's Heroes*, and of course *Gomer Pyle, U.S.M.C.*—the country bumpkin meets the Marines. Television's penchant for pleasing teenage girls can be seen in the increase of sitcoms with a young female central character: *The Patty Duke Show*, *Gidget*, *Mona McClusky*, and *Tammy*.

Other sitcoms defy easy categorization: the stranded shipmates of *Gilligan's Island*, the spy show parody *Get Smart*, and *The Smothers Brothers Show*, the talented brothers' first effort in which they played themselves in a sitcom setting. But the basic nuclear family still held on. Besides long-running favorites like *Ozzie and Harriet*, *The Lucy Show*, and *The Donna Reed Show*, others had debuted with sixties-ish accents, like the classic *Dick Van Dyke Show* (starring Mary Tyler Moore) and *Please Don't Eat the Daisies*, featuring a modern working family with four children, a writer mother, and a professor husband.

Drama

In place of the early fifties roster of live anthology dramas, more standardized, usually hour-long dramas of various types took up much of the prime-time schedule. Long a favorite film and radio genre, the TV western outgunned all other program types. And

on television they evolved from their former role as primarily juvenile entertainment to a new category of "adult western." Led by *Gunsmoke*, other westerns that attracted large adult audiences and a certain amount of critical approval included *The Life and Legend of Wyatt Earp, Cheyenne, Wagon Train*, and Emmy award-winning *Maverick* and *The Rifleman*, written during its early years by, among others, future film auteur Sam Peckinpah.

In 1965, twelve westerns remained on the air, from the long-lived *Gunsmoke* (18 seasons in the top 20) and top-rated *Bonanza* (which displaced *Gunsmoke* at the top of the ratings in 1964 and stayed in the top 20 for 12 years). Other popular western hits included *The Big Valley, Rawhide*, and *The Virginian*, the latter running an unusual hour and a half in length; it lasted seven years. Despite the performance of these perennials, the western was in its downward slide. They had reached a high in the 1959 to 1960 season, with 30 westerns taking up over 26 percent of total network prime time; in the previous season westerns were 9 of the 11 top-rated programs.

Many have speculated on the dominance of this particular genre during these years, unparalleled either before or since. Some attribute its popularity to the way it lent itself to the Cold War mentality, with the stalwart freedom-loving lawman, cowboy, or homesteader in a battle of resourcefulness and values with the godless Indians, one-dimensional black-hatted bad guys, and all those who would attempt to thwart the spread of good old American manifest destiny. Westerns were an island of masculinity (in what seemed to many an oozing puddle of feminine consumerism), urging self-sufficiency, grit, and self-discipline in the spaces between commercials. Like Herbert Philbrick's militant family man, the male office worker whose biggest physical hurdle was cutting the grass on Saturday afternoon could project his own efforts as paterfamilias onto the virile, buckskinned upholders of law and order on the television set, and find justification there.

A surprising number of westerns, while featuring a tight-knit family, found it expedient to cut Mom out of the picture altogether. The Cartwright family on *Bonanza* consisted of patriarch Ben Cartwright and his three sons, with a Chinese manservant to do the domestic chores around the ranch. *The Rifleman*, starring former professional athlete Chuck Connors, centered on a widower and his young son. Others featured rootless single heroes, like *Cheyenne, Sugarfoot*, and *Have Gun, Will Travel*. One of its main attractions seemed to be the way the western could take current social issues and problems, transport them back into a safe yet heroic American past, and resolve them the old-fashioned way: man to man, without impediment of women, social welfare agencies, cops, nannies, or federal regulators. An aura of nostalgic fantasy clung to the western genre, where whatever was good for the right-minded American individualist (male variety) was right for the world. No need to argue—just duke (or shoot) it out.

Even those concerned with the effects of violence on children had far less trouble with the western than they did with the other major branch of hour-long prime-time drama that came into its own in the sixties: the crime-adventure-suspense drama. Though many different emphases could find a home under this broad rubric, the classic programs featured police, detectives, and their clients (*Dragnet, Hawaiian Eye, The Defenders, Naked City, 77 Sunset Strip, Perry Mason, The Fugitive*), government agents and spies (*The Untouchables, I Spy, The Man From U.N.C.L.E., The F.B.I., Slattery's People, Amos Burke, Secret Agent*), or soldiers in the now practically nonexistent war

drama genre (*Convoy, Combat, Twelve O'Clock High*). Another variant was the medical drama, a staple of television fare, which set its adventure in a hospital or medical practice: *Dr. Kildare* and *Ben Casey*, in a straight line through *Marcus Welby, MD*, to *St. Elsewhere* and *ER*. The mystery-suspense variant included such classics as *Alfred Hitchcock Presents*, Rod Serling's *The Twilight Zone*, and *The Outer Limits*.

Connection "Just the Facts, Please, Ma'am"

One of the most influential early programs in the crime genre was producer Jack Webb's *Dragnet*. It started on radio in 1949 and ran until 1957, but a television version debuted on NBC in 1951 and held its place in the Thursday night lineup until 1958. Then it disappeared for a while, only to return in 1967 for a further three-year run. Its absence during the heart of this network-building period is a significant one. In many ways the story of *Dragnet* is the story of the changing cultural role of television. From its early, fact-filled authoritarian tone, replete with the "authentic" credibility of real-life police drama, to its eclipse during the classic network-building years as standards shifted around it, to its return in the late sixties, unchanged but now hopelessly out of context, *Dragnet* also marks the changing image of public authority in America's decade of prosperity.

From the beginning, *Dragnet* prided itself on its close adherence to actual police procedure, starting with cases taken directly from case files of the Los Angeles Police Department. With full cooperation from the LAPD, actor, director, and producer Jack Webb developed the deadpan narrative style of Sergeant Joe Friday to frame each week's real-life story. The LAPD provided the cases and approved the rough edits, a fact that each episode emphasized, as did the show's promotion and publicity. In the form of a policeman's note-book, action proceeded point by point, with careful attention to detail: "It was 3:55. . . . We were working the day watch out of Homicide," "4:56. Rounded the corner of Elm and Main and approached the crime scene." Despite the show's lengthy run, the personal lives and characters of Friday and his partner (Officer Frank Smith for most of the show's early run) were never developed (reminiscent of today's *Law & Order*); they didn't have personal lives as far as the program was concerned. The program made ample use of police procedural jargon—"Book him on a 358"—and at the end of each program, the result of trial and sentencing ran in script across a blank screen. The show's arresting theme music, its laconic delivery, and its deadpan, plodding quality made it a popular target for satire. Nevertheless, it was one of the most successful and highly praised crime shows on early television.

As historian Jason Mittell summarizes, *Dragnet* remained one of the most highly rated programs throughout its 1950s run, actually beating *Lucy* in a poll conducted in 1953 (Mittell 2004). It won numerous awards and honors, from *TV Guide*'s "best cop show" of the fifties to sequential Emmys for Best Mystery, Action or Adventure Program in 1952, 1953, and 1954. In 1954 the TV series' popularity won Webb a contract with Warner Bros. for a filmed version of *Dragnet;* it was Warner's second-highest-grossing film of the year. Webb went on to produce several more films for that studio after the show's cancellation in 1958. Other

Jack Webb (right) as Sergeant Joe Friday, with partner Ben Alexander in the early version of *Dragnet*, sifting through documents for "just the facts."

historians have remarked that *Dragnet* represents a turning point in early TV, moving away from the comedy and variety that had previously dominated schedules. *Dragnet* was one of the first regular crime series to appear, and its popularity assured the permanent prominence of this genre on American television—and indeed, in the television entertainment of virtually all nations.

In fact, law-and-order shows have a particularly fraught relationship with issues of national identity; the nature of social authority; the hierarchies and rules that bind citizens together; and the lines that are drawn between private and public, normalcy and deviation, good and bad. Through the mechanism of the law enforcement and justice system, they sketch out every night exactly where our often shifting boundaries of right and wrong lie: What constitutes a crime, who is likely to commit one, who are the typical victims, what kind of punishment should criminals receive, will they get the treatment they deserve?

In the universe of *Dragnet*, the police stand as the harassed but steady thin blue line between safety and disorder. Hardworking, blue-collar white men (there were no policemen of color in the *Dragnet* world, and certainly no women), they patrolled the excesses of the overprivileged middle class as well as those who transgressed from hardship or bad judgment or just plain meanness. Justice was colorblind in *Dragnet*: Few minority characters figured as criminals, indicating a justice system that worked the same for all; race was so irrelevant that it didn't even need to be depicted (crime statistics and unequal

incarceration rates to the contrary). When women appeared, they were either hangers-on to the true criminals, or wives and mothers.

Each week's crime received less attention than its discovery and correction. The show's very title suggested a slow but steady netting of all society's bottom feeders. Matter-of-fact, workmanlike, dispassionate, paternal—these were not the police who would terrorize or threaten anyone, treat anyone unfairly, or even contemplate taking shortcuts with the law. The American system of justice worked, and it worked for everyone. Case closed. And, as Mittell points out, justice on *Dragnet* was far from violent. Webb consciously kept the number of gunshots to one for every five episodes, and very rarely did anything like a shootout or even a fistfight occur. Clearly the American law enforcement system was built around consensus, not coercion.

Webb's factual universe worked very well in an early television system that, for reasons that we have examined, stressed its ability to translate real life onto the screen, to provide a live, authentic, transparent view of important aspects of American life. Like *I Led 3 Lives*, its validity as a true story played a crucial role in its claim for attention and serious regard. Even its visual style emphasized its lack of artifice and fiction. Its awkward realism underlined the show's seriousness and documentary quality, all helping to offset the fact that it was actually a filmed series produced in Hollywood. Its very clumsiness gave it critical credentials.

Yet by 1958 this equation had begun to change. Hollywood-filmed series now dominated prime-time schedules, and the major film studios had moved heavily into production for television. Now *Dragnet* began to look plodding, amateurish, dull. Its ratings slumped, the show was canceled, and Webb went on to other projects. In 1963 he briefly became director of television production at Warner Bros., where one of his less-good ideas was to take the Warner/ABC hit series *77 Sunset Strip*, a detective show that featured a much more stylish, ironic view of the world (in fact, it had been created specifically in reaction to *Dragnet*), and turn it into a *Dragnet* clone. Despite an innovative use of continuing story lines—foreshadowing such shows as *Hill Street Blues*—and a stellar cast, the new *Strip* declined precipitously and was canceled at the end of its first season. So was Webb's contract with Warner's. It was not until 1967 that Webb would hit again with a successful show, a remake of his former show, now called *Dragnet 67* (and *68*, and so on) to distinguish it from its former version, still running in syndication. We'll take up this story in the next chapter.

Music and Variety Shows

Music on television experienced a decided split during the 1955 to 1965 decade. It is easy for us to forget how many musical variety and comedy variety programs remained on the air well into the 1970s—despite their almost total eclipse today. In 1965 Andy Williams, Perry Como, Red Skelton, Danny Kaye, Bob Hope, Dean Martin, Jimmy Dean, Lawrence Welk, Jackie Gleason, and Ed Sullivan all hosted their own variety programs. All of them had started in radio; their average age was somewhere around 55. Their musical tastes were by and large conservative. Ed Sullivan did pride himself on a somewhat more youthful outlook; the Beatles performed on his program in 1964, as did most of the emerging sixties rock stars. (The Rolling Stones had to change the lyrics of their hit song from "Let's spend the night together" to "Let's spend *some time*

together" to clean it up for Ed, and Elvis could be televised only from the waist up.) Ed's show finally went off the air in 1971.

But most of these programs featured a more established assortment of talent; you might have Dinah Shore or the Lennon Sisters singing a cover of a Judy Collins song, but you weren't likely to see Judy. And you weren't likely to see any African Americans hosting such programs, either. Nat King Cole had debuted a 30-minute prime-time variety show in 1956 on NBC, but despite its high ratings and a stellar lineup of artists, no sponsor was willing to take a chance and associate its product with an African American venue. A program starring a black host would not be tried again until 1966, with the equally short-lived *The Sammy Davis Jr. Show*. Women had started out strong in the television variety format, and Dinah Shore, Betty White, Edie Adams, and Kate Smith all hosted variety programs during this period. Only Dinah Shore, on her *Dinah Shore Chevy Show*, hit it big; but by 1965, no women hosted in prime time.

On the other hand, television had long been host to a genre of teen music show, started by *American Bandstand* (led by Dick Clark), which was a daytime show originally out of Philadelphia in 1952 that ran until, amazingly, 1987. It spent one brief season in prime time in 1957. It featured up-and-coming rock 'n' roll performers, lip-syncing to their hits, and a troupe of local teenagers dancing in front of the stage. *American Bandstand* begat the prime-time programs *Shindig* and *Hullaballoo*. *Shindig* ran on ABC from 1964 to 1966 and brought on well-known acts, from Bobby Sherman and the Righteous Brothers to Glen Campbell and Sonny and Cher. Its dancers were professionals, but it still featured audience participation. *Hullabaloo* was NBC's answer to *Shindig*, from 1965 to 1966. It distinguished itself during its debut months by bringing on the British, with such artists as Herman's Hermits, Marianne Faithfull, and the Moody Blues.

But television, especially prime-time TV, was an uncomfortable place for rock music. Its lyrics were often unsuitable for family audiences, as were its performers; the sound on most television sets was pretty terrible, and TV studios had a hard time handling the increasingly high decibels of rock's typical concert situation. It would take MTV to make rock feel really at home.

Folk music got a brief shot at prime time in 1963 and 1964 on ABC in the form of *Hootenanny*, a live acoustic show broadcast from a different college campus each week, hosted by Jack Linkletter. But here again there were dangers in music: Blacklisting by network and sponsors kept political activist singers like Pete Seeger and the Weavers off the show. In turn it was boycotted by other sympathetic musicians like the Kingston Trio, Joan Baez, and Peter, Paul and Mary. This did little for its credibility in socially conscious folk circles.

Quiz and Game Shows

We've mentioned the controversial game show genre in the light of the late fifties scandals. Seeing that the quiz show was already a popular program type on radio, television leapt into the business with alacrity. With the debut of *The $64,000 Question* in 1955 and its ensuing top ratings, other high-profile, high-award prime-time games proliferated. *You Bet Your Life* (hosted by Groucho Marx), *I've Got a Secret*, *The $64,000 Challenge*, *The Price Is Right*, *Name that Tune*, *To Tell the Truth*, and *What's My Line?* all made it into the top-20 prime-time shows during this period—most of

them completely unfazed by the rhetoric of scandal swirling around them. Many other less-popular quiz programs filled in the schedule for the daytime and fringe times. One of the more notorious was *Queen for a Day*, which featured women contestants one-upping each other's tragic sob stories; the one with the most pathetic case, as rated on the "applause-o-meter," won not only her heart's desire but also a wide array of shiny consumer goods. Other popular shows included *Beat the Clock*, *Dough-Re-Mi*, *Concentration*, and *Truth or Consequences*.

It was not the silliness or basic consumer greed on most of these programs that troubled critics; it was often the audience participation aspects. In a medium that had not yet invented the daytime talk show, opportunities for audience members to engage in unscripted participation in the goings-on were limited to a few kiddie shows and the game show genre. The audience thus revealed was often goofy, banal, greedy, overwrought, and trivial minded (and above all, female), and many who believed television should be a more serious, informative medium reviled such foolishness. On the other hand, if it involved men painting their faces and dressing up in team paraphernalia, well . . . that was different.

Sports

Big-league sports finally became big-league TV during this period. The surprising success of CBS's coverage of the Olympic winter games from Squaw Valley in 1960 drew attention to the possibilities. The passage in 1961 of the Sports Broadcasting Act allowed professional sports franchises to suspend normal anticollusion business regulations and negotiate the sale of national broadcast rights as a collective unit. This helped to draw both national networks and regional sports nets into expanded coverage, which particularly helped airings of National Football League and National Basketball League series. Boxing and wrestling slowly lost out on the national level to these more prestigious sports.

With the development of videotape in the early sixties, the instant replay was born, infinitely enhancing sports coverage on television. NBC and CBS both carried Major League Baseball. CBS purchased the New York Yankees in 1964, becoming the first but not the last major media company to tie in with sports in holy synergy. CBS paid $28 million for NFL rights for the 1964 and 1965 seasons, more than generously recouping its investment from several well-pleased sponsors. As a desperate attempt to compete, ABC's *Wide World of Sports* got started in 1961 under producer Roone Arledge, though it would take another few years for *Monday Night Football* to emerge. The prime-time network exposure and enthusiastic audience response to these ABC shows, spurred by their regularly scheduled time slots and high profile, would immensely expand the popularity and character of televised sports in the sixties and beyond. Local stations continued to feature regional and local teams very profitably; as networks got into the business, the practice of local blackouts—making the broadcast of an event unviewable in the area in which it was being held, so as not to undercut attendance—became increasingly contentious.

Talk

Pat Weaver's brainchildren, *The Today Show* of the early morning hours and *The Tonight Show* after the kiddies were in bed, continued to hold audiences and to spawn a variety of imitators. On *Today*, host Dave Garroway clowned around with companion

J. Fred Muggs, a chimpanzee, creating a frivolous environment; this format had offended the British gravely when they allowed NBC to broadcast Queen Elizabeth's coronation in 1953 and found the ceremony interspersed with laxative commercials and a monkey. Garroway and friend gave way to John Chancellor and then Hugh Downs. The morning magazine show gradually lost some of its silliness and placed a heavier emphasis on news and interviews. *The Tonight Show*, which had started out with Steve Allen and then Jack Paar, hit pay dirt in 1962 with the debut of Johnny Carson and his announcer-sidekick Ed McMahon. As the variety show waned, the late-night talk program would become a venue for musical performance and stand-up comedy of the type formerly found on variety. The main differences were that the host sat behind a desk and did interviews as well, and that this format had now been squeezed out of prime time into its more marginalized nighttime slot; there it could get away with a lot more culturally risqué moves that its predecessors hadn't dared.

Soaps and Serials

While NBC continued in the mid-1950s to rely mainly on game shows in the daytime, CBS countered with the first two half-hour daytime serials on television, both introduced on the same day in the winter of 1956: Irna Phillips's *As the World Turns* (1956–present) and *The Edge of Night* (1956–1975) experimented with crime and courtroom themes in the serial context. Both of these, along with *Guiding Light* and *Search for Tomorrow*, were owned and produced by Procter & Gamble, which knew well the value of the daytime serial for attracting its key market. The success of its daytime lineup provided the bulk of CBS's profits throughout the 1950s and 1960s. NBC finally introduced some longer-running soaps in the summer of 1958, with *From These Roots* (1958–1961) and *Today Is Ours*. Although it lasted only 6 months, *Today Is Ours* provided the central characters for a bigger hit, *Young Doctor Malone* (1958–1963), a partial carryover from radio. Not until the fall of 1960 would ABC debut its first soap, *The Road to Reality*. This too had a 6-month run; but finally, in winter 1963, ABC got it right with *General Hospital* (1963—present), a success story by anyone's standards.

Meanwhile, prime time got its first successful serial program, and what a program: *Peyton Place* debuted in 1964 on ABC and ran until 1969, for a few years airing three times a week, usually in the last half-hour of prime time due to its adult content. The show, based on the best-selling novel by Grace Metalious, was set in a small New England town where everyone not only knew everyone else's business, they *were* everyone else's business: illicit affairs, illegitimate births, intrigue, scandal, murder trials, numerous marriages and even more divorces, mysterious diseases and mental conditions—all the glorious elements of the melodramatic soap opera form. One of the first continuing casts of black characters was added to the story late in its run, with neurosurgeon Dr. Harry Miles and his family. Its most memorable new stars were Mia Farrow, during the last two years, and Ryan O'Neal as the youngest Harrington son throughout its run. In its first season the serial cracked the Nielsen top 20, and it maintained very respectable ratings for all five years. However, so strong was the prejudice against soaps as a form (and so difficult were they to schedule during prime time) that not until *Dallas* would a prime-time serial finally break through the respectability barrier.

Saturday Morning World

During this period of American television, a cherished institution of childhood took shape and flourished: the Saturday morning children's ghetto. As late as fall 1951, Saturday morning consisted of a few kids' shows, like *Rootie Kazootie* and *Kids and Company*, mixed in with programs directed at the adult female audience, like *The Betty Crocker Star Matinee* and *Personal Appearance Theater*. But in 1953, as the lifting freeze increased the number of family sets, women's shows were out and kids' shows in—though the network schedule didn't start until 9:45 on ABC and not until 11 or later on the other nets. Local stations happily filled in the time with cartoons, old movies, and local kiddie entertainers like Bozo the Clown and Uncle Phil. By 1960, although network feed still didn't start until mid-morning, some of the enduring children's classics were on the air, like *Captain Kangaroo, Shari Lewis, Soupy Sales, The Mighty Mouse Playhouse*, and *The Lone Ranger*. However, by 1965 cartoons had definitively taken over Saturday morning land. Just naming them brings back happy memories to this baby boomer: *Porky Pig and Bugs Bunny, Tom and Jerry, Underdog, Top Cat, Secret Squirrel, Atom Ant*, and *Casper the Friendly Ghost*. Many of these animated classics had started out as theatrical shorts; others were produced especially for television.

For all the attention that child audiences have received over the years, almost no one actually seems to have looked at the programming that they viewed. What messages of disorder and mayhem were young viewers soaking up? What consumer desires were they fomenting? The after school hours attracted a little more attention. The big breakthrough in the afternoons came when *The Mickey Mouse Club* debuted in 1955, but soon afterward the nets ceded this profitable late-afternoon period back to the affiliates, so locally syndicated programming ruled the day. It would take public television's Children's Television Workshop to address the child audience in a deliberate and educational way.

News and Documentary

The Cold War and the Civil Rights movement, together with the heightened regulatory focus on news and informational genres in the early 1960s, produced several changes in television programming. Cold War tensions led to the production and broadcast of more network television documentaries than ever before; commercial television would not venture so heavily into this area again as public television took up the cause in the late sixties. The civil rights movement found its representation on both documentaries and the expanding nightly news programs. Neither television news, nor the way that most Americans thought about racial issues, would ever be the same. Historian Michael Curtin explores these changes in his book *Redeeming the Wasteland*, looking at the golden age of the television documentary as a complicated moment in industry strategies, critical interventions, regulatory pressures, and both foreign and domestic politics (Curtin 1995). By what these programs failed to address and by the assumptions they made about their audiences, an opening for a more democratic use of the medium was derailed. But in many cases they proved the power of television to act as an agent of social change—or lack thereof.

Connection The Whole World Is Watching

If the potential for news that World War II had engendered languished somewhat in the first decade of television, by the late 1950s pressures from both within and outside the industry began to push against network conservatism. Curtin describes a meeting among CBS network executives in 1959 at which they determined that three things could help to offset the negative publicity attracted by the quiz show scandals: shift to the magazine concept, expand news coverage, and produce more prime-time documentaries (Curtin 1995). Emphasis on news was also fueled by the fact that some of the most trenchant criticisms of TV's tame commercialism came from inside its own news divisions. At CBS, Edward R. Murrow and his "boys"—reporters trained during the war years—frequently criticized the timidity of their own company and its steady diet of game shows and escapist entertainment, especially after Murrow's *See It Now* program was canceled in 1958.

Public interest in coverage of the 1960 election had resulted in the highest-yet rates of voter turnout, and CBS realized that news programs could at once help offset public image problems and draw respectable ratings. They responded by creating a prime-time documentary series, *CBS Reports*, in the fall of 1959. NBC followed with its *White Paper* series in 1960, and ABC introduced its *Bell and Howell Close Up!* in 1960, though it didn't become a regular series until 1961. All of these programs covered a wide range of issues, international and domestic. Interest in foreign issues stemmed partially from the expansion of American television interests abroad during the 1960s, as syndication to foreign stations and investment in other nations' television industries expanded along with American diplomacy. American business moved overseas generally during these years, with investments increasing fivefold between 1945 and 1965. American television played an important role in smoothing the route of U.S. investments, spreading American values abroad, and acting as advance publicity agents for U.S. marketing. Countries that could not afford extensive investment in their own television systems came to rely on American syndication. At the same time, in the early 1960s many countries first imposed quotas on imported programming, particularly from the United States.

Documentaries could help to override prejudice against American programs by taking an interest in other countries' social and political situations and by counterbalancing the flow of lightweight, often derided entertainment shows. They could preach the American vision of liberal democracy, founded in capitalist consumerism, to the world. As the U.S. government fostered the development of Radio Free Europe and the Voice of America (see Chapter 12), and the United States Information Agency (USIA) propagated U.S.-oriented news and culture, the commercial networks were eager to participate. Once again, industry and government worked together to spread American media worldwide and to combat Soviet influence.

CBS, NBC, and ABC documentaries often focused on struggles for democracy and independence in Third World countries, particularly in South and Central America ("our own backyard"), but also in the decolonizing nations of Asia and Africa. Two of the

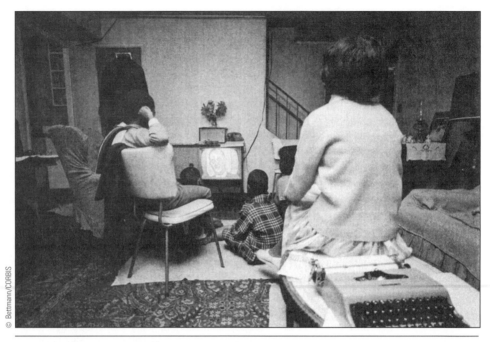

Television brought news of the civil rights struggle into people's lives in a way that no previous medium could. It helped to persuade many embattled families that they were not isolated but had the eyes of the nation on them.

most well-received of the international documentaries were NBC's *The U-2 Affair,* about the U.S. spy plane shot down over China by the Soviet Union, and ABC's *Yanki No!* about Fidel Castro's expanding influence in Latin America. By Curtin's count, international affairs received by far the most attention from the prime-time documentary series, making up about half of the subjects covered (Curtin 1995). The golden age documentaries also examined domestic issues. These ranged in subject from U.S. politics to crime, the environment, poverty, the space race, health issues, and celebrity interviews. One of the best remembered is CBS's *Harvest of Shame* about migrant workers, which actually worked to produce some protective legislation.

The area of civil rights received a relatively small amount of network emphasis; Curtin calculates that out of a total of 167 documentaries aired on these three network programs over a 5-year period, only 11 specifically addressed the civil rights struggle at home. Yet these programs attracted a significant amount of public attention. One of the first was ABC's *The Children Were Watching*, which followed a 6-year-old African American boy as he attended the first day of integrated school in New Orleans. NBC produced *Sit-In*, about a demonstration of nonviolent resistance in Nashville. ABC's *Walk in My Shoes* (1961) opened with lines that stunned many white viewers, as an African American street orator exclaimed: "This is no Communist speaking. This is an angry black man speaking. The twenty million black men of America are angry! America won't have to worry about Communism. It'll have to worry about the restless black peril here in America" (Curtin 1995, 169). As it follows a day in the life of a young black man, the civil rights struggle against

white racism and violence is traced, leaders such as Percy Sutton of the NAACP and Malcolm X are interviewed, and at the end, the nameless main character turns and says directly to the camera, "What do *you* expect me to do?" Carefully balancing its liberal pluralist perspective against the voices of an angrier, more separatist philosophy, the program used a structuring framework of white narrative, selection, analysis, and opinion to contain the black voices within it. Yet, as Curtin argues, it provides the material for perceptions that go beyond the cautious liberalism of its makers.

This was the basic nature of the bargain struck between the struggle for civil rights in America and its mainstream television coverage. The civil rights movement provided compelling, dramatic visuals that drew Americans of every color to their television sets and helped to create the expansion of the network news programs to a half hour by 1963. The March on Washington revealed Martin Luther King Jr. delivering his "I Have a Dream" speech; cameras rolled as George Wallace pledged "Segregation today, segregation forever" on the steps of the University of Alabama; and reporters with cameras became almost as popular as targets for angry white mobs as did the marchers and demonstrators themselves. It was natural TV, and even if white news reporters and anchors remained detached or even semi-hostile, the pictures escaped from their controlling narration and spoke directly and effectively to a nation used to seeing itself as the good guy, the fair-minded Westerner, the liberating GI.

For the networks, news became profitable as a sponsored medium for the first time, driven at least partly by dramatic civil rights coverage. For the civil rights movement itself, media publicity provided the very lifeblood of the nonviolent method of social resistance. In the absence of armed revolution or violent assault on the bastions of oppression, nonviolence depends on the effect of publicity, of allowing people to see what's really going on, of inducing them to feel shame and horror at what they see. It contrasts the controlled rationality and reasonable demands of the resisting group with the hysteria, violence, and brutal antidemocratic words and actions of those they oppose. It cannot accomplish that without demonstrating it for all the world to see, and here television came in at precisely the right moment. As one NBC newsman put it, network news became "the chosen instrument of the revolution": it was not just television alone, but *national* television and the news coverage it provided, that helped to turn the civil rights movement from a locally repressed struggle to a nationwide concern. And not just in the United States: The whole world was watching. Network television's global reach meant that the American civil rights struggle was beamed into homes across the world. As the network documentary units followed up with such programs as *The U.S. Versus Mississippi*, it became clear where the national interest lay. Civil rights could no longer be contained as a regional concern.

Yet even as television news and documentaries tackled social problems and revealed conflicts of relevance to all, they did so from a tightly controlled perspective. Little effort was made to incorporate African American voices or editorial control into the domestic documentaries, and the perspectives of women and their voices remained almost totally excluded from the programs' address. This kind of coverage itself distorted the events covered, as the myriad black women activists, young and old, who provided such a vital part of the civil rights struggle on all levels were systematically ignored by male reporters and cut out of the action. Reporters focused on male leaders, because they were comfortable and familiar with that model of social action and expertise.

With the pressure of scandal and regulatory reform fading in the Johnson era, the golden age of documentary drew to a close. All three networks had suspended their regular prime-time series by 1965; by 1967 the number of documentary hours on the networks was down to 100, and by 1977 it had been cut in half again. Newscasts continued in their half-hour length, however, and it is partly the shift to breaking news coverage that led away from documentary production. The birth of public broadcasting provided a new venue, and took pressure off the commercial networks, but most of all it was the pressures of commercial profitability that conflicted with documentary production as the networks defined it in the early 1960s.

Social Discourse

The period from 1955 to 1965 is one during which social discourse played an important, and very public, role in determining television industry structure, programming, and ideas about the audience. We've already traced the critical concerns leading up to the various scandals that mark the decade and the opening for social science research and public policy attention that they created. During this period network practices solidified, and conceptions about the proper nature of television and the characteristics of its audience took shape as well. The industry itself, critics and regulators, and a slowly developing academic discipline of humanistic TV studies all developed their competing ways of thinking and talking about TV.

The Measured Audience

Even as the A. C. Nielsen Company solidified its hold over television ratings, it received a measure of attention from agitated regulators who saw in the Nielsen numbers the root of television's obsession with the lowest common denominator. In 1961 Congress initiated an investigation into TV ratings, and in 1963 and 1964 hearings were held by the House Commerce Committee. The Nielsen system and its competitor in local markets, Arbitron, were found to be less interested in accurately gauging the tastes and preferences of the American public than they were in coming up with numbers that pleased and interested their clients—the networks and ad agencies. This less than surprising outcome sparked the formation of two industry self-watchdog groups: the Broadcast Ratings Council and the Committee on Nationwide Television Audience Measurements (CONTAM). The members of these industry groups had an interest in keeping numbers manipulation out of the hands of their competitors, at least, so even if the ratings system had not become more socially accurate, it did achieve some internal consistency. Still, the very young, the elderly, and members of social minorities remained undercounted, and because they (in the minds of the industry) did not represent prime consuming groups, no one kicked up much of a fuss. As far as the industry was concerned, the viewing audience was white, middle class, and between the ages of 12 and 49. It was also mostly female, though this was a subject to be discussed not in program quality hearings but in sales meetings.

Meantime, the networks had diversified into a different kind of audience testing. In the late 1940s, Frank Stanton of CBS—an Ohio University grad with a doctorate in

psychology—initiated his Program Analyzer system that allowed selected studio audiences to register their likes and dislikes on a minute-by-minute basis by means of little levers that they turned to left or right while viewing a program in a laboratory. He also initiated the diary survey technique that supplemented the Nielsen ratings by, for the first time, allowing a breakdown of audience composition by age and gender and that also, for the first time, included homes with no telephone. Now, producers and network executives could see precisely where their opinions of the quality of a show departed from those of the audience. Thus, accurate or not, these new measurement methods provided a way to break through the accretion of preferred practice, with its attendant assumptions and prejudices, for those with a mind to do so.

CBS began to apply Program Analyzer and diary findings to its program selection and development practices. The other networks soon followed suit, and by the late 1950s Nielsen and Arbitron had adopted the diary method as their main means of measurement. "Sweeps weeks" were established—the periods, four times a year, during which the two ratings services performed their most intensive, national ratings survey. A system of program pretesting also developed, extending the Program Analyzer technique to include focus groups, survey analysis, and other methods. As marketing and advertising also relied increasingly on sophisticated methods of consumer analysis, the once massed national viewing audience became increasingly conceived of in terms of segments: women 18–35, men 12–49, teens, kids under 12, and so on. Though by 1965 this way of thinking had barely taken hold—and indeed, with the three networks' vertically integrated oligopoly it was hardly necessary—audience measurement would soon assume a central role and diversify even further into lifestyle segments in the seventies.

Critical Mass

In the meantime, as we have seen, influential social critics and regulators began worrying about television's slide to the lowest common denominator of tastes and interests. Diagnosing the problem as excess commercialism, evident in the quiz show scandal and the similar payola scandal, they pointed the finger of blame at the commercial sponsors and the greedy DJs, whose bad influence had the effect of driving down the level of service from these popular media. The critics called on the original regulatory design of radio's quid pro quo system—higher public service in return for use of the public airwaves—and indicated to an increasingly profitable industry that they expected a higher level of public service. Responsible corporations should pull up their socks and take their responsibilities seriously. But what did this mean?

The initial definition—more news and documentary programming—foundered on a general lack of interest. Though some documentaries got respectable ratings, overall they trailed far behind even the most average entertainment programs. If the public was not viewing these programs, could the programs really be considered to be serving the public interest? By 1965 the attempt to reform television in the wake of the scandals and the FCC's Newton Minow years had faded away to almost nothing. Critics found a new object of blame: the commercial system itself. Increasingly, based on 40 years of experience with commercial network broadcasting, it began to look as though the combination of commercial interests with public service obligations was

simply not going to work. Perhaps a whole new broadcasting structure was necessary, as reformers had been saying for a long time. Americans began to look to the BBC system, as educational broadcasting stations gathered strength. If you could get rid of American broadcasting's original sin, commercialism, perhaps a new era of intelligence, seriousness, and high purpose could emerge. Television could fulfill its squandered potential. A discipline of public policy studies began to emerge around television, stimulated by this debate.

Is TV Art?

Besides a few influential newspaper critics like Jack Gould, John Crosby, and Robert Lewis Shayon and public intellectuals like Gilbert Seldes, who sometimes wrote on the media for magazines, television did not have much of a critical tradition. Beginning in the mid-1950s, a tentative coalition of academia, journalism, and industry attempted to address this lack by exploring new ways to talk about TV. If public service was to be judged by standards of quality, of seriousness, of good taste, how could these aspects be recognized? How could they be acknowledged and rewarded? The Academy of Television Arts and Sciences had been founded in 1946 in Los Angeles, patterned after the Academy of Motion Picture Arts and Sciences, and quickly developed the TV equivalent of the Oscars—the Emmy awards. Like the Oscars, the Emmys were recognized as being primarily a means of industry promotion. Though critics, journalists, and creative personnel were invited to nominate programs for quality, the element of self-promotion detracted from serious credibility. But the networks understandably grasped at this path toward respectability and began to broadcast the annual awards ceremony nationally in 1957.

That same year, a book appeared that pulled together some of the disparate elements of critical thought on television and other media forms. Called *Mass Culture: The Popular Arts in America*, and edited by Bernard Rosenberg and David Manning White, it struggled to mediate between the mass culture disdain for the commercialized media and the more accepting, still emergent popular arts approach (Rosenberg and White 1957). Its two editors personified the split. Bernard Rosenberg, an editor for *Dissent* magazine and a lecturer at the New School for Social Research (though also director of research for Market Psychology, Inc.), articulated the Frankfurt School suspicion of mass culture and commercialism and the lowbrow standards of the benighted audiences who supported them. David Manning White, a professor of journalism at Boston University, took a more supportive, liberal-pluralist stance, defending the popular arts despite their commercialism as capable of achieving excellence if properly encouraged. As the groundbreaking collection made its way onto university reading lists, a new space for study of the media began to open up.

The television industry observed this opening as a path toward respectability. CBS and NBC had engaged in an active defense against charges of philistinism for years by pointing out, in lavishly produced brochures and booklets, the many examples of quality programming they claimed to produce. In 1960, CBS commissioned an edited volume of television criticism, drawing on various critics and academics. Called *The Eighth Art*, it patterned itself after the Rosenberg and White volume, but without the Frankfurtian edge. In 1962 the Academy of Television Arts and Sciences got into the

act by founding the journal *Television Quarterly.* With it they hoped to stimulate a level of informed aesthetic criticism of television.

Though it would take the surprising career of the first media theorist and media star Marshall McLuhan in the late 1960s to bring the study of television into academic prominence, these efforts at redeeming television from wasteland status would grow in several different directions. The term *mass culture* would slowly be replaced by *popular culture* in the study of television as an aesthetic and cultural form, even as the developing field of *mass communications* took a more political-economic look at industry structures and practices and the social uses of television. Public policy discourse pointed to the social significance of the medium and its centrality to democratic politics and social structures. And social scientists continued to underline the key role that television's representations played in psychological development and social adjustment. Finally, as we shall see, the expanding role of syndication meant that broadcasting began to develop a sense of its own history and scope. From a live medium whose evanescent manifestations disappeared as quickly as they were received, the switch to film and videotape and the recycling of programs by syndication allowed television the opportunity to preserve, review, analyze, categorize, and even canonize its vast output. If not an art, TV could at least be an artifact (Kompare 2004).

CONCLUSION

The turbulent years from 1955 to 1965 were marked by regulatory investigation and debate, scandals in both the radio programming and quiz show industries, and a period of consolidation and standardization in television structures and programs, all part and parcel of a period of increasing social change. Television now provided the central arena for both private and public life, and the debate over its social role broadened and deepened. But the event that marks public memory most sharply during this period is also inextricably bound up with television. On November 22, 1963, handsome and popular President John F. Kennedy was shot and killed by an unseen sniper as he rode in a motorcade through the streets of Dallas, Texas, with his glamorous wife Jackie beside him. That event, captured by home-movie footage and replayed again and again, was reported to an incredulous nation via television. The image of news anchor Walter Cronkite removing his glasses to wipe the tears from his eyes as he reported the young president's death remains as much a part of the public event as the ensuing mourning, the funeral processions, and the endless investigation into the "lone shooter" theory. It was a scene that would occur all too often in the violent decade to follow, as the whole world would watch events relayed to them by television. The television industry—despite upheavals, debates, investigation, and challenges—would retain its three-network structure of control and containment in the face of burgeoning change.

THE CLASSIC NETWORK SYSTEM, 1965 TO 1975

The set of social phenomena we think of as the sixties didn't really get started until after 1965, and it continued into the mid-1970s. Demonstrations, student takeovers, Black Power, women's liberation, antiwar protests, flower power, the drug culture, the pill, police riots, free love, yippies, hippies, afros, and gurus—the swinging sixties may not have begun on any specific date, but it began in certain places: Chicago, Berkeley, Haight-Ashbury, Wounded Knee, Watts, My Lai, Woodstock, Stonewall, and the kitchens and bedrooms of homes across the country. Because the first cohort of baby boomers reached the age of 18 (not yet entitled to vote, though draftable, marriageable, and able to drink in some states) in 1965, this date may not be merely an arbitrary marker. The last of the boomers would straggle into young adulthood in 1978—by that time the drugs, disco, and yuppies era. If the decade of the fifties was the age of containment, it was in the sixties that pressure built up to a point that blew American society wide open. And though the main focus of this chapter is on the sixties at home, it should not be forgotten that these years brought an amazing explosion of political liberation movements across the world. In Paris, London, Prague, Tokyo, Mexico City, and many other cities, young people took to the streets as those in charge struggled to hold onto their authority.

SOCIAL CONTEXT: SOMETHING'S HAPPENING HERE

Race: Again, with a Vengeance

The first hint of things to come issued from the emergent Black Power movement, growing out of the civil rights struggle. In some places in the South a more militant tone had developed. In Monroe, North Carolina, Robert F. Williams led the local NAACP chapter to meet Ku Klux Klan violence with armed resistance of its own, driving the Klan out of town in 1957 as others took heed and occasionally followed his example. But by 1965, 80 percent of America's black population lived not in the rural South but in the decaying inner cities nationwide. Despite efforts to channel the fight for rights into traditional paths, such as increasing black presence at the polls after passage of the new, stiffer Voting Rights Act in 1965, the voice of Malcolm X rather than Martin Luther King began to command increasing attention. Malcolm himself was assassinated in February of that year, but his *Autobiography* continued to be widely read and his influence felt.

In August 1965, the first of the major urban riots since World War II broke out in Watts, an area of downtown Los Angeles, but this time it was not provoked and carried out mainly by whites against blacks. This time, in reaction to several acts of police violence, the African American community erupted in outrage. Over the next few years, other cities followed: Chicago, Detroit, Cleveland, Newark, New York. A federal commission set up to study the problem reported 8 major uprisings, 33 serious but not major outbreaks, and 123 minor disorders in 1967 alone. Yet amid the violence some progress was made. Voting reform in the South and a more political stance elsewhere brought more African Americans to the polls than ever before. By 1977, over two thousand African Americans held local or state office in the South, including two members of Congress, but whites still controlled 97 percent of elected offices across the country. College and university minority enrollment improved, and busing began to integrate city schools. Yet in 1977 almost 35 percent of young black people were unemployed, and the median black family income was only 60 percent that of whites.

*"One, Two, Three, Four, We Don't Want Your ****ing War!"*

In 1964, President Johnson sent troops into Vietnam in an undeclared war against Soviet influence that rapidly escalated. By early 1968 more than a half million American soldiers had been sent overseas. Various Americans protested U.S. entry into such a murky political situation, without benefit of approval by Congress, especially on the country's college campuses. The military began drafting young men to serve in Vietnam as early as 1962; by 1964 the first draft resistance movement had begun, not surprisingly among the ranks of civil rights activists, who saw the war as an extension of American racism overseas. Public draft card burnings took place across the country, and thousands of men whose numbers had been called simply failed to show up; some fled to Canada.

The war became a key issue in the elections of 1968. The Tet offensive had occurred in January of that year and was an escalation that provoked a turning point in press coverage. Led by network news reporters like Dan Rather and Walter Cronkite, public opinion began to shift as well. With Robert Kennedy assassinated as he ran for Democratic nomination, Vice President Hubert Humphrey contested Senator Eugene McCarthy's antiwar platform at the Democratic National Convention in Chicago. A riot broke out between police and demonstrators outside convention headquarters. As hundreds were arrested, the police ventured inside to manhandle reporters who had captured the melee on video, and Humphrey got the nomination. Alleged ringleaders of the demonstration would become known as the Chicago 7 in a protracted trial with elements of the circus about it. As the police beat the demonstrators and dragged them away, the television cameras rolled. On the sound track the youthful protestors could be heard chanting, "The whole world is watching! The whole world is watching!" They were right.

On college campuses, populated by draft-age men and their feminine sympathizers, protests reached a peak in May of 1970 when the Ohio National Guard opened fire on students at Kent State University who were protesting President Nixon's decision to invade Cambodia; four students were killed. The deaths of these white, middle-class students provoked far more publicity than the state police shootings of students at all-black Jackson State University the next day. By 1970 most Americans agreed that the United States should quickly extricate itself from its involvement in Vietnam, yet in February 1971 the Nixon administration mounted a renewed offensive into neighboring Laos. In the meantime, it was finally revealed to the American public

that a heinous massacre of innocent civilians had taken place in the villages of My Lai and Song My two years before. Graphic pictures of dead women and babies in a ditch with sullen American troops standing above them, rifles at the ready, appeared on the evening news and in the glossy magazines. In 1971 the biggest mass arrest in history took place in Washington, D.C., as 14,000 protestors who had sought to tie up D.C. traffic were hauled off and booked.

Yet still the war continued. Richard Nixon began withdrawing troops in 1970, while still invading Laos. The withdrawals increased, until by early 1972 only 95,500 troops remained from a high of over 500,000 in 1968. Peace talks were announced, but the bombing kept on. Finally a peace agreement was signed on January 23, 1973, and a few months later American withdrawal was complete. No victory had occurred, no objective had been met, and Americans were left wondering what all the loss of life and social disruption had really won them.

But soon they would have the scandal of Watergate to distract them. The illicit activities of some of Richard Nixon's campaign workers in 1972 led to discovery, cover-up, and denial in the highest office in the land. Americans, already suspicious of a government that had fomented war and brutal repression of homegrown political movements, now had their worst fears confirmed. From the president on down, big government seemed to be in cahoots with big industry and more than happy to lie, conceal, and deny wrongdoing to the American public. Though Nixon was reelected in 1972, the ongoing investigation rapidly undercut his credibility, and in August 1974 he became the first American president to resign from office. Vice President Gerald Ford took over the presidency of a country sunk deep in cynicism and distrust.

Peace, Love, and All That

In the midst of urban riots and antiwar demonstrations, a distinct youth counterculture began to develop. With roots in the 1950s beatnik movement—disaffected young people, wearing black, congregating in coffee houses and listening to rebel poetry and folk music—the American demographic bulge of people under 30 congregated on college campuses and in a few other spots across the country. They met in various rural communes and in colorful enclaves in most cities to experiment with new lifestyles, Eastern philosophies, mind-altering drugs, new kinds of relationships, and a general rejection of the tenets that had driven forties patriotism and fifties materialistic complacency. It is no accident that it was mainly affluent middle-class white kids who could afford such disaffectedness and no coincidence that their antimaterialist ethos led to a huge market in youth culture products—from love beads and Indian-print clothing to drug-related paraphernalia, incense, sandals, and above all music. Alternative media sprang up, some of it commercial and some not.

Certain key events—like the three-day rock concert in 1969 on a farm near Woodstock, New York—became emblematic of an entire social moment. Back in the days when it was still relatively safe to hitchhike, it sometimes seemed like a whole generation was on the move, standing on the side of roads across the country with their dogs, backpacks, and sleeping bags, thumbs out for a ride from the next Day-Glo-stickered VW van. Political content may not have been entirely lost—the free speech, antiwar, lowered voting age, and legalization of marijuana movements

attracted huge numbers at demonstrations—but much of the counterculture believed in living its politics (comfortably), not necessarily lobbying for them. And it was those who could best afford to differ with authority—the pampered, educated youth of suburbia—who sometimes ventured into the most radical political actions. An extremist branch of the Students for a Democratic Society (SDS), the Weathermen, staged bank robberies to fund their movement, set bombs in various institutional locations, and finally blew up a New York townhouse in 1970, killing three Weathermen. The kidnapping of Patty Hearst, scion of the Hearst media empire, by a group called the Symbionese Liberation Army in 1974 attracted enormous media attention, especially when she became seemingly converted to their cause and assisted in a bank robbery in which a security guard was killed. The horrific murders of a houseful of minor Hollywood celebrities by Charles Manson's brigade of half-crazed countercultural drifters in 1969 seemed to expose a dark side to all the freedoms that youth culture had promised. By 1975 much of the idealism of the earlier movement appeared to have spent itself in drugs, self-indulgence, and the violence it had once rejected.

Deep Social Change

In the end, after the hashish smoke cleared and the war limped to a halt, even in the depths of post-Watergate malaise a few lasting elements of social reform emerged. The decades-long struggle for civil rights provided a model and an inspiration for other subordinated social groups to follow; the youth movement had added numbers, a sense of historical entitlement, and an outraged recognition that within the very centers of the activist movement were their own forms of discrimination and repression. Women who worked in the civil rights and antiwar movements found their efforts dismissed, their roles confined to making coffee and providing sexual favors, and their claims to equal standing denied. Homosexuality, male and female, received a certain amount of recognition and tolerance from the sixties generation on an individual level but still remained closeted in that sphere of activity marked "private" and thus not amenable to political action. And on the Native American reservations across the country, long considered not truly a part of the U.S. body politic, the American Indian Movement (AIM) took shape as it attempted to solidify a new kind of identity. All of these groups began to organize and agitate for recognition and change in the 1960s and 1970s and would produce the most lasting forms of progress toward social equality after the noise and shouting receded into the past.

Betty Friedan, author of 1963's best-seller *The Feminine Mystique,* helped to found the National Organization for Women (NOW) in 1966. It was the first national organization to lobby for women's rights since the demise of the suffrage movement in the 1920s. Still the largest women's political organization in the country, NOW led the (failed) drive to ratify the Equal Rights Amendment in the seventies and supported the numerous lawsuits that helped to turn the green light of federal legislation into actual progress in legal and economic gains for women. Membership in NOW grew dramatically from 1,200 in 1967 to over 48,000 in 1974, with 700 chapters in the United States and in nine other countries. As campus chapters of NOW and other more radical women's organizations opened up on campuses and cities across the country, the young women of the baby boom generation actually began to believe in and insist on the formerly empty promises of equal treatment and opportunity that their nation had long declared. Rejecting the bad postwar

bargain their mothers had been obliged to make, women swelled college and university populations, went for advanced degrees, and began moving in unprecedented numbers into professions previously closed to them.

As Susan Douglas writes, "In 1970, the women's liberation movement burst onto the national agenda" (1994, 166). The Women's March on Washington brought media attention to what had been an often overlooked social phenomenon, and women's groups began to lobby for passage of the Equal Rights Amendment and for changes in representation in politics, economic organizations, and media. The first sex discrimination suits were filed by the Justice Department in 1970, and in August a massive Women's Strike for Equality took place across the country. Women's groups called attention to gender biases in advertising and in language itself, coining the terms *sexism* and *male chauvinism*. (*Sexual harassment* would have to wait a couple of decades.) Lawsuits were filed against both *Time* and *Newsweek* for discrimination in hiring and promotion of their female employees. Clearly the media would remain at the center of this struggle for civil rights.

Consciousness-raising groups, a primary tactic of sixties second-wave feminism, gathered women in homes and meeting halls to begin redefining the private problems of individual women into matters of public policy. Publication of Germaine Greer's *The Female Eunuch* in 1971 helped to clear away the remnants of the sexual double standard that had complicated and circumscribed women's lives. The approval and increased availability of birth control pills starting in 1960 meant that women at last could exercise some meaningful control over their own reproductive capacities, with enormous effects on their sexual and professional lives. Other publications, such as Kate Millett's *Sexual Politics* and Susan Brownmiller's *Against Our Will*, revealed some of the ways that women had been injured by dominant Western modes of thinking about gender and helped to promote feminism among the upcoming generation of young men and women.

The key political phrase of the second half of the twentieth century, "the personal is political," was generated by the women's movement and helped to break down the private-public dichotomy that had confined women to inferior status since the birth of the republic. The gay rights movement became the next to politicize the personal. The event credited with sparking the current movement was the Stonewall riot in June 1969, when New York City police attempted a vice raid on the Stonewall Inn, a gay bar on Christopher Street in Greenwich Village. Its clientele resisted, and a riot ensued that continued in the form of demonstrations for three days. A number of gay rights organizations formed in response to the momentum thus gained and began to lobby for repeal of antiquated sodomy laws and for antidiscrimination legislation. The riot's most prevalent accomplishment, however, was to bring out into the open an unapologetic and unashamed homosexuality, to reveal how very arbitrary and artificial the divide between hetero- and homosexuality in fact was, and to allow gay relationships to come "out of the closet," in the phrase that is now ubiquitous, and into the mainstream of American life. The 1960s saw the beginnings of this process, which intensified in the seventies.

The American Indian Movement also rests on a redefinition of identity and a redrawing of public-private lines. The history of the United States constitutes a long, brutal story of attempts by encroaching European settlers to remove the continent's native population from its homeland, settle them in distant and remote locations where they could be ignored until those lands were needed, discourage preservation of Native

American culture and tradition through enforced schooling, and deny reservation inhabitants the basic rights of citizenship. Separated by location and by original tribal distinctions, Native Americans staged many isolated attempts to resist U.S. influence and restore tribal lands but were consistently defeated by a hostile U.S. government and the schemes of those who profited by possession of Indian lands and resources. The more militant movement that emerged in the sixties not only renewed demands for basic rights for Native Americans but also forged a redefined identity that linked the interests of many tribes into a united push for common goals.

In 1973 three hundred Oglala Sioux, led by AIM, led an action to occupy the town of Wounded Knee, South Dakota, a location with a long, tragic history in the oppression of the Sioux. Sparked by the murder of a local man by a white resident whom Indians did not believe had received appropriate justice, the occupiers were met by more than two hundred federal agents, marshals, and police from the Bureau of Indian Affairs who began firing on the Native Americans with rifles, machine guns, and grenades. A siege ensued that lasted for 71 days, with messages of support for the Indians coming in from all over the world. The U.S. government was forced to promise to investigate the concerns that had led to the siege and to reevaluate the 1868 treaty that had taken land away from the Sioux. The united Indian movement would continue into the 1970s, winning land and resource concessions from state and federal governments.

Thus did the World War II–inspired rhetoric of freedom and democracy play itself out two decades later, as the children of the war generation recognized the many areas of American life that had remained outside of democratic privilege. They were assisted by their sheer numbers as well as by a proliferation of media that spread their messages and images across the nation and across the world. No previous generation could claim this recipe for impact, and neither American culture nor American media would survive unchanged.

THE REVOLUTION IN MEDIA

The revolutionary decade of the 1960s depended heavily on the media. Like the civil rights movement before it, the push for social change was conveyed through the nation's largely commercial media system. Hippies in their patched jeans and flowered hair, Black Panthers sporting afros and dark glasses, protesters having their heads beaten in by police in riot gear, and free love everywhere made really great footage. Although television was a key component of the sixties politics and lifestyle, other media participated more directly. This was the period of a flourishing underground press: Hundreds of shoestring papers, newsletters, and magazines sprang up to allow the various political and social groups to communicate with themselves and the outside world. Larger outlets, like *The Village Voice, Ms.,* and *Rolling Stone,* became commercial successes out of the radical and feminist counterculture. Radio spoke to youth like no other medium did, and an enormous expansion of the music industry took place. Rock overtook folk as the politically conscious voice of the new generation. Movies recognized the youth market and struggled to craft an appeal, while independent filmmakers proliferated and began to provide an alternative to Hollywood slickness. And finally advertisers, never ones to be left in the dust when a market beckons,

successfully incorporated liberation politics into carefully crafted appeals, selling material products that an antimaterialist youth culture just couldn't get along without.

The Underground Press

For purposes of bringing local communities together, allowing a number of different views to flourish, and doing it cheaply and quickly, nothing beat the print medium (until the advent of the Internet many years later). The so-called underground press—meaning noncommercial, often personally subsidized, inexpensively printed and distributed, relying on unpaid writers and other labor, and usually left wing—filled these functions in the sixties and, being archivable, has left the best record we have of these turbulent times. Often addressed at a specific group or emanating from a specific organization, copies circulated from hand to hand, were passed out free at demonstrations and in music and head shops, and were generally hidden from one's parents, because they often took pride in flouting the usual indecency and obscenity standards, too.

Some of them predated the sixties. *The Village Voice* had been started in 1955 by a group of Greenwich Village writers and intellectuals, among them Norman Mailer. Always antiestablishment, by 1970 it had achieved a national circulation of 150,000. *I. F. Stone's Weekly* had provided an anti-McCarthy voice of sanity since 1948. The sixties generation's contributions started with the *Los Angeles Free Press* in 1964, the *Berkeley Barb* in 1965, and by the late sixties included *The Washington Free Press*, Chicago's *Seed*, Atlanta's *The Great Speckled Bird*, Milwaukee's *Kaleidoscope*, the San Francisco *Oracle*, *The East Village Other*, and many more. Most were weeklies, with a heavy emphasis on graphics, political cartoons, and the radical arts. The black liberation movement offered alternatives to the established black press, such as *Black Truth*, *Black Liberator*, *The Black Women's Committee News*, *Muhammad Speaks*, and *Black Panther*. *El Malcriado*, started by Cesar Chavez in 1964 to support the unionization of migrant workers in the San Joaquin Valley, and *La Raza* in 1967 in Los Angeles helped to organize and unify Latino/a causes. Native Americans started *Akwesasne Notes* in 1968, publishing activists like Vine Deloria Jr. Many of these papers drew on the services of two alternative press associations started in the sixties: the Liberation News Service and the Underground Press Syndicate.

Alternative magazines reached a national audience that the newspapers often did not. More expensive to produce and distribute, many politically conscious publications found it difficult to balance their highly critical content with the needs of advertisers. One of the more successful was *Ms.* magazine, founded in 1972 by a group of feminists and edited by Gloria Steinem. Determined not to accept advertising of products that it deemed antithetical to its feminist purpose, *Ms.* struggled along without the makeup, diet, and fashion advertising so endemic to women's magazines. Nonetheless, it attracted a circulation of over 500,000 eager to hear news and commentary from a feminist perspective and became a publishing and political success. For black women there was *Essence*, edited by Marcia Ann Gillespie, that debuted in 1970 with close ties to the Black Power movement and by 1990 had reached a circulation of almost a million. *Rolling Stone* kept its focus on music, but ranged widely over political and cultural topics with contributions from well-known left-wing journalists like Hunter S. Thompson and Tom Wolfe. Publications like *Ramparts*, edited by Robert Scheer, occupied the space to the left of liberal weeklies like *The Nation* and *The New Republic*.

Radio

It was during the 1960s that the long underutilized FM band finally began to reach its full potential and to fill up, at first, with the low-budget, quirky, alternative music and personalities often known as underground radio. With AM grinding out top-40 and other standardized formats, FM became the place to tune in for something different, offbeat, aimed at the countercultural audience. Many FM stations simply repeated the AM offerings that their combined owners found most profitable. But an FCC ruling in 1964 forbidding "combo" simulcasting sent broadcasters scrambling for something different—and inexpensive. Historian Michael Keith, in his book *Voices in the Purple Haze,* quotes famous top-40 DJ Bruce Morrow ("Cousin Brucie"): "The owners reasoned that they could hire strange hippies as FM disc jockeys, letting them play whatever they thought their contemporaries wanted to hear. And, best of all, since they would be on 'underground' FM stations, they wouldn't command big salaries like their AM counterparts" (Keith 1997, 71).

Furthermore, FM transmission was superior to AM in many ways: less prone to electronic interference (static) and able to broadcast in stereo. The rise of rock music and its many sixties branches—psychedelic, folk rock, metal, reggae—and the shift from the 45 record to the LP meant that the 3-minute song limit of AM increasingly couldn't handle the interests of sixties audiences and the demands of their music. Led by nonprofit and college stations like WBAI-FM in New York, KSAN in Berkeley, and WORT in Madison, commercial stations like KMPX-FM in San Francisco and WOR-FM in New York soon began to adapt the new freeform style to profit-making purposes. By 1968 the phenomenon had spread across the country. Early underground DJs avoided not only format but often genre categorization, mixing and matching across rock, jazz, blues, and even classical as they spun out their own highly personal musical visions. Underground DJs and their guests tended to be outspoken politically as well, interspersing music with commentary and news about radical and liberation movements.

Yet as underground became more popular and pressure built to commercialize access to the hard-to-reach youth market, the same kind of process that had changed early rock 'n' roll radio into top 40 began to operate. By the early seventies many underground stations had become highly standardized, playing only top-selling albums with a set rotation frequency, and a new format was born: album-oriented rock, or AOR. FM revenues increased from $40 million to $260 million between 1967 and 1975. Other formats also shifted to FM, including "beautiful music," soul, country-western, progressive jazz, and classical. A generation shifted its allegiance to FM and has never shifted back. AM began its slow transition to more talk than music, with the debut of all-news formats.

Though noncommercial public radio would not get started nationally until 1969, the growing Pacifica network began providing a model for public radio as early as 1949, when the Pacifica Foundation, a pacifist organization established by Lewis Kimball Hill, was awarded a license for KPFA-Berkeley. This was the first of the new FM licenses in the educational band awarded to a group not affiliated with an educational or religious institution, and it set an important precedent. KPFK-Los Angeles and WBAI-New York joined the Pacifica group in 1960, and KPFT-Houston came along in the seventies. These stations were supported by their listeners and by foundation grants and provided an eclectic mix of news, commentary, music, and

discussion—open to a wide cross section of views and community interests. Both public and community radio would grow out of the Pacifica precedents in the late sixties.

Movies

The changing habits of American audiences had created a box office slump for the movie industry by the early 1960s, hitting a low point in 1962. As older audiences increasingly stayed home and watched Hollywood-produced filmed series on TV, the moviegoing audience became younger, more visually sophisticated, and unsatisfied with the wide-screen spectacles and big-budget musicals studios were turning out. In the meantime, a new wave had swept Europe, as filmmaking auteurs in France and Italy, in particular, produced low-budget, high-art films that expressed a more sophisticated and literate sensibility. The movement led to new opportunities for independent filmmakers in Hollywood, as young directors like Francis Ford Coppola, Stanley Kubrick, and Arthur Penn established their reputations in independently financed films that were produced far from the interfering arms of studio moguls.

But the studios saw an opportunity in distributing such films to theaters as a way to make up for lost revenue and to compete with their European counterparts. A number of young directors incubated in television moved into film production, such as John Frankenheimer, Sidney Lumet, and Sam Peckinpah. As the Motion Picture Association of America (MPAA) code was abolished in 1968 and a new, more permissive system of Hollywood representation was ushered in by the new ratings system, the increasingly adult content of movies awakened an interest in their study and analysis as expressions of visual art. University film courses proliferated, and the first pioneering film departments opened their doors. The second wave of theater building began in the seventies, as the now ubiquitous multiplex first appeared in outlying suburban and mall areas.

Films that appealed to the countercultural sensibilities of the sixties generation made an impact on young audiences across the world. Arthur Penn's *Bonnie and Clyde* and Mike Nichols's *The Graduate* in 1967, Stanley Kubrick's *2001: A Space Odyssey* and Sam Peckinpah's *The Wild Bunch* in 1968 paved the way toward a more graphic depiction of sex and violence, as well as spreading messages of social criticism. Other more expressly youth culture films like *Easy Rider, Medium Cool,* and *Alice's Restaurant,* all released in 1969, drew young people into the theaters along with a host of not-so-great imitators. By the early seventies, the phenomenon of the blockbuster film had begun to emerge, in the wake of more mainstream box office successes like *Love Story* and *Airport.* Other popular and critical successes that would lead to trends of the late seventies and eighties include *The Godfather, The Exorcist, Jaws, Jesus Christ Superstar,* and *The Towering Inferno.*

By 1975, major studios that in the forties and fifties would have turned out a hundred films a year found their capital tied up in only five or six huge-budget blockbusters, with distribution of independent films and production for television providing the daily bread. With weakened balance sheets, studios in the sixties proved attractive takeover targets. Universal Studios became part of the MCA empire in 1962, Paramount was engulfed and devoured by Gulf + Western in 1966, United Artists merged with the Transamerica Corporation in 1967, MGM was purchased by financier

Kirk Kerkorian in 1970, and Kinney Services bought out Warner Bros. in 1969. More mergers would take place in the early eighties.

Advertising

Advertisers were not slow to incorporate signs and symbols of the rising sixties tide of nonconformity and rebellion into their product pitches. Commercials and ads everywhere lured young consumers' attention with psychedelic art, hip lingo, and forms of anti-advertising. Desiring nothing more than to reroute revolutionary impulses toward revolutionary new products, much of sixties advertising touted material solutions to social problems in a way that at once attracted and infuriated its young targets. And the new sexual freedom seemed to add up primarily to a new level of sexual suggestiveness in advertising. Noxzema ads urged shavers to "Take it off, take it all off." National Airlines ads featured a smiling young stewardess suggesting that travelers "Fly Me." Virginia Slims incorporated feminist appeal in its "You've Come a Long Way, Baby" campaign, with the clincher line, "You've got your own cigarette now, baby/ You've come a long long way."

In 1971 one of the more bloodless revolutions took place in the advertising business. In the wake of the 1964 surgeon general's report, finally recognizing the health dangers of smoking, cigarette manufacturers were required to put warning notices on their packages and in their ads. In 1967, responding to a lawsuit filed in New York, the FCC decided that the Fairness Doctrine (discussed later in this chapter) should apply to cigarette advertising and mandated that stations give equal time to antismoking messages in public service spots in a proportion of 3 to 1. This seems remarkable, and it is; but in the context of a proposed Federal Trade Commission (FTC) ban on all radio and television cigarette ads, it began to seem like voluntary compliance would be the way to go. Broadcasters, unwilling to lose tobacco industry revenues, favored a 4-year gradual suspension. Cigarette manufacturers wanted a quick, across-the-board halt, so that the commercial playing field would remain equal. Congress had to step in and pass a law banning broadcast cigarette advertising. On January 2, 1971 (the date selected so that the college bowl games could encourage smoking one last time), cigarette ads were pulled from TV and radio. The era of catchy jingles was over. A revved-up FTC went on to propose some of the most stringent restrictions on television advertising ever attempted, even going so far as asking the FCC to require that broadcasters provide airtime for counteradvertising messages to offset advertisers' exaggerated claims. The FCC declined.

The Classic Network System and Its Discontents

As we noted in Chapter 8, the period from 1960 to 1980 marks the height of the vertically integrated three-network oligopoly system in television. NBC, CBS, and ABC jockeyed for first position in the ratings and in profits; but in the booming sixties economy and with such a lock on the flourishing TV market, no one need shed any tears over the performance of even the third-place network (usually ABC, until the mid-seventies). The VHF band filled up almost to its full capacity, while the UHF

band remained largely vacant. The three networks split the field of affiliates almost evenly: In 1970 NBC had 31.8 percent of all affiliated TV stations, CBS had 28.5 percent, and ABC trailed slightly with 23.6 percent. By 1975 the percentages had evened out, with CBS up to 30 percent and ABC up to 26 percent. The total percentage of stations affiliated with a network actually declined slightly during these years, from a high of 96 percent in 1960 to only 87 percent in 1975. This reflects the growing viability of independent stations in many markets, as advertising revenues more than doubled during this period. It also reflects the increase of public broadcasting stations after the founding of PBS in 1968.

But for the commercial networks and their affiliates, it was a fat and happy time. The shift to multiple sponsorship, the magazine concept, and network control over programming in the wake of the quiz show scandals meant that by 1965, the networks either owned or held some kind of profit-participation shares in fully 91 percent of their prime-time programs. Not only did networks receive their full share of all advertising revenues attracted by the popular shows, they continued to profit as the programs were sold to stations on the syndication market, receiving payments known as *residuals* for many years, sometimes the life of the program. The FCC made its first attempt to cut back on this kind of vertical integration as early as 1965, proposing the so-called 50–50 rule that would have kept network ownership to no more than 50 percent of prime-time non-news programming. But its efforts were deflected, and although the Financial Interest and Syndication Rule (fin/syn) was passed in 1971 (see "Fin/Syn and PTAR," later in this section), it would take the rest of the decade to implement. The FCC did pass and implement the Prime-Time Access Rule (PTAR) in 1970, which freed up an hour of the prime-time schedule and gave it back to the affiliates to program. This rule was intended to weaken the industry's vertical integration as well, taking back a little of the networks' control.

However, despite the nets' heavy ownership and scheduling control, the market created for filmed series and, increasingly, made-for-TV movies supported a flourishing Hollywood-based production industry. A host of independent production companies sprang up alongside the major studios, sometimes with close ties to only one network but more often producing hit programs for all three. Some independent producers became mini-studios in their own right, such as Desilu, which in 1957 had purchased the former RKO production facilities and became one of TV's largest program suppliers in the 1960s, with hits including *The Untouchables*, *Our Miss Brooks*, *The Lucy Show*, and *The Danny Thomas Show*. Others formed partnerships with big studios, with the studios providing financing, office and production space, and distribution while the smaller company did the creative work.

As the sixties progressed, talent agents became increasingly central to the production process, often putting together a package of star, writer, director, and other creative talent that was then sold to an independent producer. The indie could then work out a distribution deal with a major studio, which then might sell the program to a network. This complex, interlocking system of players at various levels of control and viability encouraged a certain amount of competition and diversification, as each struggled to differentiate its product from another. But the dominance of only three buyers in the end—the three networks—meant that all programs had to fit within a narrow range of accepted practice. Although the market was big enough and their

dominance secure enough that all three nets could survive comfortably without often breaking a sweat, they did attempt to establish some kind of relative identity as the sixties went on.

ABC became the new "we try harder" network, and increasingly sought out younger viewers with more trendy, controversial programming. It was on ABC that slightly cheesy, youth-oriented shows such as *The Mod Squad* (three hippie undercover cops—one white guy, one black guy, and one white "chick"), *The Rookies* (young police recruits), and such paradigmatic seventies shows as *The Brady Bunch*, *The Partridge Family*, and *Room 222* could be found.

CBS, which had become the spot for rural comedies in the sixties, dumped its hillbilly lineup in 1970 and went after a young, urban, more socially relevant image, showcasing the Norman Lear empire of *All in the Family*, *Maude*, *The Jeffersons*, and *Good Times* and other hits like *The Mary Tyler Moore Show*, *M*A*S*H*, and *The Sonny and Cher Show*. Under the direction of programming wunderkind Fred Silverman, CBS moved into first place in the ratings overall and gained a critical reputation for quality programming. NBC took its socially relevant revisions into more ethnic and racial diversity—somewhat. The drama *I Spy* brought Bill Cosby to the screen in 1965, as half of a two-man action-adventure team. *Julia*, starring Diahann Carroll, in 1968 became the first prime-time show with a black female star since *Beulah*. Comedies *Sanford and Son* (1972, starring Redd Foxx) and *Chico and the Man* (1974, starring Freddie Prinze) proved successful, as did *The Flip Wilson Show* (1970), a top-rated comedy-variety program. NBC also went after the youth market with *Rowan & Martin's Laugh-In* and its comedy based around a simulated pop-rock group, *The Monkees* (1966–1968).

All three networks also underwent management changes in the decade from 1965 to 1975. Leonard Goldenson, who had headed ABC since its merger with his home company United Paramount Theaters, moved upward and made room for Elton Rule to take over as network chief. At CBS William Paley still held sway as chairman of the board, with longtime associate Frank Stanton under him as president and a changing roster of lower-level executives. Stanton retired in 1973, ushering in a period of revolving doors. David Sarnoff, the head of NBC since its inception, died in 1971, and his son Robert took over the reins. When Robert was summarily fired in 1975 by a board unhappy with financial instability, an era ended at NBC.

Agents of Change

The tight control exercised by the three major networks over television production at once encouraged competition and inhibited it. The size and profitability of the market induced many to vie for the few open network spots, producing an excess of potential series each year; once the networks turned down these series, there was little to do with them besides pitch them to the still struggling local syndication markets. With a system that attracted a national audience and a market so neatly divided between the nets, few openings existed for creative, innovative productions that challenged the bland, formulaic network patterns. And the ownership interests and profit skimming done by the nets (and the major studios as distributors) meant that even if an independent producer were able to sell a series to a network, the profit margin could

be quite limited. Major studios in particular balked at the amount of risk they were required to assume in producing a new series (as color production drove costs skyward) and at the relatively small amount of control they had over selling or marketing their product once it was scheduled. Something had to give, most producers felt. Possible reforms would be limiting the ownership interests of the networks, freeing more of the schedule of network domination so that other buyers could enter or developing other outlets for television programming.

In the end, all three things happened. The fin/syn and PTAR rules passed by the FCC in the early seventies limited network ownership and opened up the first hour of prime-time for scheduling of syndicated or locally produced programming. And though it would take the new technology of satellite transmission to bring it to fulfillment, competition from cable television began to make itself felt by the mid-1970s. This event promised major change in the number of channels available to the average consumer. Someone—who better than Hollywood producers?—would have to fill up those channels with programming. Cable also had the capacity to strengthen existing independent stations, especially those in the handicapped UHF band, as they brought clear, sharp pictures into homes right alongside the big VHF channels. This feature promised to strengthen the syndication market—more buyers! Public television opened an outlet for more innovative, creative programs of the sort thought to be less than viable under a commercial system. Before 1975 most of these forces for change remained in their developmental stage, but they would combine to blow the classic network system to smithereens in the 1980s.

Cable

Community Antenna Television (CATV), as we have seen, started out as a way for communities unreachable by over-the-air signals to bring TV into homes via a wire. A monthly fee could be levied for such a service, and the local cable TV operator, while he was about it, could also set aside a channel for televising local events and send those out too, as a freebie. As station building spread in the late fifties, local affiliates began to serve these communities, but many customers found that they enjoyed having a few distant signals from nearby cities beamed in as well. This was especially true when the nearby metropolis had a high-power independent television station that aired programming different from the networks, or if it included local sports or lots of old movies. By 1975 almost one-sixth of the nation's homes were wired for cable. Over 3,500 local cable companies served these homes, and most of them had the capacity to send ten or more channels over the wires to their customers. A few companies began to buy and consolidate local systems, becoming the first cable *multiple systems operators* (MSOs). The National Cable Television Association (NCTA) was formed to lobby against its usual foe, the National Association of Broadcasters (NAB), and to push for cable expansion. As early as 1970 the FCC, worried about concentration of ownership, passed rules forbidding local telephone companies or existing broadcasters to operate cable television systems.

It had been unclear exactly how much power the FCC had to regulate cable, because it didn't use the public airwaves that the FCC had been formed to

supervise. In 1968 a Supreme Court ruling upheld the FCC's authority over cable, as long as it had a direct relationship to over-the-air broadcasting, as it seemed to. In 1972 the FCC finally issued some clear rules that both inhibited cable development in some ways yet also signaled its legitimacy and viability as a medium. Cable was free to expand in the top 100 TV markets. Cable operators had to offer at least one public/educational/government access channel, and the must-carry rules required that all significantly viewed local stations had to be retransmitted over the cable wires. These rules had been sparked by a coalition of interest groups that, despite competing agendas, had all seen in cable a solution to some of the problems that were beginning to be identified with commercial broadcast television. Cable was seen as providing a useful alternative to the big-three bottleneck of the airwaves (largely produced by the VHF frequency allocation decisions of the 1940s) and as a way to bring more diversity and innovation to the tube. Pay TV over cable, now permitted, promised a new market for movies and sports. Hollywood, which had been thwarted in its earlier pay TV plans, began to take notice.

The Rise of the Independent Stations

A potentially greater market began to open up as cable systems put the must-carry rules into effect, and small low-power UHF independent stations found themselves rubbing shoulders on cable TV dials with their formerly dominant VHF rivals. Now a viewer didn't have to fiddle with a special dial on the TV set or a special antenna; she merely clicked her cable box tuner to the next channel, and there it was! This provided an enormous boost for independent stations, raising viewership levels and program ratings and lifting the price that they could charge for advertising. It benefited educational stations, too. Formerly shoestring stations began to buy more expensive programming, often network reruns but also movie packages, older syndicated series that had reverted from network ownership, and a few so-called *first-run syndication* productions. These were shows produced especially to be sold to stations, not to nets. In the sixties and seventies they usually consisted of specialty formats, like game shows, talk, and specials. More independent production companies began to concentrate on these types of programs, which were sold directly to independent stations.

In addition, the syndicated market for off-network programs—reruns—also boomed in the 1960s. Not only independent stations but also affiliates—using the extra hour of prime time that they gained—and even networks themselves, especially in the summer months, began to rerun their own shows. In many ways, as Derek Kompare argues, syndicated programs were the ideal broadcast fare: They were an already successful, known quantity that took little promotion and that could be recirculated for years to eager audiences (Kompare 2004). Though network deals meant that often the producers of these series received only limited compensation for their afterlives in syndication, studios and independents became increasingly unwilling to sign away their rights as the seventies progressed. The promise of the cable-enhanced syndication market swelled the agitation for regulatory and structural change.

Connection At Last, Public Television

As we have seen, by the 1960s the United States remained one of the only countries in the world with no nationwide public broadcasting system. The Progressive Compromise bet on a TV model that placed commercial stations at the heart of U.S. broadcasting. They implicitly agreed, in turn for free use of the airwaves, to provide a space in their schedules for public service programs. What exactly these programs should consist of was left undefined.

Just as the networks had, in the past, allowed sponsors to create and produce most commercial programs, they had placed public service program production in the hands of nonprofit educational, governmental, religious, and civic groups. But public service groups had always complained that the networks pushed them to the unpopulated margins of their schedules, where it was hard to raise much of an audience. And Father Coughlin's career scared everybody, so that by the mid-1940s networks began to take public interest program production back into their own hands, as discussed in the previous chapters.

Yet educational and social reform groups, in particular, claimed that the networks were simply not doing enough. As National Educational Television (NET) strengthened through funding from groups like the Ford Foundation, which believed strongly that the United States needed its own BBC-like broadcaster, and as criticism of commercial broadcasting rose in the wake of the quiz show scandal, even commercial networks and stations began to think that noncommercial, publicly funded broadcasting might be an idea whose time had come.

In 1967, pressure to create a sector of television and radio broadcasting not dominated by the demands of the marketplace finally reached a resolution. Its blueprint first appeared in a 1967 report titled *Public Television: A Program for Action*. This report came from the Carnegie Commission on Educational Television, a high-powered research group funded by the Carnegie Corporation, long an influential funding source for institutions of American public culture, such as the public library system. It laid out a plan for "a federally chartered, nonprofit, nongovernmental corporation" (Carnegie Commission 1967) that drew on the example of other nations' public broadcasting systems—most notably the BBC—but differed significantly from all of them. As the report stated in no uncertain terms: "We propose an indigenous American system arising out of our own traditions and responsive to our own needs." The Carnegie Commission plan grew into a bill that eager advocates wrestled over before Congress—a Congress weary of NET's independent, trenchant social criticism and anxious to establish a more controllable form of public television.

After much wrangling, Congress signed the Public Broadcasting Act of 1967 in November of that year, with the hearty endorsement of the Johnson administration. It created the Corporation for Public Broadcasting (CPB), which soon begat the Public Broadcasting Service (PBS) along with a host of new or revitalized public television stations across the land. The act was designed to put production power and funding into the hands of the stations themselves, rather than to create a strong central program-producing structure, as existed in most European nations. Member stations

would propose and produce their own programs, alone or in partnership with each other or with independent producers, aided by funding from the CPB. The programs would then be shared throughout the network via PBS. The number of educational stations increased from 127 to 247 between 1967 and 1975. A few strong and innovative stations soon came to dominate PBS programming: WGBH-Boston, WNET-New York, KCET-Los Angeles, WTTW-Chicago, and KQED-San Francisco. Here was an outlet for a different kind of independent production. A boom in innovative children's programming, documentaries, news and opinion programs, talk and discussion, how-to, and original drama sprang up, even though we also tend to associate imported BBC series like *Masterpiece Theatre* with early PBS.

However, in the Carnegie Commission report, a key provision had specified that the funds for public broadcasting should come from a tax on the purchase of television sets, similar to the system in Great Britain. In this they were very firm and clear:

> We recommend that Congress provide the federal funds required by the
> Corporation through a manufacturer's excise tax on television sets (beginning
> at 2 percent and rising to a ceiling of 5 percent). The revenues should be made
> available to the Corporation through a trust fund. . . . In this manner a stable
> source of financial support would be assured. We would free the Corporation to
> the highest degree from the annual governmental budgeting and appropriations
> procedures: the goal we seek is an instrument for the free communication of ideas
> in a free society. (Carnegie Commission 1967)

The idea was that these funds would remain solely dedicated to broadcasting and thus be insulated from any kind of interference by Congress or other groups: *insulated funding,* as it was known. However, the 1967 act, while incorporating most of the commission's recommendations, did not approve the provision for insulated funding. Instead, the act placed the fledgling service at the mercy of biannual congressional appropriations; every two years, Congress would have a fresh opportunity to decide exactly how much—if any—public monies to allocate to public radio and TV.

This has proved to be a weak point in the overall structure and function of public broadcasting in the United States, making it particularly susceptible to government interference—as happened during both the Nixon administration and the Newt Gingrich era under Clinton. As a result, PBS has turned toward the support of corporate underwriters—corporations that donate money or sponsor productions—to a greater and greater degree as the decades have progressed. Radio, though originally left out of the plan, was added as a part of public broadcasting at the very last minute, through the last-ditch lobbying efforts of a group of radio supporters. National Public Radio (NPR) was established in 1970 to provide a similar coordinating and funding purpose for radio.

Yet, despite the difficulties, the U.S. public broadcasting system has added a vital and necessary component to our media structure. From *The French Chef* to *Sesame Street, Firing Line* to *The MacNeil/Lehrer Report* and *Washington Week in Review, Mister Rogers' Neighborhood* to *This Old House,* and from *All Things Considered* to *Talk of the Nation,* public radio and television have struggled with questions of diversity, seriousness, and competing definitions of the public. With *public*

broadcasting really never clearly defined—educational? cultural? uplifting? innovative? *not* commercial, but what about underwriting?—it may be easy to levy charges of elitism or narrow focus at its offerings. Yet, surely it produces an element of diversity with a different relationship to audiences and the marketplace than that of most of our television and radio fare. If the weakness of its funding scheme and its growing dependence on corporate funding produces what critic Patricia Aufderheide has called a propensity for "safely splendid programming," its heavily localized structure opens up opportunities for citizen involvement unknown to commercial broadcasting (Aufderheide 1999).

Almost immediately public television proved controversial, as President Nixon vetoed funding of CPB in 1972, complaining that its news and public affairs shows were too critical of his administration. Charging that CPB and PBS had become too much of a national network (as had NET previously) and insisting that more power be given to local stations, Nixon exacerbated a fault line in the public broadcasting system. Too often local interests (often more conservative) are played off against national efforts (frequently more liberal) to create bland and politically safe programming. Corporate underwriting also tends to rein in more radical tendencies and to place a greater emphasis on attracting ratings numbers.

Laurie Ouellette's recent work, *Viewers Like You?* shows how public broadcasting in the United States has always been torn between its populist and its elitist impulses (Ouellette 2002). On the one hand dominated by programming that appeals primarily to the educated upper middle class, on the other motivated by a more democratic, populist model that emphasizes local production, diversity, and public participation, PBS is always a subject of contention. Though very successful in reaching children under the age of 14 and adults over 50, its total audience share has never amounted to more than 3 percent of the U.S. public overall, leaving it open to charges of irrelevance and obsolescence in the era of hundreds of cable channels. Yet it provides a free, over-the-air national outlet for programs that no other venue could distribute so widely to a national audience. And the public television audience may be small, but it is an affluent and powerful one, as undermining politicians have found to their dismay. Generations of Americans have now grown up on *Sesame Street*, and though they may not have tuned to PBS since the age of 12, the day is not far away when they will return to it and its aural cousin, NPR. The 1960s produced many significant revolutions in media, and public broadcasting stands at the top of the list.

REGULATION: BREAKING THE BOTTLENECK

The decade from 1965 to 1975 presents a remarkable contrast to the complacent, industry-friendly FCC administrations of previous years. Perhaps because the turbulent times were directing so much attention elsewhere—Vietnam, race riots, Watergate—the FCC embarked on an astonishingly active campaign to reform the structure of broadcasting, to open up competition, to present alternatives, and to uphold and clarify a strengthened Fairness Doctrine. Though its efforts would not take full effect until the

1980s, the FCC set the stage for the breakup of the classic network system and the increased diversity and abundance of channels, services, and technologies of the nineties.

Fin/Syn and PTAR

We've already briefly described the intention and effects of these two rules, both initially proposed by the FCC in 1970. The financial interest and syndication (fin/syn) rules were passed in 1971, though they took a long and curious route before they could be implemented. They were designed to limit the number of programs that a network could own (have a *financial interest* in) to only 15 hours a week of non-news shows it produced itself in-house. This meant that the networks had to stop exercising their oligopoly power by insisting on owning a piece of production companies whose programs they purchased. Now, production companies could stay independent of network ownership and could also retain full ownership of their programs. The *syndication* part of the rules carried this principle over into subsequent sales. The networks were only allowed to buy such independently produced programming for a limited, one- (or two-) time run. After its network run, all rights to the program would revert to the producer, who could sell it into syndication and keep all the profits. Syndication is where most producers break even, so this was an enormous boon for production companies.

On the other side of this newly freed-up market, the Prime-Time Access Rule was designed to force stations in the top-50 markets to stop taking network feed for the first hour of prime-time ("access hour") and come up with their own programming: They could either produce it themselves (hence the explosion of half-hour local news programs) or they could buy it from the now-independent producers (first-run or off-net syndication, leading to the explosion of game shows and reruns after the news). Though limited by law to only the top-50 markets, this realistically meant that the networks would simply stop offering feed during this hour, so that *all* stations ended up having to comply. These rules were designed to break up the effects of the networks' vertically integrated oligopoly and to increase competition and diversity in the production sector.

However, the way of increased competition did not run smooth. Though compliance with PTAR began immediately, the networks appealed the more sweeping fin/syn rules and received a temporary reprieve until the case could be considered. Although a federal court upheld the rules in 1972, the networks failed to take steps to comply, prompting the Federal Trade Commission—still in its activist phase—to file an antitrust suit against NBC, CBS, and ABC, charging them with monopolizing program supply and distribution as well as restricting competition. However, the networks argued that the antitrust suit had been politically motivated—a kind of revenge from the Nixon administration, which was unhappy with network coverage of Vietnam and now Watergate. The Justice Department, after two years of tortuous argument, did indeed dismiss the antitrust suit in 1974 but did so "without prejudice"—meaning that they were making no ruling on the validity of the FTC charges, only on the convoluted politics. The FTC doggedly refiled the suit in December 1974, and NBC settled by consent in 1977. ABC and CBS battled on, contesting the settlement, but finally lost their bid in 1979. Not until 1980 did the full impact of fin/syn begin to make itself felt, although just the process of contention had loosened things up a little.

Untying Cable

The FCC's Third Report and Order on Cable Television in 1972 ushered in a new cable era. This didn't happen out of the clear blue sky; rather, it was a culmination of new thinking about cable stemming from a variety of perspectives and agendas emerging in the late sixties and early seventies. Historian Thomas Streeter, in his article "The Cable Fable Revisited" (1987), traces three main groups that contributed to cable's reconfiguration as an alternative to broadcast television. First, there was a contingent of policy reformers, many of whom had been involved in the Carnegie Commission study of public television or had been affiliated with other liberal think tanks like the Rand Corporation or the Ford Foundation. They envisioned sweeping structural changes that would produce a new kind of television, and it was not hard to see that cable opened up possibilities along these lines.

Second came organizations such as the American Civil Liberties Union (ACLU), the Americans for Democratic Action (ADA), and other progressive social action groups (heirs to the Second World War's Office of War Information writers and the Progressive critics before them); they lobbied for change that would transform television into a community-oriented, grassroots, locally regulated medium. They advocated strict regulation of the new technology, assuring a maximum of community control. The appearance of Ralph Lee Smith's book, *The Wired Nation,* in 1972 helped to consolidate this view on cable.

Third, the utopian rhetoric of the progressive and policy groups played very well into the interests of cable operators themselves. The industry could happily join in the chorus of social reform predictions for cable, as long as it meant that their industry would finally be given the green light and be allowed to expand. Promising to give over a channel or two to local access didn't seem too much to ask of an industry that had only a handful of program sources to offer, anyway. Cable operators began to sound reform-minded notes in their testimony before the FCC and in trade journals.

There were deep contradictions in the overall agenda and purposes of these advocates, but they would not be revealed until later. As the industry grew and consolidated its power, many of the conditions that the Progressives had warned against would come to pass: local cable monopolies, concentration of ownership, dominance of existing media powers, and duplication of the same kind of economics and programming to be found on over-the-air commercial television. But cable was on a roll, and the introduction of satellite transmission in the late 1970s would provide a lever to undermine the classic network system.

Fairness Doctrine

This period marks the high point of FCC enforcement of the loose body of rules that came to be known as the Fairness Doctrine. As we have seen, in the late thirties Father Coughlin provoked the FCC into shifting its former emphasis on the old Progressive Compromise concept, by which stations were expected to enable diversity of views on the airwaves by selling time to anyone who had the money (or providing it for free to authorized nonprofit groups), to a standard that expected stations to exercise some editorial control. Stations themselves were to be held responsible for a balanced

presentation of diverse views, using their own judgment as to what merited inclusion and what did not. They could, in fact, get in trouble for allowing a too-provocative point of view, like Father Coughlin's, to remain on the air unanswered.

Yet another key ruling, the Mayflower decision in 1941, stipulated against going too far the other way: allowing a station to become merely an outlet for its owner's views. As the court opinion stated, "In brief, the broadcaster cannot be an advocate." In other words, balanced programming that acknowledged the broad mainstream interests and opinions of the whole community, not those of the station owner nor those of moneyed political extremists, was the order of the day. By the sixties this view had begun to shift to a more militant stance. Broadcasters were enjoined not to try getting around the rules by avoiding controversial opinions of any kind, as many of them had, but to actively seek out alternative, well-rounded viewpoints on issues of importance in the community and to make sure that all were adequately represented on the air. This more active pursuit of public interest content was referred to as "ascertainment."

The Red Lion decision in 1969 confirmed this principle of active ascertainment and balanced inclusion, basing its charge to broadcasters on the principle of spectrum scarcity: Because use of the spectrum was a limited privilege, the FCC was justified in curtailing broadcasters' First Amendment rights (to refuse controversial points of view or to present their own points of view) accordingly. By 1974, the FCC had declared that fulfillment of Fairness Doctrine principles was the most important factor it would consider in license renewal applications. Yet the coming abundance of cable and the new competitive market would soon spark an about-face.

Citizen Action

Underlying FCC activity was a new conception of the role of the great, impassive audience in the regulatory process. Along with citizen activism in most spheres of American life, television too attracted citizen protest, demonstrations, petitions, hearings, and mandated change. One key legal case in particular redefined the role of citizens in the license renewal process and set the FCC on a course it would ride into the eighties.

Connection Sorry, We Are Experiencing Racial Difficulties

As historian Steven Classen writes, station WLBT in Jackson, Mississippi, differed little from stations in other southern towns in the early 1960s in its policy toward programming that either featured African American performers or that advocated civil rights activism: It simply did not air such programming (Classen 1995). Taking FCC-inspired editorial responsibilities in a segregationist direction, station owners and managers reasoned that because race was a controversial issue in the South, and because merely showing African Americans on the air would advocate racial equality and spark outrage on the part of white citizens, the best response was to cut off all representations of black thought or action on TV. Additionally,

white citizens in the South were used to discounting the citizenship of blacks; businesses, though dependent on black consumers, also were accustomed to treating African Americans as though their economic participation were negligible. Thus the opinions and dollars of whites loomed far larger in the minds of Jackson's station owners and programmers (all white) than did the opinions and dollars of their black viewers—although African Americans comprised almost 40 percent of Mississippi's population.

Due to slow station growth in the South, stations like WLBT often had both primary and secondary affiliations throughout the 1950s and 1960s. NBC was WLBT's main network; but when something like *The Nat King Cole Show* came on, it would simply switch to whatever ABC, its secondary network, was airing. Or it would run a syndicated program. When network news reports showed civil rights protests in Montgomery or covered Martin Luther King's address to the Washington marchers, WLBT found it expedient to disrupt the network feed by running the standard graphic that said, "Sorry, cable trouble," over a black screen. The graphic would remain in place until the news moved on to another topic, and then the broadcast would resume. By many accounts, this was a common practice in the South.

The Jackson chapter of the NAACP, led by citizen activist Medgar Evers, brought its objections to these practices to the FCC as early as 1954. The FCC declined to hear their case until WLBT's next regularly scheduled license renewal in 1958, but civil rights supporters kept on collecting incriminating incidents. In 1957 Evers and the NAACP brought evidence that WLBT—along with many other southern stations—while refusing time to civil rights organizations, weekly aired the syndicated discussion program produced by the virulently racist, pro-segregation Citizens Council. Yet in 1959 the FCC dismissed such complaints and renewed WLBT's license for seven more years.

Over the next three years, as the civil rights movement stepped up its efforts toward racial justice in Mississippi, WLBT refused to cover local or national events or did so with a heavy white supremacist bias, even going so far as to broadcast editorials urging whites to resist integration of the University of Mississippi and other institutions. When in 1961 Rev. R. L. T. Smith became the first African American man to run for Congress in Mississippi since Reconstruction, WLBT refused to sell him airtime. He, Medgar Evers, and other concerned groups began a barrage of petitions to the FCC citing Fairness Doctrine violations. Consistently, the station publicized white racist groups' activities and allowed segregationists ample time on local television, while denying and suppressing comparable publicity for civil rights advocates. Finally, on May 20, 1963, under federal pressure, WLBT allowed Medgar Evers onto the airwaves to deliver an editorial on a local news program. Evers spoke out forthrightly and urgently in favor of ending segregation and the denial of rights to African Americans in Mississippi—the first time such an outspoken message had been seen and heard on Jackson airwaves. Just three weeks later, on June 12, Medgar Evers was shot and killed in the driveway of his Jackson home. His murderer would not be brought to justice until 1994.

In July the FCC issued a public notice confirming that a balanced presentation of racial issues was required under Fairness Doctrine guidelines. At this point local volunteers in Jackson began a covert monitoring campaign of the station's output, keeping records of fairness violations. Buttressed by strong evidence, in April 1964 local citizens, joined by the United Church of Christ (UCC), filed a number of petitions to the FCC protesting any further renewal of WLBT's station license. And although in 1965 the FCC staff recommended that WLBT's license be at least temporarily denied so that hearings could be held, the commission

Medgar Evers addresses a national audience over WLBT in Jackson, Mississippi, on May 20, 1963. He and the NAACP had fought for many years to be allowed to deliver a pro-civil rights editorial on the air. Three weeks later, he was shot and killed in the driveway of his home.

issued a 1-year probationary approval and declined to hold hearings. The Jackson/UCC citizen's group appealed this decision, and the U.S. Court of Appeals found in their favor in March 1966. Finally, in May 1967, the FCC began formal hearings on WLBT's license in Jackson. However, in June 1968 it ruled to approve the renewal. Again, citizens mounted an appeal, and again the court reversed the decision and ordered a comparative renewal process to begin. But not until June 1971 was a decision reached to turn operation of the station over to an interim organization, and not until December 1979 did the FCC finally award the station license to a group organized by local citizen advocates, with 51 percent black ownership. WLBT joined the very sparse ranks of stations denied license renewal, becoming the only one ever denied on the basis of poor public service to a racial group.

This tortured history shows how slowly the wheels of regulation can turn and how the presumption of automatic renewal works to prevent the legal mechanism of station licensing from producing very much in the way of public service, especially where the public is divided and oppositional. By the time this case reached resolution, a new era in broadcasting had begun in which all power of televisual representation no longer remained in white hands and in which no station could have prevented the mere exposure of black voices and faces in a local market the way that WLBT had. It is likely that even if WLBT had retained its former ownership, its broadcasting practices would have changed with the times as well.

Yet the significance of this decision—and it was not one that led to a rash of license denials—lies in the process that the citizens of Jackson initiated. For the first time, the FCC was forced to recognize the voice of the citizens in its renewal process—to give citizens *legal standing,* in the jargon of regulatory ritual. Previously, only corporate competitors had

the right to propose an alternative to the existing station ownership; only corporate voices could be heard in the renewal process. Now the FCC had opened the door to more direct community involvement and, potentially, community impact. This was a sign of the times as well as a triumph of political activism. At long last the television industry's perceptions of its audience as a unified, consuming whole was being challenged as the political tensions of the 1960s came to the fore.

PROGRAMMING: THE AGE OF RELEVANCE

It was during the 1965 to 1975 period that all three networks drove the first wedge into the notion that their prime-time public consisted of an undifferentiated mass audience of white middle-class families. With more sophisticated ratings data, an advertising industry adopting more segmented marketing research, and above all observations of the great generational divide opening up between baby boomers and their parents, networks discovered the youth market. Suddenly it wasn't enough to offer a few rock groups on *Ed Sullivan* alongside the singers and comedians that had entertained the World War II generation; and it wasn't sufficient to provide only a few isolated teen shows like *American Bandstand* in the fringe periods. It was the age of relevance: Now the youth audience had to be considered in virtually all programming decisions.

What was this youth audience? Besides their numbers, their age, and their highly disposable incomes, it was known that youth were rebellious against the values of their parents' generation. They were less racially conservative, more interested in overt political content, and more tolerant of frank talk and confrontation. They wanted to see people like themselves on TV: young, hip, not completely white, and exercising the freedoms that had become so important to them. Above all, they wanted *realism*. What did this mean? The networks weren't entirely sure, but it seemed definitely not to include the sugar-sweet sitcoms of the fifties and early sixties. Yet the networks were mindful that their older audiences had not simply disappeared. Most of the programs catering to more youthful sensibilities were careful to balance transgression with tradition. They could not go too far in a socially liberal or controversial direction, because during this period all three networks strove to hang onto their integrated oligopoly.

Though many programs, both long- and short-lived, addressed the youth audience of the late sixties and early seventies, a few have become emblematic of the decade. The first to confront the limits of old-fashioned network mentality in the name of a new, politically conscious generation was *The Smothers Brothers Comedy Hour*. Its polite yet zanily subversive humor and increasingly overt political stance led to escalating conflicts with its CBS parent until the show was summarily canceled while still commanding respectable ratings. *Dragnet* returned, but this time in a new double-edged format that attempted to entertain the youth audience and its parents at the same time, with mixed results. The comedies of Norman Lear on CBS, starting with *All in the Family* and spinning off *Maude, Good Times,* and *The Jeffersons,* have been credited with permanently changing the nature of American television comedy. *All In the Family,* in particular, brought politics into the heart of the American family,

yet showed the way to keeping that beleaguered group together. And another TV family, the Louds, seen on PBS's groundbreaking documentary serial *An American Family,* seemed to capture the experiences of a whole period in American culture—one that is often pointed to as the forerunner of today's reality shows.

Other programs also reflect the increasingly segmented, youth-oriented flavor of sixties television. *The Mary Tyler Moore Show* (CBS 1970–1977) took up the abandoned tradition of early 1950s career-woman comedies and transposed a budding feminism onto it. Young, attractive, interested in building her career more than in meeting Mr. Right, and capable of asserting her own rights in a man's world, Mary provided an engaging, nonthreatening introduction to the gender revolution that would find fuller depiction in the late seventies and eighties. *The Flip Wilson Show* (NBC 1970–1974) not only featured a black comedian as host of a top-rated show but also brought a variety of African American artists into prime time, this time in a program directed and controlled by Flip Wilson himself. Despite attracting some of the same criticism that the much-later *In Living Color* on the Fox network would—that it played into damaging stereotypes in order to pander to white tastes—many of Wilson's skits and characters contained knowing black self-satire and poked fun at white society in a way that his African American viewers could pick up on and appreciate. In a related vein, black singer Leslie Uggams hosted a short-lived musical variety show on CBS from September to December 1969, featuring a virtually all-black cast doing comedy and musical performances. And *Rowan & Martin's Laugh-In* on NBC (1968–1973) offered a kaleidoscopically fast-paced comedy variety show that nurtured many a comic talent (including Goldie Hawn, Pigmeat Markham, Lily Tomlin, and Judy Carne) and fostered several national catchphrases like "you bet your bippy" and "look that up in your Funk and Wagnalls." It seemed to capture the more lighthearted, colorful zeitgeist of the decade and rapidly shot to number one in the ratings.

The networks were trying to have it both ways: drawing in the profitable, youthful audience with programs that promised some recognition of their politics and values but keeping well within the mainstream so as not to drive away other viewers. In the limited oligopoly of the classic network system, this made good economic sense. But what was the best way to go about this? In the next section we'll look at three strategies tried by CBS and NBC to achieve this balancing act: *The Smothers Brothers Comedy Hour* (CBS 1967–1970), *Dragnet 1967* (NBC 1967–1970), and *All In The Family* (CBS 1971–1979).

Generational Politics and the American TV Family

When their show first debuted on CBS in February 1967, there was little about the clean-cut boyishness of hosts Tom and Dick Smothers that indicated the center of controversy they would become. *The Smothers Brothers Comedy Hour* featured calm, capable Dick playing the foil to Tom's bumbling, childlike airhead who was constantly muffing lines and becoming overexcited about inappropriate things. Dressed in neat dark suits, playing folk guitar, the brothers presided over a seemingly traditional variety format, complete with costumed dancers, a marching band skit introduction, and well-known guest stars. Yet as they increasingly sought to draw in a more youthful audience, at first by means of double entendres that went right past the censors at CBS and the

© Henry Diltz/CORBIS

The Smothers brothers clashed with CBS over the limits of good taste in politics and other matters. Network television had difficulty handling the political movements of the sixties.

older audience and later by more overt political content and guests, the *Smothers Brothers* show became the flashpoint and emblem of generational conflict in the sixties.

It was the musical guests who took the program in an unmistakably left-wing direction and provoked the heaviest network censorship. For the premiere fall 1967 episode, the brothers invited formerly blacklisted protest singer Pete Seeger to sing his song "Waist Deep in the Big Muddy," about a World War II troop led to their deaths by uncaring and misinformed officers. The final stanza ran, "Now every time I read the papers/ That old feelin' comes on/ We're waist deep in the Big Muddy/ And the big fool says to push on." CBS censors immediately recognized the song as a thinly veiled reference to President Johnson's leadership in Vietnam and insisted that it be cut from the show. In late 1968, Singer Harry Belafonte attempted to sing his song "Don't Stop the Carnival," which contained specific references to the Chicago riots. The brothers wanted to intercut his performance with actual footage from Chicago, and the network agreed as long as there were no scenes of violence. Because violence was endemic in Chicago this was difficult, but even after a few nonviolent clips had been found, they took on new meaning in the context of the song. The network summarily cut the segment and replaced it with an advertisement for the Nixon-Agnew campaign. When Joan Baez attempted to preface her song with a brief dedication to her husband David Harris, then serving time in jail for refusing the military draft, CBS pulled that segment from the March 9, 1969, show. Though they relented and allowed the taped segment to appear a few weeks later, they cut Baez's opening remarks (Bodroghkozy 2001).

As the brothers grew increasingly restive under these decisions, they responded by encouraging the writers (who included a young Steve Martin) to create more openly political material, to be performed by such unobjectionable (and liberal) stars as Kate

Smith and Burl Ives. The network stepped up its efforts to tone them down and increasingly refused to okay the taped shows sent in for approval by their Standards and Practices division. Affiliate stations, run by management often more conservative than the national audience or national advertisers, began to complain. Also, the show's ratings, which had rivaled those of time-slot competitor *Bonanza* at first, began to slip. On April 3, 1969, the network informed the brothers that their contract was canceled. This represents one of the few examples of a successful network show to be canceled because of politics. Though overtly antiwar and antiestablishment politics might draw in the youthful viewers, many other viewers were offended and put pressure on the network. Clearly, the "youth market" strategy of openly addressing political issues would not work within the cautious, mainstream industry that was network television.

Meantime, NBC was trying a different technique. What if you could produce a program that would play on two levels simultaneously: an overt text on top and a hidden, "coded" subtext underneath, that would be decodable only by those with the right knowledge to recognize it? And what if "youth" was the code? Enter Jack Webb in a new version of the venerable *Dragnet,* now subtitled *1967* (and so on, until 1970). Once again, the dour adventures of Friday, now teamed with Officer Gannon (Harry Morgan) graced the living rooms of families across the nation. But as Jason Mittell (2004) observes, the program, though using all its old box of tricks to appear realistic, factual, and the height of commonsense rationality, in fact could be read on a whole new level. The first episode of *Dragnet*'s returning season was titled "The Big LSD." Capitalizing on recent publicity about this new psychotropic drug and the nationwide campaign to make it illegal, the story follows Friday and Gannon as they pursue tripped-out, upper-middle-class, drug-addled drug dealer Benjie Carver, who goes by the moniker "Blue Boy." He's in the throes of a bad LSD experience when they encounter him, but they can do little because at the time of the encounter LSD had not yet been criminalized. Viewers are then treated to a time-compressed series of bad drug stories, leading up to Blue Boy's inevitable death from an overdose.

The show is filled with sober pontifications and explanations of LSD's deleterious effects. For the older generation, on the surface, it's a cop show as usual, upholding the forces of social order and American justice, with hardworking law enforcement agents as the last resort of troubled families with spoiled, errant children. Mom and Dad, and Grandma too, could watch in calm recognition of a familiar form. But for the kids, the show amounted to a parody of itself. The spectacle of good, gray *Dragnet* stars attempting to come to grips with drug slang and to portray the experience of an LSD trip was not only laughable, it pointed exactly to how clueless such explanations were. Webb would produce several other episodes dealing with the dangers of uncontrolled youth culture, including one called "The Prophet" dramatizing the criminal misdeeds of a Timothy Leary–like character. But it was a polysemic burden too heavy for such a fragile framework to support for long. Most episodes reverted to the more traditional cops 'n' robbers fare, of a kind that Webb would develop in his next series, *Adam-12.*

Like many of the skits on *The Smothers Brothers Comedy Hour* and *Laugh-In,* such *Dragnet* episodes clearly invite a reading on two levels. On the one hand, they invite the youthful, in-the-know audience to laugh *at* Friday and Gannon's hopelessly plodding attempts to understand the effects and appeal of a drug that had become a

© Bettmann/CORBIS

Life was conducted at a high volume in Norman Lear's *All in the Family*. The show's primary innovation was to take overt political discord and give it a generational twist. Edith wavered in the middle, much like the audience.

central component of youth culture. On the other hand, as Mittell's reading of contemporary reviews and commentary supports, most mainstream, older audiences took the shows at their face value, buying into the realistic, factual ethos of *Dragnet* for a few more years, at least. But it took the talents of producer Norman Lear to come up with a solution to the generational conflict in the television audience. His adaptation of a British television sitcom called *Till Death Do Us Part*, titled in the United States *All in the Family*, brought the divisive politics of the 1960s out in the open, laid them defiantly on the table in the family dining room, and let everyone fight it out at top volume—but all in the family. The American family once again proved its value as a great mediator, holding even the most violent opposition of political ideas together in the family matrix.

All in the Family brought politics into the living room in the form of generational conflict. Its forthright language, outspoken racism and prejudices, and raging family confrontation marked it out immediately as different from the usual network fare. But after a season of shaky ratings, the show went on to become one of the classics of American television. It ran for 12 years, starring Carroll O'Connor as Archie and Jean Stapleton as his beleaguered wife Edith throughout. Sally Struthers played their daughter, Gloria; she was married to Mike Stivic (Rob Reiner), though Archie usually referred to him as "Meathead." Gloria and Mike lived (uneasily) with her parents in their small, crowded house until 1975, when they moved next door and soon after

produced a baby, Joey. After 1978, when both Struthers and Reiner left the show, it gradually began to feature Archie more and Edith less. Edith was scripted out as the scene shifted to the bar that Archie ran, retitled *Archie Bunker's Place* until it finally went off the air in 1983.

All the while, a host of strong supporting characters played off Archie's archetypal conservative ideas: the Jeffersons, an African American family who lived next door and returned Archie's slurs insult for insult; Edith's cousin Maude, an outspoken liberal feminist who drove Archie crazy; the Italian family the Lorenzos, whose main offense consisted not in being Italian but in that Frank loved to clean and cook while Irene was the household handyman. But Archie's prime opponents were his son-in-law Mike— sociology graduate student (to Archie, this meant "unemployed")—and Gloria, his bleeding-heart liberal daughter. Edith played the middle as an addle-brained but sympathetic and lovably fair-minded spouse, whose good-hearted attempts at neighborliness saved the show from veering too far toward the offensive.

The debut program was actually prefaced with a disclaimer from the network: "The program you are about to see is *All in the Family*. It seeks to throw a humorous spotlight on our frailties, prejudices and concerns. By making them a source of laughter we hope to show—in a mature fashion—just how absurd they are." How maturely audiences handled the show's ethnic taunts and airing of treasured prejudices is a matter of much study and debate. Some researchers claimed that viewers took away what they brought to the show. Those who shared Archie's sentiments found his declamations reassuring and confirming and laughed with him; those who were inclined to sympathize with Mike and Gloria confirmed their liberalism by laughing at him. To a certain extent the show's preferment of liberal views could not be ignored. Archie was surrounded by liberals and people more tolerant than he was, and in each episode his ideas were proved wrong. Yet each week he came back with the same attitudes: It was his pleasure in refusing to learn that made many critics distrust the show's political effect, even as they praised its writing and performances.

The show became wildly popular and spawned almost equally popular spin-offs. *Maude* (CBS 1972–1979), with Bea Arthur as Maude Finley, was one of the most outspoken feminists ever on television and the first woman to be portrayed sympathetically as she chose to have an abortion. *Maude* spun off *Good Times* (CBS 1974–1979), starring Esther Rolle as Florida Evans; she had played Maude's maid in the earlier show, though Jimmie Walker as J.J. became the best-known cast member. *The Jeffersons* (CBS 1975–1985) "moved on up" to their own sitcom about a successful black middle-class family headed by George (Sherman Hemsley) and Louise (Isabel Sanford). George had played Archie's counterpart on *All in the Family*, as outspoken in his disapproval of whites as Archie's was of blacks. Their neighbors, the Willises, were the first regular interracial couple to be featured on network TV. And less well remembered, *Gloria* (now divorced) got her own show briefly from 1982 to 1983. Lear went on to produce other shows, under a sweetheart deal with CBS, as well as the satiric soap *Mary Hartman, Mary Hartman* for syndication. Contemporary programs like *Roseanne, The Simpsons,* and *Married . . . with Children* owe their transgressive humor to the model set by *All in the Family* in the 1970s.

All in the Family's double-edged meaning, so typical of commercial network television's strategies in the 1960s, found its strange twin in another, very different

program about the American family that debuted a few years later on PBS. It provided a striking contrast to the audience-juggling strategies of the commercial networks by proposing that Americans of all ages would tune in to a documentary, of all things, in prime time. It also created a worldwide impact through its pioneering of a new kind of "reality" TV that would echo the loudest in public service broadcasting networks abroad, as other nations spotlighted their own typical families, up close and personal.

Connection A "Real" American Family on PBS

An American Family was a 12-part documentary focused on the Loud family of Santa Barbara. In a vérité style, often credited today as the inspiration for the television reality show genre, the filmmakers virtually lived with the Louds over a 7-month period from 1970 to 1971 and documented their lifestyle, personalities, interactions, emotional outbursts, trials and tribulations, then edited the 300 hours of video they collected to produce the series that ran on PBS from January to March 1973. If CBS's *All in the Family* brought a certain element, often called realism, to prime-time comedy depictions of the U.S. family, *An American Family* took that one step further. Although later the Loud family members would go public with their disappointment in the series and their feelings that it distorted and exploited their family's troubles and upsets, the series gained high ratings for PBS and, many felt, captured something of the turmoil experienced by real-life families across the nation.

The Louds were somewhat unusual already by the fact of having five children. Bill, a businessman, and Pat, a traditional housewife at the time of the documentary, were shown in a troubled marriage heading for divorce; they separated during the show's run. Their rocky relationship touched a chord in viewers' lives even as it mirrored a demographic trend of the era. Oldest son Lance made the biggest impact, by coming out of the closet as a gay man after a move to New York. The episode in which he reveals his sexuality to his mother, who is visiting him in Greenwich Village, became the most talked-about event in the series. Other children were Delilah, Grant, Kevin, and Michele. As the camera followed them through their days, closed in on their reactions during family disputes, and put a spotlight on their affluent, dysfunctional lifestyle, the distance between the way that American families actually lived—even if distorted—and the overdrawn portraits on commercial television was revealed and highlighted. The process of being documentary subjects may have brought on some of the family crises, several Loud family members admitted later. When interviewed in 1993, son Grant, who was a teenager in 1973, said "I hated my father, and he didn't like me. I was scared of him. Now I have a really good relationship with him, and it's because the series forced me to think about the relationship" (*People Weekly* 1993, 61).

This real-life family revealed aspects of American life in the 1970s that its commercial counterpart, *All in the Family,* avoided. The Bunkers fought and argued, called each other names and threatened to leave, but never did. In true sitcom form, they stayed together over the years and changed very little. Though race, religion, and ethnicity figured frequently in the

show, with women's liberation a running subtheme, the issue of homosexuality rarely came up, in a program that placed a premium on the same kind of unquestioning heterosexuality that *Donna Reed* and *Lucy* had championed. On the other hand, though *An American Family* took on family fragmentation and homosexuality, the Louds lived in a privileged, white world of affluence and ethnic homogeneity. They argued and talked their way through life's crises, but as the documentary's producer Craig Gilbert put it, "The series was about a land of plenty that produces mindless people, who talked all the time, but not about the things that were troubling them. . . . In some ways, all American families resemble the Louds" (*People Weekly* 1993, 61). If an enduring political message of the era was that the personal is political, these programs turned the tables and made the political personal, as they took on wider social issues and encapsulated them within the dynamics of the family.

An American Family is frequently pointed to as one of the founding programs of the burgeoning reality genre. But it had to make a long detour overseas before returning to American screens—with a vengeance. The very next year after PBS's experiment, the BBC took up the vérité challenge with its own series, called *The Family* (BBC 1974). Eschewing both the melodrama and the affluent setting of its U.S. model, *The Family* followed the fortunes of the working-class Wilkins family of Reading, a small and decidedly unglamorous city just west of London. Airing 12 episodes of only 30 minutes apiece, as opposed to the 12 hours for *American Family* on PBS, the BBC show focused on matters at once more domestic and less dramatic, but far more telling on issues of social class and the construction of English identity (Biressi and Nunn 2004, 64). The program's success prompted the BBC to move toward the development of the genre that would eventually be known as the "docusoap," a multipart form that uses documentary techniques to trace the lives of real people, filmed on location in their own settings, but edited to form a series of coherent narratives based on central personalities.

However, in the meantime, American commercial television would come up with a new, gripping kind of factual programming in the late 1980s in shows such as *America's Most Wanted* (Fox 1988) and *Rescue 911* (CBS 1989), which combined reality footage with dramatic reconstructions, in an appeal to audiences based more on fast-paced entertainment than thoughtful observation and information. These new forms would in turn morph into the reality show craze of the 1990s, a story we take up again in Chapter 13.

One more "family" show in the sitcom tradition marks this decade and set important precedents as it handled the explosive politics of the sixties and early seventies. *M*A*S*H* (CBS 1972–1983), although about an Army hospital unit operating during the Korean War, made obvious reference to Vietnam, as had the Robert Altman film on which the show was based. Written and later produced by established comedy writer Larry Gelbart, the series created a different kind of family, a kind of workplace family but one faced by a whole range of life- and sanity-threatening situations in keeping with the political turmoil of the times. With Alan Alda as Hawkeye, Wayne Rogers as Trapper John, Loretta Swit as Margaret "Hot Lips" Houlihan, Larry Linville as Frank Burns, and many other stellar actors, this was also one of the first true ensemble cast comedies. Its combination of war-related tragedy and slapstick, and often salacious humor, commented on war specifically and human nature generally with many telling parallels to the contemporary political situation. *M*A*S*H* also espoused an atmosphere of resistance to

authority, mocking the Army and government institutions for their hypocrisy and inanity. It could slip strong antiwar messages past watchful authorities in a way that the Smothers Brothers and their guests could not.

Drama, Talk, Movies: The Sixties Mix

Sitcoms remained strong in the sixties (with at least 22 on the air most seasons), but a genre of programming that blossomed and became dominant during this time was the hour-long action-adventure show. By fall 1973 the prime-time schedule featured over 24 of these shows, which took up over a third of prime-time hours. They ran the gamut from *Gunsmoke*, the last of the holdover westerns, to medical dramas (*Medical Center; Marcus Welby, MD; Doc Elliot*) to the most prominent by far, crime and police series. Popular titles from the early seventies include *The Rookies, Hawaii Five-O, Cannon, Kojak, Ironside, Mannix, Police Story, Shaft* (the first to feature a black detective, played by Richard Roundtree), *Barnaby Jones,* and in a slightly different category, *The Six Million Dollar Man,* which debuted in 1974 and would soon touch off a bionic superhero craze.

A few variety shows still hung on—Bob Hope, Dean Martin, Carol Burnett, and Sonny and Cher—and movies had become staples on the network schedules. Every night featured a "movie of the week" on one net or another, some made for TV, others from Hollywood. NBC debuted its *Tomorrow* show at 1:00 a.m. following the *Tonight* program, with Tom Snyder as host. And a few prime-time shows of the period defy categorization: *Love American Style,* an anthology of love-related weekly playlets, with famous guests in the main roles; *The Waltons,* an hour-long family drama set in America's historical past, that deliberately turned its back on the tempestuous times in favor of traditional values and homespun truths; and last but far from least, *Star Trek,* whose initial run from 1966 to 1969 on NBC sparked an empire of thoughtful, original sci-fi programs and would produce one of the most persistent and creative fan cultures ever.

The Living Room War

Television news expanded and deepened during the years of political unrest and war. Having established the network news show in the half-hour before prime time, the networks built up both their brand-name anchor teams and their coverage of the world's hot spots. CBS had Walter Cronkite, ABC featured Harry Reasoner and Walter K. Smith, and NBC headlined the team of Chet Huntley and David Brinkley. As can be seen by this list of anchors, network television news remained a resolutely white male bastion. Though a few women reporters worked on the fringes, not until 1976 would Barbara Walters put the voice of authority in a woman's mouth. And though a black face might occasionally be seen as a correspondent—Mal Goode was hired by ABC in 1962—significant inclusion of African Americans or other minorities in network news coverage would have to wait until the 1980s. This was a war that various social groups organized to fight as the sixties went on.

Daytime newscasts increased in length and frequency, and with the advent of technologies such as satellites and portable electronic news-gathering (ENG) equipment using videotape, news could be instantly transmitted from anywhere on the globe, from virtually anyone. Local stations began to cover news in their local areas,

not just for local audiences but for pickup by the network. But it was in their coverage of the war in Vietnam—up close, on the scene, in full color, often shooting as the action happened—that television news finally came of age. Many attribute the country's growing antiwar sentiment, so unlike its attitude toward previous wars, directly to television news gathering, which for the first time beamed into the living rooms of American families pictures of the war as it really was, soon after it really happened. And as historian Chester Pach argues, it was television's faithfulness in capturing the random violence, the contradictory politics, the incoherence and lack of clear-cut front lines or ideological goals of the war itself, and the display of its own uncertainties about how to cover such a war, that provoked the upsurge of revolt against it (Pach 2001). Never again would military authorities allow American news media such uncontrolled access to a war zone.

Although the quantity of documentary productions, outside of breaking news, would never again rival that of the early 1960s, a few controversial programs provoked discussion and outrage. CBS's 1971 *The Selling of the Pentagon* angered many in the military establishment for its hard-hitting look at the military's production of propaganda for the American public. CBS's groundbreaking newsmagazine show that debuted in 1968, *60 Minutes*, brought longer pieces of investigative reporting to prime time on a variety of topics. The Watergate hearings, carried live for many hours between May and August 1973, held audiences fascinated as they watched presidential trustworthiness crumble. Political reaction was not always favorable; President Nixon made the media, especially television, one of his primary targets in pointed criticism, and Vice President Spiro Agnew took up the gauntlet with his famous "nattering nabobs of negativity" quote (referring to the media).

Sports

Two of the most enduring television sports institutions premiered during this decade: the first Super Bowl in January 1967, followed by the debut of *Monday Night Football* on ABC in 1970 under the direction of Roone Arledge. In between, the 1968 summer Olympics broadcast live from Mexico City enthralled the nation with compelling physical performances as well as the outcropping of political protest in the midst of victory, when several U.S. athletes shocked the nation by giving the Black Power salute during the medals ceremony. This set the stage for the most tragic convergence of sports and political violence ever seen on TV during ABC's coverage of the 1972 summer Olympics. In the hands of Roone Arledge and Howard Cosell, viewership of the games rose to new heights, attracting 52 percent of the TV audience some nights. When Palestinian terrorists invaded the Olympic compound in Munich and captured a group of Israeli athletes, ABC covered the breaking story from standoff to bargained agreement to the final tragic shootout with police, during which all the hostages were killed.

ABC moved into the position of sports leader during this period as a strategy to improve its customary third-place ranking. Advancing technology, multiple-camera coverage, quick editing, and instant replay, all enhanced by fast-paced commentary, music, and vivid graphics, became the elements we associate with sports realism on television—an effect some argue worked to trivialize and sensationalize athletics, turning them away from authentic competition into a cheapened form of showbiz.

Sports had now truly become a fundamental element of network and local television, and increasingly the organization, economics, and even rules of sports themselves changed to accommodate this persistent new presence.

In 1973 the FCC eliminated the practice of imposing local blackouts for games that sold out more than three days prior to the event, as income from television rights began to overwhelm stadium receipts. By the late seventies, the annual Super Bowl had become the priciest commercial property on television, with sponsors paying millions of dollars for a 30-second spot. Many claimed to watch the event primarily for the cutting-edge ads. Things had changed since the early days of sports as public service.

SOCIAL DISCOURSE

During the crucial decade from 1965 to 1975, loosely described in most accounts as the sixties, ways of thinking and talking about television varied as widely and exhibited the same conflicted pressures as the decade itself.

Violence Redux

It is hardly surprising that with riots, demonstrations, and war coverage on the news, and with the networks featuring action-adventure shows in prime-time while children's Saturday morning schedules were filled with superhero cartoons, objections to the rising level of violence would once again attract national attention. In the assassination-ridden year of 1968, President Johnson instituted the Commission on the Causes and Effects of Violence. Its report contained a lengthy and condemnatory chapter on the media, particularly television, which prompted Senator John Pastore of Rhode Island to request that the surgeon general form a panel to review research on the subject. Amazingly quickly, as legislators grasped at a way to pinpoint the source of violence—in a way reflecting credit on themselves—a research program was initiated and funded to the tune of $1.5 million.

A mixed panel of industry, academic, and neutral experts reviewed existing studies and commissioned 23 more, sparking a boom in the academic social science field of TV effects. Their final report, issued in 1972, became a subject of controversy itself, as industry panelists fought to tone down and exclude some of the more definite findings about ways in which television might encourage or motivate violent acts, particularly among children. Although the report concluded tamely that "for some children, some of the time" there might be a relationship between heavy TV viewing and a tendency to act out violently, other studies purported to show a much more direct and powerful relationship. An ongoing assessment of the level of network TV violence was commissioned, and departments of social-science-based media research sprang up in universities all over the country, funded by government and foundation grants.

But few questioned the basic economic and regulatory structures and inherited representational systems by now solidified in American television. Critics charged that the entire methodology and scope of such studies begged the real questions facing television in a democracy. As an emergent conservative, religious right began to take up some of the same dystopian views of television's violent and often controversial

address, liberal critics of the media wondered if the violence debate had really led them down the right road. Was censorship the answer? Into whose hands would it be placed? If government regulation combined with industry self-interest could not produce a fair and representative television system, and if public television's alternative remained cautious and fettered by its funding, where might a solution be found?

Citizen Activism

Here the debate might have languished had not the militant citizen action groups of the 1970s jumped into the fray. One in particular, Action for Children's Television (ACT), had been formed in the late sixties by Peggy Charren and a group of Boston women concerned about television's effects on their children. In 1970, they petitioned the FCC for requirements that stations provide more quality children's programming and attracted support from the John and Mary R. Markle Foundation, allowing them to expand into a national organization. The group's regulatory efforts would later pay off in limits on advertising to children, the creation of a family viewing hour, and eventually passage of the Children's Television Act in 1992.

Another group focused on the public television scene was the Children's Television Workshop (CTW), founded in 1968 with support from the Ford and Carnegie Foundations and the U.S. Department of Education. It produced the groundbreaking children's program *Sesame Street*, one of the first to combine highly original and fast-paced entertainment techniques with a no-nonsense educational message. Preschool-aged children learned their numbers and ABCs in a multicultural, socially conscious environment populated by enduring childhood companions like Big Bird, Bert and Ernie, and the Cookie Monster. CTW followed up its first success with *The Electric Company*, aimed at older children.

Women's groups and organizations concerned with racial and ethnic representation also made their complaints and objectives known to the FCC, broadcasters, and the general public during this period. In 1977 the lack of women and minorities in news organizations was explored in a study done by the U.S. Commission on Civil Rights and tellingly entitled, "Window Dressing on the Set: Women and Minorities in Television." The study found that U.S. news organizations had done a very poor job of integrating nonwhite, female reporters, producers, and managers into either their news operations or their news coverage. The National Organization for Women (NOW) mounted a large-scale public awareness campaign focusing on the sexual objectification or disempowerment of women in media and advertising, which found a widely read outlet in *Ms.* magazine. Meanwhile, groups such as the National Black Media Coalition, the National Black Media Producers Association, and Black Effort for Soul in Television (BEST) consolidated the gains that African Americans were beginning to make in national media and agitated for more.

Another area of activist concern was the emerging sphere of public, educational, and governmental (PEG) access channels just beginning to open up on cable systems, as required by federal law. Public access, in particular, began to seem like a solution—some would claim a sop—to the competing demands of local grassroots activists, left-wing video artists, and a PR-hungry cable industry. Development in the early seventies of lightweight, inexpensive video portapaks—which allowed everyday citizens to

become video producers—brought television production down to a community and individual level, and public access channels provided an outlet. Local governments and schools also began to produce informational material and to air board and council meetings. The possibilities seemed limitless, although the late seventies and eighties would begin to sketch out where the limits lay.

CONCLUSION

In this chapter we've examined some of the ways in which our basic understanding about television was changing during the turbulent decade of 1965 to 1975. The period of tight network control that had been brought on by the quiz show scandals of the fifties began to totter under a rhetoric that blamed the vertically integrated commercial network oligopoly for a host of problems. The emergence of PBS in 1967 pointed exactly to all those things that the commercial networks failed or refused to do: educational programs for kids, serious public affairs and documentary series, coverage of art and culture, inclusion of racial minorities, and a host of other long-awaited program initiatives. The commercial networks responded by creating youth-oriented shows that addressed the political currents of the day through the device of generational conflict, either overtly or via double-edged, dual-level messages that could be read differently depending on the audience member's understandings. Network news covered the struggle for civil rights and for women's equal rights but reproduced the repressive racial and gender system in its own organization and basic orientation. Television coverage of Vietnam brought war into America's living rooms.

Pressures from reformist, political, and competing industry groups created a groundswell of regulatory measures that would undermine the tight network cartel. The fin/syn and PTAR rules pointed to places where the big-three networks exercised excessive control. The utopian rhetoric developing around cable television pointed to a new, diverse, multichannel television universe still unavailable yet beckoning. The WLBT-Jackson case demonstrated how television could be used as an instrument of social oppression, yet also lighted the way toward increased citizen action. And while television brought home the stresses and strains of the sixties in a way unprecedented in U.S. history, it also challenged parental authority and reawakened fears of the power of this influential medium in an increasingly institutionalized way.

As the sixties ended, arguably in spirit if not in date around 1975, television existed in an uneasy relationship to the politics and temper of the times. Attracting blame from both the right and the left, having lost much credibility with the movement for racial rights and with the women's movement, challenged on all sides by new technologies, rival industrial groups, and more active citizens, for TV a way out had not yet emerged. However, changes in industry regulation pointed in a direction that would become dominant by 1980: the deregulatory movement ushered in formally during the Reagan administration. The old notion of Progressive control gave way to a new emphasis on competition, diversity, and consumer choice. Whether these new catchwords would do a better job than regulation, compromise, and exclusion remained to be seen.

RISING DISCONTENT, 1975 TO 1985

Quick: the seventies. What do you think of? Platform shoes, polyester pointy-collar shirts, bell bottoms to the nth degree, John Travolta, the Fonz, disco dance floors with strobe lights and a pulsing beat, long lines at gas stations, no jobs for college grads, cocaine on the coffee table, *Roots, Hill Street Blues, The Love Boat*, the Bicentennial— as an anticlimax. The list could go on, but clearly many of the things we identify as properly belonging to the seventies represent the fallout from the sixties or elements taken to a new and sometimes excessive degree. During the period that ran roughly from 1975 till 1985, the nation sobered up from the heady intoxications of the 1960s and found it had a giant headache.

SOCIAL CONTEXT: CRISIS OF CONFIDENCE

As long as times were prosperous, warring social elements had scraped along, but the embargo placed on Middle Eastern oil after the Yom Kippur war in 1974 marked the beginning of the energy crisis and a declining economic situation. Gas prices rose 10 percent and a period of stagflation commenced, marked by both inflation (high interest rates, prices rising faster than paychecks) and economic stagnation. The unemployment rate rose to 9.7 percent by 1982—its highest since 1940 and the all-time peak of the post–World War II period. The country's mood darkened. As Treasury Secretary William Simon said in a speech in 1976, "Vietnam, Watergate, student unrest, shifting moral codes, the worst recession in a generation, and a number of other jarring cultural shocks have all combined to create a new climate of questions and doubt. ... It all adds up to a general malaise, a society-wide crisis of institutional confidence" (Zinn 1995, 323).

And, in this final pre-AIDS period, society plumbed new depths of dissipation and decadence, or so many believed. The electronically enhanced disco beat began to dominate the music scene, spawning a new attention to dance clubs and urban night life. Drugs formed an important part of this scene, and it is during the seventies that emphasis shifted from the psychedelics and pot of the sixties to the cocaine craze, a prelude to the crack epidemic of the late eighties and early nineties. The election of Ronald Reagan in 1980, promising a "new morning in America," eclipsed the disappointing Ford and Carter administrations and started a business-dominated era.

Baby boomers traded in their bell-bottoms and love beads for the dress-for-success look, and the yuppie era—named for the *young urban professionals* that the boomers had become—was born. On the plus side, minorities and women who had demonstrated for equal access to democracy and the good things of American life marched out of college and professional schools into new careers. The numbers of women working outside the home—now often in areas previously closed to them—climbed to over 50 percent, and the black middle class expanded significantly for the first time since the 1920s. On the negative side, a new emphasis on material acquisition and social status evolved from the two-paycheck family; the eighties became the "me decade." The divorce rate continued to skyrocket, reaching a peak in 1980 of 52 percent of all marriages that has yet to be equaled. As the echo boom (children of the baby boomers, later to become generation Y) commenced in the early eighties, families faced the problem of juggling child rearing with professional advancement. And generation X, those born between 1960 and 1975 in the fallout of the baby boom, began to come of age still overshadowed by the sheer bulk of the preceding generation.

It was the sixties space race that had led to the key piece of technology that made globalization possible. The Soviets had launched the first orbiting satellite, Sputnik, in 1957, and in 1963 the United States countered with the first *geostationary satellite*, perched permanently at 22,300 miles above the earth's surface so that it rotated at exactly the same speed as the earth itself. This meant that a satellite receiver on the ground could remain stationary and still pick up the signal, rather than having to track across the sky with the satellite's orbit, sometimes losing it altogether. It didn't take long for the commercial possibilities of this sort of technology to reveal themselves, and in 1964 AT&T's Early Bird satellite created the first live television link between the United States and Europe. It was launched by NASA for the Communications Satellite Corporation (COMSAT), a coalition of government and industrial corporations concerned with development of space technology. It was Western Union's Westar satellite that first made transponders available for lease by other companies. The effect of satellite technology on media, not just in the United States but centrally to its global interconnections, is one of the least recognized but most significant developments of the latter half of the twentieth century. It would have an enormous impact on all aspects of American life, and especially on the media.

MEDIA CHANGES

The most sweeping changes in the media industry would take place in television in the 1970s, with films, newspapers, and even radio reacting in ways that wouldn't reach full fruition until the late eighties. New companies and ventures were born as others went under. The emphasis on the youth market carried over but diversified as the baby boom generation moved into adulthood. The emergence of satellite transmission, videocassette recorders, expanded cable television, lightweight video cameras, computer-generated graphics, and a host of related technologies began to change the media industries and, along with mergers and consolidations, to blur their edges more completely.

McPaper

No development rocked the world of the print media more than the birth of *USA Today*, the first national newspaper, in 1982. Building on advances in satellite distribution, the basic idea behind this new McPaper, as some called it, was that it would be printed out at hundreds of sites across the nation, from a signal sent from various Gannett editorial offices around the world. Its national distribution and intended market meant that it would break certain time-honored rules of the newspaper business. Rather than focus in depth on traditionally serious topics, *USA Today* would skip lightly over breaking news, sampling from all corners of the nation and the globe, but land heavily on those topics of universal appeal: sports, weather, and entertainment. Enlivened by catchy graphics, charts, and syndicated features, the publication seemed to many to bear the same relationship to real journalism as McDonald's hamburgers did to real food. But business travelers, hotels, airlines, and those who wanted to keep up on U.S. news in other countries quickly saw its potential. The paper would not make its first profits until 1993, but its parent company's increasingly global media holdings propped it up while its unique identity sustained it.

The seventies were a time of expansion and merger for dominant newspaper groups. Out of the formerly diverse ownership of the multiple papers serving most cities in the 1960s, a handful of major media conglomerates arose: Gannett, Knight-Ridder, Newhouse, Times Mirror, the New York Times Company, Dow Jones, the Chicago Tribune Company, Cox Enterprises, and a few others owned papers in cities across the country and often had extensive holdings in other media as well. Many cities lost treasured historic daily newspapers during these decades, as the *Chicago Daily News*, the *Washington Star*, the *Philadelphia Bulletin*, the *Cleveland Press*, and the *Columbus Citizen-Journal* bit the dust. However, others such as the *New York Times*, the *Los Angeles Times*, the *Washington Post*, and the *Wall Street Journal* effectively became national papers of a different, deeper sort than *USA Today*, even while keeping their local base.

Movies

The seventies marks the last decade during which we can really talk about the film industry as separate from television, even though many boundaries had already blurred. With passage of the Financial Interest and Syndication (fin/syn) Rules, Hollywood studios moved ever deeper into television production, dominating prime time and making inroads into production for first-run syndication and cable. Studios also began to participate in cable channel ownership, even as cable companies moved into film production. In 1986, the first of the studio-network alliances would form with the emergence of Rupert Murdoch's Fox network, as will be discussed in Chapter 11. The most pertinent technological innovation of the eighties, the videocassette recorder or VCR, wouldn't achieve wide distribution until 1988. But studios saw it on the horizon and began making plans. All the major studios had formed home video distribution arms by the mid-1980s, with Paramount Home Video making the biggest splash in 1982 by releasing *Star Trek II: The Wrath of Khan* for a sell-through price of only $39.95—designed to be purchased by individual VCR owners, not by rental stores, as previous policy had dictated. Soon studios would see more of their overall profits produced by formerly secondary distribution

channels—cable, network TV, videotape, and foreign sales—than by first-run box office exhibition. This would fundamentally change the nature of the business.

Meanwhile, merger mania continued. The emphasis on blockbusters, combined with the more segmented films that the cable market sustained, produced record profits in the film business in the late seventies and early eighties; 1980 was the most lucrative year the film industry had ever experienced. Most studios became takeover targets. The Coca-Cola corporation bought Columbia Pictures in 1982 as an addition to its growing entertainment division. Cable mogul Ted Turner purchased MGM/UA from Kirk Kerkorian in 1985 but later sold off both its production facilities (to Lorimar-Telepictures) and ongoing business as MGM/UA (back to Kerkorian) in order to hold onto what he really wanted: the vast MGM film library, which included a significant number of RKO and Warner properties. In 1981, 20th Century Fox was purchased by Denver oil millionaire Marvin Davis, who sold it to Rupert Murdoch in 1985. Other mergers would follow.

The many mini-majors and independents that sprang up during this period show the impact that cable and television had on the circumstances of film production as well as the increasing globalization of the film/TV market. Tri Star Pictures, organized in 1982, brought together the production capacities of Columbia, HBO cable, and CBS television, an early synergistic venture by which Columbia would produce films and then HBO would show them on pay cable, followed by network exhibition on CBS. The Cannon Group, an independent firm taken over in 1979 by Israeli filmmakers Menahem Golan and Yoram Globus, produced low-budget action-adventure films for U.S. and foreign venues (known as "Cannon fodder" to those in the industry). Its most famous release was *Death Wish II* with Charles Bronson in 1982. By 1984, foreign distribution of film and television brought in over $2 billion in income for U.S. studios. Cable television helped to bring more foreign-produced films into the American market, and coproductions in which U.S. studios cooperated with European or Asian studios proliferated.

Radio

Few dramatic developments marked radio in the seventies, though the trends that had emerged in the earlier decade intensified. Satellite transmission allowed the movement toward syndicated formats to spread and deepen. Now a station's music, DJ patter, commercials, and news could be sent out from a central point by satellite, leaving a few blank spots for local ads and weather. This created not only a homogenization of radio formats, but a slicing of the market into ever-thinner slivers, defined nationally. The numbers of people listening to the dominant formats rose overall, even as each local market found itself divided into increasing numbers of stations and categories. For instance, the blanket category of country-western now included subformats of country-politan, contemporary country, and modern country. The old standby formula called middle of the road or MOR subdivided into adult, adult contemporary, bright, up-tempo, and easy listening. A new black format brought together the former rhythm and blues and the new soul sounds. Progressive included underground, album-oriented rock, hard rock, alternative, free-form, and folk. All-news and talk formats increased greatly. FM continued to be the band of choice, as AM shifted uneasily and tried to find a new role. The overall number of stations on the air rose, and it was not unusual for a major

city to find 30 to 50 stations competing for its listening audience, with perhaps eight or ten providing an outlet for each top national format and its slight variations.

The shape of things to come appeared in the advent of satellite-delivered talk shows. Although radio had always been full of talk, new technologies now not only delivered syndicated talk programs nationwide but also allowed national call-in via satellite-based 800 numbers. Mutual Broadcasting debuted long-running talkmeister Larry King in 1978, and other radio networks followed. NBC launched its Talknet service in November 1981 with a financial call-in show hosted by Bruce Williams, followed by self-help and personal relationship talk mediated by Sally Jesse Raphael. Soon the format would make the transition to TV.

Deregulation, Breakup, and Merger

It might at first glimpse seem ironic that it was the institution of new regulation—the fin/syn and PTAR rules—as well as the FCC's decision to make cable an officially regulated industry that eventually led to the deregulatory decades of the Reagan era. Perhaps it might even show the fundamental contradiction of the deregulatory position: Free markets usually require some kind of regulation to create and maintain them. Even at the height of the deregulatory craze, no one, least of all the television industry, actually wanted complete deregulation. That would mean no protection from foreign or unusually rapacious interlopers, of the kind that the TV business had always enjoyed. That would mean no station frequency allocations, no orderly parceling out of the airwaves—at least, not for free, in the sweetheart deal from which the industry had so long profited so enormously. Complete deregulation would pit smaller businesses against enormous media conglomerates, creating an unfair battle that the giants were sure to win. No, complete deregulation was never in the cards, as even its primary Reaganite guru, FCC head Mark Fowler, stated very clearly (though most chose not to hear).

But the diversification of control that fin/syn and cable had brought in their wake allowed the never completely quiescent giant of Hollywood to enter into the television lobby, meaning that no longer could the corporate radio and TV giants of previous years hold onto their cozy and exclusive relationship with the federal government. Like it or not, Hollywood studios—as well as the growing cable industry—were now vociferous players in the television regulatory game. And they didn't like the old rules they had been forced to play by.

Connection Mark Fowler's Toaster

Even before President Reagan was elected to office on a free market, pro-business platform in 1980, there had been deregulatory stirrings at the FCC. Carter-appointed chairman Charles Ferris had led a revision of cable regulations from 1979 to 1980, after

commissioning two studies purportedly showing that cable competition would not harm broadcasting. When President Reagan appointed Mark Fowler head of the FCC in 1981, deregulation of the telecommunications industry more generally moved into high gear. Fowler came to the FCC with a strong conviction that competition in the marketplace, not government regulation, would provide the best service to consumers in a variety of fields.

Defining his task as "pruning," "chopping," "slashing," "eliminating," "burning," and "deep-sixing" a half century of legislation from an agency that he called "the last of the New Deal dinosaurs," Fowler immediately embarked on a campaign to break up AT&T's telephone monopoly, end the requirements for educational children's programming so recently achieved, revoke the fin/syn rules, slash caps on station ownership, deep-six the Fairness Doctrine, and eliminate the requirement that licenses be held for 3 years before transfer of ownership, sparking a boom in station sales and skyrocketing prices (M. Brown 1981). At some of these he succeeded; at others he was balked. Fowler is most famously remembered for his statement that television should be treated as nothing more than another household appliance, a "toaster with pictures." This phrase stuck, and Fowler's toaster for a while became the equivalent of Occam's razor: the principle of philosopher William of Occam that the simplest explanation is always the best one. For Fowler, the marketplace solution was always the best one.

A former college DJ who went by the on-air moniker "Madman Mark," Fowler served as communications counsel to Ronald Reagan's presidential campaigns of 1976 and 1980. Reagan appointed him chair of the FCC in May 1981, with a clear mandate to carry through deregulatory Reaganite policies. In 1982, with coauthor Daniel L. Brenner, his legal assistant, Fowler published an article in the *Texas Law Review* that laid out his basic principles. Titled simply "A Marketplace Approach to Broadcast Regulation," the article rebuts the basic principles behind 50 years of FCC regulation of commercial broadcasting and proposes a new set of standards by which broadcast performance should be judged—all or most of which could, these authors argued, be achieved more readily through untrammeled marketplace competition than through government regulation. According to Fowler and Brenner, the FCC's hold over radio and television rests on ideas that they call "a series of legal fictions," the most fundamental of which is *scarcity* of broadcast frequencies. Because early officials perceived that frequencies were scarce and thus had to be allocated, they imposed an unprecedented infringement of broadcasters' First Amendment rights by requiring operation in the "public convenience, interest, or necessity." This "original electromagnetic sin" has led to a state of affairs in which broadcasters possess fewer rights than do other media—the print media in particular (Fowler and Brenner 1982).

Fowler contended that scarcity was never the problem that regulators made it out to be, and that certainly by the 1980s it was completely a thing of the past. Pointing to the vast unused expanses of the UHF spectrum and to new technologies such as cable (which could have been developed much earlier), Fowler proposed that had the government allowed spectrum users to compete for use of the airwaves, perhaps by paying a spectrum usage fee, a better level of service to the public would have resulted. The marketplace would have taken closer note of the public's needs and desires and provided a wider range of services than the regulated system could. Here Fowler goes back to the notion (rejected by the Federal Radio Commission so long before) that "the public's interest, then, defines the public interest" and that competition in the free, unregulated market can best identify and serve those interests.

But an even more compelling result of deregulating broadcasting, for Fowler, is that it would rid radio and television of the nefarious effects of government infringement of their First

Amendment rights. Regulated broadcasting might have smoothed over controversy, but it set a dangerous precedent for treatment of all media. Fowler and Brenner sum this point up:

> This first amendment interest is, or should be, coextensive with the first amendment rights of the print media, regardless of whether the public is best served by its uninhibited exercise. A broadcaster's first amendment rights may differ from its listeners' rights to receive and hear suitable expression, but once the call is close, deference to broadcaster judgment is preferable to having a government agency mediate conflicts between broadcasters and their listeners. (Fowler and Brenner 1982, 242)

This aggressive version of conservative populism so representative of the Reagan years often created strange bedfellows and attracted unanticipated enemies. Fowler's deregulatory measures ran afoul of a Democrat-controlled Congress, especially when he tried to eliminate preferences for minority candidates for low-power television licenses and to repeal the Fairness Doctrine. In retaliation, Congress cut the FCC from seven members to five, eliminating a favorite Fowler appointee. His proposals to rescind the fin/syn rules brought Hollywood screaming to Washington in full force, with the ultimate objection coming from former Hollywood insider Ronald Reagan himself. After a forceful briefing from the president, Fowler agreed to let that one sit on the back burner for a while. Besides the noteworthy AT&T breakup, which the Federal Trade Commission (FTC) mandated but the FCC supervised, Fowler's administration did succeed in simplifying the license renewal process significantly, creating seven hundred new FM channels for allocation and eliminating the long-standing requirement that radio and TV provide some news and public affairs programming. And in a compromise, Fowler's proposal that station ownership caps be completely removed did raise the total allowable number from 7 to 12, with coverage of 25 percent of the population the ultimate limit.

From the old justifications of public resource, scarcity, and intrusiveness on which prior regulation was based, Fowler redirected the emphasis to goals of diversity, competition, and innovation. To many, it seemed as if Fowler didn't care how those terms were defined and that he was abandoning all notions of standards and control to a marketplace that actually was not as free and competitive as his model claimed. As scholar Duncan H. Brown points out, the final part of Fowler and Brenner's influential article contains an important qualifier to the marketplace approach (D. Brown 1994, 257). Fowler acknowledges that there might indeed be certain audiences or types of programming that the marketplace will tend not to supply. He calls these "merit goods" and uses the examples of "locally oriented news, public affairs, and cultural programs," "experimental programs," and "age-specific programming" such as that for children and the elderly, because they might not be attractive consumers to advertisers. To take care of such special cases, Fowler proposes that public broadcasting's mandate be adjusted to specifically provide these merit goods, and even goes so far as to suggest that Congress could, if it wished, use part of the spectrum fee imposed on commercial broadcasters to support such a service.

Yet Fowler never followed through on this idea, and the idea of a spectrum fee met with such fierce opposition from virtually all players—government, public, and industry alike—that he rarely brought it up again. In this sense, critics have accused deregulation under Fowler of being inconsistent and too random to be effective. Lacking the political savvy or clout to implement his sweeping vision of a perfect telecommunications marketplace, he left instead a piecemeal legacy of only those changes that industry groups most supported: in the end, it

was just another example of the FCC working in the service of the telecommunications industry, as it had for decades. Only now there were more players. One FCC commissioner, Henry M. Rivera, likened the FCC under Fowler to "a cross-eyed javelin thrower. He won't break any records, but he sure as hell has the attention of the audience" (Wilke, Vamos, and Maremont 1985, 48). However, it is also true that the number of channels, services, and formats available to the average audience member expanded greatly in the seventies and early eighties, and not all of them were commercial or exclusionary. In our ongoing discussion of the industry, we will reveal some of these strengths and continuing weaknesses. Though Fowler left the FCC in 1987 to take a job in private industry, the deregulatory momentum that he helped to create continued through the eighties and nineties, leading to the industry-friendly Telecommunications Act of 1996. The principle of Fowler's toaster remains with us still.

Deregulation wasn't the only FCC concern during this period. The agency's first experimentation with low-power television, or LPTV, occurred in the early eighties. LPTV was intended to create thousands of 100-watt or lower stations in the UHF band across the country, with preference going toward minority and female broadcasters; the FCC envisioned very local "neighborhood" stations with a broadcast radius of only 5 or 6 miles. However, when large corporate entities like Sears deluged the agency with applications for hundreds of such stations, envisioning a nationwide network of LPTV outlets, the FCC was forced to backpedal and in 1982 instituted a lottery system of license assignment. Some LPTV stations struggled onto the airwaves in the years to come, but they were hampered by lack of advertising revenues due to small potential audiences. Even the cable must-carry rules, under challenge during this period, did not always help the LPTVs, because they exceeded the number of stations cable systems were required to carry in most locations.

For cable, the Cable Communications Policy Act of 1984 brought to fruition various attempts to free the technology from its bondage to broadcast television, as well as acknowledging its new potential with satellite distribution. The cable industry could not have been happier with the act's provisions. It virtually eliminated all federal restrictions that had affected program offerings, subscription rates, and franchise fees. Now each municipality would have to negotiate its own deal and make its own rules for cable. The cities held only a limited degree of power in these negotiations, considering that in most cases cable remained a local monopoly and overbuilding—allowing two cable companies to compete in the same area—was allowed but extremely unlikely. Cable was just too capital intensive to encourage companies to compete with each other. The must-carry rules remained in place, though under attack. National cable channels and multiple systems operators (MSOs) were free to expand, without any of the ownership caps or restrictions that kept broadcasters in check.

The FCC's deregulatory ideology brought Congress into the regulation picture to an extent not seen since the 1930s. Many traditional liberals were not ready to succumb to the marketplace idea if it meant giving up principles of centralized control, and they fought the commission on a number of issues, including battling to keep the Fairness Doctrine in place (at least temporarily) and to limit other deregulatory attempts. On the other hand, Congress made multiple attempts to reform the Communications Act of 1934 during the late seventies and early eighties, and many of those

attempts went even further than Fowler's proposals had. Notably, the House Communications Subcommittee, under the leadership of Democratic representative Lionel Van Deerlin of California, explored the notion of instituting a spectrum usage fee that would make broadcasters pay for use of public airspace, providing funds that could be channeled to public, minority, and rural broadcasters. Out of this committee came the proposed Communications Act of 1978, which out-Fowlered Fowler in its deregulatory proposals. It met with little support, as did Van Deerlin's similar 1979 House bill, and contributed to his defeat in the 1980 elections. Yet the notion of rewriting the Communications Act would continue into the nineties.

Clearly the explosion of new technologies and enhanced competition during the seventies and early eighties had produced a feeling of general malaise, a crisis of institutional confidence that extended into traditional liberal and conservative ideologies. It was not helped by the 1979 Justice Department antitrust suit against the National Association of Broadcasters (NAB) radio and television codes, which in 1982 prompted the NAB to drop its program guidelines for both media. This eliminated a source of program standards (though voluntary and not often enforced) that had been around since 1939, even as the networks cut back on their staffing of standards and practices departments. Citizens' action groups fell back in disarray and defeat; networks watched their ratings begin to fall under competition from cable, and program standards shifted in the direction of sexual titillation and violence. Liberals split between those who wanted government out of the regulation of television content under free speech principles and those who insisted that deregulation would lead to an era of even greater corporate domination, monopoly, censorship, and exclusion. Conservatives supported marketplace deregulation to free competition from government restraint, but an emerging Christian right demanded even tighter control over harmful and offensive content. The old order was coming to an end, and it was not clear what would replace it.

INDUSTRY EXPLOSION

By 1985, the classic network system had not yet died away completely, but it was feeling rather ill. A remarkable change came over television in the late seventies and early eighties, such that people who remember television before 1975 cannot really expect those who came along later to think of the television universe in the same way. From a local market served by only four or five stations and a national universe of only four networks, including PBS, most people's options had expanded to include upward of 20 channels by the end of the eighties. Cable penetration had reached almost 50 percent of homes by 1985, and a variety of channels had sprung up to serve them. Network ratings began the long decline that intensified in the eighties and nineties: From a situation in which the big three split over 90 percent of the viewing audience among them, by 1985 their combined audience share totaled less than 75 percent and would fall much further. Not only cable viewing but watching movies at home on the VCR contributed to the competition, though VCR ownership would not reach critical mass until the advent of very inexpensive players in the mid-1980s. What made the classic network system crumble, and what sort of system replaced it? During the seventies we got our first glimpse of what was to come.

57 Channels

If we take Mark Fowler's new regulatory goals of diversity, competition, and innovation as our guidelines when we look at cable, the picture painted by the 1975 to 1985 decade is decidedly mixed. For some, Bruce Springsteen's 1992 hit, "57 Channels and Nothing On," summed it up nicely. For others, concerned more with good taste, public service standards, and access—well, the picture was equally cloudy. Early cable programming was marked by a great deal of imitation, a certain amount of innovation, diversity that extended only so far, and a level of service that included many who had been excluded yet did not always give them what they would have liked—or what others thought they should have. But it is certain that between 1972 (when Home Box Office—HBO—made its first local debut) and 1985 (by which time well over 52 new cable channels were providing service), the television universe expanded exponentially. If it is hard for people born after 1980 even to distinguish an over-the-air (OTA) network like ABC from a cable network like USA or a superstation like WGN, that experience speaks both to the diversity and the sameness of the period after the classic network system when satellite-distributed and deregulated cable began.

Other countries were much slower to adopt cable wholesale than was the United States, due often to the competition it threatened for government-owned OTA systems. In these cases, VCRs provided a first dose of television diversity, often from pirated videotapes; direct broadcast satellites in the nineties would begin the new multiple-channel era. But in the United States, cable began proliferating even before passage of the 1984 act. Cable *systems operators,* meaning companies that ran cable wires through cities and towns and provided a number of channels to homes for a monthly fee, had existed since the 1940s but began to prosper and spread in the seventies. By 1980 several large *multiple systems operators* (MSOs) had emerged, including American Television and Communications Corp. (ATC), TeleCommunications Inc. (TCI), Cox Cable, Sammons Communications, Warner Amex (a joint venture of Warner Bros. and the American Express Company), Westinghouse, TelePrompTer, Viacom, and many other smaller companies. Over the next decade most of the smaller ones would be bought up by larger MSOs, and other well-known media names would enter the business.

This period witnessed a wild scramble to sign contracts with as-yet-unwired sections of the country in what became known as the franchise wars. Would-be MSOs promised cities anything their hearts desired to win the standard 15-year franchise against their competitors; many would later renege on these lofty promises, creating ill will that would come back to haunt cable later. Some of these MSOs ventured into the provision of cable channels, beginning the vertical integration later endemic to the industry. But what kind of services would work on cable? What could compete with established networks enough to justify the monthly fees that cable subscribers had to pay?

Pay Cable

Pay cable had beckoned with its promise of uncut theatrical films, special sporting events, and certain kinds of forbidden (X-rated) material ever since the suppression of subscription television in the 1950s. Home Box Office, purchased by media conglomerate Time Inc., was the first to emerge as a viable pay cable channel in 1978, charging customers a hefty fee

above their basic cable subscription for uncut movies and no advertising. The signal went out in a scrambled state from the cable headend, so that unsubscribed viewers couldn't receive it. Soon other channels followed, including Showtime, owned by Viacom, and The Movie Channel, owned by Warner Communications. HBO began a second service, Cinemax, in 1980. CBS invested in the Rainbow Group's Bravo Channel, featuring more highbrow fare, and the American Movie Classics channel in 1984. The Playboy Channel took advantage of cable's adult potential in 1982, and on the other side of the coin Disney started its Disney Channel, aimed at children, in 1983.

Pay cable economics most closely resemble those of the movie industry: You want a product, you pay for it. No advertiser middleman intrudes in the consumer choice process, and no one gets the service who doesn't specifically ask and pay for it. No public spectrum comes into the picture, and thus no standards of public interest. This would allow pay cable to venture into types of programming that OTA or basic cable networks feared to pursue—for better or worse.

Basic Cable

Basic cable channels are the ones that most people receive as part of the least expensive package, or *tier,* of cable services to which they subscribe. Most basic cable channels are advertising supported, and although their usually small ratings might not allow a broadcast station to survive on the revenues thus produced, basic cable channels can survive and even profit because they have another source of income. The local cable operator must pay the cable channel a monthly fee for its service, usually 5 to 10 cents per subscriber per month (sometimes much more). This can mount up to a good supplemental income for the cable channel provider and allows the kind of small-segment *narrowcasting* that cable is known for. In addition, some channels, via their specialized programming, can bring in such a narrowly targeted audience that advertisers who wish to reach that market are willing to pay more for such ads than they would for those on broadcast—such as teen products for MTV or those aimed at male consumers on ESPN. Also, because many basic cable channels are owned by cable MSOs, it is profitable for these systems to fill up their service with channels they themselves own and profit from.

Superstations

One of the first basic services to emerge was the *superstation,* a local television station, usually an independent, distributed to a national cable audience via satellite transmission. The pioneering innovator here was Ted Turner, owner of a small independent station in Atlanta left to him by his father, who also happened to own the Atlanta Braves baseball team. Reasoning that through satellite-distributed cable he might find a national audience for the Braves, Turner leased a transponder on Satcom I and began offering WTBS's signal to any cable system bold enough to try it. He aimed to recoup his transmission costs by charging advertisers to reach his new national audience. The plan was successful, and by 1984 WTBS had over 30 million subscribers. Before long other independent stations had followed Turner's lead: WGN-Chicago went superstation in 1978, followed by WOR-New York in 1979 and WPIX-New York in 1984. Both also had

substantial sports interests: WGN's parent the Tribune Company owns the Chicago Cubs, WOR had a lock on the New York Mets games, and WPIX carries the Yankees.

Niche Channels

Turner did not stop there. By 1980 he had conceived of the cable service that would bring him greater fame or notoriety: Turner's Cable News Network (CNN), launched on June 1, 1980. Though it was at first derided as the Chicken Noodle Network for its struggling, low-budget operations, it quickly began to capture a national, even global, audience. It is one of the best examples of cable's type of innovation: expansion of a type of niche or specialized programming, in this case news, that already existed but not in such concentrated form. CNN soon eclipsed older forms of television news to become an innovative component of the television scene and a vital and unique source of information, first nationally, then globally. Though some might scoff at its commercialization and at what CNN chooses to leave uncovered, the fact remains that cable news channels offered original, creative, and necessary alternatives to the relatively scarce offerings long provided by the broadcast networks. Eventually Turner would add CNN Headline News, CNN International, and CNNFn for financial news. Additionally, Turner would use his purchase of the MGM film library to form Turner Network Television, or TNT, a general entertainment channel featuring films, sports, and children's programs.

Another example of innovation by niche expansion is the wildly successful Entertainment and Sports Network, or ESPN. ESPN began as a regional sports network in New England mostly airing sports that no one else was interested in: arena league football, roller derby, aerobics, and the like. The Getty Oil Company purchased the cable service in 1979, and in 1980 ABC, building on its strength in sports coverage, bought a part interest. By the mid-1980s ESPN would become an increasingly important player in national sports, winning rights to Major League Baseball games and bringing a new level of attention to sports that once had a hard time finding regular airspace on network TV, like golf, tennis, hockey, sailing, and soccer. Though regional cable channels like MSG and Sports Channel soon joined it on the cable dial, ESPN retained its head start on this profitable sector of television programming, eventually expanding to a second channel, ESPN2, in 1993 (See Connection in Chapter 11).

Two other examples of expansion programming deserve mention. The Arts and Entertainment Channel, or A&E, started out by promising the kind of high-quality cultural programming minimally provided by PBS, the scarcity of which was so frequently bemoaned by broadcast television's critics. A joint venture of the Hearst Corporation, ABC Home Video, and NBC, it resulted from the 1984 merger between ARTS and the Entertainment Channel, and promised to carry 200 hours each year of programming from the BBC. Focusing on theater, dance, documentary, and adaptations, A&E expanded into rebroadcasts of quality network fare and also into coproductions with British television. Some of its earliest successes came with its offering of the BBC series *Mystery* and other British miniseries. In 1979 came the inception of the kid-oriented Nickelodeon, which specialized in classic network television reruns as well as innovative children's shows. It was originally owned by the MSO Warner Amex, whose next idea opened up a new era in entertainment.

MTV, the Music Television channel, brought not merely an expansion of existing programming but something entirely different to the cable universe. Though music-centered shorts, sometimes called soundies, had existed to highlight musical acts since the 1950s, they rarely found airtime. MTV capitalized on the booming recording industry to add a unique component to both television and recording: the music video. Having targeted the under-14 crowd with Nickelodeon, Warner Amex turned to something unique for its next selected demographic: the 14-to-34 segment. Reasoning that musical taste is something that separates this age group from all others, MTV set out in 1981 to sell young viewers on adding visuals to their musical enjoyment and to sell advertisers on the specialized and desirable market their programming could attract. Controversy arose in the mid-eighties as the channel's primarily white-oriented focus led to the virtual exclusion of black artists and music—leaving a niche that Black Entertainment Television (BET) would exploit. MTV networks later expanded to serve an older group with VH1 in 1985. The Nashville network sprang up in 1983 to target the country-western crowd.

Some cable channels took this demographic segmentation in another direction, with programming developed specifically for minority or underrepresented groups. This category of cable innovation includes BET; the Spanish International Network (later called Univision); and Lifetime, a channel focused on women. Founded in 1980 by former National Cable Television Association Vice President Robert L. Johnson, BET addressed itself squarely to an African American audience, unhampered by ideas about what might be acceptable to mainstream white viewers. Johnson's idea was not to provide entirely different forms of programs but rather to emphasize "the full creative range of black entertainment, whether it's soap operas, game shows, sitcoms, dramas, or Grambling College football games. We'll provide an option that's not there" (Shales 1979b). Music video and syndicated offerings made up most of BET's schedule, leading to some criticism of its failure to provide original black-oriented programming. Eventually BET would diversify into news as well, providing the one spot on television where black reporters related black-centered news.

The Spanish International Network (SIN) had been in existence since 1976, beaming Spanish-language programming mostly produced in Mexico, Spain, and South America for the burgeoning Latino/a population of the United States. As cable expanded into urban areas and into the Southwest, SIN's audience grew. In 1982 the company announced the formation of a new pay cable channel, GalaVision, that would provide an entertainment diet of telenovelas, movies, and sports. Even into the 1990s, SIN (which later became Univision) and its spin-offs represented virtually the only source of non-American programming regularly available to U.S. viewers, even if most of those who took advantage of it were Spanish speaking (and, unfortunately, SIN rarely subtitled). Cable provided the necessary platform for this kind of material, in a media system that had not allowed opportunities for minority languages or cultures.

Lifetime was a little different from BET and SIN, in that its targeted audience was a majority, not a minority. With the slogan "television for women," Lifetime would seem to merely repeat the focus of the vast majority of commercial media, all pitching their programs and products at the great consuming female audience. But Lifetime proposed a somewhat different approach, and in doing so revealed some of the shortcomings of mainstream television, produced supposedly for women but by men and often with a dominantly masculine sensibility. Starting out as primarily an information

channel populated with talk and discussion about health, fitness, family, and home, the channel began to expand in 1985 when it added psychologist Dr. Ruth Westheimer in a call-in show titled *Good Sex.* From there Lifetime increasingly diversified into fictional programming of interest to women, as well as celebrity profiles, talk shows, and in a 1986 coup, extensive coverage of the British royal wedding. It was purchased by the Hearst/ABC/Viacom joint cable programming enterprise and soon expanded into sponsorship of women's sports, original movies, and miniseries.

Public Service, Public Access

As cable's offerings began to include more and more upscale, high-culture commercial services such as A&E and Bravo, along with others like the Discovery Channel and The Learning Channel, some began to worry that cable was undercutting PBS. In addition two types of programming unique to cable seemed to offer public television's fare. C-SPAN debuted in 1979 as a nonprofit joint venture of a consortium of cable companies to provide coverage of the U.S. House of Representatives and eventually expanded into public affairs programs of various kinds. A brainchild of Brian Lamb, former journalist and political press secretary, C-SPAN operated on a shoestring but in 1984 did begin to seek out corporate underwriting.

Regarded by many as the cable industry's attempt to brush up its image with legislators, it nonetheless provides the kind of intensive coverage of such political events as conventions, debates, hearings, and press conferences that the commercial networks and even PBS had long since abandoned. C-SPAN II was created in 1986 to cover the Senate and related events. It has provided access to government proceedings to a degree unprecedented in U.S. history and unknown in most other nations. Though the presence of the camera can sometimes distort—for instance, cameras in the House and Senate are not allowed to pull back for a long shot when a representative is speaking on the floor, so as not to show the empty seats around him or her—it also contributes a depth of politically oriented public service programs not previously available.

Finally, cable's unique local public, educational, and governmental (PEG) access channels must be considered. Though the 1984 act took away the federal requirement that such channels be provided in each local franchise, it did stipulate that cities and towns could institute such a requirement as a condition of granting the franchise. Most did, and by the mid-eighties some system of local public access had been instituted in many cities. Besides supporting such channels through a direct fee paid to the city, local cable operators typically provided studio space, equipment, and training for would-be local producers. Though public access became known in some places for its sexually explicit material, its basic function as a public soapbox by which any citizen could gain access to a wider public with a self-produced program added a rich layer of local culture to television offerings, enriching the democratic public sphere.

Video artists, local political activists, senior citizens, minority groups, community organizations, youth groups, high schools and colleges, and many others began to produce often rough-edged but original programming. City governments used cable to air council meetings, public hearings, announcements, and information. Schools developed educational programming for classroom use, as well as airing school board meetings, special events and presentations, and sports. A few production groups started out on local access

but began to distribute their material to cable systems nationally. *Paper Tiger TV,* beginning as a media-critique group in New York City, leased transponder space and went national with its collectively produced half-hour examinations of various aspects of U.S. media culture. *Austin City Limits* brought bands from that city's lively music scene to viewers across the country and later moved to public television. A few shows made it to the big time, like *Mystery Science Theater 3000,* which had started as a basement public access program in Minneapolis, eventually went national, and evolved into a commercial cable hit—as well as a movie! Though cable access is constantly under siege, by virtue of its precarious economics as well as its often controversial inclusiveness, and although the audience for public access may be miniscule, it represents an intervention into the politics of television access harking back to the radio amateur model.

Other areas in which cable has allowed expansion or innovation include religious programming (PTL, Christian Broadcasting Network, Eternal Word), home shopping (QVC and the Home Shopping Network), self-improvement (Home and Garden, the Food Network, the Therapy Channel, and the Health and Fitness Network), and highly specialized information or services (NASA TV, The Love Network, the Hobbycraft Network, the Recovery Network, and many others). Another type of pay cable—pay-per-view—allows cable systems to distribute special events for a separate payment to cable subscribers at home. By the end of the seventies era—meaning by 1985—only 50 percent of homes had these channels available to them, but clearly the lock on television service that the big-three networks had enjoyed for so many decades had begun to crumble. The next decade would only continue the trend. Deregulation, of cable at least, had begun to pay off in diversity, competition, and innovation, although many were far from happy with the new opportunities for commercialism, tastelessness, violence, sex, and simply more of the same that cable provided.

Public Television

Public radio and television went through growing pains during the seventies. Adapting to the satellite age with alacrity, both public radio and television began to distribute their programming via Westar in 1980. Having survived the budget cuts of the Nixon years, the Corporation for Public Broadcasting (CPB) found itself under attack again under the Reagan administration. Tight budgets meant an increasing emphasis on corporate underwriting. Even so, the still-struggling National Public Radio (NPR) service nearly went under in 1983 with a $6 million deficit, until CPB came through with a last-minute loan. Despite the growing popularity and credibility of its evening newsmagazine program *All Things Considered,* started in 1979, and its expansion into a morning news program, *Morning Edition,* in 1985, NPR seemed to lack a clear and consistent vision of its public and its role. A few competitors to NPR sprang up in the early eighties, led by Garrison Keillor's success with *A Prairie Home Companion,* a return to the sort of musical variety program previously found on network radio, with a quirky homespun twist. Produced by Minnesota Public Radio from the Twin Cities, the show's popularity led to the creation of a new national producer of noncommercial radio, the American Public Radio network, in 1981. It began to offer alternatives to NPR to public radio stations, such as the news program *MonitoRadio,* produced by the *Christian Science Monitor.*

Public television expanded its offerings, moving away from overtly instructional material to informational programming of more general interest. *The Robert MacNeil Report,* soon to become the *MacNeil/Lehrer News Hour,* debuted in 1976, joining series like *Washington Week in Review* and *Wall Street Week* that would prove successful and run on into the next century. *Frontline* provided independently produced documentaries. *Nova,* produced since 1974 by WGBH-Boston, featured high-quality science-oriented documentaries. Dramatic programs like *Masterpiece Theatre, American Playhouse, Mystery!* and special miniseries like *Jewel in the Crown* and *Brideshead Revisited,* mostly imported from England, attracted high ratings (for public television). A number of acclaimed multipart documentaries explored topics in depth. *Vietnam: A Television History,* produced by WGBH in cooperation with French and British television in 1983, attracted criticism from the right, as did *The Africans* in 1986. PBS became the home of *Tony Brown's Journal,* virtually the only black-oriented public affairs discussion program on the air during this period, after the host's brief flirtation with commercial television from 1976 to 1981.

Throughout this time of embattled finances and experimentation, public television met with mounting criticism from the right, the left, and from minority and women's groups. Right-wing groups complained of leftish bias in PBS programs, despite conservative offerings such as *The McLaughlin Group,* a syndicated show that many public stations picked up; *Firing Line,* hosted by William F. Buckley Jr.; and documentaries like *Crisis in Central America* and *The Chemical People,* an antidrug program hosted by Nancy Reagan. Left-wing critics countered by pointing out that PBS favored the established powers so frequently in its programs that it could hardly be accused of anything more than a mildly left middle-of-the-road position, especially as corporate underwriters stepped up their involvement in program production. More serious charges were raised in a 1975 report by the Task Force on Women in Public Broadcasting, which charged that "women are not stereotyped on public television, they are overlooked" (Ledbetter 1997, 109). Women were not just seriously underrepresented on CPB and PBS staffs, management teams, and executive boards, they were simply excluded from most PBS thinking and address. Like its commercial counterparts, PBS had bought into a definition of what constituted serious, informative programming that excluded anything feminine from that category. Minority groups found themselves in the same position—regarding employment and decision-making roles as well as program content.

For a service that had pledged itself to act as an alternative to the weaknesses of commercial broadcasting, to serve the underrepresented and provide a voice for the whole community, these were serious omissions. The situation at NPR was not much better. As an alternative to the commercial networks, PBS and NPR found themselves reproducing the same hierarchy of white males on top (and elite white masculine values) that their commercial counterparts did. And emphasis on local stations meant that in some states, like Alabama, public television's record of airing programs on race issues was nearly as bad as that of Mississippi's WLBT: They simply cut them out. The FCC went as far as refusing to renew Alabama Educational Television's six licenses after a challenge in the mid-1970s, on the grounds of its history of disservice. A negotiated compromise in the 1980s allowed the state to keep its stations. Yet, at least the structure of public broadcasting provided a forum to discuss such issues. However, with cable

television cutting deeper and deeper into the audiences and program forms that PBS had adopted as its own, the seventies were a decade of turmoil in public broadcasting.

The End of an Era

Even though more companies and services now competed for a share of the television pie, it seemed as though the pie just kept getting bigger—or at least people were paying bigger and bigger prices for their particular slice. The easing of caps on station ownership had sparked a boom in station sales, with group owners (the broadcast equivalent of MSOs) such as Capital Cities, Clear Channel Communications, Knight-Ridder, Hearst, Liberty, Metromedia, Taft, and Westinghouse expanding their holdings in radio, TV, and cable. In 1985, to mark the official end of the classic network system, all three networks changed ownership hands for the first time since their birth.

Like a gigantic fish swallowing a merely enormous one, mega-conglomerate and longtime electronics manufacturer and defense contractor General Electric bought the RCA company, and with it NBC. As NBC became part of a goliath of defense, technology, electronics, and home appliances, people expressed anxiety about the future integrity of its news division and separate existence as a purveyor of entertainment. Would NBC now become just the public relations arm of a company with tentacles in virtually every arena of human life? Could it be trusted to continue operating as fairly and disinterestedly as it ever had (and many questioned that it ever had), not only in news but in the provision of non-self-interested entertainment?

In what many perceived as a reverse of the NBC process, the big fish of ABC was swallowed by a smaller one: Capital Cities Communications, the owner of a group of highly profitable radio and TV stations, purchased ABC to add the network's lineup of owned and operated (O&O) stations to its own station arsenal. But the relatively tight finances of this deal meant that ABC was under renewed pressure to turn a profit, even in its news division. A great deal of consternation resulted, and many believe that this transaction marks the beginning of the end of the golden age of network news. A greater degree of entertainment value crept into news coverage, it is asserted, and the bottom line became more important than journalistic standards. Here we can glimpse an age-old dichotomy: the fear that a powerful individual company would distort a network's message, as with NBC, balanced against the fear that the pull of the popular, driven by a need to produce profits, would cause standards to degenerate as at ABC. In the worst-case scenario, both would occur.

CBS, with Paley and his heirs now retired, had long been vulnerable to takeover. When Ted Turner proposed to add CBS to his Atlanta-based empire, the network turned to a corporate white knight to repel the proposed takeover by purchasing the company itself. Lawrence Tisch, head of Loew's Corporation, stepped in gallantly by acquiring 25 percent of CBS's stock and nixing Turner's bid. Once again, the finances of merger dictated a great amount of belt tightening at the "Tiffany network," and when Tisch in 1986 demanded the resignation of CBS chairman and former newsman Thomas Wyman, an outcry resulted. Unlike his two competitors, Tisch stabilized CBS finances not by expanding into other fields such as cable, but by retrenching. CBS Records was sold to the Sony Corporation, and CBS remained primarily a broadcast television company as it always had.

Amid all the clamor, fears, and hype that such big changes produced, the notable decline in network viewership in the seventies (from the onslaught of cable and other competitors) marked the undeniable end of the classic three-network system. The camel's nose was inside the tent, and it was only a matter of time before the rest of the camel followed. But with the temporary exception of CBS, the former dominant networks fought back by expanding into their rival's businesses. The eighties, an age of synergy, would bring an even greater wave of mergers and acquisitions. The American public continued to watch more television than ever; in 1986 viewing time for the average household rose to a new high of 7:08 hours per day—40 minutes more than in 1975. Network television struggled to hang onto those viewers in every way it could: expanding both in the direction of upscale tastes and downscale titillation, courting the new woman of the seventies by merging aspects of formerly masculine and feminine genres, adding movies and miniseries to compete with cable, and finally recognizing minority audiences as cable attempted to draw them away.

EXPANDING PROGRAMS

The fall season of 1982 echoed with cries of the death of the sitcom. This venerable form, so prominent on television schedules since the 1950s, really hadn't declined much in the seventies; actually, there were more sitcoms on the three networks' prime-time schedules in 1983 than there had been in 1975. And this decade saw some of the all-time classics debut and rise to national prominence: *Happy Days* (ABC 1974) began the fifties revival; *Welcome Back, Kotter* (ABC 1975) gave John Travolta his start; *Laverne and Shirley* (ABC 1976) spun off from *Happy Days*; and *One Day at a Time* (CBS 1976) was the first sitcom to star a divorced working woman with children. In the summer of 1976 *What's Happening!!* (ABC), an adaptation of the film *Cooley High*, brought the humorous adventures of three black high school students to ABC. *Three's Company* (ABC) debuted in fall 1977, introducing a new kind of implied homosexuality to the TV scene (Jack pretended to be gay to justify living with two women, but he wasn't *really*, so it was okay).

In that same season Susan Harris created the most outrageous comedy to date on prime-time network TV, introducing all manner of transgressive themes on *Soap* (ABC). *Soap* spun off *Benson* (ABC) in 1979, starring Robert Guillaume as a state governor's butler. *Mork & Mindy* (ABC), another *Happy Days* spin-off in the fall of 1978, marked Robin Williams's national comic debut as a native of the planet Ork who had been exiled on earth. *Diff'rent Strokes* (NBC/ABC) found a unique way of introducing race to TV by telling the story of two black children adopted by a Park Avenue millionaire. Most of these shows debuted on ABC, helping that network rise to the top of the ratings race in the mid-seventies until being eclipsed by CBS in 1979.

All of these sitcoms and many more, most short-lived, remained on prime-time schedules in 1982. And in that season itself, several durable and endearing sitcoms debuted: *Cheers* (NBC 1982–1993), beginning the 11-year run of this workplace family comedy set in a Boston bar; *Family Ties* (NBC 1982–1989), about a post-sixties family with

budding star Michael J. Fox centrally figured; and *Newhart* (CBS 1982–1990), which brought back comedian Bob Newhart in a show that rapidly moved up in the ratings. Other notable sitcoms would follow as well, like *Kate and Allie* (CBS 1984–1989), two divorced women raising their kids together; and *The Cosby Show* (NBC 1984–1992), TV's first professional, African American *Father Knows Best* family, headed by Bill Cosby.

So, it wasn't so much that sitcoms were dead—they were alive and well and still occupied much of the top-20 Nielsen ranking—but that their continuing presence had been put in the shade by the roaring rise of the hour-length adventure-drama show. It was in the hour-length form that the most talked-about genre innovations of the seventies occurred. Three other, non-sitcom developments that created a critical and popular impact far in excess of their actual time on the schedule were the miniseries *Roots* (ABC 1977), the return of the prime-time soap in *Dallas* (CBS 1978–1991), and a unique late-night show that appeared without much warning in 1975: *Saturday Night Live.* The sitcom was not dead, but it was dwarfed by the stature of these novel forms in the seventies and early eighties.

The New Dramas

We can identify several trends in the dramas that flourished on prime time in the seventies. *Roots,* running across one week of prime-time nights in January 1977, brought a serialized family drama to the evening hours that introduced viewers to a neglected and excluded part of American history. CBS followed up this triumph with a bang in the return of the prime-time soap, starting with *Dallas* (CBS 1978–1991) and moving on to *Knots Landing* and *Falcon Crest,* and created an international sensation by permanently subverting television's "no soaps in prime time" rule. It was a short step to Steven Bochco's *Hill Street Blues* (NBC 1981–1987), which combined some conventions of the soap-melodrama with the crime-adventure show. Its innovative aesthetic style helped to change the face of the cop show forever. *St. Elsewhere* (NBC 1982–1988) worked a similar transformation on the venerable medical drama form, transforming it to a setting for ensemble melodrama and a quirky visual style. *Cagney & Lacey* (CBS 1982–1988) placed the voice and face of authority on a couple of appealing young women, taking the strong women of daytime to the quintessential nighttime situation. Going beyond such predecessors as *Charlie's Angels* (ABC 1976–1981), it marked out a new era in representations of women in prime-time television. These innovations responded in complex ways to both industry and social changes of the times, but there is one name that keeps recurring throughout this history: Fred Silverman.

Connection The Many Qualities of Fred Silverman

The American television public first met Fred Silverman in the 1960s, though they probably didn't realize it at the time. When he was appointed head of daytime programming at CBS in 1963, Silverman's first move was to replace the motley lineup of game shows and sitcom

reruns that had characterized the CBS daytime schedule and set in place a solid phalanx of half-hour soaps, now starting at the earlier hour of 11:30 a.m. and running until 4 p.m. Two new soaps were introduced: *Where the Heart Is* (1969–1973) and the Irna Phillips creation *Love Is a Many Splendored Thing* (1969–1973). Phillips intended to focus on an interracial romance between an Asian American woman and a white man, the first time this had been attempted in a soap; but the network—perhaps in opposition to Silverman's wishes, perhaps not—objected and the plot line was dropped. Phillips quit. Silverman also revitalized CBS's Saturday morning children's hours with new first-run cartoon series and the *Children's Film Festival.* CBS's share of the audience rose to 40 in the daytime, and Silverman was promoted to vice president in charge of programming overall in June 1970. This emphasis on youth and an awareness of the ratings-building power of the female audience carried over into Silverman's prime-time programming initiatives. In the spring of 1971 he began the process of dumping all 13 of CBS's rural comedies—and with them an emphasis on the older audience—and brought on 28 new shows between 1971 and fall 1972, the majority oriented toward a youth audience. Most famously, *All in the Family* premiered in spring 1971, though the other new entry that season was *The New Andy Griffith Show.*

However, with *The Sonny and Cher Comedy Hour* that summer and some unusual comedy–musical variety programs the following summer—*The David Steinberg Show* and the *Melba Moore-Clifton Davis Show,* featuring the popular African American singer—a pattern began to emerge. In fall 1972 Silverman hit his stride, debuting *The New Bill Cosby Show, Maude, The Waltons, Bridget Loves Bernie, The Bob Newhart Show,* and *M*A*S*H.* There were others as well, not long-lived or particularly innovative. Before moving to ABC to make his mark, Silverman decided to entrust CBS's prime time to producer Norman Lear. By the 1973–1974 season, CBS had 9 of the top-10-rated prime-time shows, and 14 of the top 20.

Having established his reputation as "the man with the golden gut," Silverman accepted the post of president of the ABC programming division in 1975. Even though he now had to compete with his own prize-winning prime-time schedule on CBS, Silverman was able to take ABC to the top of the ratings race for the few seasons that he was there. He was hired away by NBC in 1978, and though his effects on NBC ratings would not rival his earlier accomplishments, he did succeed in introducing one of the most influential and innovative programs of recent decades, *Hill Street Blues.* After leaving NBC in 1981, Silverman became an independent producer. Despite a few successes, his earlier blazing triumph dimmed and faded from view. Yet he remains the only person in history to have had responsibility for programming at all three major networks, and his influence extended even beyond his direct decision-making positions.

At ABC, Silverman exhibited what some would view as a kind of schizophrenia even as his golden gut produced one hit show after another. His record seemed to alternate between trashy crowd pleasers and high-quality critical successes. Well attuned to the female audience by virtue of his long-term daytime experience at CBS, Silverman first turned his attention to the newly recognized audience of working women. Because over 50 percent of American women were now working outside the home and hence not available during the daytime for the programs and advertising formerly directed at them, it became more important than ever to attract the female audience at night—but without losing television's perceived "only" chance to address men. The character-oriented crime shows Silverman had introduced at CBS had done a good job of this demographic balancing act, drawing large numbers of female viewers while still proving popular with males. ABC's hits when Silverman took over

© Bettmann/CORBIS

Quintessential Silverman/Spelling series *Charlie's Angels* captured the contradictions of 1970s feminism and led to the first wave of female action heroines.

included *The Six Million Dollar Man* and its spin-off *The Bionic Woman,* both fairly lightweight action-adventure dramas featuring cyborgian superheroes.

These two shows ranked number 7 and 5, respectively, in the Nielsen ratings for the 1975 to 1976 season, and from this experience Silverman learned that female action heroes could be quite acceptable to audiences of both sexes, particularly if a certain amount of "jiggle" and sex appeal could be worked in. *Charlie's Angels* debuted in fall 1976 and *Wonder Woman* in December of that year; the Angels became the most talked-about TV characters of the season, and the show rose to fifth place in the overall ratings.

No one was handing Silverman any critical awards for shows such as these. *Charlie's Angels,* produced by Aaron Spelling, was roundly disdained by high-culture critics and feminists alike for its often bra-less and titillating heroines, seemingly incapable of acting except under the direction of a paternal male figure. "This is supposed to be a time of women's projects on TV, but somehow all these women are good-looking, well-endowed and running toward the camera," said one. Another proposed sarcastically, "I have an idea for a series. It's just three girls—one black, one redhead, one blond—who each week go from network to network doing anything, waitressing, babysitting, whatever they want. It doesn't matter. It's just a microcosm of America in 38D cups" (Farley and Knoedelseder 1978). Yet *Charlie's Angels* remained wildly popular among both men and women, including many budding feminists.

Susan Douglas explains this phenomenon by noting that the show "exploited, perfectly, the tensions between antifeminism and feminism" (S. Douglas 1994, 213) as its gorgeous,

sexy, self-reliant, and capable heroines rescued themselves and others from danger, and often made fools out of men. They fired guns, effectively, and frequently told piggish, dismissive men where to go. Yet they remained sexually objectified and under the control of a father figure, and the show never tried to be realistic but remained in the realm of fantasy along with its bionic and superhero siblings. Silverman's penchant for fantasy, in such contrast to his relevant comedies at CBS, also produced *Love Boat* in September 1977 and *Fantasy Island* in 1978, both popular shows of the type that would never win critical acclaim. As one critic put it, "If intelligence and taste ruled the airwaves, ABC's *The Love Boat* should have sunk quietly from view" (Waters 1978, 65).

But critical acclaim was thrust upon Silverman with the stunning debut of *Roots* in January 1977. Although the project had been developed primarily by a host of seasoned producers, based on the best-selling novel by Alex Haley, Silverman is given credit in the industry for scheduling it in a way that increased its impact and made it a national sensation. His motivation might have been to protect ABC prime-time ratings if it bombed; no one had much confidence in the ability of a miniseries featuring an almost entirely African American cast in a story of survival over white historical atrocities to attract a large mainstream (read white) audience. However, Silverman's decision to run it over eight consecutive nights made the show a landmark in TV history. In 12 hours scheduled over eight nights, *Roots* ended up ranking among the highest-rated programs of all time. Its final segment had a 51.5 percent rating and a 71 percent share—unrepeatable in this era of cable segmentation. Tracing the story of the African American experience—from Africa to slave plantation to post–Civil War freedom—the show starred an amazing array of black talent including Louis Gossett Jr., Leslie Uggams, Ben Vereen, Cicely Tyson, LeVar Burton, Lillian Randolph, and Richard Roundtree, as well as a host of white stars such as Chuck Connors, Ed Asner, Lorne Greene, George Hamilton, and Lloyd Bridges.

For a medium that had so long excluded the African American experience from its repertory, and after two decades of social struggle, *Roots* helped both black and white Americans to make sense out of their nation's racially inscribed past and provided a story of progress that all could attach their hopes to. It glossed over many less-reassuring historical facts—slave resistance and rebellion, everyday political and economic racism, events that couldn't be encapsulated in its basic family story line. But by placing the African American experience into the fundamental immigrant narrative so familiar to Americans, it disarmed resistant readings and allowed white audiences a not totally villainous role. Silverman had developed a background with such epics at CBS, which had won awards for miniseries like *Catholics* and *The Autobiography of Miss Jane Pittman.* This latter show had trod much of the same ground as *Roots,* but without the promotional hype that Alex Haley's best-seller lent the latter. But the widespread success of *Roots* helped to shape, as Herman Gray argues, a whole new era of African American representation on television while opening up a space for discussion and construction of black identity with the cultural mainstream (Gray 1995). The series' producers, David Wolper and Stan Margulies, won an Emmy that year, as did Lou Gossett Jr., Ed Asner, Olivia Cole, and director David Greene.

Silverman followed up this success by introducing, over the next two seasons, a trio of situation comedies that would win no awards but would quickly shoot to the top of the ratings: *Soap, Three's Company,* and *Mork & Mindy.* Critics greeted these additions to television's prime-time lineup with disdain and disapproval. Silverman had been a particular

ABC's miniseries *Roots* captured the nation's imagination with its dramatization of America's deeply divided racial history, based on the novel by Alex Haley. It marked a shift in the way that race would be portrayed on television.

proponent of *Three's Company,* picking it up for ABC when it had been turned down by another network (unspecified), and one critic claimed "ABC is the network that has led the way to most new lows" (Shales 1978). The same critic went on to complain, "If bad television did not drive out good television, then ABC would not be the No. 1-rated network today and the other two networks wouldn't be playing games of how-low-can-ye-stoop to compete" (Shales 1979a).

Soap found itself in the middle of a controversy before it even debuted. Several groups—like the Christian Life Commission of the Southern Baptist Convention, the National Council of Churches, and the National Council of Catholic Bishops—urged their members to protest, based on a short introductory article that had appeared in *Newsweek.* *Soap* focused on the serialized problems of a satirically dysfunctional family, and *Washington Post* critic Tom Shales described its premiere as follows:

> Series creator and writer Susan Harris has taken the mythical, wholesome sitcom family that ruled TV for 25 years and turned them inside out. Kindly old gramps becomes a demented cranky bigot. Faithful black servant is turned into vengeful chronic complainer. Papa Chester Tate is an adulterer and crook. Young Jodie Campbell is a simpering homosexual whose stepfather retches at the sight of him. And so on." (Shales 1977)

Many viewers found the show a hilarious satire not just of American family life but of American TV, and it shot up to number 11 on the Nielsen list. Its popularity indicated to others that television as well as American viewers themselves had reached a new low. Shales railed against all the "dopes and dumbheads" keeping quality fare off the networks, and another critic bemoaned the dominance of "the slowest common denominator" (Waters 1978, 65).

By the 1978 to 1979 season, complaints about the tide of sex and violence, often combined, in the comic book prime time of network television had reached a new high. In such diatribes Silverman's name often came up; he was the man who had led the way into the current morass. And at the networks, even though ratings and viewership remained high, the threat posed by a developing cable industry began to undermine some of the easy equations used to assess programming prospects. A fear that cable's presumably affluent audience was abandoning network television in favor of cable's more upscale offerings, combined with the rising tide of criticism, began to trouble network decision makers. Silverman, having made the jump to NBC in 1978, perceived that a new note might need to be sounded if he were to continue his success and retain his golden reputation. Publicly, the new network chief promised to put more stress on quality programming this time.

Yet leading NBC to prominence over the two networks he himself had headed before proved a task too difficult even for Fred Silverman. CBS resumed its former first-place status almost immediately upon his departure from ABC. NBC was never able to recapture it during Silverman's tenure. However, in what may be a fitting parting gesture, Silverman was directly responsible for the show that brought NBC the most critical accolades in the years to come. By many accounts, *Hill Street Blues* as it eventually evolved was Silverman's idea from the beginning. Todd Gitlin reports that "Silverman put forward the notion of a cop show set in a neighborhood with a 'heavy ethnic mix' " to Michael Zinberg, a development executive at NBC. Zinberg thought of Steven Bochco, a producer at

award-winning MTM Enterprises then writing a cop series, *Paris,* which starred James Earl Jones on CBS. Bochco had previously written and produced *Delvecchio* on CBS during the 1976 to 1977 season. There he met Michael Kozoll, a short-story writer from Wisconsin, who had served as story editor for several series before *Delvecchio*'s brief career. Initially imagining the program as "a cross between *Barney Miller* and *Police Story*" or, alternately, "a little bit of *M*A*S*H* and a little bit of *Barney Miller,*" Silverman wanted "a show that has more to do with cops' personal lives" (Gitlin 1985, 279).

Bochco and Kozoll secured an agreement from NBC that they would be allowed to develop the new program out of their own vision, without heavy network interference. The fact that they were affiliated with the respected MTM helped; this was the company headed by Grant Tinker, Mary Tyler Moore's husband, and it had produced such highly regarded shows as *Mary Tyler Moore, Newhart, Taxi, Rhoda, Lou Grant,* and many others. Silverman approved of this unusual arrangement and allowed Bochco and Kozoll to craft a cop series that departed from the common mold of the genre in several ways. First, it had the ongoing narrative structure pioneered in the soaps and recently carried onto prime time successfully in *Dallas* and in *Soap.* Not all plotlines would wrap up neatly at the end of each episode. Second, it was an ensemble drama, without one strong figure at the center but instead with a variety of central characters—another soap-like trait. Third, it featured women and people of color as part of the main cast, and it promised to deal with issues of race and gender as it went along, as part of the narrative and character development. A fourth unique feature was the program's mixture of gritty realism and comedy, a rarely tried combination that would lead to the brief "dramedy" trend of the late eighties. And finally, the program's visual style was something new: dark, cluttered, dirty, a look of controlled chaos marked the show's mise-en-scène, with lots of camera movement and rapid cutting. "Make it look messy" became the visual mantra. And the narrative would be messy, too, with overlapping plots, intermixed dialogue, no easy resolutions.

Hill Street Blues brought to TV a unique blend of the formerly scorned feminized conventions of soap opera, innovatively combined with the hypermasculine properties of the cop show, along with a dose of social realism that was serious without taking itself too seriously. By its second season, it had become the favorite show of millions of viewers. And not the "dopes and dumbheads," either. *HSB* drew critical acclaim as well as popular accolades. Captain Frank Furillo, public defender Joyce Davenport, Sergeant Phil Esterhaus, Detective Mick Belker, Lieutenant Ray Calletano, Officers Andy Renko and Bobby Hill, Detective Neal Washington, and the entire large cast became familiar household figures. Critics loved it; Tom Shales, who had so skewered Silverman's previous hits, called *HSB* "brilliant, funny, shocking, acerbic, bighearted and uncommonly rewarding . . . far, far and away the best new series of the season" (Shales 1981).

Despite its unfavorable initial timeslot of Saturday at 10 p.m., the show's audience slowly built. And after an impressive performance at the Emmys, where it won the awards for outstanding drama series, outstanding lead actor for Daniel J. Travanti, outstanding supporting actor for Michael Conrad, and outstanding writing in a drama series, it was moved to the prime slot of Thursday nights at 10. Bochco and Kozoll should receive most of the credit for the way *HSB* turned out. Silverman might also be praised for giving them the opportunity and for keeping the show on despite low ratings during its first season (though, in fact, a writers' strike had decimated program production, and NBC had little else to

replace it with). In any case the show was developed under his watch, and Silverman would go on as a producer to create popular cop series like *Matlock* and *In the Heat of the Night.* But his failure to bring up ratings overall moved NBC to replace him with MTM head Grant Tinker after just 3 years in the top position. Tinker would spend only 5 years at NBC, but under his direction it would regain its first place in the network ratings race. And *HSB*'s success would spur MTM to make another award-winning NBC series, the medical ensemble drama *St. Elsewhere,* in a style that owed much to *HSB*'s narrative and visual precedent. *St. Elsewhere* was created by the production team of Joshua Brand and John Falsey, who would go on to make many later hits.

Schlockmeister or genius? Both? Clearly, Silverman must be credited with bringing a new level of female-oriented programming to prime time, with more women in leading roles, the continuing serial narratives of the soaps, spunky action-adventure heroines, and cops and prosecutors who led the way to a more realistic depiction of women in a man's world. His attention to expanding representations of African Americans and other minorities on prime time also do Silverman credit, even though the record is mixed. Yet, the undeniable emphasis on sexualized feminine representations and fantasy may have brought in viewers but certainly alienated critics of both sexes. Were the long-standing critical barriers between the serious and the trivial breaking down? If we could have soap operas and action heroines in prime time, with outstandingly high ratings, did that necessarily mean that prime-time audiences were dopes and dumbheads—as daytime audiences had been called for years?

Dallas Days

Dallas (CBS 1978–1991), produced by Lorimar Productions, was not the first successful prime-time soap; *Peyton Place* holds that honor. And two failed attempts, *Executive Suite* (CBS 1976) and *Big Hawaii* (NBC 1977), preceded it briefly in prime time. But *Dallas* far exceeded the earlier shows in its extreme popularity and in the precedent that it set, not only for its direct spin-off *Knots Landing* (1979–1993) and imitators like *Dynasty* (ABC 1981–1989) and *Falcon Crest* (CBS 1981–1990), but for the wholesale importation of serial plotlines and soapish melodrama into prime time. And it was the first American television show to become an unqualified international hit. The entire world—or at least large chunks of it—held its breath to find out who shot J. R. at the end of the show's second season. If programs like *Charlie's Angels* and *Hill Street Blues* effectively feminized the cop-detective show, *Dallas* masculinized the world of the soaps. Suddenly it became okay for men to sit entranced as a serial story line unfolded, to organize weekend nights around the mandatory *Dallas* viewing (it shifted from Sunday to Saturday, back to Sunday, then permanently to Friday over the course of its career).

What made *Dallas* such a sensation? For one thing, the show's setting in the virile, rough-hewn world of Texas ranchers gave it a Western, red-blooded American feel—no effete New England village for this program. And its cast of obscenely wealthy new-money families elevated the action to a more flamboyant, sensational level even as its family emphasis gave us lesser folks something to relate to. Its characters were bigger

than life—the evil more evil, the good more good, the sins more scandalous, the schemers more devilish, and the sex much better and more prolific. Everyone looked fantastic. The Ewings and the Barnes families fought and loved as ferociously as any soap opera cast, and most of the action took place at the Ewing ranch, Southfork. One reviewer called them "Sun Belt Borgias" (Waters 1980, 66). In J. R. Ewing (played by Larry Hagman), the nation (and other nations as well) had a villain as big as all Texas, and by the time he was shot in the 1980 season-ending cliffhanger, there were enough likely candidates to keep speculation humming. The episode of November 21, 1980, that resolved this conundrum garnered an amazing 80 share—and that was just in the United States.

Originally, the show had been intended to wrap up every week like a traditional hour-long drama. But low ratings for the first season sparked a change to the continuing serial format. "Resolve the situation without solving the problem" became the show's primary technique (Waters 1980, 66). Viewers in more than 50 countries were soon hooked, sparking an American western craze. In Great Britain, nearly half the country tuned in for the famous cliffhanger. Many studies appeared, the most famous of which—*Watching Dallas*, by Ien Ang—looked at the way that people from all over the world made sense of the show by relating its exotic location and characters to their everyday lives. In Europe, where commercial television was making a long-delayed debut, the show inspired a term still used to stand for the noxious effects of American culture on European TV: "Dallasification."

At home, not surprisingly, the success of *Dallas* sparked a string of imitators. NBC introduced *Flamingo Road* and *The Secrets of Midland Heights* in 1980; ABC weighed in with *Dynasty* and CBS with *Falcon Crest. Knots Landing* would take the story of the middle Ewing brother, Gary, who had never had much of a role on the earlier soap, and move it to a small town in California. Also created by David Jacobs, *Knots Landing* moved away from the excesses of *Dallas* back toward the conventions of the daytime soap opera. It proved nearly as popular as its forebear and ran on CBS for 11 years. The open-ended, ensemble, melodramatic, and serial narrative form pioneered by these shows and by their *Hill Street Blues* counterpart would soon come to characterize most of the hour-length shows on television.

Another pioneering program took some of the feminized aspects of the seventies and eighties hour-long drama and became a touchstone for redefining women's roles both on television and in real life. This time explicitly originating in and grappling with the contradictions of late-twentieth-century feminism, *Cagney & Lacey* drew on some of the precedents of the late seventies, early eighties TV era, such as the new emphasis on the hour-long drama, the feminization of the cop show, the acknowledgment of the working-women audience, and the fragmentation of the television marketplace. But it differed significantly from more mainstream programs like *Police Woman* and *Charlie's Angels* as well as from innovative newcomers like *Hill Street Blues*. As historian Julie D'Acci reveals, the show was conceived as the first "female buddy" program within a lengthy tradition of male buddy representations that had previously excluded women (D'Acci 1994). It provoked much debate both inside the industry and among real-world audiences and negotiated the difficult terrain of women in public authority in a way that would lead to significant changes in the representation of women on television.

Connection Female Trouble: *Cagney & Lacey*

Cagney & Lacey began its tumultuous life in 1974 as an idea for a film developed by a politically conscious group of Hollywood writers and producers. The screenwriting team of Barbara Avedon and Barbara Corday, influenced by their reading of film critic Molly Haskell's ground-breaking survey, *From Reverence to Rape: The Treatment of Women in the Movies* (1974), began talking with Hollywood producer Barry Rosenzweig. All were involved with the feminist movement, and together they came up with a proposal for a movie that would feature the feminine equivalent of the dynamics of *M*A*S*H* or *Butch Cassidy and the Sundance Kid*—something never before tried in Hollywood film or television.

Rosenzweig approached Ed Feldman of the Filmways Corporation (now Orion), who was interested enough to provide seed money to hire Avedon and Corday to begin writing. The two longtime collaborators prepared by spending time with real-life policewomen in New York City, and the experience led them to think of the characters not as the glamorous young goddesses of most Hollywood portrayals but as mature women with less-than-perfect looks who eschewed most of the conventions of movie star femininity. In 1980 Rosenzweig, Corday, and Avedon began pitching their idea as a pilot for a weekly series. CBS liked the idea, but preferred to bring it to the screen as a less-risky made-for-TV movie. The movie was shot from 1980 to 1981 and prepared for an October 8, 1981, debut. Much was made in the pre-broadcast publicity of the movie's feminist roots. The movie did exceptionally well in the ratings, with a 42 share that was much higher than what CBS usually garnered on Thursday nights.

D'Acci links the next phase of the show's career, its transformation into a weekly series, to the fact that during this period the networks were "ardently courting and constructing a prime-time audience of working women" (1994, 64). These women were defined as primarily white, professional women whose incomes made them into highly desirable consumers. This upscale market segment was also seen as most likely to have been influenced by feminist ideas and attracted to representations that reproduced this orientation. With traditional daytime fare losing some of its female audience and cable picking them up, the networks scrambled to keep and hold their upscale model of female viewers. In 1976 the Nielsen index added the category of "working women" to its demographic groupings. These factors, which had also led to the innovation of the prime-time soap, spurred interest in female-centered dramas as well. In early 1974 CBS put the series *Cagney & Lacey* into production, with Meg Foster in the role of Cagney and Tyne Daley as Lacey.

As D'Acci argues, critics clearly recognized that visually this show differed from the general run of female representations on television, and they devoted much time to discussing the women's bodies, hair, dress, and mannerisms, in a way that it is hard to imagine a similar male cop show would have been discussed. CBS was disappointed in the show's ratings and wanted to cancel it after two episodes; but Filmways, the production company, itself financed a publicity campaign that succeeded in bringing the ratings up to a 34 share for the fourth episode. But the network was still not pleased and demanded a change: replace

Meg Foster as Cagney. The combination of Foster and Daly, they claimed, was "too tough." "They [are] too harshly women's lib. These women on Cagney and Lacey [seem] more intent on fighting the system than doing police work. We perceived them as dykes" (D'Acci 1994, 30). The program had to be softened. This criticism may have focused on Foster because of her earlier portrayal of a lesbian character in the movie *A Different Story.* Her role as Lacey, too, did not surround her with the reassuring trappings of marriage and children as did Tyne Daly's role. And simply showing a close partnership between two women was unusual enough in television's limited repertoire to spark suspicions of a lesbian relationship.

When Daly and Foster appeared on *Entertainment Tonight,* the first question they were asked was, What's all this stuff about a lesbian connection on the show? And a survey done by CBS purported to find Foster's character "too masculine." D'Acci shows that many viewers strongly disagreed with this view, but the network ignored their support of the two women's portrayals. Foster was fired in April and replaced with Sharon Gless for the fall 1982 season. The character of Cagney was softened as well: She was given an upper-middle-class mother and an ex-policeman father, a more feminine wardrobe and hairstyle, and a more avid interest in men. Explicitly feminist content was toned down, with less emphasis on women's issues and discrimination in the workplace.

Viewers and critics, despite objections to the change, soon began to appreciate the revamped series. D'Acci quotes letters from viewers offering such praise as "It's good to see smart, functioning, strong women"; "it's a pleasure to see women in such active roles"; "it's one of the few programs that neither glamorizes nor degrades women"; and "at last women are being portrayed as three-dimensional human beings" (D'Acci 1994, 44). But ratings still remained unimpressive, and again in the spring of 1983 CBS decided to cancel. An outpouring of support flowed into network and production company offices, and the National Organization for Women (NOW) organized a formal letter-writing campaign to save the program. But what may have turned the tide was the embarrassing fact that after the cancellation was announced, *Cagney & Lacey* received four Emmy nominations, with Tyne Daly winning in the best dramatic actress category. CBS reconsidered and renewed for a limited seven-episode run.

The show's slowly rising ratings prompted CBS to renew for the 1984 to 1985 season. Now the producers felt secure enough that some feminist-oriented issues could once again be introduced. Over the next few seasons *C&L* dealt with wife beating, abortion, breast cancer, sexual harassment, date rape, and alcoholism. Though this emphasis on controversial, sexy issues might be said to exploit such topics for their publicity value, the way they were handled prompted an Emmy for best dramatic program for two seasons. Tyne Daly won best actress three more times, and Sharon Gless twice. Many other awards showered down, including the Humanitas Award in 1986 and the National Committee on Working Women's best program award in 1985.

Despite the acclaim, the show's ratings never climbed above the average, with a high of 15.9 in 1984 to 1985 that would make the show a blockbuster now but fell below top numbers of the time. By 1988, *Cagney & Lacey*'s skew toward an older audience, along with CBS's lineup overall, led to a rethinking of target demographics, especially in light of competition from the new Fox network for younger viewers. It was canceled in May 1988. As D'Acci points out, although it has yet to inspire another female-buddy cop show, it left an enduring mark both on network television and on the debate about women and femininity in our culture. Its emphasis on mature, successful, competent women inspired

Right-to-life protesters picket outside CBS studios about a pro-choice plotline on Cagney & Lacey. This show resonated in the feminist politics of the mid-1980s.

representations in *LA Law, Murphy Brown, Designing Women, Moonlighting,* and many more prime-time shows, up to *Ally McBeal.* The cop show has remained an at least partially feminized format, in shows like *NYPD Blue, Homicide,* and *Law & Order.*

However, its identification of feminism with white, professional women also obscured the still-underrepresented portrayal of women of color and tended to make it easier to overlook the complicated social currents around race and gender. In a representational system that still featured black women as maids (Nell Carter in *Gimme a Break*) or a former maid now turned traditional homemaker (Esther Rolle in *Good Times*), black feminism was an overlooked matter. Pointing the way toward the representational changes that would occur in the late eighties and nineties was Debbie Allen's dance teacher Lydia Grant in *Fame* and, toward the end of the 1975 to 1985 period, Phylicia Rashad's coolly competent portrayal of a professional woman with a family in the Cosby era.

Daytime

On daytime things were changing, too, though a bit more slowly. Despite the feared drop-off in ratings caused by the existence of the working-woman audience, in fact daytime ratings remained high and daytime quite profitable. In 1980 Nielsen showed a slight increase in the audience for daytime soap operas, though many believed that this

was a result of attracting more young viewers with youth-oriented plots and hyped sexuality. For the networks, daytime soaps could produce greater profits than any other program outside of prime time. On NBC, for instance, in 1979 to 1980, *Another World* (which had gone to a 90-minute format in the summer of 1979) took in $230,000 per episode in ad revenues and cost only $71,000 to produce. This meant a profit of $159,000 per episode for NBC, compared to a $131,000 profit per broadcast of the *Tonight* show. Most soaps lengthened their format to an hour during this period, with the few that didn't—*Ryan's Hope, Search for Tomorrow, Capitol,* and *The Edge of Night*—soon being phased out. The *Dallas* craze sparked a western stampede, with *Another World* spinning off a new soap called *Texas,* set in Houston, and ABC's *One Life to Live* introduced a big-spending Texas couple, Bo and Asa Buchanan. Luke married Laura on *General Hospital* in 1981, one of the classic soap moments in one of the most popular story lines of all time.

In the first signs of the next big wave to hit daytime, longtime talk show host Phil Donahue took his Dayton, Ohio, show to Chicago in 1977 and went national via syndication. His winning recipe of low-key, woman-friendly discussion that encouraged active participation of the studio audience won *Donahue* enough recognition that in 1985 he moved production to New York City, at the crest of the breaking wave of talk that was about to deluge the television schedule. By 1982, the influx of low-cost talk shows on cable channels provoked network attention. And the outbreak of national syndicated call-in talk shows on radio, and their skyrocketing popularity, prompted networks to rethink the viability of the form. CBS signed on Mike Douglas, whose long-running syndicated show featured a celebrity-interview format, to compete with *Donahue.* In 1985 the daytime talk show would officially arrive, with the transfer of Sally Jesse Raphael to television and the debut of Oprah Winfrey, leading a host of others.

Meanwhile, morning news and talk show *Today* celebrated its thirtieth anniversary. Barbara Walters had made her mark as the first female anchor of this morning staple in 1964, but her departure in 1976 ushered in the Jane Pauley/Tom Brokaw era with Willard Scott as weatherman. Bryant Gumbel joined the crew in 1982 as a replacement for Brokaw, marking another racial first for network television. The fierce competition between the big-three morning shows—*Today, Good Morning America,* and *The CBS Morning News* as a distant third—began in 1975 and has never let up.

Nighttime News

In an atmosphere of corporate consolidation and renewed attention to the bottom line, the debate over news versus entertainment standards filled newspaper columns and critical commentary, but news as usual seemed to thrive anyway. Former sports head Roone Arledge took over news operations at ABC in 1977 with the mandate to finally catch up to the other big networks in the ratings race. He hired Peter Jennings as anchor and succeeded in pulling ABC to the top for several seasons in the eighties. ABC also premiered its highly regarded *Nightline* with Ted Koppel in 1980 to provide in-depth coverage and discussion of news events. Walter Cronkite retired from CBS in 1981 and was replaced by Dan Rather, who was advised to soften his dark suits and overly intense image with the more casual look of sweaters on the set. It seemed to work. Tom Brokaw left *Today* in 1982 to assume David Brinkley's former chair on NBC.

The basic structure of the network news show remained the same, despite competition from the varied forms on CNN. Magazine shows thrived, and CBS's veteran *60 Minutes* was joined by ABC's *20/20* in 1978 and a rival CBS program, *West 57th*, in 1985. In the meantime, syndicated soft-news programs like *Entertainment Tonight* and *Lifestyles of the Rich and Famous* utilized the new technology of satellite distribution to circulate their glossy Hollywood-oriented stories to stations around the country. They also troubled the tradition of serious journalism with their entertainment-focused, trashy, tabloid feel and their ratings, which often exceeded the nightly news. By the end of the eighties the attack of the tabloid TV shows would be on in full force.

Sports

As still-growing rivals like ESPN crept into the television sports universe, the big-three networks continued to rely on the massive and reliably male audiences that only big-league sports could bring. The Super Bowl consolidated its position as the single most-watched television event of the year, along with its reputation as the premiere spot to debut big-budget advertising campaigns. College football gained in strength and popularity, with its various bowls covered more and more on national networks. Baseball continued to be prominent in the summer and fall. Basketball finally gained an audience that would soon equal or exceed those for the other league sports, prompted by the rise in popularity of National Collegiate Athletic Association (NCAA) college basketball. All the major leagues, and most college teams, came to lucrative terms with the nets.

With ESPN making profits out of sports that the networks had long neglected, such sporting events began to feature more heavily in the network picture. The Olympic games in 1976, 1980, and 1984—especially the '84 summer games held in Los Angeles—gained greater popularity as well. The 1984 opening celebration marked a new high in entertainment value, as Hollywood producer David Wolper (of *Roots* fame) pulled out all the stops to create a gigantic Busby Berkeley–style revue. NBC paid a record-breaking amount for exclusive broadcast of the 1984 Olympics, in a never-successful attempt to monopolize network sports coverage.

Late Night

The post-prime-time hours had long been dominated by the triumphant *Tonight* show, hosted since 1962 by showman Johnny Carson, at its ritual time of 11:30 p.m. to 1 a.m. Starting with a stand-up monologue, satirizing current events and items in the news, and proceeding to the desk and the couch, Carson brought in a timely lineup of stars, performers, and glitterati and engaged them in usually witty conversation. Heir to the variety format of radio stars like Jack Benny and Fred Allen, Carson incorporated banter with the bandleader Doc Severinsen and announcer Ed McMahon and took on a variety of identities in humorous skits. Originally produced in New York, in 1972 the show moved to Burbank, California, and was usually taped a bit earlier on the same evening that it aired.

A variety of guest hosts also performed, to spare Carson the grueling schedule. One of these, the permanent guest host from 1983 to 1986, was Joan Rivers, the first

woman to host a national late-night talk show. She left for her own short-lived late-night program on Fox. Jay Leno, another frequent stand-in, would eventually inherit the mantle of host. In 1973 NBC ventured into late-late night with the *Tomorrow* show, hosted by Tom Snyder. In 1982 this show transmogrified into *Late Night with David Letterman*, bringing the laconic Hoosier comic and former weatherman into long-reigning prominence. With this kind of lineup for late night on NBC, the other networks barely bothered to compete.

In 1975, NBC elected to fill up the blank Saturday night late slot with a bold new venture: a live comedy-variety show harking back to the late forties and early fifties. *Saturday Night Live* was pitched squarely to the generation that NBC believed would be staying up late enough to watch this show—young, politically hip, now-yuppie baby boomers—and they were right. The guest host varied from week to week, but the ensemble of comedy performers returned and created a new age of TV comedy. *SNL* was like nothing else on television at the time, and several members of its original "Not Ready for Prime Time Players" went on to great renown: Chevy Chase, Dan Aykroyd, John Belushi, Jane Curtin, Garrett Morris, Laraine Newman, and Gilda Radner. Bill Murray joined in 1976.

Produced by Lorne Michaels, the show combined zany comic skits with musical performances by most of the top artists of the day—a winning combination that has lasted for over 25 years and helped to spark "a renaissance in American humor and satire" (Shales 1979c). Some of the memorable characters and sketches created in the show's first few years include "Weekend Update," with Dan Aykroyd and Jane Curtin ("Jane, you ignorant slut ... "); "The Coneheads," featuring Laraine Newman and Dan Aykroyd ("We are from ... France"); John Belushi's Samurai; Gilda Radner's Roseanne Rosannadanna; and parodies of commercials, television shows, and films. Sometimes NBC itself was skewered, as in John Belushi's portrayal of Fred Silverman as "a kind of vacillating monarch of the mediocre" and a secret "double agent" for ABC, sent to drive the rival networks' ratings down (Shales 1979c). Writers included most of the comics themselves, as well as Al Franken, Anne Beatts, Herb Sargent, Tom Schiller, Rosie Shuster, and Alan Zweibel.

Critics and viewers loved the show, calling it "one of the few TV programs in history both to dance on the cutting edge of hipness while at the same time hooting at the concept of a cutting edge of hipness" (Shales 1979c). However, simply being a live comedy show on network television brought with it considerable restrictions. Because the show went out live, anything might happen, but NBC kept careful tabs on its comic antics. Forced to avoid the ever-present pitfalls of comedy—the too public, as in politics, and the too private, as in sex—the *SNL* crew (many of whom had come from the wilder, woollier sphere of the stand-up scene) frequently felt frustrated and restricted. The "Weekly News" and a few fairly mild satires of political figures—some of the best involved Chevy Chase as Gerald Ford and Dan Aykroyd as Jimmy Carter during the initial era—marked the limit of political humor on *SNL*. And female comics, in particular, were reined in by the network's fears of transgressive sexual humor; we hadn't come that far since the days of Fanny Brice. Yet *SNL* survived to nurture succeeding generations of comic talent, and soon its reruns would provide other venues like cable's Comedy Central with endless recycled material.

SOCIAL DISCOURSE

During this period of deregulation, technological innovation, and changing industry structures, as well as social disillusionment and regrouping, television was certainly talked about a lot but with little consensus or centralization. In 1982 the National Institute of Mental Health (NIMH) released its two-volume report, *Television and Behavior: Ten Years of Scientific Progress and Implications for the Eighties.* Following up and summarizing the studies that had taken place in the wake of the surgeon general's report 10 years previously, it basically reproduced the contradictions that had dogged social science research on television all along. Although some direct effects seemed to derive from violent television representations on susceptible populations, like children, the issue was complex and resisted easy diagnosis or solution.

Another research strand, called agenda-setting theory, arose to examine and try to explain television's increasingly central role in guiding public attention and consciousness. Its basic formula, "television does not tell us what to think but what to think *about*," seemed like common sense in the media-saturated universe of the seventies and eighties. But with all the media channels competing for the public's attention by the mid-eighties, it appeared that we might be thinking about an awful lot of things. Soon nostalgia for the good old, nation-unifying days of few choices and centralized media would set in. Diversity meant fragmentation; was that good or bad?

The academic study of television took off during this period, with departments of mass communications, film, and media studies beginning to address themselves seriously to the study of television and its social and cultural impact. Many scholars still decried the nefarious commercialization and trivialization of the televisual media, in particular, but there was a general recognition that television and its populist discourse were here to stay and should be studied by the academic establishment. Meanwhile, the increased availability of ways to review television programs (the VCR and growing circulation of reruns on cable and broadcast channels) meant that scholars and critics now could capture and assess the vast heritage of television programming that had previously disappeared into the atmosphere. The idea that we could use television as a way of understanding the American past began to emerge; historian Derek Kompare calls television "the effectual Rosetta Stone of post–World War II America" (2004, 144).

The first retrospective works of television history and biography began to emerge in the sixties, with Erik Barnouw's three-volume study appearing from 1968 to 1979. The 1950s became regarded as the golden age of television, as biographies and memoirs of people and shows were published in the sixties and seventies. Television's voracious talk shows began to feature golden-age performers like Lucille Ball, Sid Caesar, Milton Berle, Imogene Coca, Jackie Gleason, Rod Steiger, and many more, who, as Kompare writes, "literally *performed* the Golden Age through anecdotes and lamentations for a bygone era" (2004, 149). The networks themselves participated in this historical narrative. NBC aired a 4-hour retrospective called *NBC: The First Fifty Years* in November 1976, and CBS followed suit in April 1978, as did ABC for its much shorter history the same year. The Museum of Modern Art had put on a groundbreaking historical retrospective of television as early as 1963, and in 1965 the Academy of Television Arts and Sciences began to establish television libraries at New York

University, American University, and UCLA to archive television's past. The Library of Congress began to archive television and radio in 1976, and the Museum of Broadcasting was founded in the same year. In 1979 Tim Brooks and Earle Marsh published their now-standard reference volume, *The Complete Directory to Prime Time Network TV Shows*, and have updated and revised it every few years since. Alex McNeil's *Total Television* first appeared in 1980 and serves a similar function, including daytime and late-night shows in its compendium of TV's history.

On the academic side, the Aspen Institute program on communications and society, directed by Richard Adler and Douglass Cater, began to incorporate television studies into the former "mass comm" and social science approaches with a series of seminars and conferences in the mid-1970s. The two volumes that derived from these events—*Television as a Social Force* in 1975 and *Television as a Cultural Force* in 1976—set television studies on their current course. The publication in 1974 of Horace Newcomb's *Television: The Most Popular Art* sparked a new generation of courses and majors in television in universities across the nation, linking TV to the traditional study of other art forms like literature, theater, and film while exploring its unique characteristics. A television canon began to emerge, marking TV's worthwhile objects of study—such as fifties live drama, news, and the relevant comedies of the late 1960s—and thus implicitly creating an academically authorized hierarchy of TV program values.

Then, in the late seventies, the influence of the British Cultural Studies school of thought reached American shores with the publication of John Fiske and John Hartley's *Reading Television* in 1978. This broadened television's cultural role beyond the traditional arts and into other areas of social significance, with a renewed attention to the way that television functioned for its viewers in the context of everyday life. E. Anne Kaplan's 1983 anthology *Regarding Television*, published by the American Film Institute, marked a key moment of legitimization for the new field. As Kompare writes, "Television Studies was thus situated as a significant component of academic cultural criticism distinct from prevailing aesthetic, mass culture and mass communication methods, and premised instead on an historical and theoretical sensibility" (2004, 167).

As television's importance in American and global society gained recognition in academic study, others recognized its political and moral significance and organized to resist or reform it. Jerry Falwell's Moral Majority movement began to take on television in its critique of contemporary social and ethical values—even as he and other fundamentalist Christians increasingly turned to television themselves to spread their messages. Many in this group felt that television was inherently evil and that it should be tightly controlled or even eliminated, because it warred with parental and traditional religious authority for the minds of America's youth. In the strange-bedfellows mode so endemic to this decade, Falwell was joined not just by conservative spokespeople like Phyllis Schlafly and Donald Wildmon but by liberal and mainstream groups like Ralph Nader and the National Parent-Teachers Association. As many observed, conservatives objected to sex, liberals to violence; and all pointed to TV as the main perpetrator. Forming the Coalition for Better Television (CBTV) in February 1981, these organizations came together to mount attacks and organize boycotts against sponsors of programs that propagated "dirt" via "suggested sexual intercourse,"

promoted "immorality" as in abortion and homosexuality, or highlighted "un-Christian behavior" (Rosenfeld 1981). Senator Jesse Helms even proposed that right-thinking people across the nation might unite and buy out CBS, thus muzzling Dan Rather and other pernicious radical influences on American popular opinion.

Producer Norman Lear was instrumental in organizing a countergroup, People for the American Way (PAW), whose members defended television but also argued for shaping it in a more responsible, ethical direction. In 1984 the group announced a $1 million campaign to counter CBTV's efforts, stating that "our campaign is designed to educate and remind our fellow Americans how fragile our constitutional freedoms are. They are under attack by a powerful group that wants to impose its own religious beliefs on all of us ("Campaign Notes" 1984). But even PAW supporter Grant Tinker had to admit, "One reason we're so vulnerable is that we're so criticizable," referring to the poor quality of much TV (Swerdlow 1981). Though the conservative and liberal groups' platforms had as much to do with wider political beliefs as they did with television, television had become a greater touchstone and nexus of social and political debate than ever, even as it became more difficult to pinpoint the responsible parties. The shouting match would become a general uproar in the late eighties and nineties, and would be increasingly joined by voices from other nations.

Conclusion

The decade of the seventies, in an atmosphere of economic and social malaise, produced the first significant cracks in the classic network system. Through a combination of deregulation, the rise of cable and satellite technology, and proliferating channels and program forms, an era of competition, diversity, and choice eventually replaced scarcity, public interest obligations (however ignored), and centralized control. Cable television created numerous forms, from superstations to niche channels to pay cable formats, and widened television's address to include formerly marginalized groups like African Americans, Spanish-speaking Americans, kids, women, and those with specialized interests. Network television struggled to adapt and experimented with novel programs such as *Cagney & Lacey*, with its female-buddy cop team; *Hill Street Blues*, a complex narrative with gritty visuals; *Roots*, a serialization of the African American experience; *Dallas*, moving the daytime serial into nighttime prominence; and *Saturday Night Live*, an innovative live comedy. Public television sought to redefine itself in relation to the new offerings on cable as well as in response to criticism of its project of providing an alternative to the commercial services. All three of the traditional networks changed ownership during this decade, foreshadowing the megamergers of the 1980s. Other significant media forms, such as the call-in radio talk show and the national newspaper, debuted and competed with television for public attention. But television continued its role as a touchstone for American social and political debates, even as it began to be studied in the hallowed halls of academia.

THE BIG CHANGE, 1985 TO 1995

In the early to mid-eighties we entered the "neo-network" period, as historian Michael Curtin has dubbed it (Curtin 1995). An ever-expanding universe of networks, channels, programs, niches, and audience segments competes urgently for our fragmented attention, with the Internet adding its unique and compelling presence by the mid-nineties. From the limited, controversial but controlled classic network system of the pre-eighties period, not only Americans but citizens around the globe found themselves in the midst of the multichannel environment of post-eighties abundance. Television seemed to offer something for everyone, to give every component of U.S. society its 15 minutes in the sun, to encompass all aspects of life within its glittering gaze; it seemed that nothing existed that had not been affected by television's voracious embrace: Media is all.

This postmodern sensibility and its threat of formless, groundless mediated relativity became in the late 1980s part of television's address, and of the industry and regulatory policies that produced it. As the radio, film, television, cable, satellite, magazine, newspaper, book publishing, advertising, and Internet industries merged, consolidated, globalized, and became virtually inseparable both in their corporate ownership and in their audiences and modes of expression, laws and regulations struggled to keep up—not only in the United States but around the globe. A new dystopian discourse of fragmentation, dissolution, and decay debuted side by side with utopian predictions of access, democracy, choice, and freedom. People driving cars with "Kill Your Television" bumper stickers on the back happily sat for hours in front of their computer screens, downloading music and video from the web. Students demonstrated against the corporate control of media by smashing television sets on the library mall, while communications became one of the largest majors nationwide, and campus life slowed down during network broadcasts of *Seinfeld* and *The Simpsons*—not to mention *Beverly Hills 90210*. And drastic changes took place around the world, as satellite and digital technologies gave rise to a new era of globalized media.

SOCIAL CONTEXT: EXTREMES AND CONTRADICTIONS

These deeply contradictory trends and attitudes were not confined to media, of course, no matter how much media might have seemed to set the agenda or monopolize the attention. The 1980s and early 1990s were themselves marked by extremes, oppositions and

contradictions, in the United States and worldwide. By 1985, the economic stagflation of the 1970s began to lift and the stock market began its long ascent, producing a steadily climbing affluence that, despite a short, sharp downturn in 1989, brought many citizens of first-world nations a higher personal income than ever before. Yet the gap between the richest and the poorest widened to the most yawning disparity yet experienced. While the wealthiest 1 percent of Americans saw their incomes soar, and corporate executives took home paychecks equal to 10,000 times what their entry-level workers were earning, a greater proportion of children lived in poverty than ever before, and pockets of starvation and disease deepened across the globe. The national debt soared to historically unprecedented heights during the administration of President George Bush, inheriting the fallout of Reaganomic tax cuts and heavy defense spending.

The AIDS epidemic first hit in the early eighties and as its depredations increased and the disease spread to various vulnerable populations, it seemed as though the sexual freedoms of the seventies had met their ultimate answer. However, sexual and personal behaviors seemed to have fundamentally changed as formerly hidden or forbidden practices like premarital sex, couples living together without the formality of a marriage ceremony, children born to or adopted by single or unmarried parents, divorces, recombinant families, openly gay lifestyles, and attention to sexual shenanigans in high places came out in the open. A deluge of cheap crack cocaine flooded into America's cities in the mid- to late eighties, producing an epidemic of drug addiction, gang-related drug activity, law enforcement crackdown, and an increasingly hysterical war on drugs that emphasized strict enforcement and punishment over treatment and diagnosis. Minorities were particularly affected, and the number of Americans serving drug-related jail terms reached disturbing new heights—especially because their numbers were overwhelmingly African American, urban, and poor. Prisons overflowed, and the corrections industry became a major employment and industrial sector.

Sizable pockets of antigovernment, right-wing isolationist groups were involved in standoffs with government agencies, as in the Branch Davidian massacre in Waco, Texas, in 1993, while the occasional lone terrorist, such as the Unabomber of the early nineties, attracted huge media attention. It all seemed to culminate in 1995, when homegrown right-wing militants bombed a federal office building in Oklahoma City; 168 people, including 19 children in a daycare center, were killed.

Yet, internationally, the United States was riding on a wave of triumph and success. The Berlin Wall came tumbling down in 1989 to claims of the end of history as we had known it, or at least as it had been defined by the old Cold War opposition to the "evil empire" of Soviet power. As the former Soviet satellite countries proclaimed independence and conversion to capitalism, often in the same breath, pundits proclaimed a new world order of American preeminence. President Bush's whirlwind 1991 Persian Gulf War seemed to cement the notion. The new media environment, teamed with the negative media lessons of Vietnam, brought a shining message of success home in a blitz of good news that would not be questioned until later. This war could be viewed live on CNN, but its coverage was tightly controlled, and victory was proclaimed before significant protest could be mustered.

When President Bill Clinton, swept into office in 1992 by a mobilization of liberal-progressive rhetoric not heard in high places for a long while, seemed poised to bring about an Israeli-Palestinian agreement in 1993—even as the cruel divisions of South

African apartheid simultaneously appeared to be nearing an end—it seemed as though the United States might be able to actualize its long-term self-image as the global white knight, riding to the rescue of oppressed nations everywhere. The fact that other brutal repressions went unremarked and unaddressed—in Rwanda, in Afghanistan, in Serbia, in East Timor, in places of less economic or public relations interest—barely made the press.

Amidst all these contradictions, a handful of court cases and hearings jumbled race, class, and gender tensions together in an inflammatory mix. In 1991, law professor Anita Hill brought the long-denied problem of sexual harassment in the workplace to national attention during the confirmation hearings of Supreme Court Justice Clarence Thomas. Though his was the immediate victory, hers would outlast the narrow issue of confirmation in its social and legal impact. The trial and acquittal in 1992 of the officers accused of brutally beating Los Angeles resident Rodney King, while he allegedly resisted arrest, outraged broad sectors of the public and led to a bloody uprising in South Central LA, all covered nonstop on numerous cable channels and discussed endlessly on radio talk shows and in the pages of the national and local press. The 1994 trial of former football star O. J. Simpson for the murder of his wife Nicole and her friend transfixed the nation. Its charges of spousal abuse, revelations of police racism and corruption, high-profile courtroom theatrics, and round-the-clock media coverage seemed to act out some of the nation's deepest obsessions and repressions and polarized the public along racial lines.

All this was happening even as the United States grew into a more diverse nation than ever. Immigration had increased slowly in the sixties and seventies, but in the eighties it became a steady flow as people from many different parts of the world fled political and economic repression. More immigrants from Latin America and Asia joined the ranks of fledgling Americans than ever before, and the face of the nation began to change. In 1980, the number of foreign-born Americans totaled around 14 million; by 1990 that number had risen to almost 20 million, nearly 10 percent of the total population. Mexico and the Philippines provided the largest groups of new citizens, with Cuba, Korea, Vietnam, China, El Salvador, India, the Dominican Republic, and Jamaica rivaling old-line European originations in numbers. By the mid-nineties, so-called white Americans totaled less than 80 percent of the entire population, while African Americans grew to nearly 13 percent and the Hispanic population increased faster than any other. From 11 percent in 1995, it was estimated that Latinos/as would make up 25 percent of U.S. residents by 2050, with Asian-derived citizenship predicted to increase from slightly less than 4 percent to more than 10 percent. Control of immigration became a political hot button in the eighties and nineties, with conservatives demanding tighter restrictions and stepped-up border patrols and liberals seeking to define political asylum more broadly to include economic deprivation and human rights violations.

The politics of race and ethnicity had already sparked a renewed attention to multiculturalism, as ethnic groups rejected the old melting-pot ethos in favor of preserving ethnic culture and heritage. The teens and twenties seemed to be repeating themselves, as the updated version of America Firsters condemned such "anti-American" ideals. Television quickly became a place where battles could be played out, as cultural groups lobbied for greater inclusion of ethnic and racial minorities, and others linked diversity and cultural difference to "moral rot." The election of 1994, as Republicans

became the majority in both House and Senate, seemed to encapsulate many aspects of the 1990s culture of oppositions. Despite promised sweeping reforms in health care, welfare, race relations, international peace efforts, and economic justice, the ultimate products seemed to be mostly heat, little light, and a partisan divisiveness that swept away the liberal programs of past decades while proclaimed protections and reforms failed to materialize in the smoke of infighting. The economy rose ever upward, encouraging an expansion of the marketplace philosophy that downplayed the role of government in favor of privatized competition—whether in health care, education, prisons, community services, or media.

During this period, the first wave of what would come to be called "globalization" made itself apparent. This happened on many fronts, a part of the worldwide corporate merger phenomenon, accompanied by ever-growing population shifts not just to the United States but from nation to nation everywhere. Transnational institutions and organizations—the World Bank, the World Trade Organization, the European Union, and numerous nongovernmental organizations (NGOs)—began rising to prominence. The media seemed to play a central role in all this. As we have seen, American media had been making waves around the globe since the 1920s, accelerating in the seventies and early eighties. By 1990 some form of private ownership and commercial competition had entered into most national systems. Cable television, satellite distribution, and later the Internet only exacerbated the trend. Most countries across the globe had developed some combination of public service and private systems in the preceding decades; a few countries—like Canada, Mexico, and Australia—had adopted this solution long before. As the Soviet Union broke up and China liberalized, state systems began to allow the entry of commercial enterprises, usually in partnership with local companies. In other nations, notably those of Asia, commercial profit-making operations remained under tight government control and often ownership.

The strong public service tradition, though perhaps over-restrictive in the years when it was the only game in town, now provided in many countries a vital complement to privatized media, rethinking its limited definition of the public and appropriate programming. As the pressure from the American entertainment colossus gained in strength, many countries responded by adapting creative hybrid forms. Taking what they could use from U.S. media output and rejecting what they didn't want, national broadcasting systems diversified and localized. Program forms originated in the United States were adapted and reworked to suit local cultures and needs. Competitive commercial markets brought greater access to populist forms that had been frowned upon by elitist public service guardians, such as soap operas, melodrama in all its forms, quiz shows, popular music, situation comedies, and talk shows; but with a heavy dose of American programming and influence, for reasons that we will discuss. Was this *cultural imperialism*—the takeover of other nations' cultures by the rampaging beast of Americanism? Or did it mark the advent of *cultural hybridity*—the newly gained ability to develop a national cultural arena marked by diversity, localism, and empowerment of formerly suppressed voices? These questions would be introduced in the 1980s and early 1990s and would rise to dominance in the following decade.

On the U.S. media front, the groundwork for the sweeping Telecommunications Act of 1996 was laid with generous contributions from media conglomerates to both parties, but particularly to the Republicans. Clinton himself seemed as closely tied to

Hollywood and its media connections as had Reagan, but this time on the liberal side. He did succeed in appointing more women and minorities to federal posts than any preceding president had, despite considerable conservative opposition and delay, including the FCC's first Asian American commissioner, Rachelle Chong (1994) and the first African American FCC chair, William Kennard (1997). And lurking in the wings was the new gee-whiz technology of the Internet, inheriting the mantle of utopian promises and predictions even as its earlier nonprofit uses began to be overtaken by corporate ownership and visions of vast economic potential.

THE DEREGULATED DECADE

The principle of Fowler's toaster continued to rule the U.S. airwaves (and influence others), long after Fowler himself had faded from the scene. During the late eighties and early nineties, a rewriting of the Communications Act began to seem inevitable, and numerous bills and initiatives were introduced that would not come together until June 1996. However, all the groundwork would be laid from 1985 to 1995, including the revocation of the Fairness Doctrine, the repeal of the Financial Interest and Syndication rule (fin/syn) and Prime-Time Access Rule (PTAR), and the push for lifting of the weakened remaining limitations on ownership not only in broadcasting but in telecommunications and cable. The loudest debates involved the Fairness Doctrine. As early as 1980, Federal Communications Commission (FCC) Chairman Mark Fowler had let it be known that his FCC would not be enforcing the Fairness Doctrine and would seek to have it repealed, as the most obvious and egregious example of the way in which broadcasters' First Amendment rights were violated by existing broadcast regulation. In October 1985, the FCC released a report stating that principle: "the fairness doctrine, on its face, violates the First Amendment and contravenes the public interest." (FCC 1985, 1). The report pointed out, much as Fowler's earlier article had, that increased expansion of the media universe made such government rules irrelevant. Second, it contended that in fact the Fairness Doctrine had had a "chilling effect" on discussion of controversial topics. Most broadcasters, it claimed, had responded to the requirement to include various points of view by simply avoiding controversy altogether.

Finally, it argued that the doctrine allowed an opening for government officials to attempt to meddle in station content, as both the Kennedy and Nixon administrations had in the past. Though a Democrat-controlled Congress attempted to introduce legislation that would instead have codified the doctrine to clarify its requirements, each bill they proposed was vetoed by the Republican president. In 1987, the Fairness Doctrine was officially repealed. The decision prompted objections from both liberals and conservatives—the former objecting to the lack of balance in favor of conservative ideas and the stifling of discussion that they feared the ruling would bring, the latter objecting to the notion that the liberal media might now be able to proceed unchecked. However, many liberals supported the repeal as a free speech measure, and some conservatives saw it as an application of marketplace ideas to broadcasting.

The most compelling argument against it, used by liberal and conservative foes alike, was that the expanding media universe had made such an old-fashioned dinosaur of a law simply irrelevant. With all the current channels of opinion competing to

discuss every manner of issue, they claimed, balanced, inclusive coverage would just naturally occur. Some would come to regret that dubious claim during the sex scandals of the late nineties.

Another legislative change that had much broader effects passed in relative silence. Only the industries concerned bothered themselves much about the expiration of the fin/syn and PTAR rules, and they preferred it if their battles remained behind the scenes. Fowler's FCC had put forward a tentative decision in 1983 that the fin/syn and PTAR rules should be repealed; at any rate some key provisions were scheduled to expire in November 1990, twenty years after their initial creation. The 1990 Bush FCC sought first to encourage the networks and studios to come up with an agreement themselves, but discussions soon polarized. Networks claimed that the rules putting caps on the number of shows they themselves could produce (15 hours per week), barring ownership of syndication rights, and otherwise restricting their free-market relationship with producers were holding them back in global competition and allowing studios to dominate the business. The fact that three of the seven major Hollywood studios were now owned by foreign corporations helped the networks to drive home their point that they were the home team, hampered by a spoiled bunch of foreign fat cats. They also argued that, given the current diversified field, the rules were simply no longer necessary. The studios contended that it was the fin/syn rules that had produced the newly evened-out network playing field and that the current state of diversity and competition would not exist without their protections.

In 1991 the FCC reached a contentious decision to loosen some aspects of the rules—raising the financial interest bar to 40 percent of a network's schedule, allowing ownership of syndication rights for foreign distribution but not domestic—but kept others in place. The networks appealed, and in 1993 the FCC, prompted by a U.S. Court of Appeals decision, eliminated most rules entirely, scheduling domestic syndication rights for repeal in 2 years; most importantly for one of the bill's major backers, the appeal gave Rupert Murdoch and the Fox network a permanent exemption from the remaining rules even as it began to build up its schedule beyond 15 hours per week. However, in the fight over the rules' imposition in the seventies, the networks had signed consent decrees that still needed to be rescinded by the courts before the repeal could take effect. This happened in November 1993, and in 1995 the fin/syn rules officially bit the dust. By this time, studios and networks had entered into new forms of cooperation that would change the playing field entirely. No one was surprised when the Prime-Time Access Rules met a similar fate in 1995, with little controversy. Now both broadcast networks and studios—which had largely become one and the same—could produce and distribute programming, on their own networks and others, and retain control of the lucrative syndication market. They could air their own shows in pre-prime time, too, and expand it to its original 4 hours if they wished.

Pressure now began to build for further deregulation of ownership limitations, particularly those that applied to cross-ownership. Media conglomerates merged precisely because they wanted the synergies that could occur when one company owned its own cable, broadcast, print, and even telephone properties; the old rules somewhat arbitrarily keeping those industries separate seemed increasingly annoying. The Telecommunications Act of 1996 would respond to these desires, lubricated by intense lobbying and campaign contributions.

But in a limited backlash, the early nineties also saw the institution of more stringent regulations in a few areas. The Children's Television Act of 1990 put in place a requirement that broadcast stations provide some educational programming for children as part of their public service obligations, though the amount was left open and stations were able to declare programs like *The Jetsons* and *Leave It to Beaver* educational. In 1996 President Clinton persuaded broadcasters to set the amount at a whopping 3 hours per week. It also limited advertising during children's programs to 12 minutes per hour on weekdays and 10.5 minutes per hour on weekends, for both broadcast and cable. The 1992 Cable Television Consumer Protection and Competition Act sought to impose new controls over the price cable operators could charge for basic service, given cable's de facto noncompetitive local monopoly over its franchise, and to impose the same kind of multiple systems operator (MSO) ownership restrictions that applied to the broadcast market. The act would soon be repealed.

If regulation once drove the industry, deregulation meant that now the industry drove the regulators. Not only the FCC but also the Federal Trade Commission (FTC), charged with enforcing antitrust laws, had adopted the unofficial policy that bigger was better, or at least that competition in the marketplace should be interfered with as little as possible. As a result, the progressive notion of centralized control, with all its elitist drawbacks, had been pretty well abandoned for a new philosophy of "let 'er rip." And if the result seemed to be concentrating the ownership of media outlets in fewer and fewer—and bigger and bigger—hands, from the perspective of those on the ground it seemed to provide a diversity, inclusiveness, and chaotic democracy of expression that all the gray do-gooders of previous decades had been unable to accomplish. But was this just the initial honeymoon period, with a heavy price to be paid later? Or could concentration of ownership actually encourage the kind of truly diversified, inclusive, and creative competition that its proponents promised? The booming economy of the mid-to-late nineties kept the answers up in the air.

MEDIA MATTERS: THE AGE OF SYNERGY

Synergy: the buzzword of the eighties and nineties. Though it enjoyed a brief vogue in the sixties, the word began to appear in articles about the media in the mid-eighties, sparked by the actions of media mogul Rupert Murdoch as he began the acquisition campaign that would eventually lead to formation of the Fox network. Until 1989 or so, writers employing the word found it necessary to provide a brief definition. *Synergy* literally describes the working together of two or more components so that they produce an effect greater than either could alone. In the media industry, people began using the word when referring to the new attempts at both vertical and horizontal integration brought about by mergers and acquisitions, expanding global conglomerates, and the efficiencies of scale that could be produced when cross-media holdings and combinations of production and distribution were used to cross-promote, create greater profits, and keep those profits in-house. As one writer summarized, "The theory is simple: assemble a communications conglomerate that can create and distribute editorial matter and video programming—as well as sell advertising against it—across all media on every continent" (Rothenberg 1989). By the early nineties synergy had become no longer a theory but a fact of life. And the movie industry led the way.

However, as we observed in Chapter 10, it became difficult by the late eighties to talk about the film industry as separate from television and other media enterprises because this is the period of consolidation. From 1985 to 1995, a second period of merger and acquisition swept former studios, networks, cable companies, publishers, and distributors together into today's double-barreled conglomerates. Starting out the new rush to merge was Australian media magnate Rupert Murdoch, with his purchase of the Metromedia group of TV stations in 1985. Coming on top of his acquisition of the Fox studios that same year, this move clearly announced his intention to get into the television network business—as he would in 1986. By 1989 the rest of the media world was paying attention. *Variety* reported that over 414 media deals of various types took place in that year.

The largest by far was the merger of Time Inc. with Warner Communications to form Time Warner Inc., the largest communications company in the world at that point. Time Inc., which had started out as a magazine publisher, by the late eighties owned not only the largest cable MSO in the country (American Television and Communications, or ATC) and part of another (Paragon) but several book publishing companies (Time-Life Books, Little Brown, Scott Foresman, and the Book-of-the-Month Club), part of the Turner Broadcasting company, as well as still publishing one of the most successful strings of magazines in the world. Its titles include *Time, Sports Illustrated, People, Fortune, Money,* and *Life,* along with a host of others. On the cable front, Time Warner owned HBO, Cinemax, and numerous others. Warner Communications owned not only Warner Studios, one of the top film and television production companies in the nation, but also Warner Cable (a major MSO), television stations, Warner Records, and several book and magazine publishing firms.

The merger allowed consolidations in cable holdings and a rich source of programs for those cable systems. As one writer summed up the possibilities:

> It will now be possible for an interesting story in *Sports Illustrated* to be made into a book published by Little Brown, which would be featured as a selection by the Literary Guild and the Book-of-the-Month Club, reviewed in *Time Magazine,* then turned into a movie by Warner Bros. The movie stars could be interviewed in *People* and pictured in *Life,* and the film spoofed in *Mad* and reviewed again in *Time.* The soundtrack could be released on the Atlantic record label. The movie could then be distributed to the video-rental market by Warner Bros., then shown by HBO and Cinemax via cable systems owned by Time Warner." (Gnoffo 1989)

The merger also seemed clearly pointed at making a run at the inception of yet another broadcast network, producing the Warner Bros. (WB) network in 1995. That same year, Time Warner purchased the portions of the Turner Broadcasting System (TBS) that it didn't already own. The new Time Warner Turner company again eclipsed all other media companies in size and reach and added CNN, TNT, and the rest of Turner's holdings to its media empire. The synergies thus produced were expected to catapult Time Warner Turner to prominence not only domestically but in the global market, where it would compete with other international conglomerates like the Sony Corporation.

In the second most talked about merger of 1989, Japanese technology giant Sony (inventor of the Betamax videocassette recorder) purchased Columbia Pictures Corporation in a hopeful synergy of hardware and software. Because this deal occurred

just 1 year after Sony's acquisition of the Columbia Records division of CBS, a joke began to circulate that Sony seemed interested in anything with the word *Columbia* in it—could the District of Columbia be far behind? This little witticism reflected a certain fear behind the ongoing rush to supersize U.S. media: that foreign conglomerates would swallow us if we didn't get there first. When another Japanese company, Matsushita (rival inventor of the VHS format videocassette technology), purchased the MCA Corporation in 1990, fear intensified. American companies then determined to become the swallowers, rather than those who were swallowed, as two more major Hollywood-based mergers were announced: The Viacom Corporation purchased Paramount Pictures in 1994, followed by the Disney Studios/ABC/Cap Cities merger in 1995. Viacom—a cable, television, and syndication distribution giant (formed when CBS was forced to divest its syndication arm in 1972)—saw in Paramount vast synergies of film and television production, with distribution to global audiences. It also clearly envisioned a foray into the television network sweepstakes, from which resulted the United Paramount Network (UPN) in 1995, head to head with The WB.

The Disney-ABC conglomeration announced in 1995 would combine the vast Disney empire—theme parks and resorts, the Disney stores, film production, television programming, home video, ESPN, and the Disney Channel—with a preeminent broadcast network that itself had strong holdings in radio, publishing, and cable as well as partnerships in several European broadcasting companies. By the mid-1990s, four Hollywood studios had jumped across historical boundaries into the television business, buttressed by extensive cross-holdings in film production and cable. Their combined activities would change the face of U.S. television and have an enormous impact across the globe.

Synergy in the sports-media field abounded as well. Disney bought the Anaheim Mighty Ducks hockey team (actually named after a movie) and the Anaheim Angels baseball team (purchased shortly after the movie *Angels in the Outfield* was released) and created the Wide World of Sports complex to complement Disney World in Orlando. Rupert Murdoch, controversially, bought the Los Angeles Dodgers. Cable mogul Kevin McClatchy purchased the Pittsburgh Pirates. And the burgeoning Entertainment and Sports Network (ESPN) empire—by 1994 including a second channel, ESPN2—had begun to capture the cream of American sports as well as introducing a whole new level of sports-mindedness to American culture.

Video

Meanwhile, all this megamerger activity could not disguise the fact that the movie business itself had changed inexorably. By the early nineties, the videocassette market had become increasingly central to film economics, prompting a Viacom/Paramount alliance with Blockbuster Home Video in 1995. From a small ad hoc business of mom-and-pop video stores, national chains like Blockbuster, Movie Gallery, Hollywood Entertainment, and Moovies began to dominate the video rental scene, with additional outlets in major chain stores like Wal-Mart and Kmart, grocery stores, and diversified book and record chains as well. On the production side, by 1990 videocassette sales accounted for over half of studios' total revenues from film production, much of that overseas. Eighty percent of American homes possessed at least one VCR by 1995, and

more than one third had two or more machines. Studios released increasing numbers of titles as "sell-throughs," encouraging consumer purchase of tapes with low prices, instead of the higher rates that tended to encourage only video outlet purchase. Video release of independent films that could not find a distributor began to open up the market in the early 1990s, especially when combined with Internet publicity and access. Minority audiences found in video rentals and sales a new way to locate and view material not frequently available in mainstream theaters or on television. By 1992, African Americans' VCR ownership rate was higher than that of the rest of the population, and they spent more on average in video rental and sales. And children, in particular, proved a lucrative market because one of the beauties of videocassettes is that they can be viewed again and again, conveniently at home. Disney's success with the video release of *The Lion King* set a new record in the business.

Print

The same forces of synergy that affected the movie business worked on the print media. Most of the expanding media conglomerates included large-print divisions as well, and the new coziness of entertainment companies with the somewhat more sacrosanct premises of print, especially serious journalism, raised fears for the future of the profession. Here the name Rupert Murdoch occurs prominently once again. The media entrepreneur had gotten his start by inheriting a small newspaper in Australia, which he built into a major national voice and eventually into an empire of over 100 papers accounting for 60 percent of total press circulation in that country. He then moved to England, where his outrageous tabloids and controversial acquisition of *The Times* of London frequently enraged the powers that be, especially in response to his strikebreaking activities and active support of the Thatcher regime. By 1990 Murdoch's News Corporation owned five British national papers and over 50 locals, with a circulation totaling over one third of the British population. His purchase of several U.S. newspapers, including the tabloid *New York Post* and *The Boston Herald,* made a splashy debut in the U.S. media scene; his deals culminated in the Fox studios and Metromedia acquisition. Murdoch was also active in the international satellite television business, with the British B Sky B and the Asian Star TV systems.

The strained relationship between the print world and media moguldom revealed itself in several places, not least in Murdoch's ongoing struggle with U.S. regulations barring cross-ownership of newspapers and television stations in the same market (a problem in Boston and New York). Eyebrows were raised when, in exchange for exemption from the rules against foreign ownership of U.S. broadcast properties (Murdoch became a U.S. citizen, but the News Corp. is an Australian company), Murdoch enlisted the support of powerful House Speaker Newt Gingrich and then agreed to publish Gingrich's self-glorifying book. Gingrich was eventually reprimanded and fined by Congress. Internationally, a similar situation occurred when Murdoch refused to publish a book (critical of Chinese policy) by the soon-to-be-former British governor of Hong Kong while agreeing to publish the memoirs of the Chinese premiere's daughter, only months before the Chinese accession of Hong Kong (where Murdoch had based vulnerable media properties). Murdoch's 1988 purchase of *TV Guide* (with the second-largest circulation numbers for a U.S. magazine) also led to

charges of conflicts of interest because he seemed to give competitors' TV listings short shrift while trumpeting Fox programs.

The biggest publisher of magazines in the country, Time Inc., now formed only a small part of the overall Time Warner conglomerate. Despite competition from other media, the total number of magazines published continued to increase, as technological developments made printing more efficient and less costly. Alongside the corporate offerings, a whole universe of small-market, sometimes fly-by-night zines burgeoned, self-published by nearly everyone for anyone who cared to take a look. More magazines were purchased by more people than ever before. The number of newspapers remained steady or declined slightly, amid continuing complaints of overattention to the bottom line in a competitive advertising market, declining readership standards from a nation becoming used to McPaper coverage, and an increased blurring of the line between editorial and advertising content. In book publishing some of the same trends could be seen, with increasing conglomeration of ownership and the rise of chain bookstores (Barnes & Noble, Borders, Books A Million), even as the number of books published and purchased rose each year. The largest U.S. publishing company, Simon & Schuster, became part of the Viacom empire with the Paramount acquisition of 1994. And by 1995, the Internet had begun to be seen as a potentially revolutionary site for the printed word, with untrammeled access, low costs, and a lack of responsible gatekeepers that was either exciting, deeply troubling, or perhaps both.

Audio

In radio, the trends begun in the 1970s continued, with the biggest innovation occurring in the realm of talk radio. Participatory call-in programming had revitalized the AM band and in the mid-eighties began moving over onto FM as well. Although, with the almost universal proliferation of syndicated formats, the cost of hosting a call-in show began to exceed its musical alternatives—requiring not only a host but a producer, an engineer, and often researchers and programmers—the boost in ratings made possible by a distinctive personality who cut through the clutter of sound-alike formats made the extra expense worth it. The talk-show hosts also created a loyal and committed audience who really listened, rather than just letting the music play like wallpaper in the background. As backers of earlier talk hosts like Mary Margaret McBride had discovered, a good talk-meister's credibility also extended to the products she or he plugged.

Susan Douglas points out in her book *Listening In* that National Public Radio (NPR) was the first to experiment with satellite delivery and attention to talk formats, but it was commercial radio's experimentation with controversial on-air personalities—today's shock jocks—that attracted national attention to the new form. And most of the talkers and listeners were men—an estimated 80 percent of the audience. An interesting bifurcation emerged: As daytime television became a site for a wild proliferation of talk shows, largely hosted by women and with an overwhelming female audience, talk radio became a ferociously male preserve, dominated by such adamant misogynists as Howard Stern and Rush Limbaugh. Other national talk hosts such as Don Imus, Bob Grant, and Larry King, as well as former politicos like G. Gordon Liddy, participated in the aggressive masculinity of talk radio as the decade progressed, most from a relatively conservative political standpoint. Limbaugh became so influential that he (along with Stern) diversified

into television and became a serious political factor in the elections of 1994. Rush Rooms proliferated all over the country, where die-hard Limbaugh fans could gather and shout "Ditto!" to his entertaining political put-downs. Aided by the FCC's abandonment of the Fairness Doctrine in 1987, conservative, heavily masculinized politics became the biggest infotainment draw on radio since Father Coughlin. By the late nineties this happy convergence of talk radio and politics would die down, as faux therapist Dr. Laura Schlesinger began to outrate Limbaugh with her blend of advice and theatrics.

The original shock jock, Howard Stern, put a slightly different face on the "hyper-democratic" world of talk. Not so much a liberal as a libertarian, Stern stretched the boundaries of free speech on the air as well as testing the limits of liberal sensibilities. Though a self-proclaimed feminist, pro-choice, and sexually anything but conservative, Stern struck back against what he saw as the strictures of polite political correctness. As Douglas points out, he specialized in a rebellious adolescent kind of humor that thumbed its nose at all the traditional authorities and sacred cows of American culture; "yet the framework within which this occurred could not have been more utterly conventional, more conformist to deep-seated American attitudes and prejudices about men, women, people of color, and the order of things circa 1952" (S. Douglas 1999, 305).

In 1986, Donald Wildmon's National Federation for Decency (among many others) complained to the FCC that Stern's show violated decency standards. Despite the Fowler FCC's reluctance to regulate the content of broadcast media, the FCC caved in to the pressure and began charging fines to Infinity Broadcasting, Stern's employer. Infinity paid a total of $1.7 million in fines by 1992, and the FCC blocked its purchase of new stations. Though Infinity threatened to challenge the decision in court, by 1995 it had given up and simply paid an FCC fine far larger than anyone had ever paid before. Apparently, it was worth it. Stern's show continued much as usual, and he became one of the most widely syndicated talk-show hosts on the air.

Meanwhile, on public radio, a different kind of talk flourished. Some complained that public radio stations were being taken over by talk, at the expense of the kind of alternative musical programming—often classical, jazz, and new age—that only public radio could provide. Shows like Terry Gross's *Fresh Air*, *Car Talk* with Ray and Tom Magliazzi, *Talk of the Nation*, and the two hours of news morning and evening on *Morning Edition* and *All Things Considered*—not to mention the hundreds of excellent local and national talk programs—provided a very different atmosphere from the hysterical hype of commercial radio. Public radio also provided considerably enhanced racial and gender diversity, despite some continuing problems. The familiar voices of hosts and reporters like Susan Stamberg, Nina Totenberg, and Linda Wertheimer gave audiences their first real taste of serious news from a female perspective.

Public radio had shifted its mission from providing a more traditional definition of serious or educational programming to presenting a diverse, in-depth alternative. As surveys showed that public radio listeners came from a variety of ethnic and income groups, with an even split of male and female listeners, the real distinction between the commercial and public radio audiences was that the latter were more highly educated than others, looking for something different, deeper, inclusive, and participatory. And public radio also provided a site for experimentation with radio as a sound medium. NPR often experimented with humor, sound effects, and attention to the aesthetic field of

sound itself in a way that its commercial counterparts had given up long ago. Despite efforts of the Republican majority to cast public radio and television as a plaything of the elite liberal upper middle class, the outpouring of support for the public alternative showed that public radio audiences crossed demographic and ideological lines.

Advertising

No media sector played a more central role in the new synergistic environment than the field of advertising did. Though some aspects of the integrated media production, distribution, and marketing system emphasized direct-payment mechanisms—pay-per-view and pay cable, satellite television, videocassettes, and a barely commercialized Internet—most of the media business depended on the old formula of selling an audience to advertisers. Indeed, the cross-promotion possibilities of the new synergistic megamedia meant more advertising of media products across fields, bringing advertising into places where it had formerly barely existed.

Movie theaters began to run not only movie previews but trailers promoting parent companies' theme parks, cable systems, television shows, retail outlets, and ancillary products. Television continued its traditional role of promoting films, but now cross-promotion deals that linked McDonalds, say, to *Batman* were trumpeted on television.

In the latter part of the nineties, as the Internet became integrated into advertising plans and into television viewing, this kind of cross-media selling would more seriously begin to blur the very concept of separation of editorial or entertainment and commercial content. And it would begin to cultivate a new method of market research as well, allowing for the individualized targeting of consumers in a whole new way. The field of specialized, narrowly targeted marketing took hold in the eighties, with magazines formulating special editions depending on zip code, demographic group, or profession and with advertising keyed to match. A new concept of integrated marketing communications (IMC) developed, with an eye to extending product advertising from traditional media to many different sites, from T-shirts to shopping bags to balloons. Companies like Coca-Cola began to create multifaceted ad campaigns that took a few central ideas and adapted them to fit its diverse age, ethnicity, income, and cultural groups across the globe. It wasn't just about placing media ads any more. In 1992, this area of sales *promotion* through a variety of marketing techniques accounted for 73 percent of the product marketing budget of companies overall, with only 27 percent going to traditional advertising (Sivulka 1998, 408).

As the nineties progressed, two forms of advertising penetration of content began to proliferate: product placement, by which commercial products seamlessly become a part of a program, and infomercials that turn selling itself into an entertainment form. Examples of product placement include the Black Pearls television campaign, in which Elizabeth Taylor appeared in four consecutive CBS sitcoms on one night, finding a way to mention her new perfume in each one; *Roseanne*'s family trip to Disney World (shortly after the ABC-Disney merger); or *Seinfeld*'s frequent working of products like Junior Mints, Kenny Rogers Roasters restaurants, or golf balls into the program's story line. Infomercials abound on specialty cable channels like QVC (Quality Value Convenience) and the Home Shopping Network, as well as on late-night local television.

Music videos present an example of a form of programming tied almost exclusively to sale of a product, in this case the recording on which the video is based. How long

could it be before an 800 number or a website allowed us to purchase Dan Rather's tie or Oprah's outfit if we felt so inclined? And how would this affect show content? It almost seemed like a return to the integrated advertising of the early radio and TV era, so that "important news" about the new Disney World attraction might follow on the heels of a discussion of Middle East peace talks on the ABC nightly newscast. Cartoons showing Peter Jennings wearing mouse ears referred to the possibilities with an uneasy snicker. These implications would become more pressing by the end of the nineties.

Global Markets

The U.S. domestic media market is so large that U.S. companies can afford to sell their television series abroad for prices well below what it would take to produce a program of equal quality in most of the smaller nations. Thus, since the 1960s, U.S. TV programs abroad have been inexpensive, of good technical and visual quality, and aggressively marketed by major media corporations. It was hard for newly minted television channels in other nations, struggling to compete and to fill their hours with attractive programs, to resist the lure of American TV. And U.S. shows are popular; audiences around the world enjoy American television series and films, though not always the ones that Americans themselves find most critically excellent or appealing. As if to confirm earlier fears of "Dallasification," in the nineties *Baywatch* became the most popular syndicated U.S. program across the world, though at home it was mostly the object of jokes.

A study done in 1994 showed a global predilection for American TV, while the programs varied from country to country. In Brazil *The Simpsons, Married . . . with Children,* and *Melrose Place* dominated. In China audiences enjoyed *Growing Pains, Dynasty,* and *The Colbys.* Defunct soap *The Bold and the Beautiful* attracted audiences in Egypt, India, Russia, Italy, South Africa, and Lebanon, while *Beverly Hills 90210* held audiences fascinated in Spain, Mexico, Japan, England, and the Czech Republic ("Channel Surfing," 1994). Yet rarely did such American imports rival the top-rated domestic productions in these countries. Brazil's top three programs in 1997 were none of those just listed, but two telenovelas (*A Indomada* and *Salsa e Merengue*) and soccer. Britain preferred *Eastenders, Coronation Street,* and *Touching Evil.* In Egypt, talk shows on various aspects of local and national affairs dominated the ratings. Germany, while importing such widely varied U.S. series as *Dinosaurs, In the Heat of the Night, Golden Girls,* and *Star Trek,* preferred soccer and its own *The Dreamboat* (though this was a German version of *The Love Boat*). India's favorite hits included a domestic Indian sitcom, *Mr. and Mrs.;* a Hindi music countdown program; and a religious serial about Hanuman, the Hindu monkey god ("The Media Business," 1997). Clearly, despite fears of U.S. domination, though other countries might borrow basic American formats or program concepts, the most popular shows remained those produced in the local language and with the national culture foremost in mind.

Restrictions placed on advertising in other nations also began to break down as competition intensified. By the late 1980s, as traditional terrestrial channels jostled for audience attention, the age of the satellite had arrived. Now countries competed with their neighbors for the domestic audience, and many nations—not just the United States—beamed a heady mixture of local, national, and foreign channels across borders and regions. Cable television, too, opened up some media systems and served as an

outlet for satellite channels. As national governments hung onto most long-established terrestrial television networks, satellite television became the place where profits could be made. European media companies responded to U.S.-Japanese merger-mania by forming partnerships and consolidating over the world.

Satellite television played a large role in these plans, and national governments reacted by defending their core broadcasting operations in various ways. In France, laws were passed that forbade any single company from owning more than a 25 percent share in a satellite channel and encouraged French ownership. By 1992 seven French-language satellite channels served Europe, Asia, and parts of Africa. Media companies extended their reach. The Bertelsmann company of Germany was Europe's largest conglomerate in the 1990s, with its most extensive holdings in publishing and music (including the RCA and BMG labels, and Bantam and Doubleday publishers in the United States). Bertelsmann quickly became a major contender in the European television market, with 40 percent of RTL Plus, Germany's oldest commercial network and one of Europe's leading satellite channels. It also had sizable interests in German radio, cable, film production, news, and digital systems. Other satellite TV holdings included a share in France's Canal Plus and Première.

Not only Europe felt the winds of change. In Latin America, a few large national corporations extended their reach across borders and into the sky. It's not surprising that the three largest countries—Mexico, Argentina, and Brazil—held the dominant media positions. Most Latin American countries had built a mixed system: a central public-state broadcaster, usually with fairly tight connections to the government in power, complemented by a vigorous private sector. By the 1990s, Mexico's two public channels competed for audiences and advertising with six private networks, divided between Televisa and TV Azteca. By the early 1990s, Televisa owned four terrestrial channels based in Mexico City and over 240 affiliated stations. In 1961 it had founded Univision, which eventually became the world's largest Spanish-language satellite channel (sold to a U.S. company in 1992). By 1996 Univision was the world's leading producer of Spanish-language programming, exporting to 93 countries.

Brazil's media market was dominated by giant Rede Globo, with a single terrestrial channel, TV Globo, and a host of other interests, including a multichannel satellite service. After Televisa, TV Globo remains the largest producer of telenovelas in the world. Argentina, whose several public networks were privatized in the 1980s, split its domestic TV market between five companies, the largest of which were Telefe and Artear. Both had a heavy share of U.S. programming and U.S. investment in their various holdings.

In Japan, government broadcaster NHK with its two channels had five commercial competitors by the mid nineties, all owned by or linked to newspaper-based companies: Nippon TV with Yomiuri Shimbun, TBS with Mainichi Shimbun, Fuji TV with Sankei Shimbun, TV Asahi with Asahi Shimbun, and TV Tokyo with Nihon Keizei Shimbun. All based in Tokyo, they possessed 187 affiliates in total across Japan. NHK additionally operated two satellite-distributed channels, DBS1 and DBS2, and joined with commercial operators for a third, Hi-Vision, a digital channel set to start up in 2000. Another satellite channel, WOWOW, was commercial.

In Africa, a continent whose continuing struggles with poverty, political instability, and war have kept broadcasting from developing consistently, digital satellite radio promised to reach populations long isolated. WorldSpace, a commercial enterprise

founded by Noah Samara of Ethiopia in 1992, extended its broadcasts to 80 percent of the world's population with three satellites positioned over Africa, Asia, and Latin America and the Caribbean. A wide variety of radio services in languages including English, French, Spanish, Arabic, Turkish, Wolof, Swahili, Portuguese, and Afrikaans, with a diversity of styles and content, is available for those who could get access to digital receivers—a minority, but growing.

But one name stands out above them all. We've already met Rupert Murdoch in his incarnation as an American media mogul. Australian by birth, Murdoch established an even greater presence in Europe and Asia than he did in the United States. With a dominant position in Australian publishing and a strong presence in English news, Murdoch's News Corporation was the first to announce an ambitious satellite venture, the Sky Channel, in 1989. Though this proved premature, some credit him with guiding the competitive rush in Europe in the direction of satellite broadcasting, rather than into cable or more organized exploitation of terrestrial systems. Sky merged with another direct satellite service, BSB, to become B Sky B—owned in partnership with Pearson, another conglomerate. It serves Britain and all of Europe with a mix of U.S., British, and European channels that is becoming increasingly popular. Murdoch's STAR TV satellite service out of Hong Kong, the first major Western intrusion into Chinese airspace, also provided service to Japan, Korea, Taiwan, and most of Indochina. In 1995 he formed a consortium with Brazil's Rede Globo, Mexico's Televisa, and America's Telecommunications Inc. (TCI) to start a satellite service to Latin America. Needless to say, Rupert Murdoch became an important spokesman for the dominant deregulatory, free-market ideology of the time. His widely reported 1993 declaration that satellite TV represented "an unambiguous threat to totalitarian regimes everywhere" made news internationally, but belied his own necessarily cooperative relationship with such governments in several nations.

TV U.S.: NOTHING SUCCEEDS LIKE EXCESS

For what remained of the traditional television industry, the most notable result of the deregulated, conglomerated, multichannel environment was the creation of three new over-the-air (OTA) broadcast networks. Not since the DuMont network expired in the 1950s had the big three of the airwaves seen significant competition. Why, in this age of cable and satellite distribution, would companies still want to mount the sizable investment that a venture into good old OTA broadcasting entailed? For one thing, despite cable's growth, a large chunk of the population still received its television primarily through the antenna. With sufficient numbers of affiliates, a broadcast network could still achieve far larger audiences than could even the most popular cable channels. Second, the cable universe, though consolidating, was still carved up into widely dispersed systems owned by 10 or 12 major multiple systems operators (MSOs) and a host of smaller ones. Each had proprietary interest in its parent company's cable offerings, and it was not always easy for a competitor to find a spot—certainly not a favorable spot with a low channel number—on a rival company's basic tier. Starting a broadcast network was a way to guarantee carriage of your programs in a low-number assignment on virtually all cable systems.

A third motivator involved those newly viable independent stations that cable's must-carry rules had created or strengthened: There were only so many of them out there, and the first network to sign them up would have an enormous advantage over any competitor to come along later. So, once Fox had proved the viability of a fourth network, Warner and Paramount jumped into a head-to-head race to sign up the remaining independents as their affiliates in cities all over the country. And finally, the imminent expiration of the fin/syn rules meant that the existing OTA networks— the big three plus Fox—would be producing more of their programming in-house and giving it the best spots on the prime-time schedules. Major studio producers, like Warner and Paramount, realized that unless they too could come up with a sure way to distribute their shows to the public, they could be squeezed out of the most profitable part of the business. And these studios had quite a bit of high-quality hit programming under syndication that they could easily use on their own networks.

Upstarts: Fox, UPN, WB

Rupert Murdoch had seen this writing on the wall as early as 1985. Launching the Fox network cautiously in 1986, with just a few hours of programming, he began to sign up affiliates in major and minor cities, usually the strongest of the independent stations in each market. Pitching his network as an organized source of original programming, backed by the public recognition and promotional capacities of the 20th Century Fox name that independent stations could use to fill in their prime-time schedules, Murdoch used the strategy of *creamskimming*: going after only prime time, the richest part of the traditional network business. No daytime programming, unprofitable fringe periods, costly news shows, or public service offerings for him. Those things he left to the stations to continue providing—or not, as they pleased. Finally, Fox promised that it would go after a currently unserved part of the TV market: young urban men. Whereas the strategy of the major nets remained focused on the lucrative group made up of women ages 18 to 49, many advertisers desired to reach the high-disposable-income market of teenage to thirtysomething urban men, and Murdoch figured that he knew how.

Led by Barry Diller, former head of Paramount Pictures, Fox debuted on October 9, 1986, with the *Late Night with Joan Rivers* show, leaving stations' prime times intact and offering a program that could compete in a hard-to-fill time slot. Starting out with 99 affiliate stations that reached 80 percent of U.S. homes, Fox expanded by fall 1987 to 115 affiliates with an 86 percent reach. The core of Fox's system was the former Metromedia group stations in major cities such as New York, Los Angeles, Chicago, Boston, Washington, Dallas, and Houston. Many of its affiliates were UHF stations that had capitalized on the cable boom. And in a break with the tradition established in the 1930s, Fox offered its affiliates no station compensation fee. Their reward would come in the increased advertising revenue they would gain from local spot sales, in effect making each station an eager partner in the new network's success.

Though Rivers had been a popular replacement host on *Late Night* with the targeted young male audience, her program proved disappointing as a stand-alone and was canceled the next May. But moving next into weekend evenings with its first prime-time shows in fall 1987, Fox introduced the highly acclaimed *Tracey Ullman Show* and other popular hits such as *21 Jump Street*, *Werewolf*, and *Married . . . with*

Children. Other new programs like *Duet, Down and Out in Beverly Hills, Mr. President, Women in Prison, Beans Baxter,* and *Second Chance* didn't fare as well but gave Fox a few nights to duke it out with the big boys. The next year Fox debuted *America's Most Wanted* (soon *Cops* and *Totally Hidden Video* would join it), the first in a string of its trademark reality-based programs that were popular with the target young male audience; also that year, Fox garnered critical respect with the quirky *It's Garry Shandling's Show*.

In 1989 the network added Monday nights to its schedule, with an hour-long version of *21 Jump Street* and another popular hit, *Alien Nation,* and ventured into stand-up comedy with *Comic Strip Live*. By 1990 the new network had hit its stride, programming all but Tuesday and Wednesday nights. Mondays consisted mainly of 20th Century Fox movies. While keeping its young urban male audience transfixed by *Married … with Children* and its comedy, science fiction, and reality shows, it made important gains among female audiences with the debut of *Beverly Hills 90210*. The frequently outrageous *In Living Color,* created by filmmaker Keenan Ivory Wayans, brought a previously unseen African American humor to the small screen; and cartoonist Matt Groening's *The Simpsons,* expanded from a short skit on *Tracey Ullman,* produced Fox's biggest critical and popular hit yet. Bart Simpson soon appeared on T-shirts and lunch boxes nationwide, and teachers' organizations spoke out against the poor example set by this smart-mouthed underachiever.

The Simpsons and *Married … with Children,* another controversial show that had been the target of conservative advertising boycotts, seemed to capture the spirit of the Fox formula: hip, irreverent, and often obnoxiously satirical. Yet it would be many years before Fox's biggest hits would climb into the Nielsen top 20. Even its top shows' ratings remained well below the level of the big three although in the desirable demographic market of young men it began to overtake CBS, the oldest-skewing of the big three. Fox introduced a lineup of children's shows on Saturday mornings and weekday afternoons, naming it the Fox Kids Network.

Finally, in 1992 Fox became a full, seven-night-a-week network. By this time it had also assembled a striking group of programs featuring African American stars and situations, from *In Living Color* to *Roc, Martin, Living Single,* and *Sinbad* as well as later shows like *Townsend Television, South Central, New York Undercover,* and *M.A.N.T.I.S.* As Kristal Brent Zook points out in *Color by Fox,* this was no accident (Zook 1999). Fox targeted the young black urban market (referred to by one of Zook's interviewees as "the Nike and Doritos audience"), and by 1995 African Americans made up 25 percent of the network's overall viewership. Giving talented performers, writers, and producers like Keenan Ivory Wayans, Robert Townsend, Charles Dutton, Martin Lawrence, Michael Moye, and Sinbad creative freedom and authority produced a string of popular hits (among whites and blacks) as well as, Zook argues, a distinct set of styles and concerns reflective of black culture in twentieth-century America.

Yet this era began to erode as the network became more successful and began to emphasize the same mainstream shows and viewers as the other networks did. Winning the broadcast rights for both the National Football Conference (NFC) and the National Hockey League (NHL) away from CBS in 1993 and 1994, as well as drawing large numbers with the *90210* spin-off *Melrose Place* and the cult favorite *The X-Files,* Fox dropped most of its black-centered shows in 1994.

By this time, too, the network had finally begun to produce a profit, and a few of its shows began to venture into the weekly Nielsen top 10. From the beginning Fox had pitched itself to advertisers as an exceptionally good bargain, offering a targeted market of young urban viewers often as large as CBS's in that category but with ad rates priced at 60 percent or less than those of its bigger rivals. For one glorious week in 1995, Fox's overall weekly ratings beat out CBS's. And in the wake of the NFC and NHL deals, some of CBS's affiliates began to jump ship, signing on with the former upstart. By 1995, Fox's ad rates had risen to just shy of the big three—just as two new networks jumped in to undercut it.

In fact, it was Fox's experience and success, along with the same factors that had prompted the fourth network's origination, that inspired the double-barreled competition of UPN and The WB, both of which debuted in January 1995. From the disparaged "coat-hanger network" (so called because of the coat-hanger antennas people would have to use to pick up its UHF affiliates' signals), Fox had become a major player in the network wars. The wars got more interesting in January 1995, with the arrival of the two baby "netlets" owned by two enormous parents. Plans for the dueling nets had been in the press since 1993. The example of Fox was very much on everyone's mind, particularly because both startups were headed by former Fox executives. Paramount's UPN debuted with former Fox network head Lucie Salhany at its helm—also marking the first time a woman had served as president of a major television network. At The WB, Jamie Kellner presided; he had served as Fox president until 1993, when Salhany took over. Both networks drew on the example of Fox's success in their pitches to potential affiliates, pointing out the boost in ratings that the fourth networks' affiliates had experienced for actual network programs as well as in their own adjacent programming. Both pointed to the high public profile and well-established entertainment track records of their corporate parents. Both had a strong suit: Warner had long been famous for its Warner Bros. cartoons, and the new WB picked a cartoon character, Michigan J. Frog, as its mascot and marketing tool, perfect for its target audience of 12- to 34-year-olds. UPN counted on its famed Star Trek franchise to float its new venture, targeted at Fox's old demographic of males from 18 to 49.

Neither netlet started out in as strong an affiliate coverage position as Fox had. UPN had signed affiliates in 80 percent of the country, but a sizable percentage of those were weak secondary affiliations (meaning that the station already had one network's programs in its prime-time slots and would have to run UPN's debut shows in fringe times). The WB also predicted 80 percent coverage, but much of that came from cable superstation WGN, meaning that in many markets there would be duplication (a local affiliate would carry the same WB programs as WGN simultaneously carried on cable in the same market)—a situation that made neither party happy. But despite these problems, The WB flipped the switch on January 11, 1995—a Wednesday—presenting 2 hours of programming starting with sitcoms *The Wayans Brothers* (an offering from the two younger members of the talented and ubiquitous Wayans family); *The Parent 'Hood*, created by Robert Townsend; and *Unhappily Ever After* (from the folks who brought you *Married . . . with Children*). This was followed by an hour-long version of *Muscle,* a comedy set in a health club. An important part of The WB offerings consisted of 3 hours of children's programming on Saturday mornings and 1 hour on weekdays, including *Animaniacs, Merrie Melody* classics, and *Freakazoid!* The following Monday, UPN made its debut with a special 2-hour episode

of *Star Trek: Voyager,* followed by sitcoms *Platypus Man* and *Pigsty.* Its second night featured two dramas—*Marker* (a Stephen J. Cannell production) and *The Watcher* (starring rapper Sir Mix-a-Lot). UPN also planned to offer Paramount movies on Saturday afternoons.

Many doubted whether even one more OTA network could make it, much less two. One industry pundit summed it up in the question, "Are Paramount and Warner Looney Tunes?" (*Business Week* 1995). Although successful, Fox still averaged a 7 rating in prime time overall (compared to 12–15 for the big three); The WB promised its initial advertisers a 3, while UPN guaranteed a 7 (both had to make substantial refunds). And at The WB, taking Fox's non-compensation stance once step further, affiliates were actually required to *pay the network* 25 percent of enhanced ad revenues—more like a cable channel than a traditional broadcast arrangement. Luckily for both Fox and The WB, they debuted into an extremely strong advertising market. However, over a decade later, all six networks survive and compete—some more successfully than others. The story of their struggles and successes will resume in Chapter 12.

Jurassic Park? The Big Three Survive

For the former big three, the 1985 to 1995 period reflects the end of their era of dominance; yet, despite declining viewership, increased competition, and sometimes frantic forays into other fields, as one article put it, "If TV networks are dinosaurs, then this is still the Jurassic age" (Marks 1995, 13). By 1995 the big-three networks' share of the prime-time audience had declined to 69 percent from its former 91 percent, and it would fall still further. Yet the prices that the nets could charge for advertising spots had actually increased. In 1995 ABC network profits went up by 84 percent over the previous year's, NBC's by 50 percent, Fox's by 22 percent, and even limping CBS showed a 5 percent upturn. In an increasingly fragmented market, the now big four continued to provide the single largest audience advertisers could buy for their products, and they had become even more valuable for that capacity. Many explained network strength by pointing to their strong distribution base in well-established local affiliates, who retained viewer loyalty and tuning habits despite cable's inroads. They remained the only place for viewers to see their own community's news and concerns reflected and retained a strong economic base in local markets. As one industry analyst commented, "Cable [stations] are purveyors of hamburger versus the networks' filet mignon" (Marks 1995, 13).

Yet at CBS, in particular, things often looked bleak. Losing first the NFC and then the NHL rights to Fox seriously damaged ratings, to the point that even well-established shows like *60 Minutes* and *Late Night with David Letterman* lost points just for being on CBS. It still reflected the oldest demographics of any network, in a marketplace that placed high value on youth. In another example of the decade's merger mania, the Westinghouse Corporation purchased CBS in 1995, removing director Lawrence Tisch from a troubled reign at the former "Tiffany network." Tisch had been known for his penny-pinching style and fiscal conservativism; as other networks diversified and expanded, CBS pulled back from publishing, records, and cable. Under Tisch, the CBS news division, once the premiere in the country, withered to a shadow of its former self; and the affiliate battles with Fox cost the network some of its most valuable affiliates in Detroit, Atlanta, Milwaukee, and Cleveland. And its

prime-time shows seemed unable to attract any more than a PBS-sized audience. Yet its newsmagazine *60 Minutes* still garnered the highest ratings of any show on television, generating $50 to $70 million a year for the network, an amount that in some years represented over half of its total revenue. CBS had already expanded its newsmagazine expertise into two moderate successes, *Eye to Eye* and *48 Hours.* And CBS produced these shows itself, making them more profitable to the network than a comparable purchased show. Westinghouse clearly saw some value in the struggling dinosaur, and its confidence would be borne out by later developments.

NBC, on the other hand, experienced some of its best years in recent memory. This was largely due to its string of hit programs. The winning lineup of *The Cosby Show, Cheers, A Different World,* and *The Golden Girls* buoyed it up through the eighties, reaching its highest point in the 1987 to 1988 season, when NBC possessed fully 13 of the top 20 shows on the air. A decline set in after 1990, as *Cheers* expired and *Cosby* and *Different World* lost ground to ABC's comeback. But by 1995 the oldest network saw signs of a return to former glory, with the debut of the juggernaut of "must-see TV"—*Seinfeld, ER, Friends, Frasier,* and *Mad About You.* Meanwhile, NBC had been busy spreading into other fields. It had started rival cable news channel CNBC in 1989, and ratings had begun to rise. Its equity positions in Bravo, Arts and Entertainment (A&E), Court TV, and 16 other cable channels; and its 1994 launch of America's Talking and Canal de Noticias, a Spanish-language news channel, positioned it strongly in cable. Its global operations put it ahead of any other network, with interests in TV Azteca in Mexico, the pan-European satellite-distributed NBC Super Channel, ANBC with business news, CNBC Asia, and NBC Super Channel Asia. And its announcement in May 1995 that it would team with computer giant Microsoft to create MSNBC, a business news network with online applications, created a potential blockbuster combination.

ABC too entered the nineties in a strong position, with *Roseanne, Home Improvement, America's Funniest Home Videos, Coach,* and *Full House* garnering high ratings on the sitcom front; *Monday Night Football* continuing its stronghold over male audiences; and newsmagazine *20/20* providing the closest competitor to CBS's franchise. When Disney made its purchase in 1995, both companies were praised for their complementary strengths. ABC brought Disney its valuable Cap Cities string of major-market stations, its cable holdings such as ESPN and A&E, and not least its national outlet for Disney-produced films and television programs as well as advertising and promotion of Disney-related products. For ABC, alliance with Disney brought not only top-rated *Home Improvement* in-house (produced by Touchstone, a Disney company) and a Disney-based Saturday morning kids' lineup to the network but also an outlet for its sports interests on ESPN that promised great things for global distribution. At any rate, this particular dinosaur was worth $19 billion to the movie studio, compared to CBS's $5.4 billion purchase price for Westinghouse. Clearly, the ice age had not yet arrived.

Cable

For cable television, this was a period of immense growth and expansion, as well as the decade's signature consolidation, despite a brief downturn in the wake of the 1992 legislation. The number and variety of cable channels increased by leaps and bounds,

spurred by cable economics as well as the introduction of fiber-optic cable. Cable systems—many of whose franchises came up for renewal in the mid-nineties—had begun to upgrade their infrastructure by replacing old coaxial cable with the new glass-based alternative, allowing transmission of many more channels to home consumers. And until the 1992 Cable Act brought the practice to a screeching halt, cable operators found that adding channels, then passing the costs on to customers with a fat profit built in, made an excellent source of profits. Typically, each new basic channel required a fee of 10 cents per subscriber, per month, from the cable operator to the channel provider. Cable systems would add, for example, three new channels to their cable lineup, and then charge consumers an extra dollar per month on their bill—producing a 70-cent profit for the operator.

During the late eighties and early nineties, consumers' cable bills rose 10 percent to 20 percent a year on average, whether they wanted the new channels or not. In 1985 the average monthly cable bill for basic service (not counting pay channels) amounted to $10.43; by 1992 it was $19.08. Given most cable systems' monopoly status—you couldn't simply switch companies if your bill made you unhappy—the FCC found itself deluged with complaints.

The 1992 Cable Act put a cap on this profiteering; now the cable operator could charge only 7.5 percent more than the cost to the local franchise. When the FCC followed up with a freeze on rate increases in 1993, a temporary dark mood ensued. Yet by 1995 operators had found a way around the new restrictions, and the average basic cable bill jumped to $23.07 per month. The 1996 Telecommunications Act phased out most of these restrictions entirely. The Cable Act of 1992 also reinstated must-carry rules, which in the late eighties had been challenged and struck down in court as a violation of cable operators' First Amendment rights. More pertinent to the operators, must-carry filled up valuable channel capacity with small-time UHF and weak independents, preventing the addition of more lucrative cable offerings. Broadcasters, on the other hand, upped the ante by arguing that for too long cable operators had benefited from carrying their stations for free: Why shouldn't local stations and networks get paid the same way that cable channels did? As a compromise, the new law instituted a system of *retransmission consent*: Broadcast stations in a local market could opt for either guaranteed transmission, under the old must-carry agreement, or they could give up their automatic carriage status and instead bargain with cable operators for payment. Most smaller and public stations opted for the former course. But powerful and popular network affiliates often succeeded in wringing compensation out of the local cable franchise—not in the form of direct payment but in valuable channel concessions. Local stations were frequently able to add an additional cable channel; now you had WCTV in its usual spot, offering its usual broadcast fare, and you had CABLE CTV, with more local and syndicated programming.

The networks were able to use their dominance to gain additional cable channels too. Thus NBC started America's Talking, while Fox debuted the FX network. Only CBS, which had held out unsuccessfully for cash payment, walked away empty handed. Some powerful group station owners were able to cash in, such as Scripps-Howard, which launched the Home and Garden (HGTV) channel. Cable operators would appear to have come out the losers entirely, except that carrying the additional channels gave them another revenue stream, and they still got valuable local stations—what most viewers watched most of the time—for free. One of the biggest winners during this

decade had to be ABC-Disney, which used this opportunity to launch ESPN2—a move that revolutionized sports programming, as well as the nature and culture of sports itself, around the world.

Connection ESPN = Entertainment and Sports Empire

It's hard to imagine, in the opening decades of the twenty-first century, that once upon a time sports occupied a relatively marginal place in America's network universe. Though economically important to the medium, sports news remained confined to brief segments on the nightly newscast, supplemented by live broadcast of only the most nationally significant of the biggest sports events (which often awkwardly displaced regularly scheduled programming). Televised sports in the United States before the 1980s reached a predominantly male audience with a thin skim of their favorite athletic contests, punctuated by blowout hyperevents: the Superbowl, the Olympics, the World Series. NBC launched the genre of regularly scheduled sports programming; its long-running *Gillette Calvacade of Sports,* first broadcast in 1944, even preceded the official debut of network TV. But it was ABC that traditionally provided leadership in this area, with its *Wide World of Sports* dating from 1961 and its exclusive agreement with the NFL that led to *Monday Night Football* in 1970, all under the visionary leadership of Roone Arledge.

When, in 1979, the father-son team of Scott and Bill Rasmussen, originators of the obscure New England Sports Network, teamed with Getty Oil to venture into the unlikely world of 24-hour-a-day cable sports, ABC quickly saw its potential and invested in the fledgling cable network in 1980. Their revolutionary perception that the same ability of satellite distribution that HBO exploited for movies could be used for production as well as for exhibition seemed ideally suited for sports: TV could go anywhere in the country, or even in the world, to pick up sporting events too small for the major networks but of great interest to sports enthusiasts outside the local broadcast region, who formerly might never have been able to see them. Over the next 20 years, ESPN and its later national, international, and cross-media spin-offs became one of the greatest success stories in cable-based commercial media and gave sports buffs a whole new way to be fans. As its opening broadcast assured, "If you're a fan, what you'll see in the next minutes, hours and days, may convince you you've gone to sports heaven" (Janis 2001, 96).

ESPN's 24-hour presence gave new prominence to popular but less mediagenic athletic events like golf, tennis, and soccer. At first, however, it wasn't so easy. As ESPN chronicler Michael Freeman describes it:

> They aired tapes of Australian rules football, auto races, high school lacrosse, a
> world Frisbee championship, tractor pulls, obscure ping pong and golf
> tournaments. The TV screen for more than three million potential viewers showed
> rodeo matches, water skiing, wind surfing, horse steeplechase races, and even
> women mud-wrestling in bathing suits. . . . The network purchased the rights to a

tennis match in Italy and dubbed the tape with commentary from Palmer [one of the early sportscasters] who was in an air-conditioned room in Bristol but simulated his attendance at the match by complaining about the heat "here in Rome". (Freeman 2000, 103)

Later, ESPN's contract with the National College Athletic Association (NCAA) meant that formerly obscure college events could finally find a home, even though the major networks still laid claim to major events and playoffs. ESPN specialized in the early rounds of popular tournaments like college basketball. The cable net managed to attract a long-term sponsorship agreement from Anheuser-Busch, even then perceiving the natural relationship between 24-hour sports and beer.

One breakthrough for the fledgling service occurred in its first year of operation, when Chet Simmons, NBC vice president for sports programming and formerly among the originators of ABC's *Wide World of Sports,* was hired as president. His experience in the field opened doors, including a crucial agreement from both NBC and ABC that would allow ESPN to use footage from their sports broadcasts to provide much-needed highlight video from major games. Much of ESPN's early personnel came from those networks, via Simmons's influence, as well. Freeman claims, "Simmons was the most influential president in ESPN's history. He molded the network and laid the foundation for what it is today" (Freeman 2000, 117). His successes in building an audience allowed the channel in 1982 to begin charging cable operators the basic fee of 10 cents per month per subscriber—a breakthrough in financial stability, though its investors were still losing money. By the end of that year the subscriber base had reached 25 million, and ABC had signed on with a purchase of 10 percent of the operation. In 1985 it purchased most of the remaining shares. By 1990 ESPN had become one of the most profitable U.S. cable channels. By 2000, subscribership reached nearly 77 million, putting it at the top of the cable lineup and ahead of CNN, MTV, and TNT (Sterling and Kitross 2002, 872).

But even more than broadcasting sporting events themselves, ESPN created a whole new genre called sports news. According to Freeman, "Its original mission was to provide substance to the sports fan who wanted more than six minutes of highlights and stupid pet tricks on the local news" (Freeman 2000, 4). ESPN took sports seriously, constantly providing information about scores, schedules, highlights, and key information on a 24-hour basis. One of its first and most groundbreaking creations was *SportsCenter,* which debuted immediately, in 1979, and became the heart and soul of the network. At first a single hour-long daily roundup of sports news featuring each day's scores and matchup previews, it eventually expanded to fill over 9 hours a day. Though *SportsCenter* was hosted over the years by a stellar lineup of sports commentators, in 1992 the late-night pair Dan Patrick and Keith Olbermann became its reigning stars. Writer Lauren Janis describes their humor and spontaneous style:

A hockey goal was a "biscuit in the basket." A long-range shot was "from way downtown . . . bang!" A phenomenal player wasn't merely on fire, but "en fuego." An injured player? "He pulled a groin . . . his own, we hope," said Olbermann. "He's listed as day to day, but then again, aren't we all?" said Patrick. (Janis 2001, 97)

Or, as *Slate* columnist Matt Feeney sums it up, "Dan and Keith infused *SportsCenter* with a knowingness (while miraculously avoiding smugness) that turned the show into a kind of metahistory of sports. In the thickly hyped world of sports television, this layer of irony was a

valuable thing." (Feeney 2004). Combining sports news, scores, highlights, interviews, and commentary, eventually expanding into such related events as coverage of Pete Rose's lengthy trial, the program also pioneered an early version of the on-screen scroll. Soon it became the central, indispensable television spot for sports fans. Other long-running shows on ESPN include *Baseball Tonight* (1993–), *College Game Day* (1989–), *NFL Primetime* (1987–), and *Outside the Lines* (1990–). Later the channel would even expand into fictional entertainment, with made-for-TV movies such as *The Dale Earnhardt Story* (2004) and the steamy, sports-centered soap *Playmakers* (2003).

ESPN's big breakthrough into major sports occurred in 1987, when it won a contract from the NFL for eight of its Sunday night games along with four preseason matches and the Pro Bowl. The network's profile rose further with an Emmy for sports coverage in 1988, for its handling of college basketball—the first time a cable network had received such distinction. In October 1993 ESPN2 was launched, a sister channel to handle an increasing roster of sports events designed to attract younger viewers. A few years later it would debut the Extreme Games (X-Games) competitions, opening up the media sports universe to a whole new definition of sport: rock climbing, boomerang throwing, kite skiing, skateboarding, mountain biking. By 1992 ESPN2 was reaching 20 million subscribers. In 1994 ESPN's Emmy catch increased to 10. Many other spin-offs—such as ESPNews, ESPN International, the Classic Sports Network, and in 1996 *ESPN: The Magazine*—along with Major League Soccer rights and expanded Women's National Basketball Association (WNBA) and NFL coverage. ESPN.-com, the channel's highly popular presence on the web, became an integral part of its operations in 1998. By 2005 the website boasted a median age of 29 for users: 94 percent were male, 87 percent were college educated with an average income of over $72,000, and fully 68 percent described themselves as "avid sports fans" who in the past 12 months had attended at least one game and purchased sports-related products online.

Freeman also reports a less-salubrious aspect of ESPN—its testosterone-charged atmosphere that led to many accusations of sexual harassment of female personnel over the years, and its longtime exclusion of nonwhite and female anchors and reporters. The record improved in the 1990s, and in fact ESPN was the first national network to hire women as sports anchors. Many have also criticized the relatively short shrift given to women's sports, though a recent study by the Women's Sports Foundation reveals that ESPN has proven more hospitable than the major networks, especially for women's NCAA events. And it has attracted increasing numbers of female viewers, especially after adding the entire Women's Basketball Tournament to its lineup.

In 1998 ESPN got its first real cable competitor, Fox Sports Net, which took cable's advantage one step further in creating a cooperative arrangement of 21 local, regional, and national cable sports channels and combining them with radio coverage as well. Sports Net set up competition with *SportsCenter* in the form of *The Best Damn Sports Show Period,* hosted by Chris Rose and Tom Arnold (Roseanne Barr's former husband). Adding popular attractions like increased NASCAR coverage, *Sunday Night Fights,* and *Ultimate Fantasy Football,* the channel began giving ESPN a run for its money in the early 2000s by focusing primarily on the local aspects of sports. Its mantra became "Sports is tribal."

Both Fox and ESPN now provide heavy competition for the former big three. Part of this has to do with the economics of cable television: Besides targeting the 18–34 male audience, notoriously hard to reach and thus valuable to advertisers with male-oriented products, cable networks also

charge cable operators substantial fees per subscriber per month. This second revenue stream has allowed ESPN and Fox to outbid the OTA nets for many major sports events, including winning away the Monday Night Football franchise from ABC beginning in 2006. It all adds up to what some have called the "cable-ization" of sports, with consequences felt around the globe.

By 1995, cable reached 66.8 percent of U.S. homes, totaling over 64 million subscribers. Concentration in the industry had steadily increased: In 1977 the four largest cable MSOs controlled less than 25 percent of the total market; by 1995 they controlled almost 50 percent. The five largest companies were TCI, Time Warner, US West, Comcast, and Cox; the largest two were more than twice as big as their nearest competitors, possessing 13.9 and 12.1 million subscribers, respectively. Additionally, most MSOs owned numerous interests in cable channels, producing the same kind of vertical integration enjoyed by the movie studios and networks. TCI, one of the nation's largest media companies, owned TV stations reaching 21 percent of the country, the Sports Radio network, and interests in over 90 cable networks including USA, Court TV, the Discovery Channel, BET, the Home Shopping Network and QVC, Prime Sports Channel, Fox Sports, Encore, the Family Channel, the Faith & Values Channel, Animal Planet, the Sci-Fi Channel, the Travel Channel, The Learning Channel, Telemundo, Starz! E! and many others. If you subscribe to TCI cable, chances are you get all or most of these—and don't get some of the channels owned by other MSOs. In 1995 Time Warner owned not only HBO, Cinemax, and the Turner channels (CNN, CNNHeadline, TNT, Turner Classic Movies, CNNfn, and TBS) but also the Cartoon Network, Ovation, and part of Comedy Central (with Viacom) and Court TV (with GE and TCI).

In addition to the expanding basic and pay-cable universe, most cable MSOs also diversified into what was shaping up to be their most potent competitor in the nineties: direct broadcast satellite (DBS). With the smaller, higher-band satellite dishes introduced in 1995, DBS promised to move into town instead of being concentrated in noncable, frequently rural areas. A dish that could be mounted even on an apartment windowsill would eventually attract millions of new subscribers, many fed up with the cable monopoly or simply seeking the practically limitless options that DBS offered. The cable MSOs observed this phenomenon and determined not to be caught on the sidelines. TCI went into partnership with GE and Time Warner to operate one of the largest DBSs, Prime-Star. DirectTV, its major competitor, was owned by Hughes Communications. DBS had languished for years on the brink of success, but after 1995 its fortunes would blossom.

And cable continued to roll. In 1995, Nielsen figures reported that cable's audience had grown 24 percent since the previous October, while the broadcast networks' ratings had declined by 7 percent overall. In prime time, cable's total average rating rose to 17 (from 14 the year before), while the big four's total average cratered at 40.5 (including Fox lowered the average; counting only the big three, total average rating hovered around 60). Specialty channels like Court TV (covering the O. J. Simpson trial intensively) and Nickelodeon showed particular gains. Some blamed the new network willingness to push the envelope of sexual and violent content, in an effort to hold onto the 18–49 age group, which drove family audiences, in particular, to cable channels they could count on to tone down the sex talk.

Besides Nickelodeon, the Discovery Channel, the Family Channel, Lifetime, ESPN, and CNN benefited from this policy and increased ratings substantially. But not until the end of the nineties would cable begin to create its own original prime-time dramatic and comedy programming to rival the networks.

PROGRAMS: PUSHING THE ENVELOPE

As the networks struggled to find the magic formula to keep them afloat in a sea of competition, several new options presented themselves. This period may rank as one of the most creative in traditional broadcasting, as networks grasped at a wide range of creative straws and opened up to possibilities never before considered. Again, a peculiar set of contradictions emerged. On the one hand, in network prime time, the emphasis was on *quality*. Only the big-three networks, they claimed, could offer viewers truly high-quality programming, head and shoulders above the nasty scrabble for profits going on at struggling cable channels—filet mignon to the cable channels' hamburger. To achieve this, the networks turned to the same devices they had used so long ago as they established radio: emphasizing authorship and well-rounded family fare. Yet, at the same time, fringe and daytime schedules began to fill up with talk shows and tabloids, sparking the same kind of controversy that daytime serials once had. Reviled as vulgar, sensational, outrageous, and unfit for family audiences, talk programs exploded during the early nineties, drawing huge audiences seemingly undeterred by the low quality of their aspirations. Quality programs on networks by night, trash TV on local schedules by day: This was the late eighties and early nineties. And cable programming began to lead, not just to follow. Though the era of original cable drama would not arrive until the late 1990s, on other channels documentary, music videos, talk, news, and above all, sports, continued to thrive and grow. By mid decade, these programs would have an enormous impact on the "traditional" OTA networks.

This is the period in which the first real system of *producer-auteurs* emerges. Led by the dramatic successes of seventies figures like Norman Lear and Grant Tinker, and supported by the growing strength of Hollywood-based production companies in television's economic system, creative individuals or teams were now able to exercise a greater degree of creative control over their programs than they had before. Writer-producers like Steven Bochco (*Hill Street Blues, L.A. Law, Hooperman, Cop Rock, NYPD Blue*), David Lynch (*American Chronicles, On the Air, Twin Peaks*), Diane English (*Murphy Brown, Foley Square, Love and War, My Sister Sam, Double Rush, Ink*), Marcy Carsey and Tom Werner (*The Cosby Show, A Different World, Roseanne, 3rd Rock from the Sun, That 70s Show*), David E. Kelley (*Picket Fences, Chicago Hope, Ally McBeal, The Practice, Boston Public*), Marshall Herskovitz and Ed Zwick (*thirtysomething, Dream Street, My So-Called Life, Once and Again*), and actor-producers like Roseanne Barr, Bill Cosby, Tim Allen, Jerry Seinfeld, and others often formed their own independent production companies. Working out a distribution and financing deal with a larger production company or studio, yet remaining separate as a creative organization, allowed them to resist outside interference and keep more of the profits of a risky business. Often a network would sign a particularly successful producer to a long-term contract, gaining right of first refusal for each new show proposed, and committing to produce a certain

number of shows over a set number of years. This gave the network an incentive to follow a producer's creative ideas down some fairly strange and unprepossessing roads, in exchange for guaranteed access to the certain-to-follow hit.

The new network emphasis on the *auteur* owes much to the deeply rooted American cultural tradition of pronouncing "quality" with a British accent. Just as PBS had turned to British-produced programs in the 1970s, so network television borrowed some key concepts from British television production in the 1980s and early 90s. On the BBC, the writing-team approach to television production had never taken hold. Most series were the work of an identifiable author and because of this were often short running: perhaps only 6 to 8 episodes. Anything else smacked of American-style mass production, and with syndication a much less accepted practice on British television schedules in a nonprofit environment, the economic pressures that mandated an infinitely expandable series narrative in the United States simply didn't exist. American television wasn't going to abandon its basic economic system, so the network approach to a higher standard of production and cultural quality became not the individual writer, as in Britain, but the writer-producer. Indeed, most American TV auteurs became notable on the producer rather than writer side: After authoring a few episodes in the first season of a successful series, they soon assign new head writers and show runners and move on to the next production. The stamp of an author—even when actual authorship was somewhat removed by the production practices of television—gave a program a degree of authenticity and legitimacy absent from television's earlier decades. This distinction was important in a decade when quality had become a national issue, a viewers' rallying cry, and the subject of considerable industry consternation.

Dramedy

By the late eighties, the television industry seemed to have lost its earlier sense of propriety and traditional safeguards over appropriate content. The jiggle years of the seventies, alternating with mindless violence, had produced an organized viewer outcry against declining standards. Now cable threatened to siphon off the educated and upscale audience, leading the desirable yuppie viewers away from traditional network fare toward the more specialized and daring programming on cable, particularly pay cable. And while critical successes like *Hill Street Blues* had proved that network TV could still produce high-profile drama, hour-long shows were not as profitable to make as the standard half-hour shows were. Longer shows didn't sell as well in the all-important syndication market, and they were harder to schedule. Yet the sitcom seemed to represent for many all that was worst about television, with its screeching laugh track, its inane dialogue, its salacious and vulgar attempts at humor, and its triviality and artificiality. What was a network to do?

In 1987, a new concept arose: Take the combination of drama and comedy that had made shows like *Hill Street Blues* so successful, but adapt it to the half-hour form. Let's call it the *dramedy*. As Philip Sewell discusses, the dramedy was initiated by the innovative *Days and Nights of Molly Dodd* (NBC 1987–1988), created by Jay Tarses and starring Blair Brown as a young woman newly moved to New York, trying to put her life back together after a divorce (Sewell 1998). Pacing itself to the small triumphs

and crises of everyday life, it garnered high critical acclaim and decent ratings in its first airing in the summer of 1987 and was renewed for spring 1988. Quickly CBS and ABC hopped on the dramedy bandwagon with *Frank's Place* (ABC 1987–1988), Bochco's *Hooperman* (ABC 1987–1989), and *Slap Maxwell* (ABC 1987–1988).

Praised as more sophisticated, intelligent, and realistic than ordinary comedies yet striving for low-key humor, dramedies demanded more of their audiences, it was claimed, than did the general run of TV programming. Their story lines did not wrap up at the end of each episode, but carried over to the next. Shot on film using the one-camera method, the dramedies did not look like standard network comedy. They also eliminated the laugh track, a favorite target of highbrow critics; its absence was touted as a sign of respect for the quality audience attracted to the dramedy. The lack of canned laughter also contributed to the shows' vaunted realism.

Frank's Place in particular, featuring actor Tim Reid as a Boston university professor who inherits his family's New Orleans restaurant, was set convincingly and uniquely in the cultural milieu of black New Orleans. Reid coproduced the program with Hugh Wilson for Viacom; they had worked together previously on *WKRP Cincinnati.* As Herman Gray recounts in *Watching Race,* Wilson and Reid were given late-eighties auteur status by CBS, which allowed them to develop the program with little interference, including hiring a multiracial crew and writing staff (Gray 1995). Following the life stories of a predominantly black cast, *Frank's Place* allowed the viewer to discover the continuities, contradictions, and deeply rooted ethnic cultures of the new South as its main character did, without exaggeration or condescension. Having somehow generated such an innovative and unusual program, the network seemed not to know what to do with it. It was shifted around in the schedule five times during its short run, and despite some of the highest critical acclaim of the season, was canceled in October 1988. For many African American viewers—and others who appreciate innovative drama—it remains an unrivaled high point in the history of network television.

Bochco and Terry Fisher's *Hooperman* starred John Ritter as a San Francisco cop, and the show mixed details of his professional and personal life. Barbara Bosson played a police captain. It lasted on ABC until 1989. Jay Tarses followed up his *Molly Dodd* success with *The Slap Maxwell Story* (ABC 1987–1988), starring Dabney Coleman as a Midwestern sportswriter. By fall 1989, however, only *Hooperman* remained of the networks' brief fling with the dramedy. Oddly enough, opposition to the moderately highly rated genre was led by NBC programming head Brandon Tartikoff, who was quoted as saying, "I just don't get it." Tartikoff complained to *Los Angeles Times* television reporter Harold Rosenberg that those who created dramedies merely announced, "we are not really funny comedy writers and we're not good drama writers" (Sewell 1998, 14). Perhaps it was ABC's stronger offerings he didn't get, or perhaps dramedy's quality TV claims cast NBC's large roster of more traditional sitcoms in a bad light (as nonquality television). *Molly Dodd* was canceled in June 1988, to much viewer outcry from groups such as Viewers for Quality Television, but was picked up by the Lifetime network in February 1989 and ran successfully until August 1991. When *Hooperman* finally expired in 1989, the short-lived dramedy era was over, at least until shows like *Sports Night* (ABC 1998–2000) and David E. Kelley's *Ally McBeal* put a new spin on the idea in the late nineties.

Family Shows in the New Era

Tartikoff may simply have been redirecting attention to another key response to fears about the decline of quality television: the revival of the family sitcom. Declared dead in 1982, the sitcom had made a roaring comeback by the late eighties, as drama moved from strength to strength. But times had changed; these new families departed from the TV norm. They put a new spin on the notion of the family, whether it was by changing the race and the cultural orientation of the family to African American, as in *The Cosby Show* (NBC 1984–1992), or by moving the family downscale into the working-class-with-an-attitude domesticity of *Roseanne* (ABC 1988–1997). With *The Simpsons* (Fox 1989–), Fox brought the first successful animated family into prime time since the 1960s and opened up the genre to satire like never before.

Connection The Postmodern Family: Cosbys, Conners, and Simpsons

The Cosby Show, created by comedian and actor Bill Cosby in cooperation with former ABC executives Marcy Carsey and Tom Werner and coproducers Ed Weinberger and Michael Leeson, is widely credited for bringing back the family-centered sitcom and for leading NBC to its ratings success in the late eighties and early nineties. What Bill Cosby had in mind was a traditional domestic sitcom that, rather than subverting or satirizing the middle-class values on which sitcoms were based, placed them in a context that took meaning from the history of television representation itself: He made the middle-class family African American, something new not to historical experience but to the white-only tradition of television sitcoms.

The Huxtables were a modern family, typical in many ways and unusual in others. Both husband and wife had challenging careers—Cliff Huxtable, played by Cosby, was an obstetrician; his wife Clair (Phylicia Rashad) was a lawyer. This put them in the top few percentage points of the population in education and affluence, and some would criticize the show for making this typical African American family so exceptional. They had five children, again more than the norm, ranging in age from Sondra (Sabrina LeBeauf), a student at Princeton, to little Rudy (Keshia Knight Pulliam). Malcolm Jamal-Warner played the only son, Theo; Tempestt Bledsoe's Vanessa was the middle child, and Lisa Bonet as Denise spun off her own series as she went to college in the fall of 1987 in *A Different World* (NBC 1987–1993).

Cosby explicitly positioned his program as an answer to the representational stereotypes that had confined African American characters and families on television and radio. As Herman Gray puts it, "The Huxtable family is universally appealing, then, largely because it is a middle-class family that happens to be black" (Gray 1995, 80). Though references to the family's special status as African Americans might be incorporated subtly in the show—African art on the walls, posters of Martin Luther King and Frederick Douglass, showcasing black music and musicians—almost never was the issue of race

discussed directly. Nor were the contradictions of race and racial politics on U.S. television ever acknowledged. Gray points out that this became painfully apparent in April 1992 as *The Cosby Show* exhibited its familiar happy domesticity even as other channels carried news coverage of the bloody, destructive Los Angeles uprising. "The televisual landscape that evening dramatically illustrated that no matter how much television tries to manage and smooth them over, conflict, rage, and suspicion based on race and class are central elements of contemporary America" (Gray 1995, 15). *Cosby*'s world began to seem like wish fulfillment for both black and white viewers, imagining a world free from the pressures of racial power and economic struggle, cocooned within private family concerns. As wish fulfillment, it was supremely effective, remaining at the top of NBC's ratings comeback for 8 years, four of them at number one. *The Cosby Show* won the Viewers for Quality Television's Quality Comedy Series award and the Humanitas Prize in 1985 and 1986; and during its first 6 years it was nominated for 18 Emmys, many of which it won.

The Carsey-Werner team struck gold again in 1988. This time it wasn't race but class that provided the twist: If the Huxtables had contained their racial difference within the reassuring framework of upper-middle-class achievement, consumption, and values, *Roseanne* (ABC 1988–1997) showed that the category "white" had its differences as well. Though in some ways resembling *All in the Family* in its ironic embrace of working-class life, *Roseanne* put a loud-mouthed overweight white woman at the center and immediately brought the basic pieties of the middle-class family into question. A woman who could claim, "If the kids are alive at five, I've done my job" was a far cry both from the June Cleavers of an earlier decade and from dim-witted domestic saint Edith Bunker—and an equally long distance from that paragon of domestic and professional success, Clair Huxtable.

The "domestic goddess" character developed by stand-up comedian Roseanne (Barr, Arnold, then just Roseanne) was smart, smart-mouthed, aware of her class status, and the dominant member of the household. Married to hapless Dan Conner (John Goodman), a sweet-natured but less-than-successful mechanic and building contractor, Roseanne presided over a family of three underachieving kids, a nasty mother, and a chronically unemployed sister. Roseanne herself at first worked on the factory line at Wellman Plastics; she then became a waitress, helped Dan in the motorcycle shop, and went into business with sister Jackie to run the Lanford Lunch Box. The program featured the characters at work as much as at home—unlike most domestic sitcoms—and showed a family made up of less-than-attractive, overweight, under-consuming individuals with untidy older homes, beater cars, chaotic family lives, and a lack of ready cash. This approach was refreshing in television's consumption-oriented universe!

The show's credits list not only Roseanne but also Matt Williams as creator-writers, and Roseanne, Marcy Carsey, Tom Werner, and Tom Arnold (Roseanne's then husband, from whom she was divorced in 1994) as lead producers. Carsey and Werner moved on to other projects early in the show's run, Williams moved on to *Home Improvement* in 1991, and *Roseanne* proceeded to go through more producers, writers, and directors than any comparable show. And though the program moved to the top of the ratings immediately and stayed there for 8 years, it was somewhat slighted by the awards. Critics' reviews were slightly disapproving, even as they praised the show's irreverence and in-your-face humor.

Roseanne took on many issues and subjects that other comedy series feared to touch. As many critics have noted, one of the program's greatest innovations was simply to focus on the issue of money—as in not having enough of it. Like most actual American families,

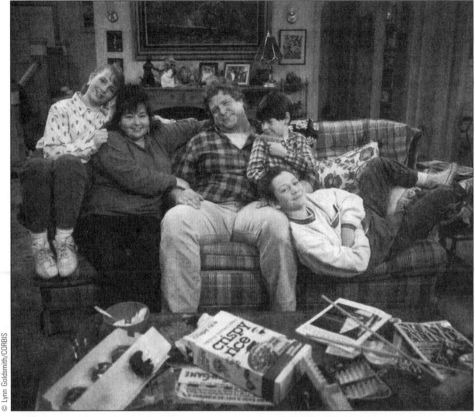

© Lynn Goldsmith/CORBIS

Roseanne not only brought an unashamedly working-class family, with working-class concerns, to television, it also enthusiastically skewered the middle-class pretensions of previous television comedy.

as opposed to those on TV, the Conners knew what it was like to be unable to pay the bills, get hassled by the boss when a child's school problem means taking a few hours off work, be fired, lose a business, kowtow to imperious bosses and customers, try to figure out the income tax form, to be unable to buy the kids the toys and clothes they ask for. This frankness about money broke the one, rock-hard, unspoken rule of American consumerist television. Maybe we were not living in the best of all possible worlds; maybe the TV consumer's paradise was not open to all, except in fantasy. Throughout, Roseanne's transgressively dominant, outspoken, convention-flouting behavior remained central to the show's focus.

The Conners were not the only working class family on network TV in the early 1990s. Perhaps the most revolutionary of all was the one still around in 2005: *The Simpsons* (Fox 1989–). James L. Brooks, MTM alumnus and producer of *Taxi* and *Lou Grant,* sought out cartoonist Matt Groening, creator of the syndicated comic strip *Life in Hell,* to produce a series of short animated segments for his *The Tracey Ullman Show* in 1987, airing on Fox. In 1990 Groening's creation became a regular series on the upstart network, reflecting Fox's edgy programming strategy and in particular its appeal to young audiences. When Fox moved the show from its original

Sunday-night time slot to compete head to head with *Cosby* on Thursday nights, a truly interesting contrast arose. The Simpsons were just about everything that the Cosbys were not.

Hailed as "the only real people on TV" by *Rolling Stone* magazine (Zehme 1990), the Simpsons' yellow skin and blue hair did not impede their ability to create biting social satire. Homer Simpson stood resolutely for every transgressive value in the American armament, from his beer drinking to his fixation with doughnuts to his extremely casual relationship to his job as a nuclear power plant inspector. Marge, his wife—she of the towering blue beehive—may have had her heart in the right place but presided over a household more dysfunctional than anything the Conners could have imagined in their worst nightmares. Bart Simpson became the spike-headed antidote to all those generations of too-good-to-be-true TV sitcom kids, in the first season even sparking a teacher's boycott against his anti-school attitude. Lisa often provided opposition in her family through her basic commonsense ideas; but she enjoyed the hyper-violent antics of the cartoon within a cartoon show, *Itchy and Scratchy,* as much as her brother did. Maggie defied every convention of the unhealthily articulate TV sitcom kid by never uttering a word.

Surrounded by a world of satirically overdrawn characters—Mr. Burns, the boss from hell; Apu, the Indian immigrant convenience store owner; Ned Flanders, the much too cheerfully over-religious next-door neighbor, and many more—*The Simpsons* gave a stellar writing cast the opportunity to lampoon almost every element of American family and cultural life. Over 94 writers are credited on imdb.com at last count—admittedly, over a 15-year span—and they include names such as headwriter Al Jean (*It's Garry Shandling's Show, The Critic*), Thomas Chastain, the novelist; David Isaacs (*M*A*S*H, Cheers, Frasier*), Conan O'Brien (*Late Night with Conan O'Brian, Saturday Night Live*), and Sam Simon (*Taxi, Cheers, the Drew Carey Show*). A considerable number of them count *Saturday Night Live* in their credits. John Schwartzwelder, formerly of *Saturday Night Live,* has written more episodes than anyone else has. At once, *The Simpsons* began racking up awards, starting with an Emmy for Outstanding Animated Program in 1990, 1991, and 1992, and winning again in a solid sweep from 1995 through 2003—pity the poor animated program in competition against it. Its various contributors all have lengthy rosters of prizes for their work as well. A special Peabody Award in 1997 praised it "For providing exceptional animation and stinging social satire, both commodities which are in extremely short supply in television today."

Indeed, as Matthew Henry points out, *The Simpsons* "works against the tradition of the family sitcom by deconstructing the myth of the happy family" (Henry 1994, 269). In the "There's No Disgrace Like Home" episode, a company picnic (where Marge gets drunk on the spiked punch) points up the Simpsons' difference from the normal, happy families around them. Peeking through a window on the way home, they observe a tableau straight out of a fifties sitcom of a family seated around a dining room table:

HOMER: *Look at that, kids! No fighting, no yelling.*

BART: *No belching.*

LISA: *Their dad has a shirt on!*

MARGE: *Look! Napkins!*

BART: *These people are obviously freaks.*

Homer decides that they need to attend family therapy, where they all end up gleefully giving each other electric shocks. Henry also remarks on the show's intertextuality, including "material

from all aspects of the cultural terrain, from film, television, literature, science fiction, and other comics, to name a few" (Henry 1994, 268). This quality allows the show to operate on several levels, much like the later *Dragnet* did for youth and parents; *The Simpsons* appeals to younger audiences and highly sophisticated adults at the same time, by allowing readings on multiple planes. In one 1993 episode, "Rosebud," Mr. Burns's childhood stuffed bear, Bobo, plays the part of the sled in Orson Welles's famous *Citizen Kane.* At Burns's birthday banquet, the Ramones perform, and the movie references in this episode alone include *Kane* as well as *The Wizard of Oz, Robocop, Conan the Barbarian,* and *Planet of the Apes.* Other episodes lampoon public access and tabloid TV ("Homer Badman"), the Hollywood blacklist ("The Front"), TV celebrity ("Bart Gets Famous"), and anti-TV violence campaigns ("Itchy and Scratchy and Marge"). Many sly and witty references to television culture itself make the program a worthy heir of the self-reflexivity of radio and TV shows from *Jack Benny* to *Roseanne.*

Besides critical acclaim not only in the United States but also around the world, in the hundreds of nations in which it has aired, *The Simpsons* has inspired an exceptionally loyal and vocal fan base—not to mention an extraordinary success in ancillary products. One of the first programs to spin off a wide range of program-related products, *The Simpsons* marketed lunch boxes, beach towels, T-shirts, books, comics, games, trading cards, toys and action figures, and of course recordings and DVDs. *Simpsons* fans take their program seriously: The Simpsons Archive website (www.snpp.com) provides a bibliography of "every magazine and newspaper article mentioning *The Simpsons*" from 1989 to 2001. There are a lot of them. Finally, its continuing satire and pointed commentary on contemporary society—its values, hypocrisies, manners, insanities, organizations, people, and politics—earned *The Simpsons* its Peabody in the way that only a cartoon can—what David Berkman calls its "visually unreal" aesthetic that leads to a very real relevance and critique.

The networks' official emphasis on quality television built up a string of excellent programs that were also serious hits in the competitive TV business of the new multichannel environment. *Roseanne* sparked a genre of comedies based around stand-up comedians, such as *Home Improvement* (ABC 1991–1999) with Tim Allen, *Grace Under Fire* (ABC 1993—1998) with Brett Butler, *Ellen* (ABC 1994–1998) with Ellen DeGeneres, and the runaway hit of the mid-nineties, *Seinfeld* (NBC 1990–1999). Ellen DeGeneres made history by coming out as gay, both in real life and in character, before millions, in a funny and controversial lesbian story line that the show explored in its last two seasons. Fox led a virtual revolution in black stand-up comedy with Martin Lawrence in *Martin* (1992–1997), the various comedians led by the Wayans brothers and sisters on *In Living Color* (1990–1994), *Sinbad* (1993–1994), *The Jamie Foxx Show* (1996), and one of the first Latino comedy shows, John Leguizamo's *House of Buggin'* (1995). ABC took this trend to higher ratings in *Hangin' with Mr. Cooper* (ABC 1992–1997), featuring comedian Mark Curry as an Oakland, California, substitute schoolteacher. The success of *The Simpsons* led to a new interest in prime-time animation, with shows including *King of the Hill* (Fox 1997), *Futurama* (Fox 1999), *Family Guy* (Fox 1999), and *South Park* (Comedy Central 1997). Older women overcame decades of limited and excluded representation in highly rated programs like *The Golden Girls* (NBC 1985–1992), featuring Bea Arthur, Betty White, Rue McClanahan, and Estelle Getty; *Murphy Brown,* starring Candice Bergen

(CBS 1988–1997); *Designing Women* with Dixie Carter, Delta Burke, Annie Potts, and Jean Smart (CBS 1986–1993); and *Murder, She Wrote* (CBS 1984–1997), starring Angela Lansbury—one of the very few hour-long detective series to star a woman, much less one of Lansbury's years. That three of these programs were on CBS illustrates why that network's demographics skewed older and how they had learned to appreciate that skew.

Trash TV

Yet even as the networks celebrated such successes, a new type of program began to emerge in the fringe hours of prime time during the late eighties. Along with the booming daytime talk shows, it would become the target for criticism in the decade's quality television fetish. Known as tabloid TV (or sometimes simply trash TV), these programs deliberately blurred the hallowed boundaries between fact and fiction, news and entertainment, talk and drama to create a much-disparaged but highly popular format. Led by the syndicated popular tabloid *A Current Affair* (originally on Fox 1987), a half-hour newsmagazine show hosted by Maury Povich that focused on crime, sex, celebrities, and scandal, it was joined by King World's *Inside Edition* (1988–) with Deborah Norville, Paramount's *Hard Copy* (1989–1999), and Fox's *The Reporters* (1988–1990). These shows mimicked the format of serious newsmagazines like *60 Minutes* but used dramatic music and recreations, sensationalized reporting, and a focus on the bizarre, scandalous, and sensational.

As a somewhat more benign but still threatening variation, the so-called reality-based shows on which Fox had built its fledgling schedule by the early nineties included *America's Most Wanted* (Fox 1988–), *Cops* (Fox 1989–), *Real Stories of the Highway Patrol* (syndicated by New World 1993), *Unsolved Mysteries* (NBC 1988–), *Rescue 911* (CBS 1989–1992), and *Sightings* (Fox 1992–1993, then syndicated 1994–). These shows often mixed "actuality" footage with dramatized recreations, in a manner that unsettled the conventions of traditional journalism. *Sightings* transgressed further by reporting seriously on paranormal activity, like UFO sightings, encounters with aliens, ghosts, and near-death experiences. But they laid the groundwork for the reality show craze that in the late 1990s would hit not just the United States, but the world. MTV picked up on a mixture of Fox-style reality and the tradition pioneered by *An American Family* back in the early seventies by premiering *The Real World* in 1992, created by Mary-Ellis Bunim. The initial series, set in New York City, put 7 twenty-something people from varying backgrounds into a house and watched them interact, with a mixture of 24-hour-a-day cinema vérité realism and such semidocumentary techniques as straight-to-the-camera confessions, coached situations, and selective editing—often selected, in this case, for melodrama. A second and third season in Los Angeles followed, and the show's franchise—and global influence—was established.

At the same time, popular entertainment-industry news shows like *Entertainment Tonight* (1981–) and *Extra* (1994–) provided information that people wanted, despite others' claims that these shows did not uphold news standards. As their ratings began to rival those of traditional news programs, an outcry against declining journalistic standards, sleazy profit-mongering, and the abominably poor taste of the viewing public once again was heard across the land. But the trappings of "factuality"—of reporters, interviews, and news footage—at least brought an aura of authenticity and seriousness to many of them. It is no coincidence that most of these tabloid shows were syndicated.

While the networks continued to resist the blurring of the lines (or so they claimed), local stations avidly snapped up programs that would bring them increased ratings. As *60 Minutes* producer Don Hewitt commented, "For years the networks prided themselves that they would never go tabloid. What's happened is that the local stations have gone tabloid without us—they all buy these shows" (Waters 1988, 72). In fact, based on content it would have been very hard to distinguish the tabloid shows from the network newsmagazines. And in syndication on daytime schedules across the nation, an atmosphere of social chaos and moral abandon seemed to proliferate uncontrollably.

Connection The Return of Unruly Women

In the beginning there was Merv. And Merv Griffin begat Mike Douglas, and they begat Phil Donahue. Focusing on celebrities and experts, with a studio audience whose participation was encouraged yet restricted, the world of the daytime talk show in the seventies and early eighties was a comfortably masculine, controlled sphere of civil conversation, where controversial or personal issues might intrude but both guests and audience were kept in check by an affable, paternal host. But in 1985 something happened to shake up this relatively staid world: The unruly women arrived. First Sally Jesse Raphael took her popular talk-radio show to television; she was followed shortly by Oprah Winfrey, who'd had early success on local TV in Chicago. Daytime talk had always been directed to a primary audience of women—women who worked at home, usually understood to be housewives with kids in school, who could afford to put up their feet for a little while and indulge in some mildly titillating voyeurism and gossip, mixed in with more serious civic-minded fare that was good for them. But with Sally Jesse and Oprah at the helm, things changed: Now women controlled the talk, picked the topics, allowed their studio audiences a greater role in the proceedings.

Talk of sex, of spousal abuse, of mother-daughter relationships, of date rape, and incest began to be heard across the land. Oprah Winfrey seemed to have accomplished the impossible: An African American woman, overweight and from a working-class background, she had through persistence, personality, and creativity alone broken into an arena where few women, much less black women, had gone before. Like Mary Margaret McBride, she started locally, formed her own company (Harpo Productions), lined up sponsors, and sold her show in syndication station by station, usually occupying a spot in the overlooked morning hours. By 1987, *The Oprah Winfrey Show* (1986–) had begun to pull ahead of *Phil Donahue* in the ratings, ranking third out of four hundred syndicated programs on the air and with an average nationwide rating of 10.7, compared to Donahue's 7.9. When she negotiated a move to more favorable afternoon slots in 1988, Oprah's ratings shot up further.

By that time, more talk-show entrants had emerged on the scene. Journalist Geraldo Rivera debuted with *Geraldo* in 1987. Rivera had reported for the ABC newsmagazine show *20/20* but had left the show in 1985 when its producers refused to air a segment on Marilyn

Monroe's personal life. After a few failed ventures (like the ill-fated "Mystery of Al Capone's Vaults," in which it was revealed, live and after much hype, that the mobster's vaults had nothing very interesting in them), Rivera turned to the talk-show format. When Rivera's nose was broken in a fight that erupted on his show between groups of black activists and white supremacists, the talk show had arrived at its new phase: It had become a new form of dramatic realism, a site for the energetic and creative performance of all the pathologies, hypocrisies, repressed experiences, and strange variations of life in the United States. Fueled by the proliferating television abundance in the late 1980s, competition heated up further. Over the next 5 years, more than 25 new talk shows would come onto the air, struggling to stay alive by targeting different audiences, featuring ever-more-sensational topics, and encouraging the kind of "confrotainment" heralded on *Geraldo.*

Yet, even the four-way competition of Oprah/Sally Jesse/Phil/Geraldo in 1988 was too much for some critics. Normally fairly liberal writer Tom Shales of the *Washington Post* waded into talk-show waters with a resounding condemnation:

> "Talk Rot infests the airwaves and pollutes the atmosphere. Where TV's daytime talk shows once dealt, at least on occasion, with serious social and political issues, they now concentrate mainly on the trivial and the titillating. Hours and hours are frittered away on shock, schlock, and folly." (Shales 1988)

Linking the new daytime talk to Reaganite deregulation, declines in viewership for respectable nightly news programs, low voter turnouts, and a general apathy for real, serious public issues, Shales gave some examples of the kinds of trivial, personal, meaningless topics taken on by Oprah and her ilk: wife beating, subservient women, transsexuals and their families, marital infidelity, teenage prostitution, gays and lesbians, battered women, and declining literacy. Huh? These are the "trivial and frivolous" topics, that "hid[e] all that is real and relevant" (Shales 1988)? Admittedly, these subjects were found in a mix that also included makeup tips, dieting advice, bad dating experiences, male strippers, and shopaholics; but what was it exactly that so upset social critics like Shales and those he turned to for support, like Ralph Nader and Andrew J. Schwartzman, director of the Media Access Project?

Cultural analyst Jennifer Wang argues that it was precisely the invasion of the once-sacrosanct masculine sphere of talk TV by women and minorities that provoked outrage and disgust (Wang 2000). By taking topics previously regarded as personal and private, and hence unsuitable for public discussion, and pushing them into the limelight, these shows carried on the political philosophy of the civil rights and women's movements—the personal is political—in a way that many defenders of the old definitions found hard to recognize. That it was being done not in the authorized forms of serious news, discussion, and documentary but in a setting that encouraged emotion, drama, audience participation, and sometimes violent reactions and name calling made the sudden proliferation of chaotic talk shows seem to some to mark the decline of Western civilization itself. And worse, such critics felt, they were dominated by women and people of color, both behind the microphone and in front of it. If this was democracy, it wasn't the kind that many authorities were anxious to endorse. And yet the rush to talk continued.

By 1992, Oprah, Phil, Sally Jesse, and Geraldo had been joined by Jenny Jones, Montel Williams, Maury Povich, Joan Rivers, Vicki Lawrence, Jerry Springer, and Regis Philbin and Kathie Lee. By 1995, a host of others had gotten in on the act, including Bertice Berry, Les Brown, Ricki Lake, Suzanne Somers, Dennis Prager, Marilu Henner, Jori Stewart, Susan

Powter, Rolonda Watts, Carnie Wilson, Tempestt Bledsoe, George Hamilton and Alana Stewart, and Gordon Elliot, all with their competing niche or shtick. By the end of the year there were 22 daytime talk shows on the air, with hardly a WASPy male face among them. Some would catch on; most would fail. Ricki Lake focused her show around the younger audience, targeting the 12–24 age group, and by November 1994 she was second only to Oprah in the ratings. Susan Powter focused on health and fitness. Several, like Regis and Kathie Lee, harked back to a more *Today*-oriented program. Others, like Jerry Springer, former mayor of Cincinnati, hopped wholeheartedly on the confrotainment bandwagon.

These were the glory days of trash talk, as frequently incredulous commentators pointed out. Shows had topics like "Mothers Who Don't Like Their Kids," "Call Girls and Madams," "Men Who've Been Raped," "Men Obsessed with Younger Women," and "Housewife Communists" (on *Oprah*); "Dialing for Sex," "UFO Rap Session," "Real Lives of Dirty Dancers," "Cats and Dogs on the Couch" (on *Geraldo*); "Interracial Lesbian Couples," "The North American Man-Boy Love Association Controversy," and "Sleeping Disorders" (on *Phil*); "Women Who Use Men and Throw Them Away" (on *Sally Jesse*). The National Registry of Talk Show Guests sprang up to serve as a central clearinghouse for people who felt their lives or situations warranted national television attention. Many seemed to be folks interested mainly in pursuing a career on TV. Some frauds were perpetrated, on audiences and perhaps on the hosts, as actors turned up in different "real-life" roles on different shows, some people made careers out of colorful audience participation, and many guests felt cheated by the way they were misled and misrepresented on the air. By the early nineties, a few cases such as the *Jenny Jones* guest who shot and killed another (who had revealed his love for him on the air) made these practices seem dangerous.

As the crowding in the daytime competitive scene edged programs ever closer to the transgressive borderline, lower ratings resulted for everyone. By 1994 even *Oprah* had declined since the previous year. To reverse the trend, she announced that her show would begin moving in a more positive direction, resisting the slide toward sensationalism and sleaze that had become more pronounced in recent months and redirecting itself toward more upbeat and family-oriented issues. Winfrey's decision might have been partially inspired by the controversy heating up on the political scene. As Wang describes, in 1993 the conservative think tank, Empower America, was organized to help the more conservative wing of the Republican Party regroup and rethink itself in the wake of the Clinton victory of 1992 (Wang 2000). Taking up the family values rhetoric used by Republican candidates in the recent elections—most notably Dan Quayle in his famed Murphy Brown speech—Empower America, under the unofficial direction of William Bennett, decided to make popular culture the stage on which it would fight the war of conservative ideology. Taking on the rap music business first, Empower America members led an investigation into the cultural pollution they claimed rap music had produced. The campaign, directed not at the hoi polloi of the actual audience for rap but at responsible (white, male) media industry executives, actually led Time Warner to sell its rap-oriented record label in 1995. With this success under its belt, the group launched a new campaign in October 1995 against the forces of trash talk.

Exempting Oprah Winfrey in recognition of her new direction, they targeted, again, not the hopelessly lowbrow audience but the companies that produced and sponsored such programs. Bennett joined with Senators Joseph Lieberman and Sam Nunn to put out a

series of press releases that vilified talk shows for their "parade of pathologies and dysfunctions that trash talk TV continues to thrust into the public square," where "indecent exposure is celebrated as a virtue" and "the housewife gets to vent like a House member" (Wang 2000). One of their main charges was that talk shows worked to wildly distort Americans' view of what was normal and real. Talk shows allowed seemingly normal people, "who look and talk just like the audience's friends, family and neighbors," to speak openly about taboo subjects like incest, adultery, and homosexuality and thus "take the abnormal and make it acceptable" (Wang 2000).

Frequently using language that made veiled references to the (feminine) gender and (nonwhite) race of the people featured on talk shows, these conservative critics linked the proliferation of such shows and the topics they discussed to moral decay and race and class mixing. One article, written anonymously in the conservative forum *The National Review* and titled "Polymorphous Perversity," pointed out an aspect of the shows that even Bennett and Lieberman had not taken fully into account: "the shows offer a window on the future of diversity-dominated America. These talk shows are the only national forum in which blacks, Hispanics, and trailer-park WASPs freely join together with the ground rules drawn from Diversity Theory. No thought or desire is ruled out as unacceptably perverse" ("Polymorphous" 1995). This nightmare vision (for *The National Review*) of the future, of America's underclasses coming together freely without the ground rules that the more privileged would like to impose on them, clearly indicates the social position from which these criticisms came. Others, a little less tied to conservative family values, put it slightly differently: "Tabloid America is also democracy in action . . . the public as a whole is getting almost exactly what it wants. The channel changer is a kind of ballot box" (Alter 1994, 34). Or maybe it was just America performing itself.

Whether because of Empower America's political criticism or because of their own ever-growing numbers, by late 1995 talk-show ratings were down, and more of the entering programs emphasized a cleaned-up agenda. Fallout ensued, and by the time *The Rosie O'Donnell Show* debuted in 1996 as a new, squeaky clean alternative to the tide of sleaze, more than half of the previous shows had left the air. Wang analyzes how O'Donnell's image was carefully manipulated to emphasize her wholesome status as a mother and good girl next door (never mind that she, like Murphy Brown, was a single mother). Her program would emphasize family-friendly fare centered on celebrities and show business, more like the *Tonight* show in the daytime than either *Oprah* or, God forbid, *Springer*.

Yet not even O'Donnell's indisputable success and Oprah's new attention to book clubs and therapy have completely removed talk shows' disruptive potential. Jerry Springer is still in there swinging, and Sally Jesse Raphael continues the kind of personal-political talk she initiated in the seventies. Geraldo Rivera switched to political commentary on *Rivera Live* on CNBC, and news-oriented talk became the growth area of the late nineties—sparked by the trashy, tabloidy sex scandals of the Clinton second term. The line between serious news and trashy talk would wobble precariously, then collapse completely, as the nation considered such matters as the definition of sexual intercourse and exactly what distinguishing private characteristics the president might have. Real life turned out to be more abnormal than the trash talk shows could imagine. But these things were yet to come.

TV and Changing Culture around the World

It was not only in the United States that television in its new forms played an increasingly important role in changing cultures. Although influences from outside, via satellite television, made an impact, the renegotiations of power at home often affected people most deeply. In Taiwan, a nation that from the beginning combined commercial economics with tight control by the government, cable television was the first medium to break through the political and economic homogeneity that its system had enforced. Competing national identities—native Taiwanese, those oriented toward mainland China, and a lingering Japanese influence—led to a strongly varied media system once liberalization had taken effect. One group able to negotiate these tensions to find a stronger voice than traditionally possible was Taiwanese women, whose stories and social roles came suddenly to prominence after decades of submission and silence. Though television is only one social arena in which this form of cultural resistance took place, it was a crucial one for women because it allowed them a voice in a changing society.

Connection Taiwan Television and Hsiang-tu Hsi

Taiwan's first television network, TTV, was managed directly by the Taiwan Provincial Government, even though its primary financing came from several commercial banks. The second television network, CTV, went on the air in 1969 with the backing of several radio broadcasting companies under the aegis of the ruling political party, the KMT. A third channel, CTS, with a primarily educational role, was operated jointly by the Ministry of Education and the Ministry of Defense, with private business investment providing the necessary capital. This triad of networks alone served Taiwan until the late eighties; all three were highly profitable enterprises supported by the sale of advertising time, with revenues going back to the state interests that owned and managed them while paying dividends to their private investors. An extremely tight link of government and economic authority thus dominated broadcasting and kept all other competitors out. Though all three developed popular programming forms designed to draw audiences in and keep profits up, the close relationship with ruling party and government objectives tightly restricted content. As media scholar Szu-Ping Lin writes, "It was . . . an apparatus that protected the interests of the political regime" (Lin 2000).

The politicization of Taiwan's broadcasting system was only exacerbated by the state of martial law that existed in the country from 1949 until 1987. The ruling KMT party, which had been exiled from mainland China after being defeated by the Chinese Communists, struggled to maintain its small country's independence and identity as the true Chinese nation. All high network personnel came from the party or from the government, and television served as an important political tool to achieve three primary goals: to ensure Taiwan's national security, to fight against Communist ideology, and to focus

opposition against the mainland Chinese, who continuously threatened to take Taiwan back into their fold.

An important part of this mission was the cultural task of promoting Chinese identity in Taiwan. This identity was in opposition to the culture and traditions of the native Taiwanese, who had lived on the island before its takeover by Chinese exiles, as well as to the lingering influences of Japanese culture from Taiwan's long period of Japanese rule. Native Taiwanese culture represented a threat to the KMT's nationalistic goals, and as Lin writes, the government, along with its broadcasting system, worked hard to suppress it: "While the traditional Chinese culture was regarded as orthodox and noble, the native Taiwanese culture—including drama, music, and many other forms of folk art—was considered crude and less refined" (Lin 2000, 49). This Chinese domination also extended to the promotion of the Mandarin language above all others. The use of native Taiwanese dialects—Minnan and Hakka—was discouraged, particularly after 1972, when the central government passed laws that mandated the gradual phasing out of dialects on television and forbade the mixing of dialects within programs.

However, beginning in the early 1980s, democratic social reform began to take shape in Taiwan. In 1987 martial law was lifted and democratic elections were held. In 1991 President Lee Tun-Hui, of native Taiwanese extraction, became the elected leader. This election was highly symbolic because, as Lin points out, native Taiwanese identity and culture had become closely connected with democratic reforms (Lin 2000). The reform process had been aided by the explosion of cable television in Taiwan in the late 1980s. Though strictly illegal, hundreds of illicit satellite receivers began receiving imported television channels and providing low-cost cable service to households in major cities. Some cable channels began to provide original Taiwan-produced programming, much of it taking an oppositional stance to the martial government. In particular, the Democratic Progressive Party (DPP), by 1991 Taiwan's major oppositional group, owned more than 28 cable stations and used them to break through the ruling party's broadcast monopoly. Pirate cable was profitable, too, as advertisers began taking an interest in this medium that reached an affluent, upscale, and educated audience. Myriad cable companies flourished, though still officially illegal. As fast as the government tried to shut them down, cutting cables and raiding stations, the cable pirates sprang back up. Some companies ran their lines through city sewers to keep from being detected. One DPP cable station named itself Sweet Potato Broadcasting because, as a spokesperson said, "No matter how many times you cut up a potato and bury it, it keeps coming up" (Thomson 1991). The name also made reference to the members of Taiwan's suppressed native culture, who were sometimes irreverently called Old Taro Roots.

Cable pirates put pressure on the established broadcasters to liberalize their political and cultural policies, not least because the central networks were losing audiences and revenues to the upstart alternative. In 1990, restrictions on the use of dialects on television were removed. The most popular type of program in Taiwan had long been the dramatic serial, aired in the 8 to 9 p.m. time slot. Most of the serials centered on historical themes; they emphasized Chinese culture and were produced solely in Mandarin. They focused on the encouragement of traditional Chinese virtues and values, emphasizing the enduring quality and timelessness of Chinese culture while virtually shutting out the history of Taiwan and its native traditions.

But in the 1990s, with the lifting of restrictions, this focus slowly started to shift. The first prime-time serial drama to feature characters speaking both Mandarin and Minnan was *Love,* broadcast on CTS in December 1990, which dealt explicitly with interethnic relations. It was hugely popular, gaining the highest ratings ever for a serial drama, and it sparked a host of imitators. The term *Hsiang-tu Hsi* began to be used in referring to these indigenous dramas dealing with the specifics of Taiwanese life and history, and they became the most consistently popular shows on Taiwanese television for the next decade. Mostly set in rural areas, mostly using the Minnan dialect, Hsiang-tu Hsi dramas dealt with sweeping historical events but with a focus on the family. The family became the site in which and through which historical, ideological, and cultural tensions played themselves out. Because the family in Chinese culture is most centrally the territory of women, the Hsiang-tu Hsi began to address topics related to women's lives, subjects had never before been broached on Taiwanese television. And, too, because the serial dramas' audiences were primarily female, commercial broadcasters wished to attract this group with female-centered story lines.

Family, the lives and actions of women, and oppositional democratic Taiwanese culture and language all came together in these serial dramas and made possible the articulation and discussion of women's social issues in a way previously impossible. And these issues, as Lin points out, became "topics of conversation and discussion in people's daily life." One of the most successful of all was *The Daughters-in-Law,* which aired on CTS from May to December 1995. The subject of the relationship between mothers and their sons' wives has always been an extremely conflicted one in Chinese and Taiwanese culture. In a society in which women's power is predicated on their ability to bear sons for their husband's family, a mother's power is threatened when her son marries. The role of the Chinese daughter-in-law is to be subservient and obedient to her husband's family, until she herself can produce a son and assume a stronger position. A woman never has as much power as a wife or daughter as she does as the mother of a son and as a mother-in-law; a daughter-in-law occupies the bottom rung in the family hierarchy. As Lin summarizes, "the term daughter-in-law in Chinese and Taiwanese cultural vocabulary has . . . become an almost fixed metaphor for someone who is dominated, oppressed, and mistreated and has to attend upon others at a disadvantageous position" (Lin 2000, 102).

As such, the figure of the daughter-in-law in the Hsiang-tu Hsi dramas became a way to talk about the position of women generally in male-dominated Taiwanese society as well as retaining a hint of the relation of the indigenous Taiwanese to Chinese-dominated culture. In a changing society, where an indigenous democratic movement struggled for reform and in which women had begun to demand more rights and power (over 45 percent worked outside the home in 1990), this was a powerful metaphor indeed. Long taboo as a subject of discussion, the attention that the Hsiangtu Hsi brought to the mother–daughter-in-law relationship extended further into issues of expanding democracy for all groups.

Becoming the single most popular dramatic genre in the 1990s, the Hsiang-tu Hsi serials extended their family and female-centered focus into various realms, including the expressly political. Series such as *Tales of Taiwan, Once Upon a Time in Taiwan,* and *The Root* placed women in key political positions in the dramas, counterposing ethnic Taiwanese with mainland Chinese women. Another serial, broadcast in 1996, attracted huge audiences and much cultural controversy—*Shun-Niang: The Women with Broken Palm*

Lines. The title refers to an ancient Chinese belief that a woman with a certain characteristic marking on the palms of her hands—a strong central line breaking the palm in two—brings bad luck onto the family into which she marries and is destined to live a tragic life. Men with a similar pattern are seen as difficult and ill tempered, but likely to achieve success. In a woman, however, the palm markings bring suspicion, mistreatment, and fear. Traditionally, a woman with such palms will be subject to cruel treatment, be able to marry only under highly unfavorable conditions, and live a life of subjugation to others. *Shun-Niang* told the story of such a woman, who fought against the system of folk beliefs and superstition that had condemned her to a lesser life and who succeeded in overcoming the prejudice and discrimination directed against her. She demanded to be able to define herself and what she was capable of and not to be held under the thrall of an unjustified system of false knowledge. Obviously, this theme spoke to the social and political conditions of women generally. It also undermined the validity of traditional ways of knowledge and the power of tradition itself, showing the arbitrariness and emptiness of belief systems that kept women in inferior status.

Besides its high ratings, *Shun-Niang* prompted an outburst of discussion and confession about palmistry and superstition across Taiwan. The production company and network reported receiving hundreds of letters and telephone calls from women with the distinctive broken palm markings; some begged them not to bring attention to the painful topic, some confessed to the mistreatment and discrimination that they had received because of it, and some attested to their own success and good fortune in the face of superstition. A Buddhist social work group, Tsu Chi, offered counseling to troubled women, and the production staff reportedly felt like amateur counselors from responding to calls and personal stories. A formerly taboo topic with deep implications for women's lives became discussable in the public sphere and helped to break through repressive traditions and resist cultural domination. It ran for 40 episodes and created a new high mark for the genre.

Production of *Shun-Niang* itself was unusual in that the series was based on a book written by a female Taiwanese academic whose work dealt with superstitious beliefs and their oppression of women. Its producer, a former television actress, spent several years trying to get the program produced, in the end mortgaging her own home to finance it. Its success vindicated the role that women had begun to play in Taiwanese television production, built on women's role as majority audiences, and confirmed the vitality of the Hsiang-tu Hsi genre with its focus on women's lives. The genre remains a dominant component of the lively Taiwanese media scene today.

Though inclusion in television's representational sphere does not automatically lead to social change or progress, it can be argued that *without* such representation, change is very unlikely to take place. At the very least, public discussion of a topic that had been buried in superstition or ruled to be outside of public concern can lead to a new awareness that eventually can work real social change. Although contrary opinions are also mobilized by discussion, sometimes provoking backlash and negation, recognition in the public sphere of a social phenomenon seems to be the basic prerequisite to accomplishing more political tasks. And where national identity-building norms of state systems work to maintain repressive hierarchies, alternative voices can sometimes break up the discursive logjam and allow debate to flow more freely.

On the other hand, though it is the commercial populism of many systems that has provided competition to hidebound state broadcasters, commercialism itself is no

guarantee of liberalization. As in Taiwan, economic concerns can also stifle speech, especially when it comes to criticism of corporate practices or maintenance of identities that are not commercially viable. When linked too tightly to political power, commercialism can create a system of control and exclusion, incorporating popular forms into the dominant regime. The prospect of this kind of corporatized centralization and control forms the basis for fears of cultural surveillance that are only exacerbated by the potential of new technology. In the early 1990s, these fears centered on the new technology of the Internet.

SOCIAL DISCOURSE: THE NET EFFECT

Lurking in the wings during this period was the new blue-sky technology that, in the grand American tradition of technical fixes, promised to get us out of our current mess and lead us into a brave new world. That technology was the Internet, and we will take up its story in Chapter 12. Though computer scientists had been developing the interconnected web of computers since the late seventies, and those in the know had been exploring its possibilities since 1990 or so, most of the rest of us didn't experience it directly until around 1993. At that point the modem became a standard piece of computer equipment, e-mail spread around the country, the World Wide Web promised even greater interconnection, and universities, schools, governments, and corporations recognized the possibilities it proffered. Structured to be decentralized, open access, interactive, and resistant to centralized control, the Internet harked back to the days of amateur radio in its potential for democratic communication and individual creativity, and many feared that it would meet the same co-opted, institutionalized fate of its older sister. It would usher in the next phase of U.S. electronic media—that of convergence and globalization.

As the industry lost its centralization in the early nineties—as concentration moved behind the scenes, into ownership of mega-conglomerates, while diversity and quantity seemed to proliferate down on the ground—criticism of media and its study and analysis became more diffuse as well. Bill Clinton ran for office with more support from the entertainment industry than anyone since Ronald Reagan. Linda Bloodworth-Thomason and her partner Harry Thomason, producers of several hit shows in the eighties and nineties—like *Designing Women*, *Evening Shade*, and *Hearts Afire*—were FOBs (Friends of Bill) from way back; they produced his effective campaign film, "The Man from Hope." Clinton appeared, playing the saxophone, on the *Arsenio Hall* show, and he used rock 'n' roll tunes for his campaign anthems. His inaugural ball eschewed stuffy pomp and ceremony for the kind of party a baby boomer could appreciate. Republican rivals charged that the liberal media gave him sweetheart treatment (at least for a while) but could hardly complain while they were also trumpeting the effectiveness of conservative enthusiasts like Rush Limbaugh, appearing on the same airwaves.

On university and college campuses, the study of communication became one of the most populous and popular majors. Some studied the media from the social science perspective, turning out analyses of media effects, quantitative content analysis,

socialization studies, media habits surveys, agenda-setting investigations, and explorations of the ties between media and political behavior. The humanities-based study of media increased, bringing new attention to history, aesthetics, authorship, genre, industrial organization, cultural power, and audience use of the medium that had previously been scorned as beneath notice. Women's studies and ethnic studies departments incorporated a consideration of television into their curricula, as a central site in which images and ideas about American culture were produced and circulated. Academic organizations devoted to the study of cultural forms—such as the Modern Language Association (MLA), the American Studies Association (ASA), the Society for Cinema Studies (SCS), the Speech Communication Association (now the National Communication Association), and the Popular Culture Association—began to include television in their sites of cultural expression and analysis. The Museum of Television and Radio in New York and Los Angeles began sponsoring lectures, panel discussions, and satellite-distributed forums where industry leaders and television creators could discuss their work with a nationwide audience.

An increased focus on fan cultures (the often elaborate, creative organizing efforts by avid viewers of certain television programs) began in the late eighties, marked by the publication of Henry Jenkins's influential book, *Textual Poachers: Television Fans and Participatory Culture* (H. Jenkins 1992); and Lisa Lewis's edited volume, *The Adoring Audience: Fan Culture and Popular Media* (Lewis 1992). Far from confirming the image of the passive, feminized audience created by the mass culture theorists of yesteryear, these studies showed that viewers of all ages, genders, races, and stripes used the media actively and creatively to define their own identities, argue about social issues, reimagine worlds that they would prefer to see, and connect with others who shared their interests. Even the most conservative, heavily commercialized media could be turned back on itself, contradicted, disputed, and satirized by fans with entirely different agendas than the show's producers or sponsors might have had. Was this good? Well ... the big argument began to be about where commercialized, corporate control ended and viewer control began. Were we just being distracted by major corporations so we wouldn't notice their domination of our lives and political systems, and their self-serving exclusions and biases? Or with all the competing sources of media so readily available, would there always be a market—with both buyers and sellers—for alternative kinds of information and entertainment?

Here again, the Internet seemed to offer a way out. This focus on fan activity would intensify as the Internet opened up new possibilities for fan communication and interaction. Just as soap operas had always paid attention to audience feedback and reaction, other television programs and companies began to encourage a higher level of viewer involvement via the web. In some cases active fans could extend a show's life when it was threatened with cancellation. This seemed to work particularly well when the subject was of intense interest to a relatively small group that was not compatible with the mainstream. We've already mentioned the case of *The Days and Nights of Molly Dodd*, taken up by Lifetime when NBC canceled it. Viewer intervention caused PBS to pick up for rerun the acclaimed civil rights drama *I'll Fly Away* (NBC 1991–1993, PBS 1993–1994), starring Sam Waterston and Regina Taylor and produced by Joshua Brand and John Falsey.

Perhaps more to the political point, as the nineties progressed some of the issues opened up for discussion first on the reviled daytime talk programs slowly seeped into the sphere of legitimate political discourse. Gay rights came out on the overt political agenda. Sexual harassment, spousal abuse, incest, date rape, AIDS, and the subtle forms of racism in the nineties moved from the hidden world of individualized shame and voicelessness to the light of media attention, study, and institutional and legislative reform. It became okay to talk about such issues in public—surely a necessary first step to getting them recognized as legitimate political issues and surely pioneered in trash talk on *Oprah, Sally Jesse, Phil, Geraldo,* and their imitators. They weren't topics that the high-minded guardians of serious news had been willing to examine in television's more controlled decades.

Television was becoming a respectable medium in which to work, unlike its poor-cousin status in relation to film during the earlier decades. Crossovers between film and television became more frequent and unremarkable for directors like David Lynch, Oliver Stone, Quentin Tarantino, and many others; and most actors worked in both media. Convergence was a fact of life in industry, academic and critical study, and viewership. As the millennium approached, it seemed as though American media and the culture that sustained and depended on it were on the verge of the greatest changes since radio's debut so long ago.

Conclusion

The late eighties and early nineties ushered in the current period of decentralization, deregulation, audience fragmentation, merger mania, globalization, and new programming strategies. The creation of three new over-the-air (OTA) networks brought attention to minority audiences and led to an emphasis on quality programs stressing auteurs on the big-three nets. Cable television became a mature medium, offering competition and alternatives to the networks. Deregulation continued, and both the Fairness Doctrine and the fin/syn and PTAR rules were phased out. A greater concentration of ownership developed, predicated on the notion of synergy and vertical integration. Yet the proliferation of channels and the competition for audiences also led to the introduction of new kinds of content, often shocking and controversial, in the growing universe of daytime TV talk shows and radio's lively discussions. The new family programs took television's familiar family sitcom and reworked it to the transgressive tastes of a more diverse era. In the United States as in other nations, diversification of media produced new program forms that spoke to previously ignored populations. By 1995 the Internet promised to add a whole new dimension to the media industry and to media participation. It would debut in the atmosphere of debate, contradiction, and consolidation that marked the early nineties.

Everything That Rises Must Converge: Regulation and Industry in a New Millennium

In the mid 1990s we entered the age of digital convergence. No sector of life would remain untouched by the forces unleashed when industry, politics, culture, media, and individual lives began in the mid 1990s to mesh with the new digital technologies, their uses, and their consequences. Not that they came out of nowhere, like silver planes bent on destruction out of a clear blue sky. The roots of the new wired world went deep, as we have seen; but they reached a watershed in 2001, on a calm September day, that it will take us decades to understand clearly. Already, it is hard to remember the boom-time spirit of optimism and confidence that preceded the dot-com crash of 2000, followed so quickly by the events of September 11 and the wars, domestic and foreign, that ensued.

Social Context: Falling Down

Perhaps the first dark cloud on the late nineties horizon in the United States came with the downfall of our bluff, confident, good-times President, Bill Clinton. Caught in a sex scandal of his own making, it was hard to believe that the Yale- and Oxford-educated, up-from-the-trailer-park "come-back kid" could have done something so incredibly stupid. And a story that might have been swept under the carpet in a previous age—like the fact of Roosevelt's mistress and Kennedy's White House dalliances—came trumpeting across the new wired networks of uncontrolled Internet and cable news sources, competing wildly in a world where all the old rules had been redrawn. Clinton's eventual impeachment was an anticlimax, but it brought George W. Bush—just barely—into office in 2000, as the enormous inflation of stock market values brought on by tremendous overconfidence in the new digital technologies crashed and burned. As the country groggily began to adjust to a new regime, in politics, culture, and economics, those two planes curved out of the sky and, unbelievably, into the side of the World Trade Center towers as the world watched on CNN. Turns out we'd been fooling ourselves on a number of fronts.

It wasn't long before Army units were scrambled and sent to Afghanistan, on the trail of the Al-Qaeda terrorists believed to be responsible for the outrage. The world did little to interfere with this action; Afghanistan was on almost no one's list of closest friends, and the Taliban regime had been terrorizing its own population for some time. But when President Bush began signaling that his next move was against Iraq (some say as early as June 2002), America's sympathetic allies began to draw aside. As

hundreds of thousands marched in protest, both at home and around the world, American troops marched into Iraq in March of 2003. Initial victory was swift and easy, and the president got some good photo ops. But soon the reality set in. There were no weapons of mass destruction, as most of the world had been protesting all along. There was also no exit strategy, and the years of occupation began to draw out, with great loss of Iraqi, American, and allied lives and no clear end in sight.

Amidst this confusion, the 2004 presidential election loomed. George W. Bush eked out another narrow victory, in a deeply divided nation still getting used to being searched in airports under the direction of something called, eerily, the Department of Homeland Security. A narrow Republican majority controlled, with difficulty, both the House and Senate. A new coalition of religious fundamentalists—Protestant, Catholic, and Jewish, cutting across historical social divides—made their opinions felt as never before, as issues like gay marriage, stem-cell research, and creationism vs. evolution became the battlegrounds of the new millennium. The Internet became the new site of mobilization and recruitment, on all sides, as well as a potential source for privacy invasion and violation of civil rights under the hastily passed Patriot Act.

Since the post–World War II years, the United States and Europe had operated in close alliance, but the events in Iraq began to drive wedges into this relationship, even with our Iraq partner, Great Britain. Partly in response to the new era of convergence—in economics, technology, communication, and population flows—the buildup of the European Union (EU) began to take on political valence as well, as a counterbalance to the aggressive superpower across the Atlantic. The EU common currency (the euro) was introduced in 2002, with Great Britain as the leading holdout. In 2000 European leaders proclaimed their new *Charter of Human Rights;* and in 2004 Cyprus, the Czech Republic, Estonia, Hungary, Latvia, Lithuania, Malta, Poland, the Slovak Republic, and Slovenia all became member states, leaving the big question of Turkey looming. This was indeed a new Europe. But was there such a thing as a European identity? Could people and nations who had spent the last two millennia warring with each other over their geographical and cultural differences really begin to see themselves as "European citizens" in a "United States of Europe?" Clearly, media would play a key role here, and indeed it was partially the new digital media's ability to cut decisively across those boundaries that had made such thinking necessary.

On the other side of the globe in Asia, economic downturn in Japan had pulled back that country's leadership in digital technology and electronics; but it remained the home of several of the world's leading media conglomerates, notably the Sony Corporation. Another site of world communication and cultural production, Hong Kong, went through its scheduled handover from British to Chinese rule in 1998. A newly free-market and open China—economically, if not politically—after the 1989 tragedy of Tiananmen Square moved into position as a major world player, even as it attempted to control some of the resistant political potential of the new communication technologies such as the Internet. A flood of Chinese imports reached Western markets, and China opened up to an influx of goods from the West—many, especially in the area of media, hastily copied and distributed without regard for such matters as infringement of Western copyrights. The age of convergence created the new phenomenon of nations—India, South Korea, the Philippines—with third-world economies but highly educated, technologically sophisticated populations. Much of the first world's software

and engineering work began to move overseas, helped along by globalizing market forces; this movement was met by an equally influential migration of skilled elites to the United States and other affluent nations.

Globalization began to create its own vociferous discontents. Besides the long-fermenting resistance to Western influences behind much of Muslim fundamentalism, placed in the spotlight by the 9/11 terrorists and the Iraq war, such globalizing engines as the World Trade Organization (WTO), the World Bank, and the North American Free Trade Agreement (NAFTA) and their policies attracted increasing protest and rebellion. This dissent came to a head in four days of anti-WTO demonstrations in Seattle in 1999. That same year, farmer Jose Bové drove his tractor into the front of a McDonalds in Millau, France, to protest the use of WTO-mandated genetically modified corn. Free trade between nations, the backbone of globalization, means that individual governments' ability to determine which economic sectors they will support and subsidize, and what foreign businesses or products they will restrict or keep out, becomes captive to larger policies set by international organizations like the WTO and the EU. Large transnational corporations, it is feared, have more power in such venues than do nations themselves, especially smaller and developing countries.

France in particular fought hard for the "cultural exception" to the WTO-proposed free trade in media-related products, which would have allowed American media into European theaters and broadcast channels without quota or control. Here is an example of pressures toward free-market globalization producing the opposite effect: a confirmation of the importance of preserving national media and national culture in the face of hybridization. As one writer put it:

> The "cultural exception" . . . is a strategy of contained resistance, less against a roughshod America than against a seductive America, the country of HHMMS, the "Harvard and Hollywood, MacDonald's and Microsoft Syndrome." . . . It represents the first real conflagration between the idea of globalisation and that of Americanisation. (Frau-Meigs 2002, 4)

Because the rise of digital media meant that its spread across national borders took place increasingly in venues outside the control of national policies, the issue of copyright protection moved to the fore. The United States found itself in the position of arguing that other country's rules shouldn't apply when it came to placing quotas on American movies, music, and so forth; but that American copyright laws should be enforced everywhere, so that U.S. corporations could benefit. This was a hard argument to make, or at least to have taken seriously. However, U.S. corporations are not alone in wanting their media products to make a profit globally, so the issues remained up in the air.

One mark of the millennial decade was this kind of blurring of traditional lines of thinking. What once was right moved left; what had been left took on elements of the right; as blogs (short for *web log*) of every description multiplied on the Internet, there seemed to be an opinion for everyone and a way of expressing it, too. Increasingly, old lines of power seemed to be blurring. Yet the new era of the power of communication and information, dispersed beyond the control of old institutions into increasingly egalitarian hands, didn't seem to affect some types of traditional, "hard" power in its roughest forms: the war in Iraq, atrocities in Rwanda and the Sudan, ongoing conflict between Israelis and Palestinians, seemingly ineradicable poverty and disease in parts

of Africa, Asia, and South America. Clearly the digital age had brought convergence in its wake. How would the world handle it? One of the few certainties was that the media, in its new expanded definition, would play a crucial role.

THE FRAMEWORK FOR DIGITAL CONVERGENCE

Two threads stitched together the media scene as we crossed the border into the twenty-first century and a new millennium. They were the *dispersal of digital media*, from computers to cell phones to digital television to the Internet, and the *convergence of formerly separate media* brought about by the digital revolution. As revolutions go, this one took a while. The first commercial computers appeared, large enough to fill an entire room, in the 1960s. Not until the 1980s did home computers become widely available to the general population, with the IBM PC introduced in 1981, thanks to Bill Gates and his Microsoft Corporation; Steve Jobs and Steve Wozniak weighed in with their groundbreaking Apple Macintosh in 1984. So from about 1985 on, a growing number of households, in the United States and across the world, had access to a form of digital information and data handling.

The term *digital* simply means that information is broken down into a series of ones and zeros and put into a form that can be easily manipulated by the amazingly smart microchips that lie at the heart of every digital device. This distinguishes computers and their many subsequent offspring from older *analog* media like film, radio, television, and audio and video recordings. Analog media rely on a physical replica (or analogue) of a physical phenomenon, like sound or pictures, that can be transmitted or preserved through some kind of physical medium, whether it's magnetic signals on a tape, electronic waves transmitted through the spectrum, or chemical changes on a strip of celluloid. Though the earliest digital media could handle only the simplest kinds of input—numbers or letters typed with a keyboard or from punch cards—by the early 1990s it became possible to convert more complex data—pictures, graphics, music, and sounds—into digital formats. But for the most part this was happening in discrete, specialized environments: the video editing suite, the design departments of architectural and engineering firms, the sound studios of recording companies, the production facilities of print media companies.

The technology that brought sophisticated digital applications together in a vast mélange available to nearly everyone forms the second strand of digital convergence and the culture it created: the Internet. Originated as far back as 1969, when the Defense Department's Advanced Research Project Agency (ARPA) began to look into a way to connect their researchers' computers, the ARPAnet, as it was called, began to serve as a means of both friendly and research-related communication among government and university scientists. In 1972 the first e-mail messages were exchanged (and the @ symbol chosen for addresses), and by 1981 ARPAnet consisted of 213 linked host computers across the country, with a new one coming online about every 20 days.

In 1982 the word *Internet* first appeared, used to define a connected set of networks that used both transmission control protocol (TCP) and Internet protocol (IP): the TCP/IP protocol combined these two protocol layers to form the basic language that computers could speak over the Internet. It essentially controlled the

way that digital messages could be broken up into packets for transmission (via TCP) and could then be reassembled (using IP) at the receiving end. In 1985 the National Science Foundation (NSF) got in on the act, forming the NSFnet to connect super-computer centers around the country via a backbone of telephone and fiber-optic lines, microwave, and satellite links. Many of these computers were at major univer-sities, so the first generation of Internet culture was heavily dominated by the nonprofit sector of government, military, and education, supported by government funding.

By 1988 this new form of connection had spread across the United States and Europe, with over 60,000 computers online. And in 1989 came the development that would speed the spread of the network and make it so user friendly that not just computer geeks could understand it: the development of the World Wide Web (WWW) by a British scientist named Tim Berners-Lee, working in Switzerland. The web was not a separate entity, but a new way of interacting with the Internet. With the web, computers could transmit and download not only data in its simplest form but also whole documents and graphics, in a simple point-and-click format that also allowed for easy links among sites.

Once Berners-Lee and his associates came up with the software to support the new URL, HTTP, and HTML applications, the Internet became far easier to use for a far greater range of materials. In 1992 the first audio and video transmission took place over the Internet, by now consisting of over 1 million host computers. Writer Jean Armour Polly coined the phrase "surfing the Internet," an occupation Americans and citizens across the world were spending more and more time doing. In 1993, when Marc Andreessen and Eric Bina, working at the University of Illinois in Urbana, came up with the web browser Mosaic—a program for accessing and creating web infor-mation that interfaced with graphical computer applications—the web became acces-sible to the general population. That year the White House went online, and the U.S. National Information Infrastructure Act was proposed and passed. Andreessen and Bina joined a new company called Netscape in 1994, which introduced the widely popular Navigator browser (soon to be challenged by Microsoft's Explorer).

With its origins in a widely dispersed set of government agencies, educational institu-tions, and corporate research facilities, the Internet's governance also followed a dispersed model. Private membership organizations like the Internet Engineering Task Force and the Internet Architecture Board jointly made decisions that affected the Internet's growth and technical configurations. The Internet Society (ISOC) was formed in the late eighties to provide an organizational home for the organizations noted earlier, as well as other inter-ested parties—governmental agencies, nongovernmental organizations, corporations, uni-versities, and foundations, and individuals—to provide "leadership in addressing issues that confront the future of the Internet" (from the ISOC mission statement). ISOC was governed by a board of trustees elected by its global membership. This structure reflected the decentralized and international character of the web itself and provided an orientation that was a mix of commercial and nonprofit philosophies. Until the mid-nineties, users were still largely confined to those with ties to educational, governmental, or nonprofit institu-tions; but by 1994, most businesses and corporations were beginning to go online. By 1995 Internet access services like America Online, CompuServe, and Prodigy began to make connecting to the web as simple as making a phone call. The Internet age was upon us.

So what does this have to do with convergence? The Internet itself marks a form of convergence, or coming together, of disparate technologies; by joining computers with

interpersonal communication media (that is, the telephone), print media, film, video, audio, and music, the Internet provides space for information to be collected and accessed in a new form. In so doing, the Internet invents whole new forms of mediated communication and information, from e-mail to personal and institutional websites, from e-publications to e-shopping. It also promotes the coming together of the industries that support such communication and commerce, exacerbating and encouraging the urge to merge that we saw in the eighties and early nineties. When the megamerger of Time Warner and AOL occurred in January 2000, it seemed to mark the millennium in a particularly appropriate way, which we'll consider in the next section.

And the proliferation of digital transmission of information was occurring in other venues as well, leading to convergence in areas only tangentially related to the Internet: in satellite communications, in recording technology, in a new generation of television sets, in cable television, in radio and television broadcasting. From compact discs (CDs) to digital audiotape (DAT) to digital video discs (DVDs) and smart VCRs (DVR and TiVo), from high-definition television (HDTV) to multiplexed standard digital television (SDTV) to WebTV to direct broadcast satellite (DBS) to high-speed cable Internet connection, from video cell phones to iPods to satellite radio (XM, Sirius)—all of these products draw on various forms of industry convergence as well as technological development.

It seems fitting to begin the regulatory section of this chapter with the U.S. legislative act that simultaneously acknowledged—under heavy industrial bombardment—the convergence of interests, technologies, and agendas brought about by the changing technological and commercial scene, creating the conditions to allow that convergence to proceed apace. For the first time since 1934, the federal government engaged in a substantial rewriting of the basic legislation under which electronic media had grown and thrived since their earliest days. Its results would be controversial and far-reaching.

REGULATION: A NEW ACT FOR THE NEW MILLENNIUM

With the passage of the Telecommunications Act of 1996 well behind us, back there in the old millennium, we are living in a media universe that has changed dramatically from the one that legislators contemplated and industries sought to move in various, often conflicting, directions in the mid 90s. Some of the act's most controversial provisions, like the Communications Decency Act, were struck down almost immediately. Others, like the V-chip legislation, remain a part of our everyday experience but have made far less impact, for good or ill, than many predicted at the time. The HDTV spectrum giveaway has moved from a highly suspect insider deal—broadcasters seemed to hoodwink Congress into giving away valuable publicly owned spectrum space for developments that would help the industry more than it would the public—to a damp fizzle, as U.S. consumers still await the full rollout of high-definition TV, and set sales still lag. But with flat-screen digital TV, digital cable, the rise of DVDs, a roaring satellite business, on top of a nation that despite all the HDTV hoopla seems to be happy with the quality of visual reproduction a cell phone can provide—who cares?

The aspect of the act that continues to generate the most controversy is the issue of media consolidation and concentration, largely due to the revitalization of the media reform movement in the late 1990s and early 2000s. An alliance of academics, media

activists, public service media defenders, and citizens groups seeking various kinds of political and social change began to agitate against the loosening of ownership caps and cross-ownership provisions in the bill that created an enormous explosion of mergers in the industry in the late 1990s—and not only in the United States. As critic Robert McChesney states the problem:

> Over the past two decades, as a result of neoliberal deregulation and new communication technologies, the media systems across the world have undergone a startling transformation. There are now fewer and larger companies controlling more and more, and the largest of them are media conglomerates, with vast empires that cover numerous media industries. (McChesney 2001)

Yet the disappearance of diversity and the stifling of a range of opinion that reformers feared is hard to prove, given the considerably greater number of media sources and the actually greater number of major media owners that prevails now as compared to, say the 1960s or even 1980s (Compaine 2005).

The 1996 act definitely accomplished an unleashing of industry convergence. It also clearly exhibited the familiar contradictions of free-market philosophy, conservative style: Liberate the industry, but crack down on content. A summary of the act's major provisions shows this schizophrenia:

- *Ownership* Caps on television station ownership were raised from 25 to 35 percent: No single company could own stations reaching more than 35 percent of the national market. The original versions from both House and Senate had suggested eliminating them altogether; scaling back to 35 percent is one of President Clinton's major saves. But caps on radio station ownership were eliminated at the national level and greatly relaxed at the local. Now a single company could own any number of radio stations nationwide that it wished, with up to eight in the largest markets (over 45 stations) and five in the smallest (fewer than 14 stations). The act also proposed allowing a single company to own up to three television stations in larger markets (revising the old anti-duopoly rule established in 1964) and allowing companies that own a big network (meaning ABC, NBC, CBS, and Fox) to own a second smaller network (like UPN or The WB). The act placed new rules on cable, restricting cable companies from owning properties that reached more than 30 percent of the national audience, and barring a cable operator from filling more than 40 percent of its channels in a given market with those that it owns itself.
- *Cross-Ownership* This avidly desired set of reforms allowed telephone companies to offer cable service in areas where they also provided telephone service. It was intended to spur competition for video offerings and Internet connection in local markets that had been virtual monopolies in both telephone and cable service. Cross-ownership of a television station and a cable franchise was also okayed for the top 50 markets, as was allowing any number of radio stations to be owned in the largest markets by a company with a TV station there. Cross-ownership of newspapers and TV stations in the same market was permitted for cities with more than three TV stations.
- *Broadcast Licenses* The new act extended the term of a broadcast station license to 8 years and streamlined the renewal process by, among other things, barring competitive applications unless the existing license holder failed to obtain a renewal due to license violations.

- *Digital Television* In a highly controversial provision, each existing television station was assigned an additional—and valuable—frequency in the UHF band earmarked for providing digital television services. They were told they would have to give back their old VHF frequencies as soon as digital television reached a benchmark level. It was thought that setting a date of 2006 would allow plenty of time for 85 percent of Americans to acquire HDTV receivers. The date was pushed back to 2008 when that plan proved way too optimistic. Meantime, the dawning digital age meant that broadcasters might use those new frequencies not just for HDTV, but for "multiplexing," or providing multiple channels on a single frequency. If so, many believed that some of the additional revenue—derived from public largess—should be channeled back into the public good, perhaps as a subsidy for public radio and TV.
- *Direct Broadcast Satellites* The Federal Communications Commission (FCC) assumed jurisdiction over DBS services, ending the ability of other bodies, such as homeowners' associations, to bar the installation of satellite dishes.
- *Cable Rates* The Cable Act of 1992 was virtually revoked, removing regulation of rates charged for basic cable and other restrictions.

Many of these new rules were immediately challenged in court, sometimes for being too loose and sometimes, by media companies, for not being loose enough. Yet these deregulatory provisions accompanied a series of efforts to tighten rules on certain areas of broadcast content, specifically those of concern to deregulation's architect Mark Fowler: First Amendment rights. Fowler had used the First Amendment argument—that broadcast regulation fundamentally violated broadcasters' free speech protections—as the backbone of his program for deregulation, but 1996 legislators seemed to want to adopt his marketplace freedoms while placing even greater restrictions on free speech.

- *The Communications Decency Act* This most controversial section of the larger act, later overturned by the Supreme Court, prohibited the transmission of "obscene, lewd, lascivious, filthy or indecent material with intent to annoy, abuse, threaten or harass another person" on any medium including television, radio, cable, and the Internet. The Internet was the main concern here, because the older media already followed fairly rigorous restrictions, and the threat to children was the main argument.
- *V-Chip and Ratings System* This provision required that all television sets sold after January 1999 be equipped with a special electronic chip to allow parents to screen out programs with violent or offensive content. The so-called V-chip required programs to carry a rating, for violent and sexual material, that could be used to trigger the V-chip setting.
- *Must Carry* This rule upheld the must-carry requirement that mandated cable carriage of all significantly viewed local stations within a 60-mile radius of the system. Cable operators had long objected to this rule as a violation of their First Amendment rights.
- *Signal Scrambling* This section of the act required cable operators to provide "lock boxes" that would scramble any portions of their signals that are "unsuitable for children," at no extra cost to the consumer.
- *Cable Right of Refusal* This rule, giving cable operators the right to refuse to broadcast programs that contained obscenity or indecency, was widely perceived to be a strike at public access programming and, as such, against the free speech rights of citizens. It also helped to defuse the cable operators' arguments against must carry.

The Telecommunications Act of 1996 also significantly deregulated the telephone industry, encouraging competition in local markets and allowing local companies to begin providing long-distance service, in a way that had been banned since AT&T's breakup in the 1980s. An enormous scramble to acquire new media properties ensued, as discussed in the following Connection. The field of radio, in particular, saw companies like Clear Channel and Infinity become major stakeholders in stations across the nation. NBC merged first with Vivendi/Universal and then with General Electric; Viacom purchased CBS; and the ABC/Time Warner/AOL merger capped them all. All took advantage of the proposed rule changes—which the FCC had not yet made into actual regulations.

On the public side, a clause introduced into the act by Senators Olympia Snowe and John Rockefeller created a special subsidy for providing Internet access to schools, libraries, and rural health clinics. Called the E-rate, it would be funded by telecommunications companies, which would pay $2.5 billion per year out of their revenues. This measure went a long way to offset one-sided corporate gains, and schools and libraries across the country rapidly scrambled to make use of it. By 2004, an impressive 95 percent of U.S. public libraries offered Internet access, and library usage was up 17 percent from 1998. Even political liberals and longtime advocates of television reform, like Representative Edward J. Markey of Massachusetts, hailed the new law: "This bill breaks down the last remaining monopolies in the telephone and cable industries and makes possible an information revolution" (Carney 1996, 289). Yet the question in many critics' minds was whether a temporary state of competition would lead eventually to even greater risk of monopoly, as the biggest players drove out their would-be competitors until only a handful were left.

Connection Media Ownership Debates

As deregulated merger madness ensued in the wake of the Telecommunications Act, the FCC under President George W. Bush seemed only too happy to accommodate it. Bush appointed Michael Powell, son of General Colin Powell, Gulf War commander and Secretary of State under Bush, to head the FCC in January 2001. Powell's libertarian philosophy and actions frequently made Mark Fowler look like a liberal, and one of his earlier remarks about the world's so-called digital divide (the gap between those with access to digital services and those without) became infamous: "I think there is a Mercedes divide. I would like to have one, but I can't afford one." He believed in opening up previously restricted telecommunications markets to competition, in order to most quickly bring the benefits of the new digital technologies to the public, and he moved quickly to deregulate the telephone industry by bringing in more players and removing old service requirements.

In 2004, when the Janet Jackson Superbowl half-time show ended with costar Justin Timberlake ripping back her costume to reveal—the shock!—her breast, Powell's FCC quickly moved to enforce indecency regulations more stringently, cracking down on such repeat offenders as Howard Stern and making 65 ABC affilliates so nervous that they

refused to air a broadcast of *Saving Private Ryan*. This seems like the typical Bush-era contradition: Liberate industry, restrict free speech. However, it should be pointed out that the commission's two Democratic members, Michael Copps and Jonathan Adelstein, enthusiastically jumped on the indecency bandwagon as well, along with many leftish critics of media conglomeration who should have known better.

And it is true that Powell did block a merger between the two leading satellite TV providers, EchoStar and DirectTV, early in his tenure, arguing that it would restrict competition. One defender claimed, "Powell isn't protecting monopolies out of a belief that bigger is always better. He's looking to create a market where those monopolies will die if they don't respond aggressively to new kinds of competition" (Werbach 2003). But when it came to rules that affected the size and scope of media conglomerates, the reining philosophy seemed to be that bigger was better. In 2003, after two years of study, the FCC issued a report to implement most of the changes proposed by the Telecommunications Act. Under Powell, it had decided that the 35 percent ownership cap was too low—45 percent would be better. By this time, however, the media merger and expansion activity that the act had produced guaranteed that the FCC's rules would get far more citizen attention than the act itself had. Media reform groups sprang up, responding as well to the new antiglobalization sentiments being heard throughout the land. Hearings were held, sparking a revival of the media reform spirit that hadn't been seen since the 1960s: Various critics, public interest groups, academics, and concerned citizens testified to their objections and anxieties, which had been fired particularly by the free-for-all in radio station consolidation in the hands of a few large companies. When the Third Circuit Court blocked the FCC's new rules, arguing that that it hadn't adequately justified some of its decisions, the case went to the Supreme Court. In June 2005 the Supremes refused to hear the case, throwing the new rules into limbo once again (even though America's largest media companies had already acted on them, in many cases). But debates raged.

Critics of deregulation claimed that America's media system was systematically being ruined by greedy corporate behemoths in search of profit. More concentrated than ever, the media was dominated by a handful of major, global firms that unlike the more focused companies of yesteryear owned a stunning array of holdings in every conceivable media field. Besides the big five of Disney (ABC), General Electric (NBC), Viacom (CBS and UPN), News Corporation (Fox), and Time Warner (WB), the roster includes Sony in Japan and Bertelsmann in Germany. These companies scooped up formerly independent movie, recording, cable, satellite, and print enterprises and combined them into huge, synergistic empires, usually along with other business interests that shaped their operations and drove their practices. In radio, Clear Channel and Infinity dominated a field formerly owned by hundreds of small broadcasters. Why was this bad? Objections focused on a few central issues.

- It was argued that the new rules encouraged *concentration* of media power and control in the hands of fewer owners than ever before. This led not only to inordinate power to influence the media, as the following points detail, but also to undue power to influence politics and economic policy at home and abroad.
- This concentration resulted in the *skewing* of news and information to reflect corporate, not public, interests. Corporate owners exercised dangerous powers of control over a wider and wider universe of content, making alternative and oppositional points of view harder to find than ever.
- It led to a *reduction in diversity* of voices, diversity itself being seen as an inherent good in a democratic system. The kind of diversity being referred to varied (and was

frequently not specified) from diversity of viewpoints or content types to diversity of race, ethnicity, age, and gender.

- Consolidation at the national and global level was *driving out localism,* leading to a neglect of local news and culture, again a bedrock necessity for citizens in a democratic state. This refers to local ownership, as well.
- It was argued that concentration produces a *decline in creativity and originality* in programming, driven out by self-serving synergistic practices that favored integrated conglomerates' own in-house products over those from outside. Only bland blockbusters survive.

The whole debate was predicated on an underlying assumption: *Ownership is what matters.* The content, direction, quality, and reliability of media are determined by who owns them, at the highest level. Usually, ownership of the parent company is seen is the primary factor for evaluation, not who wrote, produced, directed, conceptualized, or selected a given program or service.

However, the situation did not always seem so clear to those who analyzed the specific claims being made by such media reformers. The fact of concentration was certainly true—media corporations were larger; they did own more properties than ever before, across all media and indeed across national boundaries—but implied in most of the criticisms was an historical argument: *The situation had gotten worse.* BC—Before Conglomeration—things had been less concentrated, more diverse, more local, more inclusive of a wide range of opinions, more creative. This argument wasn't often clearly made, but it seems necessary: If things were in fact no better at any given time *before* conglomeration, then conglomeration can hardly be the cause. Critics of the current situation would have to look at other potential causes—or examine the effects they were claiming more closely.

One major factor complicating the "conglomerative decline" narrative was the sheer proliferation of media products, channels, and services since the 1970s. From a television universe of fewer than 800 stations in 1970, over 1,500 stations were on the air in 2000, including an increase in educational stations from 185 to 373. The number of radio stations increased from 6,889 in 1970 to 12,615 in 2000, with educational stations going from 413 to 2,066 (Sterling and Kitross 2002, 828). In 1972, only 20 percent of U.S. households could receive more than 10 TV channels; by 1999, 52 percent could receive 60 channels or more (Sterling and Kitross 2002, 868). Newer media technologies, such as VCRs, DVDs, and the Internet have been added on only recently. By 2000, 85 percent of U.S. households owned at least one VCR (Sterling and Kitross 2002, 866). Thus, today's media companies might own a far larger number of media outlets, but their percentage of the overall universe may be in fact actually *less* than the media corporations of former days.

Another way to get at concentration, given this complexity, is to look at the ability of a given media company to command the audience's attention in a given venue at a given time. This measure is also very complex; but taking the universe of television alone, it is true that during the days of the classic network system, the three major networks, each one owned by a different company, could count on 90 percent of prime-time viewership (based on HUT—households using television) between them. Benjamin Compaine (2005) provides figures showing that, between 1960 and 1980, the three networks averaged a prime-time rating of 56 percent of television homes during a prime-time evening (based on the number of homes with a television set, whether in use or not). So each evening over a 20-year period, three corporations had

access to 56 percent of the U.S. public's attention, with virtually no other alternatives for TV-delivered information. This is significant power. Compaine goes on to calculate the similar power of today's five major TV-providing corporations in the United States: Viacom, Disney, GE, Fox and Time Warner, adding together not only their major networks but also all their cable channels. The combined rating of all these company's holdings together in 2003 amounted to 51.2 percent—actually slightly less than the big three received in earlier decades, and spread over more than 37 channels and five, rather than three, owners (Compaine 2005, 11–13). These figures do not attempt to include the fact that today's big five may also own magazines, newspapers, radio stations, movie and television studios that produce the programs, and so on. But yesterday's media moguls also had cross-holdings, as we have seen.

Statistics such as these, though disputable, complicate the claims being made about the dangers of media concentration as we know it, although the dangers themselves remain valid concerns. They throw the basic contention behind fears of negative effects into some doubt. In a universe of more, maybe more *is* more, instead of less. But what about the other claims? Do media conglomerates have more power than ever to skew the news and information we receive; and if they do so, does it work to advance their own corporate needs and interests over the public interest in being able to receive a wide range of opinions over a real variety of important issues? These are major concerns that can probably never be answered definitively. But we do know that in the 1970s, television news consisted of half-hour broadcasts, repeated two or three times a day, by three networks. An average city had only three or four television stations, which might also provide a half hour of local news. By 2000, most Americans could choose from three 24-hour-a-day cable news services and could view a wide array of news and public affairs programs on several networks, including PBS. Other channels, like C-Span and the numerous city government channels available on cable, added to public affairs offerings. More local stations were providing local news, which had become a major profit center for stations by the 1990s. And of course, by 2005 the Internet had become the news source of preference for millions globally, who both consumed and produced it in the form of blogs, podcasts (downloadable audio programs), and online zines.

News ratings were up overall; more people were watching, reading, and listening to more news and public affairs than ever, spread across more channels with a greater diversity of ownership than in 1970. Are today's audiences getting good, fair, inclusive, comprehensive and objective news? Well, have we ever? It used to be, for instance, that the interests of ethnic minority communities, including African Americans and Latinos/as, were ignored in favor of the perceived interests of the white mainstream. Today, several cable channels provide news to ethnic audiences, and local news has also responded to market pressures in a newly competitive environment by becoming more inclusive. And some of the expectations that media critics place on news can be contradictory. It is hard to be objective and at the same time to provide a wide range of views and opinions. The more space there is for both of these goals to be met, the better-rounded news coverage would seem to be. Most media critics would acknowledge the need for more, different sources; Compaine (2005) and others leaning toward the neoliberal camp would say that in fact we do have more different sources, providing a greater variety of viewpoints, than in the past.

Other arguments concern the *quality* of the news, information, and entertainment purveyed in this new media age. Is there sufficient diversity, range, creativity, and localism? Given the proliferation of new channels of programming oriented to different demographics, genres, interests and viewing habits, compared to the three-network system of three decades ago, it

would be hard to make a convincing argument that programs are less diverse and less creative overall, with a more restrictive range of viewpoints, than they were in the 1970s or 1980s. We'll examine this subject in Chapter 13, looking at the expansion of perspectives as well as continuing limitations. Critics on the conservative Christian right, whom we discussed in Chapter 11, would seem to be arguing that indeed, things are way *too* chaotically diverse these days, with a range of viewpoints that they don't at all care for. As for creativity, there is a reason that the best of American television is celebrated around the world, in a way that our older programs seldom were: *The Simpsons, The Sopranos, 24, The West Wing, Friends, The Daily Show;* and the list goes on. Others may decry the impressive proliferation of our current "bad other," the reality show (see Connection in Chapter 13), but clearly many of their fellow citizens find them interesting, rewarding, and fun—and even politically meaningful (and—a little-known secret—the genre was first popularized on European public service television systems).

But what about localism? This is the true innovation, and the basic foundation, of the American system of broadcasting. If local media were to find that they no longer had a place in our media universe, then we would indeed have lost something vital. And it is true that fewer local newspapers are published today than in the past—only one per city, where before four or five might have competed. Cable television is a local medium, franchised in each city and town, but it consists primarily of national channels brought in from afar. However, we should not forget the significant addition of local public, educational, and governmental access channels that cable systems, at this writing, are still often obligated to provide. This is a boost to localism innovated in the 1970s and 1980s. So far, conglomeration has not affected the local systems much, though a few cable MSOs have taken a hostile view, and satellite providers are not required to subsidize such local public goods. Community radio stations have increased dramatically in numbers across the country—perhaps as a response to Clear Channel—many with a substantial array of local news and public affairs shows. And there are indeed more locally licensed television stations on the air than ever before, but the amount of time they spend on locally produced programs has declined across the board. Local news has survived and prospered; but the local children's, variety, public affairs, and sports shows that once proliferated across the schedule have mostly withered away.

The loss of localism took front stage in the debates over radio concentration. Here is where the Telecom Act's deregulation hit hardest—where the rules were most relaxed—and immediately, as we have discussed, the formerly scattered medium began to be bought up by a few large corporations. By 2004, Clear Channel owned over 1,200 stations, about 12 percent of commercial outlets, for about 8.8 percent of the total. Viacom's Infinity subsidiary, the second-largest group, owned 180 stations, for about 1.5 percent of the total. In some small cities, one group owner might claim up to half of the local radio stations. Many, including the companies themselves, asserted that such concentration actually increases diversity of formats; where before six separately owned stations might all complete for the top country-western format, bring in Clear Channel and only one country-western station will predominate, leaving the rest open for more variety. This may not be the best measure of diversity, however. Compaine provides a careful analysis of eight markets of varying size by ownership, to show that the presence of Clear Channel or Infinity in the universe of station group owners has made little difference in the diversity of formats or voices, and he also makes this point: "While critics complain that radio has become more homogenized or less likely to provide local news, there is little recognition of what radio was in the decades between the ascendancy of television and the Telecommunications Act of 1996" (Compaine 2005, 21)—in other words, BC.

Compaine also discusses the increased prominence of public radio, and its main network service National Public Radio (NPR) in today's local markets. With the number of noncommercial radio stations now comprising over 20 percent of the total (up from 6 percent in 1970)—many of them highly local, idiosyncratic community stations—NPR now has 750 affiliates across the country, reaching over 22 million listeners weekly, more than any commercial company outside of Clear Channel. Internet radio, as well, adds substantially to the range available to listeners in any given area, including language minorities. So we can conclude, at least, that conglomeration in the commercial sector has not led to the shutting down of noncommercial options, both local and nonlocal, in the radio sector; in fact, quite the opposite. And if the FCC's low-power radio plan ever comes to full fruition, there will be many more local stations—many of them owned and operated by local religious groups. This may not be exactly what the critics of conglomeration had in mind, but it is local diversity.

Finally, is ownership the determining factor in how a media company produces media? Compaine concludes that ownership can indeed matter—but not in the ways that we commonly think. He cites a study showing that TV stations owned by newspapers tend to produce better news service to their communities ("Does Ownership Matter?" 2003). Over the years, different ownership has made little discernible difference in the content of local news; local ownership did not produce better-quality news. For cultural studies scholars, focusing on the level of corporate ownership in fact erases consideration of all of the more immediate and pressing creative and business influences that go into producing a television program, film, radio show, recording, or performance. A complex web of decisions and creative impulses surrounds each cultural product; people can no more understand *The Simpsons* by looking at Rupert Murdoch (rather than Matt Groening, his writing team, Fox Productions management, audience demographics, etc.) than they can understand John Updike novels by looking at Simon and Schuster. Ownership is a factor, but it is only one factor. If American television has entered into a period of unparalleled creativity and global influence, can media conglomeration be all bad? Maybe, lacking evidence to the contrary, more is more. When was that golden age?

This is not to say that media critics' fears are baseless or unfounded. We *do* need diversity, transparency, creativity, localism, and a wide range of perspectives in our media. These are values well worth supporting, especially in the face of those who would attempt to shut down diversity and suppress freedom of expression—whether corporate, governmental, or private. But we should pick our fights—be sure we know the full implications of what we're arguing. The area of copyright legislation in the twenty-first century, while attracting a growing amount of attention and criticism, may be a more important venue for political action than media ownership concentration—though the two are not unrelated.

Intellectual Property in the Digital Age

In October 1998, President Clinton signed into law the Digital Millennium Copyright Act (DMCA), bringing together agreements on how to handle the complicated ownership issues arising around intellectual property in the digital age. Earlier, the World Intellectual Property Organization (WIPO), a United Nations agency, had come up with the groundwork after much debate. The act was received with enthusiasm by software, computer, and media companies, but it met with opposition from academics,

librarians, and scientists (UCLA Online Institute 2001). Its most controversial rules made it illegal to attempt to break the copyright protection chips and codes, often called "antipiracy devices," that media companies were implanting on their digital products to prevent uses different from those they wanted to encourage. Selling such devices was made illegal, as was merely distributing information about how to do it.

The DMCA placed a whole new kind of burden on those who downloaded or distributed music, however, in the wake of the popularity of peer-to-peer (P2P) file sharing over MP3 devices. Internet service providers were expected to remove sites that violated DMCA terms, resulting not only in the groundbreaking Napster case but also in a series of well-publicized instances of high school students and little old ladies being indicted for copyright infringement for sharing their music files with friends or allowing their grandchildren to use their computers to listen to music. In addition, webcasters, the new breed of "radio stations" on the web, were assessed a completely new type of license fee they had to pay. Under the old music rights agreements, radio stations could play recorded materials over the air as long as they paid a fee, calculated on the basis of music played and the size of the audience reached, to ASCAP, BMI, and the Society of European Stage Actors and Composers (SESAC); these groups then compensated the writers, composers, and publishers of the music. The new act added another level of payment, this time to the record companies—which traditional radio stations had never had to pay—on top of the usual royalty fees. And because the new technology enabled it, the fee was assessed *per website user*—unlike the blanket fees of yesteryear. Many low-budget webcasters, as well as college and community Internet radio services, were driven out of business by their own popularity. And the new rules didn't just apply in the United States: The WIPO provisions were designed to enforce intellectual property rights across the globe, with the DMCA frequently serving as model. In March 2004 the European Union adopted a Copyright Directive containing many DMCA provisions.

The reason for this change in rules and practices? Unlike the process used by analog technologies, the very act of listening to a piece of music over the Internet usually meant that a perfect digital copy was made and stored on your computer, and you could then distribute the copy to anyone you cared to. This was different than taping something off the radio, which never made a very good copy and could never so easily be recopied and distributed. The Internet was different, and the new fee reflected the recording industry's fears of losing sales due to all the unauthorized copies of music floating around on the Internet. The Recording Industry Association of America (RIAA) became a particularly ardent spokesmen for the new regime (filing over 6,000 cases since 2003), but soon the Motion Picture Association of America (MPAA) got involved as well, over fears that with the new wider bandwidths and faster transmission speeds developing all the time, movies would be the next files to be widely shared around the globe. A host of anti-DMCA groups sprang up to lobby against it, including the Electronic Freedom Foundation, the Center for Democracy and Technology, the Digital Freedom Network, and many others world-wide. Established groups like the American Civil Liberties Union (ACLU), the American Library Association (ALA), and Fairness and Accuracy in Reporting (FAIR) found much to dislike in the new legislation, as well.

And the DMCA didn't necessarily hold up. In June 2005, after a challenge by the ALA, the U.S. Court of Appeals for the District of Columbia overturned the FCC's rule

(put in place to enforce the DMCA), which was often called the "broadcast flag" provision. This would have allowed media distributors to embed an electronic code, or "flag," on a broadcast signal to prevent home viewers from making copies of recorded programs or playing them back more than once or twice. The court ruled that there was nothing in the "words of the Communications Act of 1934, its legislative history, subsequent legislation, relevant case law, and Commission practice" that would permit the FCC—unless Congress intervened further—"to control how broadcast content is used after it is received." This battle had been fought over videotaping in the eighties, when VCRs became widespread, and there too the courts had found in favor of the public's right to use publicly distributed material for personal use without restrictions. On the other hand, many writers, composers, and artists found the DMCA a necessary extension of older rules that prevented outright theft and reuse of their original works on this new and hard-to-control medium. Musicians remained divided over whether the new world of online music sharing hurt their profits, or exposed more listeners to their music than ever before, which might result not only in CD sales but in increased revenues at live concerts.

Another congressional intervention on the copyright front was the Copyright Term Extension Act of 1998, sometimes referred to as the "Sonny Bono Act" after that congressman (and pop star Cher's former partner), who had been one of its main advocates, was killed in a skiing accident just as the act was coming to fruition. The act responded to the urgent pressure of several large media-owning corporations, notably the Disney Company, to extend the number of years a given work could be protected by copyright laws from 50 years after the death of the author, as it had been under the old rules, to the author's life plus 75 years. This change was good for Disney, because the rights to its Mickey Mouse character were just about to expire. Another provision stipulated that corporate creative property, or works for hire, were protected for 95 years after publication or 125 years from creation, whichever was shorter (it had been only 75 for both). These rules applied only to works created after 1978; pre-1978 works got their copyright extended to 95 years after the first copyright was filed. This was a huge boon for copyright holders; it prevented much of the creative work of the twentieth century (everything since 1923), like Mickey, from coming into public domain, where anybody could have used or reproduced it. Again, it seemed as though intellectual property laws, designed to balance the rights of producers to profit from creative work with the rights of the public to use and borrow from it, had shifted the balance away from the public good and toward corporate interests. And as threats to digital property mounted, corporations seemed more anxious than ever to crack down whenever and wherever they could.

Regulating Global Convergence

One objection frequently made to the DMCA was that, effectively, national sovereignty in making rules and codes for media had been surrendered to an international organization. Never mind that it was largely U.S. corporations and government bodies pressing for this globalization of copyright in the digital age. Outside the United States, objections were even more vociferous. As we noted in Chapter 11, the world's media systems had changed dramatically in the 1980s and 1990s. Most nations now had many more commercial media outlets than they had in the past, and those media outlets

could not be so tightly controlled as in the days of one or two government-owned media providers. Even where public service broadcasters still thrived, as in Britain, the competition from commercial media had taken them in a much more popular, youth-oriented, trendy direction, a long way from the stuffy elitism of former decades. This often meant an influx of American media products, and national restrictions—different in each country—continued to be placed on how much "foreign" material could be allowed to reach national audiences, on both commercial and public service outlets. Restrictions, or quotas, applied to the number of U.S. films playing in theaters and on television programs as well as the quantity of music played on the radio.

Britain had initially placed a limit of 14 percent on U.S. imports for its commercial service, ITV. Though this tight quota was relaxed over the years, the rules in 2005 still stipulated that at least 50 percent of the programs aired on ITV had to originate in Europe, and 65 percent of them had to be original ITV productions. Eighty-five percent had to be ITV-produced in prime time. The Netherlands originally required that 60 percent of its programming reflect Dutch or European origins, but later lowered that figure to 50 percent. France maintained its decades-old 60 percent quota, with a similar limitation on music played on the radio. Oddly, news, sports, and game shows were exempted from most restrictions, with the result that CNN and ESPN flourished unimpeded and a deluge of American game shows confirmed critics' worst apprehensions. Another protective measure adopted by many states was to restrict and regulate the amount and intrusiveness of advertising on television. Setting a limit on the number of minutes of ads per hour, or requiring that they occur only at the beginning and end of programs, not in the middle; or exempting some kinds of programming from advertising altogether (such as educational and religious programs)—these are the most common rules designed to halt Americanization and its overcommercial ways.

However, with the rise of the European Union such rules also became transnational, falling outside the control of individual nations. Some of the fiercest battles in the EU were fought over "the cultural exception"—the exemption from free-trade rules of products in the cultural sector, including television, films, music, and other creative work that came from individual countries and, presumably, reflected their unique cultural heritage. Though they still saw the United States as the primary foe, European states began worrying about their neighbors' cultural products affecting their own as well, because the EU rules treated all European nations as one and required that each country allow the media products of the others to flow freely through its cultural space. Spain might be no happier about the prospective deluge of German sitcoms or Italian game shows than it had been about American programs—perhaps even less so—but how could they control this trend in the new era of satellite channels, digital radio, and DVDs? Perhaps even more challenging in the new world of immigration and changing national populations was the influx of media aimed at minority groups: channels like Al-Jazeera, Zee TV, Telemundo, and a host of others. National cultures had become porous, pluralist, unprotectable.

Like the United States, Europe has seen, in this digital age, an enormous expansion in the number of channels and outlets available, many of them from outside national borders, and an equal level of conglomeration of media industries, which we'll discuss in the next section. How could Europeans regulate this exploding universe, in a situation even more complex than that in the United States? In Europe, commercial media corporations, powerful public broadcasters, and a much larger regulatory infrastructure

all rub shoulders as European Union neighbors add their voices, languages, cultures, and institutions to the mix, while the U.S. media giant constantly looms in the background (or, too often it seems, in the foreground). It is a set of issues complicated even further by the much greater range of cultural differences (with 22 different official languages not the least of them) in Europe as a whole, as opposed to that in the United States, and by the tight link made in the twentieth century between media and national identity. Starting in 1989, the Television Without Frontiers Directive attempted to sort out how the most influential medium might be adjusted to the new age of convergence.

Connection Television without Frontiers

In April 2004, a *New York Times* headline read, "A Common Culture (From the U.S.A.) Binds Europeans Ever Closer." Its author, Alan Riding, reflected on the addition of ten new countries to the European Union by musing on what common cultural identity could possibly hold such diverse states together. He asserts:

> The most common cultural link across the region now is a devotion to American popular culture in the form of movies, television and music. ... Even as Europeans visit one another's cities and beaches more than ever, national self-obsessions prevail in the visual arts, new plays, literature, contemporary classical music, pop music, and movies." (Riding 2004)

Europeans rarely choose to see films from neighboring countries, he argued; in France, 50 percent of the box office income comes from American movies and 35 percent from French films, with only 4.9 percent to British, 0.8 percent to German, and 0.2 percent to Italian movies. Similar proportions apply in other countries, with the preponderance of American films rising even higher in most other nations, which produce far fewer movies themselves than does France. Some of the most popular fiction authors across all nations are American novelists John Grisham, Patricia Cornwell, and Michael Moore (along with J. K. Rowling, author of the *Harry Potter* series), who outsell all but each nation's own native writers (Riding 2004). The same is true in television and music. In other words, Europeans are far more familiar and comfortable with American popular culture (despite their misgivings about it) than they are with each other's.

This state of affairs has existed since the middle of the twentieth century, but was thrown into high relief both by the rise of the convergence culture we have been talking about in this chapter and by the rise (not unconnected) of the European Union itself. Although similar pressures exist all around the world (as we have seen in Chapter 11 and will consider further in Chapter 13), it is the debates in Europe that have produced the most highly organized and publicized working out of policy in this area, because the ongoing consolidation of the European Union has brought it all out onto the world stage. What Europe is negotiating now, most countries in the world will have to examine at some point soon, if they haven't

already. The United States is in many ways the odd man out, because our cultural traditions are much looser and more pluralistic to begin with, and our media system has been highly commercial and competitive since the early decades. Both of these issues—(1) how to cope with the new, commercial, competitive, transnationalizing forces unleashed by global convergence and (2) how to cope with the cultural dislocations that such transnational forces will bring—remain at the forefront of Europe's Television Without Frontiers.

The 1989 report identified these two problems and proposed an initial solution. First, European media industries had to do away with national barriers, coming together as a unified industry in order to compete with the American behemoth across the Atlantic. This goal aimed at strengthening the European media industry, both as a whole and in its individual, national parts. The objective was to be able to provide television programs, films, and music with as much market power as those relatively inexpensive imports from the United States have, and then market them around the world as the United States does. To this end, between 1991 and 2004, the EU allocated over 900 million euros to training, development, production, and promotion of European media products (Wheeler 2004, 352). One significant venture was the creation of the EuroNews satellite television news channel, a joint venture by a group of 11 European public broadcasters, that went on the air in 1993 in seven different languages. Ten percent of its programs must specifically focus on the European Union itself—news, culture, information. And to aid the viability of European production more generally, EU rules ensured that a majority of broadcasting time on terrestrial channels would be reserved for European works, once again staving off American programming and aiming toward inclusion of more programs from other European nations.

Second, the European media were recognized as playing a central role in creating a new kind of European identity, one that would override the centuries-old traditions of national exclusivity. However, the Europeans had to do this while still protecting the values inherent in the public service broadcasting systems, and structures of public subsidy, that still dominated most countries' mediascapes. The problem was that these two goals conflicted with each other. Public service broadcasting had come into existence precisely in order to safeguard national cultures against outsiders. To allow a supranational body of regulation—the EU—to decide what should be shown on French theater screens, or on Spanish TV, or played on Italian radio, deeply undercut each country's public service ethos and reduced its rationale for subsidizing popular arts. Furthermore, to become competitive in the global market, it would be necessary to create programming that was truly popular across all cultural, class, gender, and ethnic differences. Yet when public service broadcasters—still the largest and most powerful producers in most countries—do this, they are often accused of distorting marketplace competition, because many of them are financed by substantial public subsidies as well as advertising. Under those conditions, what private commercial broadcaster can compete? And if commercial broadcasters can't compete in their own countries, how can they build up a European media industry to compete with that of the United States? Further, when public broadcasters become too popular, they are accused of abandoning "quality" traditions that justify their public support. Thus public service and commercial broadcasters were pitted against each other, with the bone of "European identity" being mauled between them.

The area of media concentration and consolidation proved even more tricky. As in the United States, Europe in the late 1990s saw a wave of industry mergers and acquisitions. Upon attempting to pass its own rules and guidelines, like those in the Telecommunications Act of 1996, the EU found that conditions within each European country were often so

different that, say, a bar on cross-ownership between television stations and newspapers would produce completely different effects in Britain than in Italy, and it might make no sense at all in Germany. However, EU members did often rule on mergers that would affect the European Union as a whole. When Bertelsmann and Germany's second-largest media group, Kirsch, attempted a Europe-wide pay-TV venture with Deutsche Telekom, it was blocked. However, most other proposals have been approved, such as the Vivendi/Universal merger. Other areas in which the EU audiovisual regulations have attempted to assert uniform practices across the member nations are sports rights, a highly complicated area, and advertising restrictions (Wheeler 2004, 349–369).

Meanwhile, how do citizens of European countries understand their new media universe? One indication is the EuroTV website at www.euroTV.com. "More than 180 European TV channels updated every day!" it claims. You can find schedule grids by country, with all the channels and programs available in that country displayed day by day. Though the main page is in English, each country's listings are in its own language. Links to international channels are at the bottom of the TV Guide page, with Al-Jazeera nestling next to the Disney Channel and Bloomberg Television (financial news). CNN, Disney, Discover, and various Fox channels appear on several national listings. But you can also search by program type or theme: sports, news, children's, music, culture, business, movies, series. Going to the series listing, however, what do we see? In other words, which TV series are shared across all national media channels often enough to have a separate listing? They are *Baywatch, Beverley Hills 90210, Dallas* (still being shown in France), *ER, Married . . . - With Children, Melrose Place, Mr. Bean, Simpsons,* and *Top Models.* Only one series, *Mr. Bean,* is not American (it is British). Not too many other sites like this exist; most TV listing, and most likely viewing, is still done within the national context for many reasons, including linguistic ones. The television frontiers are still there, but the way we understand and work around them has changed. As digital satellite channels expand across the globe, it is not only Europe that will have to wrestle with applying local rules and standards to global fare as well as with negotiating local identities and cultures across a global landscape. In the Connection on Al-Jazeera at the end of this chapter, and the one on Indian television in Chapter 13, these ideas are developed further.

INDUSTRY CONVERGENCE

Almost immediately upon passage of the Telecommunications Act in 1996, the U.S. media industry sprang into action. So did media business across the world, as similar legislation opened up new opportunities and relaxed old rules. A wave of mergers, consolidations, buyouts, and stock swaps swept the globe. It was a telecommunications tsunami of unprecedented scope, leaving almost no communications sector unaffected. As early as 1993, a few cross-industry mergers had been announced. But in 1996 the floodgates burst. The Disney-ABC merger, discussed in Chapter 11, had anticipated the act in 1995 but became final in 1996. Murdoch's News Corporation continued expanding its satellite broadcasting empire across the globe; and in 1998, blocked by the British government from purchasing the Manchester United soccer franchise,

successfully bid for the Los Angeles Dodgers major league baseball team. In 1999, the purchase of CBS by entertainment giant Viacom made international headlines. The new, enlarged Viacom corporation owned a converged empire, with movie and television studios (Paramount, Spelling, and Viacom Productions), cable channels (MTV, Nickelodeon, Showtime, TNN, and many others), the book publishing company Simon & Schuster, a large music library, Blockbuster and Paramount Home Video, five amusement parks, the Infinity radio group, 17 television stations, one of the nation's largest outdoor advertising firms, and two television networks, CBS and UPN.

This megadeal remained the biggest news in the entertainment business for less than 6 months; it was eclipsed in January 2000 by the unthinkable: Internet startup America Online (AOL) announced that it would purchase the behemoth Time Warner company for $165 billion. Many saw the potential for high-speed cable access as the driving force behind the deal; AOL controlled 54 percent of the Internet access market, while Time Warner Cable reached over 20 percent of the U.S. public with valuable broadband connections. But the new multimegahypercorp, AOL Time Warner, also possessed significant stakes in the movie and television production business with Warner Bros. and New Line Cinema; The WB network, as well as HBO, TBS, TNT, and CNN; books and magazines; and Time Warner Records. The most amazing thing about the merger was that AOL, whose earnings were one sixth that of Time Warner, had been able to purchase the larger company because its stock was worth 12 times more—reflecting the inflated boom of Internet stocks in the late nineties. However, by 2003, the downturn in Internet stocks had driven Time Warner's value down sufficiently that AOL was dropped from the company's name. The much-ballyhooed synergies to be produced by this merger never quite seemed to materialize.

NBC and its long-time parent company RCA had been acquired by the General Electric Corporation, which in 2003 purchased Universal film and television from Vivendi, the French multi-conglomerate. The new company owned not only NBC but the USA networks, Bravo, Telemundo, MSNBC, and CNBC, along with Universal's enormous film and television library and production subsidiaries. Another major player in the U.S. media market, though barred from owning broadcast stations or networks, was Japan's Sony Corporation, owner of Columbia Tri Star Pictures in both film and television as well as theater chains, Japan Sky Broadcasting, Sony Online Entertainment, and the Sony Music Group, which includes CBS Records. Sony is also a major electronics manufacturer, maker of the PlayStation videogame consoles and software, Trinitron televisions, and the ubiquitous Walkman.

By 2005, the five largest media companies in the United States, and indeed in the world, were these mega-conglomerates, whose domination of the over-the-air (OTA) network business made up only a small proportion of their overall holdings—and profits: Viacom (CBS and UPN), Disney (ABC), General Electric (NBC), News Corporation (Fox), and Time Warner (WB). However, a few years and a considerable mood shift after the boom years of the late nineties, the swing away from conglomeration had begun. The promises of synergy hadn't always delivered. Viacom split its mega-corporation into two separate parts in the summer of 2005, one focused on CBS and broadcast holdings, one on MTV and cable networks. The remnants of the old Paramount production empire splintered between them, as film production went with the MTV group and television production with CBS. Radio behemoth Clear Channel

decided to spin off its concert promotion and live-venue business from its radio core. Cable giant Cablevision broke apart into private and public components. Even state-owned media conglomerates felt the pull, as China's State Administration of Radio, Film, and Television began to break apart its constituent pieces. Sometimes, bigger wasn't better. However, in other sectors convergence continued. Some of the former Baby Bells, like SBC, used Telecommunications Act provisions to move into high-speed Internet service, satellite TV, and cellular phone provision, as their cable company competitors began delivering Internet telephone service.

Converging Pressures on Network TV

For the broadcast television sector, as mergers went on at the top level of ownership, networks and production companies at first scrambled to consolidate their business in the wake of the Financial Interest and Syndication (fin/syn) Rule's repeal. With the old rules gone, all six broadcast networks quickly pulled production back in-house, acquiring a stake in production companies, forming their own in-house production teams, and moving into the syndication market. The impetus to consolidate fed on itself; as production companies signed on to exclusive deals for their shows with individual networks, competition intensified for the remaining successful producers, as well as for the remaining network slots. CBS acquired King World Productions, one of the largest first- and second-run syndicators in the nation, with such programs as *The Oprah Winfrey Show*, *Wheel of Fortune*, and *Jeopardy* in its stable. With the Viacom merger, CBS acquired Paramount Productions, creators of such hit shows as *Frasier, Star Trek: Voyager,* and *Beverly Hills 90210.* By 2000, for the first time since the sixties, the major networks either owned or had a financial interest in over 50 percent of prime-time programming, ranging from ABC and NBC's 44 percent share to Fox's 71 percent. An unconsolidated independent producer might have trouble finding a place to show its would-be hits, or surviving at all. And when a network could then sell its wholly or partly owned show into syndication, profits went up. By 2002, the number of partly or wholly owned programs on each network had reached a staggering 77.5 percent. "Publicly, everyone would say, 'We're just buying the best shows,' " said Kevin Reilly, president of NBC Entertainment. "But privately, they would say, 'We want to own as much as we can' " (Manly 2005).

For independent producers, things were less rosy. Their choice consisted of either being swallowed up by a larger production company cum network or remaining an outsider in an insiders' game. In 1985, when independent producers and movie studios programmed over one third of each network's schedule, five independent companies rivaled the studios for hit shows on the air: Aaron Spelling, Stephen J. Cannell, Lorimar, MTM, and Carsey-Werner. Of those five, only one, Carsey-Werner, remained independent in 2000; the rest had been absorbed by network-owning conglomerates. With the rising costs of prime-time production, where a series typically runs $10 million to $12 million in the red each season, independent producers needed to seek out financing, which usually came in the form of partial network ownership, at least of syndication rights.

However, by 2005 the situation had begun to reverse itself. Only slightly less than half of the four major networks' fall 2005 season shows originated in-house. Fox Studios had more shows on other, competing networks than it had since the fin/syn rules were repealed. ABC planned to carry just two shows from Touchstone Television,

its Disney partner. Why? For one reason, the economic realities of the television business mean that most shows fail. Vertically integrated networks end up absorbing those losses, which outnumber successes in any given year. Also, considering only in-house productions reduces the depth of the creative pool a network can dip into. If one company's production division comes up with the program that would work best on another network's schedule, crossing ownership lines leads to better results. Still, as independent producers pointed out, most of the networks' fall choices came from within the nest of five conglomerates, with independents still squeezed out. Some began pressing for a return to regulatory supervision; they included the Caucus for Television Producers, Writers and Directors, which lobbied the FCC to require that 25 to 35 percent of each network's programs come from independent production companies. It didn't seem likely, but it was worth a try.

The network share of the audience dipped below 60 percent for the first time in 1999, to a new low of 58 percent. In 2004 the industry witnessed the dreaded benchmark of "less than half": As cable ratings rose to a 51.7 share, broadcasters attracted only 46.3 percent of the TV audience (Martin 2004). This was a new era indeed. A prime-time show that might have been rated at 30 in the early years, and felt good about a 16 in the eighties, now could hit the Nielsen top 20 with a rating of barely more than 10. Yet advertising revenues remained high; in fact, as Kevin Sandler points out, "Even though the combined primetime ratings for NBC, CBS and ABC fell 19% from the 1999–2000 season to 2003–2004, the three networks' primetime advertising revenue rose to 18%" in 2004 (Sandler 2006). This disconnect between fewer viewers and higher costs seemed ultimately unsustainable, especially in the face of growing numbers of viewers using digital video recorders (DVRs—sometimes referred to as TiVos) that zap through commercials with ease.

With more and more players—including their own in-house cable channel partners—competing for the same universe of advertising dollars, networks began to search for alternate revenue streams. What used to be called product placement got a new name—embedded advertising, which includes the time-honored tradition of placing branded objects within the TV program as well as making new creative arrangements with sponsors. The 1950s have returned regarding program sponsorship; some shows once again bear the name of their sponsors. One program, The WB's *Pepsi Smash* (a music performance program first aired in summer 2003), took convergence further by becoming "the first TV property to transition to the web full time" on Yahoo, combining live footage with interviews, lifestyle segments, and so forth ("Yahoo" 2005).

As the 30-second spot wanes in usefulness and visibility, other strategies emerge. One is the single-sponsored commercial-free broadcast, with surrounding spots and product placement within the show. Ford Motor Company sponsored the commercial-free premiere of *24* on Fox in 2003, preceded by a long-form commercial—over 3 minutes—that proved highly memorable to viewers. XM Satellite Radio sponsored the 2004 commercial-free premiere of *Nip/Tuck* on Fox's FX cable channel. In spring 2005, the Audi corporation sponsored the premiere of TNT network's original series *The Closer* commercial free, but with Audi cars featured prominently throughout the narrative. It also advertised heavily on TNT in the weeks preceding the show's debut, and during the show the audience was frequently reminded: "You're watching *The Closer* presented commercial free by Audi." Traditional product placement continues to grow

in use, with, for example, GMC trucks featured on *Medical Investigation,* Hewlett-Packard products in *Las Vegas,* and the board game Operation in *Scrubs.* Procter & Gamble embedded a shampoo product within the fictional narrative in a 2004 episode of *What I Like About You,* as the two main characters, aspiring actresses, auditioned for an Herbal Essences ad in the episode, with their version of the ad itself running as a spot during the commercial break. Research firm PQ Media estimated that TV product placement has risen more than 21 percent each year since 1999, with the growth in 2005 a whopping 46 percent over 2004 (Graser 2005).

Reality shows proved particularly fertile ground for whole new kinds of arrangements between TV program and sponsor. Cars and clothes were the most frequently featured, with soft drinks running third. NBC's *The Contender* was reported as "virtually owned by boxing sponsor Everlast," whose clothing line was featured throughout; and Fox's *American Idol* heavily featured Coca-Cola products, as in its Coca-Cola Red Room. *The Apprentice* wove corporate sponsorship right into the show's structure, as contestants competed to come up with marketing or development campaigns for various corporate products: Pepsi, Proctor and Gamble, QVC, Petco, Levi Strauss, and others. However, clothing works particularly well; as one article pointed out, everyone has to wear clothes. Clothing lines with a highly identifiable brand mark, or stores with a recognizable venue, fare the best. In one episode of MTV's *Newlyweds,* Jessica Simpson went shopping in the Henri Bendel store on Fifth Avenue. "We noted a lot of customers coming in to the store saying, 'I saw Jessica Simpson wearing this,' " the store's marketing director reported (Edwards 2005).

Some producers got in on the act too, like Aaron Spelling, whose online company AsSeenIn.com made a wide variety of products from *Melrose Place* and other programs available for e-purchase, from clothing to jewelry to home furnishings. When the series ended, Spelling auctioned off items from the set online (proceeds to go to charity); the headboard from Heather Locklear's bed went for $3,050. On The WB, with its large Warner Bros. Records division, it became standard practice for shows to feature Warner recording artists, with song credits running after each show along with an 800 number and a web address for CD purchase.

Although networks courted viewers both for traditional TV and for new interactive web-based ventures, the combination sometimes had unintended effects. Fans quickly seized upon the web as a dynamic new medium for developing entire subcultures around their favorite shows or stars. Most media companies encouraged this kind of unplanned, ancillary grassroots promotion, but others ran afoul of their fans' enthusiasm. Early in 2000, as fans began circulating their own video clips, audio segments, and transcripts of its shows, 20th Century Fox attracted notoriety when it sought to curb websites featuring its popular series *Buffy the Vampire Slayer, The Simpsons,* and *The X-Files.* The network claimed that such activities violated its copyright protections, affecting not only its own legal rights but those of the various talent guilds that contributed to the show. Yet producers and networks hardly wanted to diminish or alienate a loyal fan base. As such sites proliferated, new agreements with rights organizations and guilds would have to be negotiated. Some fan sites, like televisionwithoutpity.com, became so well known that TV producers and show-runners dropped in on the discussion, and the site itself was featured on an episode of *The West Wing.*

Direct marketing of TV shows to consumers via DVD broke through as another highly lucrative revenue stream around 2003. DVD players had become extremely

affordable, as videotape machines were slowly phased out. The new digital disc format had been introduced in 1997, and it took only 7 years until almost 80 percent of American households owned at least one. By 2005, almost 60 percent of production studio revenues came from distributing films as well as TV series on DVD. One breakthrough was the DVD release of the entire 2000 season of the *X-Files*, allowing fans to enjoy the series as a complete work and without weekly delays or pesky commercials. Soon the DVD would become a new art form in its own right (see Connection in Chapter 14). From there, current series along with an endless array of classics and simply forgotten television series, compilations, and individual programs found their way onto the shelves of electronic stores and into viewers' homes. Fifteen percent of DVD sales came from TV. In 2005 the nation's largest retailer, Wal-Mart, stopped carrying VCRs altogether.

But even as DVDs reached their peak, new formats loomed, inspired by the fear of video piracy as well as the desire for evolving high-definition technology. Apple introduced a video iPod. HD-DVD promised to start up yet another remunerative revenue chain. And its implications for the traditional television business, despite the revenues flowing in, remained unclear. As *Variety* reported, the release of TV series on DVD competes with television reruns for attention. The syndication market, on both network and cable, can be significantly undercut, especially for expensive drama and comedy. Networks have embraced reality shows partially because they are cheap to produce and can maintain the network claim to original programming, in the face of competition from DVD and other venues (McClain and Hulse 2004). So money gained in DVD sales by the production subsidiary may be money lost in syndicated broadcasts by the network co-subsidiary—nobody said it wasn't complicated.

Public Broadcasting

Another sphere of media at the crossroads of such boundaries was the public broadcasting system. Public television and radio had plunged enthusiastically into the promise of digital television and the interactive possibilities it presented. Public TV stations, too, would get the extra spectrum space handed out by the digital broadcasting act; and they launched ambitious plans to make full use of it. Imagine five or six public broadcasting channels, providing a combination of general and specialized programming: a public affairs channel, a cultural channel, an educational channel, channels for schools and other learning groups. Web connections could provide background information, documents, and supporting materials for PBS programs, bringing their educational purpose to the forefront in ways never before possible. Of course, all this would take money. PBS advocates looked hopefully to proposals including a tax on digital commercial broadcasters as having potential for additional support, but in the meantime had to come up with the funds to convert stations to digital equipment and launch additional services.

In the marketplace atmosphere of the post-Fowler era, partnerships with sponsors and other commercial enterprises offered some hope. Corporate underwriters began to enjoy a more obvious presence on public television, though they were barred from direct input in programming. Longtime series *Masterpiece Theatre* became the *Exxon/Mobil Masterpiece Theatre*. General Motors sponsored the latest Ken Burns documentary on Lewis and Clark. Promotional spots for underwriters began to more closely resemble

commercials. Projects linked to Microsoft, ABC-Disney, and Turner sprang up; and opportunities for marketing products linked to PBS programs like *Teletubbies* provoked renewed criticism of PBS's traditional definition of its service as noncommercial. While producer Ken Burns likened the relationship to an older form of sponsorship—"These are my Medicis, these are my patrons"—and pointed out that such arrangements gave him more independence because the company did not interfere with content, others debated whether, for instance, *Teletubbies* even deserved to be regarded as an educational program (Linn and Poussaint 1999). PBS began to promote itself as a brand, with a desirable and committed audience. In 1997, PBS and a consortium of public TV stations came together to form the PBS Sponsorship Group "with the aim of building a national sales force to boost corporate patronage" (Bergman 1999). For those who believed in the old equation of public service as inherently opposed to commercialism, these convergences boded no good and began to erase the differences between public and for-profit television.

In 2005, Congress once again proposed cuts in PBS's budget, this time in the context of political wars. Rising tensions around the war in Iraq, as well as in the ongoing cultural debates, led to new charges that PBS displayed a liberal bias in its programming. When President Bush appointed Kenneth Tomlinson as new Corporation for Public Broadcasting (CPB) chairman, Tomlinson not only admitted that he never watched TV but proved to have strong ties to the White House; and controversy erupted. Defenders of public broadcasting pointed out that political and public affairs shows make up only a small proportion of its schedule, and that the network tried hard to provide a balance of opinion. Conservative critics produced studies that showed a liberal bias, undercut somewhat when some of the program guests they had identified as "liberal" turned out to be solid Republicans who just happened to have a viewpoint different from that in the White House. Congress, meanwhile, crafted a bill that would have phased out all funding for CPB in 2 years, beginning with a 24 percent reduction in 2005. The bill was soundly defeated. And Kenneth Tomlinson was forced to leave both the chairman's post and the CPB board.

Though public radio was included in Congress's budget cut, its fortunes were a bit less dreary than its television sister's, thanks to one of the largest bequests ever made to a public media institution. In 2003, MacDonald's heir Joan B. Kroc donated $200 million to National Public Radio, like PBS primarily a producer and distributor of programs to its 750 member stations. Public listenership had risen during this decade, from 13 million in 1998 to 22 million in 2003. Most of its income was derived not from the federal government but from station dues and programming fees (50 percent), corporate underwriting (25 percent), and the rest from foundations, contributions, and income from its endowment. But its member stations received over 33 percent of their income on the whole from individual donations and memberships, and 12 percent from Washington. Both groups might perceive public radio as rich, no longer needing such support.

Some thought that the solution to all these problems might be to create a trust fund for public broadcasting, a return to the "insulated funding" concept proposed in the Carnegie Commission Report back in 1967. Rep. Ed Markey of Massachusetts, long a supporter of public media, proposed using some of the funds gained when broadcasters' old VHF frequencies are sold in public auction in 2008 (in return for the free digital frequencies awarded them in the Telecommunications Act of 1996). Comparing this proposal to other major government initiatives like the GI Bill after World War II and the creation of public land-grant universities in the 1800s, its supporters suggested that 30 percent of such

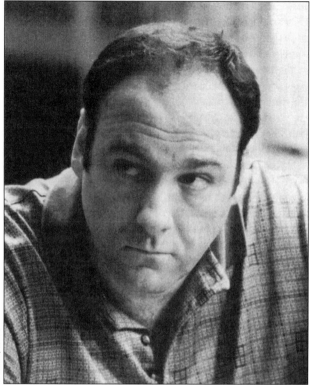

James Gandolfini as Tony Soprano in HBO's original hit series *The Sopranos*. A new era in sophisticated, R-rated entertainment premiered on cable channels in the late 1990s.

revenues might go to support public radio and television. Called the Digital Opportunities Investment Trust (DOIT), the plan was part of a larger initiative sponsored by the Digital Promise Group (http://www.digitalpromise.org/index.asp). In an era of war-driven budget deficits and threats to social security, it seemed to hark back to a more utopian era. But stranger things have happened.

Cable

These were confusing times for the cable industry. Having become the bad boy of the media business in the early 1990s—with local monopolies that stifled competition, runaway rate increases that attracted specific congressional intervention, risqué programming that alarmed parents, poor local service records, unfavorable must-carry negotiations, and an unclear place in the wireless digital universe—cable was in line for an upturn. It got it in the wake of the Telecommunications Act when major companies like Microsoft and AT&T turned their attention to the possibilities of high-speed access promised by cable's broadband transmission capacities. Digital TV gave cable an additional boost, and when original cable TV programming started to attract Emmy attention in 1999 (with the HBO series *The Sopranos*), cable was on a roll. Most companies invested in fiber-optic upgrades and began offering high-speed Internet packages, digital audio channels, searchable program listings, video on demand, digital video recorders, and even telephone services.

Cable ratings bounded up, capturing over 50 percent of the daily viewing audience by 2005. New cable channels proliferated and competed ferociously for channel slots on major systems; many were linked to web ventures, and revenues continued to stream in, increased by cable's high level of vertical integration. However, some problems remained. Charges of redlining—or ignoring inner-city and poorer neighborhoods while wiring more-affluent sections of cities—that had longed dogged cable operators took on more intensity as cable promised to become the backbone of Internet access. Minority populations were particularly affected, and protests broke out in some cities as the new fiber-optic cables were laid in wealthier suburbs first. The NAACP launched an investigation in 1998. Cable operators pointed out studies showing African Americans to be greater consumers of premium cable services than whites, so that under-wiring areas with a high concentration of black viewers would simply be bad business. Yet it remained more profitable to

© Reuters/CORBIS

concentrate fiber-optic upgrading where Internet use was the heaviest, and here minority populations lagged. Other policies, such as requiring payment by credit card for Internet access services, rather than the usual billing procedures, had the effect of screening out a higher proportion of working-class and minority consumers. As cable moved into the forefront of the convergence revolution, such issues would take on more significance.

Hollywood in the Digital Era

By 1996 most studios had established an impressive web presence, with company home pages linked to often elaborate websites dedicated to individual new releases. Disney's *101 Dalmations* presaged things to come in 1996 as it lured adult and child viewers into its web with games, puzzles, and pictures all based around spotted puppies, culminating in a popular animated Valentine's Day card (puppies find a missing bone) that circulated widely via e-mail in February 1997. One Paramount spokesman, in charge of the elaborate *Star Trek: First Contact* site, predicted a future when a movie would "serve as a trailer for an extensive entertainment service offered on the web" (Ryan 1996). The web tail would begin to wag the movie dog. Of course, a variety of fan-produced sites that weren't affiliated with studios sprang up as well, not all of them with material that the studios condoned. The Internet became particularly important to smaller production companies and the often unknown independent producers and directors they represented, as a permanent site where film clips, promotional materials, and background information could be accessed and the films marketed.

Perhaps as a result, in the late nineties independent film experienced a new boom. After a string of surprise indie hits—from Kevin Smith's *Clerks* to Edward Burns's *The Brothers McMullen* to Daniel Myrick and Eduardo Sanchez's *The Blair Witch Project*—suddenly the Sundance Film Festival and other independent fests became part of established studios' acquisition plans. Women filmmakers, formerly marginalized by the industry by the phalanx of guys in suits that each film had to pass through, emerged in numbers at the 2000 Sundance Festival as pundits proclaimed it "The Year of the Sundance Women" (*USA Today* 2000). Combined with the new hot market in DVDs, plus a handful of cable channels—the Sundance Channel, the Independent Film Channel—the independent sector strengthened even as conglomeration roared overhead.

Meanwhile, Hollywood began to see the DVD as an opportunity to convert audiences from video rental to purchasing recorded films outright. As the conversion to digital TV progressed, they reasoned, satellite television and pay-per-view would increase and video rental would drop off; indeed, this had already begun to happen. They were right; DVDs provided 60 percent of studio revenue by 2005. By packaging the films with additional footage that hadn't made the final cut, including interviews with directors and actors, and providing other ancillary materials, companies made the DVD a major marketing and cultural phenomenon. This may have reached a peak with the rollout of the groundbreaking *Lord of the Rings* franchise in 2002–2004. By June 2005, however, writer/director/producer Peter Jackson was suing distributor Time Warner for the increasingly frequent practice of "self-dealing" in the sale of ancillary rights: selling them at a price that Jackson suspected was well below market value to various in-house properties in the Time Warner media empire. Such suits had become more and more common, in television as well as movies.

The traditional theater business had begun to change as well. Many studios had gotten back into theater ownership during the deregulatory eighties, and other companies had expanded theater chain empires across the country, building ever-larger megaplexes with new features like stadium seating, different-sized theaters for different types of films, Dolby surround sound, and multiple continuous showings of the biggest releases. Some of the largest chains—like the merged United Artists/Act III/ Regal group, with over 5,300 screens nationwide, and the Cineplex Odeon company— began to pressure the studios for a bigger cut of the box office dollar.

By 1998, the top 3 percent of theater companies controlled 61 percent of the nation's theaters. The theatrical exhibition arm of the theater business, as it struggled to compete with expanding home venues from cable, satellites, DVDs, and videotapes, followed the lead of the fifties theater industry with big-screen and big-sound spectacle (and popcorn), combined with an emphasis on seeing new releases right away. More and more of a film's theater profits began to result from the first 2 weeks at the box office, with a quick fade to video and pay-per-view. And popcorn prices continued to rise. By mid-2000, however, a wave of theater expansion had produced so many screens competing in a year of lackluster film releases that several chains began to post serious losses, and several sold off their chains.

Radio

No industry segment was more affected by the wave of consolidations following the Telecommunications Act than radio was, as discussed earlier in the Connection about Media Ownership. But even as early as 1998, FCC Commissioner Gloria Tristani worried that the act had created the wrong effect. "I'm not convinced that radio is heading in the right direction," she said. "I see a real tension between becoming bigger and more efficient and serving individual communities. ... [Consolidation] can lead to lots of formats but only one voice" ("Consolidation" 1998). In many cities, while a handful of independent locally programmed stations remained, a few group owners divided up most of the market between them. A corresponding rise in nationally syndicated formats ensued, carefully crafted to appeal to specific demographic groups. In a return of an old practice, station groups began to form relationships with record labels, promoting their music in return for advertising buys. This was payola, but now in a corporate form. Small station owners found themselves squeezed, unable to match the low ad rates charged by the conglomerates and often unable to resist the substantial sums offered for their stations. Many sold out.

In response to rising fears about the loss of localism, the FCC in 2000 pressed through a new initiative to create hundreds of low-power radio stations. These would be very low power (100 watts or less), community owned and operated noncommercial stations, designed to serve very specific local communities and forbidden from networking. However, commercial broadcasters—and, sadly, National Public Radio— strongly objected, claiming that the new assignments would overcrowd the spectrum and create interference. This resistance slowed down LPFM's implementation. By 2005, due to fears of congestion, only 550 stations had gone on the air, almost all of them in rural areas and small towns. Senator John McCain, long a supporter of low-power radio, introduced a new bill to help move it along in 2004; its two co-sponsoring groups say a lot about who is most involved in the question of radio

today. They are the Future of Music Coalition, concerned with the effects of media concentration on the music industry (http://www.futureofmusic.org/), and the United Church of Christ, reflecting the long-standing interest of many religious groups in the possibilities of low-power local radio for religious broadcasting. Gloria Tristani, by then a former FCC commissioner, put her career where her speeches had been by taking a new job as head of lobbying efforts at the UCC's Office of Communication.

Satellite TV and Radio

Satellite TV had slowly improved its position in the media distribution universe through the nineties, but the main factor holding it back was its inability to deliver local television stations to its customers. Instead, the two dominant U.S. companies—DirecTV and EchoStar's Dish Network—had begun to import distant station signals into markets across the country, contracting with one of each network's affiliate (usually in a major urban location) and purveying its signal to DBS subscribers: a network-affiliate superstation. This situation made local television station owners very unhappy, because every DBS viewer represented one less set of eyeballs to be counted in the stations' local ad rates. As the FCC contemplated the competitive television marketplace during the years following passage of the Telecommunications Act, it seemed as though the best immediate solution to the problem of the local cable television monopoly might be DBS providers; indeed, this is how DBS marketed itself and the reason that many subscribers gave for switching from cable to satellite. But the lack of local stations held it back.

So the FCC in 1999 passed the Satellite Home Viewer Improvement Act, giving satellite companies specific permission to carry local affiliate signals—indeed, they were required to do so by January 1, 2002, in a new form of must carry. They had 6 months from the passage of the act to negotiate retransmission agreements with the local stations in the 30 largest markets, with the smaller markets to follow; after that it became illegal for them to offer distant affiliate signals to subscribers who were capable of receiving an OTA broadcast signal. This gave broadcasters pretty much what they had wanted, but it left satellite services unhappy about what they perceived as broadcasters' upper hand. Yet with local stations included, and with the digital capacities that satellite TV could provide, it looked as though cable TV would face stiffer competition than it had previously. In the meantime, cable competed by emphasizing the value of its wired connection for high-speed Internet access, even though satellite providers soon began to add Internet services as well, through partnerships with local digital subscriber line (DSL) providers.

Satellite radio, meantime, became a reality in the early 2000s, and not just for the drive-time in-car audience for which it had originally been envisioned. With a small digital tuner that could be taken from car to home, and a monthly subscription, listeners could choose from hundreds of commercial-free 24-hour audio services, filled with news, talk, sports, comedy, children's programming, and just about every kind and combination of music known to man. Two competing services, Sirius and XM, began aggressively acquiring well-known personalities, services, and content in 2004. Both provided a variety that tended to focus on those elements of aural culture that don't work well for traditional radio in either its corporate or local manifestations: content too quirky and marginal for mass distribution over the airwaves, and too challenging

and outrageous for many local communities. For instance, Howard Stern signed on with Sirius after becoming a target of the Bush FCC's anti-indecency campaign. By virtue of its distribution system, satellite radio fell outside both radio regulation and radio's traditional economics. It also imported a high proportion of international content, including Spanish-language services and news and talk from around the world, along with "lost" genres like radio drama, and music presented in much deeper and broader categories than commercial radio's demographics-driven service could ever permit.

Music

Though this history has dealt with the music business only tangentially, music became the canary in the coal mine for the digital era. The industrial and technological convergence of the late nineties swept music up in its hybridizing embrace, ushering in a new era marked, once again, by a great degree of consolidation at the top and an enormous explosion of diversity at the bottom. As record labels increasingly came under the aegis of one or another of the big-five music giants—Time Warner, Sony, Universal, EMI, and BMG—the Internet began to provide a venue for decentralized, small-scale, on-demand distribution of types and genres of music that had long remained below the radar of most established labels.

The software that made this distribution possible, known as MP3, began to circulate on the web as a free program in the late nineties. Anyone could use it to download music files onto his or her own hard drive and play it back. Additional technology allowed transfer of the music from computer files to compact disc. Now anyone could be a music publisher, picking up on the music that quickly began to emanate from hundreds of sites. On-demand websites sprang up; Internet radio stations began to stream continuous music to discrete taste groups (discussed in Chapter 14). College campuses, with their dorm rooms hardwired for high speed, quickly became a hotbed of MP3 use. Stereos gathered dust as students increasingly turned to their computers for music both old and new.

Record companies, and their powerful parents, were not pleased. As discussed earlier, in 1998 Congress passed the Digital Millennium Copyright Act (DMCA), under heavy lobbying from such groups as the Recording Industry Association of America (RIAA). The act forbade copying of digital material without the payment of a copyright fee to the companies that owned it. In early 2000, RIAA filed suit against MP3.com, an Internet site that served as a major distribution point for online music. Several other sites found themselves under similar judicial attack, including, in fall 2000, Napster. Many questioned the strictness of the new rules, which seemed too narrowly designed to protect the interests of large industry groups against the free marketplace of consumer demand. And some recording artists encouraged MP3 distribution, especially for songs that did not appear on CDs. Some sites paid artists greater royalties than traditional distribution did. The threat to corporate control was noted by MP3.com's director: "The coolest thing about MP3 is that it empowers the artist and the consumer. It returns the power of song ownership back to the artist and allows the consumer to make his own choice" (Szadkowski 1999). Here was a battle-front for the new cultural wars.

A GLOBAL PUBLIC SPHERE? INTERNATIONAL BROADCASTING POST-9/11

But cultural wars aren't fought only at home. Nations had long used the media to spread their political message abroad. International shortwave radio, in particular, was able to break into the closed nationalistic broadcasting systems with a rival, outsider's voice. During World War II, the country's first international radio service, Voice of America (VOA), was initiated to spread American values and propaganda messages worldwide and to counterbalance the radio propagandists of the Axis powers (see Chapter 6). The service was originally operated by the Office of War Information, but in 1948 Congress decided to extend it into the impending Cold War era, passing the Smith-Mundt Act to create the United States Information Agency (USIA). The USIA took over the VOA as well as a host of other activities designed to "tell America's story to the world," as its motto states. Interestingly, the law authorizing the agency to distribute information about the United States to other countries forbade it from disseminating this information at home, to offset any fears about domestic propaganda. The whole world could listen in, but not us here at home. In 1951, another outreach service, Radio Free Europe (RFE), was created by the Central Intelligence Agency (CIA) with broadcasts aimed specifically at Eastern Europe under the Soviet bloc; in 1953 it formed Radio Liberty (RL), transmitting directly into the Soviet Union.

These stations did not just spread information about the United States and U.S. culture; they provided an oppositional source of news about the recipient nations themselves. The VOA showcased the United States to other nations; RFE and RL showed other nations to themselves from an American perspective, countering Soviet-centered news and information with an American-slanted anticommunist alternative. The CIA ceded its broadcasting operations to the USIA in 1971. In 1985 President Reagan authorized a service to Cuba, called Radio/TV Marti, committed to an anti-Castro mission. In 1996 the USIA began its Radio Free Asia (RFA) service into China and Southeast Asia. All were operated under the auspices of the U.S. State Department/USIA's International Broadcasting Bureau (IBB).

In 1999, all external broadcasting services in the United States were consolidated under a new organization called the Broadcasting Board of Governors (BBG), a mandate of the 1998 Foreign Affairs Reform and Restructuring Act. More services were added, including Radio Farda, Radio Sawa, and Al-Hurra satellite television network, all focused on the Middle East in the wake of the heightened tensions there. Radio Sawa, initiated in 2002 and broadcasting from Dubai in six different languages, targets Middle Eastern youth with a mixture of Western and Arabic pop music, news, and entertainment programming, in a style it describes as "upbeat, modern, and forward looking." Radio Farda is a similar service in the Persian language, broadcast out of Washington and Prague, aimed primarily at Iran. These are important propaganda outlets for the U.S. government, because radio is by far the most pervasive medium across most of the world. The BBG claims that its services cumulatively reach more than 100 million listeners, viewers, and Internet users every week, around the globe (http://www.bbg.gov/bbg_aboutus.cfm.).

The United States has never been the only country transmitting outward. In radio the BBC World Service is the single most-listened-to news and information channel around the world, with an estimated regular audience of 120 million, reached via

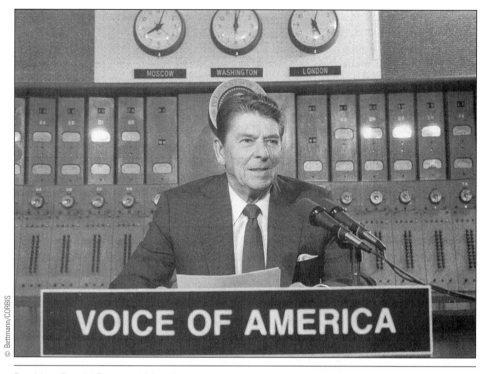

President Ronald Reagan addressing the world over the Voice of America Radio network. Reagan believed strongly in the propagandistic value of American popular culture and founded Radio/TV Marti, broadcasting to Cuba, during his administration.

43 languages. France created Radio France International to bolster French culture worldwide, in more than 20 languages. Both the USSR's Radio Moscow and China's Radio Beijing maintain extensive shortwave broadcasting services to spread political messages throughout their areas of influence.

Most countries also set up satellite-distributed international television services in the 1980s and 1990s. The USIA initiated its World Net channel "to present a balanced picture of American society" in 1983; it broadcast from Washington, D.C., to stations and cable channels, as well as U.S. embassies and cultural centers, around the world. It is now supervised by the BBG. Al-Hurra, hastily created in the wake of our entry into Iraq, focuses on news and information, both political and cultural, for an Iraqi public that might otherwise be viewing Al-Jazeera. The name Al-Hurra means "the free one," and it describes itself as "dedicated to presenting accurate, balanced, and comprehensive news." It began broadcasting in January 2004. The BBC initiated its BBCWorld television channel in 1995, broadcasting to Europe, Asia, and Africa, but as a commercial cable subscription venture because the British government declined to provide funding. It is not available in the United States or in its home country. Some of its programs are aired on BBC News 24, however, which is the BBC's digital satellite and terrestrial service available at home and abroad—even in the United States, where it can be seen on some public television stations. Radio Canada operates both Reseau d'Information (RDI) in French, and CBC News

World, in English. The latter is commercially funded, though owned by the CBC, a government corporation, like BBCWorld—and it carries some of BBCWorld's programming. Many other nations have started up 24-hour television news channels run by the national public broadcaster—distributed internationally because, once something goes on a satellite to reach a national audience, viewers in many other nations can easily receive it.

In the globally connected world postconvergence, more traditional government-sponsored, outreach-oriented international services like World Net, the BBG radio and television services, and the BBC World Service compete not only with other state-sponsored satellite broadcast channels but also with a host of private, commercial ones. CNN, MSNBC, and Fox News provide U.S.-oriented news and information to the world, probably with more reach and impact than their state-sponsored counterparts have. CNN has expanded beyond the home channel into CNN International, CNN en Español, CNN Turk, and the CNN Airport Network, along with its Headline News service and CNN Radio. CNN competes with other privately owned, commercial news networks like Rupert Murdoch's Sky News channel, the other news service besides the state-sponsored Euro-News serving all of Europe, along with Sky channels in Asia, Africa, and the Middle East. But it was not only the Western world that saw the importance of reaching out via satellite with a new kind of voice.

Connection The Rise of Al-Jazeera

Launched in 1996 when a proposed joint venture between the BBC and the Saudi Arabian government failed, the Middle East's first indigenous satellite news channel, Al-Jazeera, "burst on the Arab scene like a supernova" (Reynolds 2003). In a region dominated by highly controlled state-run television, where capturing a wide audience and keeping them informed about the issues of the day took a back seat to droning statements of government officials and religious and educational programming, Al-Jazeera, which means "the peninsula," "broke all the taboos, exposing the hypocrisy and vapidity of official news reporting and airing the concerns and opinions of the Arab population in a way that had previously been unimaginable" (Reynolds 2003). Based in the nation of Qatar, funded in part by its ruling family and partly by advertising, the channel promised to be independent of any state, to cover the entire Middle East and reflect a wide range of concerns, and to provoke the kind of questioning, hard-hitting journalism that simply hadn't been seen before in that part of the world, where national governments tended to stifle debate and censor oppositional points of view. It featured call-in shows with an unrestricted range of opinions, not just among officials but by ordinary citizens of countries across the Middle East. It allowed representatives of Arab opposition movements a new forum in which to discuss and debate their views, without censorship. And it could be picked up for free by anyone with a satellite dish. This was truly a revolution.

The channel attracted some controversy in the West from the beginning, mostly for its reporting on the Israeli-Palestinian conflict, but the events of September 11 and their aftermath raised its profile dramatically. Now, the world had an alternative to U.S.- and

British-dominated television news, and the Arab world in particular tuned in by the hundreds of thousands. During the invasion of Afghanistan, Al-Jazeera was the only major news network with a field office in Kabul. Its interviews with Taliban and Al-Qaeda spokesmen, including Osama Bin Laden, won it increasing influence along with accusations of collaboration with the terrorists (Sharp 2003). With the U.S. invasion of Iraq Al-Jazeera's audience tripled, leading to increased scrutiny by the U.S. government and military. It was kicked off NASDAQ and the New York Stock exchange. The news channel also ran afoul of the provisional government in Iraq for interviewing officials without permission.

Trying to carve out a niche for itself as objective and evenhanded, but with a Middle Eastern slant, Al-Jazeera often finds it necessary to expose current and previous attempts by Western news sources to slant the facts in their direction, as in the example cited by one author that took place on the fourth day of the war in Iraq: "Most of the interview [with Muhammad Saeed Idris of the al-Ahram Center for Strategic Studies in Cairo] discussed the recent history of American misinformation and retractions, focusing on the Bush administration's abortive attempt to establish an official disinformation unit" (Reynolds 2003). A Congressional report puts this in historical perspective:

> Many of Al-Jazeera's correspondents were drawn to work for the station
> because they felt that American and British coverage of the 1991 Gulf War was not
> even-handed in that it paid insufficient attention to topics of interest to Arab audiences,
> such as the plight of Iraqi civilians during the conflict. Thus, Al-Jazeera believes that it
> provides an alternative perspective, particularly to the American and British news
> media. Al-Jazeera's motto, "The View and the Other Point of View," reflects its desire
> to be an uncensored-authentically Arab news source for Arabs. (Sharp 2003)

Al-Jazeera reporters referred not to "coalition forces" as on CNN and the BBC, but to "American-British invaders." What the United States called "Operation Iraqi Freedom" became "the War against Iraq." Slanted? Perhaps, but part of its mission was to question the long-standing claims of objectivity and balance made by Western news media.

Yet by 2003, a congressional report stated that Al-Jazeera had "become so publicly influential that U.S. officials now regularly appear on the network" (Sharp 2003). Modeling itself on CNN and BBC World for its formats and approach, the channel's strategy of taking a critical stance toward Arab governments, Western forces, and dominant news media as well had begun to gain respect. A documentary produced about the channel in 2004, *Control Room,* directed by Jehane Noujaim, received several international awards. One tendency of the network discussed in the film, an aspect that has received much criticism from Western governments, is its use of far more graphic footage of explosions, injured civilians, heated fighting, and dead bodies—including those of dead American soldiers— than that used by its Western counterparts. These clips were often aired as visual montages of human suffering, accompanied by dramatic background music, that some have labeled inflammatory. Al-Jazeera defended this practice as greater realism, comparing it to the "sanitized" coverage in Western news media. The channel has also been accused of anti-Semitism, both in its sympathy for the Palestinian side of that conflict and in some of its programs, such as a 2000 talk-show segment unfortunately titled "Is Zionism Worse than Nazism?" and an interview given to U.S. anti-Semite David Duke. Al-Jazeera's ability to cover breaking news, however, along with its "pan-Arab, pan-Islamist" approach, make it a

major alternative source of news and information across much of the world, not only in the Middle East but wherever Arabic-speaking populations can tune in to satellite TV.

Its influence has also been felt in the generation of competitors. Al-Arabiya, a private commercial 24-hour news channel based in Dubai, began broadcasting in 2003, financed by Saudi and Lebanese business interests, among others. According to a State Department poll, by October 2003 it was more popular in Iraq than Al-Jazeera was, reaching 37 percent of those with satellite dishes. Positioning itself as a "less sensationalistic" alternative to Al-Jazeera, Al-Arabiya has nonetheless proved controversial among both Arab and Western governments. When it showed a tape of Saddam Hussein in November 2003, the U.S. military forces banned it from Iraq, and its director was threatened with a jail term. The week before, Donald Rumsfeld had described the channel as "violently anti-coalition" (Brandon 2004), though by May 2004 George W. Bush and Condoleeza Rice appeared live on the channel to denounce the atrocities at Abu Ghraib. The channel describes itself as "independent, self-empowered, informative and free-spirited. ... It is an Arabic station, from the Arabs to the Arabs, delivering content that is relevant to the Arabs." (http://www.alarabiya.tv/english.aspx). Like Al-Jazeera, it covers not only hard news but sports, culture, social issues, and entertainment, including programs like "Across the Ocean," a discussion show based in Washington, that focuses not only on politics but on the lives of Arab Americans; "Fourth Estate," which investigates Western media; and "Rawafed," a celebrity talk format.

By way of response, the U.S. government initiated Al-Hurra in February 2004. Al-Hurra, which means "the free one," is not exclusively a news channel. It runs a wide variety of programming including children's cartoons, soap operas, series, talk shows, and movies, most of them American programs subtitled in Arabic, though with more emphasis on news than might be typical. In this arena it competes with several pan-Arab and national general service channels, all providing a wide range of programming but not a primary focus on politics and news—the "softer side" of international broadcasting. This response is very much in line with the old Voice of America strategy: Who needs hard-hitting propaganda when American culture is Western ideology's strongest selling point? Its critics argue that the Al-Hurra channel's emphasis—like that of Radio Sawa—on entertainment and cultural programming, rather than discussion of issues, might draw the younger audiences it aims for but does little to inform them about U.S. policies or open up lines of dialogue.

This leaves CNN as America's primary television news channel in the Middle East, with little programming in Arabic and hence very little reach outside of elite circles. It is certainly no competitor overall with Al-Jazeera or Al-Arabiya in the Arab world. But some observers are more worried about another pan-Arab satellite channel: the Hezbollah-run Al-Manar. Hezbollah, the radical Iranian Shi'ite group that has long been condemned by the United States and other Western nations as a terrorist organization, is the only such organization to have its own satellite television service, in operation since 1991. One analyst describes it as

> propaganda in its most undiluted form. Every aspect of Al-Manar's content, from news to filler, is fine-tuned to present a single point of view: that of a militantly Islamist sponsor, consistently urging the recourse to violent "resistance" as the only legitimate response to Israel's existence and the U.S. presence in the Middle East. (Jorisch 2004)

Based in Beirut, Lebanon, Al-Manar is financed both by political contributions and by advertising; among its largest advertisers were Pepsi, Coca-Cola, Procter and Gamble, and Western Union, along with some European corporations. After a critical report exposed such

sponsorship in 2002, most American firms dropped their advertising from the channel. It is now, by its own estimate, among the five most-watched channels in the Arab world. In the wake of 9/11, it was the first news source to spread the scurrilous story that Israel and Zionists had been behind the attack on the World Trade Center, and that Jewish workers in the center had been warned to stay away that day. Unlike other pan-Arab channels, Al-Manar makes no claim of having objectivity and balance; it is overtly and proudly an outlet not only for the political views of the Hezbollah itself but also for many other militant and active anti-Western groups. Is this "the darker side of the media revolution in the Arab world"? (Jorisch 2004). Certainly this channel represents the power of globalizing media to reach beyond local boundaries to a wider audience, carrying messages from groups without official sanction but with powerfully affecting voices. As all broadcasting becomes international broadcasting, no set of political or cultural values can be kept at home, unchallenged, any longer.

In 2005, the dominance of U.S. and European international broadcasting, as well as the rising prominence of the Middle East, were in turn challenged by announcements of more players in the global news field. In Russia, the Kremlin announced the debut of Russia Today, a 24-hour English-language news channel to be beamed out of London, Brussels, Jerusalem, and Washington. Al-Jazeera announced that it would soon start an English-language service, available around the world, to bring its alternative view out of the Middle East and into non-Arab living rooms. And in June 2005 a coalition formed by government interests in Venezuela, Argentina, Brazil, and Cuba revealed its plans for a 24-hour, satellite-delivered, Spanish-language channel called Telesur, short for Nueva Television del Sur (New Television of the South). Based in Venezuela but bringing in reporters from throughout the continent, its mission would be to counter the hegemonic worldview of U.S. and European news channels and to provide in-depth coverage of South and Central American issues, so often left out. As its director general Aram Aharonian put it, for centuries Latin Americans "have been trained to see ourselves with foreign eyes. ... Now we are recovering the possibility of seeing ourselves with our eyes" (Johnson 2005). Half news and half entertainment, the new channel counts among its missions a goal to bring all the cultural diversity of Latin America to the attention of the rest of the globe. Though the new service would compete with CNN en Espanol, Fox's Latin American channels, and Telemundo, it promised to appeal to Spanish speakers in the United States as well as those in South and Central America.

Conclusion

The decade between 1995 and 2005 saw the growth, beyond all former anticipations, of both the promises and threats of globalized digital convergence. The insular national scope of media went the way of the buggy whip as convergence technologies, legislation, and industries expanded globally, inevitably drawing the whole world into the same arguments, conflicts, and utopian potentials. Not just internal boundaries but external ones too have blurred and broken as media converges. In the next chapter we will explore, in all too brief a venue, the global implications for new media and the hybrid culture they bring.

CONVERGENCE CULTURE IN THE NEW MILLENNIUM

As established media forms began to use the web as an ancillary to their older businesses, by the late nineties the web had emerged as a viable media form on its own. Drawing, as radio had, on the various industries and cultural forms that surrounded and populated it, the web presented opportunities for combinations and ways of addressing the audience that both enhanced older media and added unique, adapted offerings. In turn, older media responded by creating hybrids and adapting old formats to new demands. This often resulted in a blurring of the lines that had shaped older forms: between content and advertising, between news and entertainment, print and video, cable and broadcast, public and private, commercial and nonprofit, U.S. media and global media, audience segmentation and conglomeration. It also represented many more opportunities for profit—and for bypassing the profit system altogether.

As ownership and its putative editorial control passed into fewer and larger hands, the address of media products and the scope of their content seemed to fan out ever more inclusively and extensively. Concentration on one level, paradoxically, produced fragmentation on another; competition for the dollar destabilized other forms of social power so that, at least in a limited and partial way, less-powerful groups could exercise a new form of marketplace clout. African Americans, Latinos, Asians, young women, gays and lesbians, and myriad other groups found themselves included in the media universe and addressed by its products in ways they never had before. One thing they all had in common, though: It was always the more affluent strata of previously neglected groups that received the best service.

The boundaries of texts began to blur as well, as media properties spread out over movies, television, websites, video games, music, books and magazines, resulting in a new kind of "hyperdiegetic" space that spread across many different media venues, and opened up new interlinked avenues for profit, too. As the number and type of venues for creative work increased, television attained a level of cultural respectability it had never had before. Even its harshest critics could see the creative worth of series like *The Sopranos* (HBO) and *The Simpsons;* could appreciate the wealth of documentaries available not only on PBS but on The History Channel and the numerous Discovery Channels; and had to acknowledge the usefulness of the myriad cooking, home improvement, and heath programs—despite the growing glut of less informational reality fare. The results could be seen across a host of media.

CONVERGENCE TELEVISION

Blurring Boundaries

As usual, the biggest and most visible results of cultural convergence showed up on the home screen. Even though computer screens remained the site where most people's web browsing took place, the computer began moving closer to the TV screen, both out of the office and into the living room—as ESPN viewers sought out additional sports information while watching the game—and out of the living room onto screens in the office, the coffee shop (thanks to WiFi) and even onto the cell phone. High-speed Internet access via cable or DSL, increasingly wireless and increasingly available everywhere—worked with the increasing miniaturization of the computer to keep us all connected, all the time. The flow of information and entertainment began to swirl around across multiple venues, drawing it all ever more tightly together in seamless exchange of advertising, promotion, information, linkages, and interaction.

As boundaries among media venues and technologies blurred, so did television genres and program conventions. The nineties continued the trend toward the feminization of the prime-time schedule. As The WB and UPN differentiated themselves by seeking out youth and creating specifically black-oriented shows, the major networks concentrated on their longtime core audience of women 18 to 49, with men 18 to 49 close behind. An influx of action dramas flourished on major network prime time, combining fast-paced crime, spy, and adventure narratives with frequent forays into the emotional lives of even the toughest characters. On *NYPD Blue*, viewers suffered through the death of Andy Sipowicz's older son, the birth of his younger son, the murder of his wife, and the long, drawn-out demise of his partner Bobby Simone. NBC's *Homicide* centered around the interrelationships and personal odysseys of its diverse and highly individualized cast. Even *Law & Order*, that impassive holdover from an earlier style of crime drama, spun off a whole franchise of *Law & Order* variations, most of them in a distinctly more melodramatic vein. And not since *Cagney and Lacey* had women themselves entered this formerly masculine preserve; women were represented in all the shows just listed as well as *Buffy*, *Alias*, *24*, *Lost*, *The Shield*, *CSI* and its spin-offs, and *The Profiler*—not to mention the real-life action women on such reality shows as the *Survivor* series.

Almost all genres saw this blurring of action and melodrama, using television's unique ability to spin a series not just over a few hours but over several years, deepening characters, twisting plots, and entangling relationships. Doctors' personal lives took center screen in *ER, Chicago Hope, Third Watch, Providence,* and *City of Angels;* lawyers and judges revealed emotional complexities so convoluted that it was a wonder they got any work done at all on *Judging Amy, The Practice,* and *Ally McBeal*. Others focused unabashedly on intertwining personal relationships, formerly the realm of the daytime soap, on popular dramas like *Party of Five, Once and Again, Time and Again, 7th Heaven, Touched by an Angel, The Gilmore Girls, The OC, Dawson's Creek,* and others too numerous to name. High-profile shows like *The West Wing* and *Commander in Chief* tried to combine the seriousness of politics with the interpersonal shenanigans of the president and his (or her!) staff in the White House, but viewers weren't fooled: Melodrama by another name still makes us weep. And high-quality drama flourished as never before.

A sudden resurgence of the prime-time quiz show closed out the millennium that had heaped disgrace on its head in the late 1950s. The astounding success of ABC's

Who Wants to Be a Millionaire? in summer 1999, copied from the 1998 original British ITV version, stunned TV executives and audiences alike; by fall the race was on, with the debut of *Twenty-One* (NBC), *Greed* (Fox), and *Winning Lines* (NBC, originally ITV as well). The quiz show combination of live action, low production costs, audience participation enhanced by corresponding websites, and large sums of actual cash being thrown around worked the same magic that it had back in the Eisenhower administration. *Millionaire* catchphrases like "Is that your final answer?" and "I need a lifeline" (a call to a friend) circulated around the country. In a sea of programming that seemed very much the same, the quiz show was different, at least temporarily. And the separation of sponsor and program content that had created the quiz show scandal was a thing of the past, anyway, in every medium, not just television. The blurring lines between advertising and program, interactive web technology and traditional TV, serious information and trivial knowledge, and the fierce competition among channels put the revitalized quiz show right in the middle of the new mediated culture of convergence. It led directly to the second, and lasting, major innovation of postmillennial TV: the burgeoning reality format.

Connection Reality TV

No genre evokes the new millennium like the reality show craze. A history of this genre might send us back to *Vox Pop* on the radio way back in the thirties, stopping in for its fifties equivalent *Candid Camera,* detouring toward PBS's groundbreaking *An American Family* while simultaneously hopscotching through the numerous audience participation game shows of the seventies, such as *The Dating Game* and *Family Feud.* Then we might land with relief on Fox's early network schedule, where such shows as *Rescue 911* and *America's Most Wanted, Highway Patrol,* and their endlessly spun-out ilk clearly point the way to today's reality trend. From there, it's a snap to arrive at MTV's *Real World* in 1989 and, as they say in Britain, Bob's your uncle. But speaking of Britain, this history would also have to recognize that the current reality show craze actually originated in Europe.

Public service broadcasting had always differentiated itself from crass, formulaic, and "Americanized" commercial programming by focusing on the informational and factual. European public service systems (and even commercial networks in most nations have substantial public service requirements) produced a much higher percentage of documentary, discussion, "lifestyle" shows (cooking, home remodeling, gardening), and generally nonfiction factual programming than their commercial counterparts did, and far more of it in prime time. Even game shows, especially those of the test-your-knowledge variety, fell under this heading. This factual genre had several advantages for public service systems. First of all, it was less expensive to produce than fictional programming—no high-priced stars, no elaborate sets and costumes, no expensive screenwriters—thus stretching always hard-won license fees and governments funds a little further. Second, it was almost by definition a very "national" form of programming: It highlighted local and national cultures,

put real people in each nation up there on the screen, explored aspects of national life. It was the exact opposite of reruns of U.S. sitcoms, but often just as popular, because everyone likes seeing themselves on the screen. Third, it was more respectable—this was reality, you could learn something, it wasn't just made-up stuff. It was educational—in an entertaining kind of way.

During the 1980s and 1990s, as public service broadcasters competed with regulated commercial outlets, factual programs began to make even more sense, for both sides. They were popular and participatory, reflecting life as it was lived at all levels of the nation, not just the elite and powerful. They helped to dispel the old ideas about homogeneous national identity and revealed the new, multicultural nations that actually existed—full of ethnic, racial, and regional differences, displaying many accents and lifestyles, with vibrant immigrant communities—in a way that older forms of programming hadn't. They could take place all over the country, tying us together in a new, up-from-the-bottom, grassroots kind of way; citizens saw themselves and their neighbors, along with folks from distant parts of the nation, involved in everyday activities much like their own. And so a host of reality shows burst onto the scene in Europe in the mid-nineties, jumping across the Atlantic at the very end of the decade (Brunsdon 2004, Mosely 2003).

What is a reality show? Constant innovation by television producers makes this concept a slippery thing to pin down; but basically they are unscripted (but not unplanned and certainly creatively edited), feature real people (but also celebrities and want-to-be celebrities), and document actual events (but usually highly structured and often completely artificial). Many include some aspects of a game show, with contests, rules, voting and selection rituals, and so forth. Some of the most popular in both Europe and the United States fall into this category, like the endless *Big Brother* and *Survivor* series; other game-reality shows focus on such perennially popular subjects as dating (*The Batchelor, Blind Date, Average Joe, All You Need Is Love,* etc.) and talent contests (*Pop Idol,* which became *American Idol* in the United States; *America's Next Top Model; The Apprentice*). Some are "fly on the wall" documentary-type programs focusing on the activities of police, firefighters, hospital staff, veterinarians, and so on, carefully edited to produce story lines. One variation of this type is sometimes called the "docusoap," which follows the real lives of ordinary people through their intersecting narratives. These have been particularly popular in Britain, including such shows as *Driving School, Airport, Hospital, 1900 House,* in the U.S. *High School,* and others. In the United States they have tended to take the celebrity form, like *The Osbornes* and *The Anna Nicole Smith Show.* Another extremely successful category is the makeover show, featuring dramatic transformations of anything from homes and gardens (*Changing Rooms, Trading Spaces, Ground Force*), to personal style (*Queer Eye for the Straight Guy, What Not to Wear*), bodies and appearances (*Extreme Makeover, The Swan*), and lifestyle (*Wife Swap, Trading Spouses, The Biggest Loser, Faking It, Nanny 911*). And the list could go on.

One factor that distinguishes these shows as well, other than their basic but rather blurry focus on the "real," is their ability to cross national boundaries and transform themselves into popular programs in just about any continent and nation. CBS's surprise summer 2000 hit *Survivor* was an Americanized version of the Swedish original, which had hit it big on the BBC in 1999 before crossing the Atlantic. Since then it has spawned equally popular versions in at least 15 other countries. PBS purchased the rights to a series based on a BBC prototype called *1900 House,* which documented the experiences of a group of people adjusting to life as it was lived in 1900, while cameras rolled. And ratings were high

in 1999 for the Dutch program *Big Brother,* aired in Britain in 2000 and bought by CBS that same year, which put 10 twentysomething people into a house and watched them interact via cameras and recorders embedded in walls and ceilings. Endemol, the Dutch company that came up with the prototype, had surely been influenced by MTV's *Real World,* but adding the competitive element brought it to prime time. It was streamed onto the Internet 24 hours a day, complete with bathroom scenes and sex. Each week one cast member was voted out of the house by the cast and viewers; the last one left won a large cash prize.

Big Brother may be one of the most frequently produced reality shows around the world, and everywhere it has gone it has provoked controversy. *Big Brother Africa* gained worldwide attention by putting together young people, men and women, from 12 different nations—making it not only a showcase of pan-African identity, but a hot spot of cultural value conflicts. Malawi dropped it from the TV schedule after the first month, on charges of "immorality." *BB* in France was called *Loft Story* and turned the individual participants into couples; six couples began the show and were voted out *a deux.* By 2005 there were five pan-regional versions of the show—Africa, Central America, Middle East, Scandinavia, and Pacific—all of them drawing contestants from different countries within each region.

Why are these shows one of the first truly transnational TV forms? First, it should be pointed out that nations have always imitated and borrowed from each other's TV fare, whether in licensed, official adaptations—like *Till Death Us Do Part* and *All In the Family* in the seventies, and the many game shows—or through unofficial, well, copying. But the reality show, along with its close cousin the game show, presents a uniquely adapted strategy for making the global local—while protecting intellectual property rights. These are *format shows*—programming with a formatted structure that can be adapted to local cultures and settings around the globe. They are sold as a format—complete not only with the basic idea, structure, and set of rules but also usually with a trademark set, costumes, visual style, musical motifs, catchphrases, and so on, all of which can be altered in subtle or dramatic ways to reflect the nation in which it is produced. And all production is done at the local level, in the local language, with people—real people—drawn from local populations. It is the perfect global format for the postmodern globalizing millennium (Moran 1998).

Is it real? Is it authentic? This issue has provoked a lot of discussion, especially from those who dislike reality TV's slipperiness and claims to factuality. It is clear that audiences understand these shows in complex ways, recognizing that they are performed, edited, manipulated, and polished to the maximum entertainment effect, but still valuing them as glimpses, no matter how tainted, into the actual lives and emotions of everyday people, people like us. Their usefulness in a TV universe that, in the United States as well as the rest of the world, is faced with having to fill more and more channels on the same advertising dollars, lies in their relative cheapness and in their unending adaptability—along with their ability to plug all kinds of products in a "realistic," integrated way. They are also very well adapted to integrated web-based synergies, because many have audience participation built in, and most manage to involve their audiences intensively. They are the signature programs of the new millennium—so far.

Reality programs blurred the lines between fiction and fact, between documentary and performance, between national and global culture, between old media and new

media, between passive viewing and interactive participation, and between programs and advertising. Other kinds of strategic and textual convergence abounded during the decade as well, as media scholar John Caldwell points out (Caldwell 2004). Network and studio program archives became valuable as never before. Old content was "repurposed" and "migrated" across media platforms, as reruns of programs currently airing on the main network appeared on cable channels owned by the parent company. The Soap Channel made a business out of a schedule of endless soap reruns, current and past. TV series were released on DVD, and interest in a star of a current series might inspire that star's older series to be released as well. Some programs became "franchises," as they spun off a seemingly infinite number of slightly different versions: *Law and Order SVU, Law and Order: Criminal Intent, CSI: New York,* and so forth. Newsmagazine programs featured interviews with current season stars and producers; sweeps weeks featured "making of" documentaries and program retrospectives featuring writers, directors, set designers, and actors, all of which might eventually be offered as ancillary material on the DVD.

Transmedia and Hyperdiegesis

One way that television networks and producers attempted to hold onto loyal viewers in this age of thousands of choices was to draw them ever more deeply into the narrative and into identification with characters. Media scholar Henry Jenkins notes that "Over the past decade, there has been a marked increase in the serialization of American television, the emergence of more complex appeals to programme history and the development of more intricate story arcs and cliffhangers," (H. Jenkins 2002, 164). As we noted earlier, more and more prime-time dramas relied on *serial* plots— narratives that might resolve one or two small subplots in an individual episode but that drew most of the stories out over an entire season, and beyond—instead of the discrete episodes of the classic network system. Programs like *Hill Street Blues* had pointed in this direction, but it took the convergence and competition of the nineties to bring this basic soap opera strategy into prominence in prime time.

Serialization means that viewers tuning in to a show like *24, Dawson's Creek, Alias, The Sopranos,* or *Buffy the Vampire Slayer* had better have a pretty good knowledge of what happened in the past—the show's "backstory"—or they would be lost. Besides guides to this backstory often found in the programs themselves—recaps of past episodes before each new one, cues in the narrative that gave some context to this one, sometimes even voiceovers to clue viewers in to the basic premise of the show— the place that audiences could turn for essential information became the show's website. And not just official website; unofficial fan sites bloomed, offering many of the same features but frequently taking off in alternative narratives and pointed criticisms.

John Caldwell points to the *Dawson's Creek* site as an early example of several important new textual strategies that increasingly became an integral part of the show. "Characterized proliferations" of the text offered deeper access to the life stories and personalities of the individual characters, giving us access to such things as their "personal computers"—where we could click through to their "private" e-mails, chat rooms, diaries, Christmas lists, college essays. "Narrativized elaborations" provide

additional information about plot lines of which mere viewers of the show would be unaware. When the character Andie took a trip to Europe, we could read her postcards sent back to friends in the show's fictional town of Capeside—and even forward them to our friends via e-mail. We could take a virtual tour of Potter's Bed and Breakfast, and we could use another link to access Capeside High's fictional newspaper. Further, the show's website provided what Caldwell calls "metacritical" textuality: access to fans' and others' comments about the show, including not only discussion lists and chat rooms but also links to reviews, books, newspaper articles, and magazine profiles—and to other websites. And, of course, many *Dawson Creek*–themed products could be purchased.

Other programs have taken web-based "hyperdiegesis" even further. Writer Matt Hills defines the term *hyperdiegesis* as "the creation of a vast and detailed narrative space, only a fraction of which is ever directly seen or encountered within the text, but which nevertheless appears to operate according to principles of internal logic and extension" (Hills 2002, 137). Media scholar Derek Johnson applies this term to Fox's hit *24,* noting that the show's setting in the Los Angeles branch of the "Counter Terrorist Unit (CTU)"—a government agency where hero Jack Bauer and his team have to deal with plausibly realistic contemporary events like terrorist attacks, attempts to assassinate the president, and terrorist-linked drug cartels—gives this show unique opportunities to connect to fans in a hyperdiegetic way. First, the narrative itself ties the fictional events to real, existing government institutions by constantly referring to the State Department, the CIA, Senate subcommittees, and the whole apparatus of law enforcement and state security within which its fictional characters operate. Second, this connection is emphasized on the show's website, with "characterized prolifera-tions" called Profiles that give each character's resume, complete with colleges attended and degrees. Who knew Jack was an English major at UCLA?

Further, each episode is accompanied by a "Research File" that provides explana-tions of aspects of the plot, such as a description of the role of the Secretary of Defense or the chemical makeup of nitroglycerin. Such hyperdiegesis also is frequently extended by *transmedia* migration, producing comic books or video games or novels based on the series, but *24*'s political setting allows this to be taken even further. In 2002, Fox released a tie-in trade paperback called *The House Special Subcommittee's Findings at CTU,* which imitates a journalistic investigative report, complete with internal memos, autopsy reports, classified documents, and transcripts of testimonies of U.S. senators. The blurb on the book's cover keeps up the illusion: "Not since the *New York Times* published the Pentagon Papers has the public been afforded so rare and detailed a glimpse into the workings of key government agencies," it claims. As Johnson states, "Though it would be nearly impossible for readers to mistake this book for real news, the book nonetheless invites the reader to play in the masquerade of taking up citizenship and concern for public life within the diegesis" (D. Johnson 2005, 12).

Why go to all the trouble? Besides selling extra products, and encouraging viewers to stay tuned, there is a larger reason connected to the way that convergence media relate to the audience of the new millennium. No longer the passive "flow through" viewers of the three-network period, today's television audience is expected to be savvy, skeptical, involved, and active. According to Henry Jenkins:

The horizontal integration of the entertainment industry—and the emergent logic of synergy—depends upon the circulation of intellectual properties across media outlets. Transmedia promotion presumes a more active spectator who can and will follow these media flow. Such marketing strategies create a sense of affiliation with and immersion in fictional worlds. (H. Jenkins 2002, 165)

And yet such devices also encourage viewers to be more aware of the circumstances under which a program is produced, and to be critical of its social implications as well. The *24* website features profiles of the show's creators, and the chat rooms provide ample criticism of plot and characters as well as institutional practices—such as too many ads, poor plot resolution, and so forth. The fifth season, which centered on Middle Eastern terrorists, attracted much critical dialogue about representations of the Muslim characters as well as racial portrayals on television generally. And networks were paying attention. After consultation with Islamic American groups, the initial episode of the series was preceded by this announcement:

> Hi. My name is Kiefer Sutherland. And I play counter-terrorist agent Jack Bauer on Fox's *24*. I would like to take a moment to talk to you about something that I think is very important. Now while terrorism is obviously one of the most critical challenges facing our nation and the world, it is important to recognize that the American Muslim community stands firmly beside their fellow Americans in denouncing and resisting all forms of terrorism. So in watching *24*, please, bear that in mind.

The lines between fiction and reality might blur, but in the new convergence culture everyone knows what the stakes are. Media representations are part of real life. And the audience is no longer an undifferentiated mass, assumed to be homogeneous, but a mixture of many different groups, all with their own media outlets within reach. Just as television narratives migrated across media and beyond the borders of the text, discrete audience groups proliferated and began to demand recognition and respects. Of course, some were more equal than others.

NEW AUDIENCES, FRESH FACES, DIFFERENT STORIES

The New Youth Generation

The "youth audience" had been important to television since the 1960s, but the competitive media universe of the nineties went into youth hyperdrive. Beginning with Fox, but quickly followed by The WB and UPN, the networks announced to a whole new generation that their time had come—again. Fox had led the revolution in the mid-nineties with such programs as *Beverly Hills 90210, Married ... with Children, The Simpsons, Melrose Place,* and *Party of Five.* Of course, they'd also bombed with other youth-pointed shows like *Key West, The Heights, The Adventures of Briscoe County Jr., Hardball, Wild Oats, Models, Inc., Ned and Stacey,* and *Misery Loves Company.* Meanwhile the older networks had jumped onto the youth bandwagon, starting out several trends that would dominate prime-time television for the rest of the decade. Despite some misfires with shows like *2000 Malibu Road* and *Freshman Dorm,* NBC had pulled decisively ahead with the debut of *Friends* in 1994. The

success of this half-hour sitcom about a group of twentysomething postcollege adults trying to make it in New York set off a trend of imitators; the next season's schedule included more than 10 highly similar formats, including *Can't Hurry Love, The Crew, The Drew Carey Show, First Time Out, Partners,* and *The Single Guy.* Only a few survived.

The arrival of The WB and UPN in 1995 produced an even more pronounced youthful bias. The WB proved particularly adept at capitalizing on the trend, with programs like *Dawson's Creek, Felicity, Buffy the Vampire Slayer, 7th Heaven,* and *Charmed.* What seemed to distinguish The WB's shows from others was their combination of youthful adventures with verbal and narrative sophistication; these young characters faced adult-type problems with articulation and style, in a way that drew in older viewers while still capturing younger ones. In 1998 The WB was the only network to show an increase in ratings, rising 19 percent squarely in its desired under-30 market, even though it had yet to turn an actual profit. Some credited the upstart network's success with the fact that Fox had turned away from its original youthful, bad-boy image to attract the larger 18-to-49 audience; some pointed to the fact that most of Fox's original executive staff had transferred wholesale to The WB. What made youth such an attractive market? Analysts claimed that young people are highly impressionable and spend a lot of money, forming habits to last a lifetime. But something else marked these youth revolution shows on the major networks: The color of youth was white. What had happened to the revolution in minority-centered programs? Well, a lot of it had gone to UPN.

Though UPN had started the new network race in a better position than The WB had, both in having the Star Trek franchise and a greater number of initial affiliates, it failed to seize on that advantage. By the 1996 to 1997 season, the network needed to build audiences; as one industry observer put it, "UPN needed to do something a little different this year, so they went to the Fox model, going young and ethnic when you're starting out. Those are the easiest groups to get initially." He added, "But then as you expand to additional nights you have to broaden that audience" (Battaglio 1998). This is what Fox had done, and from first place among African American viewers it had slipped to second—though it still aired the top three shows among African American households: *Living Single, New York Undercover,* and *Martin.* UPN moved into that gap, with programs like *Moesha, Homeboys in Outer Space, In the House, Malcolm & Eddie, Good News,* and *Sparks.* In 1997, a season in which NBC lacked any program with a minority star and Fox, CBS, and ABC only had seven between them, UPN and The WB featured 10 minority-centered sitcoms. NBC's top three shows among white audiences, *Seinfeld, ER,* and *Suddenly Susan,* did not even appear on the top 20 of African American household ratings.

The strategy of ethnic programming worked, and UPN held its own until in the 1997 to 1998 season it attempted to follow the broadening strategy of the other nets and lost ground dramatically. By the end of the year its ratings were down 35 percent, and it determined to go back to its niche market of African American viewers. Picking up the sitcom that ranked number one in African American homes—*Between Brothers,* with Kadeem Hardison—which Fox had canceled, UPN began to regroup, adding other black-oriented shows like *Grown Ups, The Parkers,* and *Shasta McNasty.* (One of UPN's most high-profile new shows of the 1998–1999 season, *The Secret Diary of*

Desmond Pfeiffer, ended up being canceled before its debut due to charges of racism; it starred Chi McBride as President Lincoln's butler during the Civil War.) But it was only when the netlet also began to court the young male audience with a 2-hour block of wrestling—*WWF Smackdown!* and *I Dare You! The Ultimate Challenge,* based on the exploits of professional stuntmen—did ratings begin to rise. "If it has high testosterone, we'll air it," said UPN President Dean Valentine (Hodges 2000, 6). By spring 1999 UPN had improved its ratings by 35 percent and was the number-one network among African American households.

Yet by 2005 the tables had turned again. After some tumultuous seasons, during which new practices like the summer debut of new programming and the increasing erosion of the notion of the traditional "season" shook up old established ways, long-time front-runner NBC had fallen on hard times. With the conclusion of both *Friends* and *Frasier* in spring of 2004, and with series like *The West Wing, ER, Will and Grace,* and *American Dreams* slipping in their ratings, NBC's era of ratings supremacy had clearly ended. Even hit reality show *The Apprentice* and the various *Law and Order* clones couldn't protect it from the rise of ABC, with its hit series *Lost* and *Desperate Housewives* and CBS's *CSI* franchise and *Cold Case, Without a Trace,* and *Everybody Loves Raymond* still going strong. The WB struggled on, billing itself as the "fastest growing network" in the younger demographic and with a roster of popular shows including *Smallville, 7th Heaven,* and *The Gilmore Girls.* But Fox had begun moving up into the big three, with hits like *American Idol, The Simpsons,* and *24.* UPN hung onto the African American audience with *America's Next Top Model* and popular sitcoms *Half & Half, All of Us,* and *One on One.*

Mas Television Latina

Another ethnic minority group began to have an effect on network ratings as well. In spring 1999, Neilsen figures showed a sharp drop in the desirable 18–34 audience. Simultaneously, the Spanish-language network Univision displayed a sharp upsurge—241 percent!—among precisely that group. Surveys showed that Univision had begun to attract 92 percent of prime-time viewers in Latino/a households with its fare of telenovelas and talk shows. By fall 1999, New York's Univision station WXTV had begun to outrate UPN, both day and night: *Montel Williams* on UPN lost out to *Despierta America, Maite* won over *Jenny Jones,* and the telenovela *Tres Mujeres* even trumped *Star Trek: Voyager.* Advertisers began paying attention, targeting the young-skewing Latino/a population in both mainstream and niche ads.

Univision grew out of the first U.S. Spanish-language station network, SIN (Spanish International Network), which attained wider notice when it broadcast live coverage of the World Cup Soccer championship in 1970. By 1982, with its 16-station presence on over 200 cable systems, SIN could claim that it reached 90 percent of the Latino/a audience. At that time, almost 90 percent of its programming consisted of imported hits produced in Mexico and initially aired on Mexican television, a situation which led to charges of foreign control and its sale to the Hallmark Corporation in 1986. By 1992, however, SIN became known as Univision after being purchased by a partnership of Televisa International of Mexico and Venevision of Venezuela, between them the two largest producers of Spanish-language programming in the world. By

2005, Univision was the fifth-most-watched network in the United States, after only NBC, CBS, ABC, Fox, and The WB. For Spanish-speaking households, Univision was a throwback to the classic network system days, sometimes attracting 25 percent of Latino/a households during prime time. Its telenovelas—high-budget, long-running serials aired in primetime and featuring top Latino/a stars—dominated the ratings, as variety shows and newsmagazine programs became increasingly popular.

Arlene Davila describes Univision's original targeted audience as "recently immigrated, Spanish-speaking Hispanic, who is traditional and committed to family, to community, and to the *espiritu de superacion* (spirit of overcoming)" (Davila 2001, 158). The network reached that audience at first with a a schedule largely imported from Mexico and Venezuela, though by the early nineties it began increasing its proportion of programs produced in the United States, primarily in Miami, which became known as the "Latin Hollywood." *Sabado Gigante,* Univision's leading variety show, is produced in Miami, hosted by a well-known Chilean star, and features acts and performers from across Central and South America. This reflects a pan-Latino/a approach to programming, "linking Brooklyn and Los Angeles with Mexico, Puerto Rico, Miami, and even Spain" (Davila 2001, 159). Its newscasts focus on Latin American countries, even more than on news of U.S. Latinos/as, creating a cross-ethnic Latin identity that extends beyond the borders of the United States both geographically and culturally.

The channel's "denationalizing" stance has attracted some criticism from U.S. Latino/a viewers who would like more focus on their lives and circumstances. Some called for a boycott in 1998 when both Univision and Telemundo, its leading competitor, failed to broadcast President Clinton's State of the Union address (Davila 2001, 161). In response, Univision began to create programs like *Christina,* a talk show produced in Miami especially for U.S. Latino/a audiences, which was then carried on the network back into Spanish-language households across Latin America. Many there objected to the American emphasis on frank talk about sexuality. Clearly, transnational television has its pitfalls. However, by 2005 Univision routinely captured 30 percent of Latino/a viewers during prime time; it also increased the amount of English-language programming in its schedule, aimed at the growing numbers of "English-first" Latinos/as in the United States.

Telemundo's origins are a little different from Univision's in that it started out with a Puerto Rican emphasis, importing mostly Puerto Rican–produced programming focused on East Coast Latinos/as, whose majority heritage was from Puerto Rico and Cuba. However, it shifted to a more pan-Latin American approach in the eighties and began to feature more U.S. productions as well. In 1998 Sony Pictures Entertainment purchased the channel and embarked on a project of creating original Spanish-language sitcoms and other American-style programs aimed at the American Latino/a audience. Telemundo also began to air more Spanish-language versions of American programs. As programming President Nely Galan describes it, "I would say that our voice is the bicultural Latino who feels that he's in or she's in a tug of war between two cultures" (Baxter 1998). In recent years the channel has, via an agreement with Mexico's TV Azteca and Brazil's TV Globo, focused more on highly popular telenovelas. In 2002, NBC acquired Telemundo as part of its strategy of cross-media expansion. By 2005 the channel routinely attracted 8 percent of the Latino/a prime time audience

and was producing almost all of its telenovela lineup in Miami, with imports assigned to lesser dayparts.

Agitating for Inclusion

Mainstream, English-language television continued to slight Latinos/as, spurring groups like the Hispanic Media Coalition to propose a viewing boycott in 1999 against the big-four networks for their lack of Hispanic representations in that fall's lineup. But by then a larger controversy was brewing. That summer, when the networks announced their schedules for the new season, it became obvious that not one new program would feature minority actors in any significant roles. Meanwhile, the disparity in viewing patterns for whites and minorities had diverged ever more widely. The only two network programs to reliably attract large percentages of both audiences were *60 Minutes* and NFL football, with *ER* in a distant third place. The top-rated show among black viewers, *The Steve Harvey Show* on The WB, ranked just 127th among whites. NBC's *Homicide,* a show with a significant number of minority characters, had been canceled despite respectable ratings.

Other programs that featured a few black, Latino, or Asian actors—like *NYPD Blue, Law & Order, Ally McBeal, Felicity, Spin City,* and *The Practice*—displayed a disturbing tendency to relegate those characters to the briefest of supporting roles and rarely gave them a developed story line. Under the leadership of Kweisi Mfume, the National Association for the Advancement of Colored People (NAACP) and a coalition of national minority activists decided to take action, accusing the networks of perpetrating a virtual whitewash in programming and threatening a boycott during the important upfront advertising sales period. After a period of negotiation, the networks announced a significant initiative to improve African American representation both on the screen and behind it. The networks, led by NBC but with the others soon joining in, promised to embark on a program that would provide internships to minority students in the network and production industry, fund minority scholarships for the study of communications at the college level, and increase the networks' program purchases from minority producers. Additionally, NBC agreed to fund the addition of a minority writer to the staff of every new network show that made it to its second year, including those produced by outside firms. It was hoped that such a step would help to groom a field of minority candidates for future network and production management positions.

Other networks focused on mentoring minority employees and setting up diversity training programs—something they lagged far behind other industries in doing. Fox and CBS committed to hiring vice presidents for diversity. And to much fanfare, in January 2000 CBS broadcast the first episode of Steven Bochco's latest production, *City of Angels,* featuring a virtually all-minority cast in a hospital drama set in Los Angeles. Minority supporting actors, meanwhile, had been hastily written into a number of existing shows.

Yet many placed more blame on the prejudices of advertisers, who selected network television precisely for its audience of affluent young white viewers and neglected other groups. Black Entertainment Television (BET) and other minority channels had long protested that they received disproportionately small amounts of the

advertising dollar even when their audiences resembled white audiences in size and demographics. A study on radio advertising commissioned by Congress in 1998 had revealed advertiser avoidance of minority outlets, quoting a memo from a time-buying firm that stated, "the non-ethnic customer is more attractive" and advising the avoidance of minority stations because advertisers wanted "prospects not suspects" (Labaton 1999). Advertisers felt comfortable using black and Latino/a culture in their advertising to attract white audiences, but when it came to recognizing minority purchasing power in minority-targeted outlets, advertisers drew back. Clearly the networks hoped for large audiences of all races for programs that would combine minority and nonminority representations. The fact that it took an organized national effort to win concessions that many other businesses had applied years before pointed to entrenched resistance. However, though some commentators harked back to the "good old days" when highly rated shows like *Cosby, Benson,* and *Diff'rent Strokes* appealed to large audiences both black and white, the fact remained that minority viewers had far more choices and outlets now than they had under the "enforced unanimity" of past network television.

Out onto Prime Time

In the late 1990s, it was finally safe for gays and lesbians to come out of the closet and onto prime time TV. Though non-heterosexual identities had not been totally invisible on network television, they had tended to occupy occasional roles as "problems" or oddities, on talk shows, single episodes, or made-for-TV movies. In the late 1970s and early 1980s a few shows introduced a recurring gay or bisexual character—Peter in *The Corner Bar* (1972), Jodie Dallas on *Soap* (1977), and Steven Carrington on *Dynasty* (1981), for instance—and in the daytime, on the soaps, a few more could be glimpsed: Dr. Lynn Carson on *All My Children* (1982–1983) and Hank Elliott a little later on *As The World Turns* (1988–1989). In the early nineties, a few openly gay or sexually confused figures emerged on pay cable: the series *Brothers* on Showtime (1984–1998), with a plot that revolved around one brother coming out as gay, and the character Brian on *The Larry Sanders Show* on HBO (1992–1998). Then, in the mid 1990s, the floodgates burst. By the 1995–1996 season, almost 20 prime-time shows featured gay characters in leading or supporting roles, including such highly rated programs as *Roseanne, Mad About You, Melrose Place, NYPD Blue, Ellen,* and *Friends. Will and Grace,* despite its name, became the first prime-time sitcom to center on a gay male character, in 1998. Many more featured occasional gay characters, dealt with issues of sexuality in one or more episodes, or focused on the seemingly everyday event of being mistaken for gay. Why did this happen so suddenly? Had American culture changed so dramatically? Or was it just TV?

Historian Ron Becker argues that it was a little of both. First of all, the gay rights movement had made great strides since its emergence in the 1970s, and by the 1980s several organized groups were pushing for better recognition of gays and lesbians in the media, such as the National Gay Task Force, the Alliance for Gay and Lesbian Artists in the Entertainment Industry, and the Gay and Lesbian Alliance Against Defamation (GLAAD). Advertisers and marketers began to recognize the gay audience as a desirable one, with lots of disposable income, as the television universe began to fragment in the late eighties and all players looked to identify niche markets. Niches

meant that the family no longer watched together; so more sophisticated, adult-oriented fare stood a chance even on prime time. Becker argues that gay-oriented programming became a way for an emergent class of what he calls "slumpies"—socially liberal, urban-minded professionals—to identify themselves as hip and happening (Becker 2001). Gay became cool. Everyone had a gay friend, or at least watched one on TV. In 2001 Ru Paul, a drag queen, even got his own show on VH1. On Showtime, *Queer as Folk*—an adaptation of a British series—broke new sexual depiction barriers, as did *The L Word* a little later.

Yet by 2005 the trend had cooled. Many gay characters remained in place, and some shows, like HBO's *Six Feet Under,* went further in showing a gay male couple making love, having relational disputes, and planning to adopt a child (oh yes, they were a biracial couple, too). Reality shows like *Queer Eye for the Straight Guy* made gayness lighthearted and fun; now it was OK to laugh at Jack's more outrageous queenly moments and Carson's bitchiness. Lesbians had never had quite the box office draw, though for a while it seemed as though every self-respecting female character had to experiment with a lesbian relationship, only to decide it just "wasn't for her." Even ESPN featured a gay character on its soap *Playmakers.* Maybe this signaled the true mainstreaming of outside-heterosexual identities; maybe it had just been a fad. Or maybe the cultural politics around gay marriage in the Bush II years had made gayness no laughing matter, politicizing it and cooling advertisers' ardor. Or maybe all of the above; that year the Museum of Television and Radio in New York gave the trend the decidedly mainstream distinction of a retrospective exhibit: "Not That There's Anything Wrong with That: The History of Gay and Lesbian Images on Television." When Viacom/MTV Networks' new gay channel Logo debuted in June 2005, it did so with very little fanfare. Planning a rounded schedule of series, travel programs, documentaries, sports, reality shows and more, what one commentator called "a nice collection of entertainment for gays and lesbians that is not using gays and lesbians as entertainment." (Salamon 2005, B8), Logo also promised to highlight diversity in the gay and lesbian population—something that its prime-time representations usually left out.

CABLE: IT'S NOT TV . . .

By the first decade of the new millennium, was it possible that a cable channel existed for every single identity or interest? In the late nineties cable finally reached maturity as a medium, with over 75 percent of all households wired and a variety of original and creative programming produced specifically for its premiere channels. No longer simply a recycler of broadcast programming, cable television had already added indispensable sources of entertainment and information to U.S. culture, from CNN to ESPN to Nickelodeon to MTV. How had we gotten along without the Weather Channel, CNN Headline News, C-SPAN? Had TV drama ever really existed before HBO? Original cable programming went from being low-budget and forgettable to ranking with the best that television had to offer. Starting in 1999, television's Emmy awards recognized an unprecedented number of cable's most significant achievements, even as promising new offerings came on board. Cable, especially pay cable, could go farther, be more daring, take on difficult or touchy topics, speak more frankly and

appeal with more directness to many different groups than television had ever been able to do before. Two series, both on HBO, that gained some of the largest and most fanatically loyal audiences along with high critical acclaim were *Sex and the City* and *The Sopranos.*

Connection *Single Women and "Family" Men*

After years of writing for *Beverley Hills 90210* and *Melrose Place,* Darren Starr apparently had a lot of things to say that he hadn't been able to work into those series. Once he found *New York Observer* sex columnist Candace Bushnell's book titled *Sex and the City,* a new kind of series opened up, one that the expanding narrative universe of pay cable could actually make come true. Though ABC expressed some interest, Starr remembered the network control and restrictions on his previous work; at the time, he had likened the situation to "being in an East Bloc country" (Lotz 2004, 2066) *Sex and the City* debuted on HBO in 1998 and ran for eight seasons. More than any show had before, *Sex and the City* provided a full and frank look at female sexuality, and it captivated its audience of both men and women. In form, it marked a return of the "dramedy" by combining serious drama with humor and fun, without a laugh track. It was the first HBO original series to attract widespread attention and paved the way for David Chase's *The Sopranos,* which appeared the following year. In 2001 *Sex and the City* won the Emmy for Outstanding Comedy Series.

Sarah Jessica Parker starred as Carrie Bradshaw, the Candace Bushnell character, whose job was writing a sex column for a New York City paper. Each episode opened with her musing about a topic related to sex and dating, in voiceover, and each episode responded to the question as it played out across her life and that of her three central friends: Samantha (Kim Catrall), Charlotte (Kristin Davis), and Miranda (Cynthia Nixon). Why are there so many great unmarried women, and no great unmarried men? Can you be friends with an ex-boyfriend? How do you know when it's over? Why do men like to date models? Each question bounced off the characters like the marble in a pinball machine, reacting to their personalities. Samantha, the voraciously sexual party girl, demonstrated the woman unbound by convention and out to please herself. Charlotte, the youngest and most naïve, aspired most traditionally to a romantic marriage, home and family. Miranda played the hard-shelled but vulnerable career woman, distrustful of emotion and relation-ships. Carrie, the voice of common sense who tied them all together, went through as many boyfriends on the show as she did Manolo Blahnik pumps.

Many fans pointed out that, although the show was about sex, the most important relationships in the show were those between the women. As they met up in coffee shops and shoe stores, strolled down Fifth Avenue or through Central Park, arrived together at parties and at weddings, had adventures in Los Angeles and the Hamptons, the one constant was their ongoing conversation about their lives. Of course, you could also watch for the clothes. Debate ensued: Were these the truly liberated women of the

new millennium, living their lives as they pleased and finding happiness and fulfillment outside the old story line of love and marriage? Or were they sad and desperately obsessed single girls, grabbing at love however they could, and making a lot of wrong decisions along the way? The show's executive producer, Michael Patrick King, said: "People thought, oh it's just about sex or it's just about fashion. And then slowly over the years people start to see it's really about love ... and relationships ... and sex ... and basically the battlefield of trying to be in love—whether it be with another person or with yourself" (HBO 2004).

Whatever its appeal, it proved incredibly popular with audiences across the globe. It was broadcast on Channel 4 in Britain, and on terrestrial channels in Germany, Italy, the Netherlands, Sweden, Japan, Latvia, Australia, and Denmark, as well as a host of other countries on HBO Asia. It was banned in Singapore at first, but finally allowed to air in 2004. In the way of long-running serials, the story's characters changed and deepened over time. Its release on DVD helped to spark the realization that series could do extremely well both in purchase and in rental. Yet for all its appeal and armies of loyal fans, it would remain permanently upstaged by another series that debuted on HBO the next year. Could this be a girls versus boys thing? Or did *Sex and the City* prove too original, too different, to win the greater acclaim that its fans thought it deserved? Certainly Darren Star, who had left the series after the third season, found it difficult to succeed with his next projects. They included the extremely short-lived *Grosse Pointe* on The WB, a satire about the production of a teen soap opera; *The $treet* on Fox, focused on a Wall Street crowd, and 2003's *Miss Match* on NBC, starring Alicia Silverstone as a young lawyer whose second career is as a matchmaker. But then, that wasn't HBO—it was network TV.

Network TV rejected *The Sopranos* as well. When David Chase came up with the idea in 1995 for a series about a troubled suburban mobster trying to hold together two families—his own and the mob—and shopped it around to network TV, all four major nets turned him down. Fox came close to making a deal, but called it off when they read the pilot script. Language was one problem; mafiosi don't talk like schoolteachers. The fact that it featured a mob boss who could kill someone in the afternoon then come home for a family dinner also troubled the networks. And how could mainstream TV accommodate the mob's favorite meeting place, a topless bar called the Bada Bing? HBO had no such qualms, and introduced the show to high critical acclaim in the spring of 1999. By March, industry insiders were calling *The Sopranos* "a groundbreaker, a show whose influence is likely to be felt throughout the industry in the coming years." (Carter 1999). Produced by Brillstein-Grey Entertainment, the series was shot in New Jersey to give it an authentic look and feel, which partially accounted for its budget of $2 million per episode—about half a million more than most TV dramas. The series costs HBO $40 million a season, but drew "hundreds of thousands" (James 1999) of new subscribers to the pay network. James Gandolfini rocketed from relative obscurity to stardom as Tony Soprano, mob boss and family man, whose difficulty in keeping his multiple roles together in late-nineties suburbia has driven him to a psychotherapist.

As the show's promotional tagline read: "If one family doesn't kill him, the other one will." Featuring a roster of well-respected but lesser-known actors, the cast included Edie Falco, Nancy Marchand, Lorraine Bracco, Vincente Pastore, Michael Imperioli, and even Bruce Springsteen band member Steve Van Zandt. Called by critics "everything from the

best show of the year to the best of the decade to even the best television show ever" (James 1999), *The Sopranos* rejected both television and film's stereotyped view of mafia life by centering on the contradiction between Tony's ancient, ritual-laden violent profession and modern suburban family life in the United States. What do you do when you have to rub out a rival while escorting your daughter on a college tour in New England? How do you answer her questions about what it is you do for a living? In a mob family, attempting to put Mom in a nursing home might result in a contract hit on you executed by your own uncle. An old friend might well be wearing an FBI wire, but you still have to make jovial conversation with his wife and son in the kitchen. Maintaining a mistress is as obligatory, and as difficult, as keeping a wife. Your son finds his uncle's picture on an FBI website identifying him as a known organized crime figure, and now your countercultural sister has returned from her Oregon commune to talk some feminism into your wife and daughter. These situations leave Tony struggling with depression—not an acceptable affliction for a mafia capo.

Many critics pointed out that it wasn't just Tony's language that couldn't be accommodated on network television. As one wrote, "On network television his character would surely be sanitized, the violence toned down, the ambiguity cleared up and the entire series diminished" (James 1999). The series would also have to be made more cheaply, and if it were shot on a set there would be a tendency for realism to evaporate and clichés to creep in. The show did attract some criticism from the National Italian American Foundation, for recycling the same old Italian images and connections to organized crime. Yet the writers strove to incorporate real-life events and drew on "dribs and drabs we know from people who have been connected" (Peyser 2000, 68).

The Sopranos ran for six seasons to constant critical acclaim, topping off what was becoming a tide of interest and accolades for pay cable more generally. With high-quality drama too unusual or daring for traditional TV networks, HBO's promotional line seemed to sum it up: "It's not TV, it's HBO." HBO President Chris Albrecht described the audience that such programs sought out: "The kind of people we want to attract are people who don't watch a lot of television. These are usually better-educated, slightly older men and women age 35 to 55, who can probably more easily afford to keep our service" (Meisler 1998, 45). As another factor contributing to their program innovation, most commentators credit pay cable's lack of conservative advertisers needing to be pleased.

Other cable channels experimented with innovative programming as well. On Lifetime in 1998 and 1999, several original series debuted, including *Any Day Now*, a drama about two friends reaching across the racial divide in Birmingham, Alabama, in both the past and the present; *Oh Baby*, about a single mother's adventure into pregnancy and child rearing; and *Maggie*, a comedy about a 40-year-old woman going through a midlife crisis. Showtime debuted *Linc's*, a comedy with an African American cast set in a restaurant, and *Rude Awakening*, an adult comedy about a recovering alcoholic; but the channel received the most attention for its 2000 debut of *Queer as Folk*. By 2005 both Showtime and HBO were featuring their original series in promotion—and documenting their ability to add subscribers—as much as their previous focus on Hollywood movies. Basic cable channels got into the act as well. The FX

Network debuted the tough crime drama *The Shield* in 2002, starring Michael Chiklis and adding movie star Glenn Close in 2005; and they added edgy *Nip/Tuck,* about high-living plastic surgeons, in 2004. TNT debuted *The Closer* in summer 2005 to higher ratings than most network shows. USA premiered sci-fi serial *The 4400* in 2004. High-quality original drama programming became a feature on most prestige cable channels, either as competition with network rivals, or—as network fears of indecency smoothed down programming—a place where the parent corporations could demo edgy, risky dramas to see how they'd play out.

MTV, meantime, had identified another kind of millennial viewer. Having conquered the traditional American youth audience—and after that, the world—the popular music and culture channel turned its attention to more complex audiences at home. In the summer of 2005 it announced plans to launch three new channels that acknowledged the growing number of young people of "glocalized" identity, those so-called "hyphenated" Americans who valued strong ties to another culture while firmly embedded in the American context. By no coincidence, all three were aimed at the growing Asian American minority. MTV Desi focused on Indian Americans, MTV-Chi on the Chinese American youth population, and MTV K for Korean Americans. These were high-income groups, and growing. The schedule would not simply consist of a mixture of "normal" U.S. schedules and programs drawn from the overseas services: "Rather, they will, like their target audiences, be hybrids, blending here and there and grappling with identity issues, mostly in English" (Sontag 2005, B1). They would feature video jockeys (VJs) chosen especially to appeal to their age and ethnic cohort, and the programming would be the familiar MTV blend of music, comedy, game, and talk shows with a view on living the transcultural life. And they promised to import globally inflected music back into the American mainstream: Bollywood videos, English-Guajarati hip-hop, Mandarin rock, Canto-pop, South Korean hip-hop. Now here was a true innovation—music TV from the margins flowing back into mainstream U.S. culture. In music culture itself, this wasn't so strange—world music had been thriving for over a decade—but for the first time, the conglomerated world of big media had recognized the force of world music and used it as a model.

GLOBAL CULTURE IN A DIGITAL ERA

Around the globe, as the flow of information and culture accelerated via proliferating channels, technologies, corporations, and services, effects were most profound on those nations whose media systems had remained most closed to outside influences and to commercial competition in the preceding decades. There the sudden and ineradicable availability of streaming media that bypassed all local means of screening it out—from videotapes to cable to satellite channels to the Internet—not only brought outside influences in but also unlocked a tide of alternative cultures from inside the nation that had previously been kept subservient to the mainstream. No country experienced this "shock of the new" more suddenly, or more influentially, than India did in the 1990s.

Connection India Goes Global and Local

After the United States, India possesses the largest and most prolific film industry in the world. Based in Bombay (Mumbai), often referred to as Bollywood, Indian film producers turn out more movies per year than do their Los Angeles colleagues; and they market their movies throughout Asia and to diasporic communities everywhere. This key position in Asian media, combined with the size of India's home audience that produces economies of scale similar to those in the United States, helped to inspire the major changes that occurred in India's television structures during the 1990s.

India is a highly diverse nation, with five major languages and hundreds of dialects, five states with distinct regional cultures, several major religious groups, and a rigidly hierarchic caste system, all contained uneasily within the overarching Indian identity forged in the twentieth-century struggles for independence and prosperity. Beneath it all lie strong remnants of the nation's colonial British past, including English as a common language among educated elites, and a cordial but sometimes suspicious relation to aggressive American popular culture.

Media scholar Shanti Kumar (1999, 93) describes the process by which, under Prime Minister Indira Ghandi, the state television network Doordarshan became in the seventies and eighties a primary means of interconnecting this diverse and often contentious population. The network, under centralized state supervision, provided a diet of programs intended to aid in national development and to tie the nation together. Combined with the ambitious Satellite Instructional Television (SITE) project, Indian television spread from its roots in Delhi to five states and 2,400 villages across the country. Programming on Doordarshan focused on agricultural information, education, health, and family welfare, though it also provided some lighter fare such as informative talk shows, game shows, children's programs, feature films, and sports. Financed by the state, Indian broadcasting followed the BBC model as a public service, noncommercial monopoly. It was the only television channel that most of India's ever-growing population could receive. Unwanted foreign influences were tightly controlled, and education was regarded as far more important than entertainment.

Kumar credits India's hosting of the Asian Games in 1982 with refocusing Doordarshan as an entertainment and advertising medium. Shifting to color (it had previously broadcast only in black and white) under the directorship of Rajiv Gandhi, the prime minister's son, Doordarshan began to reinvent itself as a more entertainment-based service. It began attracting a larger urban elite audience, and with them the attention of advertisers. Prime-time programming on the Doordarshan monopoly became oriented to advertiser-sponsored "national programming"—entertainment programs directed at the general public—while daytime continued its developmental focus. As Kumar writes, "a younger, more urban, anglophile and technophile generation took charge of envisioning a new, more cosmopolitan personality for Indian television" (1999, 94) The most popular programs were historical epics and serial dramas that drew on India's mythology and history to speak directly to its sense of national identity. Usually broadcast both in English and Hindi, the genre expanded

to include more modern themes, with some Western influence. Soon Indian-produced soap operas, sitcoms, sports, and films filled the schedule. Doordarshan retained its monopoly on television throughout, with only a few low-power regional stations in a handful of major cities to compete, usually by broadcasting Doordarshan programs in the regional language. Programming tended to be cautious, politically conservative, and focused on keeping foreign and marginal interests at bay.

But in 1991, Doordarshan's national identity-building monopoly status was challenged by an interloper. STAR TV (Satellite Television Asian Region) began to offer four channels of non-Indian programming to the limited audiences that had access to satellite reception. The channels consisted of Star Plus, entertainment programming largely of European and American origination; Star Sports, emphasizing European and American sporting events; the BBC News channel; and MTV, the American music video network. At first only a small number of hotels and businesses could receive the satellite broadcasts, but quickly an entrepreneurial industry sprang up to connect a central satellite receiving dish by cable to homes in the neighborhood, charging a small monthly fee.

Within a few years this had become an established business in India's metropolitan areas. "Very quickly, STAR TV became a rage among the affluent English-speaking Indian middle class, and the satellite and television industry in India began to witness radical transformations" (Kumar 1999, 99). In 1995, when Rupert Murdoch purchased it, STAR began to change. Dropping MTV (and later the BBC News channel as well, in a highly politicized and controversial decision), STAR saw an immense opportunity in creating a television service that catered more directly to local cultures, to very specific regional and local audience tastes, not simply one that relayed programming produced elsewhere. It instituted Channel V, a pan-Asian music video channel that relayed, in two separate beams, a Chinese-based service to its northern sector, and an Indian beam to its South Asia audiences. The latter, bridging diverse Indian cultures by broadcasting in Hinglish (a mixture of Hindi and English) gave the local channel a global flavor.

Channel V opened up production centers in Delhi, Bombay, and other major cities, combining MTV-style camera work, editing, animation, and video rotation with elements of Bollywood and the local music scene. Indian and Anglo-Indian VJs became pan-Asian stars and combined a hip, globally accented presentation with revivals of older Hindi music and films. A new Indian popular music scene grew and began to reach global audiences. (Meanwhile, MTV launched its own MTV-Asia channel on a different satellite, but it remains secondary to STAR's.)

Observing Channel V's success, many other Western-based channels attempted similar hybrid strategies. CNN, TNT, the Cartoon Network, ESPN, Disney, and the Discovery Channel all expanded into Asia, all embracing some form of the localization policy initiated by Channel V. Whether through direct satellite transmission or partnerships with local broadcasters, Western media recognized the enormous potential of the Asian market and the desirability of "fashioning for themselves a culturally-sensitive 'Asian' personality" (Kumar 1999, 99).

The decisive moment for Indian media culture, however, came in 1995 when Zee TV, a privately owned Hindi channel, took advantage of the possibilities opened up by satellite broadcasting to provide the first locally originated Hindi language competitor to Doordarshan. Its strategy consisted of broadcasting the kind of programs so popular on STAR—soaps, sitcoms, and talk shows—but this time in Hindi, produced from the local

culture with local audiences in mind. Zee TV also broadcast without the centralized censorship and restrictions imposed on Doordarshan. Suddenly possibilities for debate and discussion of public issues unconstrained by the needs of the state seemed to blossom. On one popular Zee TV Program, *Aap Ke Adalat,* politicians, celebrities, and business leaders are interrogated intensely by the host, a lawyer who puts the figures on trial in a fictional courtroom setting for questioning. Such a program had not been possible on the cautious and politically sensitive state network. As Kumar summarizes, "In their eagerness to gain dominance in the economic sphere, commercial networks like Zee TV revealed to their audiences an almost suicidal willingness to disrupt the hegemony of the political sphere, something Doordarshan had always been unable or unwilling to do in its attempts to create a national programming strategy that would bind the diverse nation together" (1999, 100).

Other privately owned commercial networks soon sprang up. Some emphasized regional languages, especially in South India where Hindi and English were spoken by few. Two of the most successful, Sun TV in Madras and ETV in Hyderabad, broadcast in the Telegu language—a subculture never adequately recognized by Doordarshan or by the Hindi service of Zee TV. Again, as in Great Britain, the definition of the public had broadened. Now recognized as consisting of previously underserved regional groups and not only the primary Hindi-speaking public addressed by Doordarshan, a combination of commercial competition and outside disruption of monopoly made these social subgroups visible and able to speak for themselves. At the same time, as Kumar points out, the central network Doordarshan has thrived. Its unifying vision complements and unites the local vision of the regional stations, offering high-profile nationalistic series and films like the documentary *Discovery of India,* serials based on traditional folklore, and religious epics. Its rising advertising revenues have allowed it to provide more technologically sophisticated programs and to extend its reach, because it remains the best way to address the largest national audience.

Much as the competition from new cable and broadcast networks allowed subordinate U.S. groups to find outlets that addressed their interests more directly than did the unified, exclusionary voices of the big three, television in India—once freed from the monopoly of an enforced and restricted national identity—could allow its own unique diversity to emerge: the unique diversity that comprises Indian identity. A global voice, in this case of the Western STAR TV, challenged highly restrictive notions of national identity and offered hybrid visions of Indian-ness, prompting a rethinking of uniformity and exclusion and a recognition of the many different identities within the sphere of Indian-ness. Global intrusion promoted local diversification and the strengthening of regional identities. Its economic impact and basis must be recognized too, as the competition for audiences prompted by an advertising base disrupted the government-funded monopoly of the state broadcasting system. However, this case study also points out the limitations of the commercial media. The gap between those who are privileged to be thus addressed, through the ownership of television sets and the reception of satellite signals, is probably nowhere greater than in India, with its millions living below the threshold of commercial television's interests. These contradictions are still being played out and are far from settled.

Part of STAR TV's success was its stimulation of cultural hybridity, the combining of different cultural strains to produce a form of programming neither totally foreign nor totally local. In the example of Channel V, the imported format of the music video meshed with Indian music, personalities, industries, and audiences to produce something distinctly different from the original model. Simultaneously, it encouraged an upsurge in the Asian

pop music scene, creating new forms of music and new opportunities for artists that would most likely not have occurred without the Western influence. This trend leads in a direct line to MTV-Desi, profiled earlier.

In other places, the infiltration of centralized state systems by competing commercial networks allowed cultural resistance to develop. Media consumption and production can constitute a situation in which resistance or opposition to mainstream cultural values can occur and in which subordinate or oppositional voices can be heard. In Britain, after local commercial radio was instituted, ethnic groups were able for the first time to find an accessible outlet, creating expressly Asian, Greek, and black formats in many metropolitan areas. Several imported and domestic satellite television channels serve the British Asian community, from Zee TV and Sony to the Pakistani Channel, Asianet, Namaste, Bangla TV, B4U, Channel East, and Prime TV. Though most British Asians watch a significant amount of mainstream programming as well, not all of it suits Asian family standards. As one Scottish Pakistani producer commented,

> There is virtually nothing on the main UK television channels for Asians. . . . We watch TV as a family group and the content of the British soap operas is not suitable for family viewing. Pakistani dramas don't have any sex, drugs, or anything that your children and granny couldn't watch." (Carson 1999)

Thus Scottish Pakistanis assert a cultural identity that is British but resists some elements of mainstream British culture. In Britain as well as in India, cultural identity takes place on a variety of levels and in a variety of forms, not just in a one-size-fits-all national version.

In countries where dissident politics can get you thrown in jail, the Internet's access to a whole world of political information and organizing presents a challenge indeed. China has attempted to curb its citizens' use of the Internet to access certain sources by requiring all content and service providers to obtain a security certification. The government has made it illegal for individual users to send e-mail containing state secrets, which in China could include any news not officially released to the public. Observers believe it is directed particularly at chat rooms, which frequently serve as sites for discussion and criticism of government policies. Additionally, it has required all encrypted information coming into China to use scrambling technology developed in that country—to which Chinese government officials have access. In a different vein, France has passed laws requiring all organizations doing business on French soil to provide Internet information primarily in French, to help stem the worldwide tide of English.

As long as Internet access and computer ownership are confined to the elite educated classes who have always had ways of obtaining forbidden culture, repressive governments can overlook the problem. But as Internet use widens, stronger efforts at crackdown, both political and cultural, are sure to follow. Meanwhile, organizations working toward the free flow of information across the globe sometimes contend with the contradictions posed by Third World countries defending their cultural heritage. When women in the Philippines and Korea use information from Western feminist organizations to combat the mail-order-bride trade and put pressure on local

governments, are they importing unwanted Western cultural values into their country or accessing important information previously unavailable to them? When black British youth play American rap tunes downloaded from the web on local radio stations, are they erasing British culture or developing it in a new direction?

SOCIAL DISCOURSE: THE DECLINE OF MASS CULTURE

The Internet changes everything. In the concluding chapter we will look at a few ways that traditional media seem to be changing irrevocably under the influence of the new convergent digital technologies, now available everywhere from TV screen to laptop to iPod to cell phone. So much discourse is produced in the media, about the media, that it is hard to summarize the main trends of this recent decade. However, one small strand of change can be discerned that indicates our entry into the era of TV after TV: After decades of being viewed with disdain, mainstream network television is becoming respectable, even admired. This is a sure sign that TV as we know it is dying out. But let's hear it for the most reviled medium of the twentieth century.

The first sign of network television's decline as mass culture and rise as an art form appeared in the pages of the *New York Times Magazine* in 1995. Written by Charles McGrath, respected literary figure and longtime editor of the *New York Times Book Review*, the article's title and header say it all: "The Triumph of the Prime Time Novel: More than movies, theater, or even in some ways books, television drama is a medium for writers. They use its power, weekly, to tell us how we live." (McGrath 1995, 52). McGrath's argument singles out prime-time network television dramas, and his focus on the writer-producer echoes the network's quality strategies of the late 1980s and 1990s: Clearly, they are television's *auteurs,* and this is television's *Cahiers du cinéma* moment. McGrath exhorts those of the intellectual classes who claim that they never watch TV: "If you're telling the truth, though—if you *really* haven't looked lately—you should give it another chance. You're missing out on something. TV is actually enjoying a sort of golden age—it has become a medium you can consistently rely on not just for distraction but for enlightenment" (1995, 52). And all this before HBO's big breakthrough.

McGrath quickly backs down a bit, emphasizing that not all TV hits this mark, and that he is specifically excluding such genres as tabloid talk shows, sitcoms, and prime-time soaps—though he acknowledges faithfully watching *Melrose Place* and *Beverley Hills 99210.* But he also makes it clear that it's not traditional "highbrow" TV he's talking about, such as *Masterpiece Theater,* literary adaptations, and most of PBS. No, it's the weekly network dramatic series. The best ones have attained a whole new status: "call it the prime time novel" (1995, 52). McGrath compares such shows as *ER, Homicide, Law and Order, NYPD Blue,* and *My So-Called Life* to the serials produced by nineteenth-century novelists, Charles Dickens in particular. It's not their incorporation of aural and visual elements that impresses McGrath—in fact, for him the act of imagination required by words on page will always be superior to anything flashy sound effects and visuals can achieve. No, it is the scope for good writing, week after week, year after year. TV is a *writer's* medium, he asserts, more than today's movies or theater, and it is this aspect that has won his regard. Why?

For all its commercialism, television is now less under the thumb of the money men than either the movies or the Broadway theater, if only because with any given episode there's so much less at stake financially. TV, as a result, is frequently more daring and less formulaic than either the stage or the big screen, both of which have to make back huge investments very quickly. Television can afford to take chances, and often enough, it does" (1995, 52, 54)

And, unlike Hollywood and the theater, where the director determines all, in television the writer-producer calls the shots, so to speak. Writers are celebrated, while directors remain anonymous. This leads away from an emphasis on spectacle and visual display for its own sake and toward the kinds of quality attributes literature has always valued: complex characterizations, intricate plots, the "closely observed details" of contemporary life in the classic tradition of American realism along the lines of, as McGrath asserts, novelist Theodore Dreiser or artist Edward Hopper (1995, 54). In this manner, "they frequently attain a kind of truthfulness, or social seriousness, that movies, in particular, seem to be shying away from these days" (1995, 56). Above all, they *talk*: Television is all about dialogue, not spectacle.

McGrath's accolades show certain prejudices that have traditionally worked in the arts and worked against TV. Why do most of his examples focus on the lives and work of middle-aged men? Why necessarily exclude "prime-time soaps" out of hand? What about drama series of the time of considerable daring and inventive writing that focused on and appealed to younger audiences—*Party of Five, The X-Files,* and *Northern Exposure*? One suspects McGrath wouldn't have taken *Buffy the Vampire Slayer* seriously, either, though it would seem to fit his stated criteria. His omission of sitcoms knocks out some of the best programs from the era, like *The Simpsons, Roseanne, Cosby,* and many others—surely the sitcom is just as writer-driven as the drama. What about daring and acclaimed dramedies like *Frank's Place*?

Yet surely this kind of analysis was a move in a different direction. Over the next few years, the ascendancy of pay cable's original, prize-winning programming would prove McGrath right, and the emergence of television series DVDs would expose audiences to the experience of watching their chosen series without the commercial interruptions so often decried by critics. In DVD, a viewer could get a sense of a show's overall scope and through line, watching a number of episodes in one evening rather than drawn out over weeks and months. The emergence of DVRs, or TiVos, allowed the same kind of commercial-free viewing, and equal freedom from the network schedule. Both of these devices raised the possibility of television not as a streaming, continuous, controlled-from-above service, but a kind of bookstore of the air. In the future, we could choose our television viewing experience on our own terms, in our own sweet time. All of this was yet to come when McGrath wrote his article.

A full decade later, the appearance of another essay in the same prestigious magazine heralded a similar change. In an even more provocatively entitled article, "Watching Television Makes You Smarter," author Steven Johnson set out to debunk all the classic bromides about television and its ill effects. "Forget what your mother told you," the subtitle reads, "today's prime time shows are giving you a cognitive workout" (S. Johnson 2005, 54). The article begins with these famous lines from Woody Allen's film *Sleeper,* about a 1970s health food store owner who is just waking up after being suddenly catapulted into the future:

> SCIENTIST A: *Has he asked for anything special?*
>
> SCIENTIST B: *Yes, this morning for breakfast ... he requested something called "wheat germ, organic honey, and tiger's milk."*
>
> SCIENTIST A: *Oh yes, those were the charmed substances that some years ago were felt to contain life-preserving properties.*
>
> SCIENTIST B: *You mean there was no deep fat? No steak or cream pies ... or hot fudge?*
>
> SCIENTIST A: *Those were thought to be unhealthy. (2005, 54)*

To illustrate this "everything bad is good for you" thesis (the title of his book), Johnson describes a recent episode of *24* that in its 44 minutes of screen time contained, by his count, more than 21 central characters and 9 distinct but interweaving narrative threads, all dependent for their meaning on the viewer's understanding of a complex set of details from previous episodes. He argues, like McGrath, that this level of diegetic elaboration comes far closer to a literary classic like George Eliot's *Middlemarch* than to the simplistic episodic television of yesteryear.

Never mind all those theories and opinions that said television was a lowest-common-denominator medium, constantly dumbing down, fit only for dopes and dumbheads, run by greedy corporations whose only interest was giving the masses what they wanted and making them pay. Instead, Johnson argues, "the exact opposite is happening: the culture is getting more cognitively demanding, not less" (2005, 55). He calls this the "Sleeper Curve," and makes the case that such formerly regarded cultural junk food, like frenetic television programs and video games, is actually good for you. It gives us a "cognitive workout"; no matter what the specific content or message of the show, the act of watching television or playing video games requires a kind of intellectual agility that is demanding and instructive.

> Think of the cognitive benefits conventionally ascribed to reading: attention, patience, retention, the parsing of narrative threads. Over the last half-century, programming on TV has increased the demand it places on precisely these mental faculties. (2005, 57)

Like McGrath, Johnson cites *Hill Street Blues* as one of the first of the more complex television dramas. Compare it to *Dragnet* or *Starsky and Hutch*, he challenges. You will see in those shows a single, straight narrative line, in contrast to the multiple, interweaving lines of *HSB* and today's dramas. And Johnson even goes a step beyond McGrath by giving credit to daytime soap operas for innovating this kind of complexity. Even the most disparaged TV form finally gets some respect!

Another aspect of today's television is the absence of what Johnson calls flashing arrows: Those plot devices that draw our attention in an obvious way to what it's important to look at or listen to; the camera that swoops in on an important clue; the line that recaps a key point ("You mean, if we don't find the bomb soon, the whole town could blow up?"). These old devices reduced the amount of mental work the viewer had to do; it was all done for us, so that a child could understand. Compare that to the dense dramas of the current period like *West Wing*, which deliberately flings about lines of dialogue on complex matters so quickly that it's hard to keep up, and comprehension often comes well after the scene has changed. The writers don't expect

us to understand every line, as in the doctor's rushed emergency room consultations over a patient's body in *ER*. These shows challenge us to keep up and to deepen our understanding. As Johnson argues, "Shows like *ER* may have more blood and guts than popular TV had a generation ago, but when it comes to storytelling, they possess a quality that can only be described as subtlety and discretion" (2005, 57).

Amazingly, Johnson goes on to say that, lest we think he's focusing only on relatively highbrow fare, it is in today's reality shows that some of the greatest brain-workout complexity can be found. They're like a video game, he argues: You have to learn a series of complicated rules as you go along, improvising and calculating until something works. The viewing pleasure in such shows as *Survivor, The Apprentice,* and even *Joe Millionaire,* he claims, "comes not from watching other people being humiliated on national television, it comes from depositing other people in a complex, high-pressure environment where no established strategies exist and watching them find their bearings" (2005, 59). We scrutinize the characters for clues to their abilities and characters, we test our social dexterity by analyzing theirs, and we second-guess their motives and decisions. This is a complex narrative stance that makes us work to fill in missing information and forces us constantly to revise our expectations. Compare a TV show, even a not-so-good one, of today to a rerun from the late 1970s, he exhorts us. The seventies program will seem slow, obvious, boring; it just doesn't require as much from its audience as today's programs do.

Why should this be? Johnson points to the need, in today's competitive marketplace, to tie viewers more closely to television programs via re-viewing (on cable and DVD), migrating cross-platform to websites and video games, and generally hooking us on the amount of time and energy we've invested so far. In concluding, he makes a kind of postmillennial, postmodern argument rarely applied to television: Perhaps it's not about the content, but about the form. Maybe we should be less concerned with the number of swear words or references to sex in a program than about its simple versus complex structures or the challenges it presents us and our children. Then, we can begin to make distinctions that don't just dump television in general, or certain kinds of programs as whole, into the trash heap while other media forms, like literature, are not generally subject to such wholesale condemnation. He suggests:

> If your kids want to watch reality TV, encourage them to watch *Survivor* over *Fear Factor*. If they want to watch a mystery show, encourage *24* over *Law and Order*. If they want to play a violent game, encourage *Grand Theft Auto* over *Quake*. Indeed, it might be just as helpful to have a ratings system that used mental labor and not obscenity and violence as its classification scheme for the world of mass culture. (2005, 59)

After all, we don't put labels for violence and suggestive dialogue on the cover of literary classics—and as Marge found out in one *Simpsons* episode, censor "Itchy and Scratchy" and the next thing you know, Michelangelo's sculptures come under suspicion. These suggestions won't sit well with everyone, and few of us would want to abandon content issues altogether. But taking these two articles together, 10 years apart, as harbingers of change in the cultural standing of television, they do indicate a shift in the way we think about the medium that has so deeply affected societies around the world. Is television through changing? Not likely; and in the concluding chapter we take up some prognoses of where we might be heading from here.

CONCLUSION: TV AFTER TV

It's almost impossible to summarize nearly a century of broadcasting history, even one so narrowly focused on just one country and primarily interested in network television. There are so many stories to tell, and our basic structure in this book of context– industry–regulation–programming–social discourse traces just a few of the largest. Yet another narrative that twines through these analytical categories concerns access and control: Who can get access to media products and production? Who controls that access? These questions reflect this book's central concern with power and cultural borders. This will always be a central focus in any study looking at media in a democratic society. Free and widespread access to, and widely dispersed control of, the media—our primary means of expression and representation—are two core values of democracy.

Yet if one trend is discernible over that period of time, not only in broadcasting but in other media as well, it is the trend that sees most of our twentieth-century media emerge with disparate, scattered, largely uncontrolled roots. This early, freer stage— like that of the radio amateurs—is quickly displaced by social and economic forces that centralize control and restrict access. Usually this happens as a by-product of their dispersal. The medium might start out as relatively free space, but only for a very elite group of experts or enthusiasts. Extension to a broader audience brings with it the economics and politics of mass production and distribution: More people are let in on the game, but the ways it can be played are narrowed and restricted, and the number of those who get to make up the rules sometimes becomes very small indeed. Eventually, new technologies emerge to open up some of those restrictions, and the process repeats itself: Winston's law of the "suppression of radical potential" followed, however, by the "return of the repressed." Restrictions spark new innovations, which in turn are restricted, and so on and so on (Winston 2002).

In this book a case is made that broadcasting itself, despite all attempts to control it, has worked inexorably to open up societies and cultures around the world by virtue of its pervasive, one-to-many, information-dispersing qualities. But it's been a long, slow process; in most countries, the advent of broadcasting was seen as an occasion for greater control over the means of expression by the state than had ever been achieved before. Have we reached a stage now, with digital media, during which access and control will open up without narrowing back down again? Many today argue that we

have, despite ominous signs like concentration of corporate ownership and attempts to win tighter control over intellectual property.

One political commentator, Garry Wills, suggested in January 1998 that we might understand the twentieth century's concentration of social, media, and political power in dominant institutions as "a deviation," caused by

> The need to respond to a long-continuing crisis (Depression, World War, cold war), in which elites were given emergency powers. The longer-run progress of the nation was interrupted by this arrangement, delaying certain developments that rushed onto the scene when that interruption ended—long-delayed business dealing with women's rights, with race relations, with child-rearing ideals. (Wills 1998, 36)

Wills concludes with the observation that "The brightest side of American history has been the slow but persistent spread of egalitarianism" and links this to advances in communication technology that "encourage each person to have an equal say in things, to be his or her own expert" (1998, 45). This media egalitarianism still had to work within highly hierarchic frameworks: Some experts were more equal than others. Yet clearly, in Wills's view, barriers had broken down both in U.S. media and in U.S. public life, marking a rupture with the past.

We may now be able to conclude that it was the advent of digital media in the mid-1990s that made possible that last, circular twist back toward a more egalitarian state of access and control. Even as some axes of media and political power seem to be coagulating—the concentration of media ownership and its uses in the political public sphere, perhaps, as many critics would claim—other aspects of media access and control, at least as we have come to understand them, are clearly and quickly opening up. This trend has only accelerated since 1998. Of course, post-September 11 events have also plunged us and the world into another state of crisis, and it remains to be seen whether forces of state security and corporate interest will be sufficient to overwhelm even the current digital revolution's power to evade capture and control. The battle of the satellite TV channels, discussed in Chapter 12, gives us some idea of how this struggle will be staged in the twenty-first century. Yet the current state of file sharing on the Internet reveals some very different scenarios that may just change things for good.

Connection Geeks Supreme

In June of 2005, media observers nervously watched the Supreme Court for signs as to how the ominous *MGM v. Grokster* decision might come down. This case was yet another effort by big media corporations to enforce copyright restrictions on the web, specifically against file-sharing services. The 2001 Napster case had shut down sites of its type—those that actively collected and stored, illegally, thousands of copyrighted recordings. In its wake, several different alternatives developed, including legal, for-pay sites like Apple's iTunes, which received permission to store musical selections and charge users a fee. But other alternatives, sites like Grokster and KaZaa, set themselves up more as file-sharing

facilitators: They didn't themselves compile data banks of music and other copyrighted material—like movies and television programs, increasingly available on the web as high-bandwidth connections became more widely available—but sold a program that made file sharing easy. Grokster's website invited people to join its peer-to-peer (P2P) community of happy file sharers: "Publish and share your music and movies with the world"!—but all from their own individual computers. Despite the warning at the bottom of the web page—"Purchase of Grokster Pro is not a license to upload or download copyrighted material. Grokster urges you to respect copyright and share responsibly"—clearly Grokster's business depended on people purchasing a produce and taking their fair-use rights much further than coporate giant MGM and associates such as the Recording Industry Association of American (RIAA) or the Motion Picture Association of America (MPAA) thought was proper. MGM sued; two lower courts found in Grokster's favor based on the 1986 Betamax case, which had ruled that VCR manufacturers could not be held liable for what users of their technology did with the tapes they had legally recorded.

But the corporations' appeal to the Supreme Court produced a decision that, while not so good for Grokster and its codefendant, Streamcast, did clearly point to an open avenue of great potential. Jon Pareles of the *New York Times* (2005) called it a "don't ask, don't tell" standard: As long as users don't themselves profit from sharing files on the web, and as long as they don't solicit any kind of information about what those with whom they share are doing with the files, the "geek culture" of the Internet could proceed unabated. Geeks like to trade files and share software and information for no profit at all, just for fun and to see if it can be done. As Pareles put it:

> The court did not give the movie and recording businesses much ammunition to attack the Robin Hoods of the Internet: those software geeks and culture fans who really just want to share. They are online right now building Web sites that don't make a dime and editing "mp3 blogs"—Web page collections of downloadable songs. They hook people up, basically because they can and because people want access to art. (2005, B1)

Even before the decision, versions of software like KaZaa Lite and BitTorrent were circulating on the web; such programs stripped out the ads and spyware, eliminated the payment, and just let people share. With the Supreme Court's tacit acceptance of this geek aspect of Internet culture, the corporations' insistence on a model of copyright created in the last century seemed increasingly perverse and self-defeating. And, as many had pointed out, what the media corporations were asking for was actually a higher level of copyright protection than they had levied on previous new technologies like radio—that is, payment to performers and recording companies as well as song writers. In previous cases such as radio and VCRs, the corporations, after figuring out a new way to make money on the alternative uses pioneered by fans and geeks, discovered whole new revenue streams—like selling videotapes directly to consumers and using radio as a giant record-promotion device.

A whole new universe of user-created content is, some argue, changing the nature of the web itself. The introduction of podcasting programs, designed to allow iPod and other MP3 owners to automatically update their files from sites on which anyone who cared to could post their own aural "blogs," took the media world by storm in 2004–2005. Podcasts could be anything—whole musical programs put together by Sally down the block from her

living room; daily musings on politics or art; comic routines and humorous dialogues about travel, or books, or dogs, or what the participants had for breakfast that day; sexual dialogues; opinionated rants; audio art. Or, they could be additional outlets for voices already heard in other venues; both conservative radio-TV commentator Rush Limbaugh and liberal humorist-commentator Al Franken started their own podcasts, based on their radio programs. This was a kind of radio without the usual licensing, regulation, technological, or even time and space restrictions with which the previous media had grappled. Its potential for variety and diversity seems limitless, and sites that gather and allow sophisticated searches make it easily available—a "from many, to many" medium rather than the "from one to many" model so prevalent during previous centuries.

The ability of the Internet to bring people together without intervening institutions played out across the web. As John Markoff argues, "the abundance of user-generated content—which includes online games, desktop video and citizen journalism sites—is reshaping the debate over file sharing" (2005, C1). As one example, the article profiles Yahoo's design of a new "social search engine" that allows groups of users to share the results of web searches and then distribute these rankings to a wider community. This method, an alternative to the "most hits overall" ranking system used by Google and others, allows those with a specific interest to highlight content that might remain obscure and hard to find under the older system. It helps to solve the problem of making materials available to a widely disparate audience without inserting institutionalized points of control. As Jonathan I. Schwartz of Sun Microsystems said, "The really interesting thing about the network today is that individuals are starting to participate. The endpoints are starting to inform the center" (Markoff 2005, C5). Another example of this trend is the growing web-based encyclopedia Wikipedia, which compiles information sent in by users rather than taking the expert-driven, top-down approach of most encyclopedias. The information may be incomplete; it may be wrong; but it often brings together material in a way that more official sources would not dream of duplicating. And it encourages an attitude of skeptical analysis and contributory knowledge that inspires further research and critical thinking. Yahoo calls this a "folksonomy" rather than the traditional taxonomy organization of information. Said Katarina Fake of Flickr, a photo-sharing technology, "We're creating a culture of generosity" (Markoff 2005, C5).

PEER TO PEER

To take another example, web radio has provided a home for individual broadcasters by the thousands, people who would formerly have been regarded as "pirates" and kicked off the airwaves, fined, and sometimes even jailed. Under the old system, many individuals and small groups, frustrated with the lack of access to U.S. airwaves, set up unauthorized radio stations. The FCC patrols the spectrum for these pirates, often raiding the stations, seizing equipment, and levying fines against the operators. Nevertheless, because there were few other alternative ways of finding an audience, pirate radio has been an ongoing phenomenon in this country and in others. Mbanna Kantako has operated Zoom Black Magic Liberation Radio from his housing project apartment in Springfield, Illinois, since 1986, broadcasting a mix of music, news from the streets,

political discussion, and community information. His 1-watt station covers only a few square blocks, but because of Springfield's highly segregated housing patterns, he can reach three fourths of the local black community. He calls his station "an important act of social protest" (Harrison 1990). Free Radio Berkeley, operated by Stephen Dunifer, could be heard on the air in California from 1993 until the FCC closed it down in 1998. Dunifer not only ran his own pirate station, but built transmitters and offered advice to others interested in low-power radio. Dunifer and his cohorts are among the founding members of the micropower broadcasting movement, dedicated to encouraging the proliferation of small-scale "people's radio." He has helped to establish pirate stations in Mexico City (Radio TeleVerdad), Guatemala, El Salvador, Chiapas, and Haiti.

As radio consolidation swept the country in the mid-nineties, the number of illicit broadcasters rose into the hundreds. Despite fines and frequent moves forced by FCC investigation, Kantako, Dunifer, and others continue to resist what they perceive as FCC attempts to restrain democracy and access to the means of communication. Others who have defied the FCC in speaking openly about their pirate stations are Mario Hernandez in San Marcos, Texas, and Doug Brewer in Tampa, Florida. Both men used their stations to bring their communities the music, talk, and local color currently unavailable on local commercial stations.

All of these broadcasters specialized in the kind of individual, politically subversive, culturally transgressive content the FCC has long sought to repress on the airwaves. They believe in the right to broadcast as an extension of the right of free speech. When in 1995 a judge in California denied, on First Amendment grounds, the FCC's injunction to shut down Free Radio Berkeley, the agency's lawyer claimed that the decision would unleash "anarchy and chaos" (Boudreau 1996). The FCC lawyer also claimed that "the public interest would not be served by licensing a low-power FM broadcast service" (Boudreau 1996). Justification? Technological interference. With the new LPFM legislation, that argument has been ruled no longer valid. However, the new low-power assignments will not be authorized to anyone who has previously ignored FCC orders to close down unlicensed stations or who has been charged with illegal broadcasting. These pioneering pirates of the airwaves will have to remain illicit—or, they can switch to webcasting. An alternative, though imperfect, is available.

Another category of "geek culture" on the Internet is the huge and growing arena of "citizen journalism." With roots in the underground papers of the 1960s, the illicit *samizdat* media circulated in the Soviet Bloc countries pre-1989, and grassroots journalism everywhere, the Internet has provided the opportunity for such "people's reporting" to expand exponentially. "Blogs" (sites for citizen reporting, opinions, and commentary, linked together by subjects and circulated informally), chat rooms, message boards, wikis (contributory compilations of information) and other sites sprang up by the thousands, aided by new mobile computing devices such as Blackberries and, increasingly, cell phones. South Korea's "OhMyNews" service became one of the best known in the world when it emerged as a voice for oppositional politics and became a considerable power in that country. By the 2004, bloggers had become recognized by both Democratic and Republican parties in the U.S. presidential campaign reporting. Everyone could have his or her own blog, and it seemed like most people did.

Because the Internet allows and in fact encourages this kind of exchange from ordinary person to ordinary person, cutting out the middleman, it resists attempts to limit access and assert control, even by giant media corporations intent on protecting their franchises. Radio amateurs had the same vision; but their use of public spectrum space gave controlling forces—regulators operating on the principle of the greater public interest—the chance to step in, make rules, and drive out the radical potential. Other, less-restricted media, like print and film, could be produced at ground level; but distribution was costly and restricted. The cultural arena of music might be the best model for a less-centralized media form; despite all efforts to mass-produce, copyright, limit access, and maximize profits, music is created and performed at all levels of society and across all cultures; and because of this, it has remained one of the most responsive forms when it comes to reflecting cultural diversity and social change. It is no coincidence that many of our social panics have come from musical sources: jazz, crooners, rock 'n' roll, punk, rap, hip-hop. And it should come as no surprise that it is music-file sharing on the Internet that sparked the first major content control disputes in this new medium. But the Internet promises more. And we should not overlook the fact that Internet access and use depend on access to computers, online services, and a certain degree of know-how. There is a digital divide; but as we have seen, it doesn't always cut across social categories in the way we might anticipate. Publicly funded or mandated projects, such as the U.S. government's E-rate, have placed Internet access into widely dispersed hands. So has the upsurge of cybercafés and low-cost wireless computer networking around the globe.

The Outlook

Of course, there is a negative potential to all this. Surveillance and invasion of privacy are also made easier than ever before. Viruses and identity theft became the growing threats of the new millennium, both thriving on the shareware culture of the Internet. Yet as the new millennium gets under way, we are witnessing a very rich period in U.S. and global media, with a plethora of channels, media, products, and voices to choose from. Despite disturbing aspects, including the tendency for power to concentrate at the top in global industry mergers and consolidations, here on the ground we are experiencing an exponential breakthrough in the quantity, diversity, inclusiveness, and even quality of the media that surround us. However, we should remain mindful of the disparities and inequities that such abundance can conceal. New technologies do not automatically take care of social problems; indeed, they tend to become the heart of the next social problem, unless we keep our historical perspective firmly in mind. As economic power and political force seek to find their own self-interested path through the maze of new opportunities, many people and groups are working to ensure that access, choice, diversity, and freedom continue to characterize the media environment in which we live and breathe. This is not a dry, dead process that can be neatly contained within the covers of a history book: It's what you do when you put this book down, how you use the knowledge you have obtained, and how you create history yourself. The history of the future is in your hands. Only connect.

Bibliography

Alter, Jonathan. "America Goes Tabloid." *Newsweek*, December 26, 1994: 34.

Ang, Ien. *Watching Dallas: Soap Opera and the Melodramatic Imagination*. London: Methuen, 1985.

Appleby, Joyce, Lynn Hunt, and Margaret Jacob. *Telling the Truth About History*. New York: Norton, 1994.

Aufderheide, Patricia. *Communications Policy and the Public Interest*. New York: Guilford, 1999.

Barlow, William. *Voice Over: The Making of Black Radio*. Philadelphia: Temple University Press, 1999.

Barnouw, Erik. *A History of Broadcasting in the United States: The Golden Web* (vol. 2). New York: Oxford University Press, 1968.

———. *A History of Broadcasting in the United States: The Image Empire* (vol. 3). New York: Oxford University Press, 1970.

Battaglio, Stephen. "UPN Catches Fox." *Arizona Republic*, February 19, 1998: C8.

Battema, Douglas. "The Airwaves Meet the National Pastime: Baseball and Radio in the 1920s and 1930s." In *The Cooperstown Symposium on Baseball and American Culture*, edited by Peter M. Rutkoff and Alvin Hall. Jefferson, NC: Macfarland, 2000.

———. "'The Picture Is Not Black …': TV Discourse in the African American Press, 1948–1953." Communication Arts 950 Seminar, University of Wisconsin–Madison, Spring 1996.

Baxter, Kevin. "As Telemundo Turns." *Los Angeles Times*, December 20, 1998: B1.

Becker, Ron. "Prime Time Television in the Gay 90s: Network Television, Quality Audiences, and Gay Politics." In *Connections: A Broadcast History Reader*, edited by Michele Hilmes, 323–42. Belmont, CA: Wadsworth, 2001.

Bergman, Anne. "Persistent Pledge Drives Show System the Coin." *Variety*, November 1, 1999: 74.

Biressi, Anita, and Heather Nunn. *Reality Television: Realism and Revelation*. London: Wallflower, 2004.

Boddy, William. *Fifties Television*. Urbana: University of Illinois Press, 1990.

Bodroghkozy, Aniko. *Groove Tube: Sixties Television and the Youth Rebellion*. Durham, NC: Duke University Press, 2001.

Boudreau, John. "Battle of the Bandwidth in Berkeley," *Washington Post*, March 15, 1996: A3.

Brandon, James. "Shooting the Messenger," *Arab Media Watch*, January 11, 2004. http://www.arabmediawatch.com/modules.php?name=News&file=print&sid=1221

Broadcasting Advertising. "We Pay Our Respects To: Bertha Brainard." September 1, 1937.

Brown, Duncan H. "The Academy's Response to the Call for a Marketplace Approach." *Critical Studies in Media Communication* 11, no. 3 (September 1994).

Brown, Merrill. "FCC Changes in Broadcasting Rules Pledged," *Washington Post*, June 13, 1981.

Brunsdon, Charlotte. "Life-Styling Britain: The 8-9 Slot on British Television." In *Television After TV: Essays on a Medium in Transition*, edited by Lynn Spigel and Jan Olsson, 75–79. Durham: Duke University Press, 2004.

Business Week. "Are Paramount and Warner Looney Tunes?" January 9, 1995: 46.

Caldwell, John. "Convergence Television: Aggregating From and Repurposing Content in the Culture of Conglomeration." In *Television After TV: Essays on a Medium in Transition*, edited by Lynn Spigel and Jan Olsson, 41–74. Durham: Duke University Press, 2004.

"Campaign Notes: Norman Lear Group Opens $1 Million Drive." *New York Times*, September 21, 1984: B12.

Carnegie Commission on Educational Television. *Public Television: A Program for Action*. New York: Harper & Row, 1967.

Carney, Dan. "Congress Fires Its First Shot in Information Revolution." *Congressional Quarterly Weekly Report*, February 3, 1996: 289+.

Carson, Brenda. "Boxed Into a Corner." *The Scotsman*, August 13, 1999.

Carter, Bill. "A Cable Show Networks Truly Watch," *New York Times*, March 25, 1999: E1.

"Channel Surfing Through U.S. Culture in 20 Lands," *New York Times*, January 30, 1994: 30+.

Classen, Steve. "Broadcast Law and Segregation: A Social History of the WLBT-TV Case." Ph.D. dissertation, University of Wisconsin–Madison, 1995.

Cohen, Lizbeth. *Making a New Deal: Industrial Workers in Chicago, 1919–1952*. New York: Cambridge University Press, 1990.

Compaine, Benjamin. "The Media Monopoly Myth," 2005. http://www1.primushost.com/~bcompain/

"Consolidation in Radio Ownership Was a Topic of Speech Thursday by FCC Comr. Tristani to Texas Association of Broadcasters," *Communications Daily*, September 4, 1998: 1.

Coontz, Stephanie. *The Way We Never Were: American Families and the Nostalgia Trap*. New York: Basic, 1992.

Curtin, Michael. *Redeeming the Wasteland: Television Documentary and Cold War Politics*. New Brunswick, NJ: Rutgers University Press, 1995.

D'Acci, Julie. *Defining Women: Television and the Case of Cagney & Lacey*. Chapel Hill: University of North Carolina Press, 1994.

Davila, Arlene. *Latinos Inc.: The Marketing and Making of a People*. Berkeley: University of California Press, 2001.

Dewey, John. *Democracy and Education*. New York: Macmillan, 1915.

"Does Ownership Matter in Local Television News: A Five-Year Study of Ownership and Quality," Washington, D.C.: Project for Excellence in Journalism, April 29, 2003.

Douglas, Susan. *Inventing American Broadcasting, 1899–1922*. Baltimore: Johns Hopkins University Press, 1987.

———. *Where the Girls Are: Growing Up Female with the Mass Media*. New York: Random House, 1994.

———. *Listening In: Radio and the American Imagination, from Amos 'n' Andy and Edward R. Murrow to Wolfman Jack and Howard Stern*. New York: Times Books, 1999.

Edwards, Jim. "No Such Thing as Too Much Inside TV's Promo Wardrobe." *Brandweek*, May 23, 2005: 14.

Ernst, Robert. *Weakness Is a Crime*. Syracuse, NY: Syracuse University Press, 1991.

Ewen, Stuart, and Elizabeth Ewen. *Channels of Desire: Mass Images and the Shaping of American Consciousness*, 2nd ed. Minneapolis: University of Minnesota Press, 1992.

Farley, Ellen, and William K. Knoedelseder Jr., "Prime-Time Girls" *Washington Post*, February 19, 1978: G1.

Federal Communications Commission (FCC). "Fairness Report," 102 F.C.C.2d 142, 246 (1985).

Federal Radio Commission (FRC). *Third Annual Report of the Federal Radio Commission to the Congress of the United States Covering the Period from October 1, 1928 to November 1, 1929*. Washington, DC: U.S. Government Printing Office, 1929.

Feeney, Matt. "*This* is SportsCenter?" *Slate*, March 31, 2004.

Fones-Wolf, Elizabeth. "Creating Favorable Business Climate: Corporations and Radio Broadcasting, 1934 to 1954." *Business History Review* 73.2 (Summer 1999): 221+.

Fornatale, Peter, and Joshua E. Mills. *Radio in the Television Age*. Woodstock, NY: Overlook, 1980.

Forster, E. M. *Howards End*. London: Arnold, 1973.

Fortune. "Radio I: A $140,000,000 Art." May 1938a: 47+.

———. "Radio II: A $45,000,000 Talent Bill." May 1938b: 55+.

Fowler, Gene, and Bill Crawford. *Border Radio*. Austin: Texas Monthly Press, 1987.

Fowler, Mark S., and Daniel L. Brenner. "A Marketplace Approach to Broadcast Regulation." *Texas Law Review* 60 (1982): 207–257.

Frau-Meigs, Divina. " 'Cultural Exception,' National Policies, and Globalisation: Imperatives in Democratization and Promotion of Contemporary Culture." *Cadernes de CAC* 14 (2002).

Freeman, Michael. *ESPN: The Uncensored History*. Dallas: Taylor Publishing, 2000.

Garofalo, Reebee. "Crossing Over: 1939–1989." in *Split Image: African Americans in the Mass Media*, edited by Jannette Dates and William Barlow, 57–124. Washington, DC: Howard University Press, 1990.

Gilbert, James. *A Cycle of Outrage: America's Reaction to the Juvenile Delinquent in the 1950s*. New York: Oxford University Press, 1986.

Gitlin, Todd. *Tnside Prime Time*. New york: Pantheon, 1985.

—— "The Clinton-Lewinsky Obsession." *Washington Monthly*, December 1998: 13+.

Gnoffo, Anthony Jr. "Warner Finds that Batman Pays Off More Ways Than One," *Toronto Star*, August 7, 1989: B3.

Graser, Mark. "Product Placement Spending Poised to Hit 4.25 billion in '05." *Advertising Age*, April 4, 2005: 16.

Gray, Herman. *Watching Race: Television and the Struggle for "Blackness."* Minneapolis: University of Minnesota Press, 1995.

Greene, Herndon. "What Is Woman's Place in Broadcasting?" *Radio News*, November 1927: 477.

Hangen, Tona. "Redeeming the Dial: Evangelical Radio and Religious Culture, 1920–1960." Ph.D. dissertation, Brandeis University, 1999.

Haralovich, Mary Beth. "Sitcoms and Suburbs: Positioning the 1950s Homemaker." In *Private Screenings: Television and the Female Consumer*, edited by Lynn Spigel and Denise Mann, 111–41. Minneapolis: University of Minnesota Press, 1992.

Harrison, Eric. "Out of the Night: Mbanna Kantako," *Los Angeles Times*, November 19, 1990: E1.

Haskell, Molly. *From Reverence to Rape: The Treatment of Women in the Movies*. New York: Holt, Rinehart and Winston, 1974.

Henry, Matthew. "The Triumph of Popular Culture: Situation Comedy, Postmodernism and *The Simpsons*." *Studies in Popular Culture* 17.1 (1994): 85–99. Reprinted in *Critiquing the Sitcom*, edited by Joan Morreal. New York: Syracuse University Press, 2002.

Hills, Matt. *Fan Cultures*. London: Routledge, 2002

Hilmes, Michele. *Radio Voices: American Broadcasting 1922–1952*. Minneapolis: University of Minnesota Press, 1997.

———. *Hollywood and Broadcasting: From Radio to Cable*. Urbana: University of Illinois Press, 1990a.

Hodges, Ann. "Accepting the Ultimate Challenge." *Houston Chronicle*, January 18, 2000: 6+.

Home Box Office. *Sex and the City: A Farewell*. 2004.

Horten, Gerd. "Radio Days on America's Home Front." *History Today* 46.9 (1996): 47.

James, Caryn. "Addicted to a Mob Family," *New York Times*, March 25, 1999: E1.

Janis, Lauren. "ESPN: Home Field for Sports Addicts." *Columbia Journalism Review*, 40, no. 4 (November–December 2001): 96–97.

Jenkins, Henry. *Textual Poachers: Television Fans and Participatory Culture*. New York: Routledge, 1992.

———. "Interactive Audiences?" In *The New Media Book*, edited by Dan Harris, 157–170. London: British Film Institute, 2002.

Jenkins, Keith. *Re-Thinking History*. New York: Routledge, 1991.

Johnson, Derek. "24's Story World, Cultural Citizenship, and the Public Sphere." Unpublished seminar paper. University of Wisconsin–Madison, 2005.

Johnson, Reed. "World News from a New Point of View." *Los Angeles Times*, June 19, 2005: E1.

Johnson, Steven. "Watching Television Makes You Smarter," *New York Times Magazine*, April 24, 2005: 54+.

Jorisch, Avi. "Hizbullah TV, 24/7." *The Middle East Quarterly*, Winter 2004.

Kackman, Michael. *Citizen Spy: Television, Espionage, and Cold War Culture*. Minneapolis: University of Minnesota Press, 2005.

Keith, Michael C. *Voices in the Purple Haze: Underground Radio and the Sixties*. Westport, CT: Praeger, 1997.

Kompare, Derek. *Rerun Nation: How Repeats Invented American Television*. New York: Routledge, 2004.

Kumar, Shanti. "An Indian Personality for Television?" *Jump Cut* 43 (2000): 92–101.

Labaton, Stephen. "The Government's First Study on Discrimination in Radio Advertising Finds a Lot of Fodder." *New York Times*, January 14, 1999: C4.

Lasswell, H. D. *Propaganda Techniques in the World War*. New York: Knopf, 1927.

Ledbetter, James. *Made Possible By . . . : The Death of Public Broadcasting in the United States*. New York: Verso, 1997.

Lenthall, Bruce. "Critical Reception: Public Intellectuals Decry Depression-Era Radio, Mass Culture, and Modern America." In *Radio Reader*, edited by Michele Hilmes and Jason Loviglio. New York: Routledge, 2001.

Levine, Lawrence. *Highbrow/Lowbrow: The Emergence of Cultural Hierarchy in America*. Cambridge, MA: Harvard University Press, 1988.

Lewis, Lisa, ed. *The Adoring Audience: Fan Culture and Popular Media*. New York: Routledge, 1992.

Lin, Szu-Ping. "Prime Time Television Drama and Taiwanese Women." Ph.D. dissertation, University of Wisconsin–Madison, 2000.

Linn, Susan E. and Aluin F. Poussaint, "The Trouble with Teletubbies," *The American Family Prospect* (May/June 1999): 18+.

Lotz, Amanda. "Sex and the City." In *Encyclopedia of Television*, 2nd ed., edited by Horace

Newcomb, 2066–2088. Chicago: Fitzroy Dearborn, 2004.

Loviglio, Jason. "Blasting at the Borders: Dr. Brinkley and the Talking Cure." Paper presented at the American Studies Association Conference, November 1995, Washington, DC.

Manly, Lorne. "Networks and the Outside Producer: Can They Co-Exist?" *New York Times*, June 20, 2005: C1+.

Marchand, Roland. *Advertising the American Dream—Making Way for Modernity*. Berkeley: University of California Press, 1985.

Markoff, John. "By and for the Masses," *New York Times*, June 29, 2005, C1, 5.

Marks, Alexandra. "If TV Networks Are Dinosaurs, Then This Is Still the Jurassic Age," *Christian Science Monitor*, October 23, 1995: 13.

Martin, Denise. "Cable's Neat Sweep," *Daily Variety*, December 9, 2004: 6.

McChesney, Robert. *Telecommunications, Mass Media, and Democracy: The Battle for Control of U.S. Broadcasting; 1928–1935*. New York: Oxford University Press, 1994.

——"Policing the Thinkable." October 25, 2001. http://www.opendemocracy. net/debates/article.jsp?id=8&debateId=24&articleId=56

McClain, Buzz, and Ed Hulse. "TV Is Hotter than Ever ... On DVD, That Is," *Variety*, December 2004 (Special DVD Edition), 19.

McCracken, Allison. "'God's Gift to Us Girls': Crooning, Gender, and the Re-Creation of American Popular Song, 1928–1933," *American Music* (Winter 1999).

McGrath, Charles. "The Triumph of the Prime Time Novel," *New York Times Magazine*, October 22, 1995: 52+.

McMullen, Frances Drewry. "Bertha Brainard, Radio Pioneer." *Woman's Journal*, November 1928: 18–19.

"The Media Business: What Is Playing in the Global Village." *New York Times*, May 26, 1997: C9.

Meehan, Eileen. "Why We Don't Count." In *The Logics of Television*, edited by Patricia Mellencamp. Bloomington: Indiana University Press, 1990.

Meisler, Andy. "Not Even Trying to Appeal to the Masses," *New York Times*, October 4, 1998: 45+.

Mittell, Jason. *Genre and Television: From Cop Shows to Cartoons in American Culture*. New York: Routledge, 2004.

Moran, Albert. *Copycat TV: Globalisation, Program Formats, and Cultural Identity*. Luton, UK: University of Luton Press, 1998.

Mosely, Rachel. "The 1990s: Quality or Dumbing Down?" In *The Television History Book*, edited by

Michele Hilmes, 103–107. London: British Film Institute, 2003.

Newman, Kathy M. "Poisons, Potions, and Profits: The Consumer Movement and the Antidote to Radio Advertising in the 1930s." In *Radio Reader*, edited by Michele Hilmes and Jason Loviglio. New York: Routledge, 2001.

Ouellette, Laurie. *Viewers Like You? How Public Television Failed the People*. New York: Columbia University Press, 2002.

Pach, Chester. "And That's the Way It Was: The Vietnam War on the Network Nightly News." In *Connections: A Broadcast History Reader*, edited by Michele Hilmes. Belmont, CA: Wadsworth, 2001.

Pareles, Jonathan. "The Court Ruled, so Enter the Geeks," *New York Times*, June 29, 2005, B1, 9.

People Weekly. "Reality Checks," March 22, 1993: 61.

Peyser, Mark, with Yahlin Chang. "The Sopranos: Making a Mob Hit." *Newsweek*, January 17, 2000: 68+.

"Polymorphous Perversity." *National Review*, November 27, 1995, 18+.

QST. "This Word 'Citizen.'" (July 1921): 24.

Reynolds, Gregg. "Alternative TV." *Christian Century* 120, no. 8 (19 April 2003): 8.

Riding, Alan. "A Common Culture (From the U.S.A.) Binds Europeans Ever Closer," *New York Times*, April 26, 2004: C1+.

Rosenbaum, David E. "Republicans Like Both Previews and Reruns," *New York Times*, December 11, 1994, 4:1.

Rosenberg, Bernard, and David Manning White, eds. *Mass Culture: The Popular Arts in America*. Glencoe, IL: Free Press, 1957.

Rosenfeld, Megan. "The Battle for Prime-Time Decency," *Washington Post*, February 3, 1981: B1.

Rothenberg, Randall. "Time-Warner Bid for Global Marketing," *New York Times*, March 6, 1989: D11.

Ryan, James. "Hollywood Puts Out a Welcome Mat in Cyberspace," *New York Times*, November 16, 1996: 21+.

Salamon, Julie. "Logo, a New Gay Channel, Looks 'Beyond Sexuality,'" *New York Times*, June 28, 2005, B1, 8.

Sandler, Kevin. "Programming Strategies in the New Millennium." In *NBC: America's Network*, edited by Michele Hilmes, Berkeley: University of California Press, 2006.

Sarnoff, David. "Possible Social Effects of Television." In *Annals of the American Academy*, edited by Herman Hettinger. Vol. 213 (January 1941): 145–152.

Savage, Barbara. *Broadcasting Freedom: Radio, War, and the Politics of Race, 1938–1948*. Chapel Hill: University of North Carolina Press, 1999.

Sewell, Philip. "From Discourse to Discord: 'Quality' Television and the 'Dramedies' of 1987." Unpublished seminar paper, University of Wisconsin–Madison, 1998.

Shales, Tom. "Beyond 'Benson,'" *Washington Post*, November 30, 1979b: C1.

———. "Bored and Offended, Folks?" *Washington Post*, February 19, 1978: G1.

———. "Fantasyland Reality," *Washington Post*, January 3, 1979a: B1.

———. "Hill Street Blues: TV's Embattled Precinct," *Washington Post*, March 8, 1981: M1.

———. "Live and Passionate, It's Saturday Night," *Washington Post*, May 31, 1979c: D1.

———. "The New Season: Pryor's Angry Humor, the Savagery of Soap," *Washington Post*, September 13, 1977: B1.

———. "Talk Is Cheap," *Washington Post*, November 18, 1988.

Sharp, Jeremy M. "The Al-Jazeera News Network: Opportunity or Challenge for U.S. Foreign Policy in the Middle East?" *Congressional Research Service*, July 23, 2003. http://fpc.state.gov/documents/organization/23002.pdf

Sivulka, Juliann. *Soap, Sex, and Cigarettes: A Cultural History of Advertising*. Belmont, CA: Wadsworth, 1998.

Smith, Ralph Lee. *The Wired Nation*. New York: Harper & Row, 1972.

Sontag, Deborah. "I Want My Hyphenated-Identity MTV," *New York Times*, June 19, 2005, B1, 29.

Sterling, Christopher H., and John M. Kitross. *Stay Tuned: A Concise History of American Broadcasting*, 3rd ed. Mahwah, NJ: Erlbaum, 2002.

Streeter, Thomas. "The Cable Fable Revisited: Discourse, Policy, and the Making of Cable Television." *Critical Studies in Mass Communication* 4.2 (June 1987): 174–200.

Swerdlow, Joel. "The Great American Crusade in Televisionland," *Washington Post*, June 7, 1981: K1.

Szadkowski, Joseph. "Music Gets on the Net," *Insight on the News*, December 20, 1999: 32.

Thomson, Lori. "Illegal Cable TV Thriving in Taiwan," *San Francisco Chronicle*, April 3, 1991: A13.

Trouillot, Michel-Rolph. *Silencing the Past: Power and the Production of History*. Boston: Beacon, 1995.

UCLA Online Institute for Cyberspace Law and Policy. "The Digital Millennium Copyright Act." 8 February 2001. http://www.gseis.ucla.edu/iclp/dmca1.htm

U.S. Commission on Civil Rights. "Window Dressing on the Set: Women and Minorities in Television." Washington, DC: Commission on Civil Rights, 1977.

Wang, Jennifer. "'Everything's Coming Up Rosie': Empower America, Rosie O'Donnell, and the Construction of Daytime Reality," *Velvet Light Trap* (Spring 2000).

———. "49 Million Serial Listeners Can't Be Wrong: Gender Alternatives and Industrial Imperatives in World War II." Paper presented at the Society for Cinema Studies Conference, April 1999, West Palm Beach, FL.

Warren, Donald I. *Radio Priest: Charles Coughlin, the Father of Hate Radio*. New York: Free Press, 1996.

Waters, Harry F. "The Leer Boat," *Newsweek*, January 2, 1978: 65.

———. "Trash TV," *Newsweek*, November 14, 1988: 72.

———. "Who Shot that Nice Mr. Ewing?" *Newsweek*, November 17, 1980: 66.

Werbach, Kevin. "The Real Michael Powell," *Slate*, February 19, 2003.

Wheeler, Mark. "Supranational Regulation: Television and the European Union." *European Journal of Communication* 19, no. 3 (2004): 349–369.

Wiebe, Robert H. *The Search for Order, 1877–1920*. New York: Hill and Wang, 1967.

Wilke, John, Mark N. Vamos, and Mark Maremont. "Has the FCC Gone Too Far?" *Business Week*, August 5, 1985.

Wills, Garry. "Whatever Happened to Politics? Washington Is Not Where It's At." *New York Times Magazine*, January 25, 1998: 26+.

Winston, Brian. "How Are Media Born?" In *Connections: A Broadcasting History Reader*, edited by Michele Hilmes. Belmont, CA: Wadsworth, 2002.

"Yahoo Brings Pepsi Smash Back on the Web." 5 June 2005. http://www.strategiy.com/mnews.asp?id=20050605140608

"The Year of the Sundance Women." *USA Today*, January 20, 2000: 1D.

Zehme, Bill. "The Only Real People on TV," *Rolling Stone*, June 28, 1990: 40–42+.

Zinn, Howard. *A People's History of the United States*. New York: Harper, 1995.

Zook, Kristal Brent. *Color by Fox: The Fox Network and the Revolution in Black Television*. New York: Oxford University Press, 1999.

Index

399